THE GONZAGA OF MANTUA
AND
PISANELLO'S ARTHURIAN FRESCOES

JOANNA WOODS-MARSDEN

The Gonzaga of Mantua
and
Pisanello's Arthurian Frescoes

PRINCETON, NEW JERSEY

PRINCETON UNIVERSITY PRESS

MCM · LXXXVIII

COPYRIGHT © 1988 BY PRINCETON UNIVERSITY PRESS
PUBLISHED BY PRINCETON UNIVERSITY PRESS, 41 WILLIAM STREET
PRINCETON, NEW JERSEY 08540
IN THE UNITED KINGDOM: PRINCETON UNIVERSITY PRESS, GUILDFORD, SURREY

WOODS-MARSDEN, JOANNA, 1936–
THE GONZAGA OF MANTUA AND PISANELLO'S ARTHURIAN FRESCOES.

BIBLIOGRAPHY: P.
INCLUDES INDEX.
1. PISANELLO, 1395–CA. 1455—CRITICISM AND INTERPRETATION.
2. MURAL PAINTING AND DECORATION, ITALIAN—ITALY—
MANTUA—ATTRIBUTION. 3. MURAL PAINTING AND DECORATION,
RENAISSANCE—ITALY—MANTUA—ATTRIBUTION. 4. ARTHURIAN
ROMANCES IN ART. 5. GONZAGA, LUDOVICO, MARCHESE,
1414–1478—ART PATRONAGE. 6. PALAZZO DUCALE
(MANTUA, ITALY) I. TITLE.
N6923.P497W66 1988 758'.980880351'094528 88–31631
ISBN 0–691–04048–6 (ALK. PAPER)

THIS BOOK HAS BEEN COMPOSED IN LINOTRON BEMBO

CLOTHBOUND EDITIONS OF
PRINCETON UNIVERSITY PRESS BOOKS
ARE PRINTED ON ACID-FREE PAPER, AND
BINDING MATERIALS ARE CHOSEN FOR
STRENGTH AND DURABILITY. PAPER-
BACKS, ALTHOUGH SATISFACTORY FOR
PERSONAL COLLECTIONS, ARE NOT
USUALLY SUITABLE FOR
LIBRARY REBINDING

PRINTED IN THE UNITED STATES OF
AMERICA BY PRINCETON UNIVERSITY PRESS
PRINCETON, NEW JERSEY

. . . un' arte chessi chiama dipingnere, che conviene avere fantasia e hoperazione di mano, di trovare cose non vedute, chacciandosi sotto ombra di naturali, e fermarle con la mano, dando a dimostrare quello che nonne sia.

. . . a craft known as painting, which calls for imagination and skill of hand, in order to discover things unseen, hiding themselves under the shadow of natural forms, and to fix them with the hand, making clearly visible that which does not actually exist.

—CENNINO CENNINI, *Libro dell'arte*, chap. I

CONTENTS

LIST OF ILLUSTRATIONS

(GFN: Gabinetto Fotografico Nazionale)

ACKNOWLEDGMENTS

THIS BOOK started as a dissertation for Harvard University in 1978. Only the material presented in chapters 6 and 7, however, was included in the thesis, which was primarily concerned with Pisanello's technique, working methods, and style. During a fruitful and stimulating fellowship year in 1979–80 at Villa I Tatti, the Harvard Center for Renaissance Studies in Florence, research was started on the seven chapters that deal with the cycle's physical, cultural, social, political, and ideological contexts. This work continued in Florence and Mantua over several summers before being written up in Vancouver, British Colombia, in 1983–84 and revised in Los Angeles in the summer of 1986.

I thus have many people to thank, beginning with those who had written earlier on the cycle, on Pisanello, and on the Gonzaga. Giovanni Paccagnini kindly answered many questions before his untimely death in 1977. Ilaria Toesca, former Soprintendente per le Gallerie di Mantova, never failed to grant whatever seemed necessary for this study, and was invariably generous in sharing with me her own scholarship on the work. A conversation with Michael Baxandall, whose work on Pisanello and the humanists is referred to throughout this book, helped focus my research at an early stage. Elisabeth Mahnke, now publishing as Elisabeth Swain, was always generous in sharing with me her dissertation, her ideas on Lodovico Gonzaga's career as a *condottiere*, and her archival references. All scholars of life and art in Mantua owe a huge debt to the publications of Rodolfo Signorini; the ease with which he discovers important documents rivals that of his great predecessors Luzio and Renier. Amedeo Belluzzi and Grazia Sgrilli were indefatigable in helping to reconstruct the fifteenth-century *Corte* and measuring the original *Sala del Pisanello*. Gino Corti always gave enthusiastically of his wisdom in archival matters. No words can express my gratitude to the staffs of the Palazzo Ducale in Mantua and the Archivio di Stato of Mantua for their help and kindness over the years, especially Anna Maria Lorenzoni.

I owe a special debt of gratitude to those who patiently read an earlier draft of this manuscript: James S. Ackerman, David S. Chambers, Werner L. Gundersheimer, Debra Pincus, and Jeffrey Ruda. Without their hard work and helpful criticisms, this would be a poorer book. They did their best to rid it of errors and I alone am responsible for those that remain. The following also generously gave indispensable help at various critical moments: Lilian Arm-

strong, Janos Bak, Roseline Bacou, Umberto Baldini, Adele Bellù, Jean S. Boggs, Eve Borsook, Kathleen Weil-Garris Brandt, Daniel Bridgman, Beverly L. Brown, Penelope Brownell, E. Jane Burns, Humphrey Butters, Carol Chase, Keith Christiansen, Assirto Coffani, Maria Teresa Cuppini, Pellegrino D'Accierno, Bernhard Degenhart, Lise Duclaux, Melva Dwyer, Sabine Eiche, Kurt W. Forster, Maria Fossi Todorow, Reginald T. Foster, Riccardo Fubini, Frances Hadlock, Sir John Hale, Daniel Javitch, Ernst Kitzinger, George Knox, David Kunzle, Gregory Lubkin, Ercolano Marani, Elisabeth MacDougall, Timothy McNiven, Dario Meloni, Geneviève Monnier, Paolo Mora, John Najemy, Ottorino Nonfarmale, Konrad Oberhuber, John Onians, Linda Pellecchia, Francesco Pelessoni, Valeria Pizzorusso Bertolucci, Brenda Preyer, Ugo Procacci, Mario Quaresima, Margaret and Dyrk Riddell, Artur Rosenauer, James Russell, Maurice Sérullaz, Barbara Shapiro, Marianna Shreve Simpson, Craig Hugh Smyth, David Solkin, Leonetto Tintori, Giorgio Vigni, Jean S. Weisz, Karl Zaencker. I also thank Elisa Liberatori, who helped to read the proofs and create the index.

I am especially grateful to the librarians of Widener library and the Fogg library at Harvard University; the Biblioteca Berenson, Villa I Tatti; the Kunsthistorisches Institut, Florence; the Biblioteca Hertziana, Rome; the Warburg Institute, London; and the American Academy in Rome; and to the art librarians and the interlibrary loan librarians of the University of British Columbia and the University of California, Los Angeles. I also wish to thank the Leopold Schepp Foundation for a fellowship in 1979–80, the University of British Columbia for summer research grants in 1981 and 1982, and the Social Sciences and Humanities Research Council of Canada for a research grant to finish the book in 1983–84.

Two people have been of special importance for my work and for this book. James S. Ackerman and Sydney J. Freedberg, my teachers at the Fogg, not only offered invaluable advice and criticism, but also remain for me exemplars of what our discipline can be. I wish here to thank them both.

August 1986

NOTE ON THE TEXT

THIS STUDY centers on a hall in an Italian palace, a room whose name—the *Sala del Pisanello*—comes from a contemporary letter. I have departed from the modern convention in which the name of a building or room is set in roman type. When I refer, with seeming inconsistency, to the *Sala del Pisanello* but to the Sala dei Principi (a later name given to this same space), it is to distinguish between names that derive from contemporary documents (set here in italic) and those that are post-Renaissance coinages (set in roman). In thus highlighting the names quoted from contemporary sources, it is my aim to increase awareness of the resonances and implications of the ways in which Renaissance people referred to their environment.

GLOSSARY OF FRESCO TERMS

arriccio. The coarse layer of plaster below the *intonaco* on which *sinopie* are sometimes found

fresco. Painting done only on freshly laid wet *intonaco*

giornata. A patch of *intonaco*, varying in size, representing the amount of the scene that the painter planned to complete in a day's work or single working session

intonaco. The uppermost, smooth layer of plaster to which the colors were applied

mezzo fresco. Painting done on *intonaco* which had already dried but was again moistened before the colors were applied

pastiglia. A paste sometimes applied to the *intonaco* for relief ornament

secco. Painting done when the *intonaco* had already dried

sinopia. Preparatory drawing on the *arriccio*, usually done in red earth

spolvero. The transfer of a cartoon to the *intonaco* by dusting pigment through its perforated lines

strappo. A method of fresco transfer in which only the surface of the *intonaco* incorporating the colors is removed

terra-verde. Green earth

INTRODUCTION

THREE LETTERS mark the day in 1480 when a beam collapsed in a room of the Gonzaga palace in Mantua taking part of the ceiling with it. The letters referred to the ruined room as the *Sala del Pisanello*, establishing the existence of a hall in the fifteenth-century *Corte* that was known by Pisanello's name— a curious, indeed unique, designation for a *sala* in a Quattrocento palace. The letter writers made no mention of any frescoes adorning the *Sala*'s walls, although the humanist Bartolomeo Fazio, in a biography of Pisanello written immediately after the artist's death, had noted that in Mantua he painted "some highly praised pictures."[1] Seeking this *Sala* in the mid-1960s, Professor Giovanni Paccagnini, Soprintendente per la Provincia di Mantova, discovered a room in the Ducal Palace with one frescoed wall and three walls of *sinopie*. Paccagnini attributed the frescoes to Pisanello, dated them to the second half of the 1440s, and related the subject matter to thirteenth-century French Arthurian literature, positions that, with some variants, are also argued in this book. He assumed—and it still seems a reasonable assumption—that he had discovered the *Sala del Pisanello*, the room mentioned in the letters, and, per-haps, the "highly praised pictures" noted thirty years earlier by Fazio.

Discoveries of major works by major artists in any field are rare, and the *Sala del Pisanello* is surely the most exciting postwar recovery of a lost Renaissance work. Its importance is underlined by the irretrievable loss of the other mural cycles that Pisanello is known to have painted in Venice, Rome, Pavia, and elsewhere. Indeed, few undisputed paintings by this artist, who on his medals signed himself PISANVS PICTOR, "Pisanus the Painter," survive. The situation was particularly unfortunate in that Pisanello worked for the major Italian princes, and the many poetic tributes that their court humanists paid him provide important clues to the terms in which his contemporaries perceived and discussed his art. Without a major large-scale work, however, it was difficult for the historian to evaluate these contemporary critical statements on his work and on the value of art as such for Quattrocento *signori*. The Arthurian cycle, one of the monumental works for which the artist was so renowned, now affords a basis for discussion of the relation among critic's vocabulary, artistic style, and patron's taste in the early Renaissance.

Once the cycle is dated to the late 1440s, the patron of the work can be identified as a figure fully as notable as the artist. The work represents a meeting point in the careers of the aging court artist and the young Lodovico

Gonzaga, just emerging as a major patron of the arts. "Though he be a small marchese, yet is he a man of quality," wrote a Mantuan ambassador in a judgment with which we would still today agree.[2] The comment sums up two perhaps interrelated factors: the relative unimportance of the Mantuan state and the prince's reputation as a man of integrity and discernment. The Marchese's contemporaries called him *intendentissimo*, knowledgeable in artistic matters, and admired his expertise in *disegno*, and, although all the talent had to be imported, he became one of the most effective patrons of art in the fifteenth century. This achievement was all the more remarkable in that Mantua was one of the less powerful Italian states, a reality that must have increased Lodovico's sense of rivalry with the neighboring and closely related, but larger and wealthier, states of Milan and Ferrara. In his patronage of the visual arts Lodovico could apply his intelligence and judgment to reduce the competition with them to equal terms. The *Sala del Pisanello*, his first major commission, thus documents the early intentions and ambitions of an outstanding Renaissance patron.

A cycle such as Pisanello's at a court such as Lodovico's raises many questions. As the only Renaissance painting on an Arthurian theme to survive in Italy proper, it represents an aspect of Quattrocento civilization that has hardly been touched upon by cultural historians. Why should Lodovico, best known for his patronage of the humanist works of Alberti and Mantegna, have commissioned the illustration of a thirteenth-century romance—with French inscriptions to boot—in an important site in his palace? Beyond the questions peculiar to the Mantuan situation, the work raises other more general ones on the nature of court art as such. What, if any, characteristics were intrinsic to works commissioned by the early Renaissance court patron? Did the art have a different function from works produced for other milieux? Should greater account be taken of a prince's needs and aspirations than those of other, less exalted, patrons when interpreting a work commissioned by him? What role may the prince have played in its inception and development? These and other questions about the relation of court patron and court artist in the fifteenth century have yet to be treated adequately in the literature.

The genre of monumental secular painting in this period itself awaits serious study. While we begin to have a grasp of some of the contexts—ecclesiastical, theological, liturgical—within which religious painting should be interpreted, the equivalent framework and criteria have yet to be established for secular work. That the Quattrocento itself distinguished between sacred and profane realms emerges from letters.

> We cannot always attend to spiritual matters if we are not also allowed some
> time to relax and attend to worldly things [*cose corporale*],

Bianca Maria Visconti once wrote to Barbara of Brandenburg in explicit crit-
icism of Pope Pius II's austere standards of behavior.[3] Just as most Renais-
sance princes took their recreation seriously in the apparent conviction that
devotion of time and effort to the pleasures of this world did not prejudice
their chances in the next, so the worldly purposes of secular images should be
fully integrated into their interpretation. My own interest in pursuing this
kind of art history is reflected in the sequence in which the patrons and the art
are named in the title of this book. This, then, is not only a study of a painted
room but also of the court for which it was decorated.

The chapters that follow, each dealing with a different set of issues raised
by the painted hall, are linked but independent. The first three establish the
premises on which the study as a whole is based. Dealing with the site,
chapter 1 offers a reconstruction of the architectural complex that was the
mid-fifteenth-century Gonzaga *Corte* and a measured survey of the surviving
murals and *sinopie* reconstructed inside the *Sala*. Chapter 2 is devoted to the
iconography, and includes identification of the subject, a discussion of the
volumes of French fiction on the shelves of North Italian libraries, and con-
sideration of other Italian works of art from the Trecento and the Quattro-
cento that illustrate chivalric subjects. Chapter 3 recapitulates the career of a
quintessential court artist through study of all the documents mentioning Pi-
sanello that have so far been discovered. The Arthurian frescoes are dated to a
period late in his career, 1447–48, shortly after Lodovico inherited the Mar-
quisate of Mantua.

Having established the site, the subject, and the date of the cycle, we then
consider the iconography as it related to the patron's situation. Chapter 4 sug-
gests that the political circumstances of the Mantuan state at the beginning of
Lodovico's rule, including his marriage alliance with the Hohenzollern of
Brandenburg and his career as a *condottiere*, influenced his choice of subject.
Chapter 5 discusses the commission of this Arthurian work within the con-
text of Lodovico's education, his career as a patron, and the cultural climate
at his court.

Two chapters follow dealing with the ways in which Pisanello translated
the abstract language of the romance into concrete visual images. Chapter 6
relates Pisanello's pictorial design for the cycle to the narrative structure and
techniques of the prose *Lancelot* and other contemporary cycles, and analyses

the many changes made to the composition of the tournament scene between *sinopia* and fresco. Chapter 7 considers the physical execution of the work, and develops hypotheses concerning Pisanello's working methods in fresco, his use of *sinopie* on the *arriccio*, and his use of drawings on paper.

The last two chapters seek to elucidate the significance of the frescoes, in terms of iconography and style, for their first viewers. In chapter 8 contemporary letters are used to reconstruct some of the life that took place in such a *sala*, focusing on the subjects depicted in the frescoes, so as to clarify the connotations of the painted events and motifs for Quattrocento *signori*. Chapter 9 addresses questions of literary style and pictorial style in relation to each other and to the values, pretensions, and illusions of the Gonzaga court. It is suggested that analysis of concepts proper to the period—terms used by court humanists in their enthusiastic ekphrases on Pisanello's work—help us to recognize the character of the artist's style as it was perceived by his patrons. This study accordingly combines a traditional art-historical concern for pictorial structure, facture, and language with a desire to re-integrate the frescoes into fifteenth-century court life in general and into the circumstances of the Gonzaga of Mantua in particular.

The literature on this recently discovered cycle—all of it indispensable for my research—is still sparse. In 1972 Giovanni Paccagnini published a monograph on its discovery recounting his search for the frescoed *Sala* and integrating the new work into Pisanello's oeuvre. His primary interest lay in questions of attribution and chronology, although he also devoted chapters to the technique and the iconography of the work. His book was followed by a long article by Bernhard Degenhart, author of an earlier monograph on Pisanello, which investigated the cycle's iconography and technique and discussed an important compilation of Trecento and Quattrocento drawings on chivalric themes, some of which were attributed to Pisanello. Since these studies appeared, the only contributions of substance have been on specialized aspects of the frescoes: Valeria Pizzorusso Bertolucci's identification of the iconography and Ilaria Toesca's series of articles on the heraldry and the date based on suggested identification of some of the depicted emblems. The major thrust of the literature has accordingly been on the traditional art-historical questions of attribution, dating, iconography, technical means, and sources. I offer a study that tries to do something new in this field: to throw light on fifteenth-century court life and court ideals through a discussion of their artistic and symbolic expression in a work by a great court painter.

It was a happy coincidence that the cycle should have been discovered in Mantua, where Gonzaga letters in the Archivio di Stato provide an apparently

inexhaustible flow of information about Quattrocento court life. It was equally fortunate that so much of this material should already have been unearthed around the turn of the century by those indefatigable archivists Luzio, Renier, Davari, and Venturi. Whenever possible, the transcription of the documents—many of which were originally published with small inaccuracies, were cited in incomplete form, or lacked archival references—have been checked against the originals in the archives of Modena, Milan, Verona, Venice, Florence, Rome—and, of course, Mantua. Exceptions include some citations made by nineteenth-century archivists that could not be tracked down and a document in Naples that was destroyed in World War II.

Any book that bases many of its conclusions on archival documentation in foreign languages poses the problem: to translate or not to translate. Because I wished to make the material as accessible as possible, I decided to translate quotations in the text. Unavoidably, however, what is terse and idiomatic in one language may lose much of its immediacy and expressiveness—not to mention its sense—when rendered into another. A comment by one of Borso d'Este's scribes on the subject of translation therefore struck a deep chord when I came across it:

> Io non ne deti mai a lo exercitio de tradurre libri se non da pocho tempo in qua.
> . . . Et quasi mi pento de essere intrato in tale lambirinto et havere pigliato
> peso tropo grave a le mie infirme et debile spalle.[4]

A minor example of the possible ambiguities facing the translator is the *noi*, or royal we, that the Gonzaga used for the first person singular, which I have left as "we." The quotations are in any case always given in the original language in the notes, occasionally with a fuller context. It has been my principle to cite the archival material rather than merely give a reference—in any case impossible with unpublished material—to its previous publication, often in obscure, and for the American scholar inaccessible, local Italian journals. I wanted to produce a book that functioned on two levels: a text that was accessible to those with a general interest in Italian Renaissance art, and notes that constitute a research tool for other historians of the art and culture of this region in this period. Having benefited so greatly from the scholarship of my predecessors, I should like to think that my own work may in turn serve as a stepping stone for my successors.

THE GONZAGA OF MANTUA
AND
PISANELLO'S ARTHURIAN FRESCOES

Site

I. *The* CORTE

THE Ducal Palace in Mantua, a rambling labyrinth begun in the thirteenth century and continually added to until the eighteenth (Fig. 1), bears little resemblance today to its appearance in the late 1440s when Pisanello began to fresco an Arthurian cycle for Marchese Lodovico Gonzaga (born 1412, 1444–78) and his wife, Barbara of Brandenburg (1422–81). In the course of endless rebuilding campaigns by succeeding generations of Gonzaga rulers, so many of the late-medieval buildings were either demolished or incorporated into later structures that reconstruction of the Quattrocento palace is fraught with uncertainty.[1] Nonetheless the general configuration of the palace can be established, if not its details, and because frescoes became part of the walls on which they were painted, the precise location of the Arthurian cycle within the overall complex can be ascertained. As we shall see, the *Sala del Pisanello* was the hall into which visitors entered as soon as they had passed through the *Porta Grande*, the main entrance to the fifteenth-century palace, and ascended the stairway that led up to the *piano nobile*.

The Quattrocento Gonzaga residence consisted of two adjacent Gothic palaces: the Magna Domus dating from the end of the thirteenth century and the larger Palazzo del Capitano dating from the beginning of the fourteenth.[2] Both had been built by the Bonacolsi, who ruled Mantua from 1273 to 1328. The Gonzaga (or, more accurately, the Corradi of the town of Gonzaga) wrested the city from the Bonacolsi in 1328, and in 1355 acquired these two palaces; at the same time they also gained control over some houses that lay behind the Magna Domus around the small church of S. Croce that stood to the east of it.[3] During the next hundred years, these palaces and houses were remodeled and connected together to form one palatial entity. Figure 2 shows a schematic plan of the complex around 1450, when it was usually called the *Corte* or, very occasionally, *Palazzo*.[4] The separate buildings that made up the fifteenth-century *Corte* can also be recognized in a detail from the bird's-eye view of Mantua engraved by Gabriele Bertazzolo in 1628 (Fig. 3).[5]

The long rectangular block of the Palazzo del Capitano (no. 19 on the Bertazzolo view) was connected at its north end to a complex of buildings, rec-

tangular in plan, constructed on three sides of a central court, the *cortile* of S. Croce. On the northwest side of this court ran the Magna Domus (no. 179 on the Bertazzolo view). The alignment of its portico with that of the Palazzo del Capitano enabled the two buildings of different sizes to present a common front to the Piazza San Pietro.[6] Domenico Morone's painting *The Expulsion of the Bonacolsi in 1328* shows how imposing the *Corte*'s Gothic facade must have appeared to the fifteenth century (Fig. 4).[7] The main entrance to the *Corte*, the *Porta Grande de Corte*, was located in the center of the Palazzo del Capitano.[8] It consisted of Gothic portals on both east and west facades of the Palazzo which were linked by an *androne*, or vaulted passageway, running at ground level from Piazza San Pietro to the *brolo*, or orchard, that stretched behind the palace.[9]

To the rear of the palace, on the far side of the court from the Magna Domus, ran a range of buildings that lacks a convenient designation. This rear block incorporated, on the *piano terreno*, or ground floor, a suite of rooms known in the sixteenth century as the Appartamento Isabelliano di S. Croce[10] and, on the *piano nobile*, or first floor, the Sala dei Papi (Fig. 1, room 14) and a suite of rooms known since the eighteenth century as the Appartamento degli Arazzi (Fig. 1, rooms 18–21).[11] The Palazzo del Capitano was connected to this rear block by a modest structure that stood southwest of the court, close to the feature indicated as no. 20 on the Bertazzolo view (Figs. 3 and 5; Fig. 1, room 13). The entire *piano nobile* of this connecting building was taken up by the *Sala del Pisanello*.[12] Below the *Sala* ran a three-arched loggia that opened out onto the *brolo*, the walled orchard or garden with fruit trees and flowers that 15th-century princes found a refreshing escape from the somber castles in which they lived.[13] Overlooking the *brolo*, the *Sala del Pisanello* was amply lit by two large Gothic windows on its longitudinal axis that faced southwest—providing what a Quattrocento observer might well have called *felicissima luce*.[14]

The palace's general configuration can thus be established, but later alterations make it impossible to reconstruct the fifteenth-century arrangements of the rooms on either the *piano terreno* or the *piano nobile* of the *Corte*. A large number of Trecento and early Quattrocento decorative schemes are partially preserved on both floors of the *Corte*,[15] but only in two spaces on the *piano nobile* do they survive sufficiently unaltered to enable the scale and appearance of the rooms to be reconstructed and their 15th-century function to be identified: a chapel in the Palazzo del Capitano with a Crucifixion scene frescoed across one wall (Fig. 1, room 10)[16] and the nearby *Sala del Pisanello* with its walls half frescoed on an Arthurian theme. The *Sala*, measuring 17.40 × 9.60

meters, was located at a central juncture of three wings of the palace (Fig. 2). Close to the center of the long rectangular block formed by the Palazzo del Capitano and the Magna Domus, the hall connected both these buildings to the rooms on the *piano nobile* of the rear block.[17] The door between the *Sala* and the rear block survives near one window; that between the *Sala* and the Palazzo del Capitano was destroyed by later renovations but was almost certainly located on the same axis, near the garden facade.[18]

The fifteenth-century arrangement of the rooms on either side of the *Sala* is not known. Inventories and letters, however, refer to two otherwise unknown halls on the *piano nobile*—the *Sala Bianca* and the *Sala Verde*—that can be tentatively linked to existing spaces in the rear block. The *Sala Bianca* and the *camere bianche* can be hypothetically identified with the present Sala dei Papi,[19] and the *Sala Verde* with the present Appartamento degli Arazzi (Fig. 1, rooms 14, 18–21).[20] In the second half of the Quattrocento these three halls, the *Sala del Pisanello*, the *Sala Bianca*, and the *Sala Verde*, seem to have formed a sequence of large important spaces on the *piano nobile* of the *Corte* which were used for special events and festive occasions, and to house senior members of the family and important visitors. Niccolò d'Este of Ferrara, for instance, nephew of Lodovico Gonzaga and son of his sister Margherita and Marchese Leonello d'Este, used the *Sala del Pisanello* as a dining hall for his household in the early 1470s.[21] The "white suite" was particularly popular: the Florentine ambassador was lodged in the *camere bianche* in 1483; as a widow Barbara of Brandenburg lived in the same rooms; and the wedding festivities of her third son, Gianfrancesco, took place in the *Sala Bianca* in 1479.[22]

On those occasions when they expected huge crowds of guests the Gonzaga would, however, have recourse to a room they called the *Sala Grande*, a space which can be tentatively identified with an enormous hall on the top story of the Palazzo del Capitano measuring 65 × 15 meters, also called the *Armeria*. The *Sala Grande* held eight hundred people seated at twenty-seven tables in 1463 for the marriage feast celebrating the important alliance of Lodovico's heir, Federico Gonzaga, with Margaret von Wittelsbach of Bavaria.[23] It was probably also in this same hall—the *Sala Grandissima*—that the Council of Mantua had been held a few years earlier. When all the princes, ambassadors, and envoys were gathered in the hall in 1459 to hear Pope Pius II open the Council, there may well have been even more people crammed into the *Sala Grande* than on the occasion of Federico's wedding.[24]

The main access to these imposing spaces on the upper floors of the palace was an exterior stairway placed against the rear, or west, facade of the Palazzo

del Capitano. The stairs ran north of the *androne* to the *piano nobile* at the west corner where the wing containing the *Sala del Pisanello* abutted the Palazzo del Capitano (Fig. 5).[25] The small doorway connecting the stairs with the *Sala* is still visible on this building's garden, or southwest, facade. Thus visitors to the Gonzaga court entered the precincts of the palace through the *Porta Grande* that led from Piazza San Pietro to the *brolo*, and then proceeded to the *piano nobile* through the *Sala del Pisanello*. The placement of stairs at the rear giving direct access into a *sala* seems to have been common practice. In Ferrara, for instance, access to the *piano nobile* of the Palazzo Schifanoia was also by means of exterior stairs, also placed against the palace's rear, or garden, facade. Here too the stairway gave into a large room, the *Sala dei Mesi*, which like the *Sala del Pisanello* was frescoed with an important program.[26]

In mid-Quattrocento palaces built anew, the interior staircase also often led directly to the largest and most public space on the *piano nobile*. In the Ducal Palace in Urbino, this space was the so-called Sala del Trono; in the Medici Palace in Florence, the *Sala Grande*.[27] The stairs in the Rucellai Palace in Florence opened directly into the *Sala Principale* without any intervening corridor, and in Milan visitors to the *Corte Ducale* of the *Castello di Porta Giovia* entered either the huge *Sala Verde Superiore* or the *Sala delle Caccie*, depending on which staircase they took to the *piano nobile*.[28] Perhaps Alberti was influenced by this practice when he suggested in *De Re Aedificatoria* that the *sala* and similar spaces should be located where they could be reached most directly from other parts of the palace. Stairs and corridors should end in these rooms, he said, because the *sala* was the hall in which the lord received his guests.[29]

The location of stairs in relation to reception halls was important to Quattrocento society because stairways played a role in ceremonial entrances. A letter describing the ritual surrounding the 1479 marriage of Gianfrancesco Gonzaga, Marchese Lodovico's third son, probably refers to the stairs that entered the *Sala del Pisanello*.

> The bride entered Mantuan territory at 21 hours . . . and with a large number of men and women, all in the proper order, to the sound of pipes, a trombone, trumpets, and other instruments, and was conducted to the *Corte* where, at the foot of the stairs, she was welcomed by Your Excellency's illustrious mother [Barbara of Brandenburg], and then she ascended the stairs between her ladyship and my illustrious lady [Margaret of Wittelsbach] and entered the *Sala Bianca*,[30]

wrote a secretary to Lodovico's heir, Federico Gonzaga. The place where each visitor was welcomed formed part of the elaborate etiquette of fifteenth-cen-

tury ritual, and Gianfrancesco's bride had sufficient status to be greeted by her mother-in-law and sister-in-law at the foot of the stairs rather than at their head or within the *Sala* itself. As it happens, these particular stairs may not have been impressive by Italian or even general European standards. Cardinal Isidore of Kiev, at any rate, visiting Mantua for the 1459 Council, found them *strita e mal apparente*, narrow and unprepossessing, in comparison to the *Corte* as a whole, which he compared favorably—as *magnifico, apto*, and *superbo*—with palaces he had seen in Greece, Hungary, and Italy, and suggested that the Marchese should spend some money to improve "the stairway that leads to the first *sala* where you enter the *Corte*."[31]

During the first half of the fifteenth century the *Corte* was the principal residence of the Gonzaga family when in Mantua. The *Sala del Pisanello* must have been a frequently traversed space. The scale of the hall and its location between the three wings of the *Corte*, as well as its direct access by a stairway leading from the main entrance, suggest that this was one of the principal *sale* of the mid-century palace. In the middle of the century its frescoes would have been visible not only to members of the Gonzaga household as they went from one part of the *Corte* to another on their daily business, but also to all visitors to the palace who entered or left the *Corte* by the *Porta Grande*. It was not until the 1450s, after Pisanello had abandoned the frescoes in the *sala* that bears his name, that Lodovico started to refurbish the *Castello* (rooms 108–24 in Fig. 1). For a period the family seems to have lived in both buildings.[32] In May 1459, however, ten days before the papal court arrived in Mantua for the Council, the Milanese ambassador visited Lodovico Gonzaga and Barbara of Brandenburg in the *Corte* only to find a vacant palace. He discovered them instead living in the *Castello* surrounded by throngs of plasterers and carpenters and barely surviving the dust and noise of the renovations.[33] They had left the palace hurriedly as the papal train approached Mantua to enable Pope Pius II and his suite to lodge in the *Corte*, and found their new quarters uncomfortable and cramped. "Our palace is completely full, and here in the castle we could not be packed in more tightly," Lodovico wrote to a prospective visitor warning him of the scarcity of spare rooms in Mantua as the great event approached.[34] Barbara of Brandenburg in particular missed the spacious and airy apartments that she had left behind in the *Corte*, and complained bitterly about the discomforts of her new residence: "I feel as if I were in a prison that gives me a fever almost every day," she wrote to the Duchess of Milan.[35] Living space continued to be in short supply at the Mantuan court even after the departure of the papal court, owing to the rapidly expanding Gonzaga family.[36] The *Corte* was divided up among Lodovico's sons Federico and

Rodolfo with their wives and children and his nephew Niccolò di Leonello d'Este, and the Marchese and his wife settled permanently in the *Castello*, resigned to its discomforts because, in Lodovico's words, "if we and our illustrious consort were not living in the castle, we would have nowhere else to stay."[37]

II. *The* SALA DEL PISANELLO

> The illustrious lord Niccolò d'Este has let me know that, for security reasons, he would very much like to have his cooking done in the *Sala del Pisanello*, where up to now his household has eaten. . . . He wants them to eat instead in the *camera dei cani*. I thought of telling him that the damage usually done in kitchens would rot the ceiling.[38]

Thus wrote Giovanni Michele Pavesi to Lodovico Gonzaga in 1471 about the lodging arrangements of the Marchese's nephew Niccolò di Leonello d'Este. Rooms in the Quattrocento did not have clearly defined functions, and it was relatively easy to transform a hall from one purpose to another. Nonetheless, it was not customary to convert a large important reception hall into a kitchen. Only the exceptional circumstances surrounding Niccolò, pretender to the Duchy of Ferrara, could have produced such a request. Niccolò and his Gonzaga relatives had good reason to be concerned about his kitchen and eating arrangements. In the winter of 1471 Niccolò's uncle, Ercole d'Este, who had only recently succeeded Borso d'Este as Duke of Ferrara and felt threatened by the existence of his brother Leonello's legitimate son, sent an envoy to Mantua with the express purpose of poisoning his nephew.[39]

It seems likely that Lodovico granted the Ferrarese prince's request, because Giovanni Michele Pavesi's worst fears were realized and the *Sala*'s ceiling beams did indeed rot. Large sections of the *Corte* must in any case have been poorly built. In September 1480 the wall shared by the *camera grande d'aparamento* and Marchese Federico Gonzaga's own room fell down, causing damage as far as the *Sala Verde*.[40] Later that same autumn Luca Fancelli became concerned over the condition of the ceiling in the *Sala Bianca*, where the widowed Barbara of Brandenburg was then living, and took precautions to prevent it too from collapsing.[41] But it was in the adjacent *Sala del Pisanello* that the disaster occurred a couple of months later. The fumes and smoke of Niccolò's temporary kitchen apparently rotted the beams sufficiently to cause one of them to give way and part of the ceiling to fall on 14 December 1480.[42] Hearing of the disaster while at his villa in Goito, Marchese Federico

resignedly instructed his retainers to "conserve things as best you can" in the *Sala del Pisanello*.[43]

The collapse of the ceiling in 1480 was only the first of many structural violations to be suffered by the hall and its unfinished frescoes. Successive Gonzaga rulers repeatedly restructured their palace to conform to prevailing fashion, and these various rebuilding campaigns inflicted extensive damage on the frescoes in the *Sala*. In the sixteenth century, Duke Guglielmo remodeled the whole wing.[44] On the *piano nobile* three new rectangular windows replaced the two Gothic openings on the garden facade, demolishing most of the images on that wall, the cycle's most serious loss. A new chimneypiece destroyed the cycle on the lower zones of the opposite wall, the heat from the flue having already damaged the images above the fireplace. The floor was lowered by 1.10 meters, and stairs had to be installed to give access from the hall into the Palazzo del Capitano. New central doorways were installed at either end of the *Sala*, creating yet further losses. Below, on the *piano terreno*, the loggia was walled up and a new entrance created on the same axis as the original external entrance to the *piano nobile*.[45] Twice again, in the eighteenth and nineteenth centuries, the *Sala* was renovated, each time inevitably to the detriment of Pisanello's frescoes. The most serious damage was the lowering of the ceiling by 1.50 meters, which created the row of large, uneven holes that deface the upper reaches of the murals.

In Figure 6 the walls of the hall are numbered in the sequence established in chapter 2 for the painted narrative. When Giovanni Paccagnini discovered the cycle in the mid 1960s, *sinopie* still survived on three of these walls.[46] The subjects depicted consist of a tournament on Wall 1 (Fig. 7) and a continuous landscape on Wall 2 (Fig. 11) and half of Wall 3 (Fig. 12). Most of the cycle was abandoned at this *sinopia* stage, and the tournament on Wall 1 was the only scene to reach the point of being partially painted (Fig. 8). *Intonaco* was also spread around the corners of each end of this wall to cover small areas of the adjacent walls: standing knights and some maidens in a tribune on Wall 2 (Figs. 13 and 14) and a landscape on Wall 4 (Fig. 15). Fragments of *sinopia* were also discovered on these two walls: a group of waiting knights from Wall 2 (Fig. 16) and a lone dwarf from Wall 4 (Fig. 17).

Several factors stand in the way of an easy understanding of these murals. To begin with, the artist left the cycle unfinished.[47] Then, the hall was repeatedly modified during subsequent centuries so that much of Pisanello's work was destroyed. Last, but not least, the frescoes and *sinopie* in the *Sala*, all of which were detached from the wall upon discovery are now exhibited sepa-

rately in three different rooms, an arrangement that violates the unity of the original ensemble and prevents an overview of it. Nonetheless, despite the damage, the appearance of the *Sala* when Pisanello saw it for the last time, probably in 1448, can be established. A measured survey of the hall, in which the surviving frescoes and *sinopie* are reconstructed inside the *Sala*, which is itself reconstituted to its original dimensions, establishes that enough of the cycle is preserved to enable the subject matter of the murals to be identified.[48]

The appearance of the *Sala* when Pisanello abandoned its decoration can be reconstructed with precision (Fig. 6).[49] The hall measured 17.40 × 9.60 meters, had a flat timbered roof, and was architecturally quite plain. All four walls had the same height of 6.75 meters. Only two large windows and three small doorways interrupted the surfaces of the four walls to be painted.[50] A frieze of heraldic emblems—unpainted but outlined in *spolvero*—runs across the top of Wall 1 and around onto Wall 2. Traces of the same frieze on Wall 3 indicate that it was planned to encircle the hall.[51] The most complete surviving paintings, on Wall 1, show a tournament scene for which both fresco and *sinopia* survive (Figs. 7 and 8). The surviving fresco is 4.35 meters in height, but a photograph taken before the murals were detached from the wall establishes that the *sinopia* of the tournament, with fragmented images of a fallen horse and broken lances, extended 1.25 meters below the fresco (Fig. 18).[52] The tournament *sinopia* accordingly extended at least 5.25 meters from the ceiling. Since the height of the walls was 6.75 meters, an area exists of approximately 1.50 meters between the floor and this mural for which Pisanello's design is unknown. Quattrocento mural cycles always start well above floor level, however, and the zone beneath the surviving *sinopia* must have been taken up by a dado or wainscot without narrative content that ran around the room. A consistent feature of 15th-century fresco cycles, a dado on the lower area of the walls was a practical precaution to prevent the surface of the paintings from being abraded or otherwise damaged by people or furniture. In the mid Quattrocento the dado usually took the form of a painted textile, simulated marble slabs, or fictive architectural details.[53] Thus, when the existence of a dado is taken into account, it can be seen that virtually no narrative content is missing from Wall 1.

Our perception of the cycle as a whole also changes when the 1.50 meters of this painted dado are added to the dimensions of the surviving *sinopia* on the other walls. Figure 19 is a perspective rendering of how the *Sala* looked when Pisanello abandoned its decoration.[54] Standing with our backs to the adjoining Palazzo del Capitano, we see on our right the small door that led from the outside stairs into the *Sala* and the two handsome Gothic windows

that overlooked the *brolo* on the garden facade.[55] The entire narrative along this garden facade, Wall 4, and the part of Wall 3 adjacent to it and behind us has been lost, with the exception of a lone dwarf and some landscape at the farthest end (Figs. 16 and 17).[56] Facing us at the opposite end of the hall, to the left of the small door that leads into the present Sala dei Papi (perhaps the *Sala Bianca* in the fifteenth century), is the wall on which the paintings survive almost complete: Wall 1, on which the combined fresco and *sinopia* extend from the ceiling to within 1.50 meters of the floor. On the right of the scene and near the corner, a family of lions inhabit a rocky, barren landscape (Fig. 73). Below them, an equestrian knight, wearing a broad-brimmed hat and followed by three mounted dwarfs (Figs. 34 and 35), approaches a tournament in which over sixty self-possessed warriors display their enviable prowess and their exuberant enjoyment in this slightly dangerous sport. At lower left knights prepare for the fray (Figs. 86, 94, and 95); at upper left they engage in a joust with lances to the sound of trumpets (Fig. 82). Led by a commander on a rearing black horse in the center of the scene (Fig. 100), they batter each other in the confusion of the *grande mêlée* at upper right (Fig. 140). Along the lower surviving edges they aim their lances and brandish their maces in individual skirmishes (Figs. 90 and 118). To our left, at center and right of Wall 2 facing the windows, as much as 40 or 50 percent of the narrative has been lost above the area of the dado.[57] Here we see, reading leftward from the far end of the long wall, a jostling crowd of mounted knights in armor, waiting their turn to enter the fray (Fig. 13), then an elevated tribune, crowded with splendidly dressed maidens, and an imposing fortified castle similar in appearance to the *Castello* that lay a few minutes away from the *Corte* (Figs. 13 and 32). Closer to us on Wall 2 are representations of two tents: a small pavilion sheltering under a tall and bushy tree (Fig. 33), and the upper folds of a much larger tent. Nearer still to us on the left side of Wall 2, we see many knights-errant engaging in quests that range across an expansive landscape dotted with animals and vegetation and crowned at its upper edge by well-ordered towns and impressive castles silhouetted against the sky (Fig. 11). Very close to us the cycle originally extended only half a meter below the *sinopia* drawing of the knight galloping toward a fallen foe (Fig. 31). The smiling landscape filled with further questing knights-errant continues behind us on Wall 3 (Fig. 12), where only about a meter of narrative is missing between the area of the dado and the image of a knight being decapitated (Fig. 30). We may conclude that more of the cycle survives than could have been imagined under the circumstances. Indeed, as we shall see, enough remains to identify the subject that Pisanello started to paint here.

Luca Fancelli's decision in 1480 to pull down the other beams in the *Sala del Pisanello* to prevent them from inflicting further damage is our last documentary reference to the hall that contains these frescoes.[58] The room was, however, in too central a location in the *Corte* to have been permanently abandoned in this condition, and the ceiling was undoubtedly repaired so that the hall could be used. The unfinished frescoes in the *Sala* would have been considered an eyesore in the mid Quattrocento, and the room could have been made habitable in later years for guests such as Niccolò d'Este only by the addition of tapestries. The Gonzaga often made their living quarters pleasanter and warmer by hanging one or another set of tapestries, as a letter from Barbara of Brandenburg shows: "I want you to prepare the *camera delle ali* with the other rooms upstairs . . . putting up our everyday hangings because your father . . . doesn't want to lodge in the *Castello* any more . . ." she wrote in 1457 to her son Federico, revealing the portability of this kind of interior decoration.[59] Tapestries were of course a more visible expression of the lord's splendor than frescoes and, unlike the latter, were worth writing home about. In 1474 the Mantuan ambassador admired the rich tapestries that covered the walls of the *sala* in which King Christian of Denmark, Lodovico's brother-in-law, dined with the Duke of Milan,[60] and in 1463 Rodolfo and Gianfrancesco Gonzaga wrote their mother that they had been suitably honored by the tapestries hung in their lodgings in Innsbruck.[61] The *Sala del Pisanello*, its two long walls exposed to the elements, must have been cold and damp in the raw Mantuan winters. The warmth of wool hangings would have increased the comfort of the people who used the room, providing them with the same protection against cold drafts as the tapestry painted in the January miniature showing the Duke of Berri seated at his banqueting table (Fig. 74). The hangings that must have covered the walls of the *Sala* in later years, concealing Pisanello's frescoes and *sinopie*, provide an explanation for the lack of references to these murals in the second half of the fifteenth century. Had frescoes by such a famous artist as Pisanello—even murals that were only half-painted—been visible on a regular basis, we would expect visitors to the *Corte* to have commented on them, just as visitors to the *Castello* later commented on such a tourist attraction as Mantegna's *Camera Dipinta*.

Iconography

I. *The Arthurian Frescoes and the Prose* LANCELOT

AS WE shall see, the frescoes in the *Sala del Pisanello* illustrate an episode from the prose *Lancelot*, a thirteenth-century romance in French which forms the central branch of the Vulgate Cycle. The main features of the particular tale depicted in Mantua are a tournament given at King Brangoire's castle in which the hero Bohort takes part, a banquet following the tournament in which twelve knights make distinctive vows, and the seduction of Bohort by King Brangoire's daughter.

The compilation of Arthurian romances known as the Vulgate Cycle was probably the most widely read of all Arthurian stories in medieval France. It is organized into cycles of tales that recount the entire history of the Grail from its origin in the Passion of Christ to the successful accomplishment of its quest by Galahad, Lancelot's son. It consists of five roughly sequential narratives. The first two branches are *L'Estoire del Saint Graal*, the early history of the Grail including the story of Joseph of Arimathea who caught Christ's blood in the holy vessel after the Crucifixion, and *L'Estoire de Merlin*, in which the enchanter Merlin establishes the future King Arthur's authority by having him pull the sword from the stone, and ensures his military supremacy by suggesting ingenious combat strategies. The prose *Lancelot*, the third and by far the longest branch of the Cycle, details the adventures of the knights of the Round Table (the meeting place of King Arthur's most valiant warriors), in particular those of its most popular but flawed hero Lancelot, who undertakes a series of exploits to prove his worth to Guinevere, Arthur's queen, with whom he has fallen in love. The fourth and fifth branches are *La Queste del Saint Graal*, the finding of the mysterious Grail vessel by Galahad, Perceval, and Bohort, the particular hero of the *Sala del Pisanello*, and *La Mort le Roi Artu*, the chronicle of King Arthur's last days, his death, and the fall of his kingdom. The composition of this vast series of stories, which covers thousands of printed pages in its modern edition, is usually dated between 1215 and 1235.[1]

The story illustrated in the *Sala* is typical of the many hundreds of tales of secular chivalry that make up the prose *Lancelot*. In the midst of an earlier

adventure, Bohort, Lancelot's cousin and one of the most important knights
of the Round Table, is invited to take part in a tournament given by King
Brangoire at the Chastel de la Marche on the anniversary of his coronation.
The king has gathered together a thousand knights and probably as many
maidens. The damsels are to be assigned husbands from among the knights
who distinguish themselves in the tournament; the most valiant knight of all
will marry the king's beautiful daughter. When Bohort arrives, the tourna-
ment has already started and he notices the maidens watching it from a
tribune. Bohort hesitates as to which side he should join, but the king's
daughter, who is immediately struck by the hero's beauty, prompts him to
fight on her father's team by insinuating with a mocking remark that he has
no lady to fight for. During the tournament Bohort performs many feats of
valor, defeating single-handed all sixty knights who oppose him. The
watching damsels declare him the champion of the day, and the king then
offers his guests an elaborate banquet. He orders two pavilions or tents to be
pitched near a pine tree, one for himself and another for Bohort and the
twelve knights who nearly equal him in valor. Urged to choose wives for
himself and the twelve knights, Bohort excuses himself from selecting his
own bride on the grounds that he is engaged in a quest and has vowed celibacy
until it is accomplished. He asks the king instead to choose brides for the
twelve knights. The banquet proceeds, and the king's daughter asks each of
the twelve knights for a vow in return for serving spices at table. The first
knight to speak, Kallas le Petit, swears that for a year he will only fight with
his right leg slung over his horse's neck. The second knight, Sabilor as Dures
Mains, vows to pitch his tent at the entrance to the forest and to stay there
until he has defeated ten other knights. The third knight, Arfassart li Gros, is
also concerned with proving his prowess: he will not enter house or castle
until he has defeated six other knights. The thoughts of the fourth knight,
Sardroc li Blont, are elsewhere: he will not lie naked with a maiden until he
has defeated three other knights. The fifth knight, Maliez de Lespine, follows
Sardroc's lead: for a year he will not meet a maiden escorted by a knight
without fighting her companion. The sixth knight, Agoiers li Fel, has even
more violent ideas: for a month he will fight no knight without beheading
him. The seventh knight, Paridés al Cercle Dor, returns to the theme estab-
lished by Sardroc: he will kiss by force any maiden being escorted by another
knight. The eighth knight to speak, Meliduns li Envoissiez, commits himself
to fight for a month without wearing armor, and the ninth knight, Garengaus
li Fors, decides to fight all knights who try to water their horses at a certain

ford. The remaining three knights continue to stress the same themes of love and arms: Malaquins li Galois will search for the most beautiful maiden of all; Agrocol li Bials Parliers wishes to defeat ten knights while wearing only his shirt and his lady love's chemise and wimple; Li Lais Hardis wants to allow his horse to wander without halter or bridle for a year. The twelve knights having spoken, the guests at the king's banquet turn to the divertissements of dancing and singing.

The king's daughter (whose lack of given name typifies the denigration of women in this period) has fallen in love with Bohort's prowess and beauty. She is profoundly chagrined by the hero's rejection of her, especially since the king has arranged for the twelve other damsels to marry the twelve lesser champions. She confides to her nurse her disappointment at the hero's indifference. The old woman, knowledgeable in enchantments, visits Bohort's chamber that evening and persuades him to place a magic ring on his finger. The enchantment works. Bohort is overcome with passion for the princess and spends the night with her, and a son, Helain le Blanc, future Emperor of Constantinople, is conceived. Next morning, when the ring falls from Bohort's finger, he realizes that he has been deceived but promises nonetheless to return in six months to claim the child as his. He then leaves the castle and the princess—whom incidentally he never sees again—and gets caught up in his next adventure.[2]

This story was first identified as the basis of Pisanello's frescoes by Valeria Pizzorusso Bertolucci on the evidence of five inscriptions in the *sinopia* that refer to the vows taken at Brangoire's banquet.[3] Each inscription consists of a knight's name in French preceded by a roman numeral identifying the second, third, fourth, fifth, and eighth personages of a consecutive sequence. The inscriptions run counter-clockwise along Walls 2 and 3. Starting in the center of Wall 2 (Fig. 20), the names and numbers read from right to left:

> ii *lor as dures ma.ns* (Fig. 21)
> iii *arfassart li gros* (Fig. 22)
> iiij . . . *droc* . . . (Fig. 23)[4]

and on Wall 3 (Fig. 12):

> v *Maliez de lespine* (Fig. 24)
> viii *ns li envoissiez* (Fig. 25)

When the missing letters in the names of the second, fourth, and eighth knights are supplied, the names inscribed on the walls of the *Sala* can be rec-

ognized as those of five of the knights at the king's banquet: [Sabi]lor as dures
mains, Arfassart li gros, [Sar]droc [li blont], Maliez de lespine, and
[Melidu]ns (or [Mandi]ns) li envoissiez.[5] Identification of these knights is
confirmed by the particular combination of the knights' names, epithets (or
nicknames), and roman numerals. Such a combination occurs only once in
Arthurian romance, in the episode in the prose *Lancelot* where the twelve
knights who take vows to honor King Brangoire's daughter speak in exactly
the same sequence as their arrangement and numbering in the Mantuan
murals.

 Illustrating the enactment of the knights' vows, each of the five surviving
labeled scenes in the *sinopia* is identified by the name of the knight who made
the vow and by the roman numeral indicating the order in which he spoke at
the banquet. The second knight, Sabilor as Dures Mains, or Sabilor of the
Hard Hands, made this vow to King Brangoire's daughter:

> At the entrance to the first forest I come to, I shall pitch my tent and stay there
> until I have defeated ten knights or have been overcome. If I defeat them, you
> shall have their horses.[6]

In the *sinopia* (Fig. 26) a knight is shown at the entrance of a tent with a squire
standing beside him and a page squatting at his feet adjusting his spurs. An
unwary horseman approaches from the left. The third knight to speak, Arfas-
sart li Gros, or Arfassart the Great, depicted on Wall 2 to Sabilor's left, told
the princess:

> I shall enter neither house nor castle before I have defeated six knights or have
> been overcome. If I defeat them, you shall have their helmets.[7]

In the *sinopia* (Fig. 27) we see the back view of an equestrian knight followed
by a mounted dwarf. The fourth knight to take a vow at the banquet was Sar-
droc the Blond:

> I shall not lie naked with a maiden until I have defeated three knights or have
> been overcome. If I defeat them, you shall have their swords.[8]

Today the *sinopia* in the *Sala* shows only two riderless horses with fragments
of two dismounted knights (Fig. 28). The two vows remaining on Wall 3 (Fig.
29) are fortunately more legible than Sardroc's planned exploit. Maliez de
Lespine, or Maliez of the Thorn, the fifth speaker, swore:

> For a year I shall not meet a maiden escorted by a knight without fighting her
> companion until I have won the maiden or have been overcome. All the
> maidens I win will be sent to your service.[9]

Meliduns li Envoissiez, or Meliduns the Joyful, the eighth speaker, committed himself as follows:

> I shall ride for a month wearing only shirt, helmet, shield, lance, and sword; thus equipped I shall fight all the knights I encounter. I shall send you the horses of those I defeat.[10]

Pisanello depicted Maliez as an equestrian knight in profile riding toward the right (Fig. 29). The folds of a maiden's skirt can barely be deciphered in the damaged *sinopia* that lies in front of him. Above and to the left of Maliez, Pisanello drew Meliduns from the back disappearing behind a hill, wearing no armor but carrying lance, helmet, and shield.

Two other scenes survive in the *sinopia*, one on Wall 2, the other on Wall 3. Because they were placed lower on the wall, the captions with names and numbers have been lost, but their actions match the vows given by the sixth and ninth knights to speak. The sixth, Agoiers li Fel, or Agoiers the Wicked, made a suitably sinister vow:

> In this month I shall fight no knight without beheading him. I shall send you the heads of those I defeat.[11]

In the *sinopia* on Wall 3 (Fig. 30) a knight kneels in submission before his captor, who places one hand on his victim's head and clasps an uplifted sword in the other. The ninth knight, Garengaus li Fors, or Garengaus the Strong, told the princess:

> I shall guard a ford in the woods and no knight will water his horse without fighting me. I shall send you the swords of those I defeat.[12]

On Wall 2 (Fig. 31) a knight on horseback charges his foe, but the badly damaged *sinopia* in front of Garengaus shows only his adversary's extended lance and part of his horse. Finally, a detail of a lady survives in the center of Wall 3 just below the castle—perhaps a maiden about to be accosted by Paridés of the Golden Circle, the seventh knight, who swore to force every woman he met to kiss him (Fig. 12).

Accordingly, of the twelve vows made to the princess during King Brangoire's banquet as recounted in the prose *Lancelot*, seven can be identified with scenes in the *Sala del Pisanello*. Depictions of the remaining five vows were probably located in parts of the *sinopia* that were later destroyed: the first knight, Kallas the Small, on Wall 2 near or below the second knight, Sabilor, and the seventh, tenth, eleventh, and twelfth knights—Paridés of the Golden Circle, Malaquins the Gaul, Agrocol the Fine Speaker, and (the only knight

to have an epithet without a name) The Rash and Ugly One—to the center and left of Wall 3, where today nothing remains.[13] Valeria Pizzorusso Bertolucci's conclusion that the vows taken at King Brangoire's banquet were among the subjects illustrated in the *Sala del Pisanello* seems unquestionable.

The knights' extravagant vows, however, are not the only visual elements in the *Sala* that match the tale of Bohort's visit to Brangoire's castle. The most obvious correspondence is the one between the partially painted tournament on Wall 1 (Fig. 8) and the tournament in which Bohort participated at the Chastel de la Marche, but several other surviving motifs in the *sinopia* also allude directly to details in the story. The tribune that Bohort sees on his arrival, and from which the damsels view the tournament, still survives in both the fresco and the *sinopia* (Figs. 13 and 32). The large castle to the left of it, similar in structure to the *Castello* in Mantua, probably represented the Chastel de la Marche. The images of the banquet itself are unfortunately lost, but the upper folds of the tent in which the feast took place are still visible at the center left of Wall 2 (Fig. 11). The size of this tent—it stretched at least five meters—indicates that the depiction of the knights and damsels seated around the table was an important scene that would have formed the central attraction of this long wall. The other, smaller, tent still survives to the center right of Wall 2 under the shade of a tall and bushy tree (Fig. 33, a detail of Fig. 11). Finally, the knight with wide-brimmed hat approaching the tournament from the right, unpainted and thus visible only in the *sinopia* (see Figs. 9 and 10, where the important knights are given arabic numerals and he is identified as Knight 24), can be read as the hero Bohort (Fig. 34). Figure 35 shows this knight integrated into the scene before the *strappo* of the *intonaco*, the uppermost layer of plaster. Bohort had been riding all day and this *sinopia* knight, not yet dressed in armor, wears a wide-brimmed *cappello* of a kind used in the Quattrocento for traveling. As we shall see, this *sinopia* knight is also identified as a Gonzaga.[14] Thus, of all the surviving pictorial motifs on the walls of the Mantuan *Sala*, only one lacks a parallel with the prose *Lancelot*: the family of lions living in the heart of the forest to the right of Wall 1 (Fig. 73). Although lions are nowhere mentioned in our episode, we shall see that there is, nonetheless, a convincing explanation for their presence in this Gonzaga stronghold.[15]

Of all the elements in the episode in the prose *Lancelot*—Bohort's arrival at the Chastel de la Marche, the princess and the damsels in their tribune, King Brangoire's tournament, the tent in which the banquet took place, the vows of the twelve champions, and the love intrigue between the princess and Bohort—only the last element is totally missing from the *Sala del Pisanello*. In

the *Lancelot* the love affair unfolds in three scenes: the lovesick princess's confession to her nurse, the old woman's visit to Bohort's chamber to persuade him to wear the magic ring, and the resulting love scene between the enchanted Bohort and the impassioned princess. Looking at the reconstruction of the *Sala* in Figures 6 and 19, and keeping in mind the hypothetical placement of the lost vows of the seventh, tenth, eleventh, and twelfth speakers at the banquet on the left half of Wall 3, we see that these three scenes between hero, heroine, and go-between would have fitted comfortably along Wall 4, placed in a counter-clockwise direction on the empty zones between the door and the two Gothic windows.[16] The immediately succeeding image (Figs. 34 and 35) on Wall 1 of the knight identified as Bohort may have served to represent the hero's departure as well as his arrival. In this reading of the narrative, the penultimate scene of Bohort and the princess together, placed between the windows on Wall 4, was succeeded by the depiction of Bohort's departure with his retinue of dwarfs, extending around the corner from Wall 4 to Wall 1 (Fig. 15).

The iconography of these frescoes has previously been identified as a conflation of various unrelated and incomplete episodes, extracted from several different and disparate romances.[17] Although tournaments occur with repetitive frequency in Arthurian romance, Pisanello's tournament was arbitrarily identified as the important joust held at Louverzep, during which the two great heroes Tristan and Lancelot competed on opposite sides.[18] The remaining images in the *Sala* were held to be illustrations of other, unconnected, stories from the prose *Tristan* and the *Queste del Saint Graal*, as well as the banquet scene from the prose *Lancelot*.[19] There is, however, no precedent in Quattrocento mural decoration for such a combination of miscellaneous scenes from different sources, and the evidence instead overwhelmingly points to a simpler solution: the *Sala* as a whole was to be frescoed with one episode as a whole, that of Bohort's adventures at King Brangoire's castle, starting with his arrival, extending through the tournament, the banquet, and the love affair, and ending with his departure. This iconographic solution accounts for all the principal surviving visual features of the cycle, while at the same time providing the right amount of subject matter to fill those parts of the room where nothing now remains. We need to make an imaginative leap to visualize the room as a frescoed whole with the story of Bohort's visit to Brangoire's castle as its fundamental narrative unit—a day in the life of an Arthurian hero, so to speak—rather than concentrating on the one scene, the tournament, that happened to be partially painted.

Before this identification was made possible by Pizzorusso Bertolucci,

scholars oscillated between defining the fighting on Wall 1 as a tournament and as a battle.[20] One important feature, however, always distinguishes depictions of tournaments from those of battles: the spectators. Ladies and courtiers are never shown calmly watching and enjoying battles in the many Quattrocento *cassoni* panels which show identifiable battles.[21] A fifteenth-century hanging, possibly commissioned by Philip the Bold of Burgundy, showing the Battle of Pharsalus (on the right of Fig. 36), Uccello's *Battle of San Romano*, and Piero della Francesca's *Victory of Heraclius over Chosroes*—to cite verified representations of battles in tapestry, panel, and fresco—all proceed without avid onlookers.[22] Moreover, such undisputed battles are fought in a more confused and undisciplined way with greater carnage and death than the conflict seen in the Mantuan frescoes.[23] Spectators were, however, an intrinsic element in depictions of unquestionable tournaments, as was to be expected since the joust was in large measure a spectacle put on for their enjoyment.[24] The ladies and other onlookers are usually situated high off the ground at palace windows or, as in Mantua, in a specially constructed tribune which enables them to get a good view of the action (Figs. 13 and 32). The tribune is normally placed centrally, behind the jousting on folio 55 of *Guiron le Courtois* or the *grande mêlée* on folio 4v of *La Queste del Saint Graal*, both illustrations of tournaments in Lombard manuscripts from about 1400 (Fig. 75 and 76).[25] The same compositional scheme prevails in the joust drawn by Jacopo Bellini around the middle of the Quattrocento (Fig. 78), and in the tapestry showing a tournament that was commissioned in the late fifteenth century by Frederick the Wise, Elector of Saxony (Fig. 79).[26] Only in frescoes was this formula varied very slightly, as in the *Sala del Pisanello* in Mantua and the *turnyr camer*, the tournament room, at Castelroncolo, where the tribunes packed with female spectators were placed off to one side, the two muralists taking advantage of the considerable lateral wall space at their disposal to give an unobstructed view of the exciting event (Fig. 80).[27] The evidence of prevailing formulas in contemporary tournament illustration thus further confirms the identification of the fighting on Wall 1 of the *Sala* as the tournament at King Brangoire's castle in which Bohort proved himself a champion.[28]

II. *French Romances in North Italian Libraries*

Because the inscriptions identifying the knights on Walls 2 and 3 of the *Sala del Pisanello* are in French we know that Pisanello and his patron used a manuscript of the prose *Lancelot* written in that language.[29] A North Italian court commission of frescoes based on a French text is not as unexpected as it might

appear. Mid-Quattrocento North Italian princes were still deeply influenced by the culture and literature of medieval France that had dominated the region in the late Middle Ages. It was fashionable, for instance, for ladies to have French mottoes and phrases embroidered on their sleeves and gowns, and even a humble book of edicts at the Mantuan court had an inscription in jumbled French and German—POUR VIVRE MET MANT—on its back cover.[30] As we shall see, other surviving fifteenth-century secular frescoes, such as those depicting the Heroes and Heroines and the Fountain of Youth in the castle at La Manta, also had extensive inscriptions in French.

French was widely diffused across northern Italy in the late Middle Ages.[31] Dante considered French the easiest and most pleasing vernacular in which to write romance, calling it the proper language for such prose narratives as "King Arthur's beautiful and fantastic adventures."[32] Thirty years earlier, the Venetian Martin da Canal had justified his choice of French when writing a history of Venice for his compatriots by explaining that "the French language is diffused throughout the world and is more pleasing to read and to hear than any other."[33] For a century and a half, from the mid thirteenth century to the end of the fourteenth, French was the dominant literary language of northern Italy. Numerous manuscripts in French, covering such subjects as natural history and theology, and including historical chronicles, Bibles, and translations of the Latin classics, were copied for an Italian public in the Veneto, Lombardy, and Emilia. For a writer in this region the obvious alternative to Latin was French, and writers began to compose works in a hybrid language known as Franco-veneto, which was predominantly Venetian but had French words thrown in as exotic and ennobling elements.[34] Franco-veneto was mostly used for verse, and such epic poems of the Charlemagne cycle as the *Chanson de Roland* were popularized in Italy through this literary language. The *Matière de Bretagne*, or stories of King Arthur's Round Table, on the other hand, became known in Italy through French prose versions. Being in prose, the Arthurian romances either were less attractive or were considered less suitable by Italian writers for reworking into Franco-veneto. Although some Arthurian romances were translated into Italian, readers at Italian courts preferred the texts in the original language.[35] In the Trecento knowledge of French was undoubtedly a sign of distinction for the new aristocratic class of this region. The language was still so widely diffused in the following century that it was apparently read with greater ease than Latin.

I would rather read books in Latin than in French, [wrote the youthful Galeazzo Maria Sforza in 1457 to his father] but I can share my pleasure with

everyone when reading the French ones, so I pray Your Excellency to send the key to the French books [in the Pavia library] so that I can take two of them with me to read and enjoy on board ship. [36]

This revealing comment on the preference of Milanese courtiers for French books indicates that medieval French as a language posed no difficulties for court readers. We can imagine how the contrast between the everyday vernacular of northern Italy—colloquial, familiar—and the language of the romances—foreign, exotic, fashionable—must have strengthened the tales' evocative charm and enhanced their snobbish appeal. "Nothing about a literature can be more essential than the language it uses," one literary critic has written; "a language has its own personality, implies an outlook, reveals a mental activity and has a resonance, not quite the same as those of any other."[37]

In some North Italian libraries, accordingly, volumes in French by far outnumbered those in Italian. Such was the case with Mantua. In 1407 the Gonzaga library had a particularly rich collection: out of 392 volumes, 67 books were in French, compared with 32 in Italian.[38] Of the 67 French codices, 44 were fiction, including 22 *chansons de geste* of the Charlemagne cycle and 17 Arthurian prose romances.[39] Four of the branches of the Vulgate Cycle, including the prose *Lancelot*, were represented.[40]

The Gonzaga started collecting such books in the early Trecento, and several of the manuscripts added to the library in this period, including a *Tristanus* of around 1300 and some mid-fourteenth-century Carolingian *chansons de geste*, can be identified.[41] The Gonzaga sought expert advice in forming their library, and Petrarch himself sent them a copy of the *Roman de la Rose* in 1339.[42] By the mid Trecento the Mantuan collection was well known to other North Italian readers, and loan requests became frequent. In 1378, for instance, Luchino Visconti of Milan turned to the Gonzaga because, as he wrote, they were known for the beautiful and enjoyable books they owned. He hoped to alleviate the boredom of his forthcoming sea voyage to Cyprus by borrowing "an eloquent romance of Tristan or Lancelot or other beautiful and pleasing subjects," *pulcra et delectabili [sic] materia*, words that evoke the subject matter of the later *Sala del Pisanello*.[43]

It is often assumed that the contents of the Visconti, Este, and Gonzaga libraries in Pavia, Ferrara and Mantua reflected one another, but while the library holdings were broadly similar, the interests of the three families differed in emphasis.[44] As it happens, the Gonzaga collected more books in French and more *chansons de geste* and prose romances than either the Este or,

especially, the Visconti. In the 1436 inventory of the Este library, a collection considerably smaller than Mantua's in 1407, the proportion of French to Italian codices was similar: 57 volumes in French to 20 volumes in Italian out of a total of 279 books.[45] But only 19 of the French volumes in Ferrara were tales of chivalry (of which 11 were Arthurian stories) in comparison to the 44 volumes of French fiction owned by the Gonzaga.[46] The contrast with the Visconti is even more striking. In 1426 the library in Pavia, one of the richest collections in Italy, amounted to almost a thousand volumes, but the Visconti owned proportionaly fewer books in French, and fewer romances, than their neighbors in Ferrara and Mantua: 90 codices in French (compared to 52 in Italian), of which only 8 or 10 were Arthurian romances.[47] The Gonzaga thus owned twice as many French adventures as the Este and four times as many as the Visconti, despite the enormous difference in the size of their respective libraries. Although no inventory of Gonzaga books survives from the mid-Quattrocento, contemporary with the Pisanello frescoes, the importance of French romances in the Mantuan library in 1407 was presumably still apparent later in the century. The number of French romances in both Ferrara and Pavia, for instance, remained constant throughout the fifteenth century: in 1488 the Este owned 17 or 18 such volumes,[48] and in 1470, when Borso d'Este wrote to Milan for a list of the Arthurian books in French in Sforza possession, the librarian Giovanni degli Attendoli could find—or so he claimed—only 13 such manuscripts in the Pavia library.[49]

Published research from the court of Ferrara is suggestive of the care with which these volumes were treated. Many payments are recorded for the transcription, binding, and illumination of French romances under both Leonello and Borso d'Este. In 1441 Gulielmo de Franza, *scriptore*, received 20 gold ducats "for writing books in the French tongue," and payments were still being made in the 1460s for the transcription of such manuscripts as the *Reali de Franza*.[50] Many of these volumes—including a *Saint Graal*, a *Guiron le Courtois*, an *Aspremonte*, a *Meliadus*, a *Tristan*, a *Galahad*, and another book in "lengua gallica" being read by Folco da Villafora—were bound or rebound in 1447–48, the years when the Arthurian cycle was being commissioned in Mantua.[51] The care of this category of books continued under Borso d'Este, and a "large French book called *Re Borso* [King Bohort]" and "a book called *Lanzaloto* in French" were both rebound in the late 1450s.[52] These codices were also considered important enough to be embellished. Jacomo Barbiri, *scritore et aminiadore de libri*, added miniatures to a *Merlin* at an unspecified date; in 1464 Borso paid Girardo di Ghisuleri 8 ducats to illuminate a *Lanzalotum* in Italian; and in 1468 the same artist again illuminated "un libro francese chia-

mato le più novelle di Lanzilotto," "a French book called the stories of *Lancelot*."[53]

The contents of these libraries reflected the resources of the courts but not necessarily the courtiers' current intellectual interests, since mere possession of a book, as we all know, does not necessarily guarantee that its owner has read it. Loan registers and letters therefore provide important evidence about the literary taste of North Italian princes at mid century. French chivalric romance still held immense appeal for such Este courtiers as Folco da Villafora, Leonello's favorite. In 1460–61 Francesco Accolti, rector of the University at Ferrara and a translator of Homer, borrowed six romances, four of them in French and probably all of them Arthurian, for eighteen months: "One *Merlin*, one *Meliadus*, one *Lanzaloto* in French, one French book called the *Saint Graal*, one French book without a name and another French book," having already in 1458 borrowed the *Merlin* and the *Meliadus* and in 1459 the "French book called *Saint Graal*."[54] In 1455 Giacomo Ariosti borrowed "one *Meliadus* in the French language, one book called *Lancelot* in French, one French book," in 1457 he again borrowed the "French book called *Meliadus*, in 1458 and again in 1459 the "Lanzeloto in franchois," in 1461 a "Tristano in lingua gallica," and five years later took home the "stories of *Lancelot*" just before it was sent off to Girardo di Ghisuleri to be further embellished.[55] These particular books also circulated widely to other borrowers. The "Tristano in gallica" was carried off by Meliaduse d'Este, and the *Merlin* by Galeotto di Campofregoso; Petrecino del Bondeno perused both French and Italian versions of *Lancelot* while Troilo Giocoli read it in French and Gian Francesco della Mirandola in Italian.[56] The book on "Lancelot's birth" borrowed by Lorenzo Strozzi was in French; the language of other versions of this same romance that were enjoyed by Benedetto Strozzi, Bertolazzo di Pizolbeccari, Francesco d'Este, and Anselmo Salimbeni remained unspecified.[57] The owner of all these volumes, Borso d'Este, had himself enormous enthusiasm for all things Arthurian. In 1461 he had a "Lanzaloto in franceze" brought out to his villa, along with a "Lanzaloto in vulgare" and a French Bible.[58] By 1470, having exhausted the resources of his own library—even though it included five versions of *Lancelot*, four of the *Saint Graal*, and four of *Tristan*—he wrote to Ludovico di Cunio, who had himself earlier borrowed an Este "libro franchois":

> I have just finished reading all the French books that I can find at home. Because you are indebted to me, I send you this messenger begging you to send him back loaded with as many French books as you can, that is, those of

the Round Table, reminding you that I shall receive more pleasure and contentment from them than I should from gaining a city.[59]

The Este were not prompt to return the books they borrowed, a failing that understandably irritated the princes who were obliged to lend them volumes. When in 1464 Borso asked Lodovico Gonzaga if he might borrow a "libro francese che tratta de Gurone" (a French book about Guiron), the Marchese of Mantua found it necessary to remind the Duke of the copy of *Guiron le Courtois* belonging to the Gonzaga library that had not been seen since its loan to Ferrara by his father, Gianfrancesco.[60] This appropriated *Guiron* remained a sore point with Lodovico, who was himself conscientious about returning books. As the Marchese noted, he could not refuse to lend codices to the Duke of Ferrara, but he did so reluctantly, on one occasion suggesting to his wife that the messenger delivering "our French book called Madona Agnese" to Borso should ensure that the Duke make a note of the loan "so that this one doesn't get lost as did our *Guiron*, which was lent in the same way and which we were never able to get back . . ."[61] That same day in 1468, concerned over Borso's record as a book borrower, Lodovico had already written to the Duke to ask him to return yet another codex belonging to the Gonzaga library, "el libro nostro franceze che tracta de Lanciloto" (our French book about Lancelot), perhaps the very volume used for the frescoes in the *Sala del Pisanello*.

> Because this book is always kept in our room and we take pleasure in reading
> it from time to time, we would be grateful if your Lordship would return it
> when you have read it,[62]

wrote Lodovico hopefully, indicating that he so enjoyed French Arthurian romance that he still kept the *Lancelot* in his room some twenty years after the *Sala* commission.

Fewer account books and loan registers survive in Mantua than in Ferrara, but letters concerning loans confirm that the mid-century Arthurian vogue also extended to the Gonzaga court. In 1466 a Gonzaga administrator referred to the "French book on the death of Palamides" that had been borrowed by the Mantuan court, and in 1471 Lodovico thanked a friend for lending him a *Reali de Franza*.[63] These documents and the Marchese's determination to replace the lost *Guiron* with another manuscript specially transcribed for his own library further confirm that, like Borso d'Este, the ruler of Mantua read and enjoyed tales of French chivalry well into the second half of the fifteenth century.[64] The surge of interest in classical literature that took place in fif-

teenth-century Italy thus only partially displaced the longstanding attach-
ment of many, if not most, North Italian *signori* to French chivalric litera-
ture.[65] Indeed, the popularity of these tales was so pervasive that even the
library that was created in Pesaro as late as the 1450s and 1460s by Alessandro
Sforza included a "Lancilotto in franzese" as well as a "De historie de i cavalier
franzesi."[66]

The number of French romances in the Mantuan collection at mid cen-
tury, when the *Sala del Pisanello* was commissioned, cannot be determined
precisely for lack of a contemporary inventory but, because the numbers of
French romances remained stable in Ferrara and Pavia during this period, it
can be safely assumed that the many romances on hand in 1407 remained an
integral part of the library holdings throughout the century. In 1542, the date
of the next extant Mantuan inventory, many of these French romances still
formed part of the Gonzaga library, including multiple volumes of the prose
Lancelot:

> three books of *Lancelot du Lac* in French
> two books of the first volume of *Lancelot*
> two books of the second volume of *Lancelot*
> one book of the third volume of *Lancelot*.[67]

Thus, the literary source of the frescoes in the *Sala del Pisanello* remained
in demand throughout the Renaissance; the prose *Lancelot*'s reputation was
great enough to justify the printing of as many as seven editions in the late
Quattrocento and early Cinquecento.[68] Clearly the Renaissance would have
endorsed the evaluation of one twentieth-century critic: "the prose *Lancelot*
was not perhaps the most perfect work of romance and mysticism that Medi-
eval France produced, but it was certainly the most powerful."[69]

III. *Arthurian Romance in Italian Art before Pisanello's Cycle*

One index of the great popularity of Arthurian romance in Italy lies in records
of given names. At the beginning of the twelfth century, some years earlier
than existing Arthurian texts, the names Artusius and Galvanus were already
popular in northern Italy. In the thirteenth and fourteenth centuries these
were joined by Isotta, Tristano, Lancilotto, Ginevra, Perceval, Galeasso,
Ivain, Meliadus, Galeotto, and Merlino.[70] In the Quattrocento the names that
Niccolò III d'Este of Ferrara imposed on sundry offspring prove the con-
tinued interest in the *Matière de Bretagne*: Meliaduse, Leonello, Maria Gurone,
Ginevra, Isotta (twice), and Rinaldo, as well as Borso, the particular hero of
the *Sala del Pisanello*.[71]

The earliest surviving Italian instance of romance illustration also predates surviving texts:[72] the low relief carving of the rescue of Winlogee by Artus on the Porta della Pescheria of Modena Cathedral around 1120–30.[73] Still in the twelfth century, the equestrian figure of "Rex Arturus" was included among the many images on the mosaic pavement of Otranto Cathedral in 1163 and, at the beginning of the thirteenth, the pavement of S. Giovanni Evangelista in Ravenna was adorned with scenes from the legend of King Arthur.[74] Because the most notable reelaboration of Arthurian matter in the Italian language was the *Roman de Tristan*, reworked as the *Tavola Ritonda*, the story of Tristan was widely illustrated in Italy, especially in the applied arts.[75] In Sicily, for example, stories of Tristan and Isolde were included in about 1380 among those on the wooden ceiling of the Palazzo Chiaramonte in Palermo,[76] and two linen quilts, illustrating twenty-two episodes from Tristan's youth, survive with captions in the Sicilian vernacular.[77] They bear the arms of the Guicciardini and Acciaiuoli families of Florence; a marriage that linked these families in 1395 may have been the occasion for their commission.

The largest number of Italian illustrations of Arthurian matter survive, as we would expect, in the pages of manuscripts devoted to Arthurian romance. During the thirteenth and fourteenth centuries, many French manuscripts written in Italy of such texts as the prose *Lancelot*, the prose *Tristan, Guiron le Courtois*, and *La Queste del Saint Graal* were illustrated with lively, if crude, images of tournaments and jousts.[78] More sophisticated miniatures were produced at the end of the fourteenth century for the cosmopolitan court of Gian Galeazzo Visconti of Milan, where Lombard artists, specializing in the illustration of secular books, produced manuscripts such as the *Guiron le Courtois* and a combined *Queste del Saint Graal* and *La Mort Artu*, today in the Bibliothèque Nationale in Paris.[79] The most important such manuscript for our purposes is contemporary with the *Sala del Pisanello* and contains a compilation of stories from the *Tavola Ritonda* involving Lancelot, Tristan, and Perceval. Written by a Venetian scribe in 1446, it was illustrated with 289 pen drawings of considerable charm that have been convincingly attributed to Bonifacio Bembo, a Lombard artist who worked extensively for the Dukes of Milan.[80] His style, although marked by distinctive mannerisms, is sufficiently close to that of Pisanello to evoke the character of the lost narrative units of banquet and bedchamber in the *Sala del Pisanello* (Figs. 37 and 38).

Much Arthurian imagery remains in manuscripts and elsewhere, but few large-scale murals survive. The *Sala del Pisanello*, as the only surviving Italian Renaissance cycle depicting an Arthurian romance, is historically isolated. It can be argued, however, on the basis of the names of rooms in castle inven-

tories on the one hand, and of surviving cycles that illustrate chivalric if not specifically Arthurian subjects on the other, that the Arthurian frescoes in Mantua are representative of an entire corpus of work that has since vanished. The notorious Agnese Visconti, wife of Lodovico's grandfather Capitano Francesco, for instance, used the *camera Lanzaloti* of the Trecento palace in Mantua (which also boasted a *camera Paladinorum*), and Margherita Gonzaga, Leonello d'Este's first wife and mother of the Niccolò d'Este who wanted to convert the *Sala del Pisanello* into a kitchen, resided in the *chamera de Lanziloto* in the *Palazzo di Piazza* in Ferrara in 1436.[81]

Most monumental chivalric frescoes predating the Pisanello murals survive only in remote centers and are therefore provincial in character. Thirteenth-century frescoes were recently discovered in the Castle of Rodengo, near Bolzano, in a room immediately adjacent to the *cortile*.[82] The vigorous paintings include twelve episodes from the cycle of Ivain, based on Hartman von der Aue's version of Chrétien de Troyes's poem. An entire building at nearby Castelroncolo, referred to as the *Sommerhaus* in a 1493 inventory, was frescoed around 1400 with chivalric stories. Commissioned by Nicolaus Vintler, a financial power in the Tyrol, the four surviving cycles provide useful comparative material for the *Sala del Pisanello*.[83] Stories of Wigalois, based on the poem by Wirnt von Eschenbach, were painted in *terra-verde* in an open loggia, called the *Vigelas sal* in the 1493 inventory. The long exterior balcony leading to the *piano nobile* was painted with the Nine Worthies, with triads of Knights of the Round Table (Perceval, Gawain, Ivain), with famous pairs of lovers (including Tristan and Isolde), and with the three strongest giants and three wildest giantesses. The two rooms on the *piano nobile* above the Wigalois loggia were frescoed with, respectively, stories of Tristan and Isolde, based on the poem by Gottfried von Strassburg, and twenty-two scenes from Der Pleir's *Garel von dem Blühenden Tal*. These cycles share not only their chivalric iconography with the Pisanello frescoes in Mantua but also, in the case of the one Arthurian work, the Tristan stories on the *piano nobile*, important aspects of their narrative design (Fig. 39).[84]

Two other Italian secular cycles illustrating chivalric material predate the Pisanello room. In Florence, frescoes depicting the *Dama del Verzù*—an early fourteenth-century Italian version of a late thirteenth-century French poem, the *Chastelaine de Vergi*—decorated a room on the second floor of the Palazzo Davanzati.[85] This cycle has been dated to the mid Trecento in connection with a marriage in 1350 between the Davizzi and Alberti families, whose arms decorate the fictive hangings on the wainscot.[86] The dramatic subject, a complicated story of love, jealousy, revenge, and death, perhaps based on an actual

scandal at the Burgundian court, is eminently unsuited to successful transla-
tion into pictorial narrative, but was nonetheless often also depicted on
French ivory caskets.[87]

Closer in location and date to the Mantuan cycle are the well-preserved
frescoes in the castle at La Manta near Saluzzo in Piedmont, in a room that
was identified as the *sala superiore* in 1587.[88] The murals represent two well-
known subjects often depicted on tapestries and ivories: first, the *preux*, the
Nine Worthies of medieval legend—those exemplary *condottieri* of the past—
and the *preuses*, the nine illustrious women; and second, on the opposite wall,
the Fountain of Youth.[89] A literary source that combines these two fashion-
able themes has not yet been identified.[90] The humor and descriptive detail
with which the Fountain of Youth is depicted, however, make familiarity
with the poem or romance unnecessary for comprehension and enjoyment of
the paintings (Figs. 40 and 41). The frescoes were commissioned, probably
around 1420–30, by Valerano of Saluzzo, who together with his wife can be
identified among the Worthies by means of the French royal collar of broom
pods and liberal use of the family motto *leit* in German.[91] The many inscrip-
tions throughout the cycle, however, are in French. Each illustrious man and
woman was carefully identified by several lines of French verse, and the three
episodes of the Fountain of Youth were also punctuated by the protagonists'
speeches in French. The similarities that these frescoes, too, show to the pic-
torial organization of the *Sala del Pisanello* will be discussed in chapter 6.

These few remaining fresco cycles represent a minute percentage of an
enormous corpus of work that has vanished forever. Because they were of
little monetary value, the walls of frescoed halls were never included in inven-
tories of castle possessions. Other forms of room embellishment, however,
such as tapestries, were carefully inventoried precisely because of the capital
investment they represented. Unfortunately, an inventory listing the fif-
teenth-century tapestry collection of the Mantuan court no longer survives,
but those made of the collections of other princes include many hangings with
chivalric subjects. The two chivalric heroes most frequently depicted on
tappiz a images in fourteenth-century France were Tristan and Chrétien de
Troyes's Perceval le Galois; hangings depicting these heroes or their exploits
were owned by the Duke of Burgundy in 1379, 1390, and 1395, Philip the
Bold in 1404, Margaret of Flanders in 1405, and Philip the Good in 1420.[92]
Philip the Bold's collection also included an *Istoire du Roy Artus*, and two other
Arthurian subjects—a *Saint Graal* and a *Messire Yvain*—graced that of Charles
V.[93] A payment was recorded in 1462 from Philip the Good to Pasquier
Grenier for three tapestries of the story of the Swan Knight, a subject that had,

as we shall see, a particular significance for descendants of the Dukes of Lorraine such as Barbara of Brandenburg.[94]

Many northern princes owned tapestries illustrating the *Roman de la Rose*, a subject that was therefore also fashionable at Italian courts. Once again, valuable evidence survives from Ferrara. Borso d'Este paid the incredible sum of 9,000 gold ducats for five enormous Flemish hangings made of velvet and embroidered with gold, silver, and silk, depicting "la jstoria de Romanzo de la ruosa," only a few years after the commission of the *Sala del Pisanello*.[95] Almost 5 meters high and extending from 12½ to 14 meters in length, these sumptous *cortine* covered the walls of the *Sala Grande* in the castle in Ferrara from 1476 to 1529. Both Leonello d'Este and Borso d'Este owned extensive collections of tapestries, but the precise subject of many of these hangings was often ill defined by the two officials, the *governadori de la tapezarie*, responsible for inventorying them in the 1450s and 1460s. Many of the hangings listed, however, such as the very large tapestry described as "figures fighting a city guarded by women and defended with roses called the Story of Virtue," must have represented romance subjects.[96]

Whether chivalric or not, some of the identifications of Este tapestries could serve well as Quattrocento descriptions of the Arthurian cycle in Mantua. "A tournament with men on horseback with clubs in hand," "men on horseback fighting by a barrier," and "a hanging of tapestry with gold . . . with several figures on foot and on horseback" all evoke the theme of the tournament scene on Wall 1 of the *Sala del Pisanello* as well as recalling the Flemish tapestry of a tournament ordered by the Elector of Saxony (Fig. 77).[97] References to two sets of bed hangings, one showing "people who eat" and the other depicting "a man dressed in black embracing a woman dressed in blue," seem to describe subjects similar, on the one hand, to the banquet at which the twelve knights took vows and, on the other, to the love scenes between Bohort and the princess.[98] Many other tapestries, such as that described as being "all with greenery and towns . . . and animals and air and many other things," must have displayed landscapes similar to that on Walls 2 and 3 of the *Sala*.[99]

The reader will have noticed that Bohort's name has been conspicuously absent from this discussion of chivalric and Arthurian imagery predating the *Sala del Pisanello*. Bohort did not share in the popularity of such other heroes of the Vulgate Cycle as Lancelot, Gawain, and Perceval, whose adventures were frequently extracted from the context of a story and illustrated separately. Some Arthurian heroes and themes were more popular than others, but none of the Vulgate Cycle heroes could match the popularity of Tristan, whose story dominated Arthurian imagery throughout the late Middle Ages,

becoming an immensely popular theme for the decoration of every conceivable kind of luxury object from ivory boxes to textiles.[100] Even Lancelot's exploits make few appearances in surviving works of art outside the manuscripts, apart from the lost frescoes that presumably decorated the walls of the two *camere Lanzaloti* in the palaces of Mantua and Ferrara.

Lodovico Gonzaga was, therefore, not choosing a frequently depicted story at random when he decided to illustrate one of Bohort's adventures on the walls of his *Sala*. Yet despite the lack of other surviving depictions of his tale, Bohort was an extremely well-known knight of the Round Table and one of the most important figures in the slow unraveling of the plot of the Vulgate Cycle. A very long portion of the prose *Lancelot*, representing an important percentage of the romance as a whole, was devoted to Bohort and his deeds, of which the story frescoed in Mantua was only one adventure among many. He repeated many of his cousin Lancelot's adventures and, toward the end of the prose *Lancelot*, fought as an equal against his cousin so that his peers assessed him as "li mieldres d'euz tous" (the best of them all).[101] As Lancelot's behavior became demonstrably more flawed, his cousin Bohort was advanced to a position second only to Galahad as an embodiment of valor and modesty. Finally, Bohort became one of the three heroes who actually accomplished the quest for the Holy Grail. His companions, Galahad and Perceval, who unlike Bohort had retained their virginity, were allowed to see openly the mystery of the holy vessel, but Bohort, who had been seduced by Brangoire's daughter, was initiated into some only of the Grail's mysteries. Galahad and Perceval died soon afterwards in ecstasy, leaving Bohort as the sole successful quester to return to Camelot to spread the news. A remarkable future also awaited the son that Bohort conceived with King Brangoire's daughter: it was foretold that Helain would become Emperor of Constantinople and would outdo Alexander.[102]

We can conclude both that the regular reader of Arthurian romance—in other words, North Italian court society in general—must have been fully familiar with Bohort's adventures and that Bohort would have been considered a hero eminently worthy of depiction on the walls of the Gonzaga *Corte*. The care with which the episode from the prose *Lancelot* must have been selected and the specificity of the choice suggest that the story had personal meaning for Lodovico Gonzaga and his family, a meaning that will be explored in chapter 4 on the political context of this commission.[103] Having identified the subject of the cycle, we must now determine the date of its commission and consider how the frescoes can be integrated into Pisanello's oeuvre as a whole.

The Artist and the Date

I. *Pisanello's Career*

ANTONIO PISANO called Pisanello was born, probably in Pisa, in or shortly
before 1395, of a prosperous Pisan father and a Veronese mother.[1] By 1404 his
mother, widowed and remarried, had moved her family back to Verona.[2] A
letter written in 1416 by the humanist Guarino da Verona, then in Padua,
reveals that "Magister Antonius Pisanus" was already, at the age of twenty-
one, linked by common intellectual interests with one of the most distin-
guished scholars of the day and suggests that he may have had some humanist
education.[3] In other respects Pisanello's early career and training are uncer-
tain. Fifteenth-century sources and documents attribute to him a fresco in the
Sala del Maggior Consiglio in the Ducal Palace in Venice, where Gentile da
Fabriano had worked on the same cycle between 1409 and 1414.[4] It is possible
that Pisanello's mural, since lost, depicting an episode in the struggle between
Pope Alexander III and the Emperor Frederick Barbarossa, was painted in the
late teens.[5] Of Pisanello's certain works that survive, the earliest was painted
when he was over thirty: a fresco of the Annunciation dating about 1426,
forming part of the tomb for Niccolò Brenzoni in S. Fermo Maggiore,
Verona, created by the sculptor Nanni di Bartolo.[6] The work shows, as might
be expected, the formative influences of Gentile da Fabriano, the most accom-
plished painter working in northern Italy; of Stefano da Zevio, the leading
Veronese painter of the early Quattrocento; and of Altichiero, whose mural
cycles in Padua were the most substantial surviving pictorial achievement of
the late Trecento in northern Italy.[7]

By the early 1420s Pisanello's reputation was established—in 1424 he was
referred to as *pictor egregius*—and he had settled into his lifelong pattern of
moving among various North Italian courts, in particular Mantua and Fer-
rara.[8] Having established his residence in Mantua in 1422, in 1425 and 1426 he
was on the payroll of Lodovico Gonzaga, the thirteen-year-old son of Capi-
tano Gianfrancesco.[9] By the end of the decade Pisanello was also working for
Filippo Maria Visconti, Duke of Milan, and sixteenth-century sources attrib-
uted to him frescoes of hunting, fishing, and tournament scenes (since
destroyed) in Pavia Castle.[10] In 1431 Pisanello was in Rome, as part of the

household of the Venetian Pope Eugenius IV, to finish the cycle on the life of St. John the Baptist in St. John Lateran. Gentile da Fabriano had left it unfinished when he died in 1427; like most of the murals by these two artists, the cycle was later destroyed.[11] While in Rome, Pisanello made many drawings after classical works of art, some of which survive in the form of copies by his followers.[12]

By the early 1430s Pisanello had begun his long association with Leonello d'Este, son of the ruler of Ferrara. Leonello first acquired from the artist a panel of the Virgin.[13] This was followed by an image of Julius Caesar, a humanist theme favored by the prince, commissioned around the time of his marriage to Margherita, Gianfrancesco Gonzaga's daughter, in 1435.[14] Also in Ferrara, in 1438, during the church Council of Ferrara and Florence, Pisanello made sketches of the authorities attending the conference—an early example of an artist functioning as a journalist by taking notes as the historic event unfolds (Fig. 43).[15] Copies after drawings by Pisanello of Florentine works by Filippo Lippi, Fra Angelico, and Donatello suggest that the artist visited Florence around this time, perhaps following the Council when it moved to the Tuscan capital in 1439.[16]

Pisanello may well have been more fully integrated into the intellectual life and growing humanist interests of the North Italian princes who employed him than was usual for an artist in the early Quattrocento. The Este attracted a number of well-known humanists to Ferrara, including Pisanello's compatriot Guarino da Verona, who arrived in 1429 as Leonello's tutor.[17] Pisanello's close contacts with Guarino and other humanists stimulated him virtually to reinvent the antique art form of the bronze medal, and during the early forties he created medals for most of the dominant personalities in North Italian politics: the rulers Leonello d'Este of Ferrara and Filippo Maria Visconti of Milan and the *condottieri* Niccolò Piccinino and Francesco Sforza.[18] In Ferrara in 1441 both Pisanello and Jacopo Bellini painted portraits of Leonello d'Este. According to a sonnet by Ulisse degli Aleotti commemorating this competition, Bellini's work was preferred to Pisanello's.[19]

Leonello succeeded as Marchese of Ferrara later that same year, and in the early 1440s the poets and humanists at his court started to celebrate Pisanello in verse, choosing an artist with interests similar to their own for the exercise of their art. It became fashionable to write poems and ekphrases in praise of Pisanello's artistic skill. Ulisse degli Aleotti's sonnet—on the artist's defeat rather than his victory—is likely to have been written in 1441–42 and the Latin poem written in his honor by Guarino and the elegy by Tito Vespasiano Strozzi probably both date from this period.[20] Further afield, at the court of

Urbino, Angelo Galli wrote two sonnets in 1442.[21] In 1447–48 Basinio da Parma, one of Guarino's pupils, wrote in praise of Pisanello's work in the convention by now firmly established at the court of Ferrara.[22] The theme of these literary exercises was the artist's skill in giving eternal life to princes; Pisanello's contemporary fame rested primarily on his portraits and what was perceived, or at least vaunted, as their verisimilitude.

In 1422 Pisanello had purchased a house in Verona, and documents attest to his continued Veronese citizenship and legal domicile in the contrada of S. Paolo through the 1430s and the 1440s.[23] His immediate family consisted of his mother, Isabetta, his half-sister, Bona, who married Bartolomeo di Andrea della Levata, and his daughter, given the classicizing name Camilla when she was born in 1429.[24]

Pisanello's precise whereabouts during most of the 1430s are unknown, but much documentation survives from the forties, during which he divided his time between the courts of Mantua and Ferrara. In 1439, 1440, and parts of 1441 and 1442 he worked at the Gonzaga court.[25] This is the moment when political events revealed Pisanello's anti-Venetian sentiments—the understandable resentment felt by many Veronesi against Venice, the power then occupying their territory. Verona was a pawn in the struggle between two essentially foreign powers, Milan and Venice, for territorial domination of northern Italy. In November 1439 the city, which had passed from Milanese to Venetian rule in 1405, was occupied briefly by Milanese troops under the command of Gianfrancesco Gonzaga, who in 1438 had sought release from his position as Venetian commander general in order to sign a *condotta*, or treaty, with the republic's arch enemy, Filippo Maria Visconti of Milan.[26] Pisanello became involved: "Pisano the painter came and went back with the Marchese [of Mantua]," as the *rettori* of Verona later recorded. The Venetian authorities, who in 1439 had ordered all Veronese citizens residing in Mantuan territory to return home, were incensed by the disloyalty of those Veronese subjects who, like Pisanello, were seen as having gone over to the enemy.[27] Angered by Pisanello's continued allegiance to the Milanese camp and by his return to Mantua after the three-day Gonzaga capture of Verona, the Venetian Republic moved against the artist by accusing him of various political crimes during the occupation of his native city. In July 1441 he was registered as having plotted in his sister's home, "behaving nefariously in the house of Andrea della Levata;" at the same time his brother-in-law, as a relative of "Pisan the painter, a rebel," was also placed on a list of Veronese citizens under suspicion.[28] In October 1441 witnesses were questioned without success about Pisanello's alleged presence near a pawnshop while it was being

looted by soldiers during the occupation.[29] In the spring of 1442 the state finally named Pisanello among the thirty-three prominent Veronese citizens whose property was slated to be confiscated because they had actively worked against the Republic.[30] In the fall of that year the Council of Ten proceeded to condemn him on the grounds of using vile and dishonest language against the Republic in Mantua with the Marchese's son, Lodovico Gonzaga, "pro verbis turpibus et inhonestis quibus usus fuit in Manthua cum domino Ludovico de Gonzaga." A proposed sentence of amputation of the tongue to take place ceremonially between the two columns in Piazza San Marco was unanimously rejected by the Council of Ten, which instead voted to sentence the artist to be confined to Venice, with the ominous rider that disobedience would result in confiscation of the artist's property in Verona.[31]

The documentation dealing with the status of *Pisan pentor rebello* as a Veronese subversive and Milanese supporter and his alleged defamation of the Republic reveals Venice's oppressive hand as an occupying power and shows how little its posture as "liberator" impressed the citizens of the *terraferma* whom it was supposedly benefiting.[32] The evidence, unusual in the biography of a Quattrocento artist, also confirms the fame attained by Pisanello within North Italian artistic circles and his allegiance to the political fortunes of his patrons. On the one hand, he must have been a prominent figure to be singled out by the Republic for harassment; on the other, he must have had influential friends among the ruling classes to get off so lightly. His sentence was in effect waived almost immediately. Only a month after he had been confined to Venice, Pisanello was permitted to go to Ferrara for a period of two months, thanks to the intervention of Gonzaga's son-in-law Leonello d'Este. The Council of Ten, however, continued to limit Pisanello's possibilities of employment by forbidding the artist to enter Veronese or Mantuan territory.[33] In June 1443 the Council of Ten renewed Pisanello's permission to stay in Ferrara, and he continued to reside there through 1443 and eventually until 1448.[34] During these years he made as many as nine medals for Leonello d'Este, including one celebrating the Marchese's second marriage, to Maria of Aragon, in 1444.[35] Still in Ferrara in 1445, Pisanello provided a painting for Leonello's palace at Belriguardo, and in 1447 he was paid 25 florins for another unspecified work for the Ferrarese court.[36]

In 1443 and 1444 Pisanello received four letters from Gianfrancesco Gonzaga, the only correspondence addressed to the artist that survives. They indicate the easy terms on which the two men stood. At the end of February 1443, hearing that Pisanello had reached Ferrara but was banned from Mantuan territory, the Marchese wrote to Guglielmo Gonzaga referring to the sentence

passed on Pisanello in October 1442: "We understand that *Pisano pinctore* is there and says that he is not going to come and stay with us because, . . . if he does, his goods will be confiscated."[37] The artist must have written immediately, because on 3 March, only four days after Gianfrancesco's letter to Guglielmo, the Marchese replied, acknowledging Pisanello's letter and the reasons why he could not leave Ferrara.[38] In September Gianfrancesco answered another letter from Pisanello, in which the artist asked for money, outlining a decision that was probably linked to the September expiry date of his *permesso* to stay in Ferrara and that involved a trip he proposed to make to the court of Naples. The Marchese expressed support for Pisanello's imminent departure from northern Italy but refused to subsidize the artist's journey south.[39] A letter written in November 1443 demanding the immediate return of a canvas of God the Father, which Pisanello had apparently taken with him to Ferrara, indicates that, despite the Council of Ten's edict, the artist visited Mantua in the fall of 1443.[40] In March 1444, Gianfrancesco replied to yet another letter from Pisanello, who, still in Ferrara, had answered the Marchese's queries about rooms he used to occupy in the *Corte* in Mantua as well as announcing the further delay of his departure for King Alfonso's court in Naples.[41]

In 1445 Pisanello created two medals for Sigismondo Pandolfo Malatesta, Lodovico Gonzaga's first cousin, perhaps while resident at his court in Rimini;[42] and in 1447, two and a half years after the death of Gianfrancesco Gonzaga, he was probably once again in Mantua. There Pisanello produced medals of the new Marchese, Lodovico, and his sister Cecilia, and probably also the posthumous medals of the Marchese's father, Gianfrancesco, and his tutor Vittorino da Feltre.[43]

In 1444 Leonello d'Este had married Maria of Aragon, daughter of King Alfonso V of Naples. Contact with her Neapolitan retinue, coupled with the restrictions placed on his movements by the Council of Ten, perhaps first stimulated Pisanello's desire to visit the Neapolitan court. The journey, as we saw, was postponed in March 1444, possibly because of the Council of Ten's oversight in demanding his return to confinement in Venice.[44] Still in northern Italy in the summer of 1448, the artist made the medal of Pier Candido Decembrio that Leonello d'Este had commissioned as a gift for the Milanese humanist.[45] By the end of 1448, however, Pisanello finally reached the court of Naples, where in February 1449 the King issued a *privilegium* declaring him a member of the royal household with an annual stipend of 400 ducats, a salary that compares favorably with the annual stipends of Gentile da Fabriano in Rome in 1427, Guarino da Verona in Ferrara in the 1430s, and

Bartolomeo Fazio at the court of Naples in 1446 (respectively 300 florins, 350 ducats, and 300 ducats).[46] The impact of Pisanello's art on a receptive contemporary shines through the verbose humanist rhetoric of King Alfonso's *privilegium*:

> . . . Seeing therefore that we had heard, from the reports of many, of the multitude of outstanding and virtually divine qualities of Pisano's matchless art both in painting and bronze sculpture, we came to admire first and foremost his singular talent and art. But when we had actually seen and recognized those qualities for ourselves, we were fired with enthusiasm and affection for him in the belief that this age of ours has been made glorious by one who, as it were, fashions nature herself.[47]

Pisanello created three medals for the King and worked on other projects for which only drawings survive.[48]

Pisanello died in 1455, and the 1449 *privilegium* is the last document that can be connected with him.[49] The continued praise of humanists in Naples and Rome, however, suggests that he was still active in 1450. In 1449 Porcellio, secretary to Alfonso V, wrote an elegy.[50] In 1450 in Rome Flavio Biondo of Forlì mentioned the artist and Guarino's poem about him in his *Italia Illustrata*, and it is likely that Leonardo Dati's undated epigram was written in Rome at this time.[51] The silence surrounding Pisanello in the years just before 1455 suggests that he was inactive, perhaps incapacitated by illness, at the end of his life. In 1456 Bartolomeo Fazio, working at the court of Naples, included the artist's biography among those of only three other artists in his *De Viris Illustribus*, stressed the high esteem in which Pisanello was held by Italian princes, and—just possibly—made an oblique reference to the Arthurian cycle in Mantua.[52] Long after Pisanello's death, humanists, chroniclers, and theorists were still writing of his pictorial and sculptural skill.[53] In the early sixteenth century Pomponio Gaurico commented on Pisanello's ambition, basing himself on two medals of the artist which he believed to be self-portraits.[54] Today attributed to Antonio Marescotti (dated around 1440–43) and Nicholaus of Ferrara (dated around 1445–50), the medals serve as confirmations of the artist's contemporary prestige. It was also for the subtlety of his low-relief medals—halfway between plane surfaces and sculptural volume—that Cinquecento artists most valued Pisanello's work.[55]

Little art is left to show for Pisanello's continual travels, his high-powered patronage, and the humanists' unstinting praise. Of the works mentioned above, only twenty-three medals, the S. Fermo Annunciation, and the *Portrait of Leonello d'Este* in Bergamo have survived.[56] Vasari attributed to him another

work, otherwise undocumented, in a Veronese church: the fresco showing St. George and the Princess over the entrance arch of the Pellegrini Chapel in S. Anastasia, probably painted in the mid or late 1430s (Fig. 42).[57] The only other paintings of which attribution to Pisanello is universally accepted are three small panels destined for domestic settings: a portrait of an Este princess, probably Leonello's sister, Ginevra,[58] and two private devotional panels, *The Vision of St. Eustache* and the signed *Apparition of the Virgin and Child to SS. Anthony and George*.[59] This short list of paintings and medals is augmented by some four hundred drawings by Pisanello and his followers.[60] Forming one of the largest bodies of drawings to survive from the early Renaissance, these sheets give an excellent idea of the range of tasks faced by a court artist, because they illustrate the consuming interests of his princely patrons. Some sheets show the appurtenances of war: helmets, decorated cannon, and soldiers in armor. Others show such precious objects as coins, medals, saltcellars shaped like fantastic dragon-borne vessels, rings, and crowns, as well as designs for stained glass. Pisanello also sketched the brocades, the elaborate costumes, and the headdresses that his patrons loved. He recorded their features and drew the delights of nature for them: flowers, birds, and animals. Some of these, such as deer, hounds, horses, falcons, and hares, were associated with the hunt; others, such as peacocks, monkeys, and camels, must have been among his patrons' more exotic possessions.

Pisanello's modern reputation is inevitably based on his surviving medals and drawings rather than on his paintings, although he always signed his medals OPVS PISANI PICTORIS, "the work of Pisano the Painter." The attribution of the Arthurian cycle in Mantua to this eminent artist accordingly makes a significant addition to his meager corpus of surviving paintings. A work of great beauty, it is his only known large-scale fresco cycle and his only surviving work on a secular narrative theme.

II. *Artistic Style and Date*

The Arthurian cycle in Mantua is undocumented and therefore undated. Not even the drawings traditionally, but hypothetically, associated with it can be firmly dated.[61] Previous scholars have dated the frescoes to two different periods in Pisanello's career: about 1439–42, when the artist is documented as resident in Mantua, and about 1447–48, contemporary with medals that he created for the Gonzaga court. The earlier date makes Gianfrancesco Gonzaga the patron of the cycle; the later date establishes it as a commission of his son Lodovico, who succeeded Gianfrancesco in 1444.

The later date was first proposed by Giovanni Paccagnini and Bernhard Degenhart on grounds of artistic style.[62] They both perceived stylistic similarities between the *Sala del Pisanello* frescoes and works produced by Pisanello for the Neapolitan court in 1448–49 that convinced them that the frescoes should be dated late in the artist's career. The earlier date, on the other hand, is preferred by scholars concerned by the lack of archival evidence documenting Pisanello's presence in Mantua after 1442 or puzzled by the choice of chivalric iconography on the part of Lodovico, a patron renowned for the humanist orientation of his later commissions.[63] In a series of important articles, Ilaria Toesca has based her own case for the earlier date on identification of an emblem depicted in the frieze of the *Sala del Pisanello* as the Lancaster collar of SS, the English royal livery which was granted to Gianfrancesco between 1409–10 and 1416 and which is recorded in Gonzaga jewelry inventories from 1416 on.[64] Thus, if Toesca's identification is accepted, the frescoes could have been begun at almost any point in Pisanello's career, from the moment of his first stay in Mantua in 1422 to his presumed visit in 1447 to create medals for the Gonzaga. Toesca, however, argues that 1436, the year in which Henry VI of England granted Gianfrancesco permission to distribute a collar, *colerae nostrae aut devisamenti*—presumed to be the same Lancaster collar of SS—to fifty persons of noble blood, should be taken as the terminus post quem for the cycle, and 1444, the year in which Gianfrancesco died, as its terminus ante quem.[65] In the next chapter, however, in which we explore the political circumstances that dominated the Mantuan court at mid century, a different identification of the collar depicted in the frieze is proposed, along with an interpretation of what the story illustrated in the cycle meant for the Gonzaga of Mantua in the second half of the 1440s.[66] In short, I shall join Paccagnini and Degenhart and argue for the later date of around 1447–48.

The primary evidence for the dating of the undocumented frescoes lies within Pisanello's artistic career. The cycle, however dated, must above all be convincingly integrated into the artist's total oeuvre and his development as an artist. Explorations of artistic style are inevitably more subjective than discussions of dated documents, particularly in the case of Pisanello, whose certain oeuvre includes few dated works. Indeed, only one painting falls into the category of universally accepted works that can be surely dated: the signed fresco of the Annunciation of around 1426 in S. Fermo, Verona, that was created at the very beginning of his known career.[67] Of Pisanello's work in other media, his earliest datable drawing was created some seven years later: the likeness of the Emperor Sigismund, probably made on the occasion of the Emperor's journey to Italy in 1432–33, during which he visited both Ferrara

and Mantua.[68] It is likely, but not certain, that a sheet of sketches, probably drawn at the Mantuan court, also dates no later than 1433.[69] Two other sheets, drawn during the Council of Ferrara, at which the union of the Greek and Latin churches was discussed, and associated with the medal, usually dated 1439, that Pisanello made for the Byzantine Emperor John VIII Paleologus, can be dated to 1438 (Fig. 43).[70] From 1440 to 1447 Pisanello created a series of medals for the courts of Ferrara, Rimini, and Mantua, many of which he dated. Finally, both drawings and medals survive from his stay at King Alfonso's court at the end of his career.[71] Since we lack a firmly dated painting from Pisanello's maturity to use as comparative material, we are obliged to compare the style of the Arthurian frescoes with these works in different media: dated medals that span a ten-year period from 1439 to 1449 and datable drawings produced in 1432–33, 1438, and 1448–49. It is perhaps a fortuitous coincidence that what survives of the unfinished cycle in Mantua consists for the most part of drawing: *sinopie* on the *arriccio* of Walls 2 and 3 and *terra-verde* underdrawings on the *intonaco* of Wall 1.[72]

Pisanello's artistic style was already fully formed when we first encounter him in 1432 as a draftsman at the age of at least thirty-seven; his datable drawings do not, therefore, vary greatly in style. Nonetheless, a development can be observed between the mode employed in the 1438 Council of Ferrara sheets, which predate his corpus of medals, and that of the 1448–49 Neapolitan drawings, which postdate most of his work in low relief, a development that goes beyond the (perhaps) different circumstances in which the drawings were created.

The recto of the Council of Ferrara sheet in the Louvre (Fig. 43), among our earliest observations of known individuals who were not deliberately posing for their likenesses, shows, from the right, the mounted Emperor John VIII, an Eastern official seen from the back, a horse's head seen in three-quarters, and quick sketches of two other individuals. Across the top of the sheet runs an inscription in Arabic, copied from a textile, below which Pisanello made elaborate color notes. Although the artist was probably working under some pressure, his graphic style is extremely careful and relatively timid. The figures are recorded with short, tight, parallel strokes, the contours are closed, hatching is relatively little used, and not much interest is shown in the use of light to describe volume or in the effects of light gliding over surfaces.

The sense of meticulous care that Pisanello brought to all his work is still present in drawings done for the court of Naples ten years later. In one important respect, however, the character of these Aragonese sketches differs from

that of the earlier Ferrarese sheets. Pisanello's intervening experience of medals has stimulated his interest in light values, and during the 1440s he developed a graphic style that expressed this fascination. His drawings usually show how light is absorbed by the flat, smooth ground of a metallic surface but reflects off a raised, centralized motif. In a drawing dating from 1448–49 that depicts King Alfonso riding a caparisoned horse, for instance, Pisanello used extensive diagonal hatching to create the effect of a ground in shadow against which the king and his horse could be highlighted as if in low relief (Fig. 44).[73] These same effects of light and shadow are pursued on another Aragonese sheet in the Louvre (Fig. 49), where parallel diagonal hatching creates a dark background against which the designs for the medals stand out.[74] Another drawing for the King, showing Alfonso's profile in duplicate, reveals another aspect of the influence of medals on Pisanello's graphic style in these years (Fig. 50).[75] Here the contrast of profile against ground in the lower sketch is obtained exclusively through the use of a contour that imposes the king's features incisively on the sheet with a precision and an economy that derive from the artist's experience of chiseled forms. None of these characteristics, although all incipiently present in the Council of Ferrara sheets, were developed to this extent in 1438. In the even earlier drawing of the Emperor Sigismund made in 1432, as in the sheet of Gonzaga sketches that is perhaps contemporary with it, Pisanello interpreted the Imperial features by using long, light, curving, and slightly hesitant strokes that waver, repeat, and overlap along the contours.[76] In these early drawings Pisanello generally restricted his strokes to the edges of the forms.

When we analyze the character of the stroke employed by Pisanello in the *terra-verde* underdrawings on the *intonaco* of the tournament (Fig. 8), we discover that the forms of the knights and their caparisoned horses are built up through the accretion of short, parallel lines (Fig. 45 showing Knight 9 and Fig. 46 showing Knight 10). These strokes are repeatedly retraced, especially toward the contours, creating densely layered webs of parallel and cross-hatched lines that often blend to give an impression of wash, adding to the chromatic effect already created by the use of green earth. Despite the differences in scale and medium, Pisanello's approach to the depiction of form in Mantua is very close to that used in the studies drawn in Naples in the late 1440s. The undisputed attribution to Pisanello of these Aragonese sheets, together with their sure provenance, Naples, and certain date, 1448–49—the artist even signed the drawing in Figure 44 and dated that in Figure 50—make them a valuable point of reference in discussions of Pisanello's artistic development and hence of the date of the Arthurian cycle.[77] Comparison of these

drawings with the *Sala* cycle also serves to verify its attribution to this artist, a question that is usually taken for granted.

The small signed drawing already discussed, showing King Alfonso wearing a large-brimmed hat similar to that worn by the knight identified as Bohort in the *Sala*, is a design for an unexecuted medal (Fig. 44). One of Pisanello's most beautiful sheets, such a finished drawing is rare in his surviving work—probably because this particular design was not chosen for casting and the sheet was therefore never actually used. It seems to be the final drawing prior to the stage of working on the three-dimensional model for the medal. As we shall see in chapter 7, the *terra-verde* underdrawings on the *intonaco* of Wall 1 (Fig. 8) in many ways functioned similarly, as a kind of final preparatory drawing for the gilded relief with which they were to be overlaid.[78] In both works Pisanello used a distinctive type of hatching to convey the impression of the volume that was to become actual, in a style that is unique to this period of his career. The curved strokes grouped toward the edges of the figures contrast with the centralized highlights, created by the blank plaster or white paper, that define the protruding parts of the body such as shoulder, elbow, and knee. This is well illustrated in the image of Knight 21 reeling off his horse in Figure 47 or in the figure of Knight 4 reaching up to help a companion in Figure 48. Both the *intonaco* underdrawings and the Neapolitan sheet demonstrate a similar sensitivity to internal modeling and the play of light on a surface. Pisanello's experience of the low relief in the medals he had created earlier in the decade led him to develop, in Mantua and Naples, a graphic style suggestive of rounded volumes and smoothly lit surfaces.

Details of the *sinopie* on Walls 2 and 3 of the *Sala del Pisanello*, such as the maidens in Figure 87, can also be compared to the designs for Aragonese medals in Figure 49, despite the vast difference in scale between them. Pisanello used the same graphic mode for the damsels in the tribune as he did for the archangel handing a fluttering standard to a kneeling knight on the recto, or the enthroned king on the verso, of the drawing in Figure 49. In each case the light strokes and open diagonal hatching are both descriptive and economical. As in the Neapolitan drawings, Pisanello detached the motifs from the background in the *sinopia* on Walls 2 and 3 by placing them against a contrasting plane, sometimes laid on with diagonal strokes, that reads as pink wash. The casual oblique hatching in the drawing in Figure 49 shows Pisanello's similar interest in highlighting the images by means of chiaroscuro, a concern already noted in the dense diagonal hatching in the drawing of the equestrian King Alfonso in Figure 44.

The two portrait sketches of King Alfonso dated 1449 (Fig. 50), designed

for an exactly contemporary medal, are in a very different graphic mode from the sketch of the King on horseback. The summary strokes that here articulate the King's hawk nose, weak chin, and piercing eyes are instead close to the rapid sketches found in the *sinopia* of the tournament scene on Wall 1 (Fig. 51). This is particularly true of the lower profile portrait, which seems to be the first statement on the sheet, perhaps drawn from life. The sparse, rapid strokes in both the tournament *sinopia* and the medal project express Pisanello's interest in establishing the general configuration of the motif and its placement within the composition as a whole. These drawings, sequentially earlier in the artistic process than the drawing of Alfonso on horseback in Figure 44 or the underdrawings on the *intonaco*, clearly served a different purpose. They therefore do not yet display Pisanello's current preoccupation with light and shade and volume. The small pen sketches on paper and large-scale brush drawing on plaster are surely as closely linked as they could be, given the disparity in medium, support, and scale.

When we turn to Pisanello's output as a low-relief sculptor at the end of his career, we discover that his medals also share the dominant stylistic traits of the wall drawings in the *Sala*. Pisanello's medals from the end of the 1440s, such as that of about 1448–49 for Don Iñigo d'Avalos, Grand Chamberlain of the Court of Naples (Fig. 52), have a fluidity, a mastery of organization, and a skill in placing motifs within the circular format that contrasts vividly with the relative angularity and awkward placement of the forms on the reverse of his first medal for the Eastern Emperor, John Paleologus, only ten years earlier.[79]

The emphasis in the Neapolitan medals, as in the Mantuan wall drawings, is on the smooth but richly modulated surfaces that convey very smooth transitions between concavities and convexities. Pisanello has by this date developed the low-relief sculptor's sensitivity to the swelling curves of the body. At the end of his career the artist even modified many of the shapes to conform to this vision—curved and rounded forms predominate in his work and angular forms are discarded. Pisanello used form-following strokes extensively in the underdrawings on the *intonaco* of the tournament scene, and his multiple hatchings often follow the curves of the knights' bodies (Figs. 45–48).

The depiction of light in this scene in Mantua is not related to the fall of natural light in the *Sala*, despite the light flowing in from the window on Wall 4 to the right. The knights are instead lit from the front, and their bodies recede into shade at either side.[80] The most convex plane of the curved surfaces, usually dead center, is never modeled but left blank so that the parts in

highest relief are determined by the white of the plaster. The arbitrary light
source for most of these images is thus in the eye of the beholder. Much of the
beauty of Pisanello's late medals, such as the head of Iñigo d'Avalos or the
reverse of Alfonso's VENATOR INTREPIDVS medal, about 1448–49 (Figs. 52 and
53), derives from similar light effects.[81] In many ways the fluid style of the
Mantuan wall drawings is the graphic equivalent of low relief. There is a dis-
tinct resemblance between the gently rounded modeling and incisive profiles
on the medals and a graphic mode that suggests this effect by combining a
strongly defined contour with internal hatching concentrated on surface
modeling.[82] The way in which light wavers over the smooth surfaces of the
late medals emulates the light effects of the Mantuan wall drawings. When a
medal is held in the hand facing up toward the light source, its raised central
surface catches the light, with the brightest glow on the uppermost projection
of shoulder and ear, and a narrow band of shadow gathers where the raised
surface meets the flat plane. This is an exact equivalent of the way in which
Pisanello indicated the fall of light on the protruding knees, elbows, and hel-
mets of the knights in the Arthurian cycle in Mantua.

As we saw, Pisanello's only dated painting, the S. Fermo Annunciation,
was created too early in his career to be useful for our purposes, and his only
other large-scale painting, St. George and the Princess in S. Anastasia (Fig. 42),
is itself as undocumented as the frescoes in the Sala. The most convincing date
so far proposed—contemporary with the 1438 Council of Ferrara—would
make the S. Anastasia fresco either just prior to the Mantuan cycle, if this
work is given the earlier date of 1439–42, or a whole decade earlier, if it is
instead given the later date of 1447–48.[83]

In both Veronese and Mantuan frescoes Pisanello used many of the same
motifs: youthful knights in armor, beautiful ladies in brocaded gowns, fore-
shortened horses, Gothic towers and castles silhouetted against the sky, small
undulating hills covered with leafy foliage. Both figural scale and architec-
tural scale, however, are much smaller in St. George and the Princess than in the
Arthurian cycle, especially when the location of the fresco in S. Anastasia,
high over the archway into the Pellegrini Chapel, and its distance from the
viewer are taken into account. Despite the fact that the wall surfaces to be cov-
ered in Mantua and Verona are not comparable in area, both the actual scale
and the internal scale of the protagonists in the Arthurian cycle are strikingly
larger than those in the Veronese fresco. The relationship of painting and
spectator has been taken into consideration in the design for the Mantuan
cycle; it is possible that Pisanello's late work was influenced by the presence,
since 1443, of Donatello in nearby Padua. The horror vacui so evident in the

work for S. Anastasia—the carefully distributed motifs that fill the composition to its edges so that the frame crops or nearly crops many of them—is another feature of Pisanello's painting style that is muted in the Arthurian cycle. The effort to cram so many motifs into the picture field gives to the S. Anastasia fresco a tension that is missing from the less crowded compositions in the Mantuan hall. It can thus be argued that Pisanello's artistic ideas shifted somewhat between the painting of these two frescoes, and that the Mantuan cycle is a more expansive and more relaxed work which should therefore be distanced in time from the earlier mural.[84]

We may conclude, on the one hand, that the *Sala* does not seem to be contemporary with *St. George and the Princess* and, on the other, that it fits comfortably among the low-relief medals and drawings that Pisanello created at the end of his career. The monumental wall drawings in the *Sala*, the counterpart of Pisanello's late sculpted work, can be read as dating much closer to 1448–49 than to 1438, the year of the Council of Ferrara sheets, when he had yet to create his first medal. Pisanello's cumulative experience of shaped medals throughout the 1440s had an impact on his graphic style that is, I believe, visible in both the Neapolitan sketches and the Mantuan wall drawings. Comparison of these sketches with the *Sala* frescoes thus strongly suggests that the Mantuan cycle dates from the end of Pisanello's active career, probably shortly before he left for Naples in 1448.

Based on formal analysis, this dating to Lodovico's marquisate would seem to be confirmed by recently published documents concerning the Marchese's natal horoscope chart which encourage an astrological interpretation of the family of lions to the right of Wall 1 (Fig. 73).

"... Your birth was on the day [for which] you had Leo as ascendant and the sun was your *significatore* [signifier or lord] ..."

wrote the astrologer Giovanni Cattani to Lodovico.[85] The Marchese was born on 5 June 1412 and, as usual, the precise time was noted: "13 hours [and] 13 minutes."[86] Such precision was crucial because the most important element of a natal horoscope in the Renaissance was not, as today, the monthly zodiacal sign in which the sun was located at birth—in Lodovico's case Gemini—but the ascendant sign which, changing every two hours, arose on the eastern horizon at the moment of birth—in Lodovico's case Leo.[87] Because the ascendant was thought to signify the individual's life as a whole, the planetary ruler of the ascendant sign—which for Leo was the Sun—was considered the most important lord of the entire horoscope. Lodovico was accordingly informed that he "was born under the planet Sun and bears the Sun."[88] As it

happens, the combination of Leo and Sun had a greater mystique of power associated with it than any other sign of the zodiac. According to Marsilio Ficino, "the constellation which is the house of the sun, that is, Leo, is the heart of the constellations and controls the heart of all living things."[89]

Understandably, therefore, Lodovico made extensive use of the emblem Sol, lord of the ascendant in his horoscope and referred to in letters as his *significatore* or *governatore* (governor).[90] The Sun turns up on the medal created by Pisanello (Fig. 55) and in many of the room decorations created later in Lodovico's *signoria*, often accompanied by the French motto "par un [sol] desir" (with only one desire), in which the adjective "sol" ("seul") was replaced by the image of a radiant Sol.[91] A Renaissance prince, however, was just as likely to choose his ascendant sign itself as a personal device, and Gonzaga seems to have followed this custom.[92] In 1461 the astrologer Bartolomeo Manfredi, for instance, sent Lodovico a little gold lion to wear "next to his skin" at dawn on the nineteenth of July when "the sun is ascending in Leo on the eastern horizon" because "in these hours there is so much dignity and power surrounding your illustrious birth."[93]

Under these circumstances, the family of lions on Wall 1—nowhere mentioned in the episode from the prose *Lancelot*—would surely have been interpreted by the Renaissance viewer not only as natural inhabitants of the wild and rocky forest through which the Gonzaga knight rides but also as a reference to, or image of, the auspicious configuration of the stars at Lodovico's birth, and his all-important ascendant of Leo.[94] In an age when allusions to celestial phenomena were often made in art, the informed observer would have immediately understood the precise astrological meaning of such imagery.[95]

Indeed, evidence from other sources also points overwhelmingly to the later date for the Mantuan cycle. Those who continue to date the work to an earlier period must, for instance, address themselves to the compelling evidence against it provided by the four letters that Gianfrancesco wrote to Pisanello in 1443 and 1444.[96] If Pisanello had begun to paint the frescoes between 1439 and 1442, only to abandon the work, it seems inconceivable that Gianfrancesco, who did not hesitate to demand that Pisanello return his painting of God the Father, should not have made some reference, however oblique, to the disastrously incomplete state of this major undertaking in a prominently located hall in his palace.[97] If Pisanello had had outstanding business with Gianfrancesco, then the first Marchese, better known to his contemporaries for his autocratic temper and unyielding temperament than for his equanimity, would hardly have discussed with composure the artist's imminent departure from northern Italy.[98]

Political Context

1. *The Mantuan State*

EVER SINCE seizing Mantua in 1328, the Gonzaga had sought to legitimize their claim to the state through Imperial titles.[1] Titles granted by the Holy Roman Emperor officially acknowledged the territorial claims of Italian *signori* and placed them under the protection, albeit theoretical, of Imperial sovereignty. Luigi Gonzaga thus transformed himself from a usurper into an official representative of the Empire by acquiring the title of Imperial Vicar of Mantua in 1329. At the end of the Trecento, Capitano Francesco Gonzaga sought to purchase the title of Marchese, but for reasons that are not clear the negotiations fell through even though Emperor Wenceslas reduced the *taxa* from 100,000 to 20,000 ducats. Soon after Emperor Sigismund was elected, the next Gonzaga ruler, Gianfrancesco, made another effort in the same direction, but the Emperor's asking price in 1413 was considered too high. Finally, in 1432, the moment and the price were right: for 12,000 florins, Emperor Sigismund, while in Italy for his own coronation, granted Gianfrancesco the title of Marchese and in 1433 came to Mantua to confer it on him personally.[2] Placing an *imprimatur* on Gianfrancesco's legitimacy as ruler of Mantua, the title increased Gonzaga prestige, making them equal in rank to the Este of Ferrara.

At the investiture the Emperor also announced the engagement between his new subject's heir, Lodovico Gonzaga, and Barbara of Brandenburg, granddaughter of Elector Frederick I von Hohenzollern and daughter of the current ruler of the Marches of Brandenburg, Margrave John, called the Alchemist. The Hohenzollern were an old family who had recently acquired rights to the Marches of Brandenburg through their friendship with their distant kinsman Emperor Sigismund.[3] The match accordingly enhanced the status of the Gonzaga family by linking it to the highest level of German nobility. In a striking reversal of the usual financial arrangements in such affairs, the Gonzaga paid a brideprice of 50,000 florins for the eleven-year-old girl, who arrived in Mantua in 1433.[4]

The small state of Mantua was strategically poised between two hereditary enemies, Milan and Venice, each of which sought to use Mantua as a buffer state.[5] The Gonzaga traditionally survived the rivalry of the two

powers by forming expedient political alliances with each of its neighbors in turn. Since the balance of power among the North Italian states was constantly shifting, each new Gonzaga treaty reflected a new swing of the political pendulum. Like his grandfather and father, Lodovico Gonzaga was a *condottiere*, a commander of cavalry and troops who hired out his services in the field to his more powerful neighbors. He could thus hold the prestigious position of captain general and collect a lucrative stipend while defending his own state against the encroaching power of Milan and Venice. "Both Venice and Milan," concludes one assessment of Lodovico's military career, "saw the attraction of a *condottiere-signore* like Gonzaga; the necessity of defending his own position required Gonzaga to maintain military readiness, and the vulnerability of his *signoria* insured his faithful observance of the *condotta*."[6]

"We have worn armor for a long time," declared Lodovico in 1460, and he wore it almost constantly during the years that the Arthurian cycle was being created.[7] The early years of his rule were spent at war. At first he continued his father's policy and formed an alliance with Filippo Maria Visconti of Milan in 1445, renewed the following year. In September 1446 Visconti's troops were defeated at Casalmaggiore, and Lodovico reconsidered his policy, switching alliances in February 1447 and signing a *condotta* with the anti-Visconti coalition of Florence and Venice as captain general of the Florentine troops. The powers against Milan started a successful offensive in April–June 1447, but the political situation changed rapidly when Filippo Maria died in the summer of 1447. The last Visconti's death without heirs touched off a struggle for the Milanese succession that lasted three years, and until Visconti's son-in-law, Francesco Sforza, captured the duchy in 1450, the political situation in northern Italy remained extremely unstable. In May 1448, in an explicit recognition of distinguished service, Lodovico signed a new *condotta* with Venice. In September the Venetian troops were badly defeated by Sforza at Caravaggio, but Lodovico won distinction in the battle, arguing against the decision of the other Venetian captains to press the attack and succeeding in eluding capture in the ensuing rout.[8] Before his death Visconti had appointed King Alfonso of Naples as his successor, and Alfonso now formed an anti-Milanese alliance with Venice. Having served Milan, Florence, and Venice in quick succession, Lodovico decided to see what advantage might be gained by serving Naples instead and in July 1449 signed a *condotta* as the King's *procuratore* in Lombardy. When Sforza finally seized Milan in 1450, all parties, including Mantua, reassessed the balance of power. In an important decision Lodovico switched sides and in November 1450 signed a *condotta* that was also an alliance with the new lord of Milan.

Lodovico became Sforza's lieutenant-general and for much of his life remained the supreme commander of all Milanese forces. Hostilities between Milan and Venice continued for two years, but in 1454 the peace of Lodi, recognizing Sforza as lawful ruler of Milan, stabilized the political situation among the powers of the Po valley and guaranteed a period of tranquility for Mantua that lasted the balance of Lodovico's lifetime.

The economic basis of Mantua was agricultural, and the Gonzaga owned large estates of rich farmland. The state was small and its revenues could not be compared to those of its neighbors. A contemporary estimate of the incomes of various governments in the 1490s gave Mantua 60,000 ducats a year, in sharp contrast to 1,000,000 ducats for Venice, 600,000 for Milan and Naples, 300,000 for Florence, and 120,000 for Ferrara.[9] Like other *condottiere*-princes, Lodovico relied on his earnings as a soldier to supplement his income. The unstable political and military situation of Mantua prior to the 1450 treaty with Milan was compounded by Lodovico's financial constraints in these years. The humanist Filelfo praised Gianfrancesco Gonzaga for being more generous than his descendants.[10] Family tradition in the 16th century, however, described the first Marchese as a spendthrift who boasted of squandering 200,000 ducats—perhaps one reason why the Gonzaga family was in such financial straits in 1444–47 and again in 1448–50.[11] A register of land deeds, for instance, shows that Lodovico made no significant purchases of land in these years, although he was to accumulate property at a steady rate in the 1450s.[12] Indeed, the Gonzaga family seems to have lacked money for even the absolute necessities of dress and jewelry. In 1448, for instance, Lodovico wrote imperiously—and probably ineffectively—to his wife: "We want all thoughts of the collar and clothes for the house to be put completely to one side."[13] Thus in the first six years of his rule Lodovico had little money to spare for artistic commissions.

These financial problems may have eased slightly with Lodovico's appointment as Florentine captain general in 1447, but they did not noticeably improve until the 1449 *condotta* with Alfonso of Naples, which gave him a stipend of 45,000 ducats. Larger than anything he had earned before, it made a substantial addition to Mantua's income.[14] Lodovico's decision to join Milan the following year was, in the words of his biographer, "a mercenary commitment to the side that offered the largest promise of financial gain."[15] In 1450 Sforza's hold on Milan was still precarious, and the support of Mantua seemed to him essential to the duchy's survival. Standing between Sforza and Venice, the power most likely to replace the Duke, Lodovico was able to bargain for the command and stipend that he wanted. After offering Gonzaga

30,000 ducats a year in peace and 60,000 in war, Sforza finally agreed to pay a
stipend of 47,000 ducats a year in peacetime and 82,000 in the event of war.
The terms of his 1449 and 1450 *condotte* should be compared with those of
Lodovico's 1445 alliance with Visconti, which assured him only 12,000
ducats a year, and his 1447 *condotta* with Florence, which granted him a mere
7,200 florins per annum.[16] Thus in 1449, immediately subsequent to work on
the *Sala del Pisanello*, the Marchese of Mantua signed a lucrative *condotta* with
Naples and the following year an even more advantageous one with Milan.

One of the levels of meaning of the Arthurian cycle emerges only from a
study of the advantages gained by Lodovico from his marriage alliance with
the Hohenzollern of Brandenburg. Alone among North Italian *signorie*, the
Gonzaga continually sought to increase Mantua's bargaining power by
forming marriage alliances with princes of the Holy Roman Empire, and the
new Marchese derived immense political advantage from his kinship with the
Hohenzollern of Brandenburg.[17] Elector Frederick I, Barbara's grandfather,
was succeeded by his second son, Frederick II of Brandenburg, in 1440, but
the diplomatic weight of another of Barbara's uncles, Margrave Albert of
Brandenburg, was to be more important for Mantua and the Gonzaga.[18] Edu-
cated at the court of Emperor Sigismund, Albert inherited his father's energy
and ambition. A man of great physical vigor, he earned the name Achilles
through his strength as a soldier and jouster. Albert Achilles was well known
to the Emperor Frederick III, the Habsburg who was elected King of the
Romans in 1440 and who appointed him commander-in-chief of the Imperial
troops in 1458–59.[19] In a letter to the Duchess of Milan his niece Barbara
boasted of his ties with the Imperial court:

> Margrave Albert is very friendly with the Emperor and used to be his captain
> general, and he is very well known in the court of His Majesty.[20]

Albert Achilles was also well known to Pope Pius II, who, having spent many
years in Germany as secretary to Emperor Frederick, had developed close ties
with German princes including the Hohenzollern.[21] In his memoirs Pius
praised Albert highly for his "powerful eloquence and clever diplomacy" as
well as his military expertise.[22] "Aeneas [Pius II] . . . always showed himself
the champion and defender of the Germans," wrote the Pope of himself in his
memoirs,[23] and the Mantuan ambassador's report of his first papal audience
after Pius's election in 1458 must have delighted the Gonzaga: the Pope com-
mended the wisdom of the illustrious house of Brandenburg and all its
progeny, especially the Marchesa of Mantua. Whoever desired his favor

should use Barbara as an intermediary, he said, because she would ask only for the reasonable, the saintly, and the devout.[24]

Gonzaga hopes for the new Pope's favor focused on the Congress that Pius II convoked to organize a crusade against the Turks, to whom Constantinople had fallen in 1453. In November 1458 Barbara asked her father, Margrave John, and her uncles, Margrave Albert and Elector Frederick, to promote Mantua as the site of the Congress. "No one doubts," she wrote, "that Your Excellencies will know how to persuade the Emperor to choose this city, and so we fix our hopes on Your Excellencies."[25] The Gonzaga sent a diplomat, Gabriele da Crema, to Germany to discuss strategy with the three Hohenzollern brothers and to devise a means to persuade the Emperor to agree to attend the Congress if it were held in Mantua. Margrave Albert sent his councillor, Conrad Hertenstein, to see first the Emperor and then the Pope in Rome, with a stopover in Mantua, to negotiate the Congress's location.[26] Although the Emperor did not in the end come to Italy for the Congress, Margrave Albert's diplomatic intervention may have been decisive in persuading the Pope to locate the Congress in Mantua, a site supposedly hospitable to the German tongue and certainly convenient for northern princes in general.[27]

The papal court spent eight months in Mantua in 1459–60 and reports on the city varied. The Sienese envoys were impressed:

> Mantua is adorned with prelates, lords, ambassadors, and many courtiers . . . there are many fine rooms, large and worthy, and there is an abundance of everything here.[28]

But not all accounts were so positive. To the sharp-tongued Milanese ambassador the provincial town appeared to be "a city drained of people, and, it appears, without women," and most delegates seemed to agree with his negative assessment of what Mantua had to offer.[29] Doubts had been expressed in advance about the city's ability to feed and house so many people,[30] but the Gonzaga rose to the occasion, and the papal courtiers later expressed much appreciation for the "abundance of everything," especially the generous Gonzaga cuisine.[31] Nonetheless, the cardinals cared neither for the streets, which were either muddy or dusty, nor for the oppressive heat. "It is so hot that we burn, and there is so much dust that we suffocate," they complained.[32] The end of summer is the season of disease in Mantua, and 1459 was no exception. Some delegates fell sick; others were dismayed at the sight of dead bodies being carried through the streets.[33] A century earlier Petrarch had drawn a

vivid picture of the trials of the Mantuan summer, and the frogs that had invaded the palace to watch him eat a sumptuous dinner were still omnipresent in 1459.[34]

> The place was marshy and unhealthy, the heat intense . . . most [of the papal court] were sickening; very many were catching the fever; nothing was to be heard except the frogs,

concluded Pius II in a devastating review of his Mantuan sojourn.[35] The last straw for the papal courtiers was, it seems, the ugliness of the Mantuan women.[36]

The Congress achieved as little as the cardinals expected; but if the event was a political failure for the Pope, it was a diplomatic coup for the Gonzaga, for it put Mantua on the international map. Many heads of European and Italian states and the ambassadors of the Emperor and of the Kings of Poland, Hungary, Castille, Naples, Portugal, and France and of the Dukes of Savoy, Burgundy, Brittany, and Austria came and went. The small provincial center had never seen such pageantry and splendor. The presence of so many distinguished rulers, diplomats, and humanists increased the court's cultural sophistication, stimulated Gonzaga intellectual development, and promoted the family's political ambitions.

The most tangible political result was a cardinal's hat for Lodovico's second son, Francesco (born 1444). The Gonzaga had hoped for the cardinalate in the spring immediately following the Congress, but a disappointed Barbara wrote to Margrave Albert in March 1460 that the Pope opposed the nomination of her sixteen-year-old son to the College of Cardinals on grounds of his youth, although the Gonzaga had tried to help their cause by lying about Francesco's age, and claiming that he was twenty-two.[37] The letter written on his behalf by the Emperor, engineered with Hohenzollern help, arrived too late to affect the Pope's decision.[38] In the fall of 1461 the Gonzaga mounted a full-scale public relations campaign to persuade Pius II to reconsider Francesco's candidacy at the next consistory. The Gonzaga were told by Cardinal Nicholas of Cusa, Barbara's compatriot, that if Pius acted it would be as a gesture of esteem toward the Emperor, since Frederick III was known to be well disposed toward the Margraves of Brandenburg.[39] So Francesco was presented as the voice of the Emperor, based "on the merits and loyalty of the Illustrious Lords of Brandenburg, who constitute a voice of the Empire, and from whom he [Francesco] is descended on the maternal side."[40] Indeed, about all the youth had to recommend him was his relationship to "the noblest families of Italy and Germany."[41] Discussing the letter he had

drafted for the Emperor's signature, Lodovico revealed that the Gonzaga case exploited not only the Hohenzollern connection but also Francesco's extremely distant kinship to Frederick III.[42]

> We have again stated his kinship, saying that on his mother's side the proton-otary [Francesco] descends from the Margraves of Brandenburg, who are our relations, but we have also added that there are family ties with His Majesty, as is the case, which is more honorable to the house of Brandenburg and our own.[43]

In September, Margrave Albert, who at the Congress of Mantua had been appointed second-in-command of the army to lead the crusade, sent an ambassador to remind Pius that he had come to the Congress out of love of the Church and in the hope that his house would be honored in the person of his Gonzaga nephew.[44] In November an envoy from Germany told the Pope that the Hohenzollern would regard a Gonzaga cardinal as their procurator in Rome. On 12 December letters arrived from the Emperor recommending the Hohenzollern relative to the Pope and the College of Cardinals. The cardinals were nearly unanimous in their endorsement of Francesco, as one historian has shown:

> Cardinal Bessarion and the Cardinal of S. Angelo, praising Barbara and the house of Brandenburg for its devotion to the Emperor, argued that the Emperor deserved a representative in the College as much as the King of Naples and the Duke of Milan [for whom two cardinals were being named in the same consistory]. Nicholas of Cusa reiterated the argument with the asser-tion that Gonzaga should be named first of all, as a fitting honor to the Holy Roman Emperor. The Cardinal of Avignon reminded his colleagues how much they owed the Gonzaga for their generous hospitality [at the Congress] and others followed him to express their agreement.[45]

When Pius II raised Francesco to the cardinalate at the consistory held a few days later, all agreed that the Emperor's backing had been decisive. Never had the advantage to the Gonzaga of their German connections seemed so obvious.[46] They proceeded to build on their success and to strengthen Man-tua's ties with the Empire by making further advantageous marriages with German princes. In 1463 Federico, Lodovico's heir, who was named after Emperor Frederick III, was married to Margaret of Wittelsbach, sister of the ruler of Bavaria and Barbara's third cousin, and in later years two daughters, Barbara and Paola, were married to Duke Eberhard von Württemberg (1474) and Leonard von Gorz (1477).[47]

Lodovico's artistic commissions often reflected his current political preoc-

cupations. One of the purposes of Mantegna's frescoes in the *Camera Dipinta*, started in 1465, for instance, was to focus on the newly created Cardinal Francesco.[48] Several portraits in the Meeting Scene, which shows Lodovico and other members of his family surrounding "my son, the cardinal," have been convincingly identified by Rodolfo Signorini, including that of Emperor Frederick III, third from the right.[49] In the historical circumstances, it makes admirable sense that Lodovico should have decided to include a portrait of Frederick III in the frescoes—despite the fact that the Emperor never set foot in Mantua. As we shall see, the *Sala del Pisanello*, Lodovico's first commission of a frescoed room, begun seventeen years earlier, makes similar references to the same concatenation of Imperial princely relationships by means of its Arthurian iconography and through the depiction of heraldic emblems in the frescoes. These murals can, on one level, be read as a reflection of Lodovico's determination, at the beginning of his rule, to derive the maximum dynastic benefit from his family alliance with the Hohenzollern.

II. *The Heraldic Emblems*

The new Marchese's cultural policy at the beginning of his rule was the direct outcome of his financial, political, and military circumstances at the time. For financial reasons, Lodovico's early artistic commissions were far fewer than those of later years, and none dates before the winter of 1446–47. At first he concentrated on the defense of that part of the Mantovano which he had inherited on his father's death in 1444.[50] In 1447, as part of a campaign to strengthen the fortifications system of his rural territory, he started to build the castle at Revere, a strategic location on the Po River along his eastern border.[51] He also turned to inexpensive coins and medals to give expression to his new position as ruler. Like those of Gianfrancesco, Lodovico's coins often depicted the prestigious relic of the Precious Blood of Christ, supposedly carried to Mantua by Saint Longinus, that was preserved in S. Andrea.[52] The second Marchese's earliest coins, however, testify rather to his general preoccupation with war and his current interest in chivalric motifs. Three gold *marchesani* struck in 1445 or 1446 show Lodovico, one of the first princes to have himself portrayed on coins, as a knight in contemporary armor, brandishing an unsheathed sword and holding a shield charged with Gonzaga arms (Fig. 54).[53] On the reverse the chivalric saint, George, enthusiastically slays the dragon. The inscription LODOVICVS MARCHIO MANTV E T C in Gothic lettering is strikingly similar in style to the inscriptions of knights' names in the *sinopie* of the *Sala del Pisanello*.

Lodovico's next commission, four medals from Pisanello in 1447, was probably influenced by his antiquarian-minded brother-in-law Leonello d'Este. Becoming enthusiastic over the possibilities of this new art form, Leonello in the early 1440s had ordered as many as nine medals of himself from Pisanello alone.[54] Sigismondo Malatesta of Rimini then followed his lead by commissioning an even larger number of medals of himself and his household from Pisanello and other artists in 1445–46.[55] Lodovico's own commission was limited to only four portrait medals: commemorative ones of his father and his tutor Vittorino da Feltre, who had died in 1446, and medals of his sister Cecilia, his parents' favorite child, who had entered a convent in 1445, and of himself.[56]

Identical in scale, Pisanello's medals of Lodovico and Gianfrancesco are closely related in style—placement of motifs and signature within the field, disposition and classicizing of the inscriptions—and iconography (Figs. 55 and 56).[57] Lodovico used inscriptions—IOHANES FRANCISCVS DE GONZAGA PRIMVS MARCHIO MANTVE CAPIT(aneus) MAXI(mus)ARMIGERORVM and LVDOVICVS DE GONZAGA MARCHIO MANTVE ET CET(era) CAPITANEVS ARMIGERORVM—that emphasize his father's and his own military ranks and their sequence as first and current Marquises of Mantua. Years later, the second Marchese was again to honor his father as the first Marchese by using similar wording—IOHANNES FRANCISCUS PRIMUS MARCHIO MANTUE ETC.—in another inscription.[58] The next medal commissioned by Lodovico gave his own position more precisely as commander of the Milanese forces in the early fifties: LVDOVICVS DE GONZAGA MARCHIO AC DVCALIS LOCVMTENENS GENERALIS FR SFORZA.[59] Thus the second Marchese took care to exploit the titles he received. In February 1447, for instance, after signing the *condotta* with Florence, he wrote to Barbara of Brandenburg that, although he had not yet been given the *bastone* of command, he nonetheless wanted himself to be suitably designated in his letters: "When writing to subjects we wish to be designated as above, and when writing to foreigners and others, as follows: Lodovicus Marquis of Mantua, etc. Captain General on behalf of the most excellent Commune of Florence."[60] Although Lodovico did not emphasize heraldic devices on the medals made for himself and his father, each is shown on the reverse with a specific emblem in the upper part of the field, a ring-shaped knocker for Gianfrancesco and a long-stemmed flower and a radiant sun for Lodovico. The *Sala del Pisanello*, part of the same artistic campaign as the medals, also includes inconspicuously placed heraldic devices in the frieze and within the tournament scene.

The unpainted frieze running across the top of the tournament scene on

Wall 1 of the *Sala* is composed of four intertwined heraldic emblems that form a graceful pattern (Figs. 57 and 58).[61] Three of these are among the oldest devices of the house of Gonzaga: the leashed dog, a Great Dane or mastiff (*cane alano*); the hind (*cervetta*); and the flower.[62] The dog with reverted head, which also appears on a tapestry that hangs from the ladies' tribune on Wall 2 (Fig. 59, a detail of Fig. 32), was much used at the Gonzaga court: by Gianfrancesco in a frescoed frieze dating from the early years of his rule (Fig. 60) and by Lodovico on the portal of the castle at Revere and again on a medal by Melioli created twenty-five years later.[63] The standing hind, usually shown gazing up at the sun and sometimes accompanied by the motto in Old German *Bider Craft* (*Wider Kraft*, "against power" or "contrary to might"), survives in some Trecento frescoes in the Palazzo del Capitano (Fig. 61).[64] The devices of both hind and dog were included on a folio of a mid-century manuscript illuminated for Lodovico's daughter Cecilia (Fig. 62).[65] The humanist Mario Equicola, writing in the early sixteenth century and probably reflecting an oral tradition, associated the *cervetta* with Lodovico's grandfather Francesco, and the *cane alano* with his father, Gianfrancesco.[66]

The third device, a large marigold-like flower with long stems and flamboyant curling leaves, is presented in two configurations, shown alternatively open and half closed, reflecting Pisanello's habit of studying the objects he drew from nature from several angles.[67] The flower has been identified as the botanical species *calendula* (marigold), but since none of the sources mention the emblem, we do not know what it was called in the Renaissance.[68] The daisy (*margherita*), the name of Lodovico's grandmother and sister and the flower that covered the walls of the *chamerino delle malgerite* in the Gonzaga palace, was, however, popular in Mantua.[69] Several heraldic tapestries in Este possession, woven with the combined devices of *fiori de margarita* and *cani alani*, formed part of Margherita Gonzaga's dowry on her marriage to Leonello in 1435.[70] Whether daisy or marigold, the flower was employed extensively by the first two Marchesi.[71] It seems to have held some special significance for Lodovico, appearing on the reverse of his medal by Pisanello, as a pendant jewel around his neck on his medal by Pietro da Fano, on the carved mantlepiece in the *Camera Dipinta*, and in several manuscripts in his library.[72] The Marchese's descendants also specifically associated it with him, placing the flower in two designs, one open and one closed, on a medal commemorating him (Fig. 63).[73] The fourth emblem in the *Sala del Pisanello*, not found in earlier Mantuan decoration, is a collar, a type of chain with hanging pendant, of the kind often adopted by chivalric societies as a badge of membership (Figs. 57 and 58). Like the flower, the collar is shown in two alter-

nating designs, and these two emblems are included in the frieze twice as often as the hind and the dog. The collar in Mantua has two distinguishing features: a hanging pendant of a winged bird, identified by its long neck and beak as a swan, and the single letter S on alternating images.[74]

The importance attached to family emblems in the frieze is confirmed when we turn to the narrative scenes, where the use of Gonzaga emblems was also pervasive. There the devices of flower and collar were further associated by being placed together on the caparisons of three of the horses in the Tournament scene (Knights 12 and 17 and the knight to the left of no. 10). Knight 12, who rides the central rearing horse, for instance, shows the combined devices on his horse's breastband and backcloth, as Ilaria Toesca has observed (Fig. 97 and Fig. 64a, b, c).[75] The flower alone is depicted on its chamfron (Fig. 65) and silhouetted above its rump, and other horses sport a flower crest (Fig. 66). Knight 12 and the other knights such as Knight 17 (Fig. 67), whose horses are similarly marked with flower and/or collar devices, all sport high bulbous crests on their helmets and heavily decorated mantles. Knight 12's crest is painted in Gonzaga colors of green, red, and white, as no doubt other crests would be had the fresco been finished.[76] Gonzaga family colors also appear elsewhere in the painting, such as the *giornea* (mantle) of the dwarf (Fig. 68) following *sinopia* Knight 24, who may tentatively be identified as Bohort (Fig. 35).[77] This knight, along with others in the tournament *sinopia*, is also identified by a roughly sketched collar on his horse's breastband (Fig. 34). Clearly, all the knights marked by collar and/or flower devices and identified by family colors were intended to be read as members of the Gonzaga team. We may safely assume that there would have been more knights so identified in the final painting. Emblems were, of course, a common means of identifying the patron. One North Italian example was the frescoed depiction of Valerano di Saluzzo and his wife, Clemensia di Provana, posing as the hero Hector and the Amazon queen Pantasilea, in the *Sala Superiore* of the castle at La Manta, identified by means of the French royal collar of broom pods bestowed on Valerano by the King of France.[78]

If the flower was a well-known Gonzaga device much favored by Marchese Lodovico, what of the collar with swan pendant? This device appears to represent the insignia of the Order of Our Lady of the Swan, a chivalric society that was formed by Elector Frederick II of Brandenburg immediately after he came to power in 1440 (Fig. 69).[79] The Hohenzollern were among the many European aristocrats to claim their origins in the swan, and the symbol of the Gesellschaft Unserer Lieber Frauen zum Schwan, or Schwanenorden, as it was later called, celebrated Hohenzollern descent from the Dukes of Lor-

raine, the German for which—Lothringen—was the source of the name Lo-
hengrin, the Swan Knight.[80] The new Elector formed his order on the lines of
the Order of the Golden Fleece founded in 1430 by Philip the Good, Duke of
Burgundy.[81] Like the Burgundian order, the German society was a political
creation to assert the new Elector's authority (since only a king could pretend
to rule an order) and to bind the nobility of the Marches of Brandenburg in
closer personal dependence on him. Membership in the order, initially
restricted to thirty lords and seven ladies from the Marches, was open only to
the upper ranks of the aristocracy, who had to prove their legitimate and
noble descent ("echt unde rechte van allen sinen viranen to Schilde unde
helme geboren").[82] Frederick promulgated statutes of the order in 1443 and in
1448 obtained a papal bull from Nicholas V ratifying the society and its use of
the Premonstratensian monastery of the Marienkirche near Altbranden-
burg.[83] The order proved so popular that the Elector soon expanded the
membership. By 1443 the numbers stood at 78, and in 1457 there were 129
members, including nobility from central and southern Germany.[84]

Like the Order of the Golden Fleece, ostensibly created "to worship God
and to defend our Christian faith," the avowed purpose of the Schwanenorden
was religious, in this case worship of the Virgin, described in the statutes as
"ruler of this world into which she was born and in which she became related
to us through our forefathers."[85] The members also practiced mutual assist-
ance and knightly bearing, each conducting himself "honorably and pru-
dently, guarding against openly shameful and scandalous misconduct," in
short "als ein Ritter und Rittermessig Mann," as one member recorded.[86]
Members were pledged to abide by the 1443 statutes, the elaborate rules and
regulations written with what might anachronistically be termed Prussian
precision. They included attendance at members' funerals, daily prayers
under pain of fines, and display of the order's insignia on important occa-
sions.[87]

In 1464–65 Lodovico Gonzaga and his wife were listed among the mem-
bers. Under the heading "item in der gesellschaft sind die kunig und kunigen,
fürsten und fürstin die noch nicht end sind gescriben," immediately following
the names of the Kings and Queens of Sweden, Norway, Hungary, and Den-
mark (the Queen of Denmark being Dorothea, Barbara of Brandenburg's
sister and another niece of the Elector Frederick), runs the line "marggraff zu
Mantua und seine frow."[88] Thus, along with other foreign heads of state of
importance to the Hohenzollern, the rulers of Mantua were honorary mem-
bers—the only Italian members—of this exclusive and prestigious society
founded at the court in northern Germany where Barbara had spent her child-

hood. The Gonzaga were not the only nobles to be given memberships in the society. In 1449, for instance, Frederick II's sister, Dorothea of Mecklenberg, gave the order's insignia to Bishop Nikolaus of Schwerin as a gift.[89] Elector Frederick II particularly approved of the moral influence of women; such highborn ladies as "die Hochgebornen Barbara, Marggrefin zu Branndburg and zu Mantua," as Emperor Frederick III referred to her, could even join as independent members.[90] Hypothetically, the Elector Frederick II conferred honorary membership on his Italian nephew and niece soon after the statutes were promulgated in 1443, at some point between 1444, when Lodovico acceded to the marquisate, and 1448, when Nicholas V issued the papal bull. As a knight of the order, Lodovico Gonzaga would have been invested with the society's collar, and a reference to this insignia may have been made in 1451 when the Gonzaga pawned some jewelry to raise money. In a description that exactly matches the collar drawn by Pisanello in the frieze, Barbara identified one of the pawned jewels as

Our Illustrious Lord's large collar with swan pendant.[91]

Possibly this collar should also be identified as the *collare* that Lodovico told Barbara, in the letter written in 1448 and quoted earlier, they could not afford as jewelry.[92]

The vague description in the 1443 statutes of the order's insignia, called a *cleynod*, or jewel, mentions a chain of hearts and "twitches" or muzzles and two pendant badges, one of the Virgin and one of the swan, without describing the collar's actual forms.[93] The collar that is depicted in the Mantuan frieze (Fig. 58) bears the swan badge but not the Virgin pendant. This discrepancy between German description and Italian depiction is not, however, as unexpected as it might seem. The particular formal configuration of the elements of chivalric insignia seems not to have mattered greatly to the 15th century. The design of the collar of the Order of the Golden Fleece, for instance, varied quite significantly, depending on the country in which it was created, and Piero de' Medici, to give an Italian example, used his device of the diamond ring in several different forms, sometimes including the feathers and sometimes omitting them.[94] Surviving German designs for the collar of the Schwanenorden even differ considerably among themselves, and the swan badge was sometimes emphasized by being made twice as large as the Virgin pendant (Fig. 69).[95] Membership in the society would have been conferred on the Gonzaga by letter, and the description given in it of the order's insignia was unlikely to have been any more explicit about the collar's forms than the vague wording of the 1443 statutes.[96] In the process of transmission across the

Alps, the collar's design became understandably simplified and its most dis-
tinctive—and more exotic—element, the swan, was seized upon and high-
lighted. As we shall see, the swan badge that caught the Italian imagination
was directly relevant to the Arthurian story illustrated in the *Sala*.

For the knights of the Marches the swan symbolized thoughts of death
because it sang its most melodious song as it died.[97] In Italy it also symbolized
purity of soul and was later used in this sense on a Mantuan medal made for
one Maddalena.[98] The isolated letter S, inscribed on every second collar
and on some knights' mantles and lances within Pisanello's tournament
scene, was also displayed on contemporary objects.[99] The significance of this
letter, which started to appear on works of art toward the end of the Middle
Ages, is still a mystery.[100] When the letter S became widespread in the 16th
century, however, it was recorded as symbolizing fidelity, whether political
or amorous, and it may well already have had this significance in the Quattro-
cento.[101] Of the other devices in the frieze, the dog in the fifteenth century was
also a symbol of fidelity or loyalty; hounds identified the virtuous ruler.[102]
The marigold also symbolized a just and magnanimous prince, while the
daisy, as this flower was perhaps called in the Renaissance, signified spring
and therefore innocence.[103] The motto given to the hind, itself an image of
prudence and innocence, calls for peace instead of war.[104] The hind and the
heliotropic flower both implied the presence of the sun, which they contin-
ually turned to face, and the swan in Maddalena of Mantua's medal also gazes
upwards at what can be read as a sun.[105] As we saw earlier, the Sun, which was
the planetary ruler of Leo and thus lord of the ascendant in Lodovico's natal
horoscope, was an important symbol for the Marchese.[106] For astrological
reasons Sol and Leo were closely associated and therefore often combined and
conflated in works of art, so that an image of either also alluded to the other.[107]
Hence the family of lions to the right of the tournament can be interpreted as
alluding not only to the celestial ascendant Leo of the Marchese's stars but also
to his *governatore*, the Sun, the device that he placed on Pisanello's contem-
porary medal. The sun was a common symbol of truth and wisdom, while
the king of beasts was known in the bestiaries for its majesty, nobility,
courage, strength, firmness, and magnanimity.[108] Against this background of
the possible meanings of the separate emblems, all the Gonzaga devices
together may be read as symbols, in a general way, of purity and innocence,
courage and strength, virtuous and magnanimous rule, political loyalty or
fidelity, and a yearning for peace, truth, and wisdom—all attributes that the
Gonzaga would have found entirely satisfactory in a work located in a prom-
inent hall of their palace.

But whatever other meanings they may have had—and for lack of con-temporary evidence too much sophisticated symbolic meaning should not be read into emblems in the fifteenth century—heraldic devices in this period were primarily used by princes to identify members of a dynasty.[109] The emblem on the lady's sleeve that identifies the sitter as a member of the Este family in Pisanello's *Portrait of a Princess* in the Louvre is only one of many possible examples.[110] The use of the four emblems combined together in a frieze in Mantua also recalls the practice, common in earlier secular decora-tion, of displaying shields with arms in the frieze. Examples can be seen in many Trecento rooms in Castelroncolo near Bolzano, for example the arms of the seven Imperial electors in the frieze of the *turnyr camer*, the tournament room (Fig. 80), and in the Palazzo Davanzati in Florence.[111] By analogy, the four heraldic devices, replacing coats of arms in the *Sala del Pisanello*, were an up-to-date way of making a similar dynastic statement. In this reading the larger and more frequent devices, the Gonzaga flower that Lodovico favored and the Hohenzollern insignia that he had recently acquired, alternate with the smaller devices of the dog and the hind, associated with his father and his grandfather. Proclaiming three generations of the Gonzaga dynasty, the frieze affirmed the family's ancestral claims and legitimacy while giving greatest prominence to the Marchese and the German princess who had recently suc-ceeded to the title.

We saw in Chapter 2 that no other illustration of the episode recounting Bohort's visit to Brangoire's castle survives—indicating that it was not a fre-quently illustrated story—and it was argued that Lodovico must have had strong personal reasons for selecting this particular chivalric tale.[112] The pres-ence of the collar with swan pendant in both frieze and frescoes suggests the theme that underlies the program in this painted hall. The key to the choice of Arthurian story must lie with the swan badge and the Hohenzollern leg-endary ancestor, the Swan Knight, variously known as Helias or Lohengrin. Just as Elector Frederick II chose a swan as symbol for his chivalric society in 1440 because of his family's descent from the Swan Knight, so the Gonzaga probably chose this story from the prose *Lancelot* in the mistaken—but under-standable—belief that it referred to the legend of Barbara of Brandenburg's mythical ancestor.

Gonzaga misinterpretation of the Bohort story may have been based on conflation of the names of Helias, the Swan Knight, and Helain, Bohort's son. Just as the formal configuration of the elements of chivalric insignia seems to have mattered little in this period, so there was no single standard for the spelling of proper names in the late Middle Ages. The knights who took

vows at King Brangoire's banquet, for instance, and whose names are inscribed in Pisanello's *sinopia*, were known, among other variants, as Sabilor and Talibors, Arfassart and Alpharsar, Maliez and Melior, Meliduns and Mandin, owing to different dialects and the habits of individual scribes.[113] Errors and changes of meaning were to be expected in the transmission of legends in the Middle Ages and, among the hundreds of protagonists in Arthurian romance, scribes inevitably confused knights with similar names.[114] It would thus have been all too easy for the scribe copying the manuscript, and the reader perusing it, to conflate the name of Bohort's son Helain, variously spelled Helias, Helyas, Helis, Helians, Helyam, Helayn, Helyn, Elian, Elyan, Elyam, Elin, and Alain, with that of the Swan Knight's name in French, Helias—also spelled Helyas, Elias, Elyas, Helie, Elie.[115] The name of Helain, who was called Elia or Helin in Italian, may even have been rendered as Helias or Helyas—two known variants of his name in French—in the particular manuscript followed by Lodovico, leading him to associate Bohort's son with the Swan Knight. The fact that the geographical names in the Bohort episode illustrated in the *Sala* coincide with some actual places must have reinforced this misinterpretation by further associating Helain with the Hohenzollern and their mythical ancestor. Just as the territory ruled by Elector Frederick II (and by Barbara's father, John the Alchemist, at the time of her marriage) was known as Die Mark Brandenburg, the Marches of Brandenburg or, in Italian, Le Marche, so the king in the romance, Brangoire, ruled his land from a *palazzo* called the Chastel de la Marche.

In the thirteenth century Wolfram von Eschenbach introduced the legendary Swan Knight into *Parzival* under the German name of Loherangrin, or Lohengrin, and connected him with King Arthur's court by making him a son of Perceval, one of Bohort's companions on the quest for the Grail. Like Helain le Blanc, Lohengrin was a knight of the Grail, who eventually succeeded his father as King of the Grail Castle. Lohengrin's name connected him with the territory of the Dukes of Lorraine, from whom the Hohenzollern were directly descended. Other descendants of the Lorraine family, such as the Dukes of Cleves, exploited their mythical origins by extensive use of the swan badge as symbol: Helias, for instance, supposedly founded the Order of the Swan, whose members also wore a swan hanging from a golden chain, at Cleves. In 1478 Gert van der Schuren, secretary of the Duke of Cleves, told the story of Elyas, Swan Knight—who was also, it seems, the first Duke of Cleves. A link between these two branches of the Swan Knight's progeny, Cleves and Hohenzollern, was produced in 1615 when Carlo Gon-

zaga-Nevers, eighth Duke of Mantua, whose wife was a member of the Lorraine family, tried to revive the Order of the Swan.[116]

The Swan Knight's story bears little resemblance to Bohort's adventures at the Chastel de la Marche. Widely circulated in several languages, his legend varied with the nationality and century of the writer, but the story usually tells of the arrival of a mysterious knight in shining armor, young, handsome, and courageous, in a boat pulled by a swan, at a time when a noble lady is in great peril. The Swan Knight rescues the lady, marries her, and becomes the procreator of an illustrious race; but when his wife asks the forbidden question—his name and origin—he departs as suddenly as he came.[117] This basic story deals with the adult Swan Knight. If the names Helain and Helias were conflated, however, the episode from the prose *Lancelot* would have been understood as the account of the love affair between the Swan Knight's parents, Bohort and Brangoire's daughter, that led to his conception and birth. In one version of the story it was foretold that the Swan Knight would be proclaimed a king in the Orient, giving him a future similar to that of Helain as Emperor of Constantinople, the besieged city that was much in the news in these years.[118]

The relevance of Gonzaga contemporary circumstances to this interpretation of Pisanello's Arthurian frescoes is striking. Alluding to Lodovico's membership in the Schwanenorden—the only Italian ruler to be so honored— and appropriating the story of Barbara of Brandenburg's legendary ancestor, the Swan Knight, the *Sala del Pisanello* can be interpreted as revealing the Marchese's determination, at the beginning of his rule, to stress his own legitimacy and to promote his family alliance with the Hohenzollern and his ties, through them, to the Emperor. The implications of Hohenzollern influence with Frederick III would have been readily apparent to all who entered the *Sala del Pisanello* in the mid Quattrocento. The "German connection" was being invoked to support the interests of the small state of Mantua in the shifting tides of North Italian politics. Its survival depended in part on the right choice of powerful friends to balance its powerful enemies. On one level, these frescoes reflected the dynastic clout that Lodovico hoped to exploit in dealing with his neighbors.

But the *Sala* frescoes can be read as serving yet another diplomatic purpose. The iconography also appears to make reference to a distinctively Mantuan theme. Illustration of Bohort's story would have reminded viewers of the famous relic of the Precious Blood of Christ that was preserved in S. Andrea. According to tradition, some of the Redeemer's blood had been

brought to Mantua by Saint Longinus, the blind Roman centurion who regained his sight miraculously when Christ's blood touched his eyes.[119] Throughout the Vulgate Cycle, as we saw in chapter 2, the knights of the Round Table seek the Grail. Robert de Boron's *Joseph d'Arimathie* (1191–1201) was the earliest extant romance in which the Grail was defined as the vessel used by Christ at the Last Supper in which Joseph of Arimathea subsequently caught the blood from Christ's wounds as he hung on the cross. The *Queste del Saint Grail*, one of the branches of the Vulgate Cycle, also identified the vessel with the chalice of the mass as well as with the cup used at the Last Supper and by Joseph of Arimathea at Golgotha.[120] Such identifications created an obvious parallel between the Grail and Mantua's relic of the Holy Blood, a parallel reinforced by the bleeding lance that always accompanied the appearance of the Grail. This lance was specifically identified by medieval writers with the lance used by Longinus to pierce Christ's side on Good Friday.[121] Longinus, the saint whose miraculously regained sight testified to the efficacy of the relic housed in S. Andrea, was, for obvious reasons, venerated with particular enthusiasm in Mantua. As we saw earlier, Bohort—unable to behold openly the Grail himself because he had lost his virginity, even if involuntarily, with Brangoire's daughter—was the only participant in the Grail quest who returned to King Arthur's court to recount the discovery of the Grail as the supreme mystical experience and source of divine grace.[122]

In the fifteenth century the Gonzaga explicitly associated themselves with the cult of the Mantuan relic of the Holy Blood, which in that age of pervasive relic-worship was venerated by foreigners as well as by Italians.[123] Northern Europeans made pilgrimages across the Alps to Mantua for the purpose. Displayed to pilgrims every year on Ascension Day, the popular relic became such an important source of Mantuan prestige and tourist income that Lodovico eventually decided to rebuild S. Andrea, among other reasons to provide more space for the thronging pilgrims.[124] Gianfrancesco had already promoted the Holy Blood on the reverse of a new coin displaying Gonzaga arms with quartering of Imperial eagles that was struck soon after 1433 to celebrate the recently obtained marquisate.[125] His descendants, including Lodovico, continued to commission coins showing the Holy Blood, often pairing a reliquary with images of the emblems of *cervetta* or *cane alano*, and in 1475 Lodovico specifically identified with the cult of the relic by placing the inscription LVDOVICVS II MARCHIO MANTVAE QUAM PRECIOSVS XPI SANGVIS ILLVSTRAT ("Lodovico, Second Marquis of Mantua, rendered famous by the Precious Blood of Christ") on the medal he commissioned from Melioli.[126]

Rendered famous by the Precious Blood, Lodovico could hardly fail to

take a proprietary interest in Bohort, the Arthurian pilgrim who searched for and found the ultimate romance relic. Indeed, an understanding of Bohort's role within the Vulgate Cycle as a whole—as sole narrator of the mysteries of the Grail in the *Queste del Saint Grail*—depends on knowledge of his seduction by Brangoire's daughter in the prose *Lancelot*, the very episode depicted in the Gonzaga *Corte*. In addition, the Gonzaga would surely have been peculiarly susceptible to any interpretation of the *Lancelot* episode that linked the origins of their house to this particular hero. Thus, if interest in Bohort, relic-quester, relic-discoverer, relic-recorder, had led them initially to the pages in the prose *Lancelot* on which his adventures at Brangoire's castle were recounted, then discovery, perhaps through conflation of the names of Helain and Helias, of his further role as father of the Swan Knight, Hohenzollern ancestor, may have rendered him so attractive a hero that choice of his story for the walls of the *Sala* was all but inevitable.

In some romances, as it happens, the Swan Knight story was directly linked to the Grail legend and its protagonists. Wolfram von Eschenbach was the first to connect the two legends by completing the adventures of *Parzival* with a brief account of those of Loherangrin, Perceval's son and knight of the Grail.[127] German writers in general followed his lead, making Lohengrin a Grail knight whose maternal ancestors had been Grail kings. The place whence the Swan Knight was said to issue was the Grail realm, and the Holy Grail itself chose the Swan Knight to become his father Perceval's successor as King of the Grail.[128] Hence, together with his parents, Lohengrin was named in the Grail inscription and ascended the throne in the kingdom of the Holy Grail.[129] In Konrad von Würzburg's *Der Schwanritter* (1276–90), written to glorify the houses of Cleves and Gelder, the Swan Knight possessed the mysterious power of the Grail so long as his name remained unrevealed. In a later version, however, the Swan Knight's name combined two elements pertinent to the Mantuan situation: he was called Elie Grail.[130]

Under these circumstances, the depiction of Bohort's visit to Brangoire's castle in the *Sala* must have served multiple purposes: it not only affirmed influential Gonzaga connections north of the Alps but also alluded to Mantua's prestigious relic of the Holy Blood. In that the Swan Knight in some accounts became King of the Grail and in that Lodovico wished to have himself perceived as rendered famous by the Precious Blood, the cycle can also be read as projecting an image of the Gonzaga as the relic's guardians, in other words, as modern Italian Grail-keepers—or, better yet, Grail kings.[131] By choosing the one chivalric hero, Bohort, whose story seemed to touch on Mantua's most prized relic, Lodovico perhaps celebrated the city's aspiration

to be recognized as a "Grail city," locus of a miraculous modern Grail, and his
family's self-appointed role as keepers of this venerated relic, a source of both
Mantuan prestige and tourist income.

We cannot tell whether these frescoes might have played a diplomatic role
in the mid Quattrocento had they been finished. Within the constraints
imposed by the meager resources of his small state, however, we know that
Lodovico's campaign to increase Mantuan prestige and Gonzaga consequence
was relatively effective. We have seen how he succeeded in acquiring a cardi-
nalate for the family in the early 1460s. Already in 1446 Francesco Sforza had
proposed a family alliance between the houses of Sforza and Gonzaga, and the
first provision of the 1450 treaty between Mantua and Milan arranged for the
marriage between Lodovico's infant daughter and Sforza's heir, Galeazzo
Maria.[132] It was highly unusual to include such a proposed marriage among
the terms of a *condotta*.[133] It was also unexpected for a prince in the Duke of
Milan's position to promise a legitimate child in marriage to one of his *con-*
dottieri's offspring. Given the respective degrees of power and wealth between
Milan, a great power, and Mantua, one of the lesser states in northern Italy,
this highly advantageous betrothal was a coup which the Gonzaga could not
normally have expected. Indeed, the marriage would, Sforza's ambassador
told the Duke bluntly a few years later, bring the Gonzaga greater honor and
greater reputation than had yet befallen their house, while detracting from
and diminishing Sforza's own reputation.[134] The political hopes that the
betrothal raised for the Gonzaga were, however, never to be realized. By
1463, the date set for the marriage, the relative circumstances of the two fam-
ilies had changed significantly, and the discrepancy of power between the
Marchese of Mantua's daughter and the heir to the duchy of Milan was such
that Galeazzo Maria Sforza spurned his Gonzaga bride, much to her parents'
distress.[135] Nonetheless, in 1450, the high lineage and influential northern
European connections of the Gonzaga—one of the pervasive themes of the
Sala del Pisanello frescoes—had played an important role in what was consid-
ered an exceptional diplomatic success.

III. *Arms and Chivalry*

But perhaps the most obvious advantage of the Arthurian iconography was
the valor of the chivalric heroes in combat, and hence the connotations of mil-
itary *virtù* associated with them. Lodovico's career as a *condottiere* and his mil-
itary aspirations did not flag in the years immediately succeeding work in the
Sala del Pisanello. The Marchese, as well as securing a highly advantageous

marital alliance with the Duchy of Milan, also obtained lucrative and prestigious *condotte* first from the King of Naples and then from the Duke of Milan, increasing both military status and military stipend. In 1450 he was able to bargain with Sforza in order to obtain the command and stipend that he wanted: appointed supreme commander of all Milanese troops, he increased his stipend by 300 percent over his military earnings in 1445.

"Tell His Majesty," Duke Filippo Maria Visconti had written somewhat disingenuously in 1443 when Lodovico was angling to get a job with King Alfonso, "that the lord Lodovico does not practice the profession of arms for greed of gain but to obtain honor and fame."[136] In the Renaissance as today, however, fame and gain were inextricably intertwined. Honor and fame were values that in the Quattrocento were quite quantifiable, since a *condottiere*'s reputation determined the size of his military command and hence his stipend.[137] Prestige as a warrior was accordingly crucial to Lodovico's success when negotiating *condotte* with Naples and Milan. Pisanello's grandiose tournament, disproportionate in scale to its importance within the episode from the prose *Lancelot*, was directly relevant to the Marchese's immediate need to promote his reputation as a reliable mercenary commander. The largest and most dramatic scene in the hall, it was placed where it would be most visible to the visitor entering the room, directly opposite the main entrance and on the wall with the best light (Figs. 6 and 19). In the prose *Lancelot*, Bohort took part in the tournament with remarkable success, defeating over sixty opponents. In life, a tournament or mock battle like that depicted by Pisanello served as a military exercise for cavalry; the jousters were usually professional soldiers displaying their horsemanship and military valor under the leadership, and to the greater glory, of their commander.[138]

As commander of the Milanese forces Lodovico had, on the one hand, to maintain his reputation as a leader and, on the other, to persuade other *condottieri* to defer to his orders. Our Marchese was not, as it happens, distinguished for his tactical brilliance, being no match in the field for a Malatesta or a Piccinino. *His* reputation lay rather in his "faith, constancy, integrity, *virtù*, and prudence of spirit," in the words of Filippo Maria Visconti in 1443.[139] In other words, it was in behind-the-lines diplomacy and tactful command of his peers—his *auctoritas* and *experientia*, as Pius II put it—that Lodovico could claim preeminence.[140] As Sforza conceded in 1461, men of reputation were willing to accept Lodovico's authority:

> There is no other than yourself who in past wars has been known as bold and wise, and none by whom it seems anyone should be happy to be commanded. For often, when in camp with other captains of reputation [Alessandro Sforza,

Bartolomeo Colleoni, Tiburto Brandolini], none ever complains [of insult] who has not been persuaded through your good means to be most patient and obedient.[141]

This assessment of Lodovico's commendable diplomatic strengths was made after the Marchese had commanded the Milanese forces for over a decade. In 1447, however, when the *Sala del Pisanello* was commissioned, Lodovico was still largely untried as either tactician or general. In 1448 he was even to suffer a military defeat in the rout of the Venetian troops under his command at Caravaggio.[142] In this period he would certainly not have been acclaimed for his skill in arms "as if he had invented the profession," as was to be said at his death thirty years later.[143] In order to obtain desirable *condotte* in 1447, Lodovico needed recognition as an active *condottiere* successful in battle, and a propagandistic—almost militaristic—theme of Gonzaga war preparedness was common to all his early artistic commissions. A 1446 *marchesano* displayed him in the guise of the soldier Saint George, legs akimbo, triumphantly flourishing a sword and grasping a shield charged with Gonzaga arms (Fig. 54), and Pisanello's medals, contemporary with the cycle, are equally revealing.[144] Other princes, such as Leonello d'Este and King Alfonso, devoted the reverses of their medals to heraldic devices with abstruse meanings. Lodovico's decision to have himself and his father portrayed instead as equestrian *condottieri*, in his case prepared for immediate battle in full armor with closed visor, is significant as a direct statement of his current policy (Fig. 55). Furthermore, the astrological references in Pisanello's works—the motifs of sun on the medal and lions in the *Sala* frescoes which allude to Lodovico's ascendant sign of Leo and its planetary lord the Sun—gave him the destiny, so the astrologer Bartolomeo Manfredi informed the Marchese, of "a prince happy in dominion and victorious in the military arts."[145] Lodovico's pursuit of "glory, fame, and reputation," as one correspondent put it in 1449, was thus reinforced in the *Sala* frescoes by the presence of his celestial lions, symbols of courage and strength which ensured his military success.[146]

The *signori*'s favored medium for the commemoration of their princely relatives and themselves as *condottieri* was normally bronze, and several bronze equestrian statues were reaching completion in northern Italy around this date. In Ferrara the bronze monument that Leonello d'Este commissioned to honor his father, Niccolò III, was ready for casting in the summer of 1446, and in Padua Donatello cast the equestrian sculpture of the *condottiere* Gattamelata during the spring and summer of 1447.[147] King Alfonso also wanted a bronze equestrian statue and did his best in 1452 to get Donatello to come to Naples to create one.[148] Two years later Francesco Sforza proposed setting up

equestrian statues of himself and Bianca Maria Visconti in Cremona.[149] Free-standing bronze sculpture was expensive, however, and the fact that the medium of fresco was one of the cheapest ways to make a visual statement must in part explain Lodovico's decision to use the *Sala* murals as a means of promoting his prestige as a warrior.[150] Fresco better suited the empty Gonzaga purse. Painting also had certain iconographic advantages over sculpture. The image of a rearing horse as ridden by the Gonzaga commander portrayed in Knight 12 (Fig. 97)—a figure that in sculpture would pose serious technical problems of physical support—had powerful connotations of established power in Lombardy that would again be invoked in the early designs for the equestrian monument commissioned from Pollaiuolo and Leonardo to commemorate Francesco Sforza of Milan.[151]

As a construct, the painting also allowed for wide latitude in the expression of symbolic content, and Pisanello exploited to the utmost the imaginative possibilities of the chivalric iconography. As the entering visitor would have been immediately aware, the combatants in Pisanello's tournament, unlike the knights-errant on Walls 2 and 3, were not identified by inscriptions.[152] The reason would be obvious to all. Bohort and Brangoire were not given captions because here the Gonzaga, identified by family colors and heraldic devices, participate in King Brangoire's tournament, substituting for Bohort, invincible champion as well as father of the Swan Knight, and for the other illustrious heroes on his team. The tournament displays Gonzaga fantasy identification with the valorous knights-errant of the Arthurian past.

Fifteenth-century Italy was deeply influenced by the sentiments and practices of medieval chivalry. The code of conduct known as chivalry was a doctrine of knightly service to the community that assumed a military basis for the life of the landed classes and an exalted reverence for personal honor.[153] "A knight," wrote Francesco Sansovino in 1583 in his book on chivalry, "means . . . dignity, derived in man through the exercise of arms on horseback; by use of the word 'knight' is meant a person of quality and worthy of honor."[154] In short, chivalry was equated with honor, and Sansovino would have had no difficulty in interpreting Lodovico's decision to use Arthurian iconography as a vehicle through which to project an image of himself as a fearless warrior. In his book Sansovino treated King Arthur's court in the best romantic tradition, as if it had really existed, placing his discussion of the Round Table between his pages on the actual orders of the Knights Templar and the Garter. The Round Table was a new idea without precedent, he wrote, conferring historical validity on the legend, and King Arthur accepted only those whose valor in arms rendered them worthy. Those admitted were few, he went on,

and the honor proved "their rare *virtù*, the valor of their spirits, and the nobility of their blood."[155] In Sansovino's terms, Gonzaga inclusion among the knights of the Round Table on the walls of the *Sala del Pisanello* was ultimate proof of their *virtù*, their skill in arms, and their noble lineage. Presenting himself and his family to his peers from neighboring courts in the highly favorable light of Arthurian heroes, Mantua's ruler here partook in the illusion of an illustrious past and a heroic destiny.

Such an illusion must have been profoundly satisfying to Renaissance *signori*, for despite the paucity of remaining secular images from the period, other examples of their projections of themselves as chivalric heroes still survive on castle walls. In the tournament-room fresco at Castelroncolo, for instance, Nicolaus Vintler, the patron, had himself depicted winning a joust against Albert of Habsburg and Henry of Rothenburg, each carefully identified by his arms (Fig. 80).[156] Conflation of Arthurian myth and Italian reality extended to the minor arts. The royal arms of Naples were assigned to the hero Meliadus in the romance illustrated for Louis of Tarent, King of Naples, and the Guicciardini family linked its origins to Tristan by placing their arms on his shield on the Sicilian quilts they commissioned in the fourteenth century.[157]

Such chivalric pretensions were not confined to works of art. Renaissance princes put their Arthurian aspirations into practice in life as well as art. They expressed their nostalgia for a wishful return to a vanished past by allowing Arthurian legend to have a persistent influence on the conduct of actual tournaments even in the fifteenth century.[158] At the court of King René of Anjou, jousts were held in imitation of those at the legendary Camelot, with jousters dramatizing themselves by taking the names of King Arthur's knights.[159] Philip the Good's famous Feast of the Pheasant at Lille in 1453 was preceded by a tournament in which Adolf of Cleves, another descendant of the Swan Knight, entered the lists as *le chevalier au cygne* and challenged all comers with promises of a golden swan to the winner.[160] In Italy tournaments inspired by the romances, such as the one organized in Ferrara in 1464 by Borso d'Este, that great reader of chivalric books, were called *belle fantasie* (beautiful fantasies) by contemporaries.[161] Borso's tournament was an elaborate affair with a wooden castle constructed in the middle of Ferrara, an armed giant, and a small boy dressed up as a dwarf with a long beard.[162] The jousters play-acted the roles of *cavalieri erranti* (knights-errant), and everyone praised "the good chivalry" that they displayed.[163] Asked where he was going, one knight responded in words that could have come straight out of the prose *Lancelot*: "vado cercando mia aventura," he said, "I go seeking adventure."[164]

In his study of the role of chivalry as a game played by fifteenth-century nobility, Huizinga was intrigued by the phenomenon of pretense involved in the aristocratic flight into a world of fantasy. The scholar argued that in the fifteenth-century chivalry represented "wish fulfilment, a fiction designed to keep up the feeling of personal value . . . compensating for unfulfilled longings."[165] He saw the nobles' chivalric aspirations as "collective dreams, the fiction that is inseparable from civilization."[166] On a fantasy level Pisanello's frescoes in Mantua surely embodied such a collective dream: posing as Arthurian knights, fighting on Bohort's winning team, Lodovico Gonzaga and members of his family were transformed by art into their legendary ancestral exemplars.

But, as we have seen, the Arthurian frescoes also functioned at another, very practical, level. The cycle reflects not only the dream world so beautifully articulated by Huizinga but also the political realities of contemporary Mantua. While there can be no one-to-one relationship between a work of art and everyday life, this chivalric cycle provided a poetic analogy suggestive of Gonzaga military success, Gonzaga political legitimacy, and Gonzaga influential connections within the Empire. It is hard to imagine any other iconography that could so effectively have subsumed so many of Lodovico's contemporary political concerns: dynastic, military, economic.[167]

Only when the worldly purposes of such secular images are fully integrated into their interpretation can we understand the meaning that these works held for their first viewers. "Though he be a small Marchese, yet is he a man of quality," wrote Lodovico's ambassador in Milan.[168] Whether or not he was articulating official Mantuan diplomatic policy, Vincenzo della Scalona's comment, made at a moment when relations between Milan and Mantua were strained, emphasized two perhaps interrelated factors: the relative unimportance of the Mantuan state and the Marchese's reputation as a man of integrity and character. The reality of Mantua's inferior might must have increased his sense of rivalry in the one field in which he *could* compete on equal terms: artistic patronage. Mantua may have been a lesser Italian power, but Lodovico—*intendentissimo*, that is, knowledgeable and discerning in artistic matters—was one of the most successful and effective patrons of art in the Quattrocento.[169] In the next chapter, we shall accordingly consider his education and cultural background.

CHAPTER FIVE

Patron

1. *Lodovico Gonzaga*

WE SAW that Lodovico Gonzaga, with whom Pisanello was accused of maligning Venice in 1441, was only thirteen when he first placed the artist on his payroll. Fortunately, more is known about the youthful patron than the aging court artist. Pope Pius II, for one, was well acquainted with the lord of Mantua.

> Lodovico was famous for his prowess in arms and his knowledge of letters, for he equaled his father's military glory, and under the instruction of the orator Vittorino he almost attained to the learning of his teacher.[1]

It was commonplace in the Renaissance to describe a prince as skilled in arms and letters, but the Pope's characterization of Lodovico was widely echoed, and the Marchese's understanding of the arts and his military expertise were both explicitly eulogized at his death.

> Some praised his learning [*litteratura*], some his talent for different things, such as agriculture, architecture, and art [*disegno*]. For [his skill in] arms, above all else, he was commended as if he had invented this profession.[2]

Thus wrote Bartolomeo Marasca to Federico Gonzaga from Rome. Even allowing for the ulterior motive present in all humanist communications with princes, Lodovico's contemporaries clearly believed that his strengths lay as much in learning, architecture, and art as in warfare or farming.

Gonzaga rulers traditionally combined an interest in scholarship with their military pursuits. Guido Gonzaga (ruled 1360–69), who had a passion for poetry and literary studies, gave hospitality to Petrarch and founded the family library.[3] His son Lodovico (ruled 1370–82), Marchese Lodovico's great-grandfather, was also advised by Petrarch and enriched the library with manuscripts of classical authors and vernacular poetry as well as the works of chivalry discussed in chapter 2.[4] By the end of the Trecento the classical holdings of the Gonzaga library had started to attract the attention of humanists in other centers, and Coluccio Salutati wrote to Lodovico's grandfather Francesco (born 1366, ruled 1382–1407) to find out which Latin authors the prince

owned.[5] The library continued to grow, as witnessed by the 1407 inventory, but Francesco himself was more interested in architecture, constructing S. Maria delle Grazie, the cathedral's new facade, and the *Castello*.[6] Foreign craftsmen, such as Stefano *pittore francigena* and Albertus *pictor de Alemanea*, worked in the city during this period, and in 1389 Francesco spent 5,000 ducats in Paris on jewels and tapestries.[7] Lodovico's father, Gianfrancesco (born 1395, ruled 1407–44), was praised by Leon Battista Alberti in the same terms that Pius was to use for Lodovico: "glory of arms and skill in letters."[8] Best known for his military exploits, Gianfrancesco was also a humanist prince with an enlightened cultural policy. Under his energetic rule, and stimulated by Martin V's two papal visits in 1417 and 1418, Mantua emerged in the early 1420s as an active cultural center, just as Lodovico was approaching his teens. Scribes and miniaturists were engaged in transcribing and decorating such manuscripts as the *gramatica* written in 1418 for the six-year-old Lodovico by Jacobus de Galopinus.[9] In 1420 the first tapestry manufacture in Italy was founded with weavers brought in from France and Flanders.[10] Many foreign craftsmen—jewelers, goldsmiths, embroiderers, glassmakers, weavers, miniaturists, and scribes—both from far-flung countries (for instance, Henricus de Alamania, Alfonso de Hispania, and Zaninus de Francia) and from other Italian centers (for instance, Antonio de Bononia, Antonio de Parma, and, not least, Antonio Pisano *pictor*)—were living in Mantua in the early twenties, some of them no doubt enticed by Gianfrancesco's offer of half a ducat a month for five years to all foreign professionals who settled in his city.[11]

In 1423, looking for a scholar who would add luster to his court, Gianfrancesco invited Vittorino da Feltre to Mantua as tutor for his children. The intellectual climate of the Mantuan court was profoundly influenced for the next quarter-century by the presence of this dedicated teacher and outstanding humanist. Because of its spirit, its curriculum, and its methods, Vittorino's school, known as the *Casa Giocosa* from the building assigned to him, was the most famous such establishment in Italy. The curriculum consisted of music, mathematics, astrology, and drawing as well as Greek and Latin literature and grammar, the history of the ancient world, and moral philosophy. For Vittorino the study of the Greek and Latin classics was a means of character formation rather than an end in itself. He wished to secure the harmonious development of mind, body, and character, and was as interested in his students' moral and physical development as in their intellectual capacities. Vittorino himself exercised regularly all his life, and games, such as *palla*, running, jumping, wrestling, horseback riding, archery, and fencing in the

meadow between the *Casa Giocosa* and the *Corte*, alternated with the hours of study. Like modern educational theorists, Vittorino believed that bright surroundings were conducive to intellectual concentration, and a room in the *Giocosa* was frescoed with scenes of children playing. He also studied the tastes and capacities of each child, hoping to persuade his students to learn through stimulation rather than through fear of punishment.[12]

His young charges responded well. In 1424, at the age of twelve, Lodovico was able to recite a Latin speech by heart. Guarino da Verona spoke of his exceptional love of learning in glowing terms, offered him the choice of a volume by Cicero or Terence as a gift, and urged him to take books—by which he meant classical volumes—more seriously than princes usually did:

> Search for books, read books, get used to taking books with you to the country and on journeys, as others take dogs, sparrow hawks, and dice.[13]

Some ten years later another humanist, Ambrogio Traversari, expressed amazement at the younger Gonzaga children's precocious knowledge of Latin and Greek. Gianlucido, reputed to know much of the *Aeneid* by heart, recited two hundred lines of a poem he had composed in Latin for Emperor Sigismund's entry into Mantua two years earlier. At the age of seven Cecilia knew Greek well enough for Vittorino to purchase the gospels in that language for her, and she astonished Traversari by the elegance of her written Greek.[14] Traversari was just as impressed by the classical volumes that Vittorino continued to acquire for the Gonzaga library with the help of such humanists as Giovanni Aurispa, Francesco Filelfo, and Guarino da Verona.[15] The Marchese was also keenly interested. Vittorino's voice can be heard in his employer's scholarly admonition to Domenico Grimaldi, charged with searching in Constantinople for a copy of Josephus's *Jewish Antiquities* in Greek:

> We don't care whether they [the manuscripts] are decorated or in exquisite lettering so long as they are thoroughly accurate.[16]

The Gonzaga children also acquired a sound knowledge of mathematics: Gianlucido, for instance, was said to have added two propositions to Euclid's *Geometry*. The inscription SVMMVS MATHEMATICVS ET OMNIS HVMANITATIS PATER, chosen by Lodovico for Pisanello's medal posthumously commemorating Vittorino, stressed his tutor's mastery of mathematics.[17] Another former student, Federico da Montefeltro, paired Vittorino with Euclid among the portraits of Illustrious Men depicted in the *studiolo* of his palace in Urbino.[18] Since the curriculum also included instruction by *pictores*, it has been suggested that Vittorino's students were among those few equipped

with the requisite skills—knowledge of Euclid, familiarity with Cicero, and understanding of the art of drawing—to understand Leon Battista Alberti's *De Pictura*, which the author dedicated to Gianfrancesco Gonzaga around 1438.[19]

Vittorino had hesitated before accepting Gianfrancesco's invitation to come to Mantua. Modest in his tastes, he despised the luxury of court life and wondered whether he would be able to treat the ruler's spoiled children with the necessary severity to form their characters. He insisted on absolute control over his students' lives. Life at the *Ca' Giocosa* was spartan, "like that of a monastery," Vittorino told Vespasiano da Bisticci.[20] The food was plain, the wine watered, and the heating minimal. As a schoolboy Lodovico was obese, greedy, and clumsy, and Vittorino encouraged him to learn self-discipline and to curb his appetite by listening to music at mealtimes and by following his tutor's example of self-restraint.[21] In later years Lodovico recalled his painful memories of how much resolve it took to diet by "eating little, drinking lots of water, and sleeping less."[22] The Marchese never lost the streak of personal austerity inculcated by Vittorino, although he himself attributed it to the years spent bivouacking as a soldier.[23]

Just as a pelican, symbol of charity, gives her blood for her young on the medal created by Pisanello for Vittorino, so this gifted teacher, devoting himself to his students, put all his efforts into *adoctrinare* instead of the Renaissance equivalent of publishing.[24] Not being in competition with his fellow academics, he was one of the few humanists on good terms with all the others: "Vittorino, the best of men, the most learned master . . . whom I love greatly, praise greatly," wrote Guarino da Verona in 1424 to the young Lodovico of his new tutor.[25] Even the disgruntled Filelfo called him *prudens* and *bonus*.[26] Both sent their sons to Mantua to study under the "Socrates of our time."[27] Vittorino had great authority with his former students, though the modern reader peruses their reverential descriptions of the life and work of this paragon with some skepticism. Vittorino's intensity, his abhorrence of comfort, and his uncompromising self-discipline must have made him at times an uncomfortable companion. Nonetheless, his cheerful style seems to have modified his earnest personality sufficiently to make him an attractive and effective model, and it cannot be denied that Lodovico spent his formative years under the direct supervision of a mentor who was remarkable both for his learning and for the respect and affection he elicited from all he encountered.[28]

Gianfrancesco much preferred his second son, Carlo, described by all as tall and handsome, to Lodovico, who was sufficiently overweight to cause his

father to call him as fat as a pig.[29] Whether cause or effect, Lodovico's early adolescent obesity reflected some family tension that emerged into open conflict in 1436. Defying his father, then captain general of the Venetian troops, Lodovico joined the rival forces of Milan under the *condottiere* Niccolò Piccinino. Outraged at the scandal created by his heir's rebellious gesture of allegiance to the enemy camp, Gianfrancesco promptly deprived Lodovico of his rights of succession.[30] Letters arrived from abroad commenting on the role played by the "Milanese snake" (presumably Duke Filippo Maria Visconti) in persuading Lodovico to act with "juvenile madness," in the words of Emperor Sigismund—although at twenty-four Lodovico was hardly a youth.[31] His former tutor, Vittorino, at any rate, felt no compunction in informing Gianfrancesco of his deep disapproval of the Marchese's, not Lodovico's, behavior.[32] It was a measure of the humanist's standing at court that he eventually persuaded Gonzaga to receive his firstborn back into the Mantuan fold, although admittedly not until 1440, when Gianfrancesco had himself left the service of Venice and entered that of Milan.[33] The quarrel, Lodovico's banishment from Mantua, and the suspension of the rights of primogeniture placed Barbara of Brandenburg, probably still suffering from culture shock after her arrival as an eleven-year-old bride in 1433, in an uncomfortable position. The concern felt by her relatives in Germany was mitigated by relief at the presence of Paola Malatesta, Lodovico's mother. In 1439 Margrave Frederick I of Brandenburg, Barbara's redoubtable grandfather, wrote that the "great humanity with which you [Paola] gave comfort and most pious consolation and advice to your and our daughter, Lady Barbara, during the time of her adversity" had placed him under an eternal obligation to her.[34] Apart from the protection afforded by her mother-in-law in the face of her father-in-law's wrath, Barbara's greatest debt during her adolescence was to Vittorino.[35] Given a humanist education, the immigrant bride became fluent in the language and mores of her new state, and if she did not altogether forget German *costumi* (habits), as Gianfrancesco would have liked, she did succeed in becoming fully integrated into the *usanze* (customs) of Italian court life.[36]

Thanks also to Vittorino, Lodovico grew up with a reputation for rectitude and integrity. He himself took pride in his constancy, boasting that "we are ever one Lodovico and made in one way,"[37] and he was rewarded by endorsements such as one from Pius II: "There isn't a man in Italy who is more reliable."[38] The degree of personal rectitude in which the Marchese believed comes through in a letter he wrote in 1457 to his ambassador in Milan.

We are friend of Socrates and friend of Plato, but still more are we the friend
of truth. If Sforza's honor is at stake, our obligation to him and his faith in us
will be betrayed if we counsel him to do anything illicit or dishonest.[39]

Several of Lodovico's other personal characteristics can be directly attrib-
uted to his schooling under Vittorino. He had, for example, a profound
respect for the detail underlying scholarship. Vittorino's standards are
reflected in a letter written by Lodovico in 1462 to his agent in Florence con-
cerning a poorly transcribed Hebrew Bible for which he had already paid 80
ducats. Instead of being *una digna cosa*, a volume worthy of his library, he
wrote angrily, the manuscript was said to be a worthless affair which the
scribe should keep, along with the money, because he, Lodovico, would have
no alternative to throwing it in the fire should he receive it.[40] When he com-
missioned "our Virgil," manuscripts of the *Georgics*, the *Bucolics*, and the
Aeneid by Mantua's native poet, the Marchese gave Platina precise instruc-
tions regarding the transcription he wanted: "The *Georgics* . . . written with
extended diphthongs, that is, *ae*, *oe*, and with bridged aspirations and with
correct spelling . . ."[41]

Trained by a perfectionist, Lodovico acquired a scholar's scruples for
accuracy. Discovering some errors in Platina's *Historia Urbis Mantuae*, a his-
tory of the city from its foundations to 1464, the Marchese threw himself
with zeal and enthusiasm into the task of correcting Platina's text while they
took the sulfur baths together at Petriolo.

> You must [he wrote to Platina] have been misinformed by others, because we
> have found statements in the text that differ from what happened. Please do
> not send out any copies until you have spoken to us. We were present at many
> of those events where you deviate a little from the truth and can give you more
> accurate accounts.[42]

We do not know how the humanist felt about having his interpretation of his-
tory so critically scrutinized—and revised—but Lodovico's letters home to
Mantua about Platina's manuscript reveal how diligently he strove for histor-
ical precision down to the most minor detail. Who exactly, he asked Barbara
to find out, was present at the siege of Governolo, and did his great-grand-
parents really die of grief at the news that his grandfather had beheaded his
wife?[43]

Lodovico focused his inquiring intelligence and passion for detail as
eagerly on the construction of buildings as on the revision of texts. One letter
gives a vivid picture of him so absorbed by the practical details of construction
on the site of the castle at Cavriana that, ignoring the cold weather, he super-

intended the work personally from the bottom of a ditch, bundled up in a cloak against the wind and the rain.[44] It was not for nothing that in his treatise on architecture Filarete called Lodovico *intendentissimo*, very learned, in the craft of construction, *l'arte del murare*.[45] Lodovico even designed structures:

> My Illustrious Lord . . . stayed at home drawing a dovecot . . . and went on to design a stable,

wrote Marsilio Andreasi to Barbara, using the word *disegnare* in the double sense of "design" and "draw."[46] Writing to Alberti in 1470, Lodovico even spoke with confidence of his own competing design, *la fantasia nostra*, for the church of S. Andrea.[47]

Educated by *pictores* and able to express his ideas in drawings, Lodovico respected visually creative people. His tact in dealing with craftsmen is revealed in his correspondence with his ambassador in Rome concerning a rock-crystal saltcellar with gold mounts commissioned from Cristoforo di Geremia. Criticizing the proportions of the legs as insubstantial, the Marchese took great pains to make his objections acceptable to Cristoforo.

> We want you to tell Cristoforo that if he were not from Mantua we would not dare to be so presumptuous, especially one such as ourself who lacks the expertise of a master such as he. But since he is from Mantua, we won't hesitate to give him our opinion, which we know he will not take amiss.[48]

The apologetic tone Lodovico adopted when explaining to the humanist Francesco Filelfo in 1457 why he had to refuse him money contrasts with his father's curt refusal of a similar request from Pisanello fifteen years earlier:[49]

> In truth, we deeply regret that we cannot help you as we would like to . . . If we had money at present or if we knew of any way of letting you have it at present, we would not hesitate to send it to you right now . . . but there is no way whatsoever, as you know we don't keep money at home, in fact we spend it long before we have it, so please excuse us and do not attribute this refusal to anything other than our impossible position.[50]

With the craftsmen he knew well, like the Florentine stonemason Luca Fancelli, Lodovico was on terms of affectionate intimacy. He liked to refer to Luca as "the master" and himself as "the disciple." "You know that in these things the disciple [Lodovico] cannot manage well without the master [Luca]," he once said, and on another occasion he responded to Fancelli's request for provisions by writing, "The master has done good work . . . the disciple is content to give that bushel of flour."[51] These exchanges were often informed by a robust humor, reminiscent of the spirit in which Vittorino

would respond to challenges. On hearing, for instance, that Luca had fallen on the construction site of S. Andrea and hurt a testicle, the Marchese replied, "The Lord God allows men to punish themselves in the place where they also sin."[52] The Marchese's style on paper reveals a mind that could be both sharp and playful. "We hope to show you something," he once wrote pointedly to Mantegna, "that will make [even] you understand that you don't know everything and that others also know some little things."[53] Lodovico's expertise in building and his love of devising *altri nuovi modi di murare* (new methods of construction) seem to have been a standing joke among his retainers.[54] In one humorous riposte his ambassador in Milan, who was on particularly good terms with the Marchese, used a series of puns to express his fear of being "walled up" by his bricklaying employer:

> I beg you not to wall me up [*murare*] inside a wall [*muro*], although I know that this is the greatest danger in the world, since it is only natural for a mason [*muratore*] to enjoy laying bricks [*murare*], even to the extent of walling men up [*murare*], were this possible.[55]

Lodovico's correspondence with artists, craftsmen, scholars, and peers reveals the mild or equitable disposition that Pius II claimed for him. The Marchese could nonetheless be impatient and bad-tempered when his authority was questioned by his *servitori*; the voluminous correspondence, for instance, about the design of the tribuna of Santissima Annunziata in Florence which he was subsidizing reveals him at his most terse. Besieged by requests to abandon Alberti's classicizing plan for the church, Lodovico on one occasion replied to his representative in Florence, Piero del Tovaglia, in tones of withering sarcasm:

> We do not know where this idea that we rely on your advice can possibly have come from, since we never heard that you were an architect.[56]

And his ambassador in Rome was rebuffed with the same biting sarcasm when he tried to take advantage of Lodovico by requesting land in payment for his service at the papal court.

> Perhaps you don't realize that if it hadn't been for us, your own [social] position hardly gives you the right to speak to a bishop, much less to His Holiness the Pope,

wrote Lodovico in a very long and angry reply to what he called Bonatto's "bestial, mad, presumptuous, and insolent" request.[57]

Elegant of speech and stylish in bearing, Lodovico was generally liked by his peers:[58]

> You please [Sforza] more than any other prince [wrote his son-in-law in 1463];
> he would rather deal with you than anyone else because your conversation is
> so pleasant and you have admirable understanding and judgment of the affairs
> of the world.[59]

The flavor of an attractive personality comes through the Marchese's letters on artistic matters. Pisanello's patron knew what he wanted and was decisive in getting it. Energetic and enthusiastic, he became passionately involved in all his undertakings, determined to master the intricacies of the particular medium. Courteous and intelligent, he strove to express his needs tactfully and to establish good relations with the artists working for him; knowledgeable in *disegno*, he unerringly gave them commissions that challenged them to produce important work.

II. *The Arthurian Frescoes in the Context of Lodovico's Later Commissions*

"When the war was over he [Lodovico] turned to peaceful works . . ." wrote Platina in the history of Mantua that Lodovico had so carefully scrutinized for errors.[60] The 1450 treaty with Francesco Sforza of Milan introduced a measure of financial and military stability into Gonzaga affairs.[61] In the same year, Lodovico undertook a new round of artistic enterprises, and during the next decade his cultural policy began to acquire the distinctive character associated with his name. In 1449 he donated a substantial portion (1,200 florins) of his unpaid back stipend as Florentine captain general to the building, in honor of his father, of the tribuna of Santissima Annunziata in Florence.[62] Influenced by his contact with Florence and the Medici, Lodovico's artistic interests underwent a change. In 1450 the young stonemason Luca Fancelli arrived in Mantua, sent by Cosimo de' Medici in response to Lodovico's request for an architect with Florentine training.[63] Between 1450 and 1452 Lodovico tried unsuccessfully to get Donatello, then in Padua, to create an *arca* in honor of Mantua's patron saint, Saint Anselmo. Only seven sculptures, now lost, were finished.[64] In 1454 Baldovinetti worked on a canvas of the Last Judgment that Lodovico had originally commissioned from Castagno.[65] After Pisanello's death in 1455 the Marchese sought a substitute as court painter and in 1456 started his determined campaign to lure the young Paduan artist Mantegna to Mantua.[66] Leonello d'Este, in the vanguard of the development of the medal, was also the first prince to commission a work from Mantegna, asking him to paint a portrait as early as 1449.[67] In Mantua Mantegna's major works for Lodovico were a chapel and the *Camera Dipinta*

in the *Castello*, painted 1465–74.[68] Leon Battista Alberti had been in contact with the Este court since the mid 1430s and had dedicated the Latin edition of his treatise on painting to Gianfrancesco Gonzaga, but he may not have met Lodovico until he came to Mantua in Pius II's suite for the Congress in 1459.[69] Lodovico immediately commissioned the humanist to design S. Sebastiano, and until his death in 1472, Alberti was an occasional visitor to Mantua, overseeing the planning of his two monumental churches, S. Sebastiano and S. Andrea.[70]

 These architectural commissions and Lodovico's expertise in architecture greatly impressed the architect Filarete, working at the neighboring court of Milan. In his treatise on architecture written in 1461–62, Filarete characterized the Marchese as *intendentissimo*, "very learned in many things but especially in matters of architecture."[71] For Filarete, Lodovico epitomized a new kind of enlightened patron, one committed to the new architectural style that had first been created by Brunelleschi in Florence. A well-known passage in the treatise that praises the *all'antica* style that Mantua's ruler had adopted ends with a reference to his castle at Revere:

> I praise those who follow the antique practice and style, and I bless the soul of Filippo di ser Brunellesco . . . who revived in our city of Florence the antique way of building, so that today no other style but the antique is used whether for churches or for public and private buildings. To prove that this is true, it can be seen that private citizens who have either a house or a church built all turn to this usage as, for example, a house created recently in Via Contrada that is called Via della Vigna [Palazzo Rucellai], in which the whole facade in front is composed of dressed stone and all done in the antique style. This is encouraging to all who investigate and seek out antique style and use antique methods. [This style] would not be used in Florence, as I said above, if it were not the most beautiful and useful. Not even the lord of Mantua, who is most learned, would use it if it were not as I say. A house that he had built at one of his castles on the Po is proof that this is true.[72]

The castle at Revere, started as a Gothic fortress in 1447, was of course given a classicizing facade after Fancelli arrived in Mantua.[73] Understandably, Lodovico is still best known for the *all'antica* architecture and painting created for him by Alberti and Mantegna in the 1460s and 1470s in a style that favored classical vocabulary and classical themes and that was, in Filarete's words, *più bello e più utile* (more beautiful and more useful) than the medieval Gothic style it replaced. For some historians, Lodovico's enthusiasm as an older man for such humanist-inspired artists as Alberti and Mantegna is incompatible with his commission of the Arthurian murals when younger, and an argu-

ment based on the cycle's chivalric iconography and Pisanello's "late Gothic" style has been presented as yet a further justification for dating the *Sala del Pisanello* within the marquisate of Gianfrancesco, the prince who patronized Pisanello for twenty years.[74]

The differences in style and iconography between the *Sala del Pisanello* and a commission such as the *Camera Dipinta*, dating twenty years later, are considerable, and a change in artistic taste undeniably took place at the court of Mantua between the painting of the former and Mantegna's arrival in 1460. To connect this shift from chivalric to classical themes, however, to the reigns and personalities of the two successive Marchesi distorts historical reality. No abrupt break in artistic policy took place between Gianfrancesco and Lodovico, the son commissioning Pisanello to create medals as long as three years after Gianfrancesco's death. Nor should it be assumed that Gianfrancesco was more interested in chivalric matter than his son. On the contrary, the surviving evidence on Gianfrancesco's interests points to his determination, at the end of his life, to augment the classical volumes in his library.[75]

The problem of apparent conflict between Lodovico's early and later commissions thus requires a more sophisticated solution than merely dating the *Sala* murals to an earlier period, especially since an earlier dating for the cycle does not fit comfortably within Pisanello's artistic development.[76] As it happens, Filarete himself provides this very explanation in words that he placed in Lodovico Gonzaga's mouth. Acknowledging the change in taste that took place in Lodovico's architectural commissions between the beginning of the castle at Revere in 1447 and Alberti's design for S. Sebastiano in 1460, Filarete/Lodovico thus explains Lodovico's conversion from modern (Gothic) to ancient (classical) style for building:

> I too was once pleased by modern buildings, but as soon as I began to appreciate the ancient ones, I grew to despise the modern. In the beginning, if I had anything built, I usually followed the modern manner, because my father also still followed this style. . . . It is true that then I too wanted to exchange this fashion for something different. Hearing that they were building in the antique style in Florence, I determined to have one of the men who had been mentioned. Dealing with them thus, I was so awakened that at present I would not build the smallest thing that was not done in the antique style.[77]

Filarete is a contemporary witness to the fact that Lodovico, when he first came to power, continued his father's artistic policies and then later, as a result of exposure to vanguard Florentine works of art, started to exercise his talent for *disegno* and to commission works *all'antica*. Examples of the new style in

architecture were in any case few and far between before 1446, the starting
date of the nave of San Lorenzo and the Medici Palace; the facade of the
Rucellai Palace, the other building cited admiringly by Filarete, was only
begun in 1455.[78] The earliest recorded work by the very young Mantegna,
who was to become the major exponent of the *modo antico* in North Italian
painting, dates from 1448.[79] Alberti became architectural adviser to Sigi-
smondo Malatesta in 1450, and examples of the new style in architecture,
such as his facade for S. Francesco in Rimini, appeared only slowly on the
North Italian scene. The first decade of Lodovico's marquisate should accord-
ingly be regarded as a transitional period both for the region and for its
patrons in terms of supply of, and demand for, works *all'antica*. During these
years Lodovico at first followed prevailing court taste and then slowly devel-
oped his preference for the new style, influenced by artists, such as Fancelli
and Donatello, who practiced it, and princes, such as Cosimo de' Medici and
Sigismondo Malatesta, who patronized it. By 1460 the Marchese was himself
part of the vanguard. Lodovico's shift in taste is dramatically documented by
the schizophrenic nature of the miniatures—some in Gothic, some in Renais-
sance, style—in a missal that belonged to Barbara of Brandenburg. It was
started by the late Gothic painter Belbello da Pavia in 1447, and only in 1461,
well after Mantegna's arrival in Mantua, did the Gonzaga dismiss Belbello
and turn the task of illuminating the missal over to Mantegna's classicizing
follower Gerolamo da Cremona.[80]

Lodovico's literary culture, on the other hand, did not evolve in the same
way as his artistic taste. Given a thorough grounding in humanist studies, the
Marchese, on the model of his ancestors, continued throughout his rule to
enrich his library with volumes by classical authors.[81] We would expect no
less from Vittorino's student. We may be surprised, however, to discover that
the Marchese's humanist education did not preclude a lifelong enjoyment of
medieval chivalric literature. So much of our information on the intellectual
life of the fifteenth century derives from the writings of the humanists that we
are overly influenced by their opinions. Most of them held romance in open
disdain. In Ferrara, for instance, Guglielmo Capello tried to claim ignorance
of Arthurian matter, telling Niccolò d'Este that he was unable to comment on
Arthurian aspects of the poem *Dittamondo* because "these French stories are
almost unknown, and I have seen few French books, much less read them."[82]
In the same city Michele Savonarola lamented the time that people spent on
"useless love songs." "On feast days," he complained, "people would rather
hear romances sung than go to church to chant Vespers."[83] Leonello d'Este, a
prince heavily influenced by his humanist advisers, even dismissed the ver-

nacular manuscripts that were being transcribed and illuminated for him as "those books which sometimes on winter nights we explain to our wives and children."[84] These snobbish protests echo Petrarch's contempt for the fantasies dreamed by the ignorant:

> Ecco quei che le carte empion di sogni:
> Lancilotto, Tristano e gli altri erranti,
> ove convien che'l vulgo errante agogni

(here are those who fill the pages with dreams, Lancelot, Tristan, and the other knights-errant, for which it is meet that the erring vulgar herd yearn).[85]

Over the centuries, however, the romances' poor showing with critics has never affected their popularity. Despite humanist sneers, there is ample evidence, as we saw in chapter 2, that mid-Quattrocento princes continued to collect, transcribe, embellish, read, and enjoy the genre.[86] Library inventories, loan registers, and letters, such as the one written by Lodovico Gonzaga to Borso d'Este in 1468, prove that the vogue for Arthurian romance was very much alive in the third quarter of the fifteenth century in the very centers where, a generation earlier, Vittorino da Feltre and Guarino da Verona had successfully revived the study of classical authors.[87] However much Vittorino and Guarino may have disapproved of medieval romance, French culture was too deeply rooted at the courts of Mantua and Ferrara to disappear with their arrival. Under their influence, enthusiasm for chivalric literature may have waned at these courts in the second quarter of the Quattrocento, but it resurfaced in the 1450s and 1460s. Lodovico's sustained interest in chivalric romance, at the age of fifty-four, long after the abandonment of the *Sala del Pisanello*, thus coincided with his enthusiasm for the revival of the classical style in works of art. Chivalric values continued to play a distinctive role in his emotional nourishment in the very years when Mantegna and Alberti were creating their works *all'antica* for him.

The two classes of literature, chivalric and classical, should therefore not be perceived as standing in a chronological antithesis, with a new enthusiasm replacing an old one.[88] A fifteenth-century prince, unlike his contemporary biographer, saw no intellectual conflict between the continuing lure of French romances and his emerging interest in classical studies. Indeed, in many respects princes confused chivalric and classical themes. Huizinga has argued:

> The image of antiquity was not yet disentangled from that of the Round Table. In his poem *Le Cuer d'amours éspris* King René depicts the tombs of Lancelot and Arthur side by side with those of Caesar, Hercules and Troilus, each adorned with its coat of arms. A coincidence in terminology helped trace the

origins of chivalry to Roman antiquity. How would it have been possible to realize that the word *miles* in Roman writings did not mean what it did in medieval Latin, that is to say, "knight," or that a Roman *eques* was not the same as a feudal knight?[89]

The origins of chivalry were traced to Rome, and Francesco Sansovino named Romulus the founder of chivalry in his book *Della origine de' cavalieri*.[90] Given this confusion, it is clear that Arthurian heroes could provide Italian nobility with models of conduct just as potent and illustrious as any classical exemplar.

Pisanello's cycle, a lone pictorial chivalric survivor from a court better known for its humanist orientation, thus documents one of the disparate but delicately interwoven threads that formed the culture of the dominant social class in Quattrocento Italy. The continued relevance of chivalric values to Italian Renaissance aristocracy is more clearly manifested in the history of Italian literature than in the history of Italian art, since its most enduring outcome was the poetic Renaissance in Ferrara, where Estense taste for French romance produced the great Italian poems of Boiardo in 1484 and Ariosto in 1516.[91] Ironically, these poets were attached to the court of Ferrara, not Mantua, despite the presence in that center of a far greater number of volumes of French fiction.[92] It was Lodovico's great-great-grandfather, the forebear who established Gonzaga power so firmly in the Mantovano, who first started collecting French books, and it is possible that, at the beginning of his rule, Lodovico turned back to the sources of his power and built on their strengths. Certainly the many volumes of French literature, part of the heritage that distinguished the Mantuan court from others in North Italy, must have increased the Marchese's interest in, and enthusiasm for, Arthurian matter.

Pisanello is sometimes classified in surveys of the history of art as a late-medieval artist, but it is only by hindsight that we attach the label "international Gothic" to his work and assess his style as less "humanist" than that of Mantegna. For his patrons in the 1440s, Pisanello was *the* "humanist artist." The virtual reinventor of the ancient medal, he was also one of the first artists to collect and study classical works.[93] He had been closely associated since 1416 with the intellectual circle of the leading North Italian humanist, Guarino da Verona.[94] The princes who patronized Pisanello (Gonzaga, Este, Malatesta, Aragon) were all bibliophiles engaged in forming humanist libraries and encouraging humanist learning. The only fifteenth-century artist to be the focus of repeated humanist rhetorical efforts, he had the unprecedented honor of having two bronze medals devoted to him during his

lifetime.[95] For an ambitious prince like Lodovico, eager to display his newly acquired power through discriminating patronage, Pisanello, who had worked for the Este, the Visconti, and the papal court and was currently being sought after by the King of Naples, was an obvious choice. The wording of King Alfonso's 1449 *privilegium* indicates the extent to which Pisanello was thought of, whether in his work or his person, as a prestigious addition to any self-respecting court.[96] To employ an artist of such recognized stature and to provide him with an opportunity to display his talents could bring only renown to the Marchese of Mantua. The wisdom of Lodovico's decision to commission Pisanello is confirmed by the name given to the *Sala* in later years, when both patron and artist were dead. It is the only known case in the fifteenth century of a room being named after the artist who decorated it. Last but not least, Pisanello's intermittent presence in Mantua during the preceding twenty-five years made this commission a form of favoritism. Nothing is more understandable than that Lodovico, continuing his father's cultural policies in the early years of his marquisate, should select for his first important commission the leading artist of northern Italy, whom he had known personally since he was thirteen years old.

The absence of surviving documentation does not permit more than speculation on the reason why the frescoes in the *Sala* were abandoned, but it may have been for reasons of political expediency. Possibly the painting was interrupted by Pisanello's journey to Naples in 1448 because King Alfonso asked for, and obtained, his services from Lodovico. This reading of the situation gains support from a documented demand made by Alfonso to which Lodovico was loath to acquiesce. Catching wind in 1450 of the King's intention to ask for the missal being illuminated by Belbello da Pavia as a gift, Lodovico wrote in haste to the Bishop of Mantua in Rome to apprise Pope Nicholas V of his cover story.

> Not knowing where to find a more innocent excuse, we thought we would say
> . . . that we had promised [the missal] to His Holiness the Pope. . . . Please
> ask His Holiness to behave, if he should hear anything, as if he knew about this
> promise. None of us will be telling lies, because, if we give it to anyone, it will
> be to His Holiness. However, as you know, it is our intention to keep it for the
> service of our priest.[97]

In 1450 Lodovico was able to devise a stratagem that allowed him to keep the missal for Mantua, but in 1448, angling for a *condotta* with Naples, he would have been less well placed to deny the King a favor. As it happens, Lodovico's nomination as Alfonso's *procuratore* in Lombardy was signed one month after

Pisanello's *privilegium* took effect in June 1449. In this document Alfonso, who had been trying to entice Pisanello to Naples since 1443, no doubt on the recommendation of his son-in-law Leonello d'Este, clearly demonstrated his high regard for the artist with fine words and a handsome salary. Lodovico could have taken advantage of his ability to do Alfonso a favor and made Pisanello a pawn in the important diplomatic game, ceding his rights, temporarily, so that the artist could go south and work for the King. His ploy would have been amply rewarded when the new *condotta* awarded him a much higher stipend than he had hitherto earned.[98] Direct evidence that Lodovico's employment with the King was responsible for Pisanello's presence in Naples rather than in Mantua in 1449, and hence for the unfinished state of the frescoes, is of course lacking, but the indirect evidence that Alfonso, unless forestalled by a diplomatic lie such as that concocted with Nicholas V, could get what he wanted is suggestive.

The silence surrounding Pisanello between 1449 and 1455 suggests that he was inactive, perhaps incapacitated by illness, in the last years of his life. The sorry state of the unfinished *Sala* must have constituted an eyesore for Lodovico, reminding him of hopes that never materialized. Incompletion plagued his early artistic commissions. Donatello refused to complete the *arca* of S. Anselmo, and, as Pius II pointed out, the castle at Revere remained unfinished.[99] If Lodovico initially had in mind the completion of the Arthurian cycle as one of Mantegna's first tasks, closer acquaintance with that artist's dilatory habits and uncompromising character would soon have changed his mind. Eventually Lodovico's change of residence to the *Castello* brought about a change in his decorating priorities, and the unfinished *Sala* located in the *Corte* dwindled in importance as his plans for the *Camera Dipinta* became a reality.

CHAPTER SIX

Formal Analysis

I. *The Pictorial Design*

WHILE THE patron surely dictated the subject of the frescoes, only the artist could give physical form to the story from the prose *Lancelot*. In the next chapters we shall therefore consider the artistic decisions taken by Pisanello as he faced the problem of translating the abstract language of the romance into concrete visual images on the walls of the *Sala*.

It may appear hazardous to analyze the formal structure of a cycle only half of which survives, but there are sufficient clues in the surviving murals to indicate that Pisanello had a clear conception of the cycle's entire design and to suggest some of its salient characteristics. His design for the *Sala* reveals several unexpected features. First, unlike Pisanello's two surviving murals in Veronese churches, the scenes in Mantua are not contained within frames.[1] The lack of framing devices contrasts strikingly with the tiered registers of many contemporary cycles. Both religious and secular cycles in this period usually consisted of scenes presented with clear separating boundaries, placed one above the other and side by side like single pictures. In the cycle designed by Fra Angelico in the late 1440s for Nicholas V's chapel in the Vatican Palace, for instance, each scene occurs in a distinct zone imposed by a geometric system (Fig. 70). In Mantua the separate narrative units are not isolated from each other in this way. On the contrary, Pisanello's scheme is so flexible that the scenes not only flow into one another but also vary considerably in size and format. This solution allowed him to place such a large, densely packed, and highly organized composition as the tournament alongside smaller scenes of a more episodic nature. In consequence, the rhythm of the successive scenes would not have been experienced by the viewer as an even succession of steady "beats," as in Fra Angelico's Vatican cycle or (to cite another contemporary example, which is, however, nonnarrative in type) Castagno's *Famous Men and Women* in the Villa Carducci in Legnaia.[2] In Mantua, Pisanello instead modulated the tempo at which the individual scenes were perceived by the observer, by presenting units of varying scale and importance with differing visual impact. The irregular intervals between the scenes, and the rela-

tion of the smaller and larger scenes to each other, would have added to the viewer's excitement in his exploration of the chivalric story.

Secondly, the cycle in Mantua was related to the rectangular hall in an unorthodox way. This relation can best be observed in the asymmetrical extension of the tournament across the corner between Walls 1 and 2, but it also occurs in the two other surviving corners. The lateral span of the tournament, starting on Wall 2 with a group of knights under a banner and ending with the *mêlée* three-quarters of the way across Wall 1, is close to the actual width of Wall 1 (Figs. 8 and 14). It could have been fitted comfortably into this wall, establishing the conventional relation of one scene to one wall, similar to Mantegna's decorative scheme for the *Camera Dipinta* (Fig. 71) or to that of Benozzo Gozzoli for the Medici Palace Chapel.[3] In the Medici Chapel, Gozzoli even stressed the corners of the room by defining the edges of the scenes with frames. Shunning such a sense of formal order in his presentation, Pisanello avoided conformity of the axes of the scenes to the boundaries of the walls by extending the scenes from wall to wall.[4] Motifs such as the fair-haired knight and the black horse in Figure 72 and the rock in Figure 73 even straddle the corners in order to emphasize continuity from wall to wall. Thus Pisanello's design for the cycle stressed the frescoes' horizontal span and the way they encircled the room. In the one area on Wall 2 that was partially painted, this thematic continuity was increased by the location of the maidens' tribune: their angle of vision of the tournament on the adjacent wall optically contracts the space used to illustrate the tale (Fig. 14).

In this respect Pisanello's design undoubtedly reflected contemporary use of tapestries. Tapestries could in theory be woven to fit the dimensions of the wall they were intended to cover, but few of those used in Italy seem to have been made to order. Very large hangings were, for the most part, purchased sight unseen by the patron, in the cities of northern Europe where they were manufactured. Although a Medici agent once hesitated to buy a tapestry on grounds that it was "so large that you would have difficulty in spreading it around your room," patrons naturally wanted the "largest and most beautiful" hangings possible.[5] Problems understandably arose when these tapestries arrived in Italy and had to be installed in palace halls. In order to circumvent such architectural features as corners, doors, and fireplaces, tapestries had to be folded around corners, much like wallpaper. A well-known French example, the battle tapestry in the January miniature of the Duke of Berri's *Très Riches Heures* shows how the lower part of a hanging would be pushed up into lumpy folds to leave the mantelpiece free (Fig. 74).[6] The idea that

scenes could continue around a corner and the story melt imperceptibly from wall to wall, as in the Mantuan frescoes, was accordingly an extremely familiar one to the culture in general.

The third unusual feature of Pisanello's design for the *Sala* is the way in which the direction of movement in the surviving narrative varies within the hall. The largest scene, that of the tournament, flows from left to right; but the scenes of the banquet and the knights' vows that follow the tournament in the *Lancelot* were not, as might be expected, placed on Wall 4, but instead along Walls 2 and 3, moving away from the combat in a right-to-left movement that reverses the left-to-right convention common to pictorial narrative in the West (Fig. 19). We saw in chapter 4 that the tournament was iconographically the most important scene for Lodovico Gonzaga and was therefore placed in the most prominent location, opposite the main entrance to the room. The fact that the tournament took place at the beginning of Bohort's visit to King Brangoire's castle, however, gave Pisanello an awkward choice. He could either continue the story against the light on the wall with the windows, where it would not immediately be perceived, or he could place the narrative "backwards" along Wall 2, facing the entrance. The relatively greater iconographic importance for the Gonzaga of the depiction of a banquet over that of a love intrigue was probably decisive, and the feast was accordingly located on the more visible side of the *Sala*.

Pisanello did not employ fixed-point perspective in his spatial construction for the Arthurian cycle, as recommended by Alberti, although his drawing of a vaulted hall in perspective proves that he was sufficiently conversant with this convention to have used it had he so wished.[7] In the tournament scene, however, there is no ground plan, no horizon, and virtually no depth or background. The action in Mantua is spread in parallel horizontal lines so that the jousting takes place over the entire vertical span of the wall, unlike Paolo Uccello's *Battle of San Romano*, a contemporary Tuscan version of a similar subject, where the fighting was restricted to the foreground plane.[8] The entire surface of Pisanello's fresco reads as the foreground space in which the combat takes place. Each knight is relatively legible because seen from his own level, without conflict between foreground and background figures. On Walls 2 and 3 the wooded panorama also recedes sharply up the wall, giving the observer a bird's-eye view of the whole.[9]

Figural scale was another important factor in Pisanello's design for the cycle. Throughout the surviving frescoes the protagonists are consistently a little less than life size. The knights in the upper reaches of the tournament scene on Wall 1, for instance, differ little in scale from those lower down on

the wall or from the lowest surviving knights in the landscape *sinopia* on Walls 2 and 3 (Figs. 8, 11, and 12).[10] When considered in relation to the dimensions of the room, the scale chosen reveals the decorative principles underlying the cycle's organization. Had the figures been smaller in size, they would have lacked sufficient impact to carry the narrative. The knights, overwhelmed by the density of detail, would have been reduced to a low level of legibility. Making them larger in scale would have been equally counterproductive; the knights would then have become too dominant. The scale chosen by Pisanello integrates the knights into the decoration as a whole without preventing effective presentation of the narrative. Even today the legibility of the tournament scene is astonishing, considering the poor condition of the fresco.

In these two respects, linear perspective and figural scale, the composition of the right half of Pisanello's only other large-scale work, *St. George and the Princess*, in S. Anastasia, Verona (Fig. 42), was based on different principles.[11] Pisanello used the same distinctive repertory of motifs in the Veronese and Mantuan frescoes—youthful knights, beautiful ladies, heavily brocaded robes, foreshortened horses, a high horizon with towns and castles silhouetted against the sky, small undulating hills covered with leafy foliage—but he organized them differently. In Verona he used some version of linear-perspective construction so that the protagonists in the foreground loom much larger than the other figures. So big that they fill half the available picture field, Saint George and the princess stand on a narrow front stage separated from the background and other motifs by a leafy hedge. The scale of the protagonists and the aggressive forms of their horses dominate the work. The composition of this fresco must be related to its fixed viewing angle in the Church of S. Anastasia. Situated far from the viewer and high over an arch, these foreground figures had to be large to convey the subject. Despite the *horror vacui* evident in the work and the carefully distributed motifs that fill the composition to its edges so that the frame crops or nearly crops many elements, our eye focuses on the ostensible subject of the religious narrative in the foreground. According to Vasari—or rather to his informant, Fra Marco de' Medici—"si vede tutto . . . in piccolo spazio benissimo."[12] In other words, because of the spatial organization and figural scale, this sixteenth-century viewer could easily read the narrative despite the size and distance of the picture field.

In the *Sala del Pisanello*, however, the viewing circumstances were very different from those in S. Anastasia. Rather than highlighting the drama, the foreshortening and overlapping necessitated by employing linear perspective would in Mantua have reduced the clarity with which the knights were pre-

sented. It would also have prevented an effective use of the entire surface of
the wall. Compositions based on conventional one-point perspective created
a direct relationship between an image and a single viewer standing in a given
position. Since the amount of wall space at Pisanello's disposal was not
restricted, his spatial organization instead encouraged many different angles
of vision of the frescoes, rather than positing a single fixed viewing position.
The flexible Mantuan scheme—its scenes of varying size without fixed-point
perspective or outsize protagonists—can be said to have taken the *Sala*'s func-
tion into account. In 1442 the court humanist Angelo Galli mentioned Pisa-
nello's skill in the handling of perspective, and the design in Mantua, emi-
nently suited to a large hall often filled with jostling courtiers, gives a context
for his comment.[13] Here the uncontained narrative flowed from wall to wall
and around the room in a horizontal sweep, so that the courtiers, themselves
moving about the *Sala*, would have been completely surrounded by the story.
Certainly the bond between the viewers in the real space of the *Sala* and the
fictive world of the paintings would have been as intimate as any achieved by
the use of one-point perspective. Linear perspective, that favored construc-
tion of central Italian theorists, did not necessarily suit all subjects and all sit-
uations, and Pisanello must have rejected it as inappropriate to this site.

II. *Literary and Pictorial Narratives*

These features of the cycle's design would be more intelligible if only they
could be discussed as part of a series of solutions to the problem of the large-
scale illustration of an Arthurian romance. As we saw in chapter 2, however,
most monumental secular decoration of the early Quattrocento has been
destroyed. Our cycle, fragmentary as it is, is one of only a few surviving
instances of chivalric iconography. Nonetheless, some of the specific features
of the Mantuan cycle are also present in those few remaining frescoes with
comparable subject matter. Thus at Castelroncolo, near Bolzano, the scenes
illustrating the Tristan legend take place in a continuous rocky landscape and
are not separated by frames.[14] Figure 39 shows, from left to right, two epi-
sodes on the voyage to Ireland, Tristan cutting out the dragon's tongue, and
galloping knights. As always in these decorations, narrative proceeds laterally
around the room, reflecting an architectural space that is predominantly hor-
izontal. The frescoes illustrating the Fountain of Youth in the *Sala Superiore*
in the castle at La Manta near Saluzzo also show, in continuous left-to-right
sequence without separating frames, the feverish dash of the elderly and
infirm toward the miraculous fountain (Fig. 40).[15] Hauling themselves into
the waters, the pilgrims experience total rejuvenation, and the rest of the wall

space, spanning a corner, is devoted to their eager enjoyment of their new-found youth and erotic vigor (Fig. 41). The narrative solution here is similar to that in Mantua, with the three main scenes and several minor ones flowing into one another. The story in Saluzzo, with its temporal sequence of before, during, and after, gains in effectiveness and dramatic power by not being broken up into isolated scenes. Other secular cycles display similar features. The tale of passion, rejection, and revenge illustrated in the Palazzo Davanzati takes place within an arcade that encircles the room.[16] In this case the number of arches used for each scene varies, so that the pace at which the story moves depends upon the particular narrative unit. While the fourteenth-century frescoes in the Papal Palace in Avignon do not illustrate a chivalric tale, the hunting scenes in the *Chambre du Cerf* also continue around the room in a horizontal sweep, without interruption at the corners, and, much as in the Arthurian hall frescoed by Pisanello, the viewer there would have been completely surrounded by the world created by the murals.[17]

The very character of its literary source may explain why the Mantuan frescoes are related compositionally to other depictions of chivalric material. The narrative scheme of the cycle can be said to share some of the structural features of the romance on which it was based. The prose *Lancelot*, the central and longest portion of the Vulgate Cycle, is crowded with hundreds of episodes and thousands of characters. To the uninitiated reader, the voluminous thirteenth-century romance appears to consist of an uninterrupted series of similar adventures, repeated ad infinitum.

> Adventures were piled up one upon another without any apparent sequence or design, and innumerable personages, mostly anonymous, were introduced in wild succession . . . the purpose of their encounters was vague and their tasks were seldom fulfilled; they met and parted and met again, each intent on following his particular "quest" and yet prepared at any time to be diverted from it by other adventures and undertakings.[18]

Until Lot's analysis in 1918, this romance was condemned by critics as a haphazard compilation and one of the most rambling works of medieval literature.[19] Its maze of repetitive quests and adventures challenged not only habitual modes of literary perception but also classical ideas of possible modes of composition.[20] Critics conventionally believed that even a medieval work should be structurally transparent and develop along a straight line without deviation.[21] Those who attempted to judge cyclic romance by these standards were, however, unable to find any semblance of rational principle behind the works. It was only when critics relinquished the idea of unity in the classical

sense of the term, and instead recognized the aesthetic validity of some form
of multiplicity as a principle of structure, that the inner mechanism of cyclic
romance became apparent to them.[22] Neglect of structure in the modern sense
did not necessarily, it turned out, imply absence of a method of composition
in a medieval romance. Hidden behind the extraordinary complexities of its
text, the structure of the Vulgate Cycle was based not on the unification of its
matter but on the multiplication of its elements, the very device that had pre-
viously been judged monotonous and therefore defective.

> Its long and complex form is characterized by multiplicity and surprise,
> [wrote one critic in 1971] rather than by the classical virtues of economy, unity
> and inevitability.[23]

Far from being an indiscriminate accumulation of unrelated episodes, the
prose *Lancelot* was now judged to consist of myriad stories, discrete and yet
inseparable from one another:

> The narrative technique consists in continually shifting from one story and set
> of characters to another. Every episode is interrupted by another, which in
> turn is broken off to continue earlier narrative.[24]

In the episode illustrated in Mantua, for instance, the invitation to Bohort
to attend King Brangoire's tournament is separated from the account of his
arrival at the Chastel de la Marche by several pages and one adventure.[25]
Therein supposedly lay the fascination of Arthurian romance: "tracing a
theme through all its phases, of waiting for its return while following other
themes and of experiencing the constant grasp of their simultaneous pres-
ence."[26] This interwoven network of adventures was isolated as a principle of
design by Lot in 1918 and called *entrelacement*, or interlacing. Scholars subse-
quently agreed that *entrelacement* reached its fullest development in early-thir-
teenth-century French literature in the central branch of the Vulgate Cycle,
the prose *Lancelot*. This romance's seemingly pointless elaboration and
apparent disorder were thus, according to Lot, essential parts of the work.
The commonly used metaphor of a web best described the romance: it was
like a fabric such as matting or tapestry, and "a single cut across it, made at
any point, would unravel it all."[27] This interpretation of the basic structure of
chivalric romance was not restricted to twentieth-century critics. It has been
assumed that Dante's allusion to "Arturi regis ambages pulcerrimae" refers to
the interlacing technique of the *Lancelot*,[28] and even in the mid sixteenth cen-
tury Jacques Peletier du Mans praised medieval romance for its handling of
the narrative:

It is good to see how the poet, having brought up some important thing . . . abandons it for a time, holding the reader in suspense and wishing to know about the event. In this I find our romances inventively written.[29]

Many of the features of Pisanello's design can be related to these interpretations of the prose *Lancelot*'s structure. We saw earlier that the very long romance has neither a preestablished plan nor episodes of fixed length or hierarchical sequence. Rather, the stories are juxtaposed so as to give the impression that none has a single beginning or ending.[30] Each tale is at once the continuation of preceding incidents and the starting point for further themes. The stories even interrupt each other, so that "everything leads to everything else but by very intricate paths," according to one critic.[31] Pisanello's design for the *Sala* can be said to parallel these narrative techniques. The flexible spaces assigned to the different narrative units and the absence of a preestablished system of registers parallel the lack of fixed length of the adventures. Pisanello's scenes are no more circumscribed visually by a fixed geometric structure than are the haphazardly related adventures within the *Lancelot*. In the murals, as in the romance, the "scenes can succeed one another not where the exigencies of a single rigid plot permit but wherever artistic fitness demands them," in the words of C. S. Lewis.[32] The scenes as they are presented in the *Sala* are as inseparable as the adventures in the *Lancelot*, where they "collide and get mixed up and drift apart."[33] Just as the threads of the stories in the romance tangle and cross, so Pisanello's illustrations, lacking the isolating and focusing factor of a frame, are not clearly demarcated one from another. The fluid presentation of scenes in the hall thus encourages the viewer's momentary awareness, not unlike the pell-mell of stories jostling for the listener's attention in the romance. The way in which, in Mantua, one scene ends and another begins without formal warning also reflects the arbitrariness and capriciousness of the knights' adventures in the *Lancelot*.[34] Both romance and murals can be said to involve a design in which a compositional pattern only slowly takes shape, rather than a structure in which a theme is initially stated and then developed.[35]

The asymmetrical presentation of the murals and the continuous movement of the paintings around the hall reflect yet another feature of cyclic romance. Both the *Lancelot* and the frescoes can be said to express a similar medieval impulse: love of the labyrinthine. The irregularity of the presentation of the frescoes, implying a rejection of a sense of formal order, resembles the acentric design and the disorder of the *Lancelot*'s stories that continue to appear and reappear until the listener loses all sense of limitation in time and

space. The narrative, in both literary and pictorial forms, "offers to the mind
or the eye something which cannot be taken in at a glance."[36] The length of
the *Lancelot* and the complexity of its structure are, according to one critic, the
"exact opposite of the Aristotelian idea of a work to be embraced in a single
view."[37] "We can never get to the end of [these adventures]," wrote C. S.
Lewis in a characterization of the literature that applies equally to the art,
"there are so obviously more and more, round the next corner."[38]

In yet another respect can the narrative style of Pisanello's frescoes be seen
as paralleling that of the *Lancelot*. A salient characteristic of the pictorial work
is the decorative pattern created by the juxtaposed details. The murals are
packed with an endless variety of similar motifs that are woven together to
form a dense pattern. That this very accumulation of detail conferred great
richness of effect on his finished work was implied in the conventions fol-
lowed by fifteenth-century humanists writing ekphrases on Pisanello's work.
It was for their pictorial variety and the rich number of their components that
Guarino da Verona and his followers in Ferrara praised Pisanello's paintings.[39]
A passage from Tito Vespasiano Strozzi's poem on Pisanello's work describes
a landscape similar in some of its motifs to the landscape *sinopia* on Walls 2
and 3 in Mantua:

> How shall I tell of the living birds or gliding rivers, the seas with their shores?
> . . . you make boars lurk in the valley and bears on the mountain. You wrap
> soft verges round the clear springs, and green grass mingles with fragrant
> flowers. We see two nymphs wandering the shady woods, one with a hunting-
> net on her shoulder, the other bearing spears, and in another part baying dogs
> flushing she-goats from their dens and snapping their savage jaws. Yonder the
> swift hound is intent on the hare's destruction; there the rearing horse neighs
> and champs at its bit.[40]

These early discussions of Pisanello's approach to storytelling focus on the
character and details of the distinctive elements. In one sense the Ferrarese
ekphrases reflect Pisanello's use of a structure in which the figures and motifs,
rather than perspective construction, were the organizing principle. Such
ekphrastic comments were also extraordinarily well suited to the design of
contemporary tapestries in which figures, inconsistent in scale and unrelated
to each other by action, glance, or gesture, were often taken from different
cartoons and juxtaposed haphazardly across the picture surface.[41] Ferrarese
ekphrases on Pisanello's art may well have been influenced not only by
existing literary conventions but also by the kinds of pictorial narrative with
which the humanists were accustomed to being surrounded.

As Michael Baxandall has suggested, fifteenth-century viewers such as Tito Vespasiano Strozzi saw the decorum of Pisanello's painting more in internal consistency among the represented objects than in any single-minded reference of these to one narrative point.[42] The unfocused narrative produced by presenting these many carefully observed details side by side is yet another feature that the *Sala* murals must be said to share with the prose *Lancelot*. Pisanello's diffuse narrative reflects the romance's discursiveness. We saw earlier that the principle of repetition dominates the *Lancelot* and that the same situations, only slightly modified, are presented time and time again.[43] The great number of motifs in the frescoes corresponds to the writers' impulse in the romance to multiply the adventures and expand the matter. Northrop Frye has defined the style of chivalric romance as "and then" narrative—as opposed to "hence" or causal narrative—and Pisanello's narrative style too can be defined as additive.[44] Both author and artist saw variety as something elegant in itself, as a feature that would enhance the aesthetic effect of their respective works. Hence the emphasis they placed on multiplying the components—of the adventures in the romance and the motifs in the murals—rather than on unifying the subject matter. In each the elaboration of the parts is the stylistic feature that determines the character of the work as a whole.

Thus many of the distinctive features of Pisanello's design for the Arthurian cycle parallel the *Lancelot*'s narrative techniques. Despite the differences between literary and pictorial conventions, the respective artistic structures and narrative styles of the thirteenth-century romance and the fifteenth-century mural cycle are surprisingly close. Whether deliberately or fortuitously, the feudal romance and the early Renaissance frescoes convey related aesthetic values.[45]

III. *Composition of the Tournament Scene*

The composition of the tournament scene would also be more intelligible if it could be compared with other contemporary frescoes of the same subject. With one exception, however—the tournament frescoed around 1390 in Castelroncolo in Bolzano (Fig. 80)—we are obliged to have recourse to chivalric works in another medium and on another scale, manuscripts illustrated at the court of Milan at the end of the fourteenth century, for material with which to compare Pisanello's handling of this scene. Despite differences in date and scale, however, these miniatures of tournaments and jousts elucidate Pisanello's approach to the Mantuan composition by yielding a glimpse of the tradition against which he was measuring himself.

The standard composition for a tournament or a joust in the late Trecento was a centralized format with horses and riders depicted in profile. Good examples are the joust with lances on folio 55 of *Guiron le Courtois* (Fig. 75) and the *grande mêlée* on folio 4v of *Queste del Saint Graal* (Fig. 76).[46] This convention had not changed appreciably by the time Bonifacio Bembo illustrated a *Tavola Ritonda* in 1446 (Fig. 77) and Jacopo Bellini drew a joust in his book of drawings (Fig. 78).[47] The emphasis in them all lies on a centralized presentation of the combat that is extremely legible. Such a design of course also reflected the event in reality where two equally matched parties charge from opposite ends of the field. The two opposing teams were depicted as being of equal size and importance so that neither side was given preference. In each case the tribune containing the ladies and other spectators was centralized behind either the clash of cavalry or the *grande mêlée*. Even works on a different scale and in a different medium, such as the large tapestry of a tournament, measuring about $5 \times 5\frac{3}{4}$ meters and created at the end of the century for Frederick the Wise, Elector of Saxony, did not appreciably vary this formula (Fig. 79).[48] Only in murals, such as those in Mantua or Castelroncolo, was the spectators' tribune placed to one side (Fig. 80).[49] The focus in the Bolzano fresco, however, still remains the center of the composition where the knights are breaking lances. The location of the tribune can, in this case, be related to the space available. A miniaturist was confined to the narrow width of his folio, but the artist in Bolzano, like Pisanello in Mantua, was able to take advantage of the considerable lateral wall space at his disposal.

Pisanello's tournament in Mantua differs fundamentally from these earlier illustrations of chivalric literature. His tournament is essentially presented from the standpoint of one only of the opposing sides: that on the left, associated with the Chastel de la Marche and King Brangoire, the team to which Bohort brought victory through his prowess. In this respect the Mantuan fresco appears to allude to the account of the tournament in the prose *Lancelot*, in which the opposing combatants served merely as foils for Bohort's feats of valor. The prose *Lancelot*, for example, emphasized the total defeat of Bohort's adversaries; they fled in disarray and sixty were taken prisoner.[50] Possibly it is these unhappy knights whom Pisanello added as an afterthought, as *pentimenti* incised into the already painted black ground at upper right (Fig. 137). Applying an asymmetrical solution to the composition that was in keeping with the emphasis in his literary source, Pisanello avoided the monotony and repetition of the earlier manuscript illustrations. The iconographic asymmetry thus achieved complements the formal asymmetry of the tournament's location across a corner of the room (Fig. 141).

While no composition drawings on paper for the tournament scene survive, the *strappo* of the fresco revealed beneath a *sinopia*—perhaps the most stunning wall drawing by an eminent Quattrocento draftsman to be discovered in recent years. Offering a rather different version of the tournament from the one presented in the fresco, the newly recovered *sinopia* allows us to analyze the evolution of this composition. As we shall see, many of the ideas articulated in the *sinopia* survived into the fresco, but in places the mural departs radically from the design on the *arriccio*, explicitly revealing Pisanello's criticism of his original composition. Analysis of the differences between the two layers of plaster accordingly offers insight into the design problem faced by Pisanello in this scene—one of the largest and most complex compositions to survive from the mid Quattrocento—and the means by which he sought to solve it.[51]

There are three characteristic patterns of treatment between the designs on the *arriccio* and the *intonaco*, ranging from exact duplication of images to a total reworking of ideas. In only one or two places did Pisanello reuse the images exactly as he had outlined them in the *sinopia*.[52] Good examples are, on the left, the foremost charging warrior, Knight 8 (Figs. 81 and 82), and, on the right, the retreating Knight 23 (Figs. 83 and 84), both of whom have precisely the same configuration and location on *arriccio* and *intonaco*. Even the vegetation behind which Knight 23 disappears is, uncharacteristically, indicated in this *sinopia*. Such literal replication of the *sinopia* image tends to occur within composition schemes A and D, those sections of the *sinopia* which, according to the hypothesis to be outlined in chapter 7, were drawn at the beginning and toward the end of Pisanello's work on the *arriccio* (Fig. 121).[53] Few of the other figures, however, correspond as exactly as these examples, and Pisanello usually modified his earlier configuration to some degree when he started painting. The mounting Knight 3, immediately below the charging Knight 8, is a typical example of the artist's usual adjustment of the *sinopia* image when he started painting (Figs. 85 and 86). The knight's profile of wildly kicking leg and arched back in the *sinopia* was converted into a three-quarters view of a more controlled vault into the saddle in the mural. A lesser instance on Wall 2 is a damsel in the tribune who in the mural turns to face her companion rather than gazing down at the tournament (Figs. 87 and 88).

The second pattern of treatment between *sinopia* and mural includes areas where Pisanello laid down the main lines of the composition on the *arriccio* but later changed the precise location of the figures. Sometimes this shift of emphasis in the presentation of the knights resulted in a change of meaning. One of the most interesting examples of this kind of subtle transformation is

the joust between Knights 15 and 21 (Figs. 89 and 90). Although Pisanello
rejected the formulas developed in illustrated manuscripts of chivalric litera-
ture for the tournament as a whole, he depended on them for the poses of
individual knights. He used, for instance, the same schema for Knights 15 and
21 as the joust depicted in the late Trecento on folio 83v of the Arthurian
romance *La Queste del Saint Graal* (Fig. 91). As the wounded knight reels back
on his mount, he flings up his arm with outsplayed gauntlet in an expressive
gesture of surrender or pain that was common both to the miniaturists (Fig.
92) and to other Quattrocento artists (Figs. 77 and 78). In the large-scale
mural Pisanello toned down this standard prototype. The violent movement
of the manuscript formula, which was slightly modified in the image of
Knight 21 in the *sinopia* (Fig. 89), was further qualified when he came to work
on the *intonaco* (Fig. 90). Pisanello shifted the knight's center of gravity and
depicted his head at a more upright angle so that the image of back and neck,
sharply arched under the impact of the lance blow in the *sinopia*, evolved into
a less extreme pose. It is typical of the changes made between *sinopia* and
fresco that the immediacy and expressiveness of the quick *sinopia* sketch con-
trasts with the more restrained image in the painting.

The relationship of the two jousters was also altered when they were
painted. In the *sinopia* they were as linked as to cause and effect as the com-
batants in Fig. 91. In the mural, however, Pisanello loosened the bond
between the two knights by distancing the challenger from his opponent and
by removing the stump of lance from the wounded knight's chest. As a result,
the attacking Knight 15's charge in the fresco became generalized rather than
focused exclusively on his opponent, Knight 21. Their interaction, as devel-
oped in the manuscript formulas and still present in Pisanello's *sinopia*, is nec-
essary to render intelligible the connection that originally existed between the
two combatants, a link that gave Pisanello a point of departure when con-
ceiving his own grouping but one that he subsequently abandoned.

Compared with these examples of creative adjustment, the third pattern
of treatment between *sinopia* and fresco amounts to virtual metamorphosis.
As we shall see in chapter 7, there were at least two zones of the composition
that Pisanello reworked extensively in the *sinopia* before starting to fresco: the
lower left corner (scheme C) and the center (scheme B).[54] In each case, he dis-
carded motifs, substituting others of a completely different nature. Figure 124
illustrates the first *sinopia*, Figure 93 the second *sinopia* for the lower left corner
of the tournament scene. Few of the knights originally planned for this area
were retained in the second *sinopia*, which concentrates on noncombatant
knights preparing for the contest, a new idea in tournament illustration. The

motif of Knight 4, who reaches up to close the visor of his colleague Knight 5a in the second *sinopia*, for instance, replaced the first-*sinopia* image of a wounded knight, Knight 5, sliding uncontrollably headlong off his horse (Figs. 95 and 96). Linking the Mantuan scene to jousts in manuscripts, where knights also inflict fearful blows on their opponents, flinging them to the ground, this first-*sinopia* figure is a good example of the kind of image that Pisanello would eventually discard in the fresco.

Most of the ideas introduced in the second *sinopia* were retained in the painting (Figs. 93 and 94), but here, as elsewhere, Pisanello modified the location and specific poses of many figures before starting to fresco. The new design on the second *sinopia* was cramped, and Pisanello, discovering that he had more wall space at his disposal than he had realized, expanded the composition to the right so that it extended over a wider area of the scene. Knight 2's horse, for instance, shown in three-quarters view in the mural, was originally depicted frontally in the second *sinopia*. The drawings for this part of the wall thus reveal that, even at this second-*sinopia* stage, Pisanello had not yet determined the spacing and exact interrelationship of the figures for this part of the composition. As he worked on the *intonaco* he took the images quickly scribbled in the second *sinopia* and rearranged them into a more expansive composition, one whose measured rhythm contrasts with the earlier more staccato and cramped design on the *arriccio*.

Much of the central zone of the wall was also a second *sinopia*, as can be seen from the surviving disjunction between the design in the center and that on the right of the wall.[55] Some of the figures of this reworked scheme were very carefully drawn and are among Pisanello's most forceful and beautiful graphic statements. There was little connection, however, between those images that Pisanello worked out carefully on the *arriccio* and those that he left unaltered. Although the central rearing horseman, Knight 12, was delineated with great elaboration in the *sinopia*, this figure underwent a conceptual transformation between the two layers of plaster (Figs. 98 and 51). In the mural this knight's conceptual significance is evident from his central location, his pose as the only rearing horseman in the scene, and his Gonzaga family colors and heraldic devices (Fig. 97).[56] His location immediately below the clash of cavalry on the uppermost zone reinforced his prominence; the tilting lances create a vertical axis leading the eye to his figure below. In the *sinopia*, however, Knight 12's importance is not yet fully apparent, and he is hard to distinguish from the lesser knights clustering around him (Fig. 99). In the mural Pisanello separated Knight 12 from the surrounding throng by moving him to a position lower on the wall (Fig. 100). When this central figure became one

of the few figures in the composition not overlapped by others, his legibility, and hence his formal consequence, increased. Endowed with Gonzaga colors and emblems and given a commander's baton to raise in an authoritative gesture as he led the way into the heart of the *mêlée*, he was transformed from a rank-and-file knight in the *sinopia* into the central Gonzaga *condottiere* in the fresco. We may speculate that the connotations of established political power embodied in the image of a commander on a rearing horse may have influenced the enlargement of this Gonzaga leader's role within the tournament.[57]

In the painting Pisanello reworked many of the surrounding images to sharpen the focus on this Gonzaga knight. The knight riding directly behind him, Knight 11, is a fusion of two separate images in the *sinopia*: the torso of a knight without a steed and Knight 7 galloping away from the central action (Figs. 101 and 102). Given the latter's attributes of cloak, horse's caparison, and Gonzaga family emblem, Knight 11 was reversed in the opposite direction from Knight 7 to accompany Gonzaga Knight 12, a device that increased the latter's importance (Fig. 100). In the *sinopia*, several other knights, such as Knight 6 on the left (Fig. 105) and Knight 22 on the right (Fig. 104), had also moved away from the center, and they too were discarded in the mural. Each was substituted for by a knight placed symmetrically in relation to Gonzaga Knight 12. Knight 22, who emerges from under the second *sinopia* to move toward the right, was replaced by Knight 18 on the piebald horse turning back into the throng (Fig. 103), his leftward direction balancing the rightward movement of Knight 11 (Fig. 102). To Knight 18's right the heads of two brown-coated horses, also additions to the mural, conspicuously face back toward the center of the scene. On the left side of the mural two fallen knights, 6a and 7a (Fig. 106), replaced the horsemen, Knights 6 and 7, who had galloped away from the fighting of the *mêlée*. They balance two other dismounted knights to the right of center: the fallen Knight 20, seen in foreshortening from the rear (Fig. 107), and Knight 19, whose presence is limited to his projecting legs (Fig. 103). All these changes subtly increased the Gonzaga commander's formal impact and helped to give more focus to the central area of the composition.

The changes also tended to endow the scene and its protagonists with a more solemn demeanor. Knights 6a and 7a, who so conspicuously forfeit all hope of winning the tournament in the mural, retire from the fray with more restraint than had their defeated predecessors in the *sinopia*, such as the knight falling head down at lower left (Fig. 96).[58] Movements and gestures of individual knights became relatively more restrained in the fresco, so that the

tournament on the *intonaco* is fought with greater decorum than that on the *arriccio*.

In the final version of the composition, more phases of a tournament are included than was usual in illustrations of these events. Pisanello departed from both manuscript prototypes and his own *sinopia* by showing, on the one hand, knights preparing for the fray and, on the other, fallen knights displaying their wounds. The standard action to represent a tournament in northern Italy in this period was invariably the cavalry charge with lances depicted through a repetitive formula of galloping horses and riders shown in strict profile, as can be seen in the tournament at Castelroncolo (Fig. 80) and the Lombard miniatures (Figs. 75 and 76). Pisanello's tournament of course included the standard charge of tilters at center left (Fig. 82), the usual encounter of knights battering each other with their swords in the *mêlée* at center right (Fig. 140), and the customary jousts along the surviving lower zones of the scene (Fig. 90). He also, however, included other facets of the activity, such as the prominent losers and jousters who prepare for the fray and wait for their turn (Fig. 14). One knight helps a colleague mount (Fig. 86); another still carries his helmet in his hand (Fig. 94). Some help with one another's armor: Knight 1 reaches down to adjust the rivet at the back of the helmet of the knight just below him (Fig. 94), while Knight 4 reaches up to adjust a peer's helmet (Fig. 95). The prose *Lancelot* provides no particular grounds for Pisanello's diversification of the matter in this way. On the contrary, the *Lancelot*'s own account of the tournament is presented exclusively in terms of Bohort's success and valor in the *grande mêlée* and ignores everything else.

Nonetheless, in one respect Pisanello's simultaneous presentation of so much activity links his mural to its literary source. The different events—the *mêlée*, tilting with lances, jousts with swords and maces—usually took place on successive days of an actual tournament, but Pisanello depicted them as if happening concurrently.[59] In this sense, his fresco relates to the perception of time in prose romance. The adventures in the prose *Lancelot* would of course have been apprehended by the listener or reader in the order in which they were presented in the text, but in *entrelacement* many themes, whose threads tangle and interrupt each other, are being followed at the same time. One of the key features of interlaced narrative lies in experiencing these sequential adventures as being simultaneous. This effect of simultaneity for the listener is approximated by the viewer's simultaneous perception of all the successive phases of the tournament in the mural.

Any interpretation of the revisions between *sinopia* and fresco must take Lodovico Gonzaga's contemporary circumstances into account. As we saw, many of the knights in the scene were identified by family emblems and family colors as members of the Gonzaga team. Given the relevance of this subject matter to Lodovico's current military aspirations, we are justified in asking whether he may have been in some way responsible for encouraging Pisanello's shift of emphasis from the composition of the tournament as outlined in the *sinopia* to that frescoed in the mural. As an experienced jouster, he could, for instance, have influenced Pisanello's decision to relocate some of the different activities on the *intonaco*. The composition in the fresco is more intelligible than the earlier design because the various phases of the tournament are confined to distinct areas. The active fighting of the *grande mêlée* and cavalry charge are restricted to the upper zones of the scene, while preparation for the tournament and some of its less pleasant results are confined to the lower wall. The massed warriors in the *mêlée*, where the individual was in any case indistinct, were thus furthest from the viewer, whereas the jousts between single knights, placed closer to the spectator, became more legible. The Marchese could also have suggested the substitution of the prominently placed wounded knights (Fig. 106) for some of the more ungainly depictions of defeat in the *sinopia* (Fig. 96). Inducing an empathetic frisson of fear and disquiet in the viewer who was an experienced jouster, the more realistic fate of these losers would have heightened the tension and excitement of the painted tournament for the male members of the Gonzaga court, as we shall see.[60]

The possible influence of Lodovico's military ambitions and jousting experience on Pisanello's tournament is suggestive, if inconclusive, but it should not be seen as the only—or even the most important—motivation underlying the changes between *sinopia* and fresco. Considerably less speculative than the patron's possible intervention are the formal and artistic problems clearly visible in Pisanello's *sinopia*. Alberti's condemnation of

> those painters, who in their desire to appear rich or to leave no space empty, follow no system of composition but scatter everything about in random confusion with the result that their *historia* does not appear to be doing anything but merely to be in a turmoil[61]

can be applied to the *sinopia* version of this scene. Its composition can be thus characterized: similar motifs, distributed at regular intervals, give a uniform pattern to the scene. Repetitive images of mounted knights are spread evenly across the picture field without a focal point of interest or a flow of directed

movement.[62] The monumental *sinopia* is a densely packed and, compared with the fresco, somewhat monotonous design. The changes that Pisanello made in response to this problem were not haphazard local modifications. They amount collectively to a campaign to improve the composition by giving it a central focus, by diversifying the action while at the same time organizing existing motifs into more lucid groupings, and by endowing the knights with a more measured demeanor.

We have already seen how Pisanello tried to unify the center by creating a flow of directed movement toward the central Gonzaga leader, Knight 12. The artist methodically eliminated knights who moved away from this figure, replacing them with horsemen moving back toward him or with the static figures of dismounted knights. Indeed, Pisanello's original design on the *arriccio* of evenly distributed single knights had by its very nature precluded a focus on any one figure or group. In the reorganized composition important knights such as 8 or 12 became the hub of a small cluster of warriors. The *sinopia*'s restless animation of uniformly scattered images gave way to denser groupings and some restful pauses, the new "slow" or quiet passages giving a context for all the "fast" or active passages of fighting knights.[63]

The intervals that Pisanello gained between the discrete clusters of knights made each of them more legible and gave a more satisfying rhythm to the composition as a whole. This rhythm is particularly evident in photographs of the tournament taken prior to the mural's *strappo*, in which the *sinopia*, visible at lower right, was still integrated into the composition (Fig. 18). There Gonzaga Knight 24 (Fig. 35), even in his unpainted state, acts as a counterbalance to the prominent figures of Knight 8 at upper left and Gonzaga Knight 12 in the center. These three large-scale equestrian knights, in imposing profile, are rendered especially visible by the relative absence of overlap with other figures. Had the *sinopia* image of Knight 24 been painted, the left-to-right sequence of slowing movement spanning the scene in a descending diagonal, which coincides with the decreasing action of the tournament, would have been clearer. The *ventre à terre* gallop of Knight 8 is succeeded by the twelfth knight's rearing horse, in turn succeeded by the trot of Knight 24 approaching the action from the opposite direction. Had the mural been finished, these large profile images would have served as strongly unifying features, providing clusters of interest diagonally across the picture plane and revealing the existence of a controlling surface pattern. They also bind together the three surviving horizontal registers of the tournament scene and help to link the left and right sections of the wall to its center.

Pisanello's introduction of new subject matter and his diversification of

the action—the knights arming, waiting, and falling wounded to the ground as well as tilting with lances, jousting, and joining in the *mêlée*—unquestionably enhance the composition by adding to the fresco's interest and excitement. He seems to have put into practice Alberti's instruction in *De Pictura* to vary the action in the *historia*:

> A picture in which the attitudes and movements of the bodies differ very much among themselves is most pleasing of all. One should take care that the same gesture and attitude does not appear in any of the figures.[64]

Over sixty knights compete in combat in the mural, and hardly a configuration is repeated in the final version of the composition. However negatively Alberti might have reacted to the large numbers of figures in the scene, he would surely have approved of its "plentiful variety." He would also have appreciated the less frenetic pace with which the action proceeds in the fresco. "Everything should conform to a certain dignity" was his refrain throughout Book 2 of the treatise.[65]

The evidence suggests that Pisanello may have been interested in applying some of the precepts of Alberti's treatise to this scene. Certainly both artist and patron were familiar with the main tenets of *De Pictura*. As a prominent artistic figure at the court of Ferrara during the 1430s and early 1440s, when Alberti was in close contact with Leonello d'Este and his brother Meliaduse, Pisanello must inevitably have been exposed to Albertian ideas.[66] It takes little imagination to realize the great interest with which Lodovico, characterized as *intendentissimo*, knowledgeable in artistic matters, would have read Alberti's treatise on painting, the Latin edition of which had been dedicated to his father.[67] The concept of Albertian influence on a chivalric work would not have seemed incongruous to the early Renaissance, a period that, as we saw, chose not to make rigid distinctions between classical and chivalric subjects.[68] Thus nothing would have been more natural than that Pisanello, an artist of the highest intelligence, and Lodovico, a patron celebrated for his fascination with *disegno*, should have been influenced by some of Alberti's ideas.[69]

Whatever may have motivated Pisanello to adjust the composition of the tournament when he came to paint it, the recovery of the *sinopia* makes possible analysis of the evolution of one of the largest and most complex compositions surviving from the mid Quattrocento. Pisanello's difficulties in resolving it were to be expected, given the absence of adequate models for this kind of composition on this scale. Considered individually, his changes to the composition appear arbitrary and inconsequential.[70] Studied collectively, they reveal a consistent objective: to achieve a more focused, more varied, and

more restrained composition in the fresco than that conceived in the *sinopia*. Gaining in organization, legibility, and drama, the scene's formal impact, and hence its meaning, would have greatly increased for the users of the *Sala*: Lodovico Gonzaga, his household, and his guests.[71] Whether or not Lodovico collaborated in the revised design, this patron—a man with an affinity for the artistic process and consumed by a passion for detail—must have greatly enjoyed watching the tournament scene evolve on the walls of his *Sala*.

CHAPTER SEVEN

Making the Art

I. *The* PASTIGLIA

THE STATE of incompleteness in which Pisanello abandoned the frescoes in the *Sala* can be ascertained from the ragged edges of *giornate* visible on the lowest surviving zones of the *intonaco* on Wall 1 (Figs. 90, 94, and 118). Had the mural been finished, these edges would have been neatly trimmed back to the painted forms to enable the plaster for the adjacent *giornate* below to be spread evenly and without disjunction. An unexpected compensation for the unfinished state of the cycle is the insight it offers into Pisanello's execution of the murals. In this chapter we shall consider the physical execution of the work, and develop hypotheses concerning Pisanello's working methods on the *intonaco*, his use of *sinopie* on the *arriccio*, and his use of drawings on paper.[1]

Only one scene—the tournament on Wall 1—reached the point of being partially painted. Because this mural was abandoned in varying stages of completion, the *intonaco*, or uppermost layer of plaster, is sometimes hard to read. Work on this wall reached, for the most part, two different stages of finish, as indicated by the irregular line drawn across Figure 108. The upper, or more nearly finished, reaches of the wall are covered with fragments of relief, specks of metal, and incised lines. None of these features appear on the lower, or less finished, areas of the surviving scene, which are instead dominated by the elaborate drawings in *terra-verde* that we considered earlier in connection with the date of the cycle.[2]

Neither the relief on the upper zones nor the extensive drawings on the lower zones of this *intonaco* conform to what is considered to have been the "standard" practice of mural technique in the Quattrocento. Frescoes, especially Tuscan frescoes, are an art form about which we have considerable information. Our earliest Italian source, Cennino Cennini's *Libro dell'Arte*, outlined the traditional methods used in Florentine workshops in the late Trecento.[3] Recently, the problem of deteriorating murals has led to a resurgence of interest in fresco technique, especially in Tuscany, and a number of important studies have been produced.[4] Across the five hundred years that separate them, there is basic agreement between Cennini and modern scholars on how the artist went about creating his mural. Put very simply, small patches of wet

plaster were smoothed on the *arriccio*, the rough first layer of plaster. In *buon fresco* the painting was done immediately on this fresh, damp plaster with pigments dissolved in water. As both plaster and pigments dried, they became integrated so that the painting became a part of the wall itself with a surface texture indistinguishable from that of its support. While there were many possible variations within the basic procedure, Pisanello's tournament scene differs somewhat from it in two important respects. He sought a rather different kind of surface finish than that usually found in Tuscan murals, and part of his working procedure involved drawing more extensively on the *intonaco* than seems to have generally been the case.

Evidence for the intended character of the finished work is still preserved on the upper zones of Wall 1, where several sections of the mural were either completed or almost completed and still survive in relatively good condition. Pisanello planned to cover extensive areas of this scene with raised relief, incised with decorative designs, and overlaid with silver and gold leaf. The hats and banners of the heralds in Figure 109 are typical examples of the *intonaco* finished in this way. A shallow relief layer of some malleable substance was laid on the plaster. This plane, known as *pastiglia*, was covered with metal and decorated with sharply etched patterns.[5] The technique is most clearly visible in the heralds' hats (Fig. 133) and their banners (Fig. 110), but extensive if fragmentary remains of this raised and decorated surface survive across the whole of the upper half of the scene. The metallic plane was applied to the depicted motifs that were fabricated or manmade, such as the knights' armor, their cloaks, their weapons and their horses' caparisons, saddles, and bridles, for example the lances carried in the cavalry charge (Fig. 111) and the caparison of Knight 12's horse (Fig. 112). Pisanello also used another type of low relief in the mural: protruding ridges of semicircular profile were applied to the wall and covered with silver to simulate chain mail (Fig. 113).[6] In addition, he seems to have applied silver directly to the *intonaco* for the undecorated armor of many of the knights, as can be seen from the multitudinous specks of oxidized silver that cover the upper areas of the scene.[7] The delicacy of the *pastiglia*'s incised designs, reminiscent of some of the drawings attributed to him (Fig. 114), show Pisanello's mastery in the application of this relief plane.[8] In view of the taxing demands of the medium, the high quality of the craftsmanship can only be called a technical tour de force.[9]

There are many places in the central area of Wall 1, less well preserved than the upper left corner, where the *pastiglia* was applied to the *intonaco* and has since partly fallen. The *intonaco* revealed by these losses consistently displays

Pisanello's elaborate *terra-verde* underdrawings, suggesting that the wall drawings (here referred to as underdrawings to distinguish them from the artist's drawings on paper) were preparatory to the application of the *pastiglia*. The accouterments of Knights 11 and 12 in Figure 100, for instance, show how Pisanello used the underdrawings. The natural surface of the brown, flecked coat of Knight 11's horse at lower right in Figure 115 was painted in *fresco* or *mezzo fresco*, but the fluttering caparison that partly covers it was first prepared by an underdrawing. Pisanello would make *terra-verde* drawings of those motifs, such as the knight's mantle (*giornea*) and his horse's caparison, that he planned to cover later with another physical layer. Most of the *pastiglia* laid over the underdrawing of the caparison of Knight 11's horse has since fallen, but some small patches of relief can still be seen. The *pastiglia* has survived in better condition in Knight 11's *giornea* above, but here too the underdrawing can be seen in places where the relief has fallen. The detail of the caparison of Knight 12's horse in Figure 116, also revealing the underdrawing exposed by the damaged relief, shows the confusing and fragmentary state of most of the upper reaches of the tournament scene.

Pisanello thus used the *pastiglia* descriptively. The raised and gilded surfaces of such textiles and metals as the heralds' banners and hats and the knights' lances and armor were a substitute in texture and color for the objects depicted. Since the subject of a tournament called for the inclusion of many knights and their mounts, all of whose trappings and costumes required this kind of finish, the *pastiglia* would have extended over wide, continuous zones, so that the parts of the work covered with metal relief would have dominated the parts that were frescoed. Pisanello's solution to the artistic problem posed by the use of so much metal can be extrapolated from the almost finished part of the scene at upper left. He planned to exploit the coloristic effect of the metals by juxtaposing the pale glistening of silver and the subdued luster of gold. The artist, for instance, alternated the use of gold and silver for the lances (Fig. 111), and a gold bird was placed against a silver ground within a gold border in the herald's banner (Fig. 110). The charging Knight 8 (Figs. 82 and 113) is a good example of the juxtaposition of both kinds of relief and metals: wearing silvered chain mail, he sits in a saddle made of gold *pastiglia*. Had the tournament scene been finished, its dominant feature would have been a richly gleaming three-dimensional surface that exploited the contrasting hues of gold and silver as well as the effects of different kinds of relief.

The upper zones of the wall are thus covered with specks of silver, fragments of *pastiglia*, glimpses of green-earth underdrawings, and incised lines (Fig. 117).[10] Only the lower zones of Wall 1, where the application of the *pa*-

stiglia was never begun, survive today as Pisanello initially prepared them with elaborate and beautiful underdrawings (Figs. 108 and 118). Extending all the way across the bottom half of the scene, they would, had the mural been finished, have been covered with *pastiglia* like the upper, almost finished, part of the wall. We saw that Pisanello painted the horse's coat in Figure 115 in *fresco* or *mezzo fresco*. On damp *intonaco*, he would paint the organic surfaces of the coats of the animals and the flesh of the knights, such as the horses' heads in Figures 130 and 131 and the heralds' faces in Figure 133.[11] Most of the other motifs in the scene, however—armor, weapons, dress, and horses' trappings—were first studied in *terra-verde* before being covered with *pastiglia*. Few large-scale Quattrocento wall drawings have come down to us worked in such exhaustive detail as these underdrawings, which were never intended to be seen (Figs. 45, 46, 47, 48, 118).[12]

The underdrawings differ in pictorial character from the *pastiglia* that covers them. Images of great clarity and volume, they were reduced to flat pattern by being overlaid with intricate and glittering designs. Pisanello's conception of form seems to have changed radically between the preparation for the mural and the finished work. Depending on the stage of preparation, he oscillated between concern for the refraction of things and concern for their palpability. In the underdrawings the knights were modeled illusionistically in light and shade, while in the *pastiglia* the vibrating surfaces of their accessories were literally reproduced. On the *intonaco* Pisanello accordingly displayed pictorial modeling in those very areas that were later to be actually molded. Thus three-dimensional modeling by use of light and shade, an aspect of painting to which Alberti pays much attention in *De Pictura*, was seen by Pisanello as a necessary first step to the actual relief.[13]

We have to make an imaginative leap to reconstruct the mural's intended effect. Metals gleam only in conditions of indirect light, and Wall 1 was side-lit from the window on Wall 4 that overlooked the *brolo*. Conditions of illumination in the *Sala* were thus conducive to a concentration of the metallic relief on this wall. The incised patterns would have varied the way in which the light struck the *pastiglia*. By presenting different facets to the light, the designs broke up a uniform reflection from the metal layer. As in his medals, Pisanello was interested here in the play of sparkling light as it reflected off a physically shaped surface and in the glow of a surface that literally caught and held the flickering light. He probably intended to contrast the effect of light vibrating off the irregular surfaces of the *pastiglia*, such as the heralds' hats and banners and the knights' *giornee* and lances, with that of light absorbed by the undifferentiated sheen of some knights' plain silver armor.[14] Incorporating

light itself into the very substance of the mural, Pisanello here communicates his love for glowing surfaces.

The use of so much *pastiglia* in the scene reinforces the observations made in the previous chapter about the lack of pictorial depth in the composition of the tournament. Any attempt at spatial illusion would have been eliminated by the surface-stressing elements of the gilded relief that extended over wide areas of the wall. The vibrant reflections of the metals would have made the wall difficult to perceive as other than surface.[15] Since motion is necessary to reveal glitter, Pisanello's surface finish would also have encouraged the visitor to move around the *Sala*. Only by shifting his position in relation to Wall 1 could the viewer have appreciated the full extent of the *pastiglia*'s luster.

In early-fifteenth-century Lombardy and Venice it was traditional to use gold relief on a panel to represent an object such as a crown, a horse stud, or a piece of armor that might in reality have been in gold and thus have sparkled under the light. In Jacobello del Fiore's painting *Justice with Saint Michael and the Archangel Gabriel* (dated 1421), for instance, Saint Michael's armor and the bodices of Justice and Gabriel were covered with gilded relief, and in a mid-century Brescian panel, *St. George and the Dragon*, actual gold and silver highlight the horse's trappings and Saint George's armor (Fig. 119).[16] The same technique of gilded relief was employed for frescoes in northern Italy, enabling them to convey an idea not usually expressed in this particular medium.[17] From the chapel frescoed in Brescia by Gentile da Fabriano for Pandolfo Malatesta in the teens of the century to the murals painted in the *Sala dei Mesi* of Ferrara's Palazzo Schifanoia for Borso d'Este around 1470, court patrons favored frescoes liberally sprinkled with silver and gold.[18] Two types of relief were imposed on these northern murals, neither of which quite corresponds to the delicately incised layer of *pastiglia* used by Pisanello in Mantua. Either heavy wedges of stucco decorated small objects such as horse trappings, crowns, and, occasionally, architecture, or regularly patterned metal was spread across backgrounds. Works such as Pisanello's own mural, *St. George and the Princess*, in S. Anastasia in the thirties (Fig. 42) or the *Camera Peregrina Aurea* frescoed in the castle at Torchiara for Count Pier Maria Rossi in the late 1450s are good examples of the first type. Much of the relief applied to the horses' bridles and saddles in the S. Anastasia mural fell during removal of the work from its original site, but the surviving relief decorating the architectural structures in the Torchiara room is so thick that in firelight it may have cast actual shadows on the pictorial surface.[19] Two cycles for the Dukes of Milan display the second type of *pastiglia*: the Teodolinda Chapel in Monza Cathedral produced by the Zavattari brothers, probably for Filippo Maria

Visconti, in 1444, and the ducal chapel in the Castello Sforzesco frescoed for Galeazzo Maria Sforza in the early 1470s.[20] In these works the *pastiglia* was primarily used for background elements such as the sky, which in Monza is entirely covered by a patterned gilded layer in a manner that is strongly reminiscent of, and was surely inspired by, illuminated manuscripts (Fig. 120). The refinement of finish and technical virtuosity of the Arthurian cycle, however, must have far surpassed these other surviving examples, being perhaps paralleled only by Pisanello's other lost cycles.

> And the walls he covered with tapestries
> and in rich cloth of gold, silver and silk,

sang one poet, celebrating Cosimo de' Medici's decoration of his palace in Florence with tapestries rather than murals.[21] *Ornamenti de tapezarie*, hangings imported from Flanders or woven in Italy by Flemish weavers, were very popular in Quattrocento Italy. The tournament scene emulates the effects of such tapestries in both its grandiose scale and its jewel-like surface. Murals may well have been understood by Quattrocento *signori* as substitutes for northern tapestries, which were a more luxurious way than paint of decorating large expanses of wall. Indeed, frescoes commissioned by Bartolomeo Colleoni for one of the *piano nobile* rooms in his castle at Malpaga a few years later were even painted in imitation of a set of hunting tapestries.[22] A perception of paint as substitute for richly worked wool and silk would, in the case of Mantua, have been reinforced by the texture and metals of the relief layer, reminiscent of the glittering silver and gold threads that enriched hangings. In the case of Flemish tapestries, the cost of the glitter was high. One reason why tapestries were so carefully inventoried and so frequently commented on was their value as investment.[23] We saw that Borso d'Este's hangings illustrating the *Roman de la Rose* cost 9,000 ducats. In 1443 his brother Leonello spent 3,000 ducats on nine new tapestries—a cost of approximately 1 ducat per square *braccia*—and a few years later Giovanni de Medici's agent in Bruges had to decide whether to spend as much as 700 ducats on a single hanging.[24] The expense of tapestries, *choxe di spesa assai*, would thus have prevented the Gonzaga from purchasing them in the late 1440s, a period of financial retrenchment for Mantua.[25]

The precise constituents of the metals used by Pisanello in the *pastiglia* in the tournament scene are unknown.[26] In his treatise, however, Cennini suggested various cheaper substitutes for gold, including *stagno dorato* (gilded tin). Though inferior in quality, such metals were, he thought, preferable for murals because of their low cost.[27] Because of Gonzaga financial constraints

in these years, it seems likely that inexpensive substitutes for the costly mate-
rials were used in Mantua. This mural would have looked more expensive
than it actually was. It would have resembled a tapestry in which the precious
materials were assessed quantitatively in the belief that their presence
increased admiration for the work. Such courtly taste for an appearance of
conspicuous consumption will be further explored in chapters 8 and 9.

II. *The Two* SINOPIE

The two adjacent *sinopie* in the *Sala del Pisanello*—the tournament on Wall 1
(Fig. 7) and the landscape with other scenes on Walls 2 and 3 (Figs. 11 and
12)—pose a puzzling problem. They stand at opposite poles in the thorough-
ness of their preparation, their graphic styles ranging from rapid notations in
the tournament to much descriptive detail in the landscape.[28]

The tournament *sinopia* on Wall 1 is a full-scale preparatory drawing that
documents Pisanello's search, sustained through several layers of plaster, for
the ideal composition.[29] The *sinopia* combines five separate compositional
sketches or schemes which Pisanello seems to have developed on the walls in
the following sequence (see Fig. 121). His first scheme (A) ran from the center
of the wall toward the right. This scheme was partly replaced by a new com-
position (B) drawn on fresh plaster in the center of the wall. Pisanello then
drew the areas at center and left of the scene (C), followed by the horizontal
zone at upper left (D). Finally, at lower left he radically revised the composi-
tion of scheme C in another second *sinopia* (E), drawing it in the same green
earth in which he later drew the underdrawings on the *intonaco*.

Pisanello probably started work with the all-important central area of his
composition (scheme A, Fig. 122).[30] The surviving right side of the scene,
including Gonzaga Knight 24 with his wide-brimmed *cappello* and his retinue
of dwarfs (Figs. 34 and 138), belongs to this scheme, as do Knights 22 and 23,
who emerge from under the crust of the subsequent layer of plaster of scheme
B in the center (Fig. 104).[31] The rapidly drawn images share in light, flick-
ering strokes. Pisanello seems to have had a firm grasp of what he wanted for
this relatively simple section of the tournament scene and later retained most
of the figures with little change. Canceling the central part of this early
scheme in a second *sinopia* (scheme B), Pisanello moved the focus of his com-
position further left. In red earth, he drew the important figure of the Gon-
zaga commander, Knight 12, and his companions above and below him as an
integral group (Fig. 99). The red-earth drawing was heavily retraced in char-
coal, possibly indicating Pisanello's growing awareness of this knight's

potential as one of the central figures in the scene.[32] To his lower right, Knights 15, 17, and 21 also form a self-contained group (Fig. 89). Some of these warriors disconcertingly straddle the boundaries of the old and new plasters of schemes A and B. The head of Knight 21, for instance, is partially superimposed over the hooves of Knight 22's horse. The different graphic modes and colors of these two adjacent knights reflect the separate campaigns of which each originally formed a part.

The images in black earth at lower left (Fig. 124) and the knights on Wall 2 clustered near the same corner (Fig. 16) were all part of scheme C.[33] Few of these figures were retained in the mural when Pisanello decided to revise this whole area radically by drawing a new composition on a second *sinopia* (scheme E in Fig. 93).[34] The knights and heralds on the wall above (scheme D in Fig. 123), however, underwent little modification in the final work. This may have been one of the last areas to be drawn, but it was probably the first to be painted, at which time the location of the heralds and the knights in the cavalry charge was altered only slightly on the *intonaco*.

A vertical gap separates schemes C and D on the left of the wall from the second *sinopia* of scheme B in the center. It indicates the juxtaposition of the several designs which Pisanello had not yet integrated. The discontinuities and overlapping of forms that characterize this section of the *sinopia* show that when Pisanello initially drew these schemes on the *arriccio* he had not yet decided which figures should be given greatest prominence. Later in the fresco the knights along this boundary line between schemes C and D on the left and scheme B in the center were to be shifted and reversed until the different designs combined more effectively and the original hiatus in the composition was hidden.[35] In the case of the second *sinopia* at lower left, the figures were drawn in the same green earth as the underdrawings on the *intonaco*, suggesting that this was probably the last part of the scene to be outlined on the *arriccio*. The graphic style of this second *sinopia*, however, could not be more different from that of the underdrawings. Animated notations hurriedly scrawled on the rough plaster to fix the main lines of the new composition as quickly as possible, these sketches are among Pisanello's most cursory surviving images.[36]

Artists occasionally used pigments other than red earth when drawing on the *arriccio*, and Pisanello provides several instances of this practice. Knight 24 leading the dwarfs, for instance, drawn in black earth with hurried, flickering strokes, was later amended in red (Fig. 34). Other details drawn instead in red were corrected in black. What seems peculiar to Pisanello's *sinopia*, however, is his occasional use of disparate colors for adjacent motifs and groups. The

central knights of scheme B, for example, were outlined in red, but those below and overlapping them were drawn in black, testifying to the chronological sequence between the two designs. On the left side of the wall, the lowest knights of scheme C were drawn in black, and the uppermost ones of scheme D were outlined in red, but the knights in the zone between the two schemes, many of whom were later replaced by different images in the fresco, oscillate in hue between black and red. Knight 3 and his companion (Fig. 85), one of the few groups in this scheme retained in the mural, and Knight 6 and the knight to his upper left, both of whom were later discarded, were all drawn in black, but Knight 7 (Fig. 105), who was also discarded, was instead outlined in red.[37]

"We will work out the whole *historia* and each of its parts by making *concepti* and *modelli* on paper," wrote Alberti in his treatise on painting in 1435–36.[38] "We will endeavour to have everything so well worked out beforehand that there will be nothing in the picture whose exact collocation we do not know perfectly," he continued, pointing up precisely what Pisanello failed to do ten years later in Mantua. The Mantuan *sinopia* cannot of course have been totally unplanned. Had Pisanello not worked out some general overall *concetto* in advance and made some small compositional sketches on paper, many more *pentimenti* and areas of uncertainty would be visible on the *arriccio*. But Pisanello evidently did not feel the need for a detailed *modello* of the composition as a whole before starting to draw on the wall. Rather, it was probably the parts of the composition and not the *historia* as a whole, that he worked out on paper before starting to *conporre et legare*, as Cennini put it, "to compose and bind together . . . according to his imagination (*fantasia*)."[39]

Pisanello evidently composed in sections or units typified by a small sketch on paper that shows a mounted knight moving left in a rolling landscape, followed by three dwarfs and accompanied by a lady in a long trailing gown (Fig. 134).[40] This drawing confirms the evidence of the tournament *sinopia* by demonstrating the size of the compositional unit in which, it seems, Pisanello habitually thought. The giant drawing on Wall 1 of the *Sala* testifies that Pisanello had only partly worked out his ideas for the scene on other surfaces before beginning to work on the wall. It was only on the actual site and at actual scale that the artist faced the issue of combining his ideas for separate parts into a unified work of art. The tournament as it reads in the *sinopia* is a montage of discrete studies laid out on the wall which Pisanello then sought to coordinate, or *legare*, into a compositional whole. His habit of drawing adjacent images and groups in different colors suggests the way he worked.

Outlining them on the wall in different hues facilitated his perception of the roles they played within the composition. It was only after considerable rethinking of the separate designs, particularly in the areas where they overlapped, that a unified work of art gradually emerged. Resolving the composition seems to have been so difficult for Pisanello that he could do it only in stages, working so that his ideas for different parts emerged slowly through a process of feedback and continual adjustment. It is symptomatic of the empirical way in which Pisanello worked that he apparently did not employ, as recommended by Cennini, plumb lines or snapped chalked cords to locate the principal horizontal and vertical axes of the composition.[41] Without these aids such a large area must have been even more difficult to handle.

The experience of working at actual scale may have been an important, perhaps essential, step for this artist. Juxtaposing the separate schemes in concrete form on the *arriccio* enabled him to evaluate the results critically and to make revisions, just as Cennini had recommended for work on panels:

> When you have finished drawing your figure [he wrote], leave it alone for a few days, going back to it now and then to look it over and to improve it wherever it still needs something.[42]

Confronting the various designs *in situ* no doubt gave Pisanello new ideas with which to improve his composition. This *sinopia* accordingly illustrates the very functional nature, for this artist, of drawing on the *arriccio*: he used it as a means of developing ideas, thinking through problems, and feeling his way to tentative solutions. The formation of ideas and their execution were perhaps so closely connected for him that they needed to be developed side by side.

The *sinopia* of the panoramic landscape and chivalric exploits on Walls 2 and 3 (Figs. 11 and 12) presents an enormous contrast to the rapidly sketched figures without context of the tournament *sinopia*. There Pisanello was primarily concerned with the poses of the knights and their relationships to other figures within the scene. In the landscape *sinopia* on Walls 2 and 3, on the other hand, he concentrated rather on the details of the setting. Precise details of a setting—especially a landscape—are rarely found in *sinopie* of the period, which usually functioned to locate figures within a composition. This *sinopia* is accordingly one of the most developed wall drawings of landscape to survive. Each bush, each hill, was indefatigably elaborated by Pisanello; each building had its straight edges strengthened in both red and black pigments (Figs. 29 and 125). The apparent finality of this *sinopia*, in which all the

motifs, both figures and vegetation, were brought to a state of high finish, is startling. The minute detail and meticulous shading here almost exceed the thoroughness advocated by Cennini.[43]

The one *pentimento* on Wall 2 illustrates the lengths to which Pisanello took his fastidious preparation before starting to fresco. A second layer of plaster was spread over a small zone of the castle to allow for a fine adjustment to its drawbridge (Fig. 32)—just the kind of insignificant background element usually omitted from a *sinopia*. This perfectionist approach to the details of minor motifs is similar to the way in which the artist approached the under-drawings on the *intonaco*. The club carried by Knight 17, for instance, was redrawn with slight adjustment in charcoal over the green earth (Fig. 126).

The landscape *sinopia* is a less powerful graphic statement than the magnificent tournament *sinopia*, but Pisanello's extensive use of shading gives it the decorative charm and delicacy of a worked-up wash drawing. Concerned with the fall of light, he followed different principles in the use of light and shade, depending on the motif he was drawing. He gave the figures and the hills a layer of semitransparent wash that emphasized the contours so that the color creates a kind of aura emanating from the forms (Fig. 29). Conversely, he used shading on the angled structures of the architectural background to indicate a fall of light from the right (Fig. 125).[44] The lower part of the landscape scene, its rounded forms depicting the animal and vegetable world, were thus treated differently from the uppermost zones, filled exclusively with the flat surfaces of geometric structures.

Various hypotheses can be proposed to interpret the dissimilar natures of the two adjacent *sinopie*.[45] Does the meticulous preparation exhibited on Walls 2 and 3 indicate that this *sinopia* was drawn not by Pisanello himself but by a laborious follower? Or does it imply rather that Pisanello intended this scene to be painted by assistants? Can the apparent differences in style between the walls be explained by dating the *sinopie* to different periods? In my view, as argued in chapter 3, on the grounds of stylistic comparison with signed and dated drawings from his Neapolitan period, Pisanello himself drew both *sinopie* toward the end of his active career.[46] We shall therefore explore a solution to this puzzling question based on the different functions of the two *sinopie* within Pisanello's working procedure in the *Sala* as I have described it. In this hypothesis his seemingly contradictory approaches in the two *sinopie* will be read as deriving from the different subject matter depicted in each scene.

The landscape *sinopia* was never covered and painted, but its intended appearance can be broadly determined. It is a panoramic landscape containing

small scenes of knights and their horses, dotted here and there with isolated animals, covered with leafy foliage, and crowned with buildings silhouetted against the sky. It would have looked much like the landscape and animals near the corner between Walls 1 and 4 (Fig. 15), and like them it would probably have been painted mostly *a fresco* or *mezzo fresco*.[47] The disparity of finish between the two *sinopie* may be the outcome of Pisanello's divergent approaches to two different problems: that of preparing a scene that was to be predominantly painted in fresco (Walls 2 and 3) and that of preparing one in which large areas were to be covered with *pastiglia* (Wall 1). In this reading, the two adjacent *sinopie* diverge in graphic mode because they served somewhat different functions within Pisanello's working procedure. On Walls 2 and 3 Pisanello would have painted the animal and landscape motifs directly onto the damp *intonaco*, as he did on Walls 1 and 4, without an intermediary underdrawing on that layer of plaster. The landscape *intonaco*, destined to receive less *pastiglia* because of the subject matter, would not have needed to be prepared with the same elaborate underdrawings as the *intonaco* of the tournament on Wall 1. Hence, if the landscape and figures on these walls were to be as fastidiously worked up as was Pisanello's wont before painting, this preparation had to take place on the *arriccio*.

Presenting contrasting characters, the two compositions also posed differing degrees of difficulty. The ambitious goal of the large tournament scene confronted Pisanello with problems of integration and unification that were not present on Walls 2 and 3. The story illustrated on these walls required small, separate scenes which Pisanello incorporated into a continuous landscape. Because they were isolated within the landscape forms, there were no overlapping areas to be worked out between the scenes. The composition on Walls 2 and 3 was sufficiently undemanding that Pisanello could solve it with relative ease; hence the more advanced stage of compositional evolution possible in its *sinopia*.

The function of the landscape *sinopia* on the *arriccio* of Walls 2 and 3 may thus be akin to that of the underdrawings on the *intonaco* of Wall 1. In each case, compositional problems were sufficiently resolved to allow Pisanello to turn his attention to details of the individual motifs. This hypothesis is confirmed by the similarity of the graphic mode—deliberate and careful—of the *sinopia* on Walls 2 and 3 and that of the underdrawings on Wall 1. The studied finish of both sets of wall drawings and the minute character of the *pentimenti* of each (the drawbridge in Figure 32 and the knight's mace in Figure 126) contrast with Pisanello's more tentative, fluid approach to the *sinopia* of the tournament, which he drew while he was still uncertain about the design as a

whole. In this reading, the drawings of landscape on the *arriccio* of Walls 2 and 3 and the tournament on the *intonaco* of Wall 1 would represent similar phases of the preparation, although they were different layers of plaster in the normal mural process.

The different functions of the two contrasting *sinopie* may thus explain the apparently conflicting evidence embodied in each. As we saw above, Pisanello's surface finish, whether *fresco* or relief, depended on the kind of motif depicted. Concomitantly, the level of plaster to receive the phase of greatest preparation for each scene depended on the type of subject illustrated in each. Appreciation of Pisanello's idiosyncratic working methods, combined with the greater ease with which he was able to resolve the composition of the landscape, provides a plausible explanation for the different styles of the two *sinopie*. The evidence they each present does not in effect conflict, because each *sinopia* fulfilled a different task.

III. *Drawings for Fresco*

Pisanello, his workshop, and his followers produced one of the most important bodies of drawings to survive from the Quattrocento. It includes some sheets that were both drawn by Pisanello himself and can be linked to the Mantuan cycle. Earlier comments on Pisanello's procedure in creating the tournament *sinopia*, here integrated with observations on how he used drawings on paper, prompt a hypothesis concerning the working practices of his shop. Having argued earlier that Pisanello's *sinopie*—drawings on plaster— were the means through which he developed his large-scale complex compositions, I shall here suggest that many of Pisanello's modelbook studies on paper, the kind of sheet that Cennini called an *essenpro* (or *exemplum*), were primarily directed toward working out very small details of his finished work.[48] Many of these *exempla* sheets, generally considered a stockpiling of useful motifs in the manner of medieval modelbooks, may also have been specifically intended as a guide to the execution of the parts of Pisanello's murals painted in *fresco* or *mezzo fresco*.[49]

One of the few drawings unquestionably by Pisanello that could have been made with this particular cycle in mind is a sheet of rapidly sketched motifs, two of which are studies of the Gonzaga emblem of *cane alano*, the dog with reverted head that was both included among the emblems in the *Sala*'s frieze and placed on the tapestry hanging from the ladies' tribune on Wall 2 (Figs. 59 and 127).[50] Other images depicted on this sheet show a page wearing a flowing mantle, a detail of his leg encased in diamond-patterned hose, the dia-

mond ring itself singled out for study at the top of the folio, a crown, and a flower that could conceivably be connected to the many Gonzaga flower emblems which decorate horse caparisons in the tournament.[51] One could, if one wished to enter into the realm of pure speculation, also suggest that the crown was a sketch for the one worn by King Brangoire or that the page represented an attendant at the King's banquet. Another drawing of a different type but also by Pisanello, an *exemplum* of a horse seen from the rear in sharp foreshortening, was perhaps also used for the Mantuan cycle (Fig. 128).[52] Offering a vivid contrast to the rapid sketches in Figure 127, the meticulously finished study in Figure 128 is reasonably close to the motif of a foreshortened horse depicted from the rear beside the knight about to be decapitated by Agoiers li Fel on Wall 3 (Fig. 12). This kind of carefully studied *exemplum* synthesizes ideas previously developed by the artist in such summary sketches as the images in Figure 127.

The unfinished state of the tournament scene in Mantua discloses an unsuspected function for these *exempla* drawings. No surviving drawing of this type, whether by Pisanello himself or by workshop assistants, corresponds exactly to any detail of the tournament, including the horse drawn in Figure 128. The *exempla* drawings that survive in such number, however, must relate to the other, lost cycles that Pisanello painted elsewhere, and the case can be made on the basis of typical examples. There are, for instance, many similarities between the beautiful drawing of a horse's head by Pisanello in Figure 129 and the frescoed horse's head in Figure 130.[53] Both display an identical concern with surface modeling and the texture of veins and coat, conveyed by the accretion of minute hatchings on the paper and by tiny adjacent strokes on the plaster. In the drawing the location of these strokes is based on the horse's underlying structure, while in the painting they are scattered more evenly across the surface in a less intelligent distribution. While the master draftsman wished to articulate the horse's anatomy as well as the texture of its coat, the apprentice painter concentrated exclusively on conveying the latter.

This kind of impeccably finished drawing may be viewed as a type of preparatory study for such frescoed motifs, revealing Pisanello's attempt—albeit, in this case, unsuccessful—to establish certain standards for their execution by his workshop assistants. It cannot surely be coincidence that the overwhelming majority of extant folios of this type by Pisanello and his school depict human faces and animal heads and bodies, the only forms in the tournament scene that were regularly painted in *fresco* or *mezzo fresco*.[54] From our previous study of Pisanello's working procedure, we may hypothesize

that these drawings on paper had as practical a function in the workshop as the underdrawings on the *intonaco* and played an equally integral role in the production of the finished work.

This hypothesis is supported by the kind of detail that was never worked out in the mural and seldom in the drawings. Figure 132, an *exemplum* sheet of a piper's face copied by an assistant or follower after a drawing by Pisanello, is very similar to the image in Figure 133 of a frescoed herald in the tournament.[55] The hat, costume, and instruments of the piper were not elaborated in the drawing, just as the hats, costumes, and instruments of the heralds were not painted in *fresco* in the mural. In Mantua, of course, these details, along with ones like the horse's bridle in Figure 131, were always completed in gilded *pastiglia* and were usually indicated on the *intonaco* by an underdrawing, as were, for example, the heralds' unfinished trumpets (Fig. 133) and the horse's unfinished bridle (Fig. 130). Since the *pastiglia* represented a separate phase of the work, it was unnecessary to include these details in the drawn guide for the frescoed part of the work.

The overall plan of *giornate* in the tournament scene was not established during restoration, but the edges of many of the *giornate* on the lower zones of the wall, such as that in Figure 86 surrounding Knight 3 and his companion, show up clearly against the black background.[56] Pisanello tended to prepare approximately one square meter of plaster as a "day's work." His typical *giornata* was therefore never devoted exclusively to the individual human or horse's head but included a great deal of work other than frescoed motifs. Under these circumstances, the need for a carefully worked-up guide becomes clear: it facilitated rapid execution of the frescoed parts of the scene as the *intonaco* dried.[57]

The composition sketch by Pisanello illustrated in Figure 134, showing a mounted knight preceded by a lady on foot and followed by three dwarfs, has sometimes been connected, without any basis, with the Arthurian cycle.[58] Conceivably, this equestrian knight could represent Bohort, the lady could be Brangoire's daughter, and the moment Bohort's departure from the Chastel de la Marche. Whether or not this sketch represents a preliminary, but subsequently unused, idea for an area of the *sinopia* toward the right side of Wall 1, it is one of only two or three composition sketches by Pisanello to survive, in contrast to the many extant *exempla* drawings of human heads and animal heads and bodies produced by both master and apprentices.[59] The imbalance that exists between surviving composition sketches and surviving *exempla* sheets can perhaps be explained by the working practices of Pisanello's *bottega*. We saw that elaborately finished *exempla*, such as the horse's head in Figure

129, correspond to the kinds of figures or details that were usually executed in *fresco* or *mezzo fresco*, such as the painted horse's head in Figure 130. Just as the requirements of fresco technique explain the preponderance of this type of *exemplum* drawing among surviving sheets, so the use to which Pisanello put his tournament *sinopia*, as discussed above, helps to explain the sparse number of surviving composition sketches. Pisanello undertook much of this phase of the work directly on the wall or the panel. The preliminary composition sketches made on paper, merely initial ideas for the parts only of the scene, became disposable objects of no value once Pisanello had started to combine his ideas for the separate parts into the *sinopia* as a whole. There would have been little point in preserving these partial composition sketches on paper since they functioned neither as guides to be used by studio *garzoni* as they frescoed on the wall nor as suitable *exempla* to be copied by these same apprentices on paper as they sought to absorb what Cennini called the master's *maniera* and *aria*, in other words, the workshop's style and conventions.[60] The requirements of the fresco medium accordingly explain a particular aspect of so many drawings by Pisanello that were copied by his workshop: the obsessive interest in the elaborate modeling of facial flesh and animal coats.

To summarize the hypothesis about Pisanello's approach to large-scale frescoes, he would first sketch out his ideas on paper for the different sections of his scene, as in Figure 134. He would then combine these concepts together in the *sinopia*, thinking through compositional problems directly on the wall. He would then consider the details of the scene—the separate motifs and the details of the motifs—as on the sheet with the *cane alano* (Fig. 127). These studies would in turn enable him to establish the *exemplum* of the whole motif to be used by the workshop as a guide to the painting on the rapidly drying *intonaco*, as in Figures 128, 129, and 132.[61]

Without denying the "repertory" nature of these *exempla* sheets or suggesting that there was a calculated one-to-one relationship between all Pisanello's modelbook drawings and his frescoes, clarification of the artist's working procedure in the *Sala del Pisanello* may extend our understanding of how he used preparatory drawings. Many of the *exempla* sheets, repertory studies of separate motifs which would later be incorporated as pleasing images into his compositions, may also have been specifically intended as guides to the actual execution of the parts of the forms that were painted in fresco. Pisanello's *exempla* drawings may thus have formed a more integral part of his working procedure, and have been more closely connected with specific tasks, than has hitherto been recognized.

IV. *Pisanello's Creative Personality*

We know a fair amount about Pisanello's artistic standing at Quattrocento courts and a bit about his allegiance to these princes. Highly regarded as an artist and an innovator, he was sufficiently prominent to attract the unwelcome attention of the Republic of Venice to his Veronese nationalism, or pro-Milanese anti-Venetian conduct.[62] Lamentably little, however, is known about Antonio Pisano the human being. We lack for him the anecdotes, with which Vasari enriched his *Lives of the Artists*, that make so many central Italian artists into distinctive individuals. The *Sala del Pisanello* cycle, an abandoned "work in progress," however, compensates for its incomplete state by telling us more about Pisanello's persistent traits as an artist than any finished work could have done. Our detailed reconstruction of the cycle's creation leads to a better understanding of this artist's temperamental working habits and hence the source of his particular genius.

While there were many variations within the basic procedure, mural painting as it was generally practiced demanded great artistic decisiveness. A technique that involved rapidly drying patches of plaster was not hospitable to indecision or belated changes of mind on the part of the artist. Pisanello's speed of execution when working on some phases of this mural, such as the underdrawings on the *intonaco*, can be assessed. The fastidious retracing of the *terra-verde* images in the *giornata* shown in Figure 86 testifies to the care with which he drew them. Their very elaboration indicates how rapidly he must have worked on the drying patch of plaster. Given the time factor involved, these underdrawings prove that Pisanello could be deliberate without being slow. His decisive handling of the underdrawings on the *intonaco*, however, contrasts sharply with his approach to both earlier and later stages of the work. This interrupted mural reveals that Pisanello never acquired the habit of proceeding in an orderly fashion and indulged in far more last-minute changes than other mural painters seem to have done. If his underdrawings exemplify Alberti's recommendation that diligence be combined with speed of execution, Pisanello was temperamentally disinclined to follow Alberti's further instruction to the painter never to apply brush to his work before he had clearly decided what he was going to do and how he would do it.[63] On the contrary, the planning stage for Pisanello was not confined to any one moment but extended throughout the execution of the work.

We saw in chapter 6 how many changes Pisanello made to the composition of the tournament scene between *sinopia* and fresco. Even more sur-

prising is our discovery that when painting on the *intonaco* he worked exactly as he had when drawing on the *arriccio*: he continually changed his mind as he frescoed, altering existing forms or inserting new ones.[64] Pisanello's predilection for continual readjustment was as unwavering during the very last stages of painting, when his "improvements" had a minimal impact on the overall work, as in the earliest stages of drawing the tournament *sinopia*, when the composition was still in flux and his decisions were important for the design as a whole. Pisanello continued to assess the results of his work critically throughout the entire execution of the cycle, trying to correct its weaknesses as he saw them.

One alteration, eventually left unresolved, is Knight 1's horse (Fig. 135). The several superimposed images of horses are sufficiently confused to make it difficult to determine which might have been Pisanello's final choice of configuration. Of the three shadowy horse's heads, the one reaching down to graze seems to be an earlier idea, and the central, frontal head the form finally preferred. Astonishingly, Pisanello's exploration of the shifts in the horse's pose was undertaken after the *pastiglia* had been applied to the original image.[65] Another such "improvement" involved the redheaded youth in profile on Wall 2 (Fig. 136). He had been painted in *fresco* or *mezzo fresco*, and that part of his profile immediately adjacent to some relief had been incised before Pisanello decided to superimpose the image of a frontal helmeted warrior over that of the young man. As the fresco survives, the alteration seems so inconsequential to the composition as a whole as to be a pointless reelaboration. A further last-minute insertion was the row of knights incised, after the black ground had been painted, into the *intonaco* at the extreme upper right of the tournament scene (Fig. 137). Their armor was to be silver, and lime white was spread to receive the paint for the flesh tones; some few traces of the relief and lime white still survive. Pisanello may have wanted to allude more obviously to the prose *Lancelot*'s account of the sixty knights captured in the tournament, or he may have wanted to ease the transition from the tournament to the adjacent landscape, or perhaps he simply decided to fill what he perceived as a compositional void. Only the *pastiglia* technique, in which the many *pentimenti* would have been concealed by the opaque relief layer, permitted such an approach to mural painting. Pisanello's extensive use of *pastiglia* may even have been encouraged by his ingrained working habits. Whatever the artist's underlying motivation, his readiness to introduce all these changes as afterthoughts is consistent with the temperamental pattern revealed throughout the work. Even in the final, "page proof" stages of the mural, he was still

involved in a process of addition and elimination. The fresco painting thus reinforces the observations made in chapter 6 about the changes made to the composition between *arriccio* and *intonaco*.

The unfinished cycle discloses two persistent traits: perfectionism and flexibility. Pisanello apparently reconciled intense concern for exactness of detail with an ability to forsake an idea at any moment in favor of a better, or newer, one. Some of the evidence on the *intonaco*—the redheaded youth, Knight 1's horse, the retracing of Knight 17's club (Fig. 126)—could be read as a sign of petty compulsiveness, a tortured reworking of the unnecessary; but we must beware of such an interpretation. Many of the changes Pisanello made between *sinopia* and fresco appeared equally inconsequential to the composition until we understood the role that each alteration played within the scene as a whole. Because the work on the *intonaco* was never brought to a finish, we cannot evaluate the long-term results of the modifications made at this stage as we can assess those made earlier to the *sinopia*. Pisanello's grasp of his essential objectives in the design of the composition was such, however, that his experimentation with different forms, even at such a late stage in the execution, should be read as a versatile flow of new ideas similar to those that benefited the work at earlier stages.

Pomponio Gaurico interpreted two medallic "self-portraits" of Pisanello as evidence of the artist's overwhelming ambition.[66] This unfinished cycle reveals the particular form it took: an unusual combination of compulsive perfectionism and an unrepressed flow of creativity. Pisanello's determination to plan as thoroughly as possible at each phase of the work is balanced by his continual willingness to consider changes. Whenever he focused his attention sharply on any detail, he displayed a readiness to jettison the very planning to which he had previously given so much fastidious care. The amount of preparation devoted to the cycle is offset by the impulsive nature of some of the alterations, giving an almost improvisational character to the forces underlying its creation. The extent to which these murals were reworked may be a rare case in the history of fresco; the art that survives is a moving testimony to the intensity of Pisanello's involvement in, and ambitions for, his work.

CHAPTER EIGHT

Social Context and
Iconography

W HEN its ceiling collapsed in 1480, the hall painted by Pisanello was referred to as a *sala*. While most rooms in fifteenth-century palaces did not have precise functions, contemporary treatises and letters indicate that the *sala* was not just another room but the hall in which the lord would receive visitors and offer hospitality.[1] Filarete, for instance, described the palace in the ideal city of Sforzinda as possessing a *maestra sala* for official ceremonies.[2] Alberti claimed that the word *sala* derived from *saltare*, to leap or dance, because it was where banquets and marriage ceremonies were celebrated with cheer.[3] At the Milanese court such ceremonies took place in the *sala grande sopra la sala verde* on the *piano nobile* of the castle at Porta Giovia, where in 1474 high officials gathered in state to witness the marriage contract of two-year-old Bianca Sforza and young Duke Filiberto of Savoy.[4] At the palace in Pesaro the marriage in 1489 between Maddalena Gonzaga and Giovanni Sforza took place in the *sala grande*, followed by a Latin oration praising the houses of Gonzaga and Sforza.[5] In Ferrara the function of the *Sala dei Mesi* in the Palazzo Schifanoia is as undocumented as that of the *Sala del Pisanello*, but scholarly opinion concurs that its location, its scale, and its decoration indicate that it was intended to be a major hall of state for public celebrations.[6] A fifteenth-century ruler needed a large space where important visitors were greeted, contracts signed, and diplomatic speeches made. The scale of the *Sala del Pisanello*, its location between three wings of the *Corte*, and its direct access by means of an outside stairway suggest that it was one of the most important spaces in the mid-century Mantuan palace and probably its main *sala*, the room in which Lodovico Gonzaga and Barbara of Brandenburg received princes from rival courts with due ceremony and suitably lavish hospitality.

In this chapter we shall therefore consider the iconography of the murals in the context of the kinds of activities that habitually took place in spaces such as the *Sala del Pisanello*, basing ourselves on fifteenth-century accounts of some of the events—tournament, banquet, love affair—and some of the motifs—horses, armor, landscape, dwarfs, clothes—depicted in the hall.[7]

Sensitivity to the connotations that these events and motifs held for Quattro-cento *signori* will help to elucidate the significance of these pictorial images for the Marchese who commissioned the cycle and the princes who looked at it. A sense of the social context—the life that unfolded in such frescoed halls—should also establish some of the criteria that influenced princes when consid-ering subjects and programs for the decoration of their personal surround-ings.

"Nuptiarum et convivarum alacritas celebretur."[8] The decorative pro-gram of the *Sala del Pisanello*—which included a banquet offered by a king fol-lowed by a *festa*—would have enhanced the cheer of the banquets and mar-riages for which Alberti said a *sala* was intended. We know that Lodovico and Barbara took pride in the hospitality they lavished on their guests during the Congress in 1459. Feasts offered at North Italian courts on special occasions such as weddings were invariably "sumptuous and overpowering."[9] Huge quantities of food were consumed. In 1463, during Federico Gonzaga's wed-ding to Margaret of Wittelsbach, eight hundred people, seated at twenty-seven tables in the *Sala Grande* of the Mantuan palace, ate and danced over a period of three days.[10] It was, his mother said, "an honorable and worthy feast."[11] They consumed, according to Schivenoglia, 84 oxen, 1,174 calves, 54 lambs and kids, 8,338 pairs of chickens, 287 cheeses, and 67,800 eggs, among other foodstuffs sent from farms in the Mantovano.[12] The banquet given in Pesaro for the marriage of Maddalena Gonzaga to Giovanni Sforza in 1489 consisted of thirteen courses. In a letter home Maddalena itemized the menu dish by dish and course by course. The feast started with candied almonds, a sweet of almond paste, a sweet of dipped pinenuts, sugar biscuits, sugar wafers, and sweet wine, followed by veal liver with sweetbreads, filets of pork, filets of chicken and goose, thrush, quail, turtle doves, and ham with white and red sweet wines; capons, veal and kid breasts, salted beef in great quantity; heads of veal, deer, hare, rabbit in pork broth, and capons in sweet cream sauce and Spanish cream soup. They then went on to tackle partridges in orange sauce, ricotta cake covered with anise seeds, capons in violet-fla-vored sauce, fried *lasagne* covered with sugar; capons, ducks, geese, veal, pork chops, stuffed suckling pigs standing upright on painted boards, refined mus-tard, fresh grapes, lemons; jellied boar, pigeon pie, chicken in the Spanish manner with pheasants and partridges, minced veal and capon, pear cakes, capon rissoles in aspic, and ostriches. They ended with stewed pears and pears covered with anise or raisins; assorted fruits, Parmesan cheese, chestnuts, marzipan, biscuits, wafers and wine, comfits, pinenuts, cinnamon, almonds,

anise, and small and large candied almonds with red wine. The meal over, the dancing went on for hours.[13]

This may sound like a lot of food, but at the feast held after a tournament in Ferrara in 1462 Federico Gonzaga counted twenty-two courses and as many wines.[14] The account of the particularly sumptuous nuptial feast given in Bologna for the marriage of Annibale Bentivoglio to Lucrezia d'Este in 1487 gives more details on the elaborate presentation of the food. At one point a sugar castle with towers and battlements was placed in the middle of the *sala*. It was full of live birds that were allowed to fly out of the castle, to the *piacere et diletto* (pleasure and delight) of the guests.[15] Another course consisted of a peacock for each guest, presented with its tail feathers spread out in a fan; each bore a shield with the guest's arms.[16] Some of the courses were veritable works of art. The cooked animals and birds were so braced on the dishes that, covered with their feathers and furs, they seemed alive to the diners.[17] The relation between the cooked dish and the live animal was much more direct than we would care for today. Rabbit pies were accompanied by a cage full of rabbits, which were allowed to run around the room "to the laughter and pleasure of the guests."[18] The *pièce de résistance* was dishes of whole suckling pig served while a fat squealing pig struggled to escape from a cage placed in the middle of the *sala*.[19] The Bentivoglio-Este banquet finally ended with the pleasanter sound of trumpets and pipes, just as the Gonzaga-Sforza marriage feast in Pesaro ended with dancing to music. Music was an indispensable ingredient at feasts. The sound of trumpets often preceded the arrival of each course, and singers and lutanists would make sweet sounds during and after the meal. One such musical entertainment put on for Lodovico Gonzaga's sons in Verona in 1463 evokes the particular site of the *Sala del Pisanello*. That hall too must have been on the *piano nobile* overlooking a *brolo*, because after supper two singers stood in the garden beneath the windows of the *sala* to sing Venetian love songs accompanied by lute.[20]

No depiction of the lavish banquet offered by King Brangoire survives in the frescoes, but we may safely assume that visitors to the *Sala del Pisanello* would have been impressed by the illusionistic display on the wall of some, if not all, of the succulent dishes and multiple courses that they were accustomed to being served on great occasions. Frescoes of eating scenes were common in fifteenth-century castles, although most have disappeared. Dictating the subjects to be painted in the Castle of Pavia in 1469, for instance, Galeazzo Maria Sforza decided to include separate scenes of himself and the Duchess of Milan being served with food and wine at table.[21] We also have the

response of a fifteenth-century commentator in Ferrara to the sight of painted scenes of food being prepared in the kitchen and eaten outdoors *sur l'herbe*. The felicity, or skill, of these frescoes in the Palace of Belfiore was such, wrote Sabadino degli Arienti, that he could almost smell the delicious aroma of the pheasants and capons.[22]

"At dinner we have several pleasures: harpsichords, lutes, and jesters," wrote Sforza Maria Sforza in 1468.[23] Seated at table, intent on Albertian *alacritas*, the *signori*'s pleasure was increased by the presence of jesters and dwarfs.[24] "Buffoonery is the life and soul of a court," declared Pietro Aretino, and collecting buffoons and dwarfs was a favorite pastime in Italian courts.[25] As the fifteenth-century chronicler Matarazzo pointed out, *buffoni*, like dogs, horses, sparrow hawks, and wild beasts, added to the magnificence of the lord.[26] Dwarfs were regarded as pets and personal property like lapdogs and parrots. Their chief appeal lay in their sensational appearance, of grotesque disfigurement combined with childish stature. "The ladies and gentlemen caressed him and were astonished at the sight of his body," reads an account of the Venetian reception accorded the Mantuan dwarf Morgantino in 1530.[27] In addition to the amusement provoked by display of his stunted form, a court dwarf, like a jester, often provided entertainment by his ready wit or his foolery.

> His simplicity was such that he seemed endowed with the most cunning talent, and his deformity pleased more than if he had been composed of the most beautiful forms,

wrote Battista Fiera when the Mantuan fool Mattello died in 1499.[28] Marchese Francesco Gonzaga was inconsolable at the loss. "I hope I could replace anyone else I lost," he wrote, "but Nature would not know how to create another Mattello."[29]

Like the romances, dwarfs and *buffoni* were often exchanged between courts to lighten illness and dispel melancholy. It was sometimes as difficult to effect their return as it was to persuade the Este to return borrowed books.[30] In 1498 Alfonso d'Este, suffering from syphilis, did not return Mattello until his brother-in-law, Francesco Gonzaga, sent a messenger to collect him. Alfonso wrote to Gonzaga,

> You cannot imagine how much delight, recreation, and pleasure I had from him . . . he relieved so much anxiety and irritation that at times I no longer felt the pain, no matter how bad it was.[31]

We can appreciate why, a couple of years earlier, Isabella d'Este, had refused

to lend Mattello to Gaspare di Sanseverino: she had no guarantee of his return and without him would be bereft of the recreation he provided.[32] Some of these dwarfs and fools peregrinated from court to court in much the same way as did court artists like Pisanello.[33] Scocola, depicted with Borso d'Este in the frescoes of the *Sala dei Mesi* in the Palazzo Schifanoia in Ferrara, was, for instance, a *soavissimo istrione* (very sweet storyteller) who was much in demand.[34] In 1462 he wrote to Lodovico Gonzaga and Barbara of Brandenburg from Milan boasting that

> these ladies and gentlemen won't let me rest; I have to go continually from one to another, and I assure Your Excellency that I made them laugh so hard that many times they lost their dinner. So long as I am here I shall try to give them pleasure by whatever means I can. I pray Your Excellency to let me know when you would like me to come [to Mantua].[35]

In the *Book of the Courtier* Castiglione described Scocola's means. It was the buffoon's profession to "make faces, weep and laugh, mimic voices, wrestle with himself . . . put on peasant's clothes in front of everyone . . . and things of that sort."[36] Fifteenth-century nobles enjoyed jokes that were usually simple-minded and often, by our terms, crude. Horseplay predominated. We have a description of Federico Gonzaga's *buffone* Pre' Stefano in 1516:

> He did many funny things: he dressed like a miller and ran among the millers throwing flour all over the men and children; the children started to throw dust and so much was thrown that they almost suffocated. Then he dressed as a woman and ran with the whores, and accompanied the whore who was last and began to cry and make faces, so that everybody died laughing, and he did many other funny things.[37]

Princes would meet on a level with their *buffoni* and join in their pranks. "I have become a greater fool than Diodato," acknowledged Galeazzo Visconti, recounting the three-part songs that he and the Duchess of Milan sang with the jester in 1491.[38] Occasionally the wit comes across on paper and we get glimpses of why *buffoni* were highly valued possessions. In 1517, for instance, Nanino, "the little dwarf," wrote in high spirits to Federico Gonzaga to tell him that his father, Marchese Francesco, had elected Nanino as first-born son and hence heir to the Mantuan state, and to suggest that Federico had better make other plans for his own future.[39]

The words that recur in connection with *buffoni* and *nani* are *recreatione*, *delectatione*, and *piacere*. "Every day I take more pleasure and solace," wrote Francesco Sforza in 1451 of his dwarf Biasio—possibly the *buffone* Biaso

depicted in the second *salletta* in Pavia Castle.[40] This sentiment is echoed again and again. "Her words and acts have become so pleasing that we estimate she will make the best jester in the world and we hope to take pleasure in her," wrote Isabella in 1491 of another jester.[41] *Buffoni* were particularly prized at the Mantuan court, where they were considered indispensable to the cheer of its social life and of banquets. There were, for instance, "several kinds of fool" at Federico Gonzaga's wedding in 1463.[42] One of these was probably Barbara of Brandenburg's dwarf, Franceschino, whose mastery of his "small horse" had earlier aroused the wonder of the court of Ferrara.[43]

Allowed great familiarity, *buffoni* used caricature freely. Mattello specialized in parodies of monks and religious ceremonies; Nanino, disguised as a bishop, satirized the Duke of Milan's ritualistic entry into Mantua in 1512.[44] A *buffonesco* charade of chivalric investiture took place at the court of Ferrara in 1491, and dwarfs would entertain their masters by emulating knightly exercises.[45] Dwarfs almost certainly imitated contests of chivalry in fifteenth-century tournaments and appear to be doing exactly this in the Pisanello frescoes.[46]

No dwarfs occur in the *Lancelot* episode illustrated in Mantua, although many are mentioned in chivalric literature.[47] Nonetheless, on Walls 1 and 4 at least three small dwarfs follow the Gonzaga knight with wide-brimmed *cappello*, identified as Bohort, who approaches the tournament from the right (Figs. 17 and 34).[48] In the *sinopia* Pisanello originally planned more dwarfs; there were at least three on Wall 1 alone (Fig. 138). Their midget proportions in the painting may be explained by the fact that dwarfs of the smallest stature were the most prized. Francesco Sforza's dwarf Biasio, for instance, had a brother, "più nano e minore ancora," more dwarfish and even smaller, whom the Duke coveted, and Isabella d'Este tried to breed a race of ever smaller dwarfs.[49] In 1462 the horse of Barbara of Brandenburg's dwarf Franceschino was described as a *cavaleto*, a little horse, but the dwarfs painted by Pisanello ride horses and wear plumed crests which, being on the same scale as those of all the other knights, emphasize their tiny stature.[50] Most of Pisanello's dwarfs were never painted and so are hard to read, but one of them, number 26, looks directly at the viewer, head cocked so that one eye peers quizzically around the neck of his outsize mount (Fig. 139), his glance reminiscent of Alberti's instruction to the painter to include someone in the *historia* who by look or gesture invites the viewer to laugh or weep with the events in the narrative.[51]

For the fifteenth-century viewer the connotations of the painted dwarfs must have been similar to attitudes toward them in actuality. On the one

hand, as anomalous natural phenomena, dwarfs were valuable possessions. It was customary to dress them up, and the dwarf (no. 25) who leads the Gonzaga knight's retinue sports the family colors of red, green, and white (Fig. 68). He would have been read as an attribute identifying the knight who precedes him as a Gonzaga while making reference to valuable Mantuan possessions. The dwarfs presumably painted in the *camera a nanis* of the Trecento Gonzaga palace must have had a similar function.[52] On the other hand, given the role of dwarfs in court life as a source of *piacere et recreatione*, Pisanello's painted *nani* must have had humorous connotations. The cocked head, impertinent expression, and mocking air of the mounted dwarf awaiting Saint George in the S. Anastasia fresco (Fig. 42) there indicate that Pisanello's depiction of these creatures reflected the license they were given in life. While determining what was visually entertaining to people of a previous age is inevitably problematic, we may speculate that these dwarfs, in life associated with laughter, would have evoked a similar response when glimpsed in art. The illusionistic *nani* can be read as inviting the Gonzaga and their guests to take *piacere et recreatione* in the murals decorating the *Sala del Pisanello*.[53]

Thanks to the publications of Alessandro Luzio and Rodolfo Renier, much is known about dwarfs at Renaissance courts. Similar information is not, however, available on questions of love and sex. The reticence that governs such personal matters in Quattrocento sources makes it much harder to assess the connotations for the fifteenth century of the images of Bohort and the princess's love affair. The silence that the historian faces on these issues is almost as inhibiting as the total loss of the images depicting the romance that once ran along Wall 4.[54] In the prose *Lancelot* the responsibility for the affair is taken by a beautiful, highborn lady who falls in love with the hero's person and prowess and entices him to her bed through magic after he has rejected her in marriage. Although stories in which women take the initiative occur in such books of the period as Boccaccio's *Decameron*, our tale has all the ingredients of a male fantasy of female sexual initiative.[55] Such fantasies must have had exciting connotations for a culture in which women were subordinate and were expected to defer to male authority. The independent princess of the Chastel de la Marche, determined to get her sexual way, would seldom, if ever, have been encountered in the circles in which Lodovico and Barbara moved. Indeed, the princess's behavior, difficult to imagine in real Renaissance life, would have profoundly shocked the authors of innumerable Renaissance treatises stating that a woman's most valuable asset was her chastity.[56] Not only chastity but also obedience to male authority was the cultural norm for highborn Renaissance ladies, even a princess like Barbara of Brandenburg.

This ruler's wife, who seems to have been quieter than her voluble Italian family, took an active, albeit unofficial, role in governing the marquisate.[57] Administering local government and directing affairs of state during Lodovico's frequent absences, she held political opinions of her own which she was not afraid of expressing. Her views won her the respect of Mantuan ambassadors, who sometimes ventured their most speculative and outspoken diplomatic evaluations to her rather than to the Marchese.[58] Yet Barbara, though she was her husband's social superior and often acted as his political equal, wrote letters to Lodovico in a tone that was consistently deferential. She submitted to his authority in most matters just as women of the period were supposed to do. Had King Brangoire's daughter been a Quattrocento princess like Barbara, she would, for instance, have accepted without demur Bohort's explanation of why he could not wed her or bed her instead of seeking—and finding—a magic solution to her—and, perhaps, also his—dilemma.[59] Under these circumstances, the fantasies embodied in the princess's curiously modern story may have had a special appeal for the Renaissance viewer.

The love affair between Bohort and the princess, with its glorification of sexual passion, implied that a union between princes in real life could involve mutual passion and love—a possible but probably not usual feature of actual marriage between Renaissance princes. Alliances between members of the ruling classes were normally arranged affairs, in which a prince married a family for political and economic reasons rather than an individual for personal reasons. Although any assessment of the quality of an intimate relationship by means of dictated letters is inevitably speculative, there are substantial hints to suggest that strong bonds of affection linked the Gonzaga couple who commissioned the Arthurian cycle. About to deliver her youngest child in 1463 at the advanced age of forty-one, Barbara used a vivid metaphor that cast the Marchese in the role of a comforting midwife, saying that Lodovico's presence nearby would help to relieve her labor pains, "for the hope I have in you, that it seems you must always help me, so that it would not be wrong to say that you serve me as a good midwife."[60] Certainly, Francesco Sforza implied that this Gonzaga marriage was a loving, sharing partnership when he instructed Lodovico to tell certain matters to nobody except Barbara— "because I know that you and she are two bodies [but] one soul."[61]

Arthurian romance in general and the prose *Lancelot* in particular were charged with erotic suggestiveness for the Renaissance. The erotic fantasies embodied in the romance are made explicit by Dante in his passage on the lovers Paolo and Francesca in the *Inferno*. They began their affair because they were overcome by the suggestiveness of the *Lancialotto*, or prose *Lancelot*, that

they were reading together.[62] The two lovers identified with those in the romance, made the *Lancelot* into their go-between, and gave it the name and function of a person. Pictures surely functioned in much the same way as medieval French prose—if not a great deal more effectively—as we may deduce from the high percentage of erotic scenes among the few secular images that survive from this period. In Florence the story of the *Chastelaine de Vergi*, a dramatic tale of love, jealousy, and a scorned woman's murderous revenge, decorated a large upstairs room in the Palazzo Davanzati. In Piedmont amorous activities and enjoyment of long-lost sexual vigor were depicted with humor and empathy on the walls of the *Sala Superiore* of the castle at La Manta (Figs. 40 and 41).[63] These cycles attest to the fact that early Renaissance patrons considered erotic subjects to be appropriate for the decoration of their *sale* or public reception halls; but they also commissioned erotic themes for their private quarters, those *camere* in which lovemaking actually took place. To dine in one's *sala* but to sleep in one's *camera* seems to have been a typical pattern for fifteenth-century high society.[64] In the 1407 inventory of the Gonzaga palace, for instance, beds were recorded in most rooms of the *Corte* except those specifically referred to as *sale*.[65] Perhaps significantly, Agnese Visconti Gonzaga conducted her doomed romance, the event that led to her beheading by Lodovico's grandfather, partly in her *Camera Lanzaloti*, presumably frescoed with the romance of Lancelot and Guinevere.[66] We may accordingly conclude that any such real-life affair as that between Bohort and the princess was unlikely to have taken place in the *Sala del Pisanello* itself, while also recognizing that the loss of these scenes of low-key titillation inevitably precludes an assessment of their meaning for the Gonzaga and their guests.

The *piacere et recreatione* associated with tournaments, like feasts and dwarfs but unlike love affairs, were frequently reiterated on paper.[67] Borso d'Este held a tournament in 1462 for the *piacere et solatio* of the citizens of Ferrara,[68] and one of Francesco Gonzaga's motivations in holding a tournament in 1485 was *honesto piacere*, innocent pleasure.

Wishing to honor as much as possible his illustrious brother-in-law, Count Delfino, and to give his lordship some innocent pleasure, the Marchese of Mantua has decided to hold a joust with arms of courtesy [*arme da demenino*], since nothing is of greater fame or praise than the military art, in which nobody can reach perfection without exercise . . . thirsting for immortal glory, imitating his illustrious ancestors who always manifested their singular virtue and magnanimity with worthy effects . . ."[69]

As Gonzaga's proclamation stated, tournaments were a standard form of exercise for soldiers in time of peace. As mock battles, they were essential practice for exercising the military skills necessary to cavalry.[70] Some of the best jousters were drawn from the ranks of professional soldiers, although the rules of at least one fifteenth-century tournament decreed that amateur status was a necessary condition of participation.[71]

A fifteenth-century tournament was fundamentally different in character from the violent encounters of the early Middle Ages, in that the aim was no longer to kill one's opponent or to take him prisoner against a large ransom. Changes were instigated to make jousting less dangerous, and as the outward trappings of the event increased, so the danger lessened.[72] Tournaments were usually held in spring and marked special occasions, such as the marriages of Federico Gonzaga in 1463 and of Francesco Sforza's daughter, Ippolita, in 1465[73] or the appointment of a new rector of Pavia University in 1452.[74] They also celebrated the conclusion of a peace treaty or the arrival of an important visitor. In 1440 a tournament in Venice celebrated the end of the war that left Mantua and Gianfrancesco Gonzaga at a disadvantage. Francesco Sforza issued *gride* or proclamations for a tournament immediately after he conquered Milan in 1450, and it seems to have become an annual event.[75] In 1442 Barbara of Brandenburg was honored by a *giostra* when she visited her grandmother on a trip home to Germany.[76] In 1474 the tournament given in honor of Lodovico's brother-in-law King Christian of Denmark lasted two days during which a hundred lances were broken.[77] Tournaments usually lasted three days, the knights jousting two hours a day, but the "vago et delectevole torniamento di homini strenui et vallerosi" given by Ercole d'Este in Reggio in 1476 went on for a week.[78]

There were a variety of ways to joust, many of which are depicted in the *Sala del Pisanello*. Divided into two teams, each with a captain and a standard, and dressed differently so as to be recognizable, the jousters would charge with heavy lances, engage in single combats with swords and clubs, and join in the *grande mêlée*. Jousts *a demenini*—with the blunted "arms of courtesy"— were also popular: one took place, for instance, at Federico Gonzaga's wedding in 1463.[79] At the upper left of Pisanello's fresco on Wall 1 (Fig. 82), knights can be seen, visors closed, charging at full tilt and smashing their lances against those of the opposite team. These tipped lances were made of soft wood that broke easily on impact, and knights would speak of "breaking so many lances."[80] In 1491 Gian Galeazzo Sforza wrote an excited letter boasting about the number and size of the lances broken at a tournament he gave:

More lances were broken than has happened in any joust in Italy for a great
many years and the lances were much larger than usual, beyond the credulity
of anyone who didn't see them.[81]

Many fragments of shattered lances lie scattered across the center of Pisanel-
lo's picture field. To the right of the tournament, knights are engaged in the
climactic encounter known as the *grande mêlée*, the "mix-up" or hand-to-hand
fight between the teams of knights (Fig. 140). The entire field has become a
swarm of knights battering each other with their swords so that the *mêlée* has
become locked in a confused standstill at upper right. Observers would prob-
ably have read the painted swords as being blunted, as were the real ones in
Ferrara in 1462.[82] The more customary single combats are fought in Pisanel-
lo's fresco along the lower zones of the scene by jousters using swords and
mazze de legno, wooden maces. In this version of the joust, recorded in the
1462 tournament in Ferrara and known in English as the baston course,
knights attacked each other with the kind of wooden club flourished by
Knight 17 in Figure 126 or the stumpy lance carried by the dwarf in Figure
68.[83]

 With all this activity, it was inevitable that some knights would be thrown
to the ground and perhaps be injured. The rules for the 1462 tournament in
Ferrara decreed that the joust was over for any knight who fell from his horse,
however this occurred: whether the animal gave way beneath him or he
received an overwhelming blow from an opponent.[84] In that tournament any
knight who even removed his helmet during the fray forfeited all hope of win-
ning the prize, although the *regolamento* governing the tournament held in
Milan in 1465 contained many exceptions to this rule.[85] Several of these less
fortunate jousters can be seen in the Mantuan fresco (Fig. 106), one of them
badly shaken up. His fate would have heightened the tension and excitement
of the depicted encounter, inducing an empathetic frisson of fear and disquiet
in the viewer who regularly jousted. The Gonzaga were in fact well known
for their skill in jousting, and Barbara of Brandenburg's uncle, Margrave
Albert, was said to have won every tournament he entered. Wearing only
shield and helmet in eighteen single combats—much like Meliduns li Envois-
siez, who swore to eschew armor for a month (Fig. 29)—the Margrave was
each time victorious.[86] "We are foremost in the tournament," he once
declared, "and intend to remain so with God's help."[87]

 The *palio* or prize at tournaments was always the same: a length of rich
cloth. In Mantua in 1463 there were two *palii*, each of 25 *braccia* of crimson
silk velvet, and both were won by members of Francesco Sforza's house-

hold.[88] In Ferrara in 1462 the prize of 20 *braccia* of silver brocade, worth 100 ducats, to be given to the knight who conducted himself "most vigorously, most valiantly, and most like a knight-errant," was awarded to the hometown favorite, Sigismondo d'Este, because, in Federico Gonzaga's words, he showed "the most prudence, spirit and virility."[89] Prizes were usually worth between 50 and 150 ducats but were sometimes especially valuable. The *palio* offered at the tournament held in Venice in 1458 was worth 500 ducats, and in 1464 Borso d'Este, well known for his ostentation, also gave each jouster a ring just for participating in his tournament.[90] Nicolò degli Ariosti was suitably impressed by the gesture. "Do not think," he wrote to Lodovico Gonzaga in a long and detailed letter that assumed the recipient's deep interest in the subject, "that the rings are worth only a florin; there are some worth more than a hundred, some worth 80, some 50, some 60, some 10, some 15 and 20 . . . [altogether] these rings cost him from 600 to 700 ducats."[91]

Quite apart from the cost of the prizes, tournaments were expensive affairs. Jousters expected local expenses, such as room and board, to be borne by the hosts. In 1476 the *Anziani* of Reggio refused to pay the expenses of participating jousters and received a strongly worded letter from Ercole d'Este pointing out how confused their priorities were. The citizens of Reggio were undertaking large expenses without questioning them, whereas it was the small expenses that brought the most honor, he said. If the cost of lodging the jousters seemed too great, they should eliminate other budget items that would bring them "less honor and less reputation."[92] The *Anziani* declined to change their minds, and in the end Ercole was obliged to pay for the jousters out of his own pocket.

Not only the jousters but also the horses cost a lot. Writing home in 1475, Rodolfo Gonzaga, Lodovico's fourth son, grumbled at the heavy expense of keeping his horses on in Florence when Lorenzo de' Medici decided to prolong the tournament.[93] Tournaments also took their toll of horses, and compensation had to be paid for *cavalli guasti*, those mounts that were maimed or killed.[94] Warfare of the period also demanded immense numbers of horses, which were both expensive and in short supply.[95] The centrality of the horse to Renaissance life cannot be overemphasized, and the many horses in Pisanello's frescoes must have been charged with significance for the fifteenth-century viewer.[96] Contemporary descriptions of tapestries, for instance, always specify whether the protagonists were shown *a pede*, on foot, or *a cavallo*, mounted, and in 1515 Sanudo noticed the pictures in the Gonzaga palace showing the Marchese of Mantua's "handsome horses" as well as his fine dogs and his dwarf.[97] By this date the Gonzaga stables were celebrated all over

Europe, and Mantua's rulers impressed foreign kings with gifts of purebred horses.[98] The Gonzaga passion for horse breeding was undoubtedly stimulated by their activities as *condottieri* and by the high cost of replacing horses in time of war. The stables were first mentioned in Lodovico's period, although they may have been started earlier. Francesco Sforza sent Lodovico two Arabian stallions to improve his stud in 1460, and three years later the Marchese wrote,

> We have started to breed a race of horses and have every kind, large, medium and small.[99]

The Gonzaga consistently promoted their stables in works of art. The *Sala dei Cavalli* in the Te palace, for instance, was part of a continuing tradition of similar rooms devoted to images of Gonzaga steeds.[100] The horses depicted in the tournament scene in the *Sala del Pisanello* should accordingly be seen as the earliest surviving instance of this propaganda campaign. Mounted on the finest steeds that money could buy or the Gonzaga could breed, Pisanello's knights show off the riches of the Gonzaga stables, riches appropriate to the *condottiere* who had to mount large numbers of men in wartime.

Meliduns li Envoissiez and the intrepid Margrave Albert of Brandenburg may have preferred to fight armed only with shield and helmet, but Pisanello's knights in the tournament scene wear the most expensive and up-to-date armor from Milan. The eye-catching butterfly elbows, the heart-shaped wings on the poleyns (knee protectors), the flat-headed rivets at the back of the helmets—characteristic features of fifteenth-century armor—can also be seen in six examples that still survive in Mantua.[101] Pisanello's designs for armor, however, seem more modish than surviving suits. His pauldrons (shoulder pieces), for example, are larger and more sweeping in design than those that have come down to us. The armor sported by the knights in the tournament is identical to that worn by Lodovico on the medal that Pisanello made for him (Fig. 55). On that medal the armorer's mark, two A's surmounted by a crown placed on the shoulder plate where it was most visible to the connoisseur, advertised Lodovico's pride in the quality and origin of his suit. He patronized the same designer—alas, no longer identifiable—as Niccolò Piccinino and King Alfonso.[102] Lodovico Gonzaga, his father, his brothers, and his nephews, however, had a longstanding account with the firm of Tommaso Missaglia and sons,[103] and his brother-in-law King Christian of Denmark also patronized the Missaglia shop when he went sightseeing and shopping in Milan during his 1474 visit.[104] In the continual struggle to obtain armor that was comfortable, the firm was known for the care with

which it fitted its custom-made suits. When in 1466 the King of France wanted armor "that does not hurt him in any way whatsoever because his body is so delicate," it was to the Missaglia that he turned.[105]

Participants in tournaments competed with each other not only in displays of physical endurance and expensive armor but also in exhibitions of up-to-date fashions. Like festive occasions generally, tournaments and banquets were excuses for ostentation in which each participant would vie with his peers in richness of clothing and jewels. In the fresco the gleaming armor is partially covered by richly brocaded mantles, called *giornee*, which, along with the horses' caparisons, were fashioned from the kind of silver and gold cloth that was given as prizes at tournaments and as bridal gifts (Figs. 126 and 102).[106] In 1463, for instance, Federico Gonzaga and Margaret of Wittelsbach were given lengths of crimson gold cloth by the city of Florence and by Bianca Maria Visconti, and a length of green gold cloth by her son Galeazzo Maria Sforza.[107] When Filippo Maria Visconti gave Emperor Sigismund a coronation gift in 1431, he chose a length of gold brocade and two lengths of crimson and red velvet.[108] The painted knights in the *Sala* wear not only richly worked *giornee* but also stylish helmets topped with extravagant bulbous crests and plumes that sweep down the wearer's back like a bird's feathers (Figs. 97 and 45). Tempting targets in the baston course, they recall the golden helmets topped with peacock plumes strutted by knights in a procession in Padua in 1466.[109] The crests *a la turchesca* worn by Lodovico's son Rodolfo and his followers in 1475 made a big hit in Laurentian Florence, where they were reportedly not used to seeing such finery.[110] Pisanello of course had a lot of practice in designing flashy helmets, and decorated those for King Alfonso with elaborate crests and coats of arms.[111]

None of this splendor would have gone unnoticed by the fifteenth-century viewer. Tapestries were always described in terms of what the figures wore rather than what they did; books were inventoried more often for their covers than for their contents. At the 1462 tournament in Ferrara, Borso d'Este congratulated Alberto de la Sala for the stylish plumes on his helmet and chose Teofilo Calcagnini as the knight with the finest surcoat.[112] In accounts of visits to each other's courts, North Italian *signori* describe their competitors' finery in repetitive detail. Interest focused on the color and the cloth used, in descriptions that read much like captions in today's society pages. In 1463 it was recorded that Margaret of Wittelsbach wore crimson gold cloth for her entry into Verona and that she was met by a hundred youths all dressed in velvet.[113] At the Este-Bentivoglio wedding, it was recorded that Enea Mal-

vezzi was dressed in pink satin, Gaspare Malvezzi and Giovanni di Battista Malvezzi both in crimson satin, Jacomaccio Bargellini in violet-blue cloth and Salustio Guidotti in green satin.[114] Because it cost a great deal, dress was important to the Quattrocento.[115] The brocades, the satins, the velvets with which these princes arrayed their persons and their horses had a significance that went beyond mere love of adornment. An expensive appearance added to one's consequence and hence to one's power, and the display of finery that they ostentatiously paraded for each other's benefit was a visible symbol of wealth and magnificence.[116]

Humanists, especially those writing for princes, were in general agreement on the importance of a magnificent appearance. Francesco Filelfo at the court of Milan and Giovanni Pontano at the court of Naples discussed the virtue of *magnificentia*. In Filelfo's *Convivia Mediolanensia*, written in 1443 and dedicated to Filippo Maria Visconti, *magnidecentia*, defined as being exclusively a virtue of the rich and the highborn and as referring to all large expenditure, was said to confer on a prince the appearance of civilized behavior.[117] In the first sentence of his treatise *De Magnificentia*, Pontano, who codified many Quattrocento concepts, wrote:

> He who says that magnificence is the fruit of money in my opinion expresses an accurate concept that is founded in real experience.[118]

Alberti articulated the same idea in his treatise on the family:

> One can gain fame and authority by adopting riches in ample and noble things with much largesse and magnificence.[119]

The most useful discussion of magnificence for our purposes occurs in Sabadino degli Arienti's treatise *De Triumphis Religionis*, presented to Ercole d'Este in 1497. Magnificence is placed in the Fifth Book, which is largely devoted to a guided tour of several Estense palaces, with special emphasis given to their fresco programs. Toward the end of his treatise, Sabadino defined magnificence succinctly and bluntly as "public deeds and big expenses."[120] He was concrete in his catalog of the items it included. Magnificence was a quality embodied both in physical possessions, such as dress, gold and silver cloth, jewelry, textiles, and furniture, and in ephemeral events, such as family weddings, theatrical performances, jousts and tournaments, and hospitality generally. Summing up, he addressed Ercole d'Este:

> Let us finish this discussion of the magnificences, the glories, and the triumph of arms in jousts and tournaments, which you have put on more to honor

others and to give pleasure to your beloved people and splendid court than for your own delight, and this has not been without exceptional expense and [you deserve] magnificent praise.[121]

For Sabadino magnificence consisted above all in "largesse and amplitude in spending gold and silver in eminent things."[122] The importance he gives to these metals, used so abundantly in the *pastiglia* of the painted tournament in the *Sala*, is confirmed by other fifteenth-century sources. Pius II, for instance, noted with approval that all the garments of Francesco Sforza's retinue "glittered with gold and shone with silver," as befitted the superior wealth of Milan when the Duke arrived in Mantua for the Congress.[123] "Make his lordship dine dressed in cloth of gold," directed Galeazzo Maria Sforza's secretary when conveying the Duke's instructions for the fresco in Pavia Castle in which he was to be shown at dinner.[124] The desire for glitter even extended to the food the *signori* were served, and roast meats were sometimes covered with silver and gold leaf. The task of maestro Bernardino di Pasti as *indoradore de paoni* was to gild the peacocks served at the court of Ferrara, and 2,100 leaves of beaten silver and gold were consumed at the banquet following Ercole d'Este's marriage in 1473.[125] When Sabadino needed a suitable figure with whom to compare Lodovico Gonzaga, *liberalissimo presul mantovano*, he settled, for obvious reasons, on Saint Nicholas of Bari: Gonzaga "gems, vases, silver, gold, cloths, horses, grains, wines" were no less worthy, he said, than Saint Nicholas's three golden balls.[126]

The pictorial splendor of Gonzaga court life as portrayed by Pisanello matches the magnificence suggested by Sabadino's words. Because they could not have been obtained without exceptional expense, the subjects depicted in the *Sala del Pisanello* came under the heading of possessions and events that would have earned Lodovico Gonzaga the kind of "magnificent praise" that Sabadino was all too ready to bestow on princes. If art was expected to reflect the standard of material existence appropriate to the patron, only a great prince could have afforded a tournament, whether in art or life, on such a lavish scale as that provided by Pisanello. The self-image projected in this surviving scene is unequivocal. Ostentatiously displaying the latest thing in armor, their *giornee* and horses' caparisons glittering with silver and gold threads, parading on purebred horses from their famous stables, their equestrian skill enabling them to defeat all opponents, these painted Gonzaga champions manifest the glory and magnificence of their house in a work of art that had a permanence not granted to such events in mere reality.

Magnificence, the product of lavish spending, not only symbolized

power, but also added pleasure and delight to life. The possessions and activities with which princes surrounded themselves—the villas, gardens, hunts, *feste*, banquets, music making, jousts, jesters, romances, and frescoes—were all designed to bring them *solacium et placere*.[127] A persistent theme of this chapter has been the Quattrocento pursuit of *piacere et recreatione*, of which the subjects depicted in the *Sala del Pisanello* all formed part. Even the landscape on Walls 2 and 3 would have struck this chord (Figs. 11 and 12). According to Alberti,

> Our spirits delight to the highest degree where we see paintings showing pleasing landscapes, seaports, fishing ponds, hunting preserves, swimming pools, pastoral pastimes, and flowers and greenery.[128]

Galeazzo Maria Sforza evidently agreed with Alberti when he demanded that the *Sala de Sopra Grande* of Milan Castle be painted entirely with woods containing "deer, bucks, and other animals."[129] Apart from knights-errant engaged in marvelous exploits against all comers, Pisanello's surviving panoramic landscape includes castles, churches, belltowers, towns, forests, deer, wolves, and other animals. Such a landscape fell squarely among the subjects traditionally favored for the decoration of painted halls. The Trecento Gonzaga Palace contained rooms frescoed variously with trees, deer, leopards, falcons, lions, mountains, meadows; and many early Renaissance tapestries were described as "estates with streams and animals."[130] Such images, including the *pescagioni, caccie, giostre* (the fishing, hunting, and jousting scenes that Pisanello had earlier conjured up on the walls of Pavia Castle for the Duke of Milan), must have reminded viewers of the pleasures that the countryside held for them, the hunting parties and open-air feasts.[131] Bernardino Prosperi provides a Renaissance response to a panoramic landscape painted as a stage set in Ferrara fifty years after Pisanello's frescoes. "You never get tired of looking at it because it includes so many different things," he wrote to Isabella d'Este.[132]

In the architectural treatise he wrote at the court of Milan in 1461–62, Filarete discussed the decoration of rooms in the buildings of the imaginary city of Sforzinda. He asked for harmony between the function of a room and the iconography of its frescoes:

> I definitely want these places to be painted and decorated . . . [with subjects] relevant to the place.[133]

Lodovico Gonzaga needed a setting with which to impress his prominent guests, the "friends, relatives, kings, princes, lords, and magnates" who

would gather in Mantua on important occasions.[134] The choice of iconography for the *Sala* together with its site reveals the patron's intentions. Harmonizing with the social activities that took place inside and outside the hall and presenting idealized versions of favorite court recreations that were "relevant to the place," the decorative program of the *Sala del Pisanello* would, had the cycle been completed, have gratified a clearly defined need. It created an appropriate setting for the entertainment and astonishment of North Italian princes. We can safely conclude that the Arthurian story chosen for the *Sala* allowed for wide latitude in the depiction of familiar subjects charged with pleasurable associations for the fifteenth-century court.

We can imagine what a pleasant hall this would have been for entertaining and feasting at day's end in the hot Mantuan summers. The perfume of ripe fruit and blossoming flowers wafting up from the *brolo* below would have mingled with the aroma of the dishes being served at table. Plucked lutes and voices would have ensured that the sense of hearing, as well as those of taste and smell, was gratified, not to mention the sense of sight feasting on the images of painted banquet, tournament, and love scenes spread out on the encircling walls. The Marchese's guests from rival courts would have been as dazzled by the display of magnificence expressive of the status to which he aspired as they were impressed by the exhibition of horsemanship and courage appropriate to a Gonzaga *condottiere*. This art had a precise function both within the particular physical setting in which it was created and within the society for which it was produced. Within the competitive social world of North Italian court life, the murals would have conferred an image of magnificence, martial glory, and lavish hospitality on the Gonzaga family in the very setting in which they received their social rivals and political superiors.

Ideology and Style

I. *The Romance*

WE HAVE seen that Pisanello spent most of his career working for North Italian rulers; the long and enthusiastic ekphrases written by their court humanists indicate that his art corresponded to an ideal fostered in fifteenth-century court circles. It was the job of the court humanist to articulate his employer's taste and values, as Michael Baxandall has reminded us.[1] Hence, the humanists' critical statements provide grounds for investigating not only the particular terms in which Pisanello's contemporaries discussed his art but also the assumptions that underlay the humanists' praise and the implications of the artist's success for his patrons' values and taste. The low survival rate of Pisanello's paintings, however, rendered such evaluations difficult until the *Sala* frescoes were discovered. As one of the monumental works for which the artist was so renowned, the Arthurian cycle now affords a basis for exploring the relation among the critic's vocabulary, artistic style, and court ideology in the early Renaissance. Can the style of Pisanello's work, as it was defined—knowingly, unknowingly—by the humanists, be said to relate to the values, interests, and pretentions—in other words, the unconscious ideology—of Lodovico Gonzaga and his peers?

To the extent that literature distills the ideals of a society and reveals its beliefs and traditions, study of the prose *Lancelot* should also disclose some of the ideals and beliefs of Quattrocento readers and hence reveal an aspect of the intellectual climate prevailing at these early Renaissance courts.[2] What meaning did the content, the style, and the tone of chivalric romance, those vernacular *libri di ventura vechio* as they were defined in one Renaissance inventory, have for North Italian *signori*?[3] As we shall discover, the ideology of the prose *Lancelot* conformed to a desirable vision of life for Renaissance rulers, and court humanists discerned qualities in Pisanello's work that echoed some of the values embodied in the romance.

Little literary criticism has been undertaken of the ideology and the spirit, as distinct from the structure, of the thirteenth-century prose romance that was illustrated in the *Sala*.[4] We lack a modern interpretation of the concepts and the tone of the prose *Lancelot*. Historians of medieval literature are

uncomfortable about the disjunction that they perceive as existing between
the consciousness of the modern reader and the consciousness behind or
within a medieval text. Paul Zumthor, for instance, in his book on medieval
poetics argues that medieval literature is an aggregate of cultural ideas so dis-
tant from us in time as to escape totally from our experience of life in the
twentieth century.[5] The interpretation of chivalric romance is seen as partic-
ularly problematic because the texts, with their oblique and reticent tone,
resist subjectivist interpretation.[6] In discussing the *Lancelot* as the literary
source of the Mantuan cycle, we face an even harder task than usual. We have
to grapple with the emotional and cognitive styles of two distinct cultural
periods, neither of them our own, and propose an interpretation of the con-
cepts of the thirteenth-century literature that seems pertinent to the fifteenth-
century court.

The rise of the Arthurian legend in the twelfth century in France and its
rapid spread throughout Europe are one of the mystifying enigmas of literary
history.[7] For as long as four centuries Arthurian and chivalric romance con-
tinued to give pleasure to the imaginations and sensibilities of Western Euro-
pean courts. The themes of these chivalric works were succinctly summed up
by Ariosto, writing in Ferrara some fifty years after the *Sala del Pisanello*:

> Le donne, i cavalier, l'arme, gli amori,
> Le cortesie, l'audaci imprese io canto.[8]

"The ladies, the knights, the arms, the loves, the courtesies, the daring deeds
I sing." The plot of the thirteenth-century *Lancelot*, a vast assemblage of
worldly and courtly adventures, consists of these loves, courtesies, and daring
deeds. Never aging or developing, the knights and ladies wend their way
slowly through the dense forest from castle to castle, "querrant aventure par
étranges terres," indefatigable in their search for adventure.[9]

> [They] journey slowly towards their objective, stopping to sleep or carry
> through adventures . . . through woods and past the dens and caves where
> action takes place, past crossroads, hermitages, chapels but nothing else,
> except the castles that are virtually small courts, down paths which always
> lend to meaningful encounters.[10]

The knights' nomadic lives and search for each night's hospitality continually
placed them in new situations. The results were jousts, wounds, captivities,
sieges, rescued damsels, meetings leading to love affairs, and fantastic vows.[11]

The story illustrated in Mantua, as outlined in chapter 2, is one of a family
of similar tales, and we must turn to the entire convention to which it belongs

for its interpretation.[12] Plot and character in the Vulgate Cycle were ritual-ized, and the prose *Lancelot* consists of ever different variations on a basic for-mula. The princess's seduction of Bohort with the connivance of her nurse, for instance, follows a traditional pattern.[13] Again, the pursuit of love and the pursuit of arms often motivate each other in these tales. In our episode the two themes are interconnected by the princess's coquettish challenge to Bohort when she tells him that his hesitation to enter the tournament shows that he has no lady to fight for. The deeds of valor continually undertaken by Bohort and his peers emphasize the importance that this literature placed on physical prowess as an ideal. The extravagant promises made by the twelve knights at Brangoire's banquet to perform impossible deeds, for example, are typical of a work in which combats often take place without any motivation other than the knights' need to prove themselves once again.[14] Indeed, personal moti-vation in either love or arms is seldom explored in the Vulgate Cycle, and the knights' combats, presented without justification or explanation, seem as inevitable as the princess's desires.

The stories in the prose *Lancelot* are situated in identifiable settings, since the adventures take place in empty forests or isolated feudal castles. The for-tified castles are separated from each other by immense stretches of wooded country that, with the exception of a few hermits and the odd *vilain*, is vir-tually uninhabited. In the heart of the forest, King Brangoire's castle is an island of leisure and luxury. Although there is little attempt at description, we are given glimpses of the living conditions. A notable adjective is *riche*. After the tournament Bohort is dressed in a rich garment of red samite and ermine. The princess is recognizable as the king's daughter *because* she is so richly dressed. When the nurse visits Bohort's chamber, he is lying on a *very* rich bed. Surrounded by luxury, Bohort and the princess are also in the flower of their youth and beauty. We are repeatedly reminded that the princess is *une des plus beles puceles del monde* (one of the most beautiful damsels in the world), and Bohort's physical appearance is as highly lauded as his heroism.[15]

Another important ideal in the *Lancelot* is the highly developed code of eti-quette known as *courtoisie*. This involved attainment of the worldly graces required of civilized circles, especially courtly bearing and gracious hospi-tality.[16] Courtesy was the keynote of chivalry, and the knight who had already made himself respectable by his physical valor strove to make himself even more acceptable by his courtesy. King Brangoire's herald, for instance, invited Bohort to participate in the tournament "par amour et par courtoisie," and the princess said she fell in love with Bohort because he was "plus courtois que len ne ma dit" (more courteous than they told me).[17] Courtesy was also

identified with education and learning, terms of approval being *courtoys et bien apris* (courteous and cultured), and those of disdain, *villain et mal enseigné* (vulgar and uninformed).[18]

In the romance, courtesy is equated with *envoïseure*, a word that translates as gaiety, pleasure, amusement.[19] Cheerfulness was a fundamental characteristic of the knights, many of whom were endowed with high spirits. Convention demanded that the knights conceal any unhappiness and present a smiling face to the world. When King Arthur, for instance, showed his sadness in public, it was his lack of courtesy that the knights of the Round Table deplored. The epithets of some of these knights' names are themselves evidence of the extent to which amusement was appreciated in the courts for which this work was originally written: Giulorete li Envoisié, Melyan li Gais, and, in the episode illustrated in Mantua, Meliduns li Envoissiez, Meliduns the Joyful.

The protagonists in the romance thus manifest not only urbane demeanor but also liveliness of spirit. The princess's challenge to Bohort on his arrival at her father's castle is typical of the banter that, as part of courtesy, was prized as a style of communication among sophisticated individuals. Literary interest in sprightly conversations and witty exchanges developed in the early thirteenth century, and the *Lancelot* contains many examples of the "finesse souriante" that was *courtoisie* and *envoïseure*.[20] Characterizing the *Lancelot*'s quality of courtly gaiety as "a certain delicacy of touch and a certain happiness, deriving from confidence and optimism," Philippe Menard came to the conclusion that of all the prose romances the prose *Lancelot* had the greatest range and variety of light-hearted scenes.[21]

The concept of courtesy cannot be separated from the concept of nobility in the late Middle Ages, and the *Lancelot* is also self-consciously aristocratic.[22] The isolated feudal castles provide a setting that is psychologically isolating for the protagonists in that they live as if physically separated from other strata of society. Bohort and his companions give the impression, to quote Auerbach, of belonging to a "community of the elect, a circle of solidarity" set apart from others.[23] One of the most obvious features of this literature is its pervasive social snobbery. The chivalric values depicted, "the association of moral virtue and social rank implied in the word noble," as defined by Northrop Frye, are never questioned.[24] Those who seek happiness in love and honor in combat are always social equals. Noble ancestors matter. When Bohort joins the princess in her chamber under the spell of the magic ring, the emphasis is as much on the lovers' noble birth as on their virginity. We are

told that this is a suitable liaison because both protagonists are of royal parentage.

Twentieth-century characterizations of the predominant features and spirit of thirteenth-century chivalric romance must inevitably differ from the way in which they were perceived by the reader in the fifteenth century. Nonetheless, at the simplest level, the meaning of the *Lancelot* and our story seems explicit. The romance offers a stable, hierarchical world in which the pursuit of love and arms was conducted along well-defined lines and in which the protagonists were given the attributes of noble birth, beautiful appearance, and courtly manners. The elegant setting reinforced the mannered ease of the social life of these cultured people. The optimistic tone of the prose and the sprightly exchanges express the protagonists' wholehearted and unquestioning enjoyment of the exclusive social sphere in which their adventures unfold. The *Lancelot* undoubtedly survived into the Quattrocento with a strong class appeal attached to it, confirming some of the more "conservative" values of its readers. The privileged world depicted must have reflected North Italian princes' images of themselves as natural leaders. Like the *signori*, the chief heroes in the romance form a compact group of some 150 knights. The chivalric warriors were often related by blood, as were their noble readers in Mantua and Ferrara. They certainly formed as limited a circle.

The fixing of these tales within a setting recognizable to the Quattrocento must have added to their appeal. In these stories the fantastic, that which is remote from existence, is firmly attached to the real. The courtly environment depicted in the prose *Lancelot* was more beautiful than any reality but was nonetheless recognizable. Things were portrayed as they conceivably could be. "Romances," wrote Tuve, "were a genre that portrayed life idealistically, but on the assumption that they were [giving] a realistic portrayal of life."[25]

The social attitudes prevailing in the Italian Renaissance were similar to those embedded in the romance. As Philip Jones has shown, a new intensified class consciousness came to the fore in the fifteenth century, especially among the older aristocracy.[26] The divisions between the classes became deeper, social mobility lessened, and advancement was prevented by increasingly restrictive standards of noble origins, amounting to an insistence on old blood and high birth. For the Florentine Giovanni Rucellai, for instance, to be born of noble blood was one of the seven indispensable conditions to human happiness.[27] In Mantua, Lodovico Gonzaga, who observed that "human kindness . . . is more fitting toward those born of good blood," did not hesitate to

remind his valued ambassador in Rome, Bartolomeo Bonatto, that he was "of low birth."[28]

The Quattrocento thus shared the *Lancelot*'s romanticizing belief in noble forefathers. Adoption of illustrious ancestors, no matter how fictional, was standard practice in an age in which political legitimacy was defined in terms of descent from an omnipotent past. The Sforza claimed the Kings of Denmark as ancestors, the Visconti claimed descent from Venus and Anchises, and both the Este and the Gonzaga turned to the Germany of Charlemagne for an acceptable version of their origins. The legend of Gonzaga descent from German royal blood was already well developed when it was first articulated by Equicola in 1521, and it was further elaborated by subsequent Mantuan historians at the same time as they systematically suppressed evidence of actual Gonzaga origins in the Corradi family from the town of Gonzaga in the Mantovano.[29] By 1606 the myth was developed to the point where Duke Vincenzo, summing up his ancestors' romanticizing attitudes toward the past, could declare that his family was descended from *cavalieri d'heroiche qualità*, knights of heroic character.[30]

Other ideals stressed in the *Lancelot*, such as physical prowess and courage, were, as we saw in chapter 4, also important Renaissance values. Military exploits were regularly recorded in chivalric terms, in that contemporary accounts of battles concentrated on their heroic aspects and emphasized the prowess of individual fighters. In words that could almost have come out of the prose *Lancelot*, Pius II, for instance, noted that Barbara's uncle the Margrave Albert of Brandenburg won every tournament he entered:

> Eighteen times he had been challenged to single combat and, with only a shield and helmet as defensive armor, had emerged victorious.[31]

War and fighting generally, the traditional occupation of the Gonzaga family, were much admired in fifteenth-century Italy. Indeed, a social mystique was associated with the conduct of war. To follow the profession of arms was to live nobly.[32]

Courtoisie was also valued in fifteenth-century society. Two hundred and fifty years after the *Lancelot* and twenty-five years after the *Sala del Pisanello*, Boiardo employed similar terms when writing his *Orlando Innamorato*. He used the words *cortesia* and *allegrezza* to describe the intertwined qualities of courtesy and *envoïseure* with which he endowed his Ferrarese listeners:

> Così nel tempo che virtù fioria

Ne li antiqui segnori e cavallieri,
Con noi stava allegrezza e cortesia.[33]

"Thus in the time when valor flowered in the ancient lords and knights, gaiety and courtesy were with us." Because of their very courtesy, Boiardo's audience deserved to experience *envoïseure* or *diletto*:

Non debbo adunque a gente sì cortese
Donar diletto a tutta mia possanza?[34]

"Must I not then to people so courteous give enjoyment with all my power?" In Ferrara, Boiardo's listeners would have responded favorably to his description of them; in Mantua, courtesy was perhaps particularly sought after by our patrons. We know, for instance, that Barbara of Brandenburg was so anxious to be seen as hospitable to her guests at the 1459 Congress that she irritated the Milanese ambassador by her mannerisms and the excessive "courtesy" which she imposed on those who were, he claimed, unwilling to receive it.[35] Having been fat and clumsy as a child, Lodovico must have appreciated the elegance and urbanity conferred on him by his pictorial Arthurian identity.[36]

We saw earlier that twentieth-century medievalists find it difficult to evaluate the prose *Lancelot* aesthetically because of its reticence, its rambling longwindedness, and also, no doubt, its eminently forgettable content.[37] Modern aesthetic judgments, however, whether positive or negative, need not preclude appreciation of the prose romances' continued appeal for the Quattrocento. Even their mannerism of overt repetition may well have been part of their profound attraction. Like the rest of the *Lancelot*, the episode illustrated in Mantua unfolds in consistent patterns with which the audience was familiar. It was so conventionalized as to resemble a game with well-known rules.[38] As Jauss points out, the consumer in the late Middle Ages enjoyed the charm of a game with known rules but still unknown surprises.[39] In addition, the *Lancelot* was not a work of literature that made serious intellectual demands of the reader. The naive matter of the tales contrasts sharply with their sophisticated presentation in interwoven narrative, as discussed in chapter 6. Instead of learning, the court audience brought to the romances an ability to surrender themselves to the stories' mood, a willingness to indulge in a play of fancy. In an evocative analysis of the place of romance in late-medieval life, C. S. Lewis has written:

The mystery, the sense of the illimitable, the elusive reticence of the best romances . . . stand apart from the habitual medieval taste . . . [the romances

were] in the Middle Ages, as they have remained ever since, truancies, refreshments, things that can only live on the margin of the mind, things whose very charm depends on their not being "of the center."[40]

The original purpose of medieval courtly romance, as Dante recognized, was to entertain a sophisticated audience. "Noi leggiavamo un giorno per diletto," began his account of Francesca and Paolo's encounter over a manuscript of the *Lancelot*; "one day we were reading for pleasure."[41] We need feel no surprise that Arthurian romance should have continued to hold the courts of Europe spellbound for centuries. The ideals of French feudal society—the light-hearted exchanges, the mannered ease, the resilient physicality—embodied in the elegance of act and emotion of the heroes, provided fifteenth-century Italian nobility with a fascinating picture of life.[42] It is a literature that suggests a way of life, and in his *Trionfo d'Amore* Petrarch indicated its power to shape the imagination of generations of readers:

> Ecco quei che le carte empion di sogni:
> Lancilotto, Tristano e gli altri erranti . . .

"Here are those who fill the pages with dreams."[43] Presenting a spectacle of superhuman feats of valor, marvelous amusements, and frankly sensual loves, the romances were still, in Quattrocento Italy, what they had always been, a source of dreams and reveries.[44] *Pulcra et delectabilis materia*, these undemanding works fulfilled an elementary need for a fantasy world of adventure and lovers' rendezvous.[45]

Converting this popular genre to literary respectability while using *Lancelot* as a source, Boiardo also offered the *Orlando Innamorato* as entertainment. The poem's purpose, he told his noble listeners at the court of Ferrara, was to give them enjoyment, "per darvi zoia e diletto," and its ultimate justification was its success in pleasing them.[46]

> Se onor di corte e di cavalleria
> Può dar diletto a l'animo virile,
> A voi dilettarà l'istoria mia,
> Gente legiadra, nobile e gentile,
> Che seguite ardimento e cortesia,
> La qual mai non dimora in petto vile[47]

"If the honor of court and of chivalry can give pleasure to the manly spirit, you will enjoy my *istoria*, graceful, noble, and well-bred people who follow daring and courtesy, which never dwell in peasant [yokel] breast." Boiardo thus flattered his audience by imagining it composed of youthful cavaliers

thirsting for glory and ladies who were gracious, witty, and beautiful.[48] As we shall see, Pisanello's pictorial *istoria*, created for the same social group for whom Boiardo wrote, complimented his audience in much the same way.

II. *The Art*

Pisanello's pictorial skill must have rendered his art as imaginatively powerful for Quattrocento *signori* as was the work of chivalric romance.[49] One stylistic trait already observed in the *Sala del Pisanello* frescoes is the glowing and palpable surface texture that would have covered much of the tournament scene had it been completed.[50] Reconstruction of the intended surface of this unfinished scene indicates that large stretches of it were to be covered with a glittering layer of raised relief overlaid by silver and gold leaf that emulated richly worked Flemish tapestries. In chapter 8 we considered the respect paid to magnificence and the patron's need for display of luxury and extravagance. One of the primary characteristics of magnificence was an appearance of large expenditure; in the words of Sabadino degli Arienti, "largesse and amplitude in spending gold and silver in eminent things."[51]

The use of *pastiglia* in the tournament scene conforms to the prose *Lancelot*'s dominant note of worldly chivalry: the ease associated with wealth and luxurious standards of material existence. The extent of the *pastiglia* should also be recognized as an imaginative response to the challenge of providing a work with a precise function within a particular context at a given moment: that of endowing Lodovico Gonzaga with an appearance of magnificence in the setting in which he received prominent visitors—at a moment when a more expensive medium than fresco for a large-scale work was out of the question. Using materials with unequivocal associations and spreading them across a wall ten meters wide, Pisanello aimed at the greatest possible effect of opulence. In the tournament scene the physical properties of the gold and silver would have asserted themselves as such. The fifteenth-century viewer would have been as overwhelmed by the value intrinsic to these precious metals as he was impressed by the craftsmanship employed in their conversion into a work of art. The scale of the scene would have produced a work that Sabadino could have defined as "sumptuous" and that hence added "fame" to Lodovico Gonzaga's reputation. As a visible product of apparently extravagant spending, this art would have symbolized Lodovico Gonzaga's power by exalting the physical splendor of his rule. The *pastiglia* in the tournament scene should accordingly be recognized as one of the important formal characteristics of the cycle. As a metaphor for the collective aspirations

that North Italian courts invested in luxurious display, the *pastiglia* was itself part of the inner content of the art.

Another outstanding formal characteristic of Pisanello's style is the polished elegance of his figures. Comparison of the tournament scene in Mantua with miniatures of the same subject helps to explain why Quattrocento princes sought Pisanello's work so eagerly. The tournament scenes illustrating the chivalric romances *Guiron le Courtois* (Fig. 75) and *La Queste del Saint Graal* (Fig. 76), typical of the secular work done for the cosmopolitan Milanese court around 1400, show the Lombard artists' crude and unrefined means.[52] The poses of the knights are awkward and strained, even when the subject is treated with sympathy and conviction. These warriors enact the kind of violent and abrupt movements that Alberti condemned when he wrote of artists who "represent movements that are too violent. . . . Because they hear that those figures are most alive that throw their limbs about a great deal, they cast aside all dignity in painting and copy the movements of actors."[53] A painting should rather, Alberti affirmed, "have pleasing and graceful movements that are suited to the subject of the action. . . . Let all the movements be restrained and gentle and represent grace rather than remarkable effort."[54] In chapter 6 we noted the shift from the relatively abrupt gestures and movements of the knights in the tournament *sinopia* to the relatively more controlled and restrained configurations in the fresco.[55] The graceful movements of the painted Mantuan knights propel them forcefully but elegantly through the thronged scene (Figs. 100 and 118). The many cavaliers thus create an exciting decorative pattern as they weave their way with varied poses across the surface of the picture plane.

Writing at the court of Urbino in 1442, Angelo Galli claimed that, among other qualities, Pisanello's work displayed *maniera* or style:

> Arte, mesura, aere et desegne
> Manera, prospectiva et naturale
> Gli ha dato el celo per mirabil dono.[56]

"Art, measure, air, draftsmanship, *maniera*, perspective, verisimilitude, these Heaven gave him as a miraculous gift." A hundred years later Vasari also commented on Pisanello's "grace and beautiful *maniera*."[57] The term derived from the medieval French *manière*, which described in part a code of desirable behavior at thirteenth- and fourteenth-century French courts. Associated with concepts such as *bien enseignié* and *bien appris*, *manière* suggested education or culture, and also knowledge or *savoir*—hence *savoir faire* or sophistication.[58] Thus a young knight would be described as *bien appris et emmanieré*,

and *La Dame Manière* was first among the allegories of the virtues of the perfect knight. [59] This concept was introduced into Italian love poetry in the fifteenth century, with Giusto de' Conti praising "the *virtù*, the beauty, and the *maniera* of his lady" and Lorenzo de' Medici suggesting in verse that Florentine women should display "*maniera* and elegant gestures." "Whether you are walking, standing, or sitting, do it always with style [*maniera*]," he advised. [60] The choreographer Guglielmo Ebreo agreed with him that bodily movements should always be undertaken with "sweet *maniera*." [61]

In their letters Northern Italian princes also used this word as an attribute of personal style. Negotiating for a suitable wife in France, Galeazzo Maria Sforza instructed his ambassador to find a princess who was "elegant or with good *maniere*," and his envoy replied that the Duke's prospective bride had "the most beautiful *maniere* that I have ever seen." [62] In 1463 Gianfrancesco Gonzaga reassured his mother, Barbara of Brandenburg, by calling his new German sister-in-law, Margaret of Wittelsbach, "very *mainerosa* [*sic*]." [63] Both princes were implying a stylish demeanor that projected an image of feminine elegance and cultured refinement. *Maniera* was accordingly the term that the *signori* habitually used to express the courtly demeanor and sophistication that in the prose *Lancelot* came under the rubric of *courtoisie*. [64] This was the grace that Castiglione would define in the next century as making "whatever is done or said appear to be without effort and almost without thought." [65] Because the word *maniera* was used in everyday life to indicate a desired quality of human deportment, the concept can be equated with the knights' suave movements in the tournament. Pisanello can be said to have created knights in Mantua whose actions were marked by the effortless elegance that constituted *maniera* rather than merely by the brute strength with which the warriors in the miniatures had been endowed by his Lombard predecessors.

We saw that one of the purposes of the depiction of a grandiose tournament in the Mantuan *Sala* was to promote the patron's military reputation. [66] *Maniera*, the quality that Galli recognized in Pisanello's work, endowed his jousters with poise and courtly bearing, features that temper the propaganda message of Gonzaga war preparedness, conveyed by the imposing numbers of knights, their relatively large figure scale, and their up-to-date, heavy, glittering armor. While providing a convincing display of the military might and enviable prowess desirable in a Gonzaga *condottiere*, these frescoes would also have projected an impression of the *manieroso* demeanor and sophisticated culture of Mantua's ruler. The blend of prowess and suavity of the knights as painted has, moreover, definite stylistic affinities with the combination of physical resilience and urbanity that graced the *Lancelot*'s heroes. If the Gon-

zaga wished to identify with the courtesy and self-possession so evident in the literature, they would discover, Galli seems to be saying, that Pisanello was eminently qualified to translate these ideas into visual images.

"Feelings are known from the movements of the body," observed Alberti, "when we are . . . *hilares* (happy), our movements are free and pleasing in their inflections."[67] The humanists' use of this word is also relevant to analysis of Pisanello's style. Commenting on the artist's fresco, since lost, in the Ducal Palace in Venice, Bartolomeo Fazio wrote:

> In the Palace at Venice he painted Frederick Barbarossa, the Roman Emperor, and his son as a suppliant, and in the same place a great throng of courtiers in German costume; also the facial appearance of a priest distorting his face with his fingers, and some boys laughing at this, done so agreeably as to arouse *hilaritas* in those who look at it.[68]

The word *hilaritas* was used in classical texts to mean delight, cheerfulness, enjoyment, gaiety.[69] Both Cicero and Quintilian used it in opposition to *tristitia*, which usually meant gloom or melancholy when applied to outward demeanor, and *hilaritas* is best understood in antithesis to this word.[70] Not surprisingly, it was used in the same way by fifteenth-century humanists. In his treatise on painting Alberti opposed the concept of *hilaritas* to that of grief [*luctus*] when discussing the difficulty of rearranging facial features to convey the "infinite movements of the heart."[71] Poggio Bracciolini referred to the laws of the banquet as *hilaritas, iocus, remissio animi* (delight, play, refreshment of the spirit), in a circle of connected words which he used in opposition to terms like *severitas* and *gravitas*.[72] Like *maniera*, the word was used regularly in everyday life. "We beg you to show in your face the customary cheerfulness," wrote Emperor Sigismund when advising Gianfrancesco Gonzaga on the defection of his eldest son in 1436, implying that the same rules of etiquette that governed King Arthur's behavior also applied to the first Marchese of Mantua.[73] "Everything was pleasant and cheerful [*hylare*]," reported the Marchese of Varese about a celebration following a diplomatic victory in 1459.[74] Against this background, Fazio's use of the expression suggests that Pisanello painted motifs in Venice so beguilingly as to give "cheer" or "delight" to the viewer.

Fazio, who was at the Neapolitan court at the same time as Pisanello, and was acquainted with the artist's work in Venice, Verona, and Rome, was an informed commentator on his work.[75] We can therefore assume that the humanist's particular mention of this feature of Pisanello's Venetian fresco indicates that *hilaritas* was considered one of the strengths of the artist's work

by such patrons as King Alfonso. We do not know whether Fazio might have discerned similar motifs in the Mantuan cycle. As we saw in chapter 8, however, there are motifs in these murals that can be read as designed to arouse delight; and it was argued there that the three dwarfs in the Gonzaga knight's retinue, creatures who were a source of *piacere et ricreatione* when encountered in person, might have evoked equal pleasure when glimpsed in illusion (Figs. 68 and 139).[76] The depiction of a fallen knight in a ridiculous position, shown in extreme foreshortening from the rear, buttocks emphasized, is another motif which could be interpreted as seeking a similar response from Gonzaga courtiers, whose sense of humor was tickled by this kind of broad joke in real life (Fig. 107). Such motifs in the tournament scene may accordingly provide us with some concrete examples of what Fazio chose to define as *hilaritas* in his discussion of Pisanello's lost Venetian work. Supplying us with a link to the *Lancelot*'s *envoïseure*, these features of the Mantuan work may also correspond to the *diletto* or enjoyment that Boiardo hoped to give his listeners in Ferrara twenty-five years later.

Indeed, *hilaritas* like splendor and magnificence, seems to have been a recognized value in court society and, as such, was included on lists of desirable virtues.[77] *Ilarità* was for instance discussed in the *Book of the Courtier*. "Whatever moves to laughter," wrote Castiglione, "restores the spirit, gives pleasure and for the moment keeps us from remembering those vexing troubles of which our lives are full."[78] There is some evidence to suggest that this particular strength of Pisanello's work may have appealed especially to the Mantuan court. Ennui apparently occasionally threatened the Gonzaga family. Family letters document contemporary efforts to banish gloom, dejection, and other synonyms of *tristitia* in Mantua:

> The first rule that we must observe is always to live pleasurably and to banish all melancholy,

observed Alessandro Gonzaga to his sister-in-law Barbara of Brandenburg.[79] Many family members were frail or handicapped with the *gibositade*, the spinal malformation or hunched back that afflicted the descendants of Paola Malatesta. Even Lodovico Gonzaga was prone to bouts of depression in later life, or so Barbara of Brandenburg implied when she wrote to her children that their father suffered from melancholy and needed to have his spirits lifted.[80] Possibly paintings displaying *hilaritas* functioned in much the same way as the feasts, dwarfs, romances, and other distractions with which princes continually sought to offset their melancholy, illness, and boredom. This term may thus communicate a special quality of secular painting that

reflects its function within the Quattrocento courtly domain. On one level, Pisanello's cycle can be read as a lighthearted work of charm and humor designed to add cheer to the quality of life at court.

In 1442 Angelo Galli's definition of Pisanello's expressive means also included the word *naturale*. For his humanist contemporaries the outstanding characteristic of Pisanello's work was its verisimilitude. Amazed by his talent—"almost that of a poet," wrote Fazio—for painting "the forms of things," these scholars found his work overwhelmingly realistic.[81]

> Nostros heroas video deducere vivos
> Vivos alipedes, civum genus omne ferarum.

"I see him bring to light our heroes, live, the wing-footed alive, and every sort of people and wild beasts," wrote Dati.[82] Fazio was also much impressed by Pisanello's skill in rendering the appearances of horses and animals.[83] Vasari, describing a dog in a lost fresco as being painted with such life [*vi-vezza*] that nature could not have done it better, even assumed that Pisanello particularly enjoyed [*si dilettò*] painting these animals.[84] As these critics all imply, however, Pisanello's gift of direct observation was above all to be seen in the marginal or less essential areas of his content, in the horses and wild beasts, the realistic details of the knights' costumes and iconographically minor figures such as dwarfs. Presented as if they were photographic close-ups, the naturalistic rendering of these motifs was the result of Pisanello's intense response to the phenomena of the surrounding world and his pro-longed study of it in drawings.[85]

Pisanello's interest in realism of detail—animals, clothes, background motifs—was not, as it happens, matched by a concern for depicting the internal states of mind of his protagonists. Though it teems with naturalistic renderings of the appurtenances of life, the Arthurian world in Mantua is populated with knights and ladies whose personal style is totally unself-revealing. Ten years earlier Alberti's *De Pictura* had called for the external expression of inner emotional states as one of the most important tasks of painting.[86] In Mantua, however, Pisanello no more extended his vaunted nat-uralistic talents to the inner emotions of his "knights in love, damsels cour-teous and gracious" than had the author of the prose *Lancelot*.[87] The tourna-ment scene shows a mock battle in progress, but those warriors whose visors are raised do not grind their teeth or roll their eyes under the strain of physical exertion (Fig. 141). Even the painted ladies watching the fighting show more self-absorption than fear over the knights' fate in battle (Fig. 88). These knights and damsels are as closed to subjectivist interpretation as are those in

the *Lancelot*.[88] Pisanello's interest in the reality of the *signori*'s outward appearances rather than in that of their inner emotions reinforces the *Lancelot*'s picture of life as an unreflective surface spectacle and echoes the low premium it places on the heroes' motivation.

There was perhaps good reason why Pisanello should have directed his naturalistic talents to the less inhibiting areas of his content—to the horses, the clothes, and the background details.[89] Since passion was seen as inimical to *manière* or stylish demeanor at French courts, displays of emotion may have been equally unappreciated in North Italian court circles. The oblique tone and emotional reticence of the *signori*'s discussions of personal matters in letters, for instance, is reflected in Pisanello's depiction of the protagonists as bland stereotypes with tranquil features. The formality surrounding personal style in these centers may accordingly give a context for the restriction of facial expression in Pisanello's work to serene dignity and aloof pride.

Pisanello's style seems particularly suited to the illustration of the *Lancelot* in that the balance between realism and idealism in his work is akin to that in the romance. In the prose *Lancelot* plot and character are non-representational, but the action takes place in recognizable, if idealized, settings that render the tales almost believable as stories of real life.[90] In the murals the idealized and unself-revealing knights and damsels populate a world filled with vividly observed motifs and naturalistic, albeit idealized, effects. Presenting the unlikely as the conceivable, Pisanello's acuity of observation gave realism, and therefore credibility, to the fantastic narrative and the idealized protagonists. He succeeded, in the words of Cennini, "in discovering things unseen, hiding themselves under the shadow of natural forms . . . making clearly visible that which does not actually exist."[91] North Italian rulers must have found Pisanello's embellished naturalism a profoundly satisfying substitute for reality as they perceived it.

If we seek to analyze paintings on the basis of categories intrinsic to their periods, the terms used by the humanists—*magnificentia*, *maniera*, *hilaritas*, and *naturale*—should help us to recognize the character, and the strengths, of Pisanello's style as it was perceived by his fifteenth-century patrons. Some of the outstanding features of the cycle—the intended surface texture, the distinctive figure style, the cheerful motifs, and the idealized protagonists surrounded by realistic details—can be interpreted as reflecting concepts that were important values for Quattrocento court society: palpably rich surfaces and the appearance of magnificence; sophistication and *manieroso* elegance; pleasurable distractions from melancholy; aloof and aristocratic mien. Certain Gonzaga pretensions and illusions were, it seems, assimilated into the art.

It can thus be argued that Pisanello's internalized relationships, whether with his immediate patrons, the Gonzaga, or with the courtiers and princes who made up his wider audience, were incorporated into the process of artistic creation. Pisanello was, after all, decorating the hall in which the Gonzaga received their peers—political friends and social rivals—and his knowledge of the way in which the frescoes would function within the everyday life of the Mantuan court must inevitably, whether consciously or unconsciously, have influenced his artistic decisions. Pisanello's perception of Gonzaga wishes and exigencies, his anticipation of the response to his work by the North Italian *signori* who would circulate inside the *Sala*—*his* interpretation of *their* expectations—were all factors that became part of his artistic frame of reference. His understanding of, and empathy with, the social needs of these patrons could be said to have equaled his artistic skill.

It can further be argued that this relationship between artist and audience was, despite Pisanello's subordinate social and economic position, reciprocal. Just as Pisanello's interpretation of the dominant ideology of these closely knit court communities must have had a bearing on the formation of his style, so the Arthurian cycle, had it been finished, would in turn have helped the mid-century Mantuan court to articulate those values.[92] Indeed, artists and poets were among the few individuals to clarify or elaborate the rulers' ideology in these centers, for which little or no written body of secular doctrine or philosophy existed. Pisanello's role in Mantua, for instance, was probably akin to that of Boiardo twenty-five years later at the court of Ferrara; his tournament scene certainly complimented the Mantuan audience as flatteringly as any passage in the *Orlando Innamorato*. Just as Boiardo depicted his listeners in Ferrara as "graceful, noble, and well-bred people seeking daring deeds and *cortesia*," so the Gonzaga of Mantua were portrayed as elegant and noble warriors thirsting for martial victory yet displaying courtly demeanor.[93]

The pictorial style of the tournament scene in the *Sala del Pisanello* thus not only reveals some of the aspirations of small North Italian courts in the mid fifteenth century but also articulates assumptions and experience that the Gonzaga certainly left uncodified and probably left unsaid. These images convey ideas that were never formulated in words. On the one hand, the choice of chivalric iconography in the *Sala*—those themes that contemporaries called *pulcra et delectablis materia*, beautiful and enjoyable subjects—reveals courtly illusions about certain realms of experience.[94] Identifying with the Arthurian heroes, the Gonzaga take part in idealized versions of such real-life rituals as a tournament, a banquet, and a love intrigue. On the other hand, the expressive means used here by Pisanello surely influenced individual

understanding of these experiences in such a way as to clarify them for the Mantuan court or, at the very least, affect Gonzaga habits of thinking and feeling about them.

In every age, the ruling social class tends to project its ideals in some form of romance, according to Northrop Frye, because romance, in its removal from reality, is the nearest of all literary forms to the wish-fulfillment dream.[95] Painting, a construct as powerful as any work of literature, also lends itself to a temporary fulfillment of dreams and aspirations. Pisanello gave Lodovico an image of a confident and brilliant world in which the Gonzaga must have found his vision of them as *cavalieri d'heroiche qualità* to be a *bella fantasia*, a beautiful and profoundly satisfying fantasy.[96] Writing in the same years as the painting of the *Sala*, Basinio da Parma articulated the sentiments and gratitude of Pisanello's patrons upon experiencing his interpretation of their fantasies in pictorial form:

> Qui facis ingenuas rerum, pisane, figuras
> Qui facis aeternos vivere posse viros,
> Optime pictorum, qui sunt, quicumque fuere,
> Quique etiam magnae gloria laudis erunt, . . .
> Tu facis heroas divinae munera famae,
> Tu facis aeternum nomen habere duces
> Mantua dum maneat, dum sit Gonzaga proles.[97]

"O Pisano, you who shape the natural forms of things, you who enable men to live forever, O finest of painters living and dead and also of those who will in the future be [crowned with] glory of great fame, . . . you enable heroes to command the rewards of divine fame, . . . captains to enjoy everlasting distinction, so long as Mantua survives and the house of Gonzaga endures." As it happens, Mantua and this work by Pisanello, albeit damaged and unfinished, still survive, but the house of Gonzaga has vanished forever.

FAMILY TREES

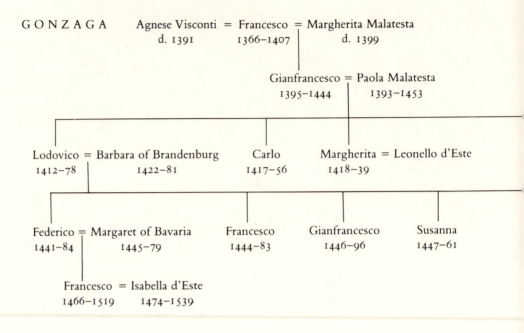

GONZAGA Agnese Visconti = Francesco = Margherita Malatesta
 d. 1391 1366–1407 d. 1399

Gianfrancesco = Paola Malatesta
1395–1444 1393–1453

Lodovico = Barbara of Brandenburg Carlo Margherita = Leonello d'Este
1412–78 1422–81 1417–56 1418–39

Federico = Margaret of Bavaria Francesco Gianfrancesco Susanna
1441–84 1445–79 1444–83 1446–96 1447–61

Francesco = Isabella d'Este
1466–1519 1474–1539

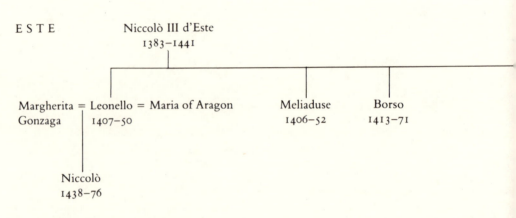

ESTE Niccolò III d'Este
 1383–1441

Margherita = Leonello = Maria of Aragon Meliaduse Borso
Gonzaga 1407–50 1406–52 1413–71

Niccolò
1438–76

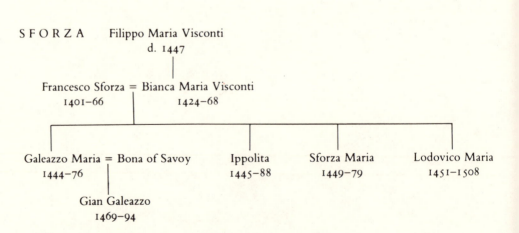

SFORZA Filippo Maria Visconti
 d. 1447

Francesco Sforza = Bianca Maria Visconti
1401–66 1424–68

Galeazzo Maria = Bona of Savoy Ippolita Sforza Maria Lodovico Maria
1444–76 1445–88 1449–79 1451–1508

Gian Galeazzo
1469–94

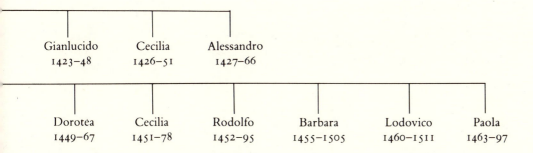

Gianlucido
1423–48

Cecilia
1426–51

Alessandro
1427–66

Dorotea
1449–67

Cecilia
1451–78

Rodolfo
1452–95

Barbara
1455–1505

Lodovico
1460–1511

Paola
1463–97

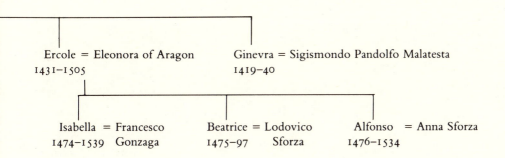

Ercole = Eleonora of Aragon
1431–1505

Ginevra = Sigismondo Pandolfo Malatesta
1419–40

Isabella = Francesco
1474–1539 Gonzaga

Beatrice = Lodovico
1475–97 Sforza

Alfonso = Anna Sforza
1476–1534

ABBREVIATIONS

ASMAG Archivio di Stato, Mantua, Archivio Gonzaga

Biadego, 1908 G. Biadego, "Pisanus Pictor, nota 1a," *Atti del Reale Istituto Veneto di Scienze, Lettere ed Arti* 67 (1908): 837–59

Biadego, 1909 G. Biadego, "Pisanus Pictor, note 2a e 3a," *Atti del Reale Istituto Veneto di Scienze, Lettere ed Arti* 68 (1909): 229–48; 69 (1909): 183–88

Biadego, 1910 G. Biadego, "Pisanus Pictor, note 4a e 5a," *Atti del Reale Istituto Veneto di Scienze, Lettere ed Arti* 69 (1910): 797–813; 1047–54

Cottafavi, 1931–32 C. Cottafavi, "Mantova: Palazzo Ducale—Palazzo del Capitano," *Bollettino d'Arte* 25 (1931–32): 377–82

Cottafavi, 1935 C. Cottafavi, "Palazzo Ducale di Mantova: restauro del pianterreno e del porticato di Piazza Sordello," *Bollettino d'Arte* 29 (1935): 239–47

Cottafavi, 1939 C. Cottafavi, *Ricerche e documenti sulla costruzione del Palazzo Ducale di Mantova dal secolo XIII al secolo XIX*, Mantua, 1939

Degenhart, 1973 B. Degenhart, "Pisanello in Mantua," *Pantheon* 31 (1973): 364–411

Fossi Todorow, 1966 M. Fossi Todorow, *I disegni del Pisanello e della sua cerchia*, Florence, 1966

Giannantoni, 1929 N. Giannantoni, *Il Palazzo Ducale di Mantova*, Rome, 1929

Gundersheimer, 1972 W. L. Gundersheimer, ed., *Art and Life at the Court of Ercole I d'Este: The "De Triumphis Religionis" of Giovanni Sabadino degli Arienti*, Geneva, 1972

Hill, 1930 G. F. Hill, *A Corpus of Italian Medals of the Renaissance before Cellini*, 2 vols., London, 1930

Luzio/Renier, 1889 A. Luzio and R. Renier, "Il Platina e i Gonzaga," *Giornale Storico della Letteratura Italiana* 13 (1889): 430–40

Luzio/Renier, 1890 A. Luzio and R. Renier, "I Filelfo e l'umanesimo alla corte dei Gonzaga," *Giornale Storico della Letteratura Italiana* 16 (1890): 119–217

Mahnke, 1975 E. W. Mahnke, "The Political Career of a Condottiere-Prince: Lodovico Gonzaga 1444–1466," Ph.D. thesis, Harvard University, 1975

Marani, 1975 E. Marani, in G. Amadei and E. Marani, *I Gonzaga a Mantova*, Milan, 1975

Paccagnini, 1960 G. Paccagnini, *Mantova: le arti*, vol. 1, *Il medioevo*, Mantua, 1960

Paccagnini, 1969 G. Paccagnini, *Il Palazzo Ducale di Mantova*, Turin, 1969

Paccagnini, 1972 G. Paccagnini, *Pisanello e il ciclo cavalleresco di Mantova*, Milan, 1972

Paccagnini/Figlioli, 1972 G. Paccagnini and M. Figlioli, *Pisanello alla corte dei Gonzaga* (exhibition catalog), Milan, 1972

Signorini, 1985 R. Signorini, *Opvs Hoc Tenve: la camera dipinta di Andrea Mantegna*, Mantua, 1985

Venturi, 1896 A. Venturi, ed., *Le vite dei più eccellenti pittori, scultori ed architettori scritte da Giorgio Vasari*, vol. 1, *Gentile da Fabriano ed il Pisanello*, Florence, 1896

NOTES

INTRODUCTION

1. "Mantuae aediculum pinxit et tabulas valde laudatas." See M. Baxandall, "Bartolomaeus Facius on Painting: A Fifteenth Century Manuscript of the *De Viris Illustribus*," *Journal of the Warburg and Courtauld Institutes* 27 (1964): 90–107.

2. See chapter 4, n. 168.

3. "Già che sempre non si dè o pò attendere a cose spirituale, che anche non sia licito qualche volta recrearse et attendere a le corporale" (letter from Bianca Maria Visconti to Barbara of Brandenburg, Milan, 16 July 1459, ASMAG, busta 1607, c. 83). The Duchess of Milan was reacting indignantly to the aspersions cast by Pope Pius II on the leopard that she had lent Barbara of Brandenburg to amuse the papal court during the Congress of Mantua in 1459.

4. "I never gave myself over to the task of translating books until very recently. . . . And almost I regret having entered into such a labyrinth, and taken on a weight too heavy for my infirm and frail shoulders." Polismagna [Carlo di San Giorgio] in the preface to his life of Filippo Maria Visconti, published in G. Bertoni, *La biblioteca estense e la coltura ferrarese ai tempi del Duca Ercole I (1471–1505)*, Turin, 1903, p. 128.

ONE · SITE

1. We lack both a systematic study of the documents pertaining to the medieval buildings and detailed measured ground plans of the buildings as they stand today. For the Ducal Palace in general, see Paccagnini, 1969. The best histories of the medieval buildings are in Paccagnini, 1960, pp. 146–52, and Marani, 1975, pp. 124–42. The ground plan in Fig. 1, taken from Marani, 1975, was first published by Clinio Cottafavi in a pamphlet written anonymously ca. 1930 for the Società per il Palazzo Ducale di Mantova. I wish to express my thanks to Professor Marani for the photograph.

2. S. Davari, *Notizie storiche topografiche della città di Mantova nei secoli XIII, XIV e XV*, Mantua, 1903 (reprinted 1975), pp. 12–15; Marani, 1975, pp. 122ff.

3. Davari, *Notizie topografiche*, p. 24; Marani, 1975, p. 138. The sale of the palace after the death of the last of the Bonacolsi was ratified in documents of 15 January and 13 April 1355 (ASMAG, busta 231, docs. 33 and 48). The church of S. Croce, demolished in 1577, goes back at least to the middle of the 12th century. See Cottafavi, 1939, pp. 40, 55–56, 61–63; Giannantoni, 1929, pp. 67, 73–74.

4. The reconstruction is based on examination of those medieval buildings that were structurally unaffected by later renovations and on accounts of the twentieth-century restorations to the palace. See the many important publications by C. Cottafavi and the early guidebooks to the palace by A. Patricolo, G. Pacchioni, and N. Giannantoni. The plan in Fig. 2, drafted by Barbara Shapiro, is based on a plan drawn in 1772 by Giuseppe Bisagni and discovered by Amedeo Belluzzi (Archivio di Stato, Milan, Fondo Camerali, p.a., 159). The designation *Palazzo della Corte* for the Quattrocento palace given in A. Martindale, *The Triumphs of Caesar by Andrea Mantegna in the Collection of Her Majesty the Queen*, London, 1979, pp. 37–42, is not found in fourteenth- and fifteenth-century documents. The designation *Corte Vecchia* for this part of the palace dates from the 16th century.

5. See C. Berselli, "La pianta di Gabriele

Bertazzolo," *Civiltà Mantovana* 2 (1967): 278–97. Bertazzolo's view is oriented so that west is at the top.

6. Cottafavi, 1935, pp. 243–44; Marani, 1975, p. 131–32; Paccagnini, 1960, pp. 149, 155–56. The two palaces, built in different city contrade (the Magna Domus in the contrada of S. Croce, the Palazzo del Capitano in that of S. Alessandro), were originally separated by a narrow lane. The Piazza S. Pietro corresponds to the present Piazza Sordello.

7. The painting is dated 1494. See Paccagnini/Figlioli, 1972, cat. 27, p. 46.

8. Giannantoni, 1929, p. 23; Paccagnini, 1960, p. 155; Paccagnini, 1969, p. 9; Marani, 1975, p. 148. The *Porta Grande de Corte* is mentioned in a letter from Federico Gonzaga to a member of his household, Pandolfo Malatesta, 14 October 1478, ASMAG, busta 2895, libro 90, c. 43r.

9. See references in n. 8. The *androne* was frescoed with Gonzaga emblems and the lion of Venice, dating from the period when Marchese Gianfrancesco (1407–44) was a *condottiere* in the service of the Venetian Republic (G. Gerola, "Vecchie insegne di casa Gonzaga," *Archivio Storico Lombardo* 45 [1918]: 97–110; Cottafavi, 1935, p. 239).

10. Isabella d'Este lived in these rooms from 1523 to 1539. See Marani, 1975, p. 274, rooms 160–64; Giannantoni, 1929, pp. 67–73. According to M. Equicola, *Dell'istoria di Mantova* (1521), 2d ed., Mantua, 1607, p. 163, the rear block incorporating older houses was built at the end of the Trecento by Lodovico's grandfather Francesco (d. 1407). A terminus ante quem of 1433 for the construction of the *piano terreno* is provided by a frescoed decorative frieze (Paccagnini/Figlioli, 1972, cats. 5 and 6, p. 21) found in one of the rooms of Isabella's ground-floor suite (Marani, 1975, p. 274, room 162).

11. The Appartamento degli Arazzi was decorated in 1780 to house an early set of the tapestries designed by Raphael for the Sistine Chapel; before then it was known as the Appartamento Verde. The Sala dei Papi was painted with a frieze of papal portraits prior to its eighteenth-century redecoration (Giannantoni, 1929, pp. 37–39). Traces of Trecento wall decoration surviving inside the Sala dei Papi date the construction of this space to the fourteenth century. The visible Gothic arch outside the first room of the Appartamento degli Arazzi suite (Fig. 1, room 18) on the southeast, or Cortile d'Onore, facade also dates this suite to the Trecento or early Quattrocento.

12. Before the discovery of the cycle by Pisanello, this room, painted with a frieze of nineteen Gonzaga rulers, was known as the Sala dei Principi or Sala dei Duchi. In the eighteenth century the room was also called the Anticamera degli Arcieri; see specifications drawn up by Giuseppe Bianchi on 10 April 1763 (A. Belluzzi, "Architettura a Mantova nell'età delle riforme," in *Mantova nel Settecento: un ducato ai confini dell'impero* [Atti del Convegno], Milan, 1983, p. 38). Traces of one of the Palazzo del Capitano windows in the wall shared by the palace and the *Sala* prove that the construction of this connecting wing postdates that of the palace. Its construction is usually dated to the late fourteenth century, as part of Capitano Francesco's rebuilding campaign (Paccagnini, 1969, p. 10), a dating confirmed by the remains of two late Trecento or early Quattrocento decorative schemes that survive high up on the walls of the *Sala*: an extensive *tapezaria* in green, yellow, and brown on the lateral walls under the pitched roof, and fragments of an elaborate red, purple, and green frieze on Wall 2 facing the windows. These fragmentary schemes indicate that the construction date of around 1415–30 proposed by Marani, 1975, p. 148, is too late. It is impossible to determine whether this connecting

wing overlooked the *cortile* of S. Croce or whether there were other buildings intervening between it and the court.

13. The *brolo* (the current Piazza della Lega Lombarda) is frequently mentioned in Trecento documents, such as the 1355 purchase document (see n. 3). Sabadino degli Arienti gives a poetic evocation of the delights of the *brolo* in the *Castello* in Ferrara: ". . . passaremo el brolo deli vaghi arbori pendenti in delectevole prato, producenti ali congrui tempi saporosi fructi, existendo lì molti arborselli de bussi intorno, alevati artificiosamente in diverse maniere, che non fia poca leticia agl'occhii con la vaghecia del bel fonte scaturiente in alto aqua chiara, che al tempo estivo renfresca le belle herbe" (Gundersheimer, 1972, p. 52). Traces of Trecento geometric frescoes surviving near the floor (which was later lowered) of the *Sala del Pisanello* indicate that the loggia on the ground floor was frescoed in the late fourteenth or early fifteenth century.

14. The outlines of the original two (and not three as stated in most of the earlier literature on this room) large and asymmetrically placed windows are clearly visible in the brickwork both from the exterior facade and from inside the room. The words *felicissima luce* were used by Sabadino degli Arienti when describing the light cast by two windows in the palace of Belriguardo outside Ferrara (Gundersheimer, 1972, p. 61).

15. Important examples of Trecento and early Quattrocento wall decoration are well preserved in the Palazzo del Capitano in the *piano nobile* suite of five small rooms located in the so-called Corridoio Passerino (Fig. 1, room 6) immediately above the facade portico (Paccagnini/Figlioli, 1972, cats. 1–4, pp. 18–21; Gerola, "Vecchie insegne"; Cottafavi, 1931–32, pp. 378–81). Other fine examples of early decorative schemes survive in a suite of rooms on the *piano terreno*

(Cottafavi, 1935, pp. 240–41, 244) and in room 8 of the suite of rooms known as the Appartamento della Guastalla on the *piano nobile*. Fragments of other schemes are visible in many other areas of the two palaces, including the *piano nobile* of the Magna Domus (Giannantoni, 1929, pp. 27, 48; G. Pacchioni, *Il Palazzo Ducale di Mantova*, Florence, 1921, p. 26). A letter written by Giovanni Galeazzo Visconti from Milan in 1380 to Lodovico Gonzaga asking for four to six *bonos depictores* capable of painting figures and animals well suggests a quantity of painters in Mantua in the late Trecento (L. Osio, *Documenti diplomatici tratti dagli archivi milanesi*, Milan, 1864, I, p. 212, doc. CXLVII).

16. Cottafavi, 1931–32, p. 379. The chapel, measuring 6.34 × 9.35 meters, now forms one of the rooms of the Guastalla suite. See Paccagnini/Figlioli, 1972, cat. 20, pp. 38–41.

17. These *piano nobile* suites are today known as the Appartamento della Guastalla (because decorated in the 18th century for the Duchess Anna Isabella di Guastalla, wife of the last Duke) in the Palazzo del Capitano (Fig. 1, rooms 7–12), the Appartamento delle Imperatrici (Fig. 1, rooms a, b, c) and the Sala Fiamminghi (Fig. 1, room 5) in the Magna Domus, and the Appartamento degli Arazzi and the Sala dei Papi in the rear block (Fig. 1, rooms 18–21, 14).

18. In the eighteenth century a chimneypiece, since removed, stood in the first room of the Guastalla suite, also known as the Sala degli Imperatori (Fig. 1, room 12), in the wall shared by this room with the *Sala del Pisanello* and in the location here suggested for the original door between the *Sala del Pisanello* and the Palazzo del Capitano. The brickwork of the wall was renewed when the chimneypiece was removed, destroying all traces of previous use. See the 1772 plan of the Appartamenti Ducale, Verde, and Guastalla on the *piano nobile* of the Ducal

Palace, Archivio di Stato, Milan, Fondi Camerali, p.a., 159, published in Belluzzi, "Architettura a Mantova," pl. 36.

19. Luca Fancelli's letter of 15 December 1480 to Federico Gonzaga (see n. 58) can be interpreted to mean that the poor repair of the ceilings of the *Sala Bianca* and the *Sala del Pisanello* was interconnected and that these two halls were therefore adjacent. The original structure and subsequent renovation history of the Sala dei Papi were also closely linked to those of the *Sala del Pisanello* (See text at n. 44). Its floor was also lowered, almost certainly at the same time; the ceiling was lowered in a later period (Pacchioni, *Palazzo Ducale*, p. 18); and the marble chimneypiece installed there by Duke Guglielmo (with the inscription GVL · D · G · MANT · ET · MONT · FER · DVX) is identical to that in the *Sala del Pisanello*. It thus seems likely that the *Sala Bianca* is to be identified with the present Sala dei Papi rather than with the first room of the Appartamento della Guastalla (Fig. 1, room 12), as suggested by Martindale, *Triumphs of Caesar*, p. 40, n. 11, since the *Sala del Pisanello* had no structural connection with the rooms inside the Palazzo del Capitano.

20. Until 1780 and their redecoration as the Appartamento degli Arazzi, these rooms seem to have been continuously known as the Appartamento Verde (see n. 11) and are therefore here tentatively identified with the *Sala Verde* mentioned in Luca Fancelli's letter to Federico Gonzaga of 9 September 1480, ASMAG, busta 2424.

21. See document in n. 38.

22. Letter from Francesco Gonzaga to his father, Federico, 20 September 1483, ASMAG, busta 2105 (re Florentine ambassador). Letter from Marchese Federico Gonzaga to Pandolfo Malatesta, 21 July 1480, ASMAG, busta 2897, libro 100, c. 39v (asking that the *camere bianche* be prepared immediately for the arrival of his mother, who had expressed the desire to move into them, and giving orders that the construction work going on in that part of the *Corte* be suspended whenever his mother requested). Letter of 21 June 1479 quoted in n. 30 (where the wording makes it clear that the *Sala Bianca* and the *camere bianche* were interconnected). A quarrel between Barbara of Brandenburg and her daughter-in-law, Margaret of Wittelsbach, reveals that the "white suite" was a highly desirable one usually given to guests: "Me pare se sia turbata grandemente e ha dicto de rincrescievole parole, lamentandose cum molte persone, ma niuno gie da rasone. Io gie mandai Pandolpho e Francisco Prendilaqua a proferirge le camare bianche de sotto e de sopra cum il zardino: disse che non volea per rispecto de li forestieri" (letter from Margaret of Wittelsbach to Federico Gonzaga, 8 May 1479, ASMAG, busta 2104).

23. Letter from Barbara of Brandenburg to Cardinal Francesco Gonzaga, Mantua, 11 June 1463, ASMAG, busta 2887, libro 41, quoted in chapter 8, n. 11.

24. "Albergò il Papa in corte e . . . si cominciò il Concilio . . . nella sala grandissima di detta corte, le cui finestre rispondano alla piazza di San Pietro" (Equicola, *Dell'istoria di Mantova*, p. 182). The *Armeria* has thirteen windows overlooking the Piazza Sordello. See also S. Gionta, *Il fioretto delle croniche di Mantova*, Mantua, 1741, p. 66. For the Council of Mantua, see chapter 4, text at n. 25ff.

25. Visible marks in the brickwork of the rear facade of the Palazzo del Capitano still indicate where the exterior stairs were placed. See G. Moretti, "Ufficio regionale per la conservazione dei monumenti in Lombardia: relazione sesta e settima, anni 1897–98 e 1898–99," *Archivio Storico Lombardo* 26, vol. 12 (1899): 248; G. Amadei, *Un secolo a Mantova*, Mantua, 1968, p. 22 (old photograph showing rear facade of the Palazzo del Capitano as described by Moretti

before the restoration of the masonry); Cottafavi, 1935, pp. 242–43, 239, 245; Giannantoni, 1929, pp. 23, 35; Pacchioni, *Palazzo Ducale*, pp. 9, 16–17; Paccagnini, 1960, p. 151. These stairs were probably constructed at the same time as the wing containing the *Sala del Pisanello* (see n. 12). For a differing view, see Marani, 1975, p. 156, where they are dated around 1440, that is, exactly contemporary with the date he assigns to the Arthurian cycle.

The stairs running from the *Porta Grande de Corte* up to the *Sala del Pisanello* do not rule out the possibility of another entrance to the palace from Piazza San Pietro and another internal stairway to the *piano nobile*. In the Trecento a portal was created out of the lane that separated the Magna Domus from the Palazzo del Capitano (see n. 6). This entrance, which was continually remodeled in later centuries and is the site of the current entrance from Piazza Sordello created by Paolo Pozzo around 1775, seems to have been closed in the Quattrocento. See Cottafavi, 1935, pp. 240, 246.

26. The walled-up doorway is still visible at the northwest corner of the north wall. See B. Zevi, *Saper vedere l'urbanistica: Ferrara di Biagio Rossetti, la prima città moderna europea*, Turin, 1971, p. 77. As in the *Sala del Pisanello*, a loggia or portico also ran under the *Sala dei Mesi*. See S. Ghironi and F. Baroni, "Note storiche sul Palazzo Schifanoia," *Atti e Memorie della Deputazione Provinciale Ferrarese di Storia Patria*, ser. 3, vol. 21 (1975): 126, 132, 134–35, figs. 2, 11.

27. P. Rotondi, *The Ducal Palace of Urbino: Its Architecture and Decoration*, New York, 1969, fig. 50; W. A. Bulst, "Die Ursprünglich innere Aufteilung der Palazzo Medici in Florenz," *Mitteilungen der Kunsthistorischen Institutes in Florenz* 14 (1970): 373, fig. 4.

28. B. Preyer, "The Rucellai Palace," in *Giovanni Rucellai ed il suo zibaldone*, vol. 2, *A Florentine Patrician and His Palace*, London, 1981, p. 173; L. Beltrami, *Il Castello di Milano*, Milan, 1894, plan p. 593. At the Palace of Belriguardo outside Ferrara, the stairway also led to the *magna sala* and also overlooked the *cortile* (Gundersheimer, 1972, p. 65).

29. "Ac veluti in urbe forum platae, ita in aedibus atrium sala et generis eiusdem habebuntur: loco non reiecto non abdito nec angusto, sed prompta sint ut caetera in eas membra expeditissime confluant. In has quidem scalarum et itionum apertiones, in has convenarum salutationes et gratulationes terminabunt" (L. B. Alberti, *L'architettura: De Re Aedificatoria*, ed. and trans. G. Orlandi, 2 vols., Milan, 1966, v, ii, p. 339). This type of arrangement was also later codified by Francesco di Giorgio: "La scala prima e principale dia pervenire sopra l'atrio dove s'entra in una sala. . . . Sopra del primo pavimento si perviene per late scale in una loggia sopra li detti cortili; et appresso a questa loggia sia una sala grande e principale la quale debba essere sopra a la piazza. . . . Trova li antichi, espertissimi in ogni arte, sempre avere usate le scale prime e principali volte a mano sinistra. . . . Dieno le scale principali essere manifeste a qualunque intra nella prima porta" (Francesco di Giorgio Martini, *Trattato di architettura, ingegneria e arte militare*, ed. C. Maltese, Milan, 1967, II, pp. 330–31, 350–52).

30. "Dopoi, circa le hore XXI, intrò in la terra la sposa cum lo ordine dato, secundo che per l'altra mia significai a la Signoria Vostra, et cum gran numero de homini et donne, et molto ben in ordine, cum soni di piffari, trombono, trombetti et altri instrumenti, fu conducta a la Corte dove, al pede de la scala, fu per la Illustrissima matre de Vostra Excellentia ricolta et in mezo de Sua Signoria et de la Illustrissima mia madona asscese a la sala biancha. Poi, subito intrata in una de quelle camare et alquanto reposata, se ritornò a la sala dove, sola cum uno

conte, suo parente, quale è venuto cum seco, danzò uno ballo . . ." (letter from Matteo Antimacho to Marchese Federico Gonzaga, 21 June 1479, ASMAG, busta 2422).

31. "Molto exaltava la citade e comendavila negli edifitii grandemente, intanto che Sua Signoria usò queste parole: che al viver suo l'haveva veduto gran parte di la Gretia, Ungaria et Italia e nominò haver veduto a Buda in Ungaria uno palazio che fiece edificar Sigismondo imperatore, a Roma Castel Santo Angelo, a Vinesia altri palazii. In summa, concluse che mai Sua Signoria non vidette il più magnifico, ni più apto, ni più superbo palazio di quello dela Vostra Illustrissima Signoria di Mantua. Ma disse gli pareva manchasse in una cosa, ché quella scala che entra ne la sala prima dove se viene in corte, gli pareva strita e mal apparente, e che cum puocha spesa la Signoria Vostra la puorria migliorare" (letter from Anselmo Folengo to Lodovico Gonzaga, Revere, 28 January 1460, ASMAG, busta 2394, fascicolo da Revere, c. 9).

32. See letter quoted in n. 59.

33. "Anday a la corte per ritrovare questo Signore e Madona ma ritrovay che lì non era veruno fino la casa vacua et me fu dicto per alcuni lì ch'el prefacto Signore e Madona erano andati ad alogiare in castello et che lassariano el pallatio a la Sanctità de Nostro Signore siché subito me partì de lì e anday al Castello et trovay così e trovay che lì se lavorano a furia . . ." (letter from Giovanni Francesco Stango to Bianca Maria Visconti, Mantua, 12 May 1459, Archivio di Stato, Milan, Sforzesco, cart. 391). "Havevemo facto venire qui una frotta de muratori e marangoni de le terre nostro de Cremonese per fornire queste stanzie" (letter from Lodovico Gonzaga to Giovanni Tommaria, Mantua, 6 May 1459, ASMAG, busta 2886, libro 30, c. 23). It should be noted that the *Castello* was not known in the Quattrocento as the Castello di San Giorgio.

34. ". . . de darti una camera a tua posta questo seria quodammodo impossibile perché come tu sai il palazo nostro tuto è occupato e qui in castello non poressemo star più strecti che quello faciamo . . ." (letter from Lodovico Gonzaga to Carlo da Forma, 20 September 1459, ASMAG, busta 2886, libro 36, c. 79v, cited in Signorini, 1985, p. 113).

35. "Io son riducta in questo castello, dove stago cum grandissimo sinestro e discunzo e paremi essere in prigione, che me fa quasi la febre venir ogni zorno" (letter from Barbara of Brandenburg to Bianca Maria Visconti, Mantua, 21 September 1459, ASMAG, busta 2886, libro 36, c. 80v).

36. See, for example, the letter from Federico Gonzaga to Pandolfo Malatesta, 14 October 1478, ASMAG, busta 2895, libro 90, c. 43r: ". . . come sapeti, la comitiva nostra tuta non pò logiar in castello et bisogna che una parte de loro logia in corte . . ."

37. ". . . Marsilio, se messer Lafrancho te dicesse de volere venire cum famiglii a stare, come'l fece altra volta, tu porai responderli che questo non seria possibile perché in Corte gli è alogiato Don Nicolò, Federico cum la mogliere e li figlioli, Ridolfo e molti altri di nostri, che occupano il tuto, et che, se nui et la Illustrissima nostra consorte non stessemo in castello, non haveressemo habitatione alcuna dove stare, e, a dirti il vero, nui non volemo in casa uno homo cum quello volto" (letter from Lodovico Gonzaga to Marsilio de Andreasi, 9 July 1472, ASMAG, busta 2892, libro 70, c. 34r). See also R. Signorini, "Two Notes from Mantua: A Dog Named Rubino," *Journal of the Warburg and Courtauld Institutes* 41 (1978): 319 n. 21, and the many documents concerning the *Castello* quoted in id. 1985, chap. 3.

38. "Lo Illustrissimo don Nicolò da Este me ha facto dir che voluntera voria far la cosina, per più sua securezza, su la sala del Pisanelo, donda fin hora ha manzado la famiglia sua. E voria dopoi far manzare

esa famiglia in la camera di cani. Son stado de responderli, consciderato che a far cosina lì, per il guazzo si fa continuamente in le cosine, che se marcirà tuto il solaro; posa etiam a farla in quel loco, etiam li farà busogno [*sic*] più legna. M'è parsi farni aviso a Vostra Excellentia di questo me ha facto dir eso don Nicolò, açiò li sapia responder il volere di quela, a la quale sempre me ricomando. Poi che questa cosa è discoverta, ho messo ordine a la cosina grande nostra donda s'è facto il manzare suo, ché lì non va persona alcuna et sta serata cum bon ordine" (letter from Giovanni Michele Pavesi to Marchese Lodovico Gonzaga, 12 December 1471, ASMAG, busta 2412, c. 291, published in A. Martindale, "The Sala di Pisanello at Mantua—A New Reference," *Burlington Magazine* 116 [1974]: 101, where the date of the letter was incorrectly given as 1472). (The hall was in fact always referred to as *Sala del Pisanello* and not *Sala di Pisanello*.)

39. E. G. Gardner, *Dukes and Poets in Ferrara*, London, 1904, pp. 125–26. Niccolò's own account of the assassination attempt, in a letter to Lorenzo de' Medici written 15 December 1471, was published in A. Cappelli, "Niccolò di Lionello d'Este," *Atti e Memorie della RR. Deputazione di Storia Patria per le Provincie Modenesi e Parmensi*, ser. 1, vol. 5 (1870): 436–37. For Lodovico Gonzaga's possible involvement in the succession to the Marquisate of Ferrara after Leonello's death, see G. Pardi, *Historie ferraresi*, Ferrara, 1646, pp. 161–62.

40. ". . . per uno certo vento vene in ruina una facata di muro che partiva tra la chamera grande d'aparamento, che è sopra la chamera di vari, e la chamera de la Signoria Vostra, dove era el pozo de lignamo è venuto in terra tuto per in fina al solaro . . ." (letter from Luca Fancelli to Federico Gonzaga, 9 September 1480, ASMAG, busta 2424).

41. Letter from Federico Gonzaga to Pandolfo Malatesta, 21 July 1480, ASMAG, busta 2897, libro 100, c. 39v; letter quoted in n. 58.

42. "Eri sera, da circha ala prima ora de nocte, cascò una giave et parte de la soffita de la sala del Pisanello. Le altre giave rimaste, secundo dice Job soprastante, son marce in li muri et stanno male. Questa mattina io gli andai a bonora, insieme cum maestro Luca, per fargli fare tal provisione che'l resto non venga in ruvina: non se gli mancarà per mantenere quella et anche altro. A la gratia de Vostra Illustrissima Signoria sempre me gli ricomando" (letter from Filippo Andreasi to Marchese Federico Gonzaga, Mantua, 15 December 1480, ASMAG, busta 2424, first published in U. Rossi, "Il Pisanello e i Gonzaga," *Archivio Storico dell'Arte* 1 [1888]: 453–56).

43. "Havemo inteso quanto ce scrivi circa la ruina in parte de la salla del Pisanello; e come tu hai fatto apontallare el resto, aciò che similiter non seguesse ruina: ne sono piaciute le provisione tuoe fatte circa ciò e commendiamotene; ala ritornata nostra dentro, ordinaremo poi quanto ne parerà: in questo mezo non si vole manchare de conservare le cose al meglio che si può" (letter from Marchese Federico Gonzaga to Filippo Andreasi, Goito, 15 December 1480, ASMAG, busta 1897, libro 101, c. 35r, published in Rossi, "Il Pisanello," pp. 453–56).

44. F. Antoldi, *Descrizione del Regio Cesareo Palazzo di Mantova*, Mantua, 1815, p. 5; Cottafavi, 1935, p. 243; Paccagnini, 1969, pp. 30–35; Paccagnini, 1972, pp. 18–19 n. 15; Marani, 1975, pp. 231ff.

45. This loggia was probably closed when the whole wing was remodeled in the late sixteenth century and the rooms on the *piano terreno* were vaulted, in conjunction with the creation of the new entrance and the installation of the monumental interior staircase, perhaps by Bertani, who is documented as working in the *Corte Vecchia* in 1567. For a differing view, see Moretti, "Ufficio

regionale conservazione," followed by Paccagnini, 1969, p. 30.

46. See the account in Paccagnini, 1972, chap. 1.

47. See chapter 7, text at n. 1.

48. Paccagnini (1972, pp. 13, 16, 45, 63) and Degenhart (1973, p. 370), not having undertaken a measured reconstruction, considered that too much was lost of the cycle to identify the iconography.

49. The reconstruction in Fig. 6 is based on a measured survey undertaken by Amedeo Belluzzi, drafted by Grazia Sgrilli, and redrawn for this book by Barbara Shapiro.

50. The hall originally had a pitched roof which was converted, before Pisanello painted his frescoes, to a flat timbered ceiling. On Wall 2 four narrow arched openings, starting at the original floor level and of unusual dimensions for either windows or doors, originally flanked the asymmetrically placed fireplace; they were bricked up before the painting was begun.

51. See I. Toesca, "Altre osservazioni in margine alle pitture del Pisanello nel Palazzo Ducale di Mantova," *Civiltà Mantovana* 11 (1977): 358 n. 11.

52. Paccagnini/Figlioli, 1972, cats. 36, 37, 39, 40, pp. 62, 74, give the following measurements for the frescoes and *sinopie* after the *strappo* (the vertical dimensions include the supports on which the detached murals were mounted): Wall 1: 4.35 x 9.60 m; Wall 2: 4.67 x 15.70 m; Wall 3: 4.67 x 3.95 m; Wall 4: 4.35 x 3.75 m.

53. See E. H. Gombrich, *Means and Ends: Reflection on the History of Fresco Painting*, London, 1976, p. 46; E. Borsook, *The Mural Painters of Tuscany*, 2d ed., London, 1980.

54. Figure 19 was drawn by Architetto Dario Melloni.

55. The reconstructed bipartite windows in Figs. 6 and 19 are based on the second-story windows in the Palazzo del Capitano (Paccagnini, 1960, pl. 121), undoc-

umented but probably dating from the early fifteenth century, and on the Gothic windows drawn by Pisanello in Louvre, inv. 2276 (Fossi Todorow, 1966, cat. 68, pl. LXXXI).

56. We know by analogy with other secular cycles that the window embrasures would have been painted.

57. The losses in the middle of Wall 2 can be blamed on the installation of the new fireplace to the right of the original flue.

58. "A questo dì pasati, per dubio chagise la sofita della sala biancha, l'abian fata discharigar d'un gran peso de parechi cara de pezame de chopi e, chome credo siate avisato, è chaduto una chorda da chiave della salla del Pisanello, chon una parte di sofita, perché tute dite chorde sono state azunte per lo pasato perché erano marze nel muro e non àno sostegnio alquno. Io le fo puntellare e tirar giù el resto della sofita aciò non chadese adoso a persona, poi Vostra Illustrissima Signioria diterminarà quelo s'abia a far, et io farò intender a quela d'altre chose, ché bisognierà far un po' de provigione, nè altro, ala grazia de quela mi rachomando" (letter from Luca Fancelli to Marchese Federico Gonzaga, Mantua, 15 December 1480, ASMAG, busta 2424, published in Rossi, "Il Pisanello," pp. 453–56). Assirto Coffani, restorer of the frescoes in the *Sala del Pisanello*, states that the frescoes were slightly scarred by the falling timber.

59. "Vogliamo che subito tu faci apparechiar e metere in ordine la camara da le ale cum le altre camare de sopra et le nostre dal canto nostro de sopra, facendoli pur metter li apparamenti che ge usamo ogni dì, perché lo Illustrissimo Signor tuo patre, per questo suo male, non vole più tornar ad alogiar in castello . . ." (letter from Barbara of Brandenburg to Federico Gonzaga, Cremona, 21 September 1457, ASMAG, busta 2885, libro 30, c. 65r). For Lodovico's *male* (severe pains in his arms and legs), see Mahnke, 1975, pp. 197 n. 128, 308–9, 366 n. 20.

60. "La prima salla dinanci a le camere è apparata dignamente tuta di panno de razzo intorno. . . . A la tavola gli è posto quel capocelo di brocato d'oro cremisi, ove manza la maestà del re. Poi gli sonno tutte quelle camere . . . tutte le mure sonno coperte di tapezarie . . ." (letter from Zaccaria Saggi to Lodovico Gonzaga, Milan, 14 March 1474, ASMAG, busta 1624, published in R. Signorini, "Cristiano I in Italia," *Il Veltro* 25 [1981]: 42, doc. 7).

61. La casa dove allozamo Redolfo e mi è assai ben hornata cum alcuni razi e banchali, suxo el lecto è un copertoro de rassa recamato, et cussì il capocelo . . ." (letter from Gianfrancesco Gonzaga to Barbara of Brandenburg, Innsbruck, 21 May 1463, ASMAG, busta 544, c. 249, published in G. Lanzoni, *Sulle nozze di Federico I Gonzaga con Margherita di Wittelsbach (1463)*, Milan, 1898, p. 21).

TWO · ICONOGRAPHY

1. J. Frappier, "The Vulgate Cycle," in *Arthurian Literature in the Middle Ages*, ed. R. S. Loomis, Oxford, 1959, pp. 295–318; A. Leupin, *Le Graal et la littérature: étude sur la vulgate arthurienne en prose*, Lausanne, 1982; E. J. Burns, *Arthurian Fictions: Re-reading the Vulgate Cycle*, Miami, 1985; id. "The Vulgate Cycle," in *The Arthurian Encyclopedia*, ed. N. J. Lacy, New York, 1985. Useful studies of specific branches are F. Lot, *Etude sur le Lancelot en prose*, Paris, 1918; J. Frappier, *Etude sur la Mort le Roi Artu*, 2d ed., Paris, 1961; A. Pauphilet, *Etude sur la Queste del Saint Graal*, Paris, 1921. See also C. J. Chase, "Double Bound: Secret Sharers in the Thirteenth Century Prose *Lancelot*," in *The Legacy of Chrétien de Troyes*, ed. D. Kelly and N. Lacy, in press; id., "Multiple Quests and the Art of Interlacing in the Thirteenth Century *Lancelot*," *Romance Quarterly* 33 (1986): 407–20.

2. Modern critical editions are A. Micha, ed., *Lancelot, roman en prose du XIIIe siècle*, 9 vols., Paris–Geneva, 1978–83, II, p. 183, no. 34 to p. 199, no. 27; H. O. Sommer, ed., *The Vulgate Version of the Arthurian Romances*, 8 vols., Washington, D.C., 1908–16, IV, pp. 262–70.

3. V. Pizzorusso Bertolucci, "I cavalieri del Pisanello," *Studi Mediolatini e Volgari* 20 (1972): 37–48.

4. Paccagnini, 1972, pp. 56, 61, transcribed no. 4 as "rot" and hypothesized that Calarrot le Petit, an Arthurian knight mentioned in the prose *Tristan*, was intended.

5. Pizzorusso Bertolucci, "I cavalieri," p. 40. F. Flûtre, *Table des noms propres avec toutes leurs variantes figurant dans les romans du Moyen âge, écrits en français ou en provençal et actuellement publiés ou analysés*, Poitiers, 1962. s.v.; G. D. West, *An Index of Proper Names in French Arthurian Prose Romances*, Toronto, 1978, s.v.

6. "Damoisele, fet il, itel que a l'entree de la premiere forest ou je enterrai ferai tendre mon paveillon et serai iluec chescun jor tant que j'avrai conquis .x. chevaliers, ou je serai outrez; et se je les conquier, vos en avrois les chevals. Et cil chevaliers avoit non Sabilor as Dures Mains" (Micha, *Lancelot*, II, bk. 48, para. 6, p. 190). The codex used by Pisanello undoubtedly differed in detail from the text as edited by Micha and Sommer; each of those editions was based on different combinations of surviving manuscripts. Ninety-three manuscripts or fragments (representing a fraction only of the total output) survive of the prose *Lancelot*, but only eight extant Mss. represent all branches of the Vulgate Cycle: London, British Library, Add. 10292, Add. 10293, Add. 10294; Paris, Bibliothèque Nationale, 98, 110, 117–20, 344; and Paris, Bibliothèque de l'Arsenal, 3479–80.

Variants in spelling were due to the different dialects or particular habits of the individual scribes of the various manuscripts. Our hero's name was var-

iously transcribed Bohort, Bohors, Boort, Bors, and Boors; the name Sabilor had the variants Cabilor, Calibor, Talibor, Talibors (Flûtre, *Table*, p. 176; Sommer, *Vulgate Version*, VIII, p. 78; West, *Index*, p. 285). For textual issues in the prose *Lancelot*, see A. Micha, "Les manuscrits du Lancelot en prose," *Romania* 81 (1960): 145–87; 84 (1963): 28–60, 478–99; A. Micha, "La tradition manuscrite du Lancelot en prose," *Romania* 85 (1964): 293–318; B. Woledge, *Bibliographie des romans et nouvelles en prose française antérieurs à 1500* Geneva, 1954, pp. 71–79; B. Woledge, *Bibliographie . . . Supplement 1954–1973* Geneva, 1975, pp. 50–59.

7. "Et li tiers dist qu'il n'enterra jamés n'en chastel n'en maison devant qu'il avra conquis .VI. chevaliers, ou il ert outrez, 'et se je les conquier, vos en avrois les hialmes.' Et cil chevaliers avoit non Arfusat li Gros" (Micha, *Lancelot*, II, bk. 48, para. 6, p. 190). The name Arfassart had the variants Arfusat, Arfasar, Alfasar, Alfarsar, Alpharsar (Flûtre, *Table*, p. 10; Somer, *Vulgate Version*, VIII, p. 7; West, *Index*, p. 14).

8. "Et li quars dit qu'il ne couchera jamés o damoisele nu a nu devant qu'il ait conquis .III. chevaliers, ou il sera outrez, 'et se jes conquis, damoisele, fet il, vous en avrois les epees.' Et l'en l'apeloit Sarduc le Blont" (Micha, *Lancelot*, II, bk. 48, para. 7, p. 190). The name Sardroc had the variants Sardruc, Sardoc, Sarduc, Sardou, Sadoc (Flûtre, *Table*, p. 170; Sommer, *Vulgate Version*, VIII, p. 75; West, *Index*, p. 269). Sommer, IV, p. 266, lines 25–28, used the variant "li blans" for this knight's epithet.

9. "Et li quins dist que devant .I. an n'encontera chevalier, por qu'il maint damoisele o lui, qu'il ne se combate tant a lui qu'il conquerra la demoisele, ou il sera conquis, 'et totes celes que je porrai conquerre vos envoierai je por vos servir.' Et li chevaliers avoit non Mallies de l'Espine" (Micha, *Lancelot*, II, bk. 48, para. 7, p. 190). The name Maliez had the variants Mallies, Melios, Malyos, Malios, Malies, Mallior, Maillot, Melior (Flûtre, *Table*, p. 136; Sommer, *Vulgate Version*, VIII, p. 62; West, *Index*, p. 218).

10. "Aprés dist li huitimes qu'il chevalchera .I. mois en chemise pure, le hialme en la teste, l'escu al col, la lance en la main, l'espee al costé, 'ne ja n'enconterai, fet il, chevalier a ki je ne joste, et de tos cels que je abatrai vos envoierai je les chevals.' Et il avoit non Melidun li Envoisiez" (Micha, *Lancelot*, II, bk. 48, para. 8, p. 191). The name Meliduns had the variants Melidun, Meldons, Meldon, Mandin (Flûtre, *Table*, p. 135; Sommer, *Vulgate Version*, VIII, p. 62; West; *Index*, p. 216).

11. "Aprés dist li sisimes qu'il ne conquerra chevalier a cui il ne trenche la teste, ou il sera conquis, 'et de tos cels, damoisele, que je conquerrai dedens .I. mois vos envoierai les testes.' Et cil avoit non Agoiers li Fel" (Micha, *Lancelot*, II, bk. 48, para. 8, p. 190). Sommer, *Vulgate Version,* IV, p. 266, lines 33–36, and West, *Index*, p. 17, both used the variant Angoires.

12. "Aprés dist li novismes: 'Damoisele, por vos ferai tant que jou irai au Gué del Bois et le garderai si que nus chevaliers n'i abeverra son cheval a qui jou ne me combate et de tous cels que je conquerrai vous envoierai je, damoisele, le escus.' Et cil avoit non Garengaus li Fors" (Micha, *Lancelot*, II, bk. 48, para. 9, p. 191). Sommer, *Vulgate Version*, IV, p. 267, lines 4–7, and West, *Index*, p. 131, used the variant Garingans.

13. See chapter 1, section II.

14. J. Herald, *Renaissance Dress in Italy 1400–1500*, London, 1981, p. 212; R. Levi Pisetzky, *Storia del costume in Italia*, Milan, 1964, II, p. 359, pls. 178, 179. For identification of the knight, see chapter 4, section II.

15. See chapter 3, section II.

16. There was a space of 6 meters between the two windows.

17. Paccagnini, 1972, pp. 56ff., considered the possibility that the images on Walls 2 and 3 might refer to the knights' vows made at Brangoire's banquet, but neither he nor Pizzorusso Bertolucci envisaged the possibility that the hall as a whole was intended to be frescoed with the story as a whole.

18. Paccagnini, 1972, chap. 3; Degenhart, 1973, pp. 370–78, 405. The tournament at Louverzep occurs late in the prose *Tristan* (E. Loeseth, *Le roman en prose de Tristan . . . Analyse critique d'après les manuscrits de Paris*, Paris, 1891, nos. 376–81) and also in the reworked version in Italian *La Tavola Ritonda* (F. L. Polidori, *La Tavola Ritonda o l'istoria di Tristano*, Bologna, 1864, pp. 385–88).

19. Paccagnini and Degenhart (loc. cit.) interpreted the knights-errant in the *sinopia* as the departure of ninety-eight Arthurian knights in search of the Holy Grail, an event that occurs in a different section of the prose *Tristan* (Loeseth, *Tristan*, p. 83, no. 395, where Sabilor was transcribed as Sibilias). The scenes labeled with inscriptions were, however, in addition interpreted as the vows taken at Brangoire's banquet; the two scenes on Walls 2 and 3 without inscriptions (Figs. 30 and 31) were instead identified as exploits taken from yet another romance, the *Queste del Saint Graal*.

The twelve knights who take vows at King Brangoire's banquet also appear in the prose *Tristan* toward the end of a list of the ninety-eight knights of the Round Table who set off from Camelot in search of the Grail, where they are included without numerals. However, if the theme of the Mantuan murals was the departure of these ninety-eight knights, one wonders where Pisanello would have found room to depict the remaining ninety-one knights not present today in the *Sala*, most of whom are listed in the romance ahead of the five knights whose names are inscribed on its walls. Furthermore, if this event were the main subject of the Mantuan cycle, it seems strange that seven of these knights should have been depicted enacting the vows they undertook at King Brangoire's banquet, vows that were quite unrelated to the search for the Grail in the prose *Tristan* and that came from a different romance, the prose *Lancelot*.

20. Paccagnini, 1972, chap. 3 and photograph captions throughout the book; Paccagnini/Figlioli, 1972, cats. 39, 41.

21. E. Callmann, *Apollonio di Giovanni*, Oxford, 1974, cat. 41, pl. 184 (Battle of Issus); cat. 23, pl. 125 (Conquest of Trebizond); cat. 55, pl. 208 (Battle of Pharsalus).

22. J. Pope-Hennessy, *The Complete Work of Paolo Uccello*, London, 1969, pls. 51, 61; K. Clark, *Piero della Francesca*, London, 1969, pl. 73; P. Verlet et al., *The Book of Tapestry*, New York–Paris–London, 1978, p. 50.

23. See also any of the battle scenes, such as the *Death of Achilles*, from the great tapestry series illustrating the Trojan War today in Zamora (G. Souchal, *Chefs-d'œuvre de la tapisserie du XIVe au XVIe siècle*, Paris, 1973, pl. p. 55), and the *cassoni* illustrated in Callmann, *Apollonio*, pls. 118, 123, and P. Schubring, *Cassoni, Trühen und Trühenbilder der italienischer Frührenaissance*, Leipzig, 1923, II, cats. 114, 150. See chapter 8 for the evidence of what 15th-century Italian tournaments were like.

24. Callmann, *Apollonio*, cat. 20, pl. 118; cat. 21, pls. 122–23 (a tournament in Piazza Santa Croce).

25. See n. 79.

26. Souchal, *Chefs-d'œuvre*, cat. 17, pp. 72–75; V. Goloubew, *Les dessins de Jacopo Bellini au Louvre et au British Museum*, 2 vols., Brussels, 1908–12, I, pl. 62.

27. See N. Rasmo, *Castelroncolo*, Bolzano, 1975; G. Gerola, "Per la datazione degli affreschi di Castel Roncolo," *Atti del R. Istituto Veneto di Scienze, Lettere ed Arti* 82, pt. 2 (1923): 511–21; references in n. 83. See chapter 6, section III, for Pisanello's organization of the tournament scene.

28. The conclusion that the scene illustrates a tournament was also reached by Degenhart, 1973, p. 374.

29. The captions are a stylized or ornamental version of *libraria Gotica* or *littera textualis*, which is a formed hand used for legal documents. See A. Bellù, "Pisanus pinctor debet habere . . ." *Arte Lombarda* 80–82 (1987): 132–39.

30. ASMAG, busta 2038–9, gridario 3.

31. For a discussion of this phenomenon, see P. Meyer, "De l'expansion de la langue française en Italie pendant le Moyen-Age," *Atti del II Congresso Internazionale di Scienze Storiche* (Rome, 1903), vol. 2, *Storia medievale e moderna*, Rome, 1906, pp. 61–104; G. Bertoni, *La biblioteca estense e la coltura ferrarese ai tempi del Duca Ercole I*, Turin, 1903, pp. 69–93.

32. "Allegat ergo pro se lingua oïl, quod propter sui faciliorem ac delectabiliorem vulgaritatem quicquid redactum sive inventum est ad vulgare prosaycum, suum est: videlicet Biblia cum Troianorum Romanorumque gestibus compilata et Arturi regis ambages pulcerrime et quamplures alie ystorie ac doctrine" (Dante Alighieri, *De vulgari eloquentia*, ed. A. Marigo, Florence, 1957, I, X, 2).

33. "Por ce que lengue franceise cort parmi le mond et est la plus delitable a lire et a oïr que nule autre" (Martin da Canal, *Les estoires de Venise*, ed. A. Limentani, Florence, 1972, p. 2).

34. See A. Roncaglia, "La letteratura franco-veneta," in *Storia della letteratura italiana*, ed. E. Cecchi and N. Sapegno, Milan, 1965, vol. 2, *Il Trecento*, pp. 727–59; A. Viscardi, *Letteratura franco-italiana*, Modena, 1941, pp. 7–49; *Documenti mar-ciani e principale letteratura sui codici veneti di epopea carolingia*, Venice, 1961, annotated bibliography pp. 15–43.

35. D. Delcorno Branca, *I romanzi italiani di Tristano e la Tavola Ritonda*, Florence, 1968; id., *Il romanzo cavalleresco medievale*, Florence, 1974; E. G. Gardner, *The Arthurian Legend in Italian Literature*, London, 1930. The Italian versions were probably circulated largely among the bourgeoisie of the city-states, where the reciting of romances was a favorite form of entertainment (E. Levi, "I cantari leggendari del popolo italiano nei secoli XIV e XV," *Giornale Storico della Letteratura Italiana*, suppl. 16 [1914]: 1–159). The Italian *Tavola Ritonda* contains no mention of Bohort's visit to King Brangoire's castle or of any of the knights who took vows at the king's banquet.

36. "Benché più volentieri io lega libri latini che franciosi, nondimancho perché de franciosi poterò prendere dilecto con tuta la compagnia, prego la Extia Vostra . . . di potere mandare . . . le chiave de li libri franciosi . . . et essere contenta ch'io ne toglie duy per potere lezere et prendere piacere in nave" (letter from Galeazzo Maria Sforza to Francesco Sforza, Pavia, 20 July 1457, Archivio di Stato, Milan, Sforzesco [fondo Potenze Sovrane], cart. 1461, published in A. Cappelli, "Guiniforte Barzizza, maestro di Galeazzo Maria Sforza," *Archivio Storico Lombardo* 21, vol. I [1894]: 406).

37. C. S. Lewis, *The Discarded Image: An Introduction to Medieval and Romance Literature*, Cambridge, 1964, p. 6.

38. The 1407 inventory has been published and discussed by W. Braghirolli, P. Meyer, and G. Paris, "Inventaire des manuscrits en langue française possédés par Francesco Gonzaga I, Capitaine de Mantoue, mort en 1407," *Romania* 9 (1880): 497–514; P. Girolla, "La biblioteca di Francesco Gonzaga secondo l'inventario del 1407," *Atti e Memorie della R. Accademia Virgiliana di Mantova* 14–16 (1923): 30–72; U. Meroni, ed., *Mostra*

dei codici gonzagheschi, Mantua, 1966, pp. 39–46; A. de Mandach, "A la découverte d'un nouvel 'Aspremont' de la Bibliothèque des Gonzague à Mantoue," *Cultura Neolatina* 21 (1961): 116–22.

39. There were also 5 verse romances.

40. *Cronica Merlini* (no. 17), a mistitled *Livre des merveilles du saint graal* (no. 31), *Infantia Lanzalotti* (no. 32) in which the incipit is the beginning of *Lancelot*, and *Questa Sancti Gradalis* (no. 30).

41. Degenhart, 1973, p. 382, figs. 54–57.

42. F. Novati, "I codici francesi de' Gonzaga secondo nuovi documenti," *Attraverso il medioevo*, Bari, 1905, pp. 263–64.

43. "Quoniam sum presentialiter comitaturus serenissimam dominam dominam reginam Yerusalem et Ciprii usque in Ciprium, et sicut novit dominatio vestra opporteat me longo spacio stare in mare, ubi propter longum otium sumuntur maxima tedia que legendo aliqua delectabilia satis faciliter a cordibus hominum evanescunt, intellexerim quoque magnificos dominos predecessores vestros pulc[h]erimis et delectabilibus libris fuisse fulcitos, qui ad vestra manus pervenerunt, deprecor dominationem vestram quatenus si possible est, placeat per latorem presentium familiarem meum unum romanum loquentem de Tristano vel Lanzaloto aut de aliqua alia pulcra et delectabili [sic] materia vobis faciliorem ad comodandum mihi mutuo transmittere, ut de ipso possim prefate serenissime domine domine Regine et michi dare solacium et placere, et tedia naufraga a nobis repellere" (letter from Luchino Visconti to Lodovico Gonzaga, Cremona, 15 June 1378, ASMAG, busta 1606, c. 33). See also Novati, "Codici francesi," pp. 266, 272.

44. The best general accounts are D. M. Robathan, "Libraries of the Italian Renaissance," in *The Medieval Library*, ed. J. W. Thompson, New York, 1939, pp. 509–88; P. Kibre, "The Intellectual Interests Reflected in the Libraries of the Fourteenth and Fifteenth Centuries,"

Journal of the History of Ideas 7 (1946): 257–97. Useful summaries can be found in R. S. Loomis and L. H. Loomis, *Arthurian Legends in Medieval Art*, London–New York, 1938, pp. 120–21; C. W. Clough, "The Library of the Gonzaga in Mantua," *Librarium: Revue de la Société Suisse des Bibliophiles* 15 (1972): 50–63.

45. R. Rayna, "Ricordi di codici francesi posseduti dagli Estensi nel secolo XV," *Romania* 2 (1873): 49–58; A. Cappelli, "La biblioteca estense nella prima metà del secolo XV," *Giornale Storico della Letteratura Italiana* 14 (1889): 1–30 (which gives the 1436 inventory); J. Camus, "Notices et extraits des manuscrits français de Modène antérieurs au XVIe siècle," *Revue des Langues Romanes* 35 (1891): 169–262.

46. Of the branches of the Vulgate Cycle, the 1436 inventory included 3 volumes of *Lancelot* (nos. 1, 16, 45), 2 volumes of *Saint Graal* (nos. 20, 30), 2 volumes of the *destruction* or *desfatione* of the Round Table (nos. 28, 49), 2 vols. of *Merlin* (nos. 6, 43).

47. E. Pellegrin, *La bibliothèque des Visconti et des Sforza ducs de Milan au XVe siècle*, Paris, 1955, pp. 16. See also G. Mazzatinti, "Inventario dei codici della biblioteca Visconteo-Sforzesca nel 1459 e 1469," *Giornale Storico della Letteratura Italiana* 1 (1883): 32–59; A. Thomas, "Les manuscrits français et provençaux des ducs de Milan au chateau de Pavie," *Romania* 40 (1911): 571–609. In 1459 the number of Arthurian romances totaled 10, including 3 copies of *Lancelot*, 2 of *Merlin*, and 1 *Re Artus* (Pellegrin, nos. 818, 823, 824, 764, 771, 820).

48. Rayna, "Ricordi di codici francesi," p. 55. These calculations remain tentative because it is sometimes difficult to identify the books listed in the inventories. Furthermore, the separate items listed are not an accurate index to the actual number of literary works in any collection, because it was customary to bind

several texts together. The 1467 and 1495 Este inventories were published by Bertoni, *Biblioteca estense*, pp. 213–52, and id., "La biblioteca di Borso d'Este," *Atti del R. Accademia delle Scienze di Torino* 51 (1925–26): 705–28; that for 1474, by id., *Nuovi studi su M. M. Boiardo*, Bologna, 1904, p. 174. The 1474 inventory included 5 copies of *Lancelot*, 5 *Saint Graal*, and 1 *Merlin*. The 1488 inventory included 5 copies of *Lancelot* and 2 *Saint Graal*; that for 1495 included 2 copies of *La Mort le Roi Artu*, 4 *Merlin*, 2 *Saint Graal*, and 2 *Lancelot*. The 1467 inventory listed 5 copies of *Lancelot*, 4 *Saint Graal*, and 1 *Merlin*.

49. The 1470 list, entitled "Infrascritti sonno li librei in lingua franzosa scritti, cioè della Tavola vechia et nova che sonno nella libraria del Castello de Pavia," was published by E. Motta, "I libri francesi della libreria sforzesca in Pavia (1470)," *Bollettino Storico della Svizzera Italiana* 6 (1884): 217–18.

50. G. Bertoni, "Notizie sugli amanuensi degli Estensi nel Quattrocento," *Archivum Romanicum* 2 (1918): 36. The payments were made in 1462 and 1465.

51. Ibid. p. 32; id., "Un copista del Marchese Leonello d'Este," *Giornale Storico della Letteratura Italiana* 72 (1918): 101–2.

52. Bertoni, "Un copista," p. 105; id., "Notizie sugli amanuensi," p. 33.

53. Bertoni, "Notizie sugli amanuensi," p. 36; H. J. Hermann, "Zur Geschichte der Miniaturmalerei am Hofe der Este in Ferrara," *Jahrbuch der Kunsthistorischen Sammlungen der Allerhöchsten Kaiserhauses* 21 (1900): 260, docs. 187 (7 September 1464), 188 (10 September 1464), 192 (23 June 1468).

54. Bertoni, *Biblioteca estense*, p. 62 n. 1 ("Uno Merlino et uno Meliaduxe, un Lanzaloto in gallico, un libro francese dito San Gradale, un libro franchois senza nome e un altro libro franchois"); id., *Guarino da Verona fra letterati e cortigiani a Ferrara 1429–60*, Geneva, 1921, p.

178; L. Chiappini, *Gli Estensi*, Varese, 1970, p. 113.

55. Bertoni, *Guarino da Verona*, p. 178; id., "Lettori di romanzi francesi nel Quattrocento alla corte estense," *Romania* 45 (1918): 118 ("Uno Meliadux in lingua gallica, uno libro dito Lanzeloto in franzox, un libro franchois").

56. A. Venturi, "L'arte a Ferrara nel periodo di Borso d'Este," *Rivista Storica Italiana* 2 (1885): 692; Bertoni, *Guarino da Verona*, pp. 179–80. These loans took place in 1459, 1460, 1461, and 1466.

57. Ibid. These loans took place in 1457, 1459, 1467, and 1468.

58. Bertoni, "Lettori di romanzi," p. 119.

59. "Nuj habiamo horamaj forniti et compiti di legere tutj li nostri libri franzisi che nui se ritrovamo havere presso de nuj. Et perché nuj ve habiamo per debitore vi mandiamo questro nostro C[avallaro] aposta pregandovi et incaricandovi ne lo vogliatj mandare carrico di quanti più libri francisj vuj poteti cioè de quelli de la tavola vechia recordandovj che ne receveremo magiore pia[ce]re et contento che di una citade che nuj guadagnassemo" (letter from Borso d'Este to Ludovico di Cunio, [? February] 1470, Archivio di Stato, Modena, Cancelleria Ducale, Registro di Lettere 1445–49, 1469–71, vol. 4, c. 57 [formerly c. 27 bis], published in G. Bertoni, *L'Orlando Furioso e la rinascenza a Ferrara*, Modena, 1919, p. 92). Id., *Guarino da Verona*, p. 179. For the Arthurian books in French in the 1467 inventory, see id., "Biblioteca di Borso d'Este," pp. 726–28.

60. ". . . che Vostra Ill. Signoria haveria piacere de haver un . . . libro francese che tratta de Gurone . . . Ben la pregiamo che quando l'habi operato voglia rimandarcelo, che la ce ne farà singular piacere, perché voressemo pur farcene transcrivere un simile, ricordandoli che altra volta fu al tempo de la bona memoria del Ill. quondam Signor nostro

padre ge ne fu mandato uno nostro quel non se rihebbi mai . . ." (letter from Lodovico Gonzaga to Borso d'Este, Goito, 5 July 1464, ASMAG, busta 2889, libro 51, c. 43r, cited in Signorini, 1985, p. 72 n. 35).

61. "Et potrasse darli comissione a qual de loro andava che quando lo presentarano ne facesseno fare qualche nota aciò che poi nol se smarissa come za fece el Curone nostro che fu prestato similmente nè may s'è possuto rehavere ma de questo ne rincresceria ben tropo s'el perdessemo. Nondimancho havendonelo richiesto el prefato Signore como l'ha non ce pare de negargelo" (letter from Lodovico Gonzaga to Barbara of Brandenburg, Goito, 19 December 1468, ASMAG, busta 2891, libro 63, c. 13r, cited in Luzio/Renier, 1890, p. 160).

62. "La Vostra Ill. Signoria a questi zorni passati ne dimandoe in prestito el libro nostro franzese che tracta de Lanciloto e cussì nui de la bona voglia, per satisfare a la richiesta sua, habiamo scripto a Mantua che subito el gie sia mandato per il portadore di questa nostra. E perché questo libro continuamente se tene a la camara nostra et nui a le volte pigliamo piacere assai de lezerlo, haremo a caro che, quando la prefata Signoria Vostra lo habia lecto ce lo voglia poi rimandare" (letter from Lodovico Gonzaga to Borso d'Este, Goito, 19 December 1468, ASMAG, busta 2891, libro 63, c.13r, published in Luzio/Renier, 1890, p. 160).

63. Letter from Marsilio Andreasi to Lodovico Gonzaga, 22 November 1466, ASMAG, busta 1623, c. 195; letter from Lodovico Gonzaga to Niccolò Fontana, 20 May 1471, ASMAG, busta 2891, libro 67, c. 28r, both references cited in Signorini, 1985, p. 72 n. 31, 32.

64. Letter quoted in n. 60.

65. For further discussion of chivalric versus classical tastes, see chapter 5, section II.

66. S. Eiche, "Alessandro Sforza and Pesaro: A Study in Urbanism and Architectural Patronage," Ph.D. thesis, Princeton University, 1982, pp. 132, 138.

67. These volumes were listed among the 29 French books out of a total of 179 volumes in the 1542 inventory. See A. Luzio and R. Renier, "La coltura e le relazioni letterarie di Isabella d'Este Gonzaga," *Giornale Storico della Letteratura Italiana* 42 (1903): 81–87, nos. 154, 164, 165, 166. Nos. 152, 154, 163, 173, 175, and 176 were stories of King Arthur and Merlin, possibly the respective branches of the Vulgate Cycle. The episode depicted by Pisanello usually occurs in the second volume of *Lancelot*.

68. Frappier, "The Vulgate Cycle," p. 317; Sommer, *Vulgate Version*, I, pp. xxvi–xxviii.

69. Lot, *Etude sur le Lancelot*, pp. 8, 279. For further discussions of chivalric romance, see chapter 5, section II; chapter 9.

70. P. Rayna, "Contributi alla storia dell'epopea e del romanzo medievale: gli eroi brettoni nell'onomastica italiana del secolo XII," *Romania* 17 (1888): 161–85, 355–65; G. Serra, "Le date più antiche della penetrazione in Italia dei nomi di Artù e di Tristano," *Filologia Romanza* 2 (1955): 225–37.

71. Bohort's name was rendered in Italian as Borso, Bordo, or Borgo lo Casto. See Polidori, *La Tavola Ritonda*.

72. The traditional date for Geoffrey of Monmouth's *Historia Regum Britanniae* is 1135.

73. See R. Lejeune and J. Stiennon, "La légende arthurienne dans la sculpture de la cathédrale de Modène," *Cahiers de Civilisation Médiévale* 6 (1963): 282–93; R. Salvini, *Wiligelmo e le origini della scultura romanica*, Milan, 1956, who gives an annotated bibliography on the Modena archivolt (pp. 178–88), dates the work around 1125–30, and calls the artist "Maestro di Artù" (pp. 175–76).

74. C. Settis Frugoni, "Per una lettura del mosaico pavimentale della cattedrale di

Otranto," *Bollettino dell'Istituto Storico Italiano per il Medio Evo e Archivio Muratoriano* (1968): 213–56; R. van Marle, *The Development of the Italian Schools of Painting*, The Hague, 1923, I, p. 227.

75. See n. 35. The major study of Arthurian illustration remains Loomis and Loomis, *Arthurian Legends*, reviewed by T. Krautheimer-Hess, *Art Bulletin* 24 (1942): 102–4. For works displaying Tristan imagery, see also N. H. Ott, "Katalog der Tristan-Bildzeugnisse," in H. Frühmorgen-Voss, *Text und Illustration im Mittelalter*, Munich, 1975, pp. 140–71.

76. F. Bologna, *Il soffitto della Sala Magna allo Steri di Palermo*, Palermo, 1975, p. 172; Loomis and Loomis, *Arthurian Legends*, pp. 61–63. The literary source has been identified as the *Tristano Riccardiano*.

77. Loomis and Loomis, *Arthurian Legends*, pp. 63–65; P. Rayna, "Intorno a due antiche coperte con figurazioni tratte dalle storie di Tristano," *Romania* 42 (1913): 517–79. For a later dating of the quilts, see A. Santangelo, *Tessuti d'arte italiani dal XIII al XVIII secolo*, Milan, 1959, p. 29.

78. Degenhart, 1973, pp. 379ff; Loomis and Loomis, *Arthurian Legends*, pp. 114ff; B. Degenhart and A. Schmitt, *Corpus der italienischen Zeichnungen 1300–1450*, pt. II, Berlin, 1980, cats. 669, 671–83, 685–87, 696; id., "Frühe angiovinische Buchkunst in Neapel: die Illustrierung französischer Unterhaltungsprosa in neapolitanischen Scriptorien zwischen 1290 und 1320," *Festschrift Wolfgang Braunfels*, ed. F. Piel and J. Traeger, Tübingen, 1977. For a discussion of the miniatures of the earliest thirteenth-century text of the prose *Lancelot*, see A. Stones, "The Earliest Illustrated Prose Lancelot Manuscript?" *Reading Medieval Studies* 3 (1977): 12–43.

79. Paris, Bibliothèque Nationale, Ms. N.A. fr. 5243 and Ms. fr. 343 (the latter text correctly identified as *Queste del Saint Graal* by E. Pellegrin, *Bibliothèque Visconti Sforza*, p. 274, no. 908, and by Loomis and Loomis, *Arthurian Legends*, pp. 118–20, all the other literature misidentifying the work as a *Lancelot du Lac*). See P. Toesca, *La pittura e la miniatura nella Lombardia*, 2d ed., Turin, 1966, pp. 160ff, pls. 321–26, 328–29, 330–34; *Arte Lombarda dai Visconti agli Sforza* (exhibition catalog), Milan, 1958, nos. 69, 72.

80. Florence, Biblioteca Nazionale, Cod. Pal. 556. See N. Rasmo, "Il Codice Palatino 556 e le sue illustrazioni," *Rivista d'Arte*, ser. 2, vol. 11 (1939): 245–81; P. Breillat, "Le ms. Palatin 556: la Tavola Rotonda et la liturgie du Graal," *Mélanges d'Archéologie et d'Histoire de l'Ecole Française de Rome* 55 (1938): 341–73; Loomis and Loomis, *Arthurian Legends*, p. 121. G. Mulazzani, *I tarocchi viscontei e Bonifacio Bembo: il mazzo di Yale*, Milan, 1981, figs. 27–31, however, attributes the drawings in this manuscript to the Master of the Colleoni tarocchi cards. For Bembo, see M. Salmi, "Nota su Bonifazio Bembo," *Commentari* 4 (1953): 7–15.

81. ASMAG, busta 398 (the 1407 inventory), cc. 33r, 35v; G. Bertoni and E. P. Vicini, *Il Castello di Ferrara ai tempi di Niccolò III: l'inventario della suppellettile del castello, 1436*, Bologna, 1906, p. 117 (c. 46v); G. Pardi, *La suppellettile dei palazzi estensi in Ferrara nel 1436*, Ferrara, 1908, pp. 11, 165; S. Davari, *Notizie storiche topografiche della Città di Mantova nei secoli XIII, XIV e XV*, 2d ed., Mantua, 1903, p. 26. A *camera* was known as *de Geneveri* or *del Gienevere*, that is, of Ginevra or Guinevere, in Sigismondo Malatesta's castle in Rimini (I. Affò, A. Battaglini, and F. G. Battaglini, *Basinii Parmensis Poetae Opera Praestantiora*, Rimini, 1794, II, pp. 673, 675).

82. N. H. Ott and W. Walliczek, "Bildprogramm und Textstruktur: Anmerkungen zu den 'Iwein'-Zyklen auf

Rodeneck und in Schmalkalden," *Deutsche Literatur im Mittelalter, Kontakte und Perspektiven: Hugo Kuhn zum Gedenken*, ed. C. Cormeau, Stuttgart, 1979, pp. 473–500; E. Battisti, *Cicli pittorici: storie profane*, Milan, 1981, pls. 1–5.

83. Loomis and Loomis, *Arthurian Legends*, pp. 48–50, 79–84; Rasmo, *Castelroncolo*; W. Haug, J. Heinzle, D. Huschenbett, and N. H. Ott, *Runkelstein: Wandmalerei des Sommerhauses*, Wiesbaden, 1982; A. Morassi, *Storia della pittura nella Venezia tridentina*, Rome, 1934, pp. 306–23. The southern Tyrol was not of course part of Italy during the Renaissance.

84. See chapter 6, section II.

85. In a critical edition of the poem, M. Catalano, "La 'Dama del Verzù,' cantare del secolo XIV," *Archivum Romanicum* 4 (1920): 141–209, restores the correct Italian title, dates the work about 1320–40, and rejects the attribution to Pucci. The text of the poem was originally connected with the frescoes by W. Bombe, "Un roman français dans un palais florentin," *Gazette des Beaux-Arts*, ser. 4, vol. 6 (1911): 231–42; id., "Die Novelle der Kastellanin von Vergi in einer Freskenfolge des Palazzo Davizzi-Davanzati zu Florenz," *Mitteilungen des Kunsthistorischen Institutes in Florenz* 2 (1912–17): 1–25.

86. P. Watson, *The Garden of Love in Tuscan Art of the Early Renaissance*, Philadelphia, 1979, pp. 44–51.

87. R. Koechlin, *Les ivoires gothiques français*, 3 vols., Paris, 1924, I, pp. 509–13; II, nos. 1301–09; III, pls. CCXXII–CCXXIII. M. Locey, "La Chatelaine de Vergi," *The Register of the Museum of Art of the University of Kansas* v. 4, n. 2 (1970): 5–23.

88. P. D'Ancona, "Gli affreschi del Castello di Manta nel Saluzzese," *L'Arte* 8 (1905): 94–106, 183–98; A. Griseri, *Jaquerio e il realismo gotico in Piemonte*, Turin [1965], pls. 58, 59, 62; pp. 61ff., 126 n. 81,

150ff.; *Giacomo Jaquerio e il gotico internazionale*, ed. E. Castelnuovo and G. Romano, Turin, 1979, pls. 26–28, 153–55.

89. For the Fountain of Youth, see L. Masson, "La Fontaine de Jouvence," *Aesculape* 27 (1937): 244–51; 28 (1938): 16–23; Koechlin, *Ivoires gothiques*, I, pp. 396–98, 440–41, 491; II, nos. 1067, 1163, 1215, 1281–84, 1288, 1300; III, pls. CLXXXII, CXCVI, CXCIX, CCXVIII, CCXIX.

90. D'Ancona's ingenious suggestion that the source was *Le Chevalier Errant*, a poem written in French by the patron's father, Tommaso III di Saluzzo, between 1394 and 1404 only explains the iconography of the Worthies.

91. The date is based on Valerano's presumed age in the frescoes (he died in 1443 at the age of seventy).

92. J. von Schlosser, "Ein veronesisches Bilderbuch und die höfische Kunst des XIV. Jahrhunderts," *Jahrbuch der Kunsthistorischen Sammlungen des Allerhöchsten Kaiserhauses* 16 (1895): 144–230, trans. G. L. Mellini, *L'arte di corte nel secolo decimoquarto*, Cremona, 1965, pp. 93–94, 98–99, 100, 102.

93. Ibid. pp. 93–94, 99.

94. *Les collections du Château Royal du Wawel*, intro. by J. Szablowski, Warsaw, 1975, pl. 1, p. 13; M. Morelowski, "L'histoire du chevalier au cygne: tapisserie à l'église Sainte-Cathérine de Cracovie," *Actes du Congrès d'Histoire de l'Art* vol. 3, Paris, 1924, pp. 672–82.

95. N. Forti Grazzini, *L'arazzo ferrarese*, Milan, 1982, pp. 39, 216 (c. 5b).

96. "Figure che combatteno una citade guardata da done e defesa cum rose che sparzono, appelata la Jstoria de la Vertude" (ibid. pp. 37, 216 [c. 4b]). The tapestry measured 4.93 × 12.97 m. The inventory published by Forti Grazzini dates from 1457–69.

97. ". . . uno turniamento de homeni a caualo cum bastoni jn mano"; "Una coltrina de razo afigurata noua cum homeni

a caualo che cumbate in una sbara";
"Una coltrina de razo cum horo da salla
lunga B.za 13 2/3 larga B.za 6 jstoriada
cum più figure a piedi e a cavalo . . ."
(ibid. pp. 217 [c. 8a], 216 [c. 5a], 215
[c. 3]).

98. "Ciello e capoleto . . . in le quali figure
sono persone che manzono"; "Copera-
turo da leto . . . cum più figure de
homeni e de done in le quale è uno homo
vestito de morelo che abraza una dona
vestito de azuro" (ibid. pp. 219 [c. 12a],
218 [c. 10a]). Had the frescoed tourna-
ment scene in Mantua been a tapestry, it
might well have been described in fif-
teenth-century inventories as "uno tor-
niamento cum più homeni a pede e a
cavalo cum un campo morello."

99. "Una spaliera de razo . . . el resto del
campo fatto a verdure e paesi . . . e ani-
mali e aiere e più altre cosse" (ibid. p.
222 [c. 21b]).

100. Loomis and Loomis, *Arthurian Legends*,
p. 70.

101. Sommer, *Vulgate Version*, V, p. 314.

102. Lot, *Lancelot en prose*, pp. 70, 73, 76, 88,
263. See also the references in n. 1. Some
literary critics give great importance to
the conception of Helain le Blanc,
because his birth presents analogies with
that of his cousin Galahad, son of Lan-
celot.

103. See chapter 4, section II.

THREE · ARTIST AND DATE

1. On 22 November 1395 his father, Puc-
cino di Giovanni di Cereto, bequeathed
600 gold ducats to Antonio. The orig-
inal will witnessed in Pisa has not been
found, but the legacy was recorded in a
deed drawn up on 8 July 1424 between
the artist and his mother, Isabetta, in
Pisanello's house in the contrada of S.
Paolo in Verona, in which Isabetta
acknowledged that she owed this sum to
Antonio (Archivio di Stato di Verona,
Archivio Notarile, Ufficio del Registro,
vol. N. 48, f. 754, 8 July 1424, published

in Biadego, 1910, pp. 1047–54). Anto-
nio's birth cannot have predated the year
of his father's 1395 will by more than a
couple of years, since in 1433 the register
for the contrada of S. Paolo recorded his
age as thirty-six (Archivio di Stato di
Verona, Archivio del Comune, Ana-
grafe della contrada di S. Paolo, vol. N.
253, 1433, published in Biadego, 1908,
p. 839, and illustrated in R. Brenzoni,
Pisanello, Florence, 1952, pl. 1).

2. In 1404 Antonio's stepfather, Barto-
lomeo da Pisa, a draper, witnessed a will
in the contrada of S. Paolo in Verona
(Biadego, 1910, p. 799).
 Much migration took place between
Pisa and Verona around 1400, when
both cities were part of the territory con-
trolled by the Duchy of Milan. See
Brenzoni, *Pisanello*, pp. 43–45.

3. Pisanello carried a Cicero manuscript
belonging to Guarino from Padua to
Venice. "M[agister] Antonius Pisanus
cum hinc discederet, Ciceronem meum
se datarum M[agistro] Petro pollicitus
est: quocirca curam hanc suscipiat
M[agister] P[etrus] oro; ipsum autem
Ciceronem tu tecum deferes" (letter
from Guarino da Verona to Zaccaria
Barbaro, June 1416, published in R.
Sabbadini, ed., *Epistolario di Guarino
Veronese*, Venice, 1915, I, pp. 115–16; III,
pp. 52–53).

4. M. Baxandall, "Bartholomaeus Facius
on Painting: A Fifteenth Century Man-
uscript of the *De Viris Illustribus*," *Journal
of the Warburg and Courtauld Institutes* 27
(1964): 106; F. Sansovino, *Venetia, città
nobilissima et singolare*, vol. 8, Venice,
1581, c. 123v. For the documents on the
restoration of the paintings in the *Sala
del Maggior Consiglio* in 1474 and 1488,
which confirm Fazio and Sansovino's
attribution, see G. Lorenzi, *Monumenti
per servire alla storia del Palazzo Ducale di
Venezia*, Venice, 1868, pp. 85–86, doc.
188, and pp. 102–3, doc. 221. See also
Venturi, 1896, pp. 29–30; K. Chris-
tiansen, *Gentile da Fabriano*, Ithaca,

N.Y., 1982, pp. 138–39. The cycle was repainted in the late Quattrocento and was destroyed by fire in 1577.

5. The appointment in July 1422 of a permanent surveyor of the pictures provides a terminus ante quem for the cycle (Lorenzi, *Monumenti*, p. 57, doc. 148). Pisanello probably worked in the room between 1415 and 1422. There is no basis for the assumption, originally made by B. Degenhart (*Pisanello*, Turin, 1945, p. 23) and repeated many times since, that Pisanello and Gentile collaborated on this enterprise. Gentile's activity is likely to date between 1409 and 1414, after which year he is documented as working for Pandolfo Malatesta in Brescia (Christiansen, *Gentile da Fabriano*, p. 139).

6. The fresco is signed "PISANVS PINSIT" below the Virgin; Niccolò Brenzoni died in 1422 (Biadego, 1909, p. 242), and the inscription on the sepulchral slab of the tomb, identified as one now in the Verona Museum, is dated 1426 (Brenzoni, *Pisanello*, pp. 26, 141–43). The frescoes should thus be dated to around 1426, since they could not have been started until the tomb was well advanced. For the dating of the tomb, see W. Wolters, *La scultura veneziana gotica 1300–1460*, Venice, 1976, cat. 220.

7. For the work of these artists, see G. L. Mellini, *Altichiero e Jacopo Avanzi*, Milan, 1965; Christiansen, *Gentile da Fabriano*; G. Fiocco, "Disegni di Stefano da Verona," *Proporzioni* 3 (1950): 56–64; L. Magagnato, *Da Altichiero a Pisanello* (catalog of the exhibition held in Verona), Venice, 1958. Pisanello's artistic sources are discussed at length in Degenhart, *Pisanello*.

8. The quotation comes from the document of 8 July 1424 cited in n. 1.

9. Two documents of 1422 dealing with his purchase of a house in Verona refer to Pisanello as "Antonio dicto Pisanello q[uondam] Pucii de S. Paulo Veronae habitatore de presenti Mantue" (see n.

23 for references). The document finalizing the sale of the house in 1423 does not, however, mention Mantua. The payments in 1425 and 1426 of 45 lire, 1 lira and 10 soldi, and 3 lire and 18 soldi are contained in the "Libro di dare e avere dell'Ecc.mo Signor Lodovico Gonzaga del soprascritto anno massime per assegni, salari, ecc." (ASMAG, busta 409b, Registro no. 24, 1425, published in Biadego, 1909, p. 185).

10. A letter from Pisanello to Filippo Maria Visconti dated 28 June [1431] from Rome, seen in the Fillon Collection by Montaiglon, who reported it to Müntz (E. Müntz, *Les arts à la cour des papes pendant le XVe et le XVIe siècle*, Paris, 1878, p. 47), has since disappeared (Venturi, 1896, p. 34). It discussed a work for the Duke that the artist could not finish before autumn and mentioned his current work in a church. Doubts have been cast on the letter's authenticity, but its vagueness and lack of specificity, typical of such documents, argue in its favor. In 1521 Cesare Cesariano (*Vitruvius: De Architectura*, translated from the Latin into Italian with commentary and illustrations by Cesare di Lorenzo Cesariano, Como, 1521, reissued in facsimile, New York–London, 1968, c. cxv), followed by M. A. Michiel in 1526–40 (*Notizia d'opere di disegno pubblicata e illustrata da D. Jacopo Morelli*, 2d ed., ed. G. Frizzoni, Bologna, 1884, p. 121), recorded Pisanello's activity in the Castello Visconteo in Pavia in rooms destroyed by French artillery at the Siege of Pavia in 1527. The description given forty years later by Stefano Breventano (*Istoria delle antichità, nobilità, e delle cose notabili della città di Pavia*, Pavia, 1570, bk. 1, p. 7), probably but not certainly of the same frescoes, suggests depictions of exotic animals and scenes of hunting, fishing, jousting, and other pleasures in which the Duke and Duchess of Milan took part. We have as yet no means of dating these lost works, which have

been arbitrarily assigned by art historians either to around 1424 (in connection with a document concerning the redecoration of the castle for the arrival of the Byzantine Emperor published by C. Magenta, *I Visconti e gli Sforza nel Castello di Pavia*, vol. 2, *Documenti*, Milan, 1883, pp. 127–28) or to around 1440 (in connection with a document of 11 May 1440 in which Pisanello witnessed some notarized statements recounting the capture of Verona in November 1439, published in G. Biscaro, " 'Pisanus pictor' alla corte di Filippo Maria Visconti nel 1440," *Archivio Storico Lombardo* 38, vol. 15 [1911]: 171–74).

11. Payments of, respectively, 40 florins, 50 florins, and 75 florins were made on 18 April and 27 November 1431 and 28 February 1432 (Archivio di Stato, Rome, Camerale 1, Mandati, busta 826, 1430–34, cc. 14v, 33, 42; published without full archival reference by Müntz, *Les arts*, p. 47, and more accurately in Venturi, 1896, p. 33). Gentile da Fabriano's salary for the work he did at the Lateran between January and August 1427 was 25 florins a month. The cycle, which was already in very poor condition in the mid Quattrocento, when Pisanello discussed it with Fazio, was destroyed in the seventeenth century when Borromini renovated St. John Lateran. See Christiansen, *Gentile da Fabriano*, cat. xix, pp. 111–13.

On 26 July 1432 Eugenius IV granted Pisanello a letter of safe-conduct, in which the artist, who intended to travel to various Italian cities with six companions and servants on horseback and on foot, is referred to as "Dilectus filius Pisanellus pictor familiaris noster" (Archivio Secreto Vaticano, Registro Eugenii IV, no. 372, c. 53r, published by D. Gnoli, "Passaporto di Pisanello," *Archivio Storico dell'Arte* 3 [1890]: 402–3, and Venturi, 1896, pp. 33, 35–36).

Materials purchased for Gentile and transmitted to Pisanello for work in St. John Lateran were sold for 10 ducats in April 1433: "Recepimus pro suppellectilibus emptis tunc per Capitolum [a] magistro Gentili, que postea remanserunt magistro Pisano pictori, venditis demum per dictum capitulum presbitero Henrico, Sacriste nostre ecclesie Lateranensis, ducatos auri decem, qui sunt florenos currentes decemocto solidos trigintanovem . . . f. xviii et s. xxxix" (Archivio Capitolare Lateranense, Liber Introitum et Exituum Ecc. Lat. ab anno 1432 per totum annum 1442 solutio censum et aliorum, CXII, c. 20v [1433, mensis aprilis], published in A. Colasanti, *Gentile da Fabriano*, Bergamo, 1909, p. 18 n. 2 [with the wrong month], and in Christiansen, *Gentile da Fabriano*, p. 172 [with the wrong month and year]). This document has been misinterpreted by B. Degenhart (originally in *Pisanello*, p. 30, the thesis being expanded in B. Degenhart and A. Schmitt, "Gentile da Fabriano in Rom und die Anfänge des Antikenstudiums," *Münchner Jahrbuch der Bildenden Kunst*, ser. 3, 2 [1960]: 71; in A. Schmitt, *Disegni del Pisanello e di maestri del suo tempo*, Vicenza, 1966; and repeated most recently in H. Wohl, *The Paintings of Domenico Veneziano*, New York, 1980, pp. 8–9) to mean that Gentile bequeathed to Pisanello the tools of his workshop, among them a number of drawings bound into a *taccuino* or sketchbook. There is, however, no basis for the claim that this source constitutes evidence of collaboration between Gentile and Pisanello on the Lateran frescoes or any other work. On the one hand, payments to Pisanello for work at the Lateran did not begin until 1431, four years after Gentile had died without a will. On the other hand, it seems most unlikely that Gentile or his heirs would have included drawings among the

12. These include one of the Dioscuri of the
Quirinale (Milan, Ambrosiana, F. 214
inf., f. 10; Fossi Todorow, 1966, cat.
182), the river god Tiber Capitolinus
(Berlin, Kupferstichkabinett, 1359;
Fossi Todorow, 1966, cat. 169), and var-
ious sarcophagi (Fossi Todorow, 1966,
cats. 168, 175–76, 178, 185–87, 190v,
195v, 204), as well as a copy after the
Navicella by Giotto in St. Peter's Basilica
(Fossi Todorow, 1966, cat. 182), most of
which should be referred to Pisanello's
followers rather than to the artist himself
or to Gentile da Fabriano. See M. Fossi
Todorow, "Un taccuino di viaggio del
Pisanello e della sua bottega," *Scritti in
onore di Mario Salmi*, vol. 2, Rome, 1962,
pp. 133–61, and the sensible discussion
of the attribution question in Chris-
tiansen, *Gentile da Fabriano*, pp. 145–48,
cat. LXVII. For a differing view, see the
important 1960 and 1966 publications by
B. Degenhart and A. Schmitt cited in n.
11, and also A. Schmitt, "Herkules in
einer unbekannten Zeichnung Pisa-
nellos," *Jahrbuch der Berliner Museen* 17
(1975): 51–86.

13. Letter written by Leonello d'Este to his
brother Meliaduse on 20 January [1432
or 1433], Biblioteca Capitolare di
Verona, codice CCXLI, f. 1r, published by
A. Venturi, "Documento sul Pisanello,"
Archivio Storico dell'Arte 1 (1888): 424–
25, in which Pisanello is referred to as
"omnium pictorum huiusce aetatis egre-
gius." See also Venturi, 1896, pp. 36–38.

 N. E. Land ("A Note on Jacopo Bel-
lini's Lost St. Michael and a Possible
Date for Pisanello," *Zeitschrift für
Kunstgeschichte* 45 [1982]: 283–86) sug-
gested that "Antonius pictor de Verona
habiator padue," one of three artists who
evaluated a painting by Jacopo Bellini on
19 April 1430 (E. Rigoni, "Jacopo Bel-
lini a Padova nel 1430," *Rivista d'Arte* 11

[1969]: 261ff.), was perhaps Pisanello.
The artist was, however, normally
referred to as Pisano da Verona, and this
would be the only occasion when he was
not so designated. Nor is there any other
suggestion that he was living in Padua in
1430.

14. Payment of 2 ducats made to a servant of
Pisanello's on 1 February 1435 for
delivery of a *Divi Iulij Caesari effigies*
(Archivio di Stato, Modena, Registro
cosidetto di Mandati N. 3, 1434–35, c.
80v, published by A. Venturi, "Il Pisa-
nello a Ferrara," *Archivio Veneto* 30
[1885]: 410). See also Venturi, 1896, pp.
38–39, and M. Salmi, "La 'Divi Julii
Cesaris Effigies' del Pisanello," *Com-
mentari* 8 (1957): 91–95.

15. For the drawings, see n. 70. For the
Council of Ferrara and Florence, see J.
Gill, *The Council of Florence*, Cam-
bridge, 1959.

16. The drawings are copies of heads in
Filippo Lippi's Barbadori altarpiece of
around 1437–38 (Fossi Todorow, 1966,
cats. 215, 219, 258), of low-relief panels
on Donatello's Prato pulpit of 1434–38
(Fossi Todorow, 1966, cats. 168, 185),
and of Saint Francis and Christ in Fra
Angelico's Crucifixion in the Chapter
House at S. Marco, of uncertain date
(Fossi Todorow, 1966, cats. 209, 212).

 Vasari attributed to Pisanello scenes
depicting "the story of the pilgrim" in
the Church of the Temple in Florence,
which however Vasari himself may not
have seen, since the church was
destroyed in 1530. There is no basis for
the suggestion, made most recently in
Paccagnini, 1972, p. 146, that Pisanello
collaborated with Gentile on the Strozzi
altarpiece in Florence in 1423. As Chris-
tiansen points out (*Gentile da Fabriano*, p.
98), there are marked differences
between the styles of the Strozzi altar-
piece and the S. Fermo Annunciation.
For a refutation of Vasari's statement
that Pisanello trained under Andrea del

Castagno, see G. Vasari, *Le vite de' più eccellenti pittori, scultori ed architettori*, ed. G. Milanesi, 9 vols., Florence, 1878, III, p. 5 n. 1.

17. The best discussion of the court of Ferrara in the 1440s is by W. L. Gundersheimer, *Ferrara: The Style of a Renaissance Despotism*, Princeton, 1973, pp. 92–126.

18. Hill, 1930, nos. 24 (Este), 21 (Visconti), 22 (Piccinino), 23 (Sforza). The medals are all undated; for reasons of style, no. 21 must be close in time to the 1438–39 Paleologus medal (Hill, 1930, no. 19).

19. The sonnet "Pro insigni certamine" by Ulisse degli Aleotti (published in Venturi, "Pisanello a Ferrara," p. 413, and Venturi, 1896, pp. 46–47) is undated, but the phrase "nuovo illustre lionel marchese" and references to paternal love suggest that the actual event took place while Niccolò d'Este was still alive but that the sonnet was written after his death and Leonello's accession to power in December 1441. The small *Portrait of Leonello d'Este* in the Accademia Carrara (Paccagnini, 1972, colorplate XVIII) is usually identified as Pisanello's competition painting.

20. Sabbadini, *Epistolario di Guarino Veronese*, I, pp. 554–57; III, pp. 209–10 (Sabbadini dates the poem to 1427, that is, before Guarino's arrival in Ferrara); Venturi, 1896, pp. 52–55. See also M. Baxandall, *Giotto and the Orators: Humanist Observers of Painting in Italy and the Discovery of Pictorial Composition*, Oxford, 1971, pp. 91–93.

21. Venturi, 1896, pp. 49–50. Galli may have been in Milan in the suite of Federico da Montefeltro in 1442 (G. Franceschini, "Il poeta urbinate Angelo Galli ed i Duchi di Milano," *Archivio Storico Lombardo*, N.S, I [1936]: 129).

22. Venturi, 1896, pp. 56–57. See R. J. Albrecht, "Zu Tito Vespasiano Strozza's und Basinio Basini's lateinischen Lobgedichten auf Vittore Pisano," *Romanische Forschungen* 4 (1891): 341–44. See also C. Cavattoni, *Tre carmi latini composti a mezzo il secolo XV in lode de Vittore Pisano*, Verona, 1861.

23. Documents relating to the purchase of the house in the contrada of S. Paolo, costing 170 ducats, with an annual land rent of 8 soldi due to the monastery of S. Maria in Organo, date from 4 July and 12 August 1422 and 10 August 1423 (Archivio di Stato di Verona, Archivio notarile, Ufficio del Registro, istromenti del 1422, vol. N. 62, ff. 1807v, 1909; istromenti del 1423, vol. N. 64, f. 937, published in Biadego, 1910, pp. 804–13). In 1433 the artist was registered as aged thirty-six and as living with his seventy-year-old mother, four-year-old daughter, and two young servants in the contrada of S. Paolo; in 1443 Pisanello was assessed in the contrada for 10 soldi and in 1447 for 9 soldi (Archivio di Stato di Verona, Estimo cittadino, vol. N. 252, 1433, N. 253, 1443, N. 254, 1447 della contrada di S. Paolo; see Biadego, 1908, pp. 839, 845, and Brenzoni, *Pisanello*, p. 34 n. 13, pl. 1). Documents survive recording Pisanello's rent payments to S. Maria in Organo in 1435, 1445, and 1447 (Archivio di Stato di Verona, Archivio di S. Maria in Organo, Introiti di Sorga, Liber dati et recepti, vol. N. 26, 1434–35, c. 33, published in Biadego, 1910, p. 801; Archivio di Stato di Verona, Archivio di S. Maria in Organo, Affittuali del 1444 segg., vol. N. 28, published in Biadego, 1908, pp. 845–46). None of these documents, however, prove that Pisanello was resident in Verona in the thirties, as is sometimes stated. The ambiguity of his residence may be reflected in the way he was registered in 1433: the artist's name was repeated three times on the list and crossed out twice.

24. Antonio's half-sister, Bona, whose age in 1433 was given as thirty-five, making her younger than Pisanello and presumably an offspring of Bartolomeo da Pisa, Isabetta's second husband, was regis-

tered in 1433 as widow of Jacobo Abatia, who was a witness to the deed of purchase of a house by Pisanello in August 1422. She made an advantageous second marriage, probably in 1434, to Bartolomeo della Levata, son of Andrea della Levata, a prominent and affluent notary who was assessed at the sum of 12 lire and 3 soldi in 1433 and who served on the Consiglio Cittadino of Verona. Bona died before 26 April 1450, when her husband drew up his will without mentioning her.

Although Pisanello and his mother were listed in the 1433 census as living together (see n. 23), they owned different houses in the contrada of S. Paolo with different boundaries and different ground rents. In 1411 Isabetta was documented as living in her own house, presumably inherited from her second husband, Bartolomeo da Pisa, who was dead by 1409. This same house, for which the land rent was 15 soldi per annum payable to S. Maria in Organo, was part of her dowry in 1414 when she married her third husband, Filippo da Ostiglia, a draper from the contrada of S. Silvestro, who made his will in 1425. In 1435 Isabetta was documented as still paying the land rent for the S. Paolo house, but by December 1438 she had moved to her daughter Bona's home, the house belonging to Andrea della Levata in the contrada of S. Maria in Chiavica, where, sick in bed, she drew up her will making Antonio and Bona her heirs (published without archival reference by Biadego, 1908, pp. 856–57). Isabetta died before 13 November 1442, when her son-in-law, Bartolomeo della Levata, on behalf of his wife, Bona, claimed the lease on a plot of land in the contrada of Isolo Inferiore, the lease having been granted to Isabetta in 1409 by Cardinal Angelo Barbarigo, Bishop of Verona.

The house that Isabetta brought to her third marriage as part of her dowry was taken over by her stepson, a tailor, Jacopo q[uondam] Filippo da Ostiglia. In 1444 Bartolomeo della Levata was registered as substituting for Bona's stepbrother Jacopo in business concerning the house in the contrada of S. Paolo, and in 1445 and 1446 he paid the ground rent of 15 soldi in Isabetta's name.

Pisanello's daughter Camilla, whose mother is unknown, was registered as four years old in 1433. Her marriage contract in 1448 with Jacomino de Turtois of Martinengo near Bergamo, resident in the contrada of S. Maria in Carmine in Brescia, included as part of her dowry the house in the contrada of S. Paolo, now valued at 200 ducats, that her father had purchased a quarter of a century earlier for 170 ducats (Archivio di Stato di Verona, Ufficio del Registro, vol. N. 145, c. 276, published in Brenzoni, *Pisanello*, p. 34 n. 19). See also Biadego, 1908; Biadego, 1910, pp. 797–813; Brenzoni, *Pisanello*, pp. 13–39.

25. On 12 May 1439 Treasurer Uberto Strozzi advised Paola Malatesta that her husband, Gianfrancesco Gonzaga, had instructed the "Rector generalis Introitum" to make a promise of 80 ducats for Pisanello: "Ulterius adviso la Celsitudine Vostra che, de comandamento del prefato Illustrissimo Signor nostro, bisogna che'l Rectore faza una promessa de ducati 80 per el Pisano pictore" (ASMAG, busta 2390, c. 62, published in Venturi, 1896, p. 44). This individual was the court official in charge of bookkeeping.

On 11 May 1440 Pisanello, witnessing a notarized account of the 1439 Siege of Verona in the Palazzo dell'Arengo in Milan, was described as "Pisano de Verona f[ilius] q[uondam] Puzii habitatore dicte civitatis Mantue" (see Biscaro, "Pisanus pictor").

On 27 March 1441 debts totaling 180 ducats were recorded against Pisanello in Mantua, the sum to be deducted from his salary (ASMAG, Libro dei decreti no.

9, 1441, c. 127r, published by U. Rossi, "Il Pisanello e i Gonzaga," *Archivio Storico dell'Arte* 1 [1888]: 454).

On 16 August 1441 a payment of 3 lire and 15 soldi was made to a helmsman for taking Pisanello from Ferrara to Mantua by water (Archivio di Stato, Modena, Conto generale, Registro C, 1441, c. 212; Archivio di Stato, Modena, Registro cosidetto dei mandati N. 6, 1441–42, c. 82v, published by Venturi, "Pisanello a Ferrara," p. 413 n. 1).

In 1442–44 an entry in the household ledger of the court of Mantua recorded that "Pisanus pinctor" was to receive 2 pounds of wax and tallow candles and 2 pounds of good-quality oil each month (ASMAG, busta 410a, Registro 1442–44, "Libro in cui sono notate le spese per il mantenimento necessario della Corte e della famiglia tutta del Magnifico Signor Marchese di Mantova," c. 104r, published by Rossi, loc. cit.).

26. See F. Tarducci, "Alleanza Visconti-Gonzaga del 1438 contro la Repubblica di Venezia," *Archivio Storico Lombardo* 26 vol. 11 (1899): 265–329. I have not been able to consult R. A. Roberts, "Mantua under Gianfrancesco Gonzaga (1407–1444): War, Politics and Diplomacy in a Lombard Buffer State," Ph.D. thesis, Warwick University, 1980.

27. On 1 December 1440, the property of some Veronese exiles, among whom "Pisan depentore, vene et tornò in driedo con el marchexe [di Mantova]" is listed, was ordered confiscated (Archivio di Stato, Venice, Cons. X, Misti, r. 12, c. 76r). At the request of the *rettori* of Verona, Doge Francesco Foscari on 30 September 1439 published a *privilegium* pardoning citizens who had fled from the plague the previous year, many of them to Mantua (Archivio di Stato di Verona, Antico Archivio del Comune, Lettere vol. N. 11, 1439–55, published in Biadego, 1908, pp. 843–44). There appears, however, to be no

basis for the statements by Venturi (1896, p. 42) and Biadego (1908, p. 844) that Pisanello was among those fleeing the plague.

28. See n. 24 for Pisanello's family relationships. In July 1441 the *rettori* of Verona sent a "Descriptio civium qui steterunt et remanserunt sequaces Marchionis Mantue et non venerunt vocati Veronam tam per rectores quam per graziam" to the Council of Ten in Venice. The first category of exiles included "Citadini de Verona che veneno cum el marchese de Mantoa, quando lui intrò in Verona e per esso erano soliciti ai suoi favori contro la Signoria e retornono via cum lui quando el fo cazado." Among those listed was "Pisan pentor operando male in casa de Andrea de la Levada." The category "citadini non sta ben in Verona per sospeto" included "Bortolomio da la Levada cugnado del Pisan pentor rebello" (Archivio di Stato, Venice, Cons. X, Misti, r. 12, cc. 183v, 185r). It is clear that in November 1439 Pisanello had stayed with his sister and brother-in-law in the house where his mother lay dying.

29. Two of the witnesses remembered seeing Pisanello among the crowd that watched the looting take place. One of them, a tailor from the contrada of S. Maria di Chiavica and therefore a neighbor of the Levata family, stated that the artist tried to prevent the looting from taking place (Archivio di Stato di Verona, Atti dei Rettori Veneti a Verona, busta N. 8, 1440–41, fascicolo "Pro Simone Judeo," cc. 439–40v, 441, 17 October 1441, published in part in Brenzoni, *Pisanello*, pp. 52–53). On 9 August 1441 the Council of Ten had ordered all Veronese citizens not yet returned home to come to Venice before the end of September to clear themselves (Archivio di Stato di Verona, Antico Archivio del Comune, Lettere vol. N. 11, 1439–55, cc. 29v–30, published in Biadego, 1908, pp. 852–53).

30. On 7 February 1442 thirty-three Veronese exiles, among whom "Pisanus pictor" is listed second, were ordered to Venice before the end of March to plead their cause before the Council of Ten; those listed who did not turn themselves in would be considered rebels. Eighteen of the rebels gave themselves up over time, but Pisanello failed to make the necessary appearance before the Council (Archivio di Stato di Verona, Antico Archivio del Comune, Lettere vol. N. 11, 1439–55, cc. 29v–30, published in Biadego, 1908, pp. 853–54; Archivio di Stato, Venice, Cons. X, Misti, r. 12, c. 98v, published in G. P. R[ichter], "Il Pisanello graziato," *Archivio Storico dell'Arte* 2 [1889]: 38). See also Venturi, 1896, p. 42.

31. On 17 October 1442, the proposal to start proceedings against Pisanello was approved in the Council of Ten by 10 votes to 4, "pro verbis turpibus et inhonestis quibus usus fuit in Manthua cum domino Ludovico de Gonzaga sicut constat per scripturas lectas in isto consilio." The sentence, approved unanimously by 17 votes, condemned Pisanello to be confined to Venice and forbidden to sell his property without special permission ("Volunt quod iste Antonius Pisanus pictor remaneat confinatus hic Vinetiis et non possit eidem dari licentia nisi per quatuor partes istius concilii, non possendo vendere bona sua sine licentia huius concilii, sed bene gaudere bonis suis. Et si contrafecerit frangendo confinem tractetur pro rebelle et eius bona intelligantur confiscata in nostrum comune") (Archivio di Stato, Venice, Cons. X, Misti, r. 12, c. 119r, published by W. Bode, G. Gronau, and D. F. von Hadeln, *Archivalische Beiträge zur Geschichte der Venezianischen Kunst aus dem Nachlass Gustav Ludwig*, Berlin, 1911, p. 121; E. Sindona, *Pisanello*, Milan, 1961, p. 109 n. 52). The property of other politically prominent Veronese citizens—Del Verme, Bevilacqua, Ca-

valli, Campagna—was subsequently confiscated.

32. See John Law, "The Commune of Verona under Venetian Rule from 1405 to 1455," Ph.D. thesis, Oxford University, 1974, pp. 344–50.

33. "Quod eidem Antonio concedatur quod possit ire Ferariam et stare mensibus duobus, non eundo Veronam nec in territorium veronensem neque Mantuam, nec in terris marchionis Mantue" (21 November 1442) (Archivio di Stato, Venice, Cons. X, Misti, r. 12, c. 120, published by Biadego, 1908, p. 842). Pisanello did not, however, leave for Ferrara until 15 February 1443.

34. On 27 June 1443 the Council of Ten acceded to a request made by Leonello d'Este and granted Pisanello, now called "Pisani pictor fideli nostro", permission to stay in Ferrara until the end of September 1443 (Archivio di Stato, Venice, Cons. X, Misti, r. 12, c. 133r, published in Brenzoni, *Pisanello*, p. 55).

35. Hill, 1930, nos. 24–32 (the last dated 1444).

36. Payment of 50 ducats was made to the artist on 15 August 1445 for a panel of unspecified subject, destined for the residence of Belriguardo (Archivio di Stato, Modena, Cancelleria dei fattori generali, Registro cosidetto dei mandati n. 7, 1445, c. 111; Conto generale, Registro B, 1445, c. 115, published by Venturi, "Pisanello a Ferrara," pp. 414–15). On 8 January 1447 a payment of 25 florins was made to the artist (Archivio di Stato, Modena, Registro cosidetto dei mandati n. 8, 1447, c. 4v, published in ibid. p. 416). In 1448 debts and pledges totaling 221 lire were listed against Pisanello's name in Ferrara (Archivio di Stato, Modena, Conto generale, Registro cosidetto dei mandati, 1448, Registro K, c. 118, published in ibid. p. 416).

37. "Perché intendemo che'l Pisano pinctore è lì e dice che'l non è per venir a star pur cum noi, perché cossì gli è commandato

et che venendoge gli seriano tolti li suoi beni, voressemo tu cercassi de intravenire se cussì è, et per tua littera advisarcene subito" (letter from Gianfrancesco Gonzaga to Guglielmo Gonzaga, 28 February 1443, ASMAG, busta 2882, libro 6, f. 5v, published in Luzio/Renier, 1890, p. 131 n. 1, where the writer is incorrectly identified as Lodovico Gonzaga [an error followed in all the subsequent literature] and the date incorrectly given as 27 February).

38. "Havemo veduto quanto ne scrivi del tuo esser venuto lì, donde non poi partirte, etcetera. E perché tu di' che riservi a dirne a bocha più oltra, noi te oldiremo voluntera, ma non sapiamo già quando trovarne a Ferrara e quelli che dicono siamo per venir lì, sanno cossa che non savemo noi" (letter from Gianfrancesco Gonzaga to Pisano de Verona, 3 March 1443, ASMAG, busta 2882, libro 6, c. 6v, published in Rossi, "Il Pisanello e i Gonzaga," p. 454).

39. "Habiamo inteso quanto per una toa lettera ne scrivi de la deliberatione per ti facta et cetera. E, rispondendo, dicemo che de ogni tuo aviamento e bene ricevemo piacer, come sempre riceveressemo. Ala parta del subsidio che ne adimandi, Dio sa che al presente non ge habiamo el modo et cussì te poressemo provedere come volare. Ma quanto più tosto serà posibile, ti faremo el dever tuo ché cossì è la nostra intencione" (letter from Gianfrancesco Gonzaga to Pisano de Verona, 11 September 1443, ASMAG, busta 2882, libro 6, c. 36v, published in Rossi, loc. cit.). For the September expiry date, see n. 34.

40. "Havendo inteso che tu hai portato cum ti una nostra tavola de tela suxo la qual è pincto Nostro Signor Dio, mandemo lì questo nostro cavallaro per tuorla, al qual debbi darla, in forma che non si possa guastare, che'l ce la reporti" (letter from Gianfrancesco Gonzaga to Pisano de Verona, 6 November 1443, ASMAG, busta 2882, libro 6, c. 44v, published in Rossi, loc. cit.).

41. "Remanemo satisfacti per la toa lettera circa quanto rechiedevemo saver da ti de quelle camere et luoghi, che solevi tenire qui in corte. A la parte tu scrivi domandando dinari et cetera, al presente Dio sa non te ne poressemo dare alcuno. Ma, in questo tempo che differarai la toa partita per andar ala Maiestà del Re, como tu di' haver deliberato, vederemo se'l serà possibile farte alcuna provisione e, possendo, lo faremo de bona voglia, perché la natura nostra sempre è stata da satisfare volentera a chi debe haver da noi" (letter from Gianfrancesco Gonzaga to Pisano de Verona, 11 March 1444, ASMAG, busta 2882, libro 7, c. 13v, published in Rossi, loc. cit.). Gianfrancesco's statements that he was financially hard up at this time were accurate. The harsh winter of 1443–44 destroyed crops in the Mantovano and resulted in a grave famine throughout his state, and, as one of the losers in the war between Milan and Venice, he also had to make reparation payments of 4,000 ducats to Venice. See G. Coniglio, *Mantova: la storia*, vol. 1, Mantua, 1958, p. 453; Prendilacqua, *Dialogus*, in E. Garin, *Il pensiero pedagogico dello umanesimo*, Florence, 1958, pp. 654–55.

42. Hill, 1930, nos. 34 (dated 1445), 33.

43. Hill, 1930, nos. 36 (Lodovico), 37 (Cecilia, dated 1447), 38 (Vittorino), 20 (Gianfrancesco). See chapter 4 n. 57 for the dating of no. 20.

44. See n. 41.

45. Hill, 1930, no. 40. Leonello sent the medal as a gift to Decembrio, accompanied by a letter dated 19 August 1448, published in Venturi, 1896, p. 58. In the preceding year Decembrio had submitted his posthumous biography of Filippo Maria Visconti of Milan for Leonello's approval. In the book, written in the early fall of 1447, he had made an admiring reference to Pisanello's skill as

a portraitist in the context of Visconti's physical appearance (". . . cuius effigiem, quamquam a nullo depingi vellet, Pisanus ille insignis artifex miro ingenio spiranti parilem effinxit"). See Venturi, 1896, p. 58.

46. Christiansen, *Gentile da Fabriano*, pp. 168–69; G. Mancini, *Vita di Leon Battista Alberti*, Rome, 1911, p. 172; C. Minieri-Riccio, "Alcuni fatti di Alfonso di Aragona," *Archivio Storico per le Provincie Napolitane* 6 (1881). In 1458 Lodovico Gonzaga was to offer Mantegna 180 ducats per annum plus room and board.

47. "Cum itaque preclara multa eximia ac pene divina de singulari et picture et sculpture enee pisani arte ex multorum sermonibus accepissemus admirabamur prius singulare illius ingenium atque artem. Ubi vero illa perspecta sunt nobis et cognita studio in eum et amore incensi sumus quippe cum arbitremur hanc nostram etatem hec velut nature opifice illustratam esse." I am grateful to Professor James Russell for help with the translation. The *privilegium* was dated 14 February 1449, to take effect 6 June 1449 (Archivio di Stato, Naples, R. camera della sommaria, Privilegi vol. 4, ff. 93v–94v [destroyed in World War II], published in Venturi, 1896, pp. 59–61). The date of 1448 for Pisanello's arrival in Naples is established by a copy after a drawing made by Pisanello in Naples and dated 1448 (Louvre, inv. 2307; Fossi Todorow, 1966, cat. 160).

Preparing for his departure for southern Italy, Pisanello gave power of attorney to his brother-in-law, Bartolomeo della Levata, on 8 January 1448 (not 1447, as given in R. Chiarelli, *Tutta l'opera del Pisanello*, Milan, 1972, p. 84). Pisanello's visits to Verona may have tapered off after his mother's death in 1442. In his daughter Camilla's marriage contract of 8 June 1448, he was described as "habitatoris de presenti Ferarie in contrata S. Marie de Vodo" (Archivio di Stato di Verona, Ufficio del Registro, vol. N. 145, 1448, c. 276, published in Brenzoni, *Pisanello*, pp. 34–35 n. 19).

48. Hill, 1930, nos. 41–43. See G. L. Hersey, "The Arch of Alfonso in Naples and Its Pisanellesque Design," *Master Drawings* 7 (1969): 16–24.

49. Pisanello died between 14 July and 31 October 1455. The terminus post quem is established by the will made out by his brother-in-law, Bartolomeo della Levata, recording the large sum owed to him by Pisanello (Archivio di Stato di Verona, Archivio notarile, Testamento 14 luglio 1455, mazzo 47, n. 67, published in Biadego, 1908, pp. 858–59, discussed pp. 849ff.). The loans, totaling 843 lire, 17 soldi, and 10 lire and beginning on 16 November 1434—presumably the year that Bartolomeo married Pisanello's half-sister, Bona (see n. 24)—were made to Pisanello and his mother, Isabetta. The terminus ante quem is provided by a letter written on 31 October [1455] by Carlo de' Medici in Rome to his brother Giovanni in Florence which includes the sentence "Io avevo a questi dì comprate circha di 30 medagl[i]e d'ariento multo buone da uno garzone del Pisanello, che morì a questi dì" (Archivio di Stato, Firenze, M.A.P., busta VII, no. 107, published in Brenzoni, *Pisanello*, p. 38 n. 22). See also Venturi, 1896, pp. 62ff.

50. Venturi, 1896, p. 61.

51. Ibid. p. 62. Dati was in Rome around 1450 (F. Flamini, "Leonardo di Pietro Dati, poeta latino del secolo XV," *Giornale Storico della Letteratura Italiana* 16 [1890]: 22), and this date seems a more likely moment for his epigram than Venturi's proposed date of 1432 (Venturi, 1896, p. 35), which would make Dati's work a prototype in this category.

52. "Mantuae aediculum pinxit et tabulas valde laudatas" (Venturi, 1896, pp. 65–66; Baxandall, "Bartolomaeus Facius," pp. 90–107).

53. For Giovanni Santi's chronicle, see M. Baxandall, *Painting and Experience in Fifteenth Century Italy*, Oxford, 1972, pp. 111–15; L. Bek, "Giovanni Santi's 'Disputa de la pictura'—A Polemical Treatise," *Analecta Romana Instituti Danici* 5 (1969): 75–102. For Ludovico Carbone's oration, see G. Zippel, "Artisti alla corte degli Estensi nel Quattrocentro," *L'Arte* 5 (1902): 405–7.

54. P. Gauricus, *De Sculptura (1504)*, ed. A. Chastel and R. Klein, Geneva, 1969, p. 259; Hill, 1930, nos. 77, 87. Both medals bear the initials of the seven virtues ("F.S.K.I.P.F.T.") on the reverse. Pisanello looks elderly in the Nicholaus medal, which could be posthumous, since Nicholaus was still working in Ferrara in 1454.

55. ". . . prestantissimo nell'opera de' bassi rilievi, stimati difficilissimi da gli artefici, perché sono il mezo tra il piano delle pitture e'l tondo delle statue" (letter from Paolo Giovio to Duke Cosimo de' Medici, Florence, 12 November 1551, published in P. Giovio, *Lettere*, ed. G. G. Ferrero, vol. 2, Rome, 1958, p. 209).

56. For a refutation of Vasari's other attributions of medals to Pisanello, see Vasari-Milanesi, III, p. 12 n. 1. For a recent attribution, see G. F. Hill, "A Lost Medal by Pisanello," *Pantheon* 8 (1931): 487–88; U. Middeldorf, "A New Medal by Pisanello," *Burlington Magazine* 123 (1981): 19–20. The *Portrait of Leonello d'Este* in Bergamo is of course undocumented.

57. Andrea Pellegrini left 900 ducats for the chapel in S. Anastasia in his will in 1429 and died soon thereafter. See O. Pellegrini, "Su di un particolare delle terrecotte di S. Anastasia in Verona," *Studi Storici Veronesi* 2 (1950): 209–14. The fresco is usually dated to the years between Pisanello's return from Rome in about 1432 and his presence at the Council of Ferrara in 1438. Michele da Firenze worked on the terracottas in the chapel in 1436. G. Gruyer ("Vittore Pisano appelé aussi le Pisanello (3ième article)," *Gazette des Beaux-Arts*, ser. 3, 11 [1894]: 427) was the first to suggest 1438 as a terminus post quem for this mural, based on such motifs in the work as the Mongol archer and the horse with split nostrils, which he believed Pisanello could only have seen in the retinue of the delegates from Eastern Europe to the Council of Ferrara and Florence in 1438. For a recent attempt to date the fresco more precisely between late 1437 and the summer of 1438, that is, before the Council of Ferrara, see L. Puppi, "La Principessa di Trebisonda," *Verso Gerusalemme: immagini e temi di urbanistica e di architettura simboliche*, Rome, 1982, pp. 44–61. For the problems raised by Vasari's description of the Pellegrini Chapel, see Chiarelli, *Tutta l'opera*, p. 94, cats. 65–68; G. L. Mellini, "Problemi di archeologia pisanelliana," *Critica d'Arte* 8, fasc. 477 (1961): 53–56; R. Chiarelli, "Due questioni pisanelliane," *Atti e Memorie dell'Accademia di Agricoltura, Scienze e Lettere di Verona* 143/144 (1967): 380–81.

58. The woman (Paris, Louvre; Paccagnini, 1972, pl. 124) can be identified as an Este by the emblem on her dress, a crystal vase with attached chains, which also occurs on two of the medals that Pisanello created for Leonello d'Este (Hill, 1930, nos. 30–31, datable to around 1440–44). See G. F. Hill, *Pisanello*, London, 1905, p. 71. The sprig of juniper on her left shoulder would seem to confirm the sitter's identity as Ginevra d'Este, who married Sigismondo Malatesta of Rimini in 1434 and died in 1440. B. Degenhart (*Pisanello*, p. 38) identified her as a Gonzaga on the basis of the red, green, and white piping on her dress, and proposed Margherita Gonzaga, who married Leonello d'Este in 1435, as sitter. As M. Levi D'Ancona (*The Garden of the Renaissance*, Florence, 1977,

p. 23) points out, however, the daisy, or *margherita*, is conspicuously absent from among the many flowers that stud the background of the painting. If the sitter is correctly identified as Ginevra d'Este, the portrait was probably connected with her betrothal and marriage and therefore dates around 1433–34.

59. *The Vision of St. Eustache* (London, National Gallery, no. 1436) is usually dated around 1436–38, contemporary with the S. Anastasia frescoes, but may be earlier. For a refutation of the attribution to Pisanello, see G. M. Richter, "Pisanello Studies II," *Burlington Magazine* 55 (1929): 134–39. The *Apparition of the Virgin to SS. Anthony and George* (London, National Gallery, no. 776) is signed "pisanvs pī" in the form of grasses and is usually dated around 1445. The identification of St. George as Lodovico Gonzaga (B. Degenhart, "Ludovico II. Gonzaga in einer Miniatur Pisanellos," *Pantheon* 30 [1972]: 193–210) is not, to my mind, convincing. For other paintings frequently attributed to Pisanello but unacceptable for various reasons, see Fossi Todorow, 1966, p. 4 n. 1.

60. Fossi Todorow, 1966, p. 15.

61. See chapter 7, section III; Fossi Todorow, 1966, cats. 65–72.

62. Paccagnini, 1972, chap. 4; Degenhart, 1973, p. 401.

63. A. Zanoli, "Sugli affreschi di Pisanello nel Palazzo Ducale di Mantova," *Paragone* 227 (1973): 23–44; M. Baxandall, review of Paccagnini, 1972, *Art Bulletin* 57 (1975): 130–31. For further discussion of Lodovico's later commissions, see chapter 5, section II.

64. ASMAG, busta 410a, cc. 12 (1416), 32 (1421), 36 (1422), 51 (1424), 62 (1432), 88v (1439). See I. Toesca, "Altre osservazioni in margine alle pitture del Pisanello nel Palazzo Ducale di Mantova," *Civiltà Mantovana* 11 (1977): 358–59 n. 10–15; id., "A Frieze by Pisanello," *Bur-*

lington Magazine 116 (1974): 210–14; id., "Lancaster e Gonzaga: il fregio della 'Sala del Pisanello' nel Palazzo Ducale di Mantova," *Civiltà Mantovana* 7 (1973): 361–77; id., "More about the Pisanello Murals at Mantua," *Burlington Magazine* 118 (1976): 622–29; id., "Postilla a proposito di un fiore," *Civiltà Mantovana* 12 (1978): 233–36; id., "Lancaster and Gonzaga: The Collar of SS at Mantua," in *Splendours of the Gonzaga*, ed. D. S. Chambers and J. Martineau, London, 1981, pp. 1–2, cat. 9. The identification is based on the single letter S on every second image of the collar. For further discussion, see chapter 4, text at nn. 79ff.

65. Letters from Henry VI of England to Gianfrancesco Gonzaga, 19 and 31 October 1436 (ASMAG, busta 387, published in A. Luzio, *La galleria dei Gonzaga . . .* Milan, 1913, p. 63 n. 1; Toesca, "Lancaster e Gonzaga," p. 366; ASMAG, busta 578, c. 78, published in A. Luzio, *L'Archivio Gonzaga di Mantova*, Verona, 1922, p. 124 n. 4; Toesca, loc. cit.). The *colerae nostrae aut devisamenti* is assumed to be identical to the King of England's *livredam seu divisam regiam* that was delivered by the Archbishop of Cologne (letter from the Archbishop of Cologne to Gianfrancesco Gonzaga, 16 April [?] 1436, ASMAG, busta 384, published in Luzio, *L'Archivio Gonzaga*, p. 124 n. 4; Toesca, "Lancaster e Gonzaga," p. 367). See also *Splendours of the Gonzaga*, cat. 6. Henry VI had already given Gianfrancesco three other collars in 1429 (Toesca, "Lancaster e Gonzaga," p. 369 n. 14). Toesca, "Altre osservazioni," p. 352, notes that the collar no longer appears in jewelry inventories after 1440.

66. See chapter 4, section II.

67. See n. 6.

68. Paris, Louvre, 2479 (Fossi Todorow, 1966, cat. 4, pl. 6).

69. Paris, Louvre, 2278 (Fossi Todorow, 1966, cat. 69, pl. 84). The drawing

includes a sketch of the coat of arms with the Lion of Bohemia and Gonzaga bars that the Gonzaga ceased to use after they obtained the right to quarter their arms with Imperial eagles in 1433.

70. Paris, Louvre, M.I. 1062, and Chicago, Art Institute, 1961.331 (Fossi Todorow, 1966, cats. 57, 58). See also J. Fasanelli, "Some Notes on Pisanello and the Council of Florence," *Master Drawings* 3 (1965): 36–47, who suggests the dates of 8 October 1438 for the drawings and July–August 1439 for the medal. The suggestion of M. Vickers in "Some Preparatory Drawings for Pisanello's Medallion of John VIII Paleologus," *Art Bulletin* 60 (1978): 417–24, that all except one of the figures on the sheets represent the Emperor in different poses wearing different clothes seems unlikely. For the 1439 Paleologus medal, see R. Weiss, *Pisanello's Medallion of the Emperor John VIII Paleologus*, London, 1966, p. 9; Hill, 1930, no. 19.

71. For the medals, see n. 48; for the drawings, see nn. 73–75.

72. See chapter 7 for further discussion.

73. Paris, Louvre, 2486 (Fossi Todorow, 1966, cat. 73).

74. Paris, Louvre, 2318 (Fossi Todorow, 1966, cat. 74).

75. Paris, Louvre, 2603r (Fossi Todorow, 1966, cat. 75r).

76. See nn. 69, 70.

77. Fossi Todorow, 1966, accepts only some 80 drawings among the 400 attributed to the artist that form part of the so-called Vallardi Codex today in the Louvre. Degenhart, *Pisanello*, on the other hand, accepts many more drawings, including most of those in the Vallardi Codex. See reviews of Degenhart by U. Middeldorf, *Art Bulletin* 24 (1947): 278–82, and C. Mitchell, *Times Literary Supplement*, 13 September 1946, p. 433.

78. See chapter 7, section I.

79. Hill, 1930, nos. 44, 19.

80. Cennino Cennini (*The Craftsman's Handbook: "Il libro dell'arte,"* trans. D. V.

Thompson, Jr., New Haven, 1933) recommends in chapter 8 that the artist arrange to have the light come from the left and to have it diffused, and in chapter 9, on working *in situ*, that the artist always draw according to the actual light source.

81. Hill, 1930, no. 42.

82. See the excellent discussions of Pisanello's graphic style in Fossi Todorow, 1966, passim.

83. Other works datable to 1438 for the same reasons are some drawings in the Louvre, nos. 2468, 2353, 2363 (Fossi Todorow, 1966, cats. 33, 35, 43), all of horses with slit nostrils, which Pisanello could perhaps only have seen in the retinue of the Eastern delegates. For the Mongol practice of slitting horses' nostrils to allow the animals to breathe, see G. F. Hill, *Dessins de Pisanello*, Paris–Brussels, 1929, p. 34. The many drawings usually associated with the S. Anastasia fresco have not here been used as evidence because of the mural's unconfirmed date. See also comments in n. 57.

84. For further discussion, see chapter 6, section I.

85. "Voliendo Vostra Excellentia andare a li bagni per santitade de la persona vostra, el se bisogna elezere queli pianeti che ve àno promesso sanitade nel tenpo de la nativitade et nel tenpo de la revolutione anovale, la quale si comenza sempre inandi al dì che se nacque in questo mondo. Et perché la nativitade vostra fu de dì, et che avestivy Lione per asendente et lo Sole fu vostro signyficatore, et in questa vostra revolutione che fu a dì 4 [corrected to 5] de zugno, hore 13, minuti 13 . . ." (letter from Giovanni Cattani to Lodovico Gonzaga, 19 July 1477, ASMAG, busta 2418, published in Signorini, 1985, p. 119).

86. The hours of the day were reckoned from sunset, the time of which of course changed throughout the year. If, say, sunset in Mantua took place around 7.30 p.m. on 4 June 1412, then Lodovico was

probably born around 8.45 a.m. on 5 June. (See J. Cox-Rearick, *Dynasty and Destiny in Medici Art: Pontormo, Leo X, and the Two Cosimos*, Princeton, 1984, app. 1, pp. 295–99.) Such a calculation explains why Cattani initially indicated the fourth of June rather than the fifth as Lodovico's date of birth. See n. 85.

87. For astrology in the Renaissance, see Cox-Rearick, *Dynasty and Destiny*, esp. chap. 7, with full bibliography; M. Quinlan-McGrath, "The Astrological Vault of the Villa Farnesina: Agostino Chigi's Rising Sign," *Journal of the Warburg and Courtauld Institutes* 47 (1984): 91–105; V. A. Clark, "The Illustrated Abridged Astrological Treatises of Albumasar: Medieval Astrological Imagery in the West," Ph.D. thesis, University of Michigan, 1979, chap. 1. I wish to thank Kathleen Weil-Garris Brandt for her sage advice in matters astrological.

88. "La Signoria Vostra nacque sotto pianeto di Sole e porta el Sole, e pensa che se non fusse el Sole che nui seremo sotoposti a le gran tenebre" (letter from Giacomo degli Ovetari, vicario di Roncoferraro, to Lodovico Gonzaga, 1 September 1459, ASMAG, busta 2393, c. 173, published in Signorini, 1985, p. 200).

89. M. Ficino, *De Sole* in *Opera Omnia*, Basel, 1576, quoted from Cox-Rearick, *Dynasty and Destiny*, p. 185 n. 23, giving the translation of A. Fallico and H. Shapiro, in *Renaissance Philosophy*, vol. 1, *The Italian Philosophers*, New York, 1967, p. 121.

90. ". . . Tuti quilly signori che àno abéto el Sole per suo significatore et el predito Sole sia stato bene disposto, si àno più proporcione ad intendere li suoy efeti del Sole che non àno quely che non sono proporcionati soto le sue influencie. . . . Et perché eo dito che lo sole se è vostro governatore, quanto più operarite soto le sue bone disposicione, tanto melio seguirà li efeti bony . . ." (letter from Giovanni Cattani to Lodovico Gonzaga,

22 July 1477, ASMAG, busta 2418, published in Signorini, 1985, p. 199).

91. See Signorini, 1985, pp. 198–204.

92. Cox-Rearick, *Dynasty and Destiny*, pp. 165, 173. Clement VII also used his ascendant sign of Leo rather than Gemini, the sign occupied by the sun at his birth.

93. "Ho inteso . . . como quella non ha recevuto a tempo quello lionzino . . . ma per questo non importa multo, perhò che adì domenega, 19 del presente [July], ad hore 9, minuti 15 in Dei nomini ve lo ponerite a dosso, e serà die et hora [del sorgere] del sole, ascendendo quello in lione, in lo cuspide oriental. Zoè quando lo corpo solare cominzarà a parere in lo oriente, ponerite solo lionzino a dosso, a presso la carne. . . . che in queste hore sune tante dignità et possanza circa la Illustre vostra natività . . ." (letter from Bartolomeo Manfredi to Lodovico Gonzaga, Mantua, 17 July 1461, ASMAG, busta 2395, c. 306, published in Signorini, 1985, p. 294 n. 326). Manfredi was answering a letter from Lodovico Gonzaga on the same subject, Cavriana, 16 July 1461, ASMAG, busta 2888, libro 46, c. 9r, also transcribed in ibid.

94. It should be noted that Pisanello's image is not a symbol of the Resurrection. The lion as symbol of the Resurrection was based on the belief that the lioness habitually gave birth to stillborn cubs which were revived three days later by the breathing or roaring of their sire. In Mantua it is the lioness, not the lion, who stands over the cubs, unlike, for instance, a similar image in one of the roundels of the decorative frieze in the Arena Chapel in Padua. See L. Reau, *Iconographie de l'art chrétien*, Paris, 1955, I, p. 93; J. H. Stubblebine, ed., *Giotto: The Arena Chapel Frescoes*, London, 1969, pl. 72 (where the subject is incorrectly identified).

95. Cox-Rearick, *Dynasty and Destiny*. An inscription on the clocktower in

Mantua, which stated that Gianfran-
cesco Gonzaga acceded to the *signoria* on
20 March 1407 aged eleven years, nine
months, and nine days, gives the first
Marchese a date of birth of 11 June 1395
(F. Tarducci, "Gianfrancesco Gonzaga
signore di Mantova (1407–1420),"
Archivio Storico Lombardo 29 [1902]: 316
n. 1). Without precise information on
Gianfrancesco's hour of birth it is of
course impossible to reckon his
ascendant sign, but it seems unlikely
that it would have been identical to
Lodovico's.

96. See nn. 38–41.
97. See n. 40.
98. See n. 41.

FOUR · POLITICAL CONTEXT

1. For what follows and for the history of
Mantua in general, see A. Luzio, "I Cor-
radi di Gonzaga, signori di Mantova,"
Archivio Storico Lombardo 40 (1913): 247–
82, 131–78; P. Torelli, "Capitanato del
popolo e vicariato imperiale come ele-
menti costitutivi della Signoria Bona-
colsiana," *Atti e Memorie della R. Acca-
demia Virgiliana di Mantova*, N.S., 14
(1921): 73–221; L. Mazzoldi, *Mantova: la
storia*, Mantua, 1961, vol. 2; G. Co-
niglio, *I Gonzaga*, Varese, 1967; E.
Sestan, "La storia dei Gonzaga nel rina-
scimento," in *Mantova e i Gonzaga nella
civiltà del rinascimento* (Atti del Con-
vegno), Mantua, 1977, pp. 17–27; C.
Mozzarelli, "Lo stato gonzaghesco:
Mantova dal 1382 al 1707," in *I ducati
Padani, Trento e Trieste: storia d'Italia*, ed.
G. Galasso, vol. 17, Turin, 1979, pp.
359–495. See also an abbreviated version
of some of the material in this chapter in
my "French Chivalric Myth and Man-
tuan Political Reality in the *Sala del Pi-
sanello*," *Art History* 8 (1985): 397–412.
2. W. Altmann, *Die Urkunden Kaiser Sig-
munds (1410–1437)*, Innsbruck, 1896,
nos. 9126–27, p. 213 (6 May 1432), no.
9674, p. 247 (22 September 1433). Sig-

ismund was in Mantua from 21 to 29
September 1433.
3. It was largely through the efforts of Bar-
bara's grandfather, Frederick IV of
Hohenzollern (1371–1440), Burgrave of
Nuremberg and ruler of Ansbach and
Bayreuth in Franconia, that Sigismund,
King of Hungary and Bohemia (1368–
1437), was elected King of the Romans
in 1410. Seeking another vote, Sigis-
mund first gave Frederick, his supporter
on battlefield and in council chamber,
the government of the Marches and then
in 1415 invested him with the title of
Elector, for which Frederick paid
400,000 gulden (Altmann, *Urkunden*,
no. 1541, p. 97). The Margrave of Bran-
denburg was one of the seven princes
who elected the Holy Roman Emperor.
See J. Schultze, *Die Mark Brandenburg*,
vol. 2, *Die Mark unter Herrschaft der Ho-
henzollern (1415–1535)*, Berlin, 1963,
pp. 9–48.
4. See E. Swain, "Strategia matrimoniale
in casa Gonzaga: il caso di Barbara e
Ludovico," *Civiltà Mantovana*, n.s., 14
(1986): 1–13.
5. This account relies heavily on Mahnke,
1975. See also references in n. 1.
6. Mahnke, 1975, p. 33. For the *condotta* (a
mercenary contract), see M. Mallett,
Mercenaries and Their Masters, London,
1974, pp. 79–87.
7. ". . . nuy de grande tempo havevemo
portato la coraza . . ." (letter from Vin-
cenzo della Scalona to Barbara of Bran-
denburg, Milan, 24 February 1460,
quoting the words of Lodovico Gon-
zaga, ASMAG, busta 1621, c. 67).
8. See A. Portioli, "La giornata di Cara-
vaggio ed i sigilli di Lodovico II Gon-
zaga secondo marchese di Mantova,"
*Periodico di Numismatica e Sfragistica per la
Storia d'Italia* 3 (1871): 125–36.
9. *Le Carte Strozziane del R. Archivio di
Stato in Firenze: Inventario*, ser. 1, 2
(1891): 833.
10. "Lo Illustrissimo Segnore Marchese
Johanne Francesco fu dignissimo et li-

beralissimo segnore quanto alchuno altro havesse l'Italia. Seguitò di po lui lo Illustrissimo Segnore Marchese Lodovico il quale fu multo meno liberale dil Segnore suo patre, ma pur dava, se non libenter" (letter from Filelfo to Zaccaria Saggi, 8 July 1478, ASMAG, busta 1626, c. 406, published in Luzio/Renier, 1890, p. 164). Filelfo was engaged in disparaging the liberality of the current Marchese, Federico.

11. M. Equicola, *Dell'istoria di Mantova* (1521), 2d ed., Mantua, 1607, pp. 135, 136, 174; Mazzoldi, *Mantova*, pp. 5, 13, 51 n. 32. A letter survives in which Gianfrancesco begs his wife to hunt for some lost money: "Paula, per Dio tenete ogni bon modo che ve sia possibele de retrovar quelli dinari, perché, come più ie guardo sovra, tanto più me par che i siano de bixogno, e quando i me mancaseno, i seria el più impacado omo del mondo" (letter from Gianfrancesco Gonzaga to Paola Malatesta, 25 August 1418, ASMAG, busta 2094, c. 70, published in F. Tarducci, "Gianfrancesco Gonzaga signore di Mantova (1407–1420)," *Archivio Storico Lombardo* 29 [1902]: 61).

12. Mazzoldi, *Mantova*, p. 53 n. 41.

13. ". . . vogliamo totalmente se metta da canto ogni pensier del collare et de le vestimente de casa . . ." (letter from Lodovico Gonzaga to Barbara of Brandenburg, 21 June 1448, ASMAG, busta 2094, c. 363, published in Mazzoldi, *Mantova*, p. 51 n. 32). A few days later, on 28 June 1448, Lodovico wrote to the humanist Jacopo di S. Cassiano that he lacked the money to buy certain proposed books (Luzio/Renier, 1890, p. 138).

14. Fifteenth-century financial records for the Gonzaga court were largely destroyed in the nineteenth century, making a comprehensive study of these military-economic aspects of the Gonzaga *signoria* difficult.

15. Mahnke, 1975, p. 124.

16. Ibid. pp. 389ff., 126. It can also be compared to the 1467 offer made by the Italian League to Federico da Montefeltro of 60,000 ducats a year in peace and 80,000 in war (J. Dennistoun, *Memoirs of the Dukes of Urbino*, 3 vols., London, 1851, I, p. 177).

17. In 1354, for instance, a double marriage took place between the houses of Habsburg and Gonzaga. Filippino Gonzaga married Werena of Habsburg, and Elisabetta Gonzaga married Rudolf of Habsburg. See Luzio, "I Corradi di Gonzaga," pp. 157–62.

18. Frederick I's military and diplomatic abilities were not inherited by his eldest son, John the Alchemist (Barbara's father), who administered the Marches incompetently from 1426 to 1437. Arranging the division of his territories in the latter year, Frederick decided that Brandenburg should pass to his second son, Frederick (1413–71), who became Elector Frederick II. John the Alchemist retired to Bayreuth, and the third son, Albert (1414–86), was given Ansbach. See Schultze, *Die Mark Brandenburg*, pp. 36–52. Albert Achilles was so well known in Italy that in 1456 he was one of the few foreigners included by Fazio in his *De Viris Illustribus* (see edition ed. L. Mehus, Florence, 1745, pp. 73–74).

19. *The Commentaries of Pius II*, bk. 2, trans. F. A. Gragg with introduction by L. C. Gabel, *Smith College Studies in History* 25, nos. 1–4 (1939–40): 196. For Frederick III, see *Ausstellung Friedrich III. Kaiserresidenz Wiener Neustadt, Amt Niederösterreichischen Landesregierung (Kulturreferat)*, Vienna, 1966.

20. "Esso marchese Alberto è amicissimo de lo Imperatore et altra volta fu suo capitaneo generale, et ha una gran familiaritade nela corte de la Maestà Sua" (letter from Barbara of Brandenburg to Bianca Maria Visconti, Duchess of Milan, 1 January 1460, ASMAG, busta 2886, libro 37, c. 22r).

21. Mahnke, 1975, p. 220. As Aeneas Silvius

Piccolomini, Pius II was the Emperor's secretary in the early 1440s and accompanied him throughout his journey to Italy in 1452.

22. Pius Secundus, *Commentarii Rerum Memorabilium*, Rome, 1584, pp. 37–38, 165–66, trans. in *Smith College Studies in History* 22, nos. 1–2 (1936–37): 67; 25, nos. 1–4 (1939–40): 275–76.

23. Ibid. p. 49, trans. in *Smith College Studies in History* 22, nos. 1–2 (1936–37): 86.

24. "Havendo ragionamento con quella de la Illustrissima Casa de Brandemburgo, [il Papa] se distese tanto in comendatione et exaltatione di quella che chi volesse impetrar gratia da essa Beatitudine, bisogrieria usar de mezo di Vostra Signoria, tanto comenda et exalta la sua progenie e dice queste formali parolle che chi nasce di quella Casa non può essere se non savio e conforta Vostra Signoria ale buone e sante opere secondo la sua fama optima e perfeta e dice che quella non gli adimanderà cosa ch'ella non gli concedda, tanta oppinione ha in quella che la non gli richiedderà se non cose rasonevole, sancte e divotissime" (letter from Zaccaria Saggi to Barbara of Brandenburg, Rome, 2 October 1458, ASMAG, busta 840, c. 346, published in Mahnke, 1975, p. 220).

25. "Nec ullus quidem [dubitat], quod si vestre Illustres dominationes ipsi domino Imperatori suadent, civitatem hanc elligendam esse, quin libenter faciat et huc se personaliter conferrat, in vobis enim spes omnium fixa et reposita est" (letter from Barbara of Brandenburg to Margrave Albert of Brandenburg, Mantua, 5 November 1458, ASMAG, busta 2886, libro 35, c. 9, published in B. Hoffman, *Barbara von Hohenzollern, Markgräfin von Mantua*, Ansbach, 1881, p. 35, app. IX).

26. Mahnke, 1975, pp. 220, 224.

27. In a letter written 15 January 1459 Barbara of Brandenburg thanked Margrave Albert profusely for his intervention (published in Hoffman, *Barbara von Hohenzollern*, p. 37, app. X). Pius II would have preferred the alternative choice of Udine as being more accessible to Wiener-Neustadt and the Emperor, but the Venetians rejected the idea for fear of retaliation from the Turks, with whom they traded. See G. B. Picotti, *La Dieta di Mantova e la politica de' Veneziani* (Miscellanea di Storia Veneta, ser. 3, vol. 4), Venice, 1912, chap. 1.

28. ". . . advisando le vostre Signorie come Mantua hoggi è molto ornata di prelati, di signori, di ambasciatori et di molta corte et é una bella Mantua: et oltra questo c'è molte stanze belle, grandi et degne, etc.: ecci etiandio habundantissimo universalmente d'ogni cosa" (letter from Nicolò Severino and Lodovico Petroni to the Signoria of Siena, Mantua, 25 September 1459, published in Picotti, *Dieta di Mantova*, p. 434).

29. ". . . il mormorare de la Corte che si dole essere in una città quasi asacomenata e spopulata dove pare che non sia done de le quali il gratioso aspetto sole essere il principale diporto e solazo de gientili cortesani volendo quanto può suplire tal mancamento . . ." (letter from Ottone del Carretto to Bianca Maria Visconti, Mantua, 29 June 1459, Archivio di Stato, Milan, Sforzesco, cart. 392, cited in Mahnke, 1975, p. 289 n. 118).

30. "Laudavano molto questa ellectione [di Mantova] per eser loco comodo ala mazor parte, ma mostravano de dubitare che'l non si faria le provisione bone ale cose necesarie per tanta multitudine, dicendo loro che al Iubileo non andarono tanti todeschi a Roma quanti veniranno a Mantua, però che questo Papa fi molto amato da loro" (letter from Gabriele da Crema [quoting some German priests he encountered at Trent] to Lodovico Gonzaga, Rothenburg, 15 November 1458, ASMAG, busta 439, c. 63).

31. "Omnia abundantissima in ea urbe exstiterunt, frumenta, vina, pulli cum reliquo victu, omni rerum caritate pe-

nuriaque abiecta" (*Le vite di Paolo II di Gaspare di Verona e Michele Canensi*, in L. A. Muratori, *Rerum Italicarum Scriptores*, n.s., 3, pt. XVI, Città di Castello, 1904, p. 28). "Tutti lodano et magnificono Mantua sopra tutte le altre terre et molto più la benignità de Vostra Illustrissima Signoria et de li cittadini: commendano somamente l'ordine che Vostra Excellentia diede in fare habondante la terra de tutti li beni et cose necessarie et de l'aloggiar così degnamente sença alcuno strepito . . ." (letter from Bartolomeo Marasca to Barbara of Brandenburg, Tivoli, 30 August 1463, ASMAG, busta 842, c. 425). ". . . se arecordano de' caponi grassi e altri apiaceri gli fiseano fatti" (letter from Iacopo d'Arezzo to Lodovico Gonzaga, Ancona, 21 July 1464, ASMAG, busta 842, c. 241). See also letter from Anselmo Folengo to Lodovico Gonzaga, Revere, 28 January 1460, ASMAG, busta 2394, fasc. da Revere.

32. "[A Tivoli] G'è tanto caldo che si brusa et polvere che se sofocha. Dicono, adesso, che quello da Mantua era niente presso a questo" (letter from Bartolomeo Bonatto to Barbara of Brandenburg, Tivoli, 24 June 1461, ASMAG, busta 841, c. 103, published in R. Signorini, "Nui da Mantua non se teniamo ponto esser cussì brutte," *Gazzetta di Mantova*, no. 308 [5 November 1976]: 10). For Lodovico's subsequent attempts to do something about the mud, see letter from Bartolomeo Bonatto to Lodovico Gonzaga, Rome, 11 February 1461, ASMAG, busta 841, c. 9r, published in M. Dall'Acqua, "Storia di un progetto albertiano non realizzato: la ricostruzione della Rotonda di San Lorenzo in Mantova," in *Il Sant'Andrea di Mantova e Leon Battista Alberti* (Atti del Convegno 1972), Mantua, 1974, pp. 233–34.

33. "questi dì, essendo così grande caldo come era et havendo visto portare alcuni morti in uno dì a Sancto Silvestro, che'l lo fece uno pocho smarir . . . ge dissi che

haveria a caro de poter andare fuora per sei over octo zorni a qualche loco qui apresso cinque o sei miglia, sì per fuzere il caldo e sì per non vedere questi morti . . ." (letter from Barbara of Brandenburg to Lodovico Gonzaga, 5 August 1459, busta 2886, libro 36, c. 52r). The Sienese ambassador Giovanni de' Mignanelli wrote to the Signoria of Siena on 29 June that he was "così un pocho stanco già di questa aria caldissima" and died in Mantua in the middle of August 1459 (Picotti, *Dieta di Mantova*, p. 434). On 23 August 1459 Antonio Guidobono wrote to Francesco Sforza telling him to postpone his visit to Mantua because of the disease and the heat: "de presente ce ne sono de li amallati asay e molti ne morano" (Archivio di Stato, Milan, Sforzesco, cart. 392, published in Mahnke, 1975, p. 240).

34. "Here indeed I have been received much more agreeably than I thought possible. A messenger of the lords of Mantua, whose grandeur often overcomes even nature itself, had been waiting for me. A sumptuous dinner was laid out: imported wine, exotic dishes, courteous hosts, pleasant faces—in short, everything elegant except the place, where the summer foretells what it may be like in winter. Now in fact it is the home of flies and mosquitoes, whose buzzing advised a hasty departure from the feast. An army of frogs came to attack; you could see them coming from their hiding places into the midst of the banquet and jumping about in the dining room" (F. Petrarca, *Le familiari*, ed. U. Dotti, vol. 2, Urbino, 1974, IX, 10, p. 992, letter to Lelius, Luzzara, 28 June 1350, trans. in F. Petrarca, *Letters on Familiar Matters*, ed. A. S. Bernardo, Baltimore, 1982, p. 29).

35. Pius Secundus, *Commentarii*, pp. 109–10, trans. in *Smith College Studies in History* 25, nos. 1–4 (1939–40): 193.

36. "De una cossa dicono quelli cortesani sono lì: ge pare de esser ritornati a

Mantua che le belle done erano sta' fugite. Non fu mai li più strafigurati visi che quelli sono lì. Chi se diletasse de maschare, non andasse altroe per farne re[cerca]" (letter from Bartolomeo Bonatto to Barbara of Brandenburg, Rome, 26 July 1461, ASMAG, busta 841, c. 141, published in Signorini, "Nui da Mantua," p. 10).

37. Letter from Barbara of Brandenburg to Margrave Albert of Brandenburg, 25 March 1460, ASMAG, busta 2886, libro 37, c. 65r, published in Hoffman, *Barbara von Hohenzollern*, p. 41, app. XVI (with date of 26 March 1460). Letter from Bartolomeo Bonatto to Lodovico Gonzaga, ASMAG, busta 841, c. 212, published in Signorini, 1985, p. 35.

38. Barbara referred to this letter from the Emperor, which Albert attached to one of his own to the Pope, in her own letter to Margrave Albert of 14 April 1460 (published in Hoffman, *Barbara von Hohenzollern*, p. 42, app. XVII).

39. "Tenessero modo che lo imperatore, el qual sapiamo esser ben disposto verso el Marchese et che lo faria volentera per complacentia del marchese Alberto et deli fratelli, scrivesse qui due littere: l'una a Nostro Signore, l'altra al colegio de cardinali, in le quali concludesse questo, che cussì ge parea honesto fusse compiaciuto ad la Sua Maestà come ad alcuno altro et pregasse et supplicasse ge fusse compiaciuto del Prothonotario" (letter from Bartolomeo Bonatto to Barbara of Brandenburg, Rome, 29 May 1461, ASMAG, busta 841, c. 85, published in R. Signorini, "Appendice: "l'elevazione di Francesco Gonzaga al cardinalato", *Mitteilungen des Kunsthistorischen Institutes in Florenz* 18 [1974]: 247).

40. ". . . estimando questo per li meriti et fideltà de li Illustri Signori de Brandeburgo, in li quali è una voce de l'imperio, da li quali depende ex latere matris . . ." (letter from Bartolomeo Bonatto to Lodovico Gonzaga, Rome, 9 October 1461, ASMAG, busta 841, c. 212, published in Signorini, loc. cit.).

41. "Franciscus Mantuanus nobilissimis Italiae atque Germaniae familijs sanguine iunctus" (Pius Secundus, *Commentarii*, p. 363).

42. Emperor Frederick III and Barbara of Brandenburg shared a great-aunt Beatrix, sister of Frederick I of Brandenburg, who married Albert III Duke of Austria in 1375. See *Stammtafeln zur Geschichte der europäischen Staaten I/II*, Marburg, 1956, vols. I–II, pp. 16, 60, 61.

43. "Havemo anchor mosso quello affinium suorum perché, digando che ex latere matris el prothonotario dessende de li marchesi de Brandimborgo, ben dice che sono nostri parenti, ma gli habiamo gionto che i sono coniunti de affinità cum la Maestà Sua, come è vero, ché a le case de Brandimborgo e a la nostra è più honorevole" (letter from Lodovico Gonzaga to Barbara of Brandenburg, 28 October 1461, ASMAG, busta 2096, published in Signorini, "Appendice: l'elevazione," p. 248).

44. Mahnke, 1975, pp. 262ff. The bull that appointed Emperor Frederick III general of the army to lead the crusade allowed for the substitution of Margrave Albert should the Emperor not be able to lead the troops in person (*Smith College Studies in History* 25, nos. 1–4 [1939–40]: 273 n. 184).

45. Mahnke, 1975, p. 265.

46. Ibid. p. 266.

47. See G. Lanzoni, *Sulle nozze di Federigo I Gonzaga con Margherita di Wittelsbach (1463)*, Milan, 1898; P. F. Staelin, *Die Heirath des württembergischen Grafen, nachherigen Herzogs Eberhard im Bart mit der Markgräfin Barbara Gonzaga von Mantua im Jahre 1474*, Stuttgart, 1874; R. Eisler, "Die Hochzeitstruhen der letzten Gräfin von Gorz," *Jahrbuch der K.K. Zentral-Kommission*, ser. 2, 3 (1905): 6–156; L. Billo, "Le nozze di Paola Gonzaga a Bolzano," *Studi Trentini di Scienze Storiche* 15 (1934): 3–22. The Gonzaga

remained proud of their German blood in later years, for example ". . . crediamo non esser bisogno racomandatione alchuna circa la natione germanica, per esser etiam nui di epso sangue derivati . . ." (letter from Giovanni Gonzaga to Marchese Francesco Gonzaga, Nuremberg, 17 March 1501, ASMAG, busta 522, c. 179).

48. For the dates, see R. Signorini, "Lettura storica degli affreschi della 'Camera degli Sposi' di A. Mantegna," *Journal of the Warburg and Courtauld Institutes* 38 (1975): 109-35.

49. R. Signorini, "Federico III e Cristiano I nella Camera degli Sposi del Mantegna," *Mitteilungen des Kunsthistorisches Institutes in Florenz* 18 (1974): 227-46.

50. In his will Gianfrancesco divided the state among his four sons. Although one son, Gianlucido, died in 1448, it was not until the deaths of two others, Carlo in 1456 and Alessandro in 1466, that all the territory governed by Gianfrancesco reverted to Lodovico. See references in n. 1.

51. J. Lawson, "The Palace at Revere and the Earlier Architectural Patronage of Lodovico Gonzaga, Marquis of Mantua (1444-78)," Ph.D. thesis, University of Edinburgh, 1979, pp. 49-50; P. Carpeggiani, *Il palazzo gonzaghesco di Revere*, Mantua, 1974, p. 55, doc. 2.

52. A. Magnaguti, *Ex Nummis Historia*, Rome, 1957, VII, p. 15, cat. 26.

53. Ibid., p. 18, no. 31; id., "Luci pisanelliane e mantegnesche sulle monete dei Gonzaga," *Rivista Italica di Numismatica*, ser. 5, 6 (1958): 5; id., *Studi intorno alla zecca di Mantova*, Milan, 1913, I, p. 19.

54. Hill, 1930, nos. 24-32.

55. Ibid. nos. 33-34, 163-71, 173-91.

56. Ibid. nos. 20, 38, 37, 36.

57. G. F. Hill, "On Some Dates in the Career of Pisanello," *Numismatic Chronicle*, ser. 5, 11 (1931): 194, revised the date of 1439-44 that he had earlier suggested for the Gianfrancesco medal (Hill, 1930, cat. 20) and argued for a posthumous dating (first proposed by A. Heiss, *Les médailleurs de la Renaissance*, vol. 1, Paris, 1881, p. 23), which is also argued in Paccagnini, 1972, p. 250 n. 113, and in *Splendours of the Gonzaga*, ed. D. S. Chambers and J. Martineau, London, 1981, cat. 13, p. 108. The reference to Gianfrancesco as first Marchese connects his medal to that for Cecilia (dated 1447), where he is similarly identified. Furthermore, by analogy with Lodovico's identification as Marchese (without a numeral), it seems unlikely that Gianfrancesco would have been called the "first" Marchese while he was still alive.

58. Letter from Lodovico Gonzaga to Leon Battista Alberti, Gonzaga, 19 October 1470, published in W. Braghirolli, "Leon Battista Alberti a Mantova," *Archivio Storico Italiano*, ser. 3, 9, pt. 1 (1869): 13.

59. Hill, 1930, no. 407. This medal by Pietro da Fano should probably be dated 1450-51.

60. "E vogliamo, se'l se scriverà a subditi, che'l se facia como qui de supra vederite e scrivendo a forestieri et ad altri como qui de supto se contene: "Lodovicus Marchio Mantue etcetera pro Excellentissima Comunitate Florentie Capitaneus generalis etcetera" (letter from Lodovico Gonzaga to Barbara of Brandenburg, 18 February 1447, ASMAG, busta 2882, libro 9, c. 55v, published in Coniglio, *I Gonzaga*, p. 52).

61. The term *impresa*, which in the sense of a personal device or emblem does not appear in fifteenth-century sources, will be avoided here. See F. Ames-Lewis, "Early Medicean Devices," *Journal of the Warburg and Courtauld Institutes* 42 (1979): 123.

62. G. Gerola, "Vecchie insegne di casa Gonzaga," *Archivio Storico Lombardo* 45 (1918): 97-110; U. Meroni, ed., *Mostra dei codici gonzagheschi*, Mantua, 1966, pls. 45 and 47. For jeweled pendants combining the devices of *cane alano* and

cervetta, see I. Toesca, "Altre osservazioni in margine alle pitture del Pisanello nel Palazzo Ducale di Mantova," *Civiltà Mantovana* 11 (1977): 361 n. 18.

63. P. Carpeggiani, "I Gonzaga e l'arte: la corte, la città, il territorio (1444–1616)," in *Mantova e i Gonzaga nella civiltà del rinascimento* (Atti del Convegno), Mantua, 1977, pl. 2, p. 170; Hill, 1930, no. 194; Paccagnini/Figlioli, 1972, p. 21, cat. 6; Magnaguti, *Ex Nummis Historia*, VII, p. 11, cat. 22. In 1472 Lodovico defined it as "nostra divisa" (letter from Lodovico Gonzaga to Giovanni Strigi, 2 November 1472, ASMAG, busta 2892, libro 69, c. 64v, cited in Signorini, 1985, p. 209).

64. Paccagnini/Figlioli, 1972, p. 20, cat. 3; Magnaguti, *Ex Nummis Historia*, VII, p. 29, cat. 92.

65. New York, Morgan Library, Ms. M. 445. See C. Perina, *Mantova, le arti*, vol. 2, Mantua, 1961, pl. 299, p. 338, where Cecilia (1451–78) is incorrectly identified; she was Lodovico and Barbara's third daughter. For the *cervetta* and the *cane alano* in the *Camera Dipinta*, see Signorini, 1985, pp. 194–213.

66. Equicola, *Storia di Mantova*, p. 163.

67. See the beautiful silverpoint drawing of roses seen from above, beneath, etc. in Louvre 2270 (Fossi Todorow, 1966, cat. 86).

68. I. Toesca, "More about the Pisanello Murals at Mantua," *Burlington Magazine* 118 (1976): 627. Before this article the flower was usually referred to in the secondary literature as a sunflower, because of its appearance and its frequent association with the sun.

69. See M. Palvarini, "A proposito di calendule anzi di margherite," *Quadrante Padano* 4, 2 (1983): 35–36 (who illustrates a maiolica tile showing [probably] the same flower, identified by the inscription *margarita*, and connects Gonzaga usage of the flower emblem or *margarita* with Margherita Malatesta, Gianfrancesco Gonzaga's mother). The

chamerino dalle malgerite is mentioned in a letter from Luca Fancelli to Lodovico Gonzaga written 13 October 1473, ASMAG, busta 2416, c. 495, cited in Signorini, 1985, p. 213.

70. N. Forti Grazzini, *L'arazzo ferrarese*, Milan, 1982, p. 217 (c. 7b): "Un apparamento da leto . . . entroui lavorato fiori de margarita cum folgie doro fino filato e cani alani bianchi e altri ornamenti per tuto el campo . . ."; p. 218 (c. 10b): "Ciello e capoleto cusidi insieme in uno pezo vechi e rotti . . . ricamato tuto lo campo . . . a lassi da cane e fiori de margarita." Possibly the flower, identical in appearance to the Mantuan *calendula*, and used as a device by the Este in conjunction with a diamond ring (Hill, 1930, nos. 103–4), should be called a *margherita*.

71. Paccagnini/Figlioli, 1972, p. 21, cats. 5–6; I. Toesca, "Postilla a proposito di un fiore," *Civiltà Mantovana* 12 (1978): 233–36. For other works of art showing the Gonzaga flower, see Toesca, "Altre osservazioni," p. 363 n. 26, and E. Marani, *La massaria a Mantova: città e castelli alla fine del Medioevo*, Mantua, 1983, pl. p. 10.

72. Hill, 1930, no. 407; frontispiece of a Latin grammar written in 1457 for Francesco Gonzaga (*Splendours of the Gonzaga*, p. 112, cat. 21); f. 1, with the motto "Ecce flos florum," of a manuscript that belonged to Lodovico, *Expositio in Psalmos*, Biblioteca Universitaria, Bologna, Ms. 2258 (B. Degenhart, "Ludovico II. Gonzaga in einer Miniatur Pisanellos," *Pantheon* 30 [1972]: pls. 25 and 26).

73. Magnaguti, *Ex Nummis Historia*, IX, cat. 12, pl. 3; Hill, 1930, cat. 276.

74. There is general consensus on the identification of the bird species. See I. Toesca, "A Frieze by Pisanello," *Burlington Magazine* 116 (1974): 213. A recently discovered hawk's hunting hood also apparently shows the same combined devices of swans, flowers, and

scrolls, also inscribed with the letter S (Toesca in *Splendours of the Gonzaga*, p. 2).

75. Toesca, "Altre osservazioni," pp. 352–53; id., "More about the Pisanello Murals," p. 625.

76. Toesca, "More about the Pisanello Murals," p. 625, was also the first to point out the Gonzaga colors in the fresco. The emblem of the flower was usually painted with the Gonzaga colors of green, red, and white (see references in n. 71; Gerola, "Vecchie insegne"). B. Degenhart, "Ludovico Miniatur Pisanellos," identifies a knight in a miniature as Lodovico Gonzaga on the basis of the green, gold, and white colors of his *giornea* and his page's crest, but these were not Gonzaga colors.

77. See chapter 2, section 1.

78. See references in chapter 2, n. 88.

79. For a differing interpretation from the following, and identification of this emblem as the Lancaster collar of SS, see references to the important articles by Ilaria Toesca in chapter 3, n. 64. The identification, based solely on the single letter S on every second image of the collar, lacks a historical basis in that the Gonzaga had no particular family or political ties with Henry VI of England that would explain why they should have wanted a Lancastrian device depicted in the *Sala* frieze.

80. A. R. Wagner, "The Swan Badge and the Swan Knight," *Archaeologia* 97 (1959): pl. XL.

81. R. Stillfried-Rattonitz, *Der Schwanenorden, sein Ursprung und Zweck, seine Geschichte und seine Alterthümer*, Halle, 1845; R. G. Stillfried and S. Haenle, *Das Buch vom Schwanenorden*, Berlin, 1881; B. Heydenreich, *Ritterorden und Rittergesellschaften: ihre Entwicklung vom späten Mittelalter bis zur Neuzeit*, Würzburg, 1960, pp. 36–46; Schultze, *Die Mark Brandenburg*, pp. 52–53; G. Schuhmann, *Die Markgrafen von Brandenburg-Ansbach*, Ansbach, 1980, pp. 401–5; L. Hommel,

L'histoire du noble ordre de la Toison d'or, Brussels, 1947. For the secular orders of chivalry, see M. H. Keen, *Chivalry*, New York, 1984, chap. 10.

82. "Born pure and legitimate to the shield and helmet from all his forefathers" (Stillfried-Rattonitz, *Schwanenorden*, p. 33). Adulterers, traitors, "violent" thieves, and immoderate drinkers were, however, excluded, regardless of ancestry.

83. "Ordensstatuen vom 15. Aug. 1443," published in Stillfried-Rattonitz, *Schwanenorden*, pp. 31–40, written in middle Low German. The papal bull of 1 July 1448 was published in Stillfried and Haenle, *Buch vom Schwanenorden*, p. 52.

84. Stillfried and Haenle, *Buch vom Schwanenorden*, p. 24. In 1459 Margrave Albert established his own branch of the order at Ansbach in South Germany, and in 1460 Pius II issued a bull extending the privileges of the Marienkirche in Brandenburg to the St. George Chapel in the Gumbertskirche in Ansbach (A. F. Riedel, *Codex Diplomaticus Brandenburgensis*, 21 vols., Berlin, 1838–69, C, I–II, p. 331, no. 209). See also J. Meyer, *Die Schwanenordens-Ritterkapelle bei St. Gumbertus in Ansbach*, Ansbach, 1900; T. Daschlein, *Der Schwanenorden und die sogennante Schwanenordens-Ritterkapelle in Ansbach*, Ansbach, 1926; W. Funk, *Der Hauptmeister der Ansbacher Schwanenordensritter*, Erlangen, 1964, pp. 136–46.

85. Stillfried-Rattonitz, *Schwanenorden*, p. 32; Hommel, *Toison d'or*, p. 10. See also n. 93.

86. "Wy hebben vorder gestiffiet, dat eyn Iowelk In der selschapp Schal sik na sinen Stade Erliken vnde fuchliken holden vnde sik vor opembare schemelike vnde schentlike misdat, vnfuge vnde vnere truweliken bewaren" (Stillfried-Rattonitz, *Schwanenorden*, p. 35; p. 12 n. 46 ["as a knight and a knightly man"].

87. Ibid. pp. 9ff., 34ff. Members had to say

seven Pater Nosters and seven Ave Marias every day or pay a penalty of 7 pfennigs to the poor. They were committed to wearing the insignia of the order whenever they came to court, to meetings of the estates and the lords, on Sundays, and on the days of the Virgin. If they failed in this duty, they paid another fine to the poor, this time of 8 pfennigs. They were pledged to attend the funerals of fellow members and to attend masses for the dead that were said four times a year at the Marienkirche. After having paid 11 Rhenish gulden on joining the society, members owed quarterly dues of 4 Bohemian groschen to the Marienkirche.

88. Stillfried and Haenle, *Buch vom Schwa-nenorden*, p. 68. The absence of the Gonzaga name from membership lists in the 1450s is puzzling but perhaps not unexpected, since many of these lists contradict each other. Some members whose names were listed in the order's account books were not recorded in its death registers; others, still alive in 1464, unaccountably were not included among the members in that year.

89. Ibid. pp. 24–25, 64. In 1475 Margrave Albert gave Elizabeth von Stolberg, Countess of Württemberg, twelve memberships to give away as gifts.

90. Letter from Emperor Frederick III to Margrave Albert of Brandenburg, 31 January 1469 (Riedel, *Codex*, C, II, no. 41, p. 38). See also Stillfried-Rattonitz, *Schwanenorden*, pp. 10, 35, 14 n. 50, where women members are listed independently of their male relatives.

91. "Havendo el magnifico conte Jacomo Picinino impetrato una littera da la Illustrissima Signoria de Vinesia per el facto de quelle zoglie se deveano mandare per recuperare quelli 3.400 ducati che'l resta havere. . . . Li pigni che se mandano sono la collana grande del Illustrissimo Signore nostro cum el cexano pendente e la collana nostra; tu farai la descriptione de le zoglie ordinatamente et anche

vederai che questi del conte Jacomo habiano mandato o littera patente da lui a ricevere dicti dinari et fare la fine et quietacione de tuta la summa di dinari che havessemi in prestito dal magnifico quondam Francesco Picinino . . ." (letter from Barbara of Brandenburg to Filippino de Grossis, Mantua, 21 February 1451, ASMAG, busta 2095, discovered by Rodolfo Signorini and cited by Toesca in *Splendours of the Gonzaga*, p. 2 n. 5). For the word *cexano* or *cesano* as a medieval variant, common in Mantua, of the late Latin *cycinus*, see Francesco d'Alberti, *Dizionario universale critico-enciclopedico della lingua italiana*, Milan, 1834, vol. 2. Toesca (loc. cit.) identifies this piece of jewelry as the Lancaster collar of SS; references to this English collar in early Quattrocento Gonzaga jewelry inventories, however, are always unambiguously identifiable as such. It should also be noted that in the letter Barbara identified the collar by its swan pendant and not by the letter S placed on alternating images of the collar, the basis for Toesca's identification of the emblem in Pisanello's frieze as the insignia of the Kings of England.

92. See n. 13.

93. "Uthleggunge vnde bedutnisz
 der geselschapp.

"Vnde vppe dat dar an vnser andacht vnde menunge ok to guder anwisunge anderen Iuden deste Kuntliker were; So hebben wy In disser vorgeschreuener andacht vnde menunge eyn Cleynod laten maken vnde augenamet to dragen in Nageschreuener wise, dat wy numen dy Geselschapp vnser liuen ffrowen dar an vnser liuen ffrowen Belde vor der Brust In cynen Man vnde Sunnenschyne henget Met deme grute: Gegrutet sistu der werlde ffrowe: In eynen teyken, dat wy der gnade dy wy dorch sy entfangen hebben, In vnsen herten gedencken, vnde Nummer vergeten scholen, vnde offt wol dy hemmelkonygynne bauen allen hilgen irhoget is, vnde schoner

wan dy Maen, vnde mer irwelet wan dy
sunne, Doch so is ok disser werlde ffor-
stynne dar In sy geboren vnde vns van
vnsen irsten olderen angesibbet is, des
wy or mit groter Innicheit vnde to
gantzer werdicheit vermanen, dat sy der
werlde fforstynne heet vnde is vnde dar
van vns In ertrike deste Barmhertiger
bescherme. In der geselschapp sin ok
premtzen dy vmme den hals gehangen,
vnde dar In hertern gepyniget werden,
In menunge, dat way vnsen strefen,
mod vnde eygen willen vnde wollust
dwingen vnde vnder der mechtigen hant
godes othmodigen, vnde vnse herten
mit premtzen, warer vnde rechtnerdiger
ruwe, Bicht vnde buthe so castigen
schole, dat wy glike Alz cyne witte
vnbeffeckede dwele, dy vmme vnser
ffrowen Bilde gewvunden is, mit Vfinge
der teyn gebod vnsers heren dat dy fran-
szen an der dwelen beduden, In eren
vnde woldat reyne vnde lutter to orem
dinste vnde loue vns schicken vnde so
gefunden werden; vnde wen Nu dy
minscheit van Jogent to sunden geney-
get is vnde dar to offte mannigerleie
bekoringe den Mynschen an vallen vnde
tokamen, dar dorch hy in unden
kommet vnde vuppe erden dar iegen
nicht en is, dat den mynschen to seligen
ende so reytzet alz betrachtunge des
swaren dodes den wy alle liden mothen;
Dar vmme hebben wy des Infiguren den
Swan vnder deme Belde vnser ffrowen
heugen laten, wen alz dy Swan synen
dod toveren weth vnde beclaget, Also
wuste vnde sede vnser here synen dod to
voren, vns to anwisunge, Offt wy wol
dy stunde vnsers dodes nicht enweten,
vnde dar vmme deste sorchffoldiger sin
scholen; So is doch ane twifel, dat wy
alle sterffliken sin, vnde van disser
werlde scheiden mothen, Denne ende to
allen Tiden vns Bicht, Ruwe vnde Buthe
mit rechter vnschult, hulpe vnde trost
der Junefrowen Marien gantz Nod is,
Dar vmme wy sy billiken gruten vnde
anrupen: Gegrutet sistu der werlde

ffrowe" (Stillfried-Rattonitz, *Schwa-
nenorden*, p. 32). I am greatly indebted to
Professor Karl Zaenker for his help in
translating this text as:

"Meaning of the Order's Insignia

"So that our devotion and persuasion
may also be better known to other
people for their moral instruction, that
is, why we (in the above-described
spirit) have had an ornament made and
have agreed to wear it which is described
below: we wear the insignia of the Order
of Our Dear Lady on our chest with its
image of Our Dear Lady surrounded by
Moon and Sun bearing the greeting
'Hail to thee, Ruler of the World.' This is
a symbol to make us remember in our
hearts the grace which we received
through her and should never forget.
And while the Queen of Heaven is raised
above all saints, more beautiful than the
moon and more exquisite than the sun,
she is, however, also the Ruler of this
world into which she was born and in
which she became related to us through
our forefathers; that is why we remind
her with great devotion and in all hon-
esty that she is and is called 'Ruler of this
World' and that for this reason she
should protect us even more mercifully
on earth. As part of the insignia there is
a set of 'twitches' hung around the neck
in which hearts are tortured. This means
that we should curb our stubbornness,
selfishness, and worldliness and should
humble them under the mighty hand of
God and that we should chastise our
heart with 'the twitch,' i.e. true and
honest penitence, confession, and
repentance so that we may be (and may
be considered) honorable, pure, and
suited for her service and praise: We
should be like the white unsullied cloth
which is draped around the image of
Our Lady, abiding by [?] the ten com-
mandments of Our Lord which are
symbolized by the fringes of the cloth.
And since man from his youth leans

toward sin and is often assailed and overcome by temptations of all sorts and since nothing on earth can urge a man more toward a blessed end than considering the bitter death which God suffered for our sake as well as considering the bitter death which we all have to suffer: therefore we have put in the figure of the swan under the image of Our Lady. As the swan knows his death beforehand and laments it, so Our Lord knew and announced his death beforehand, from which we should learn to have more foresight, since we do not know the hour of our death. We are all mortal and have to leave this world behind; that is beyond doubt; hence we need at all times confession, contrition, and penance in all sincerity as well as the help and consolation of the Virgin Mary. Therefore we justly greet her and invoke her with the words 'Hail to thee, Ruler of the World.' "

The word *Geselschapp* was used to refer to both the society and its insignia. See Stillfried-Rattonitz, *Schwanenorden*, p. 12 n. 46, for a 1512 account of a knighting.

94. B. Preyer, "The Rucellai Palace," in *Giovanni Rucellai ed il suo zibaldone*, vol. 2., *A Florentine Patrician and His Palace*, intro. N. Rubinstein, London, 1981, p. 201; Ames-Lewis, "Early Medicean Devices"; *La Toison d'Or: cinq siècles d'art et d'histoire*, catalog by H. Pauwels, Bruges, 1962, cats. 4, 19, 35, 38, 51, 57, for differing early Renaissance representations; H. Newman, *An Illustrated Dictionary of Jewellery*, London, 1981, p. 141.

95. *Illustrierter Führer durch das Hohenzollern-Museum im Schlosse Monbijou*, Berlin, 1914, pl. 120; E. Steingraeber, *Antique Jewellery*, London, 1957, pl. 100, p. 71 (where it is dated around 1453 and is said to have belonged to Peter Pot of Basle, who accompanied the Margrave of Brandenburg on a pilgrimage to the Holy Land. It seems to have disappeared

during World War II); Y. Hackenbroch, *Renaissance Jewelry*, New York, 1979, pls. 283–84; Stillfried-Rattonitz, *Schwanenorden*, pl. p. 49. Later versions of the insignia, differing among themselves, are illustrated in Daschlein, *Der Schwanenorden*, pl. p. 9; P. Ganz, "Die Abziechen der Ritterorden," *Schweizerisches Archiv für Heraldik* (Zurich), 1903, fig. 36, p. 37.

96. The omission of the Virgin pendant in Mantua may also be a result of the great distances involved. The Marches, at the extreme northeast corner of the Empire and cut off from all important trade routes, were not only far away, as Barbara grumbled (letter from Barbara of Brandenburg to Margrave Albert, Mantua, 5 November 1458, ASMAG, busta 2886, libro 35, c. 9) but also accessible only by a dangerous route, as indicated by the precautions taken in the statutes to protect members on their journey to Altbrandenburg (Stillfried-Rattonitz, *Schwanenorden*, pp. 10, 37).

97. See n. 93; G. de Tervarent, *Attributs et symboles dans l'art profane 1450–1600*, Geneva, 1958, p. 138.

98. Hill, 1930, no. 236, pl. 41; Tervarent, *Attributs et symboles*, p. 141. Claude de France, a granddaughter of Marie de Cleves, also used the swan as a symbol of purity in reference to the Cleves swan (see text at n. 116).

99. See, for example, P. Asselberghs, "Charles VIII's Trojan War Tapestry," *Victoria and Albert Museum Yearbook*, London, 1969, figs. 3–5; A. Leroux de Lincy, *Vie de la Reine Anne de Bretagne*, Paris, 1860, IV, pp. 110, 112; hawk's hunting hood mentioned in n. 74.

100. G. D. Hobson, *Les reliures à la fanfare: le problème de l'S fermé*, 2d ed., Amsterdam, 1970, p. 101.

101. Tervarent, *Attributs et symboles*, p. 328; Hobson, *Les reliures*, pp. 99–112. Although the S was often depicted open (as in roman script), a pun was made on its appearance as a Gothic barred S (S

fermé), so that the letter, however depicted, came to signify "fermesse," or fidelity.

102. Pliny, *Natural History*, trans. H. Rackham, London, 1947, pp. 101ff. (bk. viii. lxi. 141); Tervarent, *Attributs et symboles*, pp. 94–95.

103. M. Levi D'Ancona, *The Garden of the Renaissance*, Florence, 1977, pp. 78, 124, 226. If interpreted as a sunflower, the flower might symbolize the unity existing in creation between lower and celestial things (Tervarent, *Attributs et symboles*, p. 385).

104. A deer or a hind was often used as a symbol by princely families, the deer being said to symbolize prudence (Tervarent, *Attributs et symboles*, pp. 66–67; C. Ripa, *Iconologia*, Padua, 1611, pp. 441–42).

105. Hill, 1930, no. 236.

106. See chapter 3, text at nn. 85ff.

107. For Leo placed in the center of Sol, see J. Cox-Rearick, *Dynasty and Destiny in Medici Art: Pontormo, Leo X and the Two Cosimos*, Princeton, 1984, pl. 82; for Gambello's medal for Leo X showing a sungod holding a sun directly over a lion, see Hill, 1930, no. 451.

108. Tervarent, *Attributs et symboles*, pp. 242–47, 356; Ripa, *Iconologia*, pp. 78, 529; F. McCullough, *Medieval Latin and French Bestiaries*, Chapel Hill, 1962, pp. 137–40.

109. See Ames-Lewis, "Early Medicean Devices," pp. 124–25.

110. See chapter 3, n. 58.

111. N. Rasmo, *Runkelstein*, Bolzano, 1978, pls. 35, 36, 42, 49; colorplates IV, V; M. Fossi Todorow, *Palazzo Davanzati*, Florence, 1979, p. 27.

112. See chapter 2, section III.

113. See chapter 2, nn. 6–10.

114. R. S. Loomis, *The Grail: From Celtic Myth to Christian Symbol*, Cardiff–New York, 1963, pp. 26, 234–35.

115. H. O. Sommer, ed., *The Vulgate Version of the Arthurian Romances*, 8 vols., Washington, D.C., 1908–16, VIII, p. 47; F. Flûtre, *Table des noms propres avec toutes leurs variantes . . .* Poitiers, 1962, p. 65; E. Langlois, *Tables des noms propres de toute nature compris dans les chansons de geste imprimées*, Paris, 1904, pp. 186, 329; G. D. West, *An Index of Proper Names in French Arthurian Prose Romance*, Toronto, 1978, pp. 156–57; A. Micha, ed., *Lancelot, roman en prose du XIIIe siècle*, 9 vols., Paris-Geneva, 1978–85, IX, pp. 59, 88.

116. Wagner, "The Swan Badge," p. 133; R. Jaffray, *The Two Knights of the Swan: Lohengrin and Helyas*, New York–London, 1910, p. 90; Loomis, *The Grail*, p. 212; P. S. Barto, *Tannhäuser and the Mountain of Venus*, New York, 1916, pp. 62, 67; A. L. Frey, *The Swan Knight Legend*, Nashville, 1931, p. 53.

117. Jaffray, *Two Knights of the Swan*; Frey, *Swan Knight*; C. Lecouteux, *Mélusine et le chevalier au cygne*, Paris, 1982. For versions of the Helias legend in French, see *The Old French Crusade Cycle*, vol. 1, *La naissance du Chevalier du Cygne*, ed. E. J. Mickel, Jr., and J. A. Nelson, Alabama, 1977. For illustration of a different version of the story in Italian, *Historia della Regina Stella e de Mattabruna*, that instead treats the swan children, see J. von Schlosser, "Die Werkstatt der Embriachi in Venedig," *Jahrbuch der Kunsthistorischen Sammlungen des Allerhöchsten Kaiserhauses* 20 (1899): 220–82; M. A. Wyman, "The Helyas Legend as Represented on the Embriachi Ivories at the Metropolitan Museum of Art," *Art Bulletin* 18 (1936): 5–24; R. Koechlin, *Les ivoires gothiques français*, Paris, 1924, I, pp. 516–17; II, no. 1310 bis.

118. Jaffray, *Two Knights of the Swan*, p. 38.

119. I. Donesmondi, *Dell'istoria ecclesiastica di Mantova*, Mantua, 1612, pp. 4–21; Mazzoldi, *Mantova*, pp. 16–17; references in n. 1 above; R. J. Peebles, *The Legend of Longinus in Ecclesiastical Tradition and in English Literature, and Its Connection with the Grail*, Bryn Mawr, Pa., 1911.

120. Frey, *Swan Knight*, p. 34; M.J.C. Reid,

The Arthurian Legend, London, 1938, p. 130. The Grail was also variously described as the dish from which Christ ate the lamb at the Last Supper, as the dish or vessel containing the host, and as a stone.

121. Frey, *Swan Knight*, p. 35; Peebles, *Legend of Longinus*, pp. 161ff.; Loomis, *The Grail*, p. 79.

122. See chapter 2, section III. For an interpretation of Brangoire as an Arthurian counterpart of King Bron, the Fisher King, and of the banquet held at the Chastel de la Marche as a symbolic reenactment of that at Corbenic—when the Grail was glimpsed by Bohort—see R. S. Loomis, *Arthurian Tradition and Chrétien de Troyes*, New York, 1949, pp. 241ff, 64.

123. C. Eisler, "The Golden Christ of Cortona and the Man of Sorrows in Italy," *Art Bulletin* 51 (1969): 116–17; M. Horster, "Mantuae Sanguis Preciosus," *Wallraf-Richartz Jahrbuch* 25 (1963): 162–71; D. Pincus, "Christian Relics and the Body Politic: A 13th Century Relief Plaque in the Church of San Marco," in *Interpretazioni veneziane: scritti di storia dell'arte in onore di Michelangelo Muraro*, ed. D. Rosand, Florence, 1984, p. 84 n. 40.

124. E. J. Johnson, *S. Andrea in Mantua: The Building History*, University Park, Pa., 1975, pp. 6, 45–46.

125. Magnaguti, *Ex Nummis Historia*, p. 15, cat. 26. The inscription reads MANTVA FVLSISTI PCIOSO SAGVI.

126. Magnaguti, *Ex Nummis Historia*, cats. 85, 92; Hill, 1930, no. 94. For Sixtus IV's three papal briefs (of October 1472, May 1475, March 1481) conceding plenary indulgence to Lodovico Gonzaga and Barbara of Brandenburg, all their heirs, and their daughter-in-law Margaret of Bavaria for having prayed before the relic in S. Andrea, see C. Cottafavi, "L'Ordine cavalleresco del Redentore," *Atti e Memorie della R. Accademia Virgiliana di Mantova*, N.S., 24 (1935): 237–38.

127. One of the continuators of Chrétien de Troyes's *Perceval le Gallois* also connected the Swan Knight with Perceval.

128. Barto, *Tannhäuser*, p. 64; Frey, *Swan Knight*, pp. 35, 48–49, 126.

129. O. Springer, "Wolfram's 'Parzival,'" in *Arthurian Literature in the Middle Ages*, ed. R. S. Loomis, Oxford, 1959, pp. 241, 246.

130. Reid, *Arthurian Legend*, p. 174; Jaffray, *Two Knights of the Swan*, pp. 87, 113; Frey, *Swan Knight*, p. 63; Keen, *Chivalry*, pp. 59–62.

131. See similar interpretation in E. L. Goodman, "The Prose Tristan and the Pisanello Murals," *Tristania* 3 (1978): 22–35.

132. A. Colombo, "L'abbozzo dell'alleanza tra lo Sforza ed il Gonzaga," *Nuovo Archivio Veneto*, N.S., 13 (1907): 146; id., "Nuovo contributo alla storia del contratto di matrimonio fra Galeazzo Maria Sforza e Susanna Gonzaga," *Archivio Storico Lombardo* 36 (1909): 1–8.

133. Mahnke, 1975, p. 132.

134. "A questi signori per simile acto mi pare ne seguirea maiore honore et maiore riputatione che may seguisse a casa loro per veruno tempo passato. Et dubito che a Vostra Signoria ne seguirea detractione et diminutione assai di reputatione" (letter from Antonio Guidobono to Francesco Sforza, Borgoforte, 22 July 1457, Milan, Archivio di Stato, Sforzesco, cart. 391, published in A. Dina, "Qualche notizia su Dorotea Gonzaga," *Archivio Storico Lombardo*, ser. 2, 4 [1887]: 563). The addition to Gonzaga consequence even contributed to the successful outcome of the cardinalate in 1461 (letter from Bartolomeo Bonatto to Barbara of Brandenburg, Rome, 16 October 1461, ASMAG, busta 841, c. 221).

135. In 1457 Lodovico's eldest daughter, Susanna, was replaced by the next daughter, Dorotea. Susanna had developed the *gibositade*, the spinal malformation, or hunched back, that afflicted some descendants of Paola Malatesta,

Lodovico's mother. Documents on the broken engagement between Galeazzo Maria Sforza and Dorotea Gonzaga were published by Dina, "Dorotea Gonzaga"; L. Beltrami, "L'annullamento del contratto di matrimonio fra Galeazzo Maria Sforza e Dorotea Gonzaga (1463)," *Archivio Storico Lombardo* 16 (1889): 126–32; M. Bellonci, "Piccolo romanzo di Dorotea Gonzaga," *Nuova Antologia*, ser. 2, 77 (1942): 36–45, 92–99; S. Davari, "Il matrimonio di Dorotea Gonzaga con Galeazzo Maria Sforza," *Giornale Linguistico di Archeologia, Storia e Letteratura* 16 (1889): 363–90. See also Mahnke, 1975, pp. 169ff. Galeazzo Maria eventually married Bona of Savoy, sister-in-law of the King of France.

136. ". . . esso misser Ludovico qual non fa lo mestiero de le arme per cupidità de guadagna, ma solo per acquistare honore et fama . . ." (letter from Filippo Maria Visconti to Gerolamo di Siena, Milan, 21 February 1443, ASMAG, busta 1607).

137. Mahnke, 1975, p. 405. See also pp. 388, 390.

138. For more information on tournaments, see chapter 8.

139. "cusì fatto cavaliero et signore . . . quale è di tanta fede, costantia et integrità, virtù et prudencia d'animo et tanto valle in lo exercitio de l'arme et in ogni gran fatto, che meglio non se porría dire, nè pensare" (letter from Filippo Maria Visconti to Gerolamo di Siena, Milan, 21 February 1443, ASMAG, busta 1607).

140. Pius Secundus, *Commentarii*, p. 174.

141. "Non li parea ge ne fusse altro che la Signoria Vostra, la quale in le guerre passate havea conosciuto [sic] animosa et savia et tale che li parea ognuno si dovesse contentare del suo guberno. Perché più volte essendo rimasta in campo dove se era ritrovato el Signore messer Alexandro, el signor Ruberto et tucti li altri de casa sua che faceano il mestere, Bartholomeo da Bergamo, messer Tiberto et altri suoi capitanii tucti di repu-

tatione, mai alcuno se era doluto, anci ge erano stati, mediante li suoi bon modi, pacientissimi et ubedienti" (letter from Bartolomeo Bonatto to Lodovico Gonzaga, quoting Francesco Sforza, Rome, 4 February 1461, ASMAG, busta 841, cc. 2–3, published in Mahnke, 1975, p. 258).

142. See n. 8.

143. See chapter 5, n. 2.

144. Hill, 1930, nos. 20, 36; n. 57 above and, for the *marchesano*, n. 53 above.

145. ". . . che io zudegarìa uno nato in esso ponto dovesse esser reverito et tenuto da omni persona in omni facultà et precipue in dominio et facto de Armi, et è proprio como uno Re in Sedia Regale, qual ellezesse uno principe dilletto in dominio et victorioso in la arte militare" (letter from Bartolomeo Manfredi, Mantua, 17 July 1461, ASMAG, busta 2395, c. 306, published in Signorini, 1985, p. 294 n. 326). See also chapter 3, text at nn. 85ff.

146. ". . . gloria, fama et reputacione . . ." (letter from Ambrogio da Rocca to Lodovico Gonzaga, Milan, 10 June 1449, ASMAG, busta 1620, c. 293, quoted in Mahnke, 1975, p. 111 n. 57).

147. For the Niccolò d'Este monument, see C. M. Rosenberg, "Some New Documents Concerning Donatello's Unexecuted Monument to Borso d'Este in Modena," *Mitteilungen des Kunsthistorischen Institutes in Florenz* 17 (1973): 151; H. W. Janson, *The Sculpture of Donatello*, Princeton, 1963, pp. 158, 161. For the Gattamelata monument, see Janson, *Donatello*, p. 155.

148. See letter of 26 May 1452 from King Alfonso to Francesco Foscari, Doge of Venice, published in G. L. Hersey, *The Aragonese Arch at Naples 1443–1475*, New Haven, 1973, p. 66, doc. 7.

149. J. R. Spencer, "Il progetto per il cavallo di bronzo per Francesco Sforza," *Arte Lombarda* 38/39 (1973): 34.

150. The cost of the Ferrarese monument is unknown, but Donatello was paid 1,650 ducats for the monument honoring Gattamelata (Janson, *Donatello*, p. 153).

151. Spencer, "Cavallo di bronzo." For a discussion of this figure within the composition of the tournament, see chapter 6, section III.

152. See chapter 2, section I.

153. D. Hay, *Europe in the Fourteenth and Fifteenth Centuries*, London, 1966, p. 69.

154. "Cavaliero . . . non vuol dire altro che dignità, provenuto nello huomo dallo essercitio dell'armi fatto a cavallo, perciochè dicendosi Cavaliero, si intende persona di qualità e degna di honore" (F. Sansovino, *Della origine de' cavalieri, libri 4*, Venice, 1583, p. 1).

155. [Artù Re di Britannia] ritrovò la tavola ritonda, alla quale non era ammesso se non chi lo meritava per valor d'armi. . . . Tutti coloro che vi sederono furono chiamati Cavalieri della Tavola ritonda, tanto più chiari e illustri quanto che l'inventione fu nuova e senza altro essempio, e quanto che gli introdotti alla tavola furono pochi per esser la virtù rara ne grandi, oppressi dalle troppe delicatezze, perciochè essi erano senza reprensione alcuna e con quella honoranza s'approvava il valor dell'animo et la nobiltà del loro sangue" (Sansovino, *Cavalieri*, p. 50). See also R. Lull, *Libro dell'ordine della Cavalleria* (originally written in Catalan in 1275), ed. G. Allegra, Rome, 1972, pp. 176–77.

156. G. Gerola, "Per la datazione degli affreschi di Castel Roncolo," *Atti del R. Istituto Veneto di Scienze, Lettere ed Arti* 82, pt. 2 (1923): 511–21.

157. H.L.D. Ward, *British Museum: Catalogue of Romances in the Department of Manuscripts*, London, 1883, I, p. 364; B. Degenhart and A. Schmitt, *Corpus der italienischen Zeichnungen 1300–1450*, Berlin, 1968, pt. I, vol. I, pp. 145–46. The manuscript dates from 1352–62. For the Sicilian quilts, see references in chapter 2, n. 77.

158. For earlier examples, see Keen, *Chivalry*, pp. 92–94.

159. E. Sandoz, "Tourneys in the Arthurian Tradition," *Speculum* 19 (1944): 389–

420; R. S. Loomis, "Chivalric and Dramatic Imitations of Arthurian Romance," in *Medieval Studies in Memory of A. Kingsley Porter*, ed. W.R.W. Koehler, Cambridge, Mass., 1939, I, pp. 79–97.

160. Jaffray, *Two Knights of the Swan*, pp. 88–89; F. Blondeaux, "La légende du Chevalier au cygne," *Revue de Belgique*, ser. 2, 39 (1903): 44–45.

161. "Fu una bella fantaxia de trovare et una magna cosa" (*Diario ferrarese dall'anno 1409 sino al 1502*, ed. G. Pardi, in L. A. Muratori, *Rerum Italicarum Scriptores*, 2d ed., Bologna, 1934, XXI, pt. 7, p. 45, entry for 13 May 1464).

162. Letter from Nicolò degli Ariosti to Lodovico Gonzaga, Ferrara, 16 May 1464, ASMAG, busta 1228, cc. 487–88, published in C. M. Rosenberg, "Notes on the Borsian Addition to the Palazzo Schifanoia," *Musei Ferraresi* 3 (1973): 35–36.

163. ". . . la bona cavalieria che havia visto esser in luce" (ibid. p. 35).

164. *Diario ferrarese*, loc. cit.

165. J. Huizinga, *Homo Ludens*, London, 1949, p. 2.

166. E. H. Gombrich, "Huizinga's 'Homo Ludens,'" *Bijdragen en mededelingen betreffende de geschiedenis der Nederlanden* 88 (1973): 281.

167. Paccagnini, 1972, pp. 66ff., suggested that the tournament scene was a battle representing Lodovico Gonzaga's defeat of his brother Carlo at Goito in 1453. The date of Carlo's defeat, however, seems too late to be implicated in the planning for the *Sala*. Relations between Carlo and Lodovico were normal in 1447, 1449, and 1451, i.e. the years paralleled by work in the *Sala* (Mazzoldi, *Mantova*, pp. 7, 11). It was not until 1452 that bitter dissension broke out between the brothers: Carlo fled from Milan, leaving Lodovico, who had stood guarantor for him, to pay the large sum of 80,000 ducats to Sforza (Mahnke, 1975, pp. 129ff.).

168. ". . . che licet fusse uno picolo Marchese, tamen era de qualità . . ." (letter from Vincenzo della Scalona to Barbara of Brandenburg, Milan, 20 July 1462, ASMAG, busta 1622, cited in Mahnke, 1975, p. 308 n. 34).

169. See chapter 5, n. 71.

FIVE · PATRON

1. "Ex his ortus est Ludovicus, qui per tempora Pij Papae huic urbi praefuit, armorum et litterarum peritia clarus: nam et parentis gloriam militans adaequavit; et Victorinum oratorem audiens, praeceptoris propemodum doctrinam assecutus est, mitis ingenij, et iustitiae observantissimus" (Pius Secundus, *Commentarii Rerum Memorabilium* . . . Rome, 1584, p. 105, trans. in *The Commentaries of Pius II*, bk. 1, ed. F. A. Gragg and L. C. Gabel, *Smith College Studies in History* 22, nos. 1–2 [1936–37]: 186).

2. "Alcuno ha laudata la sua litteratura, alcuno lo ingegno apto a diverse cosse, como a la agricultura, a la architectura, al designo [*sic*]. A l'arme, supra tute le altre, tanto è stato comendato come s'el fusse auctore de questo mestero . . ." (letter from Bartolomeo Marasca to Federico Gonzaga on hearing of Lodovico's death, Rome, 22 June 1478, ASMAG, busta 846, c. 211r, published in R. Signorini, "Lodovico muore," *Atti e Memorie dell'Accademia Virgiliana di Mantova*, N.S., 50 [1982]: 124–25). Marasca was Cardinal Francesco's secretary. The word *disegno* was variously used to mean art, drawing, and design.

3. See letter from Petrarch to Guido Gonzaga, 13 January 1341, published in F. Petrarca, *Le familiari*, trans. U. Dotti, vol. 1, Urbino, 1974, bk. 3, letter 11, pp. 300–5.

4. For the formation of the library and exchanges of letters concerning the loan of codices in the 1360s and 1370s, see F. Novati, "I codici francesi de' Gonzaga secondo nuovi documenti," *Romania* 19

(1890): 161–200 (repr. in *Attraverso il Medioevo*, Bari, 1905, pp. 225–326); U. Meroni, ed., *Mostra dei codici gonzagheschi*, Mantua, 1966, pp. 41–46.

5. *Epistolario di Coluccio Salutati*, ed. F. Novati, Rome, 1896, III, pp. 102–5.

6. The original construction of the urban *Castello* is undocumented, but Francesco obtained papal permission before 1390 to demolish the church that stood on the site chosen for it. Linked to the *Corte*, it was constructed for defensive purposes by the Este military engineer Bertolino da Novara in imitation of the Castello Estense in Ferrara, which he had built earlier (A. Luzio, "Bertolino da Novara e il Castello di Mantova," *Archivio Storico Lombardo* 40 [1913]: 179–83; G. Campori, "Gli architetti e gli ingegneri civili e militari degli Estensi dal secolo XIII al XVI," *Atti e Memorie delle R.R. Deputazioni di Storia Patria per le Provincie dell'Emilia*, ser. 3, 1 [1883]: 11–21). For the 1407 inventory, see chapter 2, section II.

7. P. Girolla, "Pittori e miniatori a Mantova sulla fine del '300 e sul principio del '400," *Atti e Memorie dell'Accademia Virgiliana di Mantova*, N.S., 9–13 (1929): 182, 191; I. Toesca, "Lancaster and Gonzaga: The Collar of SS at Mantua," in *Splendours of the Gonzaga*, ed. D. S. Chambers and J. Martineau, London, 1981, p. 1.

8. Leon Battista Alberti, *On Painting and Sculpture*, ed. C. Grayson, London, 1972, pp. 34–35. If Alberti's dedicatory letter to Gianfrancesco is to be believed, Mantua was so attractive a humanist center at this date that the humanist wanted to enter the prince's household.

9. Meroni, *Codici gonzagheschi*, p. 50; A. Portioli, "Giacomo Galopini, prete e miniatore mantovano del secolo XV," *Archivio Storico Lombardo* 26, vol. 11 (1899): 330–47.

10. A. Bertolotti, *Le arti minori alla corte di Mantova nei secoli XV, XVI e XVII*, Milan, 1889, p. 215; W. Braghirolli,

Sulle manifatture di arazzi in Mantova, Mantua, 1879, pp. 18–23.

11. Meroni, *Codici gonzagheschi*; Braghirolli, *Manifatture arazzi*; Girolla, "Pittori e miniatori." See *grida* proclaimed 12 October 1420: "Per parte del Magnifico et Excellentissimo signore miser Zohan Francescho da Gonzaga signore de la citade de Mantua, imperial vicario generale, fi fato crida e manifesto che zascaduno magistro de arte, così citadino absentado como foresturo e non rebello, lo qual vegnirà de novo ad habitare in la citade de Mantoa cum la soa famiglia e farà l'arte soa in la soa stazone o in la casa de la soa habitatione, e così per lo simile zascaduno altro chi non fosse magistro de arte chi havesse quatro boche o da quatro in suso, così citadino absentado como foresturo e non rebello, lo qual vegnirà de novo ad habitare in la citade de Mantoa, continuamente debia havir de provisione dal Comune de Mantua mezo ducato el meso d'oro per lo fito de la stazone o sia de la casa, comenzando la provisione lo dì che lui vegnirà cum la soa famiglia ad habitar in Mantoa e duri la provisione fina a cinque anni proximi chi da vegnire" (ASMAG, busta 2038/39, reg. 3, c. 10v).

12. The primary sources for Vittorino da Feltre (Sassolo da Prato, *De Victorini Feltrensis Vita*; Francesco da Castiglione, *Vita Victorini Feltrensis*; Francesco Prendilacqua, *Dialogus*; Bartolomeo Platina, *De Vita Victorini Feltrensis Commentariolus*; Vespasiano da Bisticci, *La biografia di Vittorino da Feltre*) are all conveniently reprinted with translations in E. Garin, *Il pensiero pedagogico dello umanesimo*, Florence, 1958, pp. 505–718. See also the documents compiled in R. Signorini, *In traccia del Magister Pelicanus: mostra documentaria su Vittorino da Feltre*, Mantua, 1979, pp. 53–93. The best discussion still remains that of W. H. Woodward, *Vittorino da Feltre and Other Humanist Educators*, Cambridge, 1897, pp. 1–92. See also E. Paglia, "La Casa

Giocosa di Vittorino da Feltre in Mantova," *Archivio Storico Lombardo* 11 (1884): 150–55. For an illuminating account of the means and ends of humanist education, see A. T. Grafton and L. Jardine, "Humanism and the School of Guarino," *Past and Present* 96 (1982): 51–80.

13. "Libros quaere, libris incumbe, libri tecum assidui comites, quantum ceteris canes, accipitres alea, rusticari peregrinarique consuescant" (R. Sabbadini, ed., *Epistolario di Guarino Veronese*, Venice, 1915, I, no. 256, p. 399; III, pp. 160–61). See also ibid. I, no. 259, p. 406, where Guarino wrote to Vitaliano Faella: "Proxime generosus adulescens et herilis vere filius Ludovicus de Gonzaga ornata et dictionis flore suavissimas litteras ad me dedit."

14. The visit took place in 1435. Ambrosius Traversarius, *Latinae Epistolae*, ed. L. Mehus, Florence, 1759, bk. 7, epis. 3, cols. 313–33; E. Faccioli, *Mantova: le lettere*, Mantua, 1961, II, p. 25. The Greek gospels were purchased in 1432. Traversari was so impressed with Gianlucido that he addressed a long letter to him in 1436 (bk. 5, epis. 12, cols. 247–49). For Cecilia's subsequent career, see M. L. King, "Thwarted Ambitions: Six Learned Women of the Italian Renaissance," *Soundings* 59 (1976): 280–304; *Her Immaculate Hand*, ed. M. L. King and A. Rabil, Binghamton, N.Y., 1983, pp. 53–54, 91–105. For the teaching of Greek in Mantua, see G. Pesenti, "Vittorino da Feltre e gli inizi della scuola di greco in Italia," *Athenaeum*, N.S., 2 (1924): 241–60; 3 (1925): 1–16.

15. A. Traversari, *Hodoeporicon*, in A. Dini-Traversari, *Ambrogio Traversari e i suoi tempi*, Florence, 1912, pp. 73–74; *Vittorino da Feltre: pubblicazione commemorativa del V centenario della morte*, ed. G. Avanzi, Brescia, 1947, pp. 82–83. Aurispa was in Greece for Gianfrancesco in 1421–23, and Vittorino wrote to him in 1425 looking for two volumes of

Plato or a Plutarch (R. Sabbadini, ed., *Carteggio di Giovanni Aurispa*, Rome, 1931, no. 4, p. 5). In 1428 Filelfo acquired manuscripts in Greece for Gianfrancesco and was annoyed when Francesco Barbaro did not forward them to Mantua (Franciscus Philelphus, *Epistolarum libri XVI*, Venice, 1492, bk. 1, epis. 35). Gianfrancesco had invited Guarino to his court before turning to Vittorino (R. Sabbadini, *Guarino Veronese e il suo epistolario*, Salerno, 1885, p. 65).

16. "Non curamo che siano ornati, né de exquisita littera, purché siano boni et ben corecti" (letter from Gianfrancesco Gonzaga to Domenico Grimaldi, 21 July 1444, ASMAG, busta 2882, libro 7, c. 49v, published in A. Luzio, "Cinque lettere di Vittorino da Feltre," *Archivio Veneto* 36 [1888]: 338 n. 1). The same day Gianfrancesco wrote to Guarino of his "vehemens desiderium" to own the book "totus et integer." For the library in Gianfrancesco's period, see Meroni, *Codici gonzagheschi*, pp. 47–50. A list of employees salaried by the court in 1442 suggests the existence of an active *scriptorium* with Mantuan scribe, German (?Flemish) illuminator, and Vicentine binder: "Georgius de Mantua scriptor . . . Iohannes de alemannia imminiator . . . Stefanus de Vincentia ligator librorum" (ASMAG, busta 411, published in M. Cortesi, "Libri e vicende di Vittorino da Feltre," *Italia Medioevale e Umanistica* 23 [1980]: 106).

17. Hill, 1930, no. 38. This medal was praised at great length by Basinio da Parma in the poem he addressed to Pisanello (Venturi, 1896, p. 57, lines 34–50).

18. L. Cheles, "The Uomini Famosi in the Studiolo of Urbino: An Iconographic Study," *Gazette des Beaux-Arts*, ser. 6, 102 (1983): 1–7. Prendilacqua, who dedicated his life of Vittorino to Federico da Montefeltro, attributed this portrait, which carried the inscription PRAE-CEPTOR SANCTISSIMUS . . . HUMANITATIS LITTERIS EXEMPLISQUE TRADITA, to Pisanello (*Dialogus*, in Garin, *Pensiero pedagogico*, pp. 640–41).

19. M. Baxandall, *Giotto and the Orators: Humanist Observers of Painting in Italy and the Discovery of Pictorial Composition 1350–1450*, Oxford, 1971, pp. 127–33.

20. Vespasiano da Bisticci, *Biografia Vittorino*, in Garin, *Pensiero pedagogico*, p. 704.

21. Prendilacqua, *Dialogus*, in ibid. pp. 596–97; Platina, *De Vita Victorini Feltrensis*, in ibid. pp. 674–75.

22. ". . . tuti li medici concorevano in questo parere, che non saressemo gionti a li XXX anni a poco più, o ver che saressemo stati un saco da pane senza mai poterne valere o aiutare, che molto meglio ne sarìa stato il morire. Nui sapiamo molto bene le excuse che facevemo quando a le volte le gambe se rompevano, hora dicendo fusse stato un sinistro, hora una cosa, un' altra; dopoi, vedendo perseverare la cosa et la grasseza nostra farse maiore, deliberassemo prima morire che volere stare in quella forma, et pigliassemo il partito de ridurne a la abstinentia del manzare poco, bevere acqua asai et dormire manco, benché chi provede a la prima del manzare poco, con le altre, ché tute hanno dependentia da quella, facilmente se gli provede . . ." (letter from Lodovico Gonzaga to his son Gianfrancesco, Goito, 9 December 1473, ASMAG, busta 2892, libro 73, c. 95r, published in R. Signorini, " 'Manzare poco, bevere acqua asai et dormire manco': suggerimenti dietetici vittoriniani di Ludovico II Gonzaga al figlio Gianfrancesco e un sospetto pitagorico," in *Vittorino da Feltre e la sua scuola: umanesimo, pedagogia, arti*, ed N. Gianetto, Florence, 1981, p. 144).

23. "Né gli farà tante representatione perché di qua non sonno quelle nimphe, driade, nayade et napee, né anche ge rispondono le decime de' preti che si possano mettere in una cena, anci, se Sua Signoria

[Lodovico Gonzaga] se vole fare honore, se bisogna ridure al rectore suo per denari, concludendo che, essendo la maior parte del tempo stato soldato et sachomanno, lo tractarà pur cussì a la domestica, da sachomanno, et secondo il costume di qua gli [Cardinal Riario] farà honore" (letter from Marsilio Andreasi to Barbara of Brandenburg, 29 August 1473, repeating Lodovico Gonzaga's words, ASMAG, busta 2415, c. 32r, published in Signorini, "Lodovico muore," p. 112 n. 54).

24. The term *adoctrinare* was used in a letter from Bianca Maria Visconti to Barbara of Brandenburg, Cremona, 10 July 1448, ASMAG, busta 1607, c. 55. See the treatise attributed to Vittorino by Sabbadini, published in A. Casacci, "Un trattatello di Vittorino da Feltre sull'ortografia latina," *Atti del Reale Istituto Veneto di Scienze, Lettere ed Arti 86*, pt. 2 (1926–27): 911–45.

25. "Victorini optimi viri et doctissimi magistri . . . quem vehementer amo, vehementer laudo" (letter from Guarino da Verona to Lodovico Gonzaga, 1424, in Sabbadini, *Epistolario Guarino Veronese*, I, no. 256, p. 399).

26. Francescus Philelphus, *Epistolarum*, bk. I, epis. 6.

27. Giovanni Andrea de' Bussi, preface to Titus Livius, *Historiae Romanae*, 1469, published in B. Botfield, *Prefaces to the First Editions of the Greek and Roman Classics and of the Sacred Scriptures*, London, 1861, p. 95.

28. "Era Vittorino . . . molto allegro, di natura che pareva che sempre ridesse" (Vespasiano da Bisticci, *Biografia Vittorino*, in Garin, *Pensiero pedagogico*, p. 703). Lodovico's own awareness of his educational advantages emerges from a letter written much later to Guarino expressing concern at the quality of the education received by his sixteen-year-old son Federico: "parendone che'l non havesse bene li fondamenti de gramatica a nostro modo, la qual ce pare sia la prin-

cipal cosa che debiano haver li pari suoi, et la più utile et neccessaria . . ." (letter from Lodovico Gonzaga to Guarino da Verona, Mantua, 12 January 1457, ASMAG, busta 2885, libro 29, c. 42v, published in Luzio/Renier, 1890, p. 143). See also letter from Lodovico Gonzaga to the newly created Cardinal Francesco, Mantua, 27 April 1462, ASMAG, busta 2097, advising him that "prelato senza lettere non può esser reputato."

29. "Nui se ricordiamo che, essendone posto a la dieta, et dicendone magistro Bernardo che la era troppo grande et che se possevemo ridure al manco dieta asai, avendogli risposto che prima deliberavemo morire che stare in quella grasseza et non poterse aiutare, lo illustre signore nostro patre, che ne audite dire le parole, rispose che dicevemo molto bene et che lo dovevemo fare et più presto volir morire che star in quella forma, et che fin alhora el se havea creduto havere un porco et basta, hora gli pareva havere un homo cum rasone, et se sapessemo quelo havevemo guadagnato cum lui ne faressemo un gran maraviglia" (letter from Lodovico Gonzaga to his son Gianfrancesco, Goito, 9 December 1473, ASMAG, busta 2892, libro 73, c. 95v, published in Signorini, "Suggerimenti dietici," p. 144).

30. A succinct account of the quarrel is given by the anonymous writer of the *Diario ferrarese dall'anno 1409 sino al 1502*, ed. G. Pardi, in L. A. Muratori, *Rerum Italicarum Scriptores*, 2d ed., Bologna, 1928, XXIV, pt. 7, p. 21: "1436, de Marcio, messer Ludovico, figliolo del marchexe de Mantoa, se partite del padre et andete con cavali XVII a Milano. . . . Et il marchexe de Mantoa fece fare una crida che quilli che lo chiamavano suo figliolo ge fusse taiada la testa." The suspension of primogeniture is in W. Altmann, *Die Urkunden Kaiser Sigmunds (1410–1437)*, Innsbruck, 1896, no. 11505, p. 381 (3 November 1436). See also E. Swain, "Strategia matrimoniale in casa Gon-

zaga: il caso di Barbara e Ludovico," *Civiltà Mantovana*, n.s., 14 (1986): 12 n. 20. For Gianfrancesco's stubbornness, see also F. Tarducci, *Cecilia Gonzaga e Oddantonio da Montefeltro*, Mantua, 1897.

31. "Etsi pridem de casu atque inopinato Illustris Ludovici nati tui eventu animus noster multimoda perplexitate turbatus extiterit. . . . predictum Ludovicum, qui iuvenili furore conductus et sine forte Mediolanici serpentis suasu et, ut verius dicamus, morsu contactus in eam miseriam lapsus est . . ." (letter from Emperor Sigismund to Paola Malatesta, Iglavia, 9 June 1436, ASMAG, busta 428, c. 126).

32. Prendilacqua, *Dialogus*, in Garin, *Pensiero pedagogico*, pp. 644–47.

33. Letter from Matteo Corradi to Paola Malatesta, Milan, 15 April 1440, ASMAG, busta 1620, c. 83 (giving account of the pardon which took place in Milan), published in Swain, "Strategia matrimoniale," p. 12 n.23. See also *Diario ferrarese*, p. 24, entry for April 1440.

34. ". . . quanta humanitate solacia piissimas consolaciones et antidotiva consilia vestra et nostre filie domine Barbara in sue adversitatis tempore favorosissime exhibuistis propterquod nos ad acciones indefessas Vestre Serenitati reddendas in perpetuam obligastis . . ." (letter from Frederick I of Brandenburg to Paola Malatesta, 25 February 1439, ASMAG, busta 514).

35. For Paola Malatesta, see Vespasiano da Bisticci, *Notizie di alcune illustri donne nel secolo XV*, in *Archivio Storico Italiano*, ser. 1, 4, pt. 1 (1843): 444–45; R. M. Letts, "Paola Malatesta and the Court of Mantua 1393–1453," M.Phil. thesis, Warburg Institute, University of London, 1980. See mention of Barbara in letter from Vittorino to Paola Malatesta, Borgoforte, 1439, published in Luzio, "Cinque lettere di Vittorino," p. 336.

36. ". . . più tosto la dicta Magnifica sposa si domentegarà li costumi de Alemania, et etiam che de qua in Ytalia è simel usanza. . . . voglia obviare a tute le usanze de Alemagna e confortare si fazano le usanze Italici . . ." (letter from Gianfrancesco Gonzaga to Cardinal Cesarini, Mantua, undated but subsequent to 6 July 1433, ASMAG, busta 197, cc. 177–78, published in Swain, "Strategia matrimoniale," pp. 3, 6).

37. ". . . et sempre siamo un Ludovico et facto ad un modo" (letter from Lodovico Gonzaga to Niccolò Cattabeni, Mantua, 17 September 1448, ASMAG, busta 1417, quoted in Mahnke, 1975, p. 109 n. 42).

38. "In Italia non c'è homo a chi ne para poter credere se non a la Sua Signoria" (letter from Bartolomeo Bonatto to Lodovico Gonzaga, Rome, 18 January 1462, quoting Pius II, ASMAG, busta 841, c. 507, cited in Mahnke, 1975, p. 372 n. 63). Elsewhere, Pius wrote that Lodovico ruled "cum multa sapientia" (*De Viris Illustribus*, chap. 13). It should be noted that according to the Manilian system of Olympian zodiacal guardianship (not to be confused with the planetary rulers), Jupiter was the Olympian lord of Leo, the ascendant sign of Lodovico's natal horoscope (see chapter 3, text at nn. 85ff.; Manilius, *Astronomica*, 2. 441). It was through Leo that Jupiter gave the arts of rulership to mankind. See J. Cox-Rearick, *Dynasty and Destiny in Medici Art: Pontormo, Leo X, and the Two Cosimos*, Princeton, 1984, p. 195.

39. "Ma che amicus Socrates, amicus Plato, sed magis amica veritas, et che dove se tractasse del honor del prefato Ill.mo Signore essendogli obligati come siamo, e per la fede ch'el ha in nui ne pareva de commetere grande mancamento a consigliargli o persuadessemo cosa alcuna che ad nuy non paresse licita et honeste" (letter from Lodovico Gonzaga to Vincenzo della Scalona, Mantua, 27 December 1457, Archivio di Stato,

Milan, Sforzesco, cart. 391, c. 219, published in Mahnke, 1975, pp. 179, 204 n. 187).

40. "Nui siamo mezi impazati cum quello Zoan Francesco scriptore che ne dovea scrivere la Biblia hebrea: credevemo de haver una digna cossa da metter in la nostra libraria, ma, per quello ne fi dicto, l'è una trista littera . . . piùtosto voressemo esser senza che haverla, et non seria da altro per nui che zitarla nel foco, et seressimo quasi contenti che'l se la retenesse cum li denari che l'ha havuti . . ." (letter from Lodovico Gonzaga to Antonio da Ricavo, Mantua, 26 April 1462, ASMAG, busta 2887, libro 39, c. 17v, published in Luzio/Renier, 1890, pp. 153–54).

41. "Una Georgica . . . scripta cum li diptongi destesi, cioè *ae, oe*, e cum le aspiratione apontate e le dictione scripte per orthografia, coreta secondo che sapeti facessemo corregere la Bucolica, e che non gli manchi coelle . . ." (letter from Lodovico Gonzaga to Bartolomeo Platina, Mantua, 8 December 1459, ASMAG, busta 2886, libro 37, c. 17v, published in W. Braghirolli, "Virgilio e i Gonzaga," *Album virgiliano*, Mantua, 1883, p. 181). It was perhaps not by chance that it was to Lodovico, rather than to some other prince, that Guarino da Verona dedicated his *Compendiolum de Diphthongis* (Luzio/Renier, 1890, p. 143).

Between 1450 and 1454 Platina composed a dialogue between Marchese Lodovico and Mantua's poet, in which Virgil thanked Lodovico for having undertaken "summo cum labore, industria, diligentia, opera nostra vitio librariorum imperitorumque hominum labefactata, non inutiliter corrigere et emendare" (A. Portioli, *Divi Ludovici Marchionis Mantuae Somnium*, Mantua, 1887).

42. "Havendo un pezo transcorso el libro ne haveti mandato novamente, habiamo pur trovate alcune cose scripte altra-mente de quello che fureno, che debe esser proceduto per esser stato vui mal informato da altri. Haressemo a caro che vui non destive fora copia alcuna . . . finché non havestive parlato cum nui, perché, essendo in gran parte stati presenti a queste cose, che ne pareno deviare un pocho dal vero, ve ne informaressemo meglio, e facilmente poterestive acunciare il tuto" (letter from Lodovico Gonzaga to Bartolomeo Platina, 16 May 1469, ASMAG, busta 2891, libro 64, c. 3r, published in Luzio/Renier, 1889, p. 436).

43. "Voressemo anchora facestive intendere, over da loro over da qualch'altri antiqui, se quando el Signor Don Francesco, nostro avo, fece tagliare la testa a quella Donna Agnese di Vesconti, se trovavano vivi el Signor Don Lodovico e Madona Alda, nostri besavi, perché questo libro mette che pocho dreto moresseno tuti dui, et se extima de dolore, et nui credemo che gie fusseno morti inanti fosse questo caso, perché 'l prefato Signor Don Francesco rimase Signore molto zovene, de XVI anni" (letter from Lodovico Gonzaga to Barbara of Brandenburg, Petriolo, 26 August 1469, ASMAG, busta 2891, libro 63, c. 80v; see also letter from Lodovico Gonzaga to Barbara of Brandenburg, Petriolo, 15 August 1469, ASMAG, busta 2891, libro 63, c. 75r, also published in Luzio/Renier, 1889, p. 438).

44. "Tuto heri regnò qui un gran vento e fredo e lo illustrissimo signor mio stete in el fondo de la fossa a veder lavorare, cum la cappa intorno et el capirono in capo; ben ala fiata venea de sopra a la camera a scaldarsi, ma de lì a un poco ritornava et steteli fin a le 24 hore. Sua Signoria sollicita molto questo lavorerio" (letter from Giorgio della Strata to Barbara of Brandenburg, Cavriana, 21 August 1460, ASMAG, busta 2394).

45. Antonio Averlino detto il Filarete, *Trattato di architettura*, ed. A. M. Finoli and

L. Grassi, 2 vols., Milan, 1972, 1, pp. 227–28. For further discussion of this passage, see text at n. 71. The words *arte del murare* occur in a letter from Zaccaria Saggi to Lodovico Gonzaga, Vigevano, 18 November 1470, ASMAG, busta 1623, published in Signorini, 1985, p. 47.

46. "Lo illustre signor mio . . . stette in casa a dessignare una colombara et a le 23 hore andoe a dessignare una stalla" (letter from Marsilio Andreasi to Barbara of Brandenburg, 10 February 1471, ASMAG, busta 2100, published in Signorini, 1985, p. 47).

47. Letter from Lodovico Gonzaga to Leon Battista Alberti, 12 October 1470, published in W. Braghirolli, "Leon Battista Alberti a Mantova," *Archivio Storico Italiano*, ser. 3, 9, pt 1. (1869): 14.

48. "Et vogliamo tu digi ad esso Cristoforo, se'l non fosse che l'è da Mantua, non olsaressemo già ad usare questa prosumptione, maxime nui, che non se ne intendiamo, contra un simel magistro come l'è lui, ma perché, come è dicto, l'è da Mantua, non guardaremo a dirli el parere nostro, ché sapiamo non l'haverà per male" (letter from Lodovico Gonzaga to Bartolomeo Bonatto, 27 September 1461, ASMAG, busta 2888, libro 48, cc. 79v–80r, published in U. Rossi, "Cristoforo Geremia," *Archivio Storico dell'Arte* 1 [1888]: 407). See also discussion in *Il tesoro di Lorenzo il Magnifico*, vol. 2, *I vasi*, ed D. Heikamp and A. Grote, Florence, 1972, pp. 71–72, 75–78 n. 78. Some of Pisanello's drawings of fantasy saltcellars (such as Louvre 2259, 2291, 2292) evoke Cristoforo's *objet d'art*.

49. See chapter 3, n. 39.

50. ". . . nel vero non manco ce rincresce ad nui non potervi securere, secondo seria el desiderio nostro . . . ché se li havessemo al presente o che'l ge fosse via o modo alcuno per il qual cognoscessemo poterveli far havire al presente, non seressemo stati a questa hora a mandarveli . . . , ma el non gli è modo alcuno, e come possite sapere non tenemo denari in cassa, anci li spendemo de molti dì inanti che li habiamo; siché piazave haverene per excusati et non imputar questo ad altro che a la impossibilitade" (letter from Lodovico Gonzaga to Francesco Filelfo, 21 December 1457, ASMAG, busta 2886, libro 33, c. 27r, published in Luzio/Renier, 1890, p. 169). See chapter 4, n. 10, for Filelfo's ungracious—but perhaps accurate—assessment of Lodovico's handouts after the Marchese's death. Lodovico's letters to Alberti are also extremely courteous in tone. See his letter from Milan, 22 February 1460, ASMAG, busta 2885, libro 31, c. 51v, published in Braghirolli, "Leon Battista Alberti," p. 7.

51. ". . . tu sai che in questi principii el discipulo non può far bene senza el magistro" (letter from Lodovico Gonzaga to Luca Fancelli, 12 September 1475, ASMAG, busta 2893, libro 79, c. 57, published in C. M. Brown, "Luca Fancelli in Mantua," *Mitteilungen des Kunsthistorischen Institutes in Florenz* 16 [1972]: 155). "El maestro ha satisfacto molto bene . . . il discipulo è contento dare quello mozo de farina" (letter from Lodovico Gonzaga to Luca Fancelli, 7 October 1473, ASMAG, busta 2892, libro 73, c. 55r, published in C. Vasic Vatovec, *Luca Fancelli, architetto: epistolario gonzaghesco*, Florence, 1979, p. 351).

52. "Domenedio permette che li homeni se puniscono da sè nel loco dove anche peccano" (letter from Lodovico Gonzaga to Luca Fancelli, 2 August 1475, ASMAG, busta 2893, libro 79, c. 14r, published in Vasic Vatovec, *Luca Fancelli*, p. 135). See also H. Burns, "The Gonzaga and Renaissance Architecture," in *Splendours of the Gonzaga*, pp. 27–30.

53. ". . . Speramo monstrarti qualche cosa che comprehenderai che tu non sai far ogni cosa ma gi è anche de li altri che

sano qualche coseta" (letter from Lodovico Gonzaga to Andrea Mantegna, Mantua, 29 June 1468, ASMAG, busta 2890, libro 60, c. 86r, published in Signorini, 1985, p. 83 n. 152).

54. The quotation comes from the letter cited in n. 45.

55. "Mi racomando a Vostra Excellentia e gli supplico che la non mi vogli anchora far murare in un muro, conoscendo però questo essere el magior pericolo del mondo, però che natura è di muratore di murar volontiera e, si possibile fusse, di volere murare gli omini . . ." (letter from Zaccaria Saggi to Lodovico Gonzaga, Mantua, 15 June 1461, ASMAG, busta 2395, c. 409, published in Signorini, 1985, p. 82 n. 147).

56. ". . . non sapiamo perhò dove possa venire questa imaginatione che nui se regiamo in questo per vostro consiglio perché mai non audissemo che fustive architecto . . ." (letter from Lodovico Gonzaga to Piero del Tovaglia, Mantua, 18 May 1471, ASMAG, busta 2891, libro 67, f. 24r–v, published in B. L. Brown, "The Patronage and Building History of the Tribuna of SS. Annunziata in Florence: A Reappraisal in Light of New Documentation," *Mitteilungen des Kunsthistorischen Institutes in Florenz* 25 [1981]: 127, doc. 63). For a useful summary of this correspondence, see Lorenzo de' Medici, *Lettere*, vol. 1 (*1460–1474*), ed. R. Fubini, Florence, 1977, pp. 275–78.

57. ". . . una tua bestial, paza, presuntuosa e insolentissima littera. . . . pò essere che non consideri che, se non fussemo stato nui casone, la tua condicione a pena gingeva [*sic*] de mandarte a parlare a un vescovo non che a la Sanctità de Nostro Signore . . ." (letter from Lodovico Gonzaga to Bartolomeo Bonatto, 20 January 1462, ASMAG, busta 2186).

58. "Quella [Lodovico] parloe ellegantissimamente come è suo costume di saper fare" (letter from Zaccaria Saggi to Barbara of Brandenburg, Petriolo, 9 May 1460, ASMAG, busta 1099, cc. 322–23,
quoted in Mahnke, 1975, p. 364 n. 2).

59. "Vostra Signoria glie piaceva più che altro Signore, né persona l'havesse mai pratichato perché havea troppo piacevel conversatione e de le cose del mondo glie pareva havesse mirabile parere e iudicio e cusì che la vivesse schiettamente" (letter from Francesco Secco to Lodovico Gonzaga, reporting Gaspare da Vimercate's account of Francesco Sforza's praise, 15 July 1463, ASMAG, busta 217, libretto 101, c. 22v, published in Mahnke, 1975, pp. 113, 377).

60. "Lodovicus igitur finito bello ad opera pacis conversus, et urbem aedificiis publicus ac privatis, et agros cultura ad amoenitatem et voluptatem ornare instituit" (B. Platina, *Historia Inclytae Urbis Mantuae et Serenissimae Familiae Gonzagae*, Vienna, 1675, p. 427).

61. See chapter 4, section 1.

62. See B. L. Brown, "Tribuna of SS. Annunziata."

63. C. M. Brown, "Luca Fancelli," pp. 153–61.

64. The documents concerning this work were published in W. Braghirolli, "Donatello a Mantova con documenti inediti," *Giornale di Erudizione Artistica* 2 (1873): 4–10; G. B. Intra, "Donatello e il Marchese Lodovico Gonzaga," *Archivio Storico Lombardo* 13 (1886): 666–69; J. Lawson, "New Documents on Donatello," *Mitteilungen des Kunsthistorisches Institutes in Florenz* 18 (1974): 357–62.

65. R. W. Kennedy, *Alesso Baldovinetti*, New Haven, 1938, pp. 29, 236.

66. The documents were published in L. Puppi, *Il trittico di Andrea Mantegna per la basilica di San Zeno Maggiore in Verona*, Verona, 1972, pp. 67–76.

67. A. Venturi, "I primordi del rinascimento artistico a Ferrara," *Rivista Storica Italiana* 1 (1884): 606–7.

68. See Signorini, 1985.

69. G. Mancini, *Vita di Leon Battista Alberti*, Florence, 1911, pp. 139, 171–77. S. Lang, "The Programme of the SS. Annunziata in Florence," *Journal of the*

Warburg and Courtauld Institutes 17 (1954): 299, suggests, without providing proof, that Alberti first visited Mantua in 1455.

70. For S. Sebastiano, see R. E. Lamoureux, *Alberti's Church of San Sebastiano in Mantua*, New York, 1979; A. Calzona, *Mantova, città dell'Alberti. Il San Sebastiano: tomba, tempio, cosmo*, Parma, 1979. For S. Andrea, see E. J. Johnson, *Sant'Andrea: The Building History*, University Park, Pa., 1975; D. S. Chambers, "Sant'Andrea at Mantua and Gonzaga Patronage," *Journal of the Warburg and Courtauld Institutes* 40 (1977): 99-127.

71. "Questo [Signore] a me pareva un uomo intendentissimo in più cose, massime in edificare pareva che ancora lui n'avesse sommo piacere, dimostrò essere intendentissimo molto in queste cose dello edificare" (Filarete, *Trattato*, 1, p. 379). For the date of Filarete's treatise, see J. R. Spencer, "La datazione del Trattato del Filarete desunta dal suo esame interno," *Rivista d'Arte* 31 (1956): 93-103.

72. "Lodo ben quegli che seguitano la pratica e maniera antica, e benedico l'anima di Filippo di ser Brunellesco, cittadino fiorentino, famoso e degnissimo architetto e sottilissimo imitatore di Dedalo, il quale risuscitò nella città nostra di Firenze questo modo antico dello edificare, per modo che oggi dì in altra maniera non s'usa se none all'antica, tanto in edificii di chiese, quanto ne' publici e privati casamenti. E che vero sia, se vedete che cittadini privati che faccino fare o casa, o chiesa, tutti a quella usanza corrono; intra gli altri una casa fatta in via contrada nuovamente, la qual via si chiama la Vigna, tutta la facciata dinanzi composta di pietre lavorate, e tutta fatta al modo antico. Si che conforto ciascheduno che 'nvistichi e cerchi nello edificare il modo antico di fare, e usare questi modi, che, se non fusse più bello e più utile, a Firenze non s'userebbe, come ho

detto di sopra; neanche il Signore di Mantova, il quale è intendentissimo, non l'userebbe, se non fusse quello che dico. E che sia vero, una casa ch'elli ha fatta fare a uno suo castello in su il Po, la quale ne dà testimonianza" (Filarete, *Trattato*, 1, pp. 227-28). Brunelleschi visited Mantua twice, in 1432 and 1436 (E. Battisti, *Filippo Brunelleschi*, New York, 1981, p. 232).

73. See references in chapter 4, n. 51. Antonio Manetti Ciaccheri also worked for Lodovico at Revere between 1448 and 1451.

74. See references in chapter 3, n. 63.

75. See n. 16; chapter 3, text at nn. 97-98.

76. See chapter 3, section II.

77. "Ancora a me solevano piacere questi moderni, ma poi ch'io cominciai a gustare questi antichi, mi sono venuti in odio quelli moderni. Ancora io nel principio, se alcuna cosa facevo, andavo pure a questa maniera moderna, perché ancora il Signore mio padre seguitava pure questi modi. . . . Egli è vero che puro io ho disiderato di mutare qualche foggia che fusse diferenziata; e ancora udendo dire che a Firenze si usava d'edificare a questi modi antichi, io diterminai di avere uno di quegli i quali fussino nominati; sì che praticando così con loro, m'hanno svegliato in modo che al presente io non farei fare una minima cosa che non la facessi al modo antico" (Filarete, *Trattato*, 1, p. 380). For the identification of the lord with Lodovico Gonzaga, based on a reference to Galeazzo Maria Sforza as his son-in-law, see *Filarete's Treatise on Architecture*, trans. J. R. Spencer, 2 vols., New Haven-London, 1965, 1, pp. 174 n. 13, xxx, xxxiv-xxxvi; Spencer, "Datazione del Trattato," pp. 97-98. Filarete was not, of course, an objective observer but was presenting Lodovico as a model of enlightened princely patronage for Francesco Sforza to follow.

78. See I. Hyman, "Notes and Speculations on S. Lorenzo, Palazzo Medici and an

Urban Project by Brunelleschi," *Journal of the Society of Architectural Historians* 34 (1975): 102; B. Preyer, "The Rucellai Palace," in *Giovanni Rucellai ed il suo zibaldone*, vol. 2, *A Florentine Patrician and His Palace*, London, 1981, p. 182.

79. A. Martindale and N. Garavaglia, *The Complete Paintings of Andrea Mantegna*, London, 1967, p. 83.

80. S. Samek Ludovici, *Miniature di Belbello da Pavia*, Milan, 1954, p. 26.

81. Lodovico purchased nine Greek manuscripts from Aurispa's library in 1461. See R. Signorini, "Acquisitions for Ludovico II Gonzaga's Library," *Journal of the Warburg and Courtauld Institutes* 46 (1981): 180–83; id., 1985, pp. 25–27; A. Franceschini, *Giovanni Aurispa e la sua biblioteca*, Padua, 1976.

82. ". . . queste historie francesi sono ignorate quasi, e pochi libri francesi ho veduti non che lecti" (quoted in G. Bertoni, *La biblioteca estense e la coltura ferrarese ai tempi del Duca Ercole I (1471–1505)*, Turin, 1903, p. 69).

83. "Se delectato se è de audire inutili canti e suoni amorusi . . . se grande tempo consumato ha in cantare e sonare, se le feste stato è più voluntiera aldire cantare di romanzo cha in giesa cantare il vespro" (Ms. Est. s.7,7, containing the *Confessionale* of Michele Savonarola, f. 21r, quoted in Bertoni, *Biblioteca estense*, pp. 75–76).

84. ". . . quos apud uxores et liberos nostros, nonnunque hybernis noctibus exponamus" (Angelo Decembrio, *Politiae Literariae . . .* Augsburg, 1540, bk. 1, pars 6, p. x, trans. in E. G. Gardner, *Dukes and Poets in Ferrara*, London, 1904, p. 48).

85. *Trionfo d'amore*, quoted with translation in E. G. Gardner, *The Arthurian Legend in Italian Literature*, London, 1930, p. 232.

86. See chapter 2, section II. Snobbish criticism of the romances remained constant through the centuries. For instance, Montaigne in *De l'institution des enfants*

wrote, "Des Lancelot du lac, des Amadis, des Huon de Bordeaux, et tel fatras de livres à quoy l'enfance s'amuse, je n'en connoissois pas seulement le nom, ny ne fais encore le corps [the matter], tant exacte estoit ma discipline" (*Oeuvres complètes*, ed. A. Thibaudet and M. Rat, Paris, 1965, p. 175).

87. See chapter 2, n. 62.

88. For a discussion of contemporaneous chivalric and classical tastes, see C. Dionisotti, "Entrée d'Espagne, Spagna, Rotta di Roncisvalle," *Studi in onore di Angelo Monteverdi*, Modena, 1959, pp. 214ff.; C. Mitchell, *A Fifteenth Century Plutarch*, London, 1961, pp. 6–7; R. M. Ruggieri, *L'umanesimo cavalleresco italiano: da Dante al Pulci*, Rome, 1962, chap. 1; G. Folena, "La cultura volgare e 'l'umanesimo cavalleresco' nel Veneto," in *Umanesimo europeo e umanesimo veneziano* (Atti del Convegno), Florence, 1963, pp. 141–58; P. J. Jones, "Economia e società nell'Italia medievale," in *Storia d'Italia*, vol. 1, *Dal feudalesimo al capitalismo*, Turin, 1978, pp. 357–58.

89. J. Huizinga, "The Political and Military Significance of Chivalric Ideas in the Late Middle Ages," *Men and Ideas*, New York, 1959, p. 198.

90. F. Sansovino, *Della origine de' cavalieri libri 4*, Venice, 1583, p. 3v.

91. See D. de Robertis, "Ferrara e la cultura cavalleresca," in *Storia della letteratura italiana*, ed. E. Cecchi and N. Sapegno, Milan, 1966, III, pp. 570–74.

92. See chapter 2, section II.

93. Pisanello's collection of antique coins was sold at his death to Carlo de' Medici (see chapter 3, n. 49).

94. See chapter 3, n. 3.

95. See ibid. n. 54.

96. See ibid. n. 47.

97. ". . . perché c'è dicto che la Maiestà del Serenissimo Re de Aragona havendono [*sic*] havuto noticia ce lo vole far richedere, non savendo qual'altra scusa più honesta trovare, havevemo pensato de dire che la intencione nostra non era

de alienarlo et che, dovendolo dar ad alcuno, havemo promesso de farne uno presente a la Santità de Nostro Signore, che, essendo cossì, non poressemo cum honore nostro darlo ad altri. Il perché voressemo che fusseve cum la Santità Sua et dirli questo nostro pensero, supplicandola che, sentendone alcuna cossa, se dignasse de mostrare haver da nui questa promessa et non se dirà busia alcuna perché, quando deliberassemo darlo a persona, el seria de la Santità Sua, ma, come havemo dicto, la intencione nostra seria de tenerlo et servare al nostro prete" (letter from Lodovico Gonzaga to the Bishop of Mantua, 31 March 1450, ASMAG, busta 2883, libro 14, cc. 26v–27r, published in Samek Ludovici, *Belbello da Pavia*, p. 24, where the writer is incorrectly given as Barbara of Brandenburg).

98. See chapter 4, text at n. 16. Lodovico had tried earlier to get a job with the King of Naples. See chapter 4, n. 136.

99. Pius Secundus, *Commentarii*, p. 104.

SIX · FORMAL ANALYSIS

1. For a discussion of framing, see M. Schapiro, "On Some Problems in the Semiotics of Visual Art: Field and Vehicle in Image-Signs," *Semiotica* 1 (1969): 234ff.

2. M. Salmi, *Andrea del Castagno*, Novara, 1961, pl. 50, figs. 2, 3.

3. For a discussion of one scene to one wall, see E. H. Gombrich, *Means and Ends: Reflections on the History of Fresco Painting*, London, 1976.

4. The imperceptible divisions separating the scenes in the *Sala del Pisanello* also occur asymmetrically within the wall spaces. The end of the tournament three-quarters of the way across Wall 1 overlaps the adjacent arrival of Knight 24 with wide-brimmed hat and retinue of dwarfs. The landscape in which this procession takes place starts out on another surface, Wall 4, and continues

around the corner to Wall 1 (Fig. 16).

5. ". . . e si grande che sarebbe faticha a poterlo distendere nella sala vostra . . ." (letter from Fruoxino to Giovanni de' Medici, Bruges, 22 June 1448, published in J. del Badia, "Sulla parola 'Arazzo,'" *Archivio Storico Italiano*, ser. 5, 25 [1900]: 88). "Che siano più grandi et belli possiati atrovare . . ." (letter from Francesco Sforza to Gerardo de Collis, Milan, 8 April 1465, published in C. De Rosmini, *Dell'istoria di Milano*, Milan, 1820, IV, p. 35).

6. M. Meiss, *French Painting in the Time of Jean de Berry: The Late 14th Century and the Patronage of the Duke*, London, 1967.

7. Louvre, inv. 2520 (Fossi Todorow, 1966, cat. 99). In my view, this drawing is by Pisanello and datable to the 1440s. For a discussion of the drawing's perspective construction, see S. Y. Edgerton, Jr., "Alberti's Perspective: A New Discovery and a New Evaluation," *Art Bulletin* 48 (1966): 375ff.

8. J. Pope-Hennessy, *The Complete Work of Paolo Uccello*, London, 1969, pls. 51, 61.

9. Each motif is also seen from its own level, except for the castle to the left of the maidens' tribune, viewed from above, and the uppermost castles and towns that punctuate the horizon, depicted as if seen from below.

10. The way in which the cycle is now exhibited in Mantua creates the illusion that the knights on Wall 1 are larger than those on Walls 2 and 3. Only in the upper center of Wall 1, among the knights struggling in the *mêlée* and the lances in the upper right corner, did Pisanello introduce a slight change of scale within the tournament scene. The change of scale served to indicate the gradual disappearance of the tournament as attention shifted to the neighboring scene on Wall 4.

11. See chapter 3, n. 57.

12. Venturi, 1896, p. 3.

13. Ibid. pp. 49–50.

14. See chapter 2, n. 83.

15. See ibid. n. 88.

16. See references in ibid. nn. 85–86.

17. L. H. Labande, *Le Palais des Papes et les monuments d'Avignon au XIVe siècle*, 2 vols., Paris, 1925, II, pp. 19–30.

18. E. Vinaver, *The Works of Thomas Malory*, Oxford, 1947, I, p. xlviii.

19. F. Lot, *Etude sur le Lancelot en prose*, Paris, 1918; W. Ryding, *Structure in Medieval Narrative*, The Hague, 1971, p. 153. See also E. Vinaver, *The Rise of Romance*, Oxford, 1971; id., *A la recherche d'une poétique médiévale*, Paris, 1970; R. Tuve, *Allegorical Imagery: Some Medieval Books and Their Posterity*, Princeton, 1966; C. S. Lewis, *The Discarded Image: An Introduction to Medieval and Renaissance Literature*, Cambridge, 1964; id., "Edmund Spenser," in *Major British Writers*, ed. G. B. Harrison, New York, 1954, pp. 91–102; F. Bogdanow, *The Romance of the Grail*, New York, 1966; D. Delcorno Branca, *L'Orlando Furioso e il romanzo cavalleresco medievale*, Florence, 1973; E. Auerbach, *Mimesis: The Representation of Reality in Western Literature*, trans. W. R. Trask, Princeton, 1953; N. Frye, *The Secular Scripture: A Study of the Structure of Romance*, Cambridge, Mass., 1976; R. Crosby, "Oral Delivery in the Middle Ages," *Speculum* 11 (1936): 88–110, who maintained that the repetition in romance was the result of oral delivery.

20. Vinaver, *Rise of Romance*, p. 77.

21. Ibid. pp. 70–71.

22. Ryding, *Structure*, p. 115.

23. Ibid. p. 10.

24. J. Frappier, "The Vulgate Cycle," in *Arthurian Literature in the Middle Ages*, ed. R. S. Loomis, Oxford, 1959, p. 298. See also Vinaver, *Rise of Romance*, p. 72.

25. H. O. Sommer, ed., *The Vulgate Version of the Arthurian Romances*, 8 vols., Washington, D.C., 1908–16, IV, p. 258, line 40, to p. 259, line 22.

26. Vinaver, *Rise of Romance*, p. 81.

27. Lot, *Etude*, p. 28 and chap. 2; Ryding, *Structure*, pp. 16, 145; Vinaver, *Rise of Romance*, p. 72; Tuve, *Allegorical Imagery*, p. 359; Frappier, "Vulgate Cycle," p. 300; A. Pauphilet, *Etude sur la Queste del Saint Graal*, Paris, 1921, pp. 163–69.

28. Frappier, "Vulgate Cycle," p. 318. See chapter 2, n. 32, for text; P. Rayna, "Arturi regis ambages pulcerrime," *Studi Danteschi* 1 (1920): 91–99.

29. "il fait bon voir, comment le Poète, après avoir quelquefois fait mention d'une chose memorable . . . le laisse là pour un temps, tenant le lecteur en suspens, désireux d'en aller voir l'événement. En quoi je trouve nos Romans bien inventés" (Jacques Peletier du Mans, *L'art poétique* [1555], ed. A. Boulanger, Strasbourg, 1930, p. 201).

30. Vinaver, *Rise of Romance*, p. 76.

31. Lewis, *Discarded Image*, p. 194.

32. Lewis, "Edmund Spenser," p. 98.

33. Ibid.

34. Vinaver, *Rise of Romance*, p. 94.

35. Tuve, *Allegorical Imagery*, p. 366. For a similar discussion of *entrelacement* in relation to this cycle, brought to my attention after I completed this chapter, see E. L. Goodman, "The Prose Tristan and the Pisanello Murals," *Tristania* 3 (1978): 29.

36. Lewis, *Discarded Image*, p. 194.

37. Vinaver, *Rise of Romance*, pp. 70–71, citing Aristotle's *Poetics*, chap. 23.

38. Lewis, "Edmund Spenser," p. 98.

39. Venturi, 1896, pp. 52–55.

40. The translation comes from M. Baxandall, *Giotto and the Orators: Humanist Observers of Painting in Italy and the Discovery of Pictorial Composition 1350–1450*, Oxford, 1971, p. 93.

41. See also discussion in W. Grape, "Pisanello und die unvollendeten Mantuaner Wandbilder," *Pantheon* 34 (1976): 14–17.

42. Baxandall, *Giotto and the Orators*, p. 96.

43. Lot, *Etude*, pp. 262, 135.

44. Frye, *Secular Scripture*, p. 47. Baxandall, *Giotto and the Orators*, pp. 135ff., came

to similar conclusions, defining Pisanello's style, in humanist terms, as *dissolutus*.

45. Given the lack of surviving frescoes with which to compare the Arthurian cycle, we shall never know whether Pisanello's narrative style in Mantua was more than usually "chivalric," and hence distinguishable from his pictorial style in general.

46. See chapter 2, n. 79.

47. V. Goloubew, *Les dessins de Jacopo Bellini au Louvre et au British Museum*, 2 vols., Brussels, 1908–12, I, pl. 62. For Bembo, see chapter 2, n. 80.

48. See G. Souchal, ed., *Chefs-d'œuvre de la tapisserie du XIVe au XVIe siècle*, Paris, 1974, cat. 17, pp. 72–75.

49. See chapter 4, n. 156.

50. Sommer, *Vulgate Version*, IV, p. 263, lines 8–28; p. 262, lines 11–22.

51. For *sinopie* in general, see U. Procacci, *Sinopie e affreschi*, Milan, 1961; M. Meiss, *The Great Age of Fresco: Giotto to Pontormo, Catalogue of Mural Paintings and Monumental Drawings*, preface by M. Meiss, introduction by U. Procacci, New York: Metropolitan Museum, 1968; E. Borsook, *The Mural Painters of Tuscany*, 2d ed., Oxford, 1980. See also R. Oertel, "Wandmalerei und Zeichnung in Italien: die Anfänge der Entwurfszeichnung und ihre monumentalen Vorstufen," *Mitteilungen des Kunsthistorischen Institutes in Florenz* 5 (1937–40): 217–314. For another, shorter version of this material, see J. Woods-Marsden, "The Sinopia as Preparatory Drawing: The Evolution of Pisanello's Tournament Scene," *Master Drawings* 23–24 (1986): 175–92.

52. My conclusions were arrived at by superimposing a reproduction of the *sinopia*, printed on transparent plastic, over a reproduction of the fresco, both enlarged to the same scale.

53. See chapter 7, section II.

54. See ibid.

55. See ibid.

56. For the devices, see chapter 4, section II.

57. See ibid. section III.

58. The introduction of these wounded knights is the change to the composition that has attracted most previous scholarly attention. See Paccagnini, 1972, pp. 235ff.; Degenhart, 1973, pp. 392ff.

59. For more information on tournaments, see chapter 8, n. 78.

60. See ibid., text at nn. 84ff. For a different interpretation of the fallen knights, see Degenhart, 1973, p. 405.

61. L. B. Alberti, *On Painting and Sculpture*, ed. C. Grayson, London, 1972, para. 40.

62. See also the excellent characterization of the *sinopia* in Degenhart, 1973, p. 397.

63. This factor may explain the otherwise puzzling reduction in the number of dwarfs following Knight 24 in the mural. In the *sinopia* he was accompanied by at least five or six small retainers.

64. Alberti, *On Painting*, para. 40.

65. Ibid. para. 38.

66. G. Mancini, *Vita di Leon Battista Alberti*, Florence, 1911, pp. 171ff.

67. See chapter 5, nn. 19, 71.

68. See chapter 5, section II.

69. See chapter 5, n. 1. Paccagnini, 1972, p. 157, also proposed Albertian influence on Pisanello's work, denied by M. Baxandall in his review of Paccagnini's monograph in *Art Bulletin* 57 (1975): 131. Two other instances of Albertian influence on Pisanello's work have been suggested. Edgerton, "Alberti's Perspective," pp. 375ff., pointed out the impact of book I on Louvre, inv. 2520, a drawing of the vaulted hall in which Pisanello deliberately modified Albertian perspective theory in order to improve his composition. M. Baxandall, "Guarino, Pisanello and Manuel Chrysoloras," *Journal of the Warburg and Courtauld Institutes* 28 (1965): 195, noted that a copy of a drawing by Pisanello (Milan, Ambrosiana, Cod. F. 214 inf., f.

10r; Fossi Todorow, 1966, cat. 182) after Giotto's *Navicella* is the fifteenth-century copy that most clearly reflects Alberti's praise, in book 2, of the range of human expression in the mosaic.

70. See, for instance, Degenhart, 1973, p. 397.

71. See also Paccagnini, 1972, p. 28. Grape, "Unvollendeten Mantuaner Wandbilder," analyzed the details separately and came to the opposite conclusion.

SEVEN · MAKING THE ART

1. Thanks to the generosity of Ilaria Toesca, the former Soprintendente per le Gallerie di Mantova, Cremona e Brescia, and to the loan of his photographic scaffold by Mario Quaresima of the Gabinetto Fotografico Nazionale, I was able to make a detailed investigation of Wall 1 from a scaffold. Many of the points made in this chapter are therefore based on personal observation. Research included discussion with Assirto Coffani, the cycle's restorer; Ottorino Nonfarmale, supervisor of the mural's *strappo*; and Francesco Pelessoni, restorer of Pisanello's fresco in San Fermo, Verona. For an excellent glossary of the technique of mural painting, see E. Borsook, *The Mural Painters of Tuscany*, 2d ed., London, 1980, pp. 133–35. See also Paccagnini, 1972, chap. 2; Degenhart, 1973, pp. 367–68; G. Paccagnini, "Note sulla formazione e la tecnica del ciclo cavalleresco della 'Sala del Pisanello,'" in *Mantova e i Gonzaga nella civiltà del rinascimento* (Atti del Convegno, Mantua 6–8 October 1974), Mantua, 1978, pp. 191–215; id., "Il ciclo cavalleresco del Pisanello alla Corte dei Gonzaga. II. Tecnica e stile del ciclo murale," in *Studies in Late Medieval and Renaissance Painting in Honor of Millard Meiss*, ed. I. Lavin and J. Plummer, New York, 1977, pp. 205–18. This section of chapter 7 is a revised and corrected version of the same material in J. Woods-

Marsden, "Observations on Fresco Technique: Pisanello in Mantua," in *La pittura nel XIV e XV secolo: il contributo dell'analisi tecnica alla storia dell'arte*, ed. H. W. van Os and J.R.J. van Asperen de Boer, *Acts of the 24th International Congress of Art History* (Bologna, 1979), vol. 3, Bologna, 1983, pp. 189–210.

2. See chapter 3, section II.

3. Cennino Cennini, *The Craftsman's Handbook: "Il libro dell'arte,"* trans. D. V. Thompson, Jr., 2 vols., New Haven, 1933, chap. 67.

4. U. Procacci, *La tecnica degli antichi affreschi e il loro distacco e restauro*, Florence, 1956; id., *Sinopie e affreschi*, Milan, 1961; L. Tintori and M. Meiss, *The Paintings of the Life of St. Francis in Assisi*, New York, 1962; L. Tintori and E. Borsook, *Giotto: The Peruzzi Chapel*, New York, 1965; M. Meiss, *The Great Age of Fresco: Giotto to Pontormo, Catalogue of Mural Paintings and Monumental Drawings*, preface by M. Meiss, introduction by U. Procacci, New York: Metropolitan Museum of Art, 1968 (see reviews of the last by E. H. Gombrich, *New York Review of Books*, no. 12 [19 June 1969]: 8–14; J. Schulz and A. M. Schulz, *Burlington Magazine* 111 [1969]: 51–55; H. W. van Os, *Simiolus* 4 [1969–70]: 6–12); M. Meiss, *The Great Age of Fresco: Discoveries, Recoveries, and Survivals*, New York, 1970; Borsook, *Mural Painters*. For specifically North Italian works, see *Pitture murali nel Veneto e tecnica dell'affresco*, (exhibition catalog), ed. M. Muraro with introduction by U. Procacci, presentation by G. Fiocco, Venice, 1960; *Pitture murali restaurate: Soprintendenza ai Monumenti di Verona* (exhibition catalog with introduction by M. T. Cuppini), Verona, 1971.

5. This is the term used in all the secondary literature, presumably following Cennini, who used the word *pasta* when discussing the modeling of raised haloes (*Libro dell'arte*, chap. 102). No technical analysis of the mural was made during

restoration to determine the constituents of either the relief layer or the metals used by Pisanello. Assirto Coffani suggests (orally) that the substance might be a resin made up of *pece* (tar), *colofonia* (tree sap), and *cera* (wax), perhaps combined with other ingredients. Paccagnini, 1972, p. 31, referred to stucco studs on the horses' trappings, but these did not survive the *strappo* of the murals, nor are they visible in photos taken before the *strappo*. The *pastiglia* can be studied in many photographs taken by the Gabinetto Fotografico Nazionale, especially E 101365, 101399, 101401, 101403, 101418, 101442, 101451, 101461, 101488, 101491, 101508, 101513, 101515.

6. This kind of mass fabrication with a stamp or punch was common in the fourteenth and fifteenth centuries and is quite different in nature from the "freehand" designs of the *pastiglia*.

7. See, for instance, Paccagnini, 1972, colorplate IV; Gabinetto Fotografico Nazionale E 101253, 101295.

8. Louvre, inv. 2533 (Fossi Todorow, 1966, cat. 76).

9. The quality of the so-called secondary aspects of the mural, such as the application of the *pastiglia*, is, for instance, much higher than the general level of those drawings usually recognized as being school works (see Fossi Todorow, 1966, cats. 101–290). The variety of the *pastiglia* patterns dwindles, however, toward the right of the scene, and the designs of the lances at the extreme upper right become repetitive. Possibly this aspect of the execution required so much time and effort that it had to be simplified as the work progressed. Jeffrey Ruda also suggests a practical reason: the area near the corner was less well lit and therefore less visible than the more elaborately worked area at left.

10. Incised contours were a necessary corollary to the application of so much metal. They helped to avoid loss of the images' outline definition in the process of gilding (see Cennini, *Libro dell'arte*, chap. 101).

11. For a concurring view, see Paccagnini, 1972, p. 28. For a differing view, see Degenhart, 1973, p. 368. The underdrawings visible in the S. Fermo Annunciation were drawn *a fresco* (see *Pitture murali restaurate*, p. 85).

12. See, for example, the cursory and economical underdrawings in the scenes from monastic legends in S. Miniato al Monte, Florence, possibly by Paolo Uccello (J. Pope-Hennessy, *The Complete Work of Paolo Uccello*, London, 1969, pp. 142–44, pl. IIb). For a discussion of the style of the underdrawings, see chapter 3, section II.

13. L. B. Alberti, *On Paintings and Sculpture*, ed. C. Grayson, London, 1972, paras. 46–47.

14. Even the slight undulations and irregularities of the wall itself (assuming that this mural did not differ greatly from others still *in situ*) would have fortuitously increased the variety of reflections.

15. See the comments in Alberti, *On Painting*, para. 49.

16. S. Moschini Marconi, *Gallerie dell'Accademia di Venezia: opere d'arte dei secoli XIV e XV*, Rome, 1955, cat. 26, p. 28; G. Panazza, *La Pinacoteca e i musei di Brescia*, Bergamo, 1968, p. 116. The painting is sometimes attributed to Paolo Caylinda.

17. A Quattrocento source for this peculiarly North Italian phenomenon may have been the lost murals by Gentile da Fabriano and by Pisanello in the Ducal Palace in Venice.

18. K. Christiansen, *Gentile da Fabriano*, Ithaca, N.Y., 1982, pp. 7, 150–59 (doc. III); P. D'Ancona, *I Mesi di Schifanoia*, Milan, 1954, pls. 24, 28.

19. J. Woods-Marsden, "Pictorial Legitimation of Territorial Gains in Emilia: The Iconography of the 'Camera Peregrina Aurea' in the Castle of Torchiara,"

in *Renaissance Studies in Honor of Craig Hugh Smyth*, Florence, 1985, II, p. 560. For the relief on the S. Anastasia mural, see Istituto Centrale di Restauro, Rome, unnumbered photograph taken before the removal of the work from the archway over the Pellegrini Chapel. For discussions of Pisanello's mural technique in S. Anastasia and S. Fermo, see *Pitture murali nel Veneto*, cat. 28, and *Pitture murali restaurate*, cats. 24, 25. For a complete account of Francesco Pelessoni's restoration of the San Fermo Annunciation, see Istituto Centrale di Restauro, scheda di analisi no. 392, "Accertamento dello stato di conservazione ed analisi dei pigmenti e leganti dell'affresco di Antonio Pisano raffigurante l'*Annunciazione*, Verona, Chiesa di S. Fermo," Rome, 1970, unpublished typescript.

20. G. Marangoni, "La cappella di Galeazzo Maria Sforza nel Castello Sforzesco," *Bollettino d'Arte*, N.S., 1 (1921–22): 176–86, 227–36; R. Negri, *La cappella di Teodolinda a Monza*, Milan–Geneva, 1968; G. Algeri, *Gli Zavattari: una famiglia di pittori e la cultura tardogotica in Lombardia*, Rome, 1981, p. 10.

21. "Et le mura choprì tutte d'arazzo, / di ricchi panni d'oro, d'argiento et seta," published and trans. in R. Hatfield, "Some Unknown Descriptions of the Medici Palace in 1459," *Art Bulletin* 52 (1970): 234, 247.

22. V. Polli, *Il Castello del Colleoni a Malpaga e i suoi affreschi*, Bergamo, 1975, pls. 44–46.

23. See chapter 2, text at n. 95; R. A. d'Hulst, *Flemish Tapestries from the 15th to the 18th Centuries*, New York, 1969, pp. ixff.

24. Letter from Fruoxino to Giovanni de' Medici, Bruges, 22 June 1448, published in J. Del Badia, "Sulla parola 'Arazzo,'" *Archivio Storico Italiano*, ser. 5, 25 (1900): 89; A. Venturi, "I primordi del rinascimento artistico a Ferrara," *Rivista Storica Italiana* 1 (1884): 630; N. Forti Grazzini,

L'arazzo ferrarese, Milan, 1982, p. 30.

25. Del Badia, "Arazzo," p. 89; see chapter 4, text at nn. 9–12.

26. See n. 5.

27. Cennini, *Libro dell'arte*, chaps. 96–101. See also L. Tintori, "Golden Tin in Sienese Murals of the Early Trecento," *Burlington Magazine* 124 (1982): 94–95, for the fabrication of different kinds of gold. For evidence of the prices of real and simulated metals, see E. Borsook, "Jacopo di Cione and the Guild Hall of the Judges and Notaries in Florence," *Burlington Magazine* 124 (1982): 86–88.

28. For *sinopie* in general, see Procacci, *Sinopie e affreschi*; Borsook, *Mural Painters*; Meiss, *Great Age* (1968); F. Ames-Lewis, *Drawing in Early Renaissance Italy*, New Haven–London, 1981, pp. 23–32. The only other recovered *sinopie* on a comparable scale are those for the Trecento *Triumph of Death, Thebaid*, and *Last Judgment* in the Camposanto in Pisa. See M. Bucci et al., *Camposanto monumentale di Pisa: affreschi e sinopie*, Pisa, 1960. Virtually no other 15th-century *sinopie* have been recovered in northern Italy.

29. For a differently worked discussion of this material, see J. Woods-Marsden, "Preparatory Drawings for Frescoes in the Early Quattrocento: The Practice of Pisanello," in *Drawings Defined*, ed. W. Strauss and T. Felker, preface by K. Oberhuber, New York, 1987, pp. 49–62.

30. There was no *sinopia* for the frieze, for which a cartoon applied with *spolvero* was used. For reasons unknown, Pisanello covered some parts of the frieze with another layer of *intonaco*, on which he repeated the same design. These various layers were discovered during the mural's *strappo* and are currently exhibited separately.

31. The right side of scheme B came away with the *intonaco* during the *strappo* (Paccagnini, orally). A detached piece of *sinopia* with the rump and rear legs of two

animals apparently came from the upper right of Wall 1, somewhere between the knights at upper right and the lions (Paccagnini, orally).

32. Instead of being used for the first tentative draft on the *arriccio*, as advised by Cennini (*Libro dell'arte*, chap. 67), charcoal was here employed over the *sinopia* drawing. On Knight 16 above, charcoal was again used over the *sinopia*, this time more functionally, to shift the figure to the left, an alteration followed in the fresco.

33. No photographs document the appearance of the juncture of Walls 1 and 2 before the *strappo* of the two *sinopie*.

34. Another second *sinopia* on Wall 2 shows two maidens to the left of the painted blonde and her companion in the tribune (Fig. 14). These were also detached separately (Gabinetto Fotografico Nazionale photo E 101665).

35. See chapter 6, section III.

36. The disparity in the character of the line in different parts of the tournament *sinopia*—from fairly polished drawing in parts of scheme B to the rugged, coarse outlines of some of scheme C—was perhaps influenced by the differing surfaces drawn on. The unusual degree of smoothness of the fresh plaster on which scheme B was drawn must have facilitated the drawing of some of those fluid images, while the roughness of some of the images in scheme C was perhaps rendered inevitable by the coarse surface of the plaster at lower left.

37. The superimposition of some of the red images of scheme D over the black images of scheme C again testifies to the chronological sequence of these two designs.

38. Alberti, *On Painting*, para. 61; id., *Della pittura*, ed. L. Mallè, Florence, 1950, p. 112.

39. Cennini, *Libro dell'arte*, chap. 1.

40. Louvre, inv. 2595r (Fossi Todorow, 1966, cat. 65).

41. Cennini, *Libro dell'arte*, chap. 67. A ver-

tical axis possibly exists on Wall 1 under the added plaster of scheme B, but, given the absence of such axes on Walls 2 and 3, it seems unlikely.

42. Ibid. chap. 122.

43. Ibid. chap. 67.

44. The architectural background in the *St. George and the Princess* mural in S. Anastasia, where the natural light source is from the right, also shows a fall of light from the right (Fig. 42).

45. The differences between the two *sinopie* have been noted and mulled over by various scholars. Paccagnini, 1972, p. 235, for instance, suggested that the differences could be explained by separate campaigns, dating before and after Pisanello's visit to Naples.

46. See chapter 3, section II.

47. Another analogy is the foliated landscape painted between the architecture and the protagonists in *St. George and the Princess*.

48. Cennini, *Libro dell'arte*, chap. 8.

49. For medieval modelbooks, see Fossi Todorow, 1966, pp. 15ff.; R. W. Scheller, *A Survey of Medieval Modelbooks*, Haarlem, 1963; Ames-Lewis, *Drawing*, chap. 4. For a related discussion, see Woods-Marsden, "Preparatory Drawings for Frescoes."

50. Louvre, inv. 2277 (Fossi Todorow, 1966, cat. 70). For a differing view, see the discussion of drawings in Degenhart, 1973, pp. 394–401. Drawings not discussed here that Degenhart attributed to Pisanello as preparatory studies for motifs in the cycle are Louvre, inv. 2321, a silverpoint drawing of a head of a man similar to a head in reverse on Wall 1 (Fossi Todorow, 1966, cat. 377, attribution to Pisanello rejected); Louvre, inv. 2324, another silverpoint drawing of a head of a black, closely related to the head of a black on Wall 2 but probably a copy made after the mural (Fossi Todorow, 1966, cat. 379, attribution to Pisanello rejected).

51. For the emblems, see chapter 4, section II.

52. Louvre, inv. 2444 (Fossi Todorow, 1966, cat. 31).

53. Louvre, inv. 2358 (Fossi Todorow, 1966, cat. 39).

54. For the school drawings, see Fossi Todorow, 1966, cats. 101–259, pp. 43–51. There is of course no way of establishing how representative of Pisanello's graphic oeuvre are those drawings that survive.

55. Louvre, inv. 2616v (Fossi Todorow, 1966, cat. 247v, attribution to Pisanello rejected). B. Degenhart, *Pisanello*, Turin, 1945, pl. 129, attributes the drawing to Pisanello and discusses the facial modeling. Other similar drawings are Louvre, inv. 2628 (Fossi Todorow, 1966, cat. 287), a horse's head with blank bridle; Louvre, inv. 2432 (ibid. cat. 12), a hound with a blank harness; Louvre, inv. 2598 (ibid. cat. 229), in which the miter on a male portrait has been neglected. Sometimes the elements to be rendered in *pastiglia* were indicated but less worked up than those areas to be painted in fresco. Although no comparable guides for the relief and metal finish survive, examples of the kind of drawing that could have constituted a guide for the *pastiglia* (as a separate phase necessitating separate drawings) are the decorative motifs in Louvre, inv. 2278 (ibid. cat. 69), and the ornamental flower motif in Louvre, inv. 2533, illustrated in Fig. 114 (ibid. cat. 76).

56. See also Gabinetto Fotografico Nazionale photographs E 101371 and 101378. On the upper zones of the wall the *giornate* are, now at any rate, virtually impossible to establish because the relief layer conceals the joins between them. The mural's *strappo* also smoothed out the normal unevenness of the wall that would have helped to reveal them.

57. Paccagnini, 1972, pp. 26 and 28, suggested that there were full-scale cartoons for all the figures in the scene. However, apart from the *spolvero* used for the

repetitive motifs in the frieze, no signs of tracing or pouncing can be seen today on the *intonaco*.

58. Louvre, inv. 2595r (Fossi Todorow, 1966, cat. 65). The mounted knight is sometimes identified, without any firm basis, as a Gonzaga.

59. *Exempla* drawings of male heads can be seen in Fossi Todorow, 1966, cats. 239–52.

60. Cennini, *Libro dell'arte*, chap. 27.

61. This last step is analogous to the hypothesis published by Degenhart on the use to which Pisanello put the type of drawing that the scholar referred to as "Reinzeichnung" (B. Degenhart, "Zu Pisanellos Wandbild in S. Anastasia in Verona," *Zeitschrift für Kunstwissenschaft* 5 [1951]: 29–50). The factor of exactly corresponding scale between drawings and mural is not, however, relevant to my hypothesis.

62. See chapter 3, section I.

63. Alberti, *On Painting*, para. 59.

64. See also Paccagnini, 1972, p. 30.

65. Corrective gray pigment outlining a different configuration was splashed over the relief decorating its left flank. A similar case is the redefined arm of Knight 12, whose upheld clenched fist was redrawn as an afterthought over his already painted cloak.

66. See chapter 3, n. 54.

EIGHT · SOCIAL CONTEXT AND ICONOGRAPHY

1. For the sparse information we have on Quattrocento living arrangements, see R. Goldthwaite, "The Florentine Palace as Domestic Architecture," *American Historical Review* 77 (1972): 977–1012.

2. Antonio Averlino detto il Filarete, *Trattato di architettura*, ed. A. M. Finoli and L. Grassi, Milan, 1972, I, p. 266.

3. "... salam, quam a saltando dictam puto, quod in ea nuptiarum et convivarum alacritas celebretur. ..." (L. B. Alberti, *L'architettura: De Re Aedifica-*

toria, ed. G. Orlandi, 2 vols., Milan, 1966, I, p. 339).

4. *I diarii di Cicco Simonetta,* ed. A. R. Natale, Milan, 1962, p. 74; L. Beltrami, *Il Castello di Milano,* Milan, 1894, ground plan, p. 593, room 53.

5. "Heri matina andassimo tuti im pontificale su la sala grande ornata benissimo de razi et verdure, et se li sposoe Madonna Magdalena, et fue benedicta, recitata prima una longissima oratione latina de laude Gonzagesche et Sforcesche" (letter from Giovanni Gonzaga to Francesco Gonzaga, Pesaro, 29 October 1489, ASMAG, busta 848, cc. 169–70, published in G. Mondovi, *Per le fauste nozze Rimini-Todeschi-Assagioli,* Mantua, 1883, pp. 9–11).

6. C. M. Rosenberg, "The Iconography of the Sala degli Stucchi in the Palazzo Schifanoia in Ferrara," *Art Bulletin* 61 (1979): 382.

7. For the iconography, see chapter 2, section I.

8. See n. 3. The *Sala del Pisanello* was of course used as a dining hall by Niccolò d'Este in the early 1470s. See chapter 1, n. 38.

9. "La cena è stata sumptuosa et omnipotente" (letter from Isabella d'Este to Francesco Gonzaga, Mantua, 23 November 1500, ASMAG, busta 2114, quoted in A. Luzio and R. Renier, "Buffoni, nani e schiavi dei Gonzaga ai tempi d'Isabella d'Este," *Nuova Antologia di Scienze, Lettere ed Arti,* ser. 3, 34 [1891]: 645).

10. The room called the *Sala Grande* in 1463 is tentatively identified as the second-story hall also called the *Armeria.* See chapter 1, text at n. 23.

11. ". . . è stata una digna et honorevole festa. Gli erano de le boche 800 venute ale spese nostre, considerati quante ge ne dovevano essere de le altre. Questri tri zorni s'è atteso a dansare e far festa in la sala grande, tanto che quasi tutti nui siamo amalati de caldo e de polvere; et erano in sala XXVII tavole de nostre e forestere che gli hano manzato questi tri zorni" (letter from Barbara of Brandenburg to Cardinal Francesco Gonzaga, Mantua, 11 June 1463, ASMAG, busta 2887, libro 41, c. 52r, published in G. Lanzoni, *Sulle nozze di Federigo I Gonzaga con Margherita di Wittelsbach (1463),* Milan, 1898, p. 28).

12. Andrea Schivenoglia, *Cronaca di Mantova dal 1445 al 1484,* transcribed and annotated by C. d'Arco, in *Raccolta di cronisti e documenti storici lombardi,* ed. G. Müller, Milan, 1857, II, pp. 125ff. For a breakdown of which foods came from which villages, see F. Amadei, *Cronaca universale della città di Mantova (1745),* ed. G. Amadei, E. Marani, and G. Praticò, Mantua, 1954, II, pp. 134ff.

13. "Prima: el ge era a la colectione de confecto, saponea, pasta reale, pignochate dorate de libre meza l'una, pezuoli fati cum zucaro fino, biscotini cum zucharo fino, zaldoni cum zuchar fino, malvasia moschatella. La seconda portata: figatelli cum latesini de vitello, fidego de porco, fidigo de poli et oche, tordi, qualie, tortore, persutti cum vino biancho et vermilio dolce. La tertia inbandisone: caponi, pecti de capretto et de vitello, carne de manzo cum dil salatto in grande quantitade, teste de vitello, daini, lepore et coniolli in brodo lardero. La quarta imbandisone: caponi coperti a blanchimangiare, minestra de blanchomangiare catellano. La quinta inbandisone: pernici a la catellana cum polvere de duca et succo de neranzi, torti bianchi coperti de anexi, caponi coperti a savore pavonazo, lasagne fricte coperte de zucaro. La sexta imbandisone: caponi, anedre, ochi, vitello, lonze de porco, porchette piene in piede in su una asse depincta, mostarda fina, uva fresca, cedri. La septima imbandisone: cinghiari a galatina, crostade de pizoni. La octava imbandisone: polastri a la chatellana cum fasani et pernice, pastelli et carne de vitello o de capone, torte de pero, galatina de polpe de capone. La

nona imbandisone: ostreghe. La decima imbandisone: peri guaste et peri cotogni coperti de anexi o zebelini. La undecima imbandisone: fructe de diverse sorte, caso parmesano, maroni. La duodecima imbandisone: marzapani, morseletti, zaldoni, vino de Cerea et poi, hautto queste imbandisone, fu dato l'acqua a le mane. La terzia decima imbandisone fu questa: trazea, pignoli, cinnamomo, mandolo, anexi, coriandoli grosi e minuti cum vino vermilio. Facto che fu questo pasto, se balò un gran spatio de hore" (letter from Maddalena Gonzaga to Francesco Gonzaga, Pesaro, 30 October 1489, ASMAG, busta 1065, published in G. Carrà, "Feste e pranzo di nozze di Maddalena Gonzaga," *Civiltà Mantovana* 6 [1972]: 422–31).

14. "Se andò XXII volte ala cosina e per ogni imbandisone se mutava vino" (letter from Federico Gonzaga to Barbara of Brandenburg, Ferrara, 2 May 1462, ASMAG, busta 2097).

15. "Poi fu portato un castello di zuccaro con li merli e torri molto artificiosamente composto pieno di uccelli vivi; il quale come fu posto nel mezzo della sala, uscirono fuore volando tutti gl'uccelli con gran piacere et diletto de' convitati" (P. Cherubino Ghirardacci, *Historia de Bologna*, vol. 1, in L. A. Muratori, *Rerum Italicarum Scriptores*, N.S., Città di Castello, 1900– , p. 238).

16. "Poi appresentorono pavoni vestiti con le loro penne a guisa che facessero la ruota, et a ciascuno de' signori ne fu presentato uno, havendo uno scudo al collo con l'arme sua" (ibid.).

17. ". . . lepri vestiti con la lor pelle, che stavano in piedi, come vivi, con caprioli parimente con la lore pelle. Erano cotti in guazzetto questi animali e tutti gl'animali et uccelli che furono portati in tavola cotti, erano tanto artificiosamente fatti e addobbati con le loro penne et pelli che si mostravano vivi" (ibid.).

18. ". . . et poi un castello pieno di conigli, il quale posato nella sala, uscirono fuore

correndo chi qua et là con risa et piacere de' convitati. Seguitarono poi dietro il castello pasteletti di conigli per cotal modo composti, che non parevano differenti puntino da quelli che dal detto castello erano usciti" (ibid.).

19. "Poscia fu portato un artificioso castello ove era un grosso porco, et posto nel mezzo della sala, non potendo uscir fuori del castello, gridando drizzavasi in piedi, guardando per li merli hora uno et hora l'altro ruggendo, et così affaticandosi et gridando per fuggirsi, apparvero li scalchi con li servi con porchette cotte intiere dorate che in bocca tenevano un pomo" (ibid.).

20. "Venuta l'ora andassemo a cenare e stessemo circha una hora e meza a tavola, dove furon portate molte inbandisone e tutte a son di trombete. Dopo cena venero dui cantori cum uno liuto in uno zardino di sotto a le fenestre de li prefati Signori e canto[r]no molti canzoni e stramotti veneciani, e finita questa melodia andassemo a reposare" (letter from Antonio Gonzaga to Barbara of Brandenburg, Verona, 13 May 1463, ASMAG, busta 1595, published in Lanzoni, *Nozze Gonzaga-Wittelsbach*, p. 20).

21. "Item in la camera de la torre el Signore ad tavola solo cum Hieronymo de Becharia che gli daghi bevere, lo sescalco, et quello porta el piatello, et se faci come Sua Signoria mangia in oro et che lì siano cortesani et zentillomini intorno . . . in la terza saletta sia la illustrissima Madonna ad tavola con madona Isabetta et col signore Octaviano, lo sescalco quello porta el piatello et li altri che servono etc." (published in C. De Rosmini, *Dell'istoria di Milano*, Milan, 1820, IV, p. 148).

22. "Vedonsi in altra parte li cuochi in cocina cocere fasiani, caponi, pepioni, peveraci, spolete e torte, che per la felicità della pictura pare sentirse l'odore dele vivande, e tanto meglio quanto se vede la gaudiosa gente in altra banda reficiarse deli cotti animali, ad mensa distesa sopra

l'herba" (Gundersheimer, 1972, p. 71). The fresco seems to have been on the walls of a loggia on the second floor of the Palace of Belfiore.

23. ". . . al disnare havessimo diversi piaceri, de clavacimbali, di liuti, de buffoni . . . e non gli mancorono soni et buffoni . . ." (letter from Sforza Maria Sforza to his mother, Bianca Maria Visconti, Belfiore, 8 September 1468, Archivio di Stato, Milan, Sforzesco, cart. 1481, published in E. Motta, *Musici alla corte degli Sforza*, Milan, 1887, p. 283 n. 1).

24. "[I buffoni] . . . vivono allegramente alle spalle de' Gentilhuomini e Signori, e trionfano a' pasti de' Prencipi, mentre il dotto Poeta, il facondo Oratore et l'arguto Filosofo fa la sua residenza nel vilissimo tinello" (Tommaso Garzoni, *La piazza universale di tutte le professioni del mondo*, Venice, 1665 ed., discorso CXIX, p. 599).

25. "La buffoneria è vita et anima de la corte" (Pietro Aretino, *Ragionamenti di li corti*, 1538, quoted in Luzio and Renier, "Buffoni e nani," p. 620. ". . . Hor ne' moderni tempi la buffoneria è salita si in pregio che le tavole signorili sono più imgombrate di buffoni, che d'alcuna specie di virtuosi e quella Corte par diminuita e scema, dove non s'oda, o non si veda un Caraffula, un Gonella . . ." (Garzoni, loc. cit.). See also the following studies: G. Bertoni, "Buffoni alla corte di Ferrara," *Rivista d'Italia* 6, fasc. 3–4 (1903): 495–505; E. Welsford, *The Fool: His Social and Literary History*, London, 1935; E. Tietze-Conrat, *Dwarfs and Jesters in Art*, New York, 1957; W. Willeford, *The Fool and His Sceptre*, London, 1969; V. Cian, "Un buffone del secolo XVI: Fra Mariano Fetti," *La Cultura* 1 (13 June 1891): 650–55; V. Cian, "Fra Serafino, buffone," *Archivio Storico Lombardo* 18 (1891): 406–14; A. Graf, "Un buffone di Leone X," in *Attraverso il Cinquecento*, Turin, 1926, pp. 299–319; F. Gabotto, *La epopea del*

buffone, Bra, 1893; and the brilliant psychological interpretation of the darker side of Renaissance dwarfs' lives: P. Lagerkvist, *The Dwarf*, New York, 1945.

26. Luzio and Renier, "Buffoni e nani," p. 620.

27. ". . . quelle gentildonne et gentilhomini hebbeno altro tanto piacere di lui quanto di la festa, che tutti gli faceano carezze et staveno stupefatti in considerare la persona sua" (letter from Jacopo Malatesta to Isabella d'Este, Venice, 2 August 1530, ASMAG, busta 1464, c. 520, published in Luzio and Renier, "Buffoni e nani," pp. 135–36).

28. "La simplicità operava talmente che al tuto pareva dotata de astutissimo ingegno; la deformità, da l'altro canto, piaceva più che se la fosse stata de bellissima forma composta" (letter from Battista Fiera to Marchese Francesco Gonzaga, 27 May 1499, ASMAG, busta 2453, cc. 162–63, quoted in Luzio and Renier, "Buffoni e nani," p. 634).

29. "De ogni altra persona che mi fosse manchata sperarei pur ritrovarne una simile, ma al parangone dil Matello la natura non se saperia fare un altro" (letter from Francesco Gonzaga to Alfonso d'Este, Mantua, 4 June 1499, ASMAG, busta 2909, libro 163, c. 97r).

30. See chapter 2, section II.

31. "Veramente credo non fusse possibile immaginarsi la delectatione, recreatione et piacere ni habia preso; et più ardisco dire che l'è stato causa in questa mia indisposatione de sublevarmi tanti affani et fastidii, ché alcuna fiata non sentiva il male, benché grave sia stato" (letter from Alfonso d'Este to Francesco Gonzaga, 6 September 1498, ASMAG, busta 1187, quoted in Luzio and Renier, "Buffoni e nani," p. 633).

32. "Remaneressimo più fredde che uno giazo, quando se privassimo de lui, non havendo al presente altro buffone né matto da pigliare recreatione" (letter from Isabella d'Este to Gaspare di Sanseverino, 12 March 1496, ASMAG, busta

2992, libro 6, c. 52r, quoted in Luzio and Renier, "Buffoni e nani," p. 632).

33. Some artists were also jesters. For Bartolomeo del Palazzo detto Riverenza, see Luzio and Renier, "Buffoni e nani," p. 649, and G. Campori, *I pittori degli Estensi nel secolo XV*, Modena, 1886, pp. 58–59; for Bartolomeo Melioli, see *Una cena a Mantova nel secolo XV: lettera di Sigismondo Golfo a Benedetto Capilupi*, ed. A. Portioli, Mantua, 1888, and Baldassarre Castiglione, *Il libro del Cortegiano*, bk. 2, chap. 89.

34. A. Venturi, "Gli affreschi del palazzo di Schifanoia," *Atti e Memorie della Deputazione di Storia Patria per le Province di Romagna*, ser. 3, 3 (1886): 391. For a possible portrait of the Ferrarese fool Gonella, today in the Kunsthistorisches Museum, Vienna, see Welsford, *The Fool*, pp. 335ff, 131 n. 1.

35. "Questi Illustrissimi Signori et madonne non mi lasseno ripossare, me bixogna de continuo essere o da l'uno o da l'altro, certificando Vostra prelibata Signoria chi'io li fatio ridere in forma tale che molte volte perdono il mangiare, siché tanto ch'io starò qui me sforzarò di darli piacere per qualuncha via mi serà possibile, pregando Vostra Signoria che se degni avisarme quando gli piace ch'io vegni là" (letter from "Scocola Buffonus" to Lodovico Gonzaga and Barbara of Brandenburg, Milan, 1 July 1462, ASMAG, busta 1622, c. 456, published in Luzio and Renier, "Buffoni e nani," pp. 629–30).

36. ". . . fare i volti, piangere e ridere, far le voci, lottare da sè a sè, come fa Berto, vestirsi da contadino in presenzia d'ognuno, come Strascino: e tai cose, che in essi sono convenientissime, per esser quella la lor professione" (Castiglione, *Il libro del Cortegiano*, bk 2, chap. 50). Garzoni, *Piazza universale*, p. 599, also listed the tricks of the *buffone*: "Hora si vede il buffone con le ciglia de gli occhi dentro ascose, e gli occhi sbardellati, che par guerzo; hora con le labbre torte, che par un mascherone contrafatto; hora con un palmo di lingua fuori, che par un cagnazzo morto dal caldo e dalla sete; hora col collo teso, che par un impicato; hora con la fauci ingrossate, che fa mostra d'haver mille Diavoli adosso; hora con le spalle ingobbate, che par il Babuino da Milano: hora con le braccia rivoltate, che par un Guido propriamente: hora con le mani, e con le dita, fa gesti tali, che pare il bagatella de' trionfi. Col moversi finge il poltrone eccellentemente; col passeggiare fa del Fachin raremente: col volgersi indietro contrafà un bravo molto stupendamente: col suono della voce imita l'Asino, per ispasso con le parole i balbi, et i cocoglieri per trastullo: col gesto le bertuccie per diletto: col riso fa creppar di riso ogn'uno che lo vede . . ." In 1437 Leonello d'Este's "gesticolatore . . . fece mirabili e stupendi gesti del corpo" (quoted in G. Bertoni, *La biblioteca estense e la coltura ferrarese ai tempi del Duca Ercole I (1471–1505)*, Turin, 1903, p. 88).

37. "Fece molte cose da ridere, tra le altre cose che lui fece se vestite da molinaro et corse cum li molinari, et quando lui corea il buttava de la farina adosso alli putti et homini: tutti gli putti se le missono a trali de la polvere et gli ne fu tratta tanta che lo hebbeno a sufochare. Da poi lui andette a vestirsi da femena et corsse [*sic*] cum le puttane et volsse essere l'ultimo, et poi se acompagnò cum quella puttana che era stata ultima et cominciò a piangere et a far de li suoi voltazi che lui sa fare, che'l faceva crepar de ridere ognuno; et fece molte altre cose tutte da ridere, che fu uno gran spasso a la gente" (letter from Ippolito Calandra to Federico Gonzaga, 24 August 1516, ASMAG, busta 2494, published in Luzio and Renier, "Buffoni e nani," p. 120).

38. "Facendo tante patie, che ormai io credo de havere fato questo guadagno de essere magiore pazo che Dioda" (letter from Galeazzo Visconti to Isabella d'Este, Milan, 11 February 1491, ASMAG, busta 1630, cc. 2–3, published in A. Luzio and R. Renier, "Delle relazioni di Isabella

d'Este Gonzaga con Ludovico e Beatrice Sforza," *Archivio Storico Lombardo* 17 [1890]: 108).

39. "Per questa mia notifico a Vostra Signoria come lo Illustrissimo Signor vostro padre me ha electo suo primo unigenito figliolo per li mei boni deportamenti ed benemeriti, et spero, quando Vostra Signoria sarà gionto a Mantua, che quella se ritroverà in grandissimo erore, pensando di essere tri fratelli e poi essere quatro, e pegio che Vostra Signoria non è per haver altro dil patrimonio se non Belzoioso, al quale a questa hora è manzato le intrate et fitto; per l'avenir poco havareti per essere tempestato, siché Vostra Signoria facia nova provisione circha al viver suo. . . . A Vostra Signoria me aricomando; tuti ve aspetamo cum grandissimo desiderio, eccepto el Signor nostro padre perché Vostra Signoria sia decaduta assai dil suo amore: lontan da ochio, lontan da core" (letter from "Naninus" to Federico Gonzaga, Mantua, 16 January 1517, ASMAG, busta 2496, c. 238, published in Luzio and Renier, "Buffoni e nani," p. 133).

40. "Non vi potteressimo ringratiare a compimento per Biasio, nano, quale altre volte per vostra zintileza et liberalitade ce mandasti, perché ogni dì più ne piace et più piacere e consolatione ne piliamo" (letter from Francesco Sforza to Nicolò de' Vittellensi, Milan, 3 September 1451, Archivio di Stato, Milano, Missive ducali, cart. 6, c. 141r). "La secunda salleta ove manzano le donne la Illma. Madonna, la Illma Ma. Isabeta che zoghi al ballone, o ala pomma cum le sue donzelle ad triumphi al pelluco, et gli sia Vergilio, D. Biaso et Zohanne Antonio Buffone. La nanna porti fonzi in scosso ad Madonna" (De Rosmini, *Istoria di Milano*, IV, p. 148).

41. "E poi venuta tanto piacevole de parole et atti, che existimamo se farrà la megliore buffona del mundo et speramo haverne piacere" (letter from Isabella d'Este to Teodora Angelini, 14 June 1491, ASMAG, busta 2991, libro 1, c. 3v, published in Luzio and Renier, "Buffoni e nani," p. 143). Isabella is writing of her *moretta* (little black girl).

42. ". . . de bufonij non ge mancha di più sorte" (Schivenoglia, *Cronaca di Mantova*, p. 153).

43. "Francesco buffone n'è stato ancoi qui como el suo cavaleto, el qual, madona mia, ha fato miracoli; non nè comparacione a le cose ch'el fa a quelle ch'el faxeva al tenpo ch'el fu a Mantova: fate conto che tuto quello che'l gli è comanda', quello el fa: par propio che quel cavallo abia intelleto" (letter from Guido Nerli to Barbara of Brandenburg, Ferrara, 7 March 1462, ASMAG, busta 1228, c. 389, quoted in Luzio and Renier, "Buffoni e nani," p. 631). This is probably the same individual referred to in a letter from Barbara of Brandenburg to Bianca Maria Visconti of 26 February 1458 as "Francischino mio nano" (ASMAG, busta 2886, libro 33, c. 59r) and by Zaccaria Saggi in a letter of 9 May 1460 to Barbara of Brandenburg, complaining about the meager dimensions of the beds in the monastery of S. Maria Novella in Florence: "per me, che'l giorno a essere in Fiorenza era ad essere in paradiso e la note in purgatorio, però chio mi trovai allogiato in una cella, ove era uno lettiera fata a la forma e bisogno più di meser Franceschino che al mio . . . (ASMAG, busta 1099, cc. 322–23, published in A. Portioli, ed., *I Gonzaga ai bagni di Petriolo di Siena nel 1460 e 1461*, Mantua, 1869, p. 7).

44. "Era vestito da vescovo, che pareva la più bella cosa del mondo . . . et vine ad incontrare el Duca con gran cirimonia che non fu mediocre piacere, anzi dà ridere ad ognuno" (letter from Lorenzo Strozzi to Federico Gonzaga, 13 November 1512, ASMAG, busta 2485, quoted in Luzio and Renier, "Buffoni e nani," p. 131).

45. Letter from Bernardino Prosperi to Isabella d'Este, Ferrara, 24 March 1490, ASMAG, busta 1231, c. 738, published in

Luzio and Renier, "Buffoni e nani," p. 637. In the household accounts of Mahaut, Countess of Artois and Bourgogne, 1310–12, her jester, "le petit nain" or "le petit folet," received a specially made suit of armor; in 1321 another jester, Jeannot, "le petit folet," tilted at a quintain at Conflans (J. M. Richard, *Une petite-nièce de Saint Louis*, Paris, 1887, p. 112 nn. 2, 3). See also V. J. Harward, *The Dwarfs of Arthurian Romance and Celtic Tradition*, Leiden, 1958, pp. 24–25.

46. Dwarfs may have had a particular position in tournament ceremonial, as illustrated in the Leningrad Ms. of René d'Anjou's *Devis d'un tournoy*, ff. 6, 10v, 18, where the dwarf holds a kind of scepter (I. Toesca, "More about the Pisanello Murals at Mantua," *Burlington Magazine* 118 [1976]: 625 n. 6). See also Tietze-Conrat, *Dwarfs and Jesters*, p. 75. In 1468 a dwarf gave the signal for the jousting to begin at the tournament held on the occasion of the marriage of Charles of Burgundy to Margaret of York (R. C. Clephan, *The Tournament: Its Periods and Phases*, New York, 1919, p. 79).

47. Harward, *Dwarfs of Arthurian Romance*, passim.

48. A dwarf follows the equestrian knight on the portrait medal of Gianfrancesco Gonzaga (Fig. 56), and Pisanello also included dwarfs in two drawings in the Louvre: inv. 2595r (Fossi Todorow, 1966, cat. 65) and 2594v (ibid. cat. 66).

49. "Et perché havemo informatione ch'el c'è un altro suo fratello più nano et minore ancora che questo haverissemo singulare piacere poterlo havere . . ." (letter from Francesco Sforza to Nicolò de' Vittellensi, 3 September 1451, Archivio di Stato, Milano, Missive ducali, cart. 6, c. 141r, quoted in Motta, *Musici*, p. 280). "Io promisi già quatro anni sono a Madama Illustrissima Renea di voler dare a Sua Excellentia el primo fruto che usise della raza delli mei

nanini, dico de femina: et comme Vostra Signoria sa, hormai sono dui ani che naque una putina la qualle, anchora non dia speranza di dover restare in tutto cossì piccola come è la mia Dellia, nondimeno senza alcun dubbio remanerà nana" (letter from Isabella d'Este to Diana d'Este, 11 September 1532, ASMAG, busta 3000, libro 51, c. 64r, published in Luzio and Renier, "Buffoni e nani," p. 134). The dwarfs in Pisanello's drawings (Louvre, inv. 2594v and 2595r) are also tiny.

50. See n. 43.

51. L. B. Alberti, *On Painting and Sculpture*, ed. C. Grayson, London, 1972, para. 42, p. 83.

52. ASMAG, busta 398, c. 38.

53. Efforts to recognize humor in fifteenth-century painting have, for the most part, concentrated on paintings based on classical texts. See, for instance, E. Wind, *Bellini's Feast of the Gods*, Cambridge, 1948; E. Tietze-Conrat, "Mantegna's Parnassus: A Discussion of a Recent Interpretation," and E. Wind, "Mantegna's Parnassus: A Reply to Some Recent Reflections," *Art Bulletin* 31 (1949): 126–30; 224–31.

54. See comments in M. Baxandall, *Painting and Experience In Fifteenth Century Italy*, Oxford, 1972, p. 152. See also E. Le Roy Ladurie, *Montaillou*, New York, 1978, p. 189.

55. See N. Z. Davis, "Women on Top," *Society and Culture in Early Modern France*, Stanford, Calif., 1975, pp. 124–51.

56. See R. Kelso, *Doctrine for the Lady in the Renaissance*, 2d ed., Urbana, Ill., 1978.

57. "conoscendo la sua laudabile consuetudine de non volere tropo parole . . ." (letter from Alessandro Gonzaga to Barbara of Brandenburg, 6 May 1461, ASMAG, busta 1100, cc. 40–41, published in Portioli, *Bagni di Petriolo*, p. 32).

58. E. W. Swain, " 'My Excellent and Most Singular Lord': Marriage in a Noble Family of Fifteenth Century Italy,"

Journal of Medieval and Renaissance Studies 16 (1986); Mahnke, 1975, p. 402.

59. Knights such as Bohort in search of the Grail were supposed to retain their virginity. See chapter 2, text at n. 102.

60. ". . . e quando me trovasse nel caso del partorir sia certa la Cel. Vostra ch'el magior conforte e allevatione de dolore potesse havere seria sentendomi quella apresso per la speranza ho in lei che me pare pur me debia sempre aiutare, si che la non falla de niente a dire che la me scusaria una bona comatre" (letter from Barbara of Brandenburg to Lodovico Gonzaga, 23 September 1463, ASMAG, busta 2097, published in Swain, "Marriage," n. 94).

61. ". . . che de questo non ne parlate chon persona, io non digo chon Madonna la Marchesana, perché quando digo voi, io intendo de dire voi et liei [*sic*] perché so che siti dui chorpi et un'anima . . ." (letter from Francesco Sforza to Lodovico Gonzaga, Milan, 8 March [undated but ca. 1460], ASMAG, busta 1607, c. 65).

62. *Inferno*, V. 127–38.

63. For references to these two cycles, see chapter 2, n. 85–88.

64. The 1436 inventory of Leonello d'Este's residence in Ferrara, for instance, defines the room in which Leonello ate with his household as a *sala* but that in which he slept as a *camera*. See G. Bertoni and E. P. Vicini, *Il Castello di Ferrara ai tempi di Niccolò III: l'inventario della suppellettile del castello, 1436*, Bologna, 1906, pp. 38, 80.

65. ASMAG, busta 398, cc. 9–38; letter from Filippino de' Grossi to Barbara of Brandenburg, 29 November 1463, ASMAG, busta 2398, in which he counted fifteen beds spread over ten *camere*. The 1407 inventory did not itemize the contents of rooms called *sale*, suggesting that they contained no furniture. In the 16th century neither the *Sala Principale* on the *piano nobile* nor the *Sala Grande* on the second story of the Palazzo Rucellai in Florence contained beds or chests. See B. Preyer, "The Rucellai Palace," in *Giovanni Rucellai ed il suo zibaldone*, vol. 2, *A Florentine Patrician and His Palace*, London, 1981, pp. 173, 175. Restricted furnishing of the rooms called *sale* is also consistent throughout inventories of Medici property. See W. A. Bulst, "Die ursprüngliche innere Aufteilung des Palazzo Medici in Florenz," *Mitteilungen des Kunsthistorischen Institutes in Florenz* 14 (1970): 387, 389; J. Shearman, "The Collections of the Younger Branch of the Medici," *Burlington Magazine* 117 (1975): 17.

66. Part of the interrogation during her trial in February 1391 reads "Quod aliquibus vicibus osculatus est eam, et in camera sua Lanzaloti . . . ubi cubabat cum domino . . ." (ASMAG, busta 3451, c. 277r, reg. "Processus ac Sententiae contra dominam Agnetem de Vicecomitibus et Antonium Scandianum . . ." published in S. Davari, *Notizie storiche topografiche della città di Mantova nei secoli XIII, XIV e XV*, 2d ed., Mantua, 1903, p. 26).

67. G. Reichenbach, *Costumi della Rinascenza: una giostra*, Padua, 1925, p. 12. The words were used in connection with Ercole d'Este's joust in Reggio in 1476.

68. "Che havendo la soa excellentia deliberato da fare questa festa a piacere e a solatio de soa citade Ferrara . . ." (G. Rossi, ed., *Un torneo del 1462*, Reggio Emilia, 1883, p. 13).

69. "Volendo lo Illustrissimo Principe et Excellentissimo Signore nostro messer lo Marchese de Mantua honorare quanto li sia possibile lo Illustrissimo Signore Conte delphino, suo cugnato, in questa ritornata da Roma e dare a Sua Signoria qualche honesto piacere e che sia laudabile, ha pensato de fare una giostra ad arme da demenino, parendo che niuna cosa sia de magiore fame e laude cha l'arte militare in la qual persona alcuna non pò pervenire ala perfectione senza exercicio . . . siché lo prefato Signore

nostro cupido de imortale gloria, imitatore de li suoi illustri progenitori li quali sempre hano cum dignissimi effecti dimonstrato la lor singular virtute et magnanimitate . . ." (20 April 1485, ASMAG, busta 2038/9, fasc. 7, cc. 19v–20r).

In a joust *ad arme da demenino*, lances were fitted with enlarged blunted heads (coronels) that made it easier to strike the opposing horseman but harder to pierce his armor and kill him. See Reichenbach, *Costumi*, pp. 15–16; id., "Note sul costume cavalleresco del Quattrocento: il demenino," *Archivum Romanicum* 9 (1925): 456–57.

70. M. Mallett, *Mercenaries and Their Masters*, London, 1974, p. 212. Francesco Sforza referred to *disciplina militare* when organizing a joust to be held in Pavia in 1460 (C. Magenta, *I Visconti e gli Sforza nel Castello di Pavia*, 2 vols., Milan, 1883, II, docs. 277–78, p. 247).

71. "Et perché a questa giostra non serà admesso alcuno experto in arme . . ." (*proclama* for the tournament in Reggio Emilia, June 1476, published in Reichenbach, *Costumi*, p. 12).

72. As well as the sources quoted, this section is based on the following studies: Clephan, *The Tournament*; F. H. Cripps-Day, *The History of the Tournament in England and in France*, London, 1918; R. Barber, *The Knight and Chivalry*, New York, 1974; R. Rudorff, *Knights and the Age of Chivalry*, New York, 1974; R. Truffi, *Giostre e cantori di giostre: studi e ricerche di storia e di letteratura*, Rocca San Casciano, 1911; P. O. Kristeller, "Un documento sconosciuto sulla giostra di Giuliano de' Medici," *Bibliofilia* 41 (1939): 405–17. For an ideal and very formal tournament, see René d'Anjou, *Traité de la forme et devis d'un tournoi*, ed. E. Pognon, Paris, 1946; *Traicté de la forme et devis comme on faict les tournois par Olivier de la Marche, Hardouin de la Jaille, Anthoine de la Sale, etc.*, ed. B. Prost, Paris, 1878. For 17th-century accounts of tournaments, see Marc de Vulson

Sieur de la Columbière, *Le vray théâtre d'honneur et de chevalerie ou le Miroir Héroique de la Noblesse*, Paris, 1648.

73. "Qua ogni homo sta in festa et alegreza. . . . Dominica proxima . . . se farà el sposamento, et deinde se faranno giostre et torniamenti, et bagordamenti, et danze, et feste . . ." (letter from Francesco Sforza to Antonio de Tricio, Milan, 18 May 1465, published in De Rosmini, *Istoria di Milano*, IV, doc. XX, p. 43). The tournament in the Torre dell'Aquila, Castello di Buonconsiglio, Trent, is depicted as taking place in the month of February.

74. "Curiosità d'archivio," *Archivio Storico Lombardo* 12 (1875): 323–24. It later degenerated into a brawl in which *mechanici* and other lower-class jousters hurled stones at each other.

75. C. Morbido, *Codice visconteo-sforzesco*, Milan, 1846, pp. 338, 345 (texts of *gride* of 19 and 23 March 1450, 9 February 1452); B. Corio, *Storia di Milano*, ed. A. M. Guerra, Turin, 1978, p. 1334.

76. ". . . facendo far giostre, caze, balli et ogni cossa a zò bisogniosa . . ." (letter from Barbara of Brandenberg to Paola Malatesta, Plasimberg, 23 June 1442, ASMAG, busta 2094).

77. R. Signorini, "Cristiano I in Italia," *Il Veltro* 25 (1981): 35, basing himself on J. Petersen, *Der Holsten Chronica*, Lübeck, 1599, p. cxxvi.

78. "Charming and delightful tournament of brave and valiant men" (Reichenbach, *Costumi*, pp. 8–9).

79. G. Lanzoni, *Nozze Gonzaga-Wittelsbach*, pp. 29, 43. For *arme da demenino*, see n. 69.

80. "Corerà con voi tanto che uno de voi rompe sei lanze" (letter from Nicolò degli Ariosti to Lodovico Gonzaga, Ferrara, 16 May 1464, ASMAG, busta 1228, cc. 487–88, published in C. M. Rosenberg, "Notes on the Borsian Addition to the Palazzo Schifanoia," *Musei Ferraresi* 3 [1973]: 35).

81. "Ne pare ben affirmare senza sospetto alcuno de jactantia che in epsa [giostra]

sono rotte tante lanze quanto mai sia stato in Italia za grandissimo numero de anni in una giostra e la grosseza de le lanze è stata non solo fora de la qualità usitata ma sopra omne credulità ad chi non le havesse vedute" (letter from Gian Galeazzo Sforza to Francesco Gonzaga, Milan, 29 January 1491, published in Porro Lambertenghi, "Nozze di Beatrice d'Este e di Anna Sforza," *Archivio Storico Lombardo* 9 [1882]: 521).

82. ". . . che habiano le spade senza punta e senza taglio" (*grida* of Borso d'Este published in Rossi, *Torneo*, p. 13).

83. "Fecono tre asalti, el primo cum le spade ferasse solamente de taglio, el secundo cum le maze de legno, el terzo pur cum le maze" (letter from Federico Gonzaga to Barbara of Brandenburg, Ferrara, 2 May 1462, ASMAG, busta 2097).

84. "E se per sagura niuni de dicti torniaduri cascasse da cavalo, on chel cavalo ghe cascasse soto, on per urto de altri, on per qualche altro modo, e chel nesisse de la sella che non possi più havere el pretio et chel nesca de le sbare et chel non possi più dare adiuto ala parte soa, né a piedi né a chavalo . . ." (Rossi, *Torneo*, p. 14).

85. ". . . e che se niuno se cavarà lelmone on chel ge sia cavate per qualunca modo, chel non deba ne possa più havere el pretio . . ." (Borso d'Este's 1462 *grida*, published in ibid.). "Ancora che se alcuno de detti giostratori cascasse non possa giostrare più, excepto se cascasse per urto, o per essere il cavallo ferito o guasto dal compagno, o che'l cascassi da per si stesso senza essere urtato che in questi casi possino giostrare, et mutare cavallo" ("Regolamento delle giostre che si tennero in Milan in 1465," published in A. Angelucci, *Armilustre e torneo con armi da battaglia tenuti a Venezia addì 28 e 30 maggio 1458*, Turin, 1866, app., p. 33).

86. Pius Secundus, *Commentarii Rerum Memorabilium* . . . Rome, 1584, pp. 37–38, 165–66.

87. "Wir sind yor mit gots hilff die fordersten in Turnier gewesen und gedenkens aber zu bleiben" (quoted in R. C. Clephan, *The Tournament*, p. 43).

88. ". . . due palii de XXV braza de cetanino velutato cremesino" (Lanzoni, *Nozze Gonzaga-Wittelsbach*, p. 29). Lodovico thanked Sforza for "li giostratori suoi che quella se dignata mandare qui per honorare queste mie noze i quali nel vero se sono portati benessime et hanno facto honor assai a la Excellentia Vostra e riportano il pretio de li coretori" (letter from Lodovico Gonzaga to Francesco Sforza, Mantua, 10 June 1463, ASMAG, busta 2887, libro 41, c. 51v, cited in Mahnke, 1975, p. 364 n. 6).

89. ". . . chi ge exercitarà ed operarà in dicto torniamento per dicto tempo più gaiardamente, più valerosamente o più pelegrinamente che niuno altro . . . guadagnarà, et haverà Braza vinte de dalmaschino on cetananino Brochato de argento bellissimo de pretio de ducati cento e più" (*grida* of Borso d'Este, quoted in Rossi, *Torneo*, p. 15). "Fatta una crida longa per lo trombetta, fu dato el precio al signor meser Sigismondo como a quello che se havesse portato più prudentamente, cum più animo e chi havesse fatto più virilmente" (letter from Federico Gonzaga to Barbara of Brandenburg, Ferrara, 2 May 1462, ASMAG, busta 2097).

90. Angelucci, *Armilustre 1458*, p. 12.

91. "Né creda Vostra Illustrissima Signoria che questi anelli fosseron de precio de uno fiorino, ma ge eran de quelli che valeano più de cento, tale 80, tale 50, tal 60, tale x, tale 15 et vinte, secondo gli homini, in forma che l'è costato quelli annelli da li seicento fina a li septecento ducati" (letter from Nicolò degli Ariosti to Lodovico Gonzaga, Ferrara, 16 May 1464, ASMAG, busta 1228, c. 487).

92. "Nui se maravigliamo grandemente che vi siate tirati indreto de non vole fare le spese ali chiostradori che haverano a venire laoltre ad honorare quela vostra festa . . . et tanto più ce ne maravigliamo, quanto che vedemo, che de le cosse de grande spese non ne facti conto,

et che de questa, che è minima, et che vi cede a tanta honorificentia, ne faciati conto. . . . Et quando pur questa spesa vi paresse tropo grande, factine levar via de quele altre, che non sono de tanto honore ni de tanta reputatione . . ." (letter from Ercole d'Este to the *Anziani* of Reggio, Modena, 8 June 1476, published in Reichenbach, *Costumi*, p. 10).

93. "M'è stato necessario ritenere qua tutti questi cavalli ho im prestito, che m'è una grave ispesa che già sariano in via . . ." (letter from Rodolfo Gonzaga to Barbara of Brandenburg, Florence, 3 February 1475, ASMAG, busta 2102).

94. "Advisando cadauno, che tuti queli il quali intrarano a questa giostra haverano a dare segurtade de refare li cavali che guastesseno" (rules for the tournament held in Reggio Emilia in June 1476, published in Reichenbach, *Costumi*, p. 12). "Ancora che se alcuno giostratore ferissi cavallo de punta di lanza amazandolo, o cavandoli lo occhio, o guastandolo in modo che rimanessi guasto, sia tenuto pagharlo a lo iudicio delli iudici deputati a buttare la sententia" (rules for the tournament held in Milan in May 1465, published in Angelucci, *Armilustre, 1458*, p. 33).

95. Mallett, *Mercenaries*, p. 141. In 1494 Marchese Francesco purchased five horses, two foals, and three mules in Spain for 359 ducats and, in 1495, four Turkish horses for 280 ducats (C. Cavriani, *Le razze gonzaghesche dei cavalli nel Mantovano e la loro influenza sul puro sangue inglese*, Mantua, 1909, pp. 14–15).

96. Extensive documentation for the court of Ferrara was published in L. A. Gandini, "Viaggi, cavalli, bardature e stalle degli Estensi nel Quattrocento," *Atti e Memorie della R. Deputazione di Storia Patria per le Province di Romagna*, ser. 3, 10 (1892): 41–94.

97. "Era una camera forte adornata . . . e su per le spaliere erano quadri che erano retrati li soi belli cavali e belli cani, e li era uno nanino vestito d'oro" (*I diarii di*

Marino Sanudo, ed. F. Stefani, G. Berchet, and N. Barozzi, Venice, 1887, XXI, col. 281).

98. By 1488 Francesco Gonzaga owned 650 horses, and stables were being built for the best mares on the Te island; gifts of horses were made to Louis XII of France in 1504 and Henry VIII of England in 1514, and by 1520 it was common knowledge that the Emperor's stables were also furnished by Mantua. See Cavriani, *Razze cavalli*, pp. 3–35; R. Castagno, "Nascita e formazione delle scuderie dei Gonzaga," *Civiltà Mantovana* 10 (1976): 14–31.

99. "Havendo nui visto la prova che de questo nostro paese reiusce de boni et aventazati roncini et cussì cavaloti de meza taglia, havemo dato principio a far una raza de cavalle et havemone de ogni sorte de grande, mezane et pizole . . ." (letter from Lodovico Gonzaga to Giovanni Francesco di Bagno, Mantua, 16 March 1463, ASMAG, busta 2888, libro 45, c. 38v). See also letter from Vincenzo della Scalona to Lodovico Gonzaga, Milan, 11 January 1460, ASMAG, busta 1621, c. 14; letter from Marsilio Andreasi to Barbara of Brandenburg, Canetto, 16 May 1474, ASMAG, busta 2415, c. 1204 (about King Christian of Denmark's gift to Lodovico of a large bay horse); Signorini, 1985, p. 292 n. 279.

100. At the end of the 15th century, one of the rooms of the palace at Marmirolo, painted with Gonzaga horses, was called the *Camera dei Cavalli* (S. Davari, *I palazzi dei Gonzaga in Marmirolo*, Mantua, 1890, p. 6).

101. J. G. Mann, "The Sanctuary of the Madonna delle Grazie, with Notes on the Evolution of Italian Armour during the 15th Century," *Archaeologia* 80 (1930): 117–42; id., "A Further Account of the Armour Preserved in the Sanctuary of the Madonna delle Grazie near Mantua," *Archaeologia* 87 (1938): 311–52, esp. pls. CII–CIII; L. G. Boccia, *Le*

armature di S. Maria delle Grazie di Curtatone di Mantova e l'armatura lombarda del Quattrocento, Varese, 1982. The folios in the 1407 inventory devoted to the Gonzaga armory were published by J. G. Mann, "The Lost Armoury of the Gonzagas," *Archaeological Journal* 95 (1939): 274–83. See also V. Goloubew, *Les dessins de Jacopo Bellini au Louvre et au British Museum*, 2 vols., Brussels, 1908, II, pl. 68 (standing knight dressed in modern armor).

102. G. F. Hill, "Milanese Armourers' Marks," *Burlington Magazine* 36 (1920): 49–50; G. de Lorenzi, *Medaglie di Pisanello e della sua cerchia*, Florence, 1983, cat. 13, p. 54. For very tentative identifications of the armorer as Ambrogio de Osma of Brescia or Anrigolo d'Arconate, see Boccia, *Armature*, p. 286; C. A. de Cosson, "Milanese Armourers' Marks," *Burlington Magazine* 36 (1920): 150. For documentary references to armorers who served at the court of Mantua, see A. Bertolotti, *Le arti minori alla corte di Mantova nei secoli XV, XVI e XVII*, Milan, 1889, pp. 120ff.

103. On 17 July 1458 Antonio, Francesco, Ambrogio, and Damiano Negroni, sons of the late Tomaso, called Missaglia, arranged for their procurator Bartolomeo da Paderno in Lodi to receive from the Marchese Lodovico Gonzaga, his brothers, and his nephews "omne et totum id, quod dicti constituentes habere debent, et in futurum habebunt a prelibatis Ill. et Mag.cis dominis occasione quarumlibet quantitatum armarum diversarum manierum datarum per dictum quondam dom. Thomasium Missaliam nunquam delende memorie genitori prelibati Ill.ris d. Ludovici marchionis et fratruum suorum" (Archivio di Stato, Milan, Notarile, cart. 1415, Giacomo Brenna, 17 July 1458, published in E. Motta, "Armaiuoli milanesi nel periodo visconteo-sforzesco," *Archivio Storico Lombardo* 41 [1914]: 208). Milanese armorers also worked in Mantua; in 1436 "mastro Petro de Mediolano armarolo" was recorded "in civitate Mantue" (A. Venturi, "Relazioni artistiche tra le corti di Milano e Ferrara," *Archivio Storico Lombardo* 12 [1885]: 230).

104. ". . . passarono per le boteghe de l'arme, le quale erano tute in ordine et entroe in casa del Misaglia, la quale era tuta piena d'arme . . ." (letter from Zaccaria Saggi to Lodovico Gonzaga, Milan, 16 March 1474, ASMAG, busta 1624, published in Signorini, "Cristiano I in Italia," pp. 43–44).

105. ". . . più volte [sua Maestà] lo ha facto andare in camera soa di giorno et di nocte et quando andava a dormire; adciò [Francesco di Missaglia] vedesse la persona soa et cognoscesse el volere suo et l'aptitudine, bisognava de l'armatura a che non gli facesse male in modo alchuno; perché ha una persona molto delicata" (letter from Gian Pietro Panigarola, Milanese ambassador in France, to the Duke of Milan, 17 April 1466, quoted in Motta, "Armaiuoli milanesi," p. 210).

106. J. Herald, *Renaissance Dress in Italy 1400–1500*, London, 1981, p. 218; R. Levi Pisetzky, *Storia del costume in Italia*, Milan, 1964, II, pp. 339–40. A *giornea* was often worn with armor, was usually very rich, and was often covered with heraldic devices. Pisanello's practical designs for horse caparisons (for example, Louvre, 2632r) can be contrasted with the unlikely fantasy caparison designed by Jacopo Bellini (Goloubew, *Jacopo Bellini*, II, pl. XLVII).

107. "La Illustrissima Madonna duchessa ha facto presentare una peza de drapo d'oro cremesino; lo Illustrissimo conte Galeaz una de drapo d'oro verde; Fiorentini una de drapo d'oro cremesino" (letter from Barbara of Brandenburg to Cardinal Francesco Gonzaga, 11 June 1463, ASMAG, busta 2887, libro 41, c. 52v, published in Lanzoni, *Nozze Gonzaga-Wittelsbach*, p. 29). At the Bentivoglio-Este

marriage in 1487 gifts included a piece of gold brocade worth 150 ducats from the King of Naples, crimson velvet worth 150 ducats from the Duke of Milan, crimson silk worth 150 ducats from the Duke of Calabria, and silver brocade worth 150 ducats from Lodovico Sforza (Ghirardacci, *Historia de Bologna*, p. 239).

108. ". . . te mandiamo una pecia de brochato d'oro la quale volemo se presenti a la Majestà del re per nostra parte insieme cum doe peze integre de zatonino vellutato cremesile et roso del più bello che se trova . . ." (letter from Filippo Maria Visconti to Niccolò Piccinino, 22 November 1431, Archivio di Stato, Milan, Visconteo-Sforzesco, cart. 12, c. 53).

109. ". . . coverti il capo di celata d'oro, con penna in cima di pavone" (*Descrizione della giostra seguita in Padova nel giugno 1466*, ed. G. Visco, Padua, 1852, p. 11).

110. ". . . perché condusse molto più quantitate de cavalli e homeni vestiti a livrea che non fece alcuno di loro e in più numero de sopraveste e in più bella fogia de cimiero suso l'elmo perché e non s'è costumato di vedere qua questi capelli fatti a la turchesca e parvero belli a ciaschuno . . ." (letter from Enrico Suardo to Barbara of Brandenburg, Florence, 31 January 1475, ASMAG, busta 1101, c. 463).

111. Louvre, inv. 2295 (Fossi Todorow, 1966, cat. 80). References to beaten-up, old-fashioned tournament helmets abound in inventories (Bertoni and Vicini, *Castello di Ferrara*, p. 34, no. 456; p. 80, nos. 1364–65).

112. "Stando lor suso la piaza el duca disse che'l daseva el vanto . . . ad Alberto da la Sala che havesse la più bella foza de penagio e a Teophilo che havesse la più bella sopravesta da cavallo" (letter from Federico Gonzaga to Barbara of Brandenburg, Ferrara, 2 May 1462, ASMAG, busta 2097).

113. ". . . uno vestito de panno d'oro creme-sino . . . più de 100 zoveni vestiti tuti de veluto" (letter from Giorgio della Strada to Barbara of Brandenburg, Verona, 5 June 1463, ASMAG, busta 1595, published in Lanzoni, *Nozze Gonzaga-Wittelsbach*, p. 27).

114. "Enea Malvessi era vestito di raso incarnato con una berretta ornata tutta di perle; Gasparo Malvezzi e Giovanni di Battista Malvezzi erano vestiti di raso cremisino; Jacomaccio Bargellini era vestito di alessandrino; Salustio Guidotti era vestito de raso verde" (Ghirardacci, *Historia de Bologna*, p. 237).

115. Francesco Filelfo, for instance, was prepared to accept a second-hand *vestito degno*, valued at 100 ducats, from Lodovico Gonzaga in lieu of a financial subsidy: "Priegho la Vostra Signoria mi vogliate agiutare, per honore di le muse, di ducati cento, overo d'uno vestito degno foderato da mezzo tempo o da estate, quale pare conveniente a la Vostra Excellentia, e torrò così usato uno di vostri come nuovo, né me potrà essere corto essendo tanto minore di la Vostra Signoria quanto li pygmei erano minore di Hercole" (letter from Francesco Filelfo to Lodovico Gonzaga, Milan, 5 February 1464, ASMAG, busta 1622, c. 1043).

116. L. Martines, *Power and Imagination*, New York, 1979, p. 233; P. Zumthor, "From Hi(story) to Poem, or the Pathos of Pun: The Grands Rhetoriqueurs of 15th Century France," *New Literary History* 10 (1979): 240. See also Pisanello's studies of textiles and of male and female costume in Fossi Todorow, 1966, cats. 75–79, 84, 170, 190.

117. *Conviviorum Francisci Philelphi libro due . . .* Paris: H. Lefevre, n.d. [early-16th-century edition], unpaginated. The reference comes from A. D. Fraser Jenkins, "Cosimo de' Medici's Patronage of Architecture and the Theory of Magnificence," *Journal of the Warburg and Courtauld Institutes* 30 (1970): 166–67, who articulated the concept of magnificence

in relation to architecture, citing Aristotle's discussion of which class of people could be magnificent. Aristotle excluded the poor, *"but great expenditure is becoming to those who have suitable means to start with, acquired by their own efforts or from ancestors or connections, and to people of high birth and reputation and so on, for all these things bring them greatness and prestige"* (*Nicomachean Ethics*, trans. W. D. Ross, 1915, 1122b, lines 30ff.; emphasis added).

118. "Chi dice che la magnificenza sia frutto del denaro a mio parere esprime un pensiero giusto e fondato sulla esperienza reale" (Giovanni Pontano, *I trattati delle virtù sociali: de magnificenza*, trans. Francesco Tateo, Rome, 1965, p. 233).

119. "Puossi colle richezze conseguire fama e autorità adoperandole in cose amplissime e nobilissime con molta larghezza e magnificenza" (L. B. Alberti, *Opere volgari*, vol. 1, *I libri della famiglia*, ed. C. Grayson, Bari, 1960, p. 141).

120. "Li quali non senza degna laude et magnifico tuo recivimento anchora recordano, come magnificentia in le cose pubbliche e de spense grande consiste" (Gundersheimer, 1972, p. 78).

121. "Lassaremo stare de narrare le magnificentie, le glorie et li triumphi d'arme, de giostre e torniamenti, che hai facto più presto per honorare altrui et per dare ali toi amantissimi populi piacere et ala tua splendida corte, che per tuo proprio dilecto, che questo non è stato senza singulare spensa e tua magnifica laude" (ibid. p. 78). See also P. J. Jones, "Economia e società nell'Italia medievale," in *Storia d'Italia*, vol. 1, *Dal feudalesimo al capitalismo*, Turin, 1978, p. 356.

122. "La magnificentia dunque considerare si debbe che in cose sumptuose, grande et sublime consiste. Come il nome de epsa suona largheza et amplitudine in expendere auro et argento in cose eminente" (Gundersheimer, 1972, p. 50).

123. "Comitatus illi permagnus fuit, admodum nobilis, in quo nemo visus est, cuius vestimenta non auro fulgerent, aut argento splendida essent" (Pius Secundus, *Commentarii*, p. 131).

124. See n. 21.

125. L. A. Gandini, *Tavola, cantina e cucina della corte di Ferrara nel Quattrocento*, Modena, 1889, pp. 53, 55.

126. "Recordiamo dunque Lodovico Gonzaga antista mantuano reverendissimo, che'l suo sereno sangue e latino nome tanto honora, che de munificentia e liberalitate, de geme, de vasi, de argento, de pecunia, de auro, de pani, de drappi sericci, de cavalli e de grani, vini et de altre sue optime substantie dove se conviene ali amici probi e virtuosi et ala fede de' suoi servitori non è di minor laude dela pia e grande munificentia che fece Nicolao de Bari, episcopo sanctissimo, quando de tre riche palle d'oro munificò quel nobil patre in egestate constituto, in maritare tre sue figlie" (Gundersheimer, 1972, p. 48).

127. Words used by Luchino Visconti when requesting the loan of an Arthurian romance in the Gonzaga library. See chapter 2, n. 43.

128. "Hilarescimus maioreum in modum animis, cum pictas videmus amoenitates regionum et portus et piscationes et venationes et natationes et agrestium ludos et florida et frondosa" (Alberti, *L'architettura: De Re Aedificatoria*, II, bk. 9, chap. 4, p. 805). This of course is a shortened version of the landscape subjects that Vitruvius recommends for villa decoration (*De Architectura*, 7, v).

129. "Ad boschi cum cervi, davinij et altri animali" (De Rosmini, *Istoria di Milano*, IV, pp. 148–49).

130. "terenj cum aque et animalj" (A. Venturi, "Le arti minori a Ferrara nella fine del sec. XV: l'arazzeria," *L'Arte* 12 [1909]: 207). For the names of the rooms in the Gonzaga palace, see the 1407 inventory in ASMAG, busta 398, passim.

131. See chapter 3, n. 10.

132. "Ma quello che è stato il meglio in tutte queste feste e representatione è stato la

sena dove se sono representate, quale ha facto uno maestro Peregrino depinctore, che sta col signore, ch'è una contracta et prospectiva de una terra cum case, chiesie, torre, campanili e zardini, che la persona non se può satiare a guardarla per le diverse cose che ge sono, tute de inzegno et bene intese, quale non credo se guasti, ma che la salvarano per usarla de l'altre fiate" (letter from Bernardino Prosperi to Isabella d'Este, Ferrara, 8 March 1508, ASMAG, busta 1242, cc. 127-28, cited in L. Zorzi, *Il teatro e la città: saggi sulla scena italiana*, Turin, 1977, p. 27).

133. ". . . a ogni modo voglio che in questi palazzi siano dipinti e ornati secondo richieggono . . . si vorrà fare cose morali e anche appartenenti secondo e' luoghi . . . e così ci fece dipignere per tutto cose convenienti secondo l'edificio" (Filarete, *Trattato*, pp. 283, 285, trans. in *Filarete's Treatise on Architecture*, ed. J. R. Spencer, New Haven–London, 1965, I, pp. 129-30).

134. "Che diremo anchora dela magnificentia deli toi lauti convivii et recevimento in li toi amici, affini, Rei, principi, signori e magnati? Li quali sono stati e sono quando acade con tanta abondantia de varie delicate vivande e de zuchari, de pomposi alhogiamenti et affabilità honorati quanto se possa desiderare" (Gundersheimer, 1972, p. 77).

NINE · IDEOLOGY AND STYLE

1. See M. Baxandall, "Dialogue on Art from the Court of Leonello d'Este: Angelo Decembrio's 'De Politia Litteraria' Pars LXVIII," *Journal of the Warburg and Courtauld Institutes* 26 (1963): 304-26.

2. See A. B. Giamatti, *Play of Double Senses: Spenser's 'Faerie Queene,'* Englewood Cliffs, N.J., 1975, p. 23.

3. This description occurs in Lucrezia Borgia's library inventory of 1502-3, published in G. Bertoni, *La biblioteca estense e la coltura ferrarese ai tempi del Duca Ercole I (1471-1505)*, Turin, 1903, p. 93.

4. For the structure, see chapter 6, section II.

5. P. Zumthor, *Essai de poétique médiévale*, Paris, 1972.

6. See, among others, H. R. Jauss, "The Alterity and Modernity of Medieval Literature," *New Literary History* 10 (1979): 181-227; E. Vance, "The Modernity of the Middle Ages in the Future," *Romanic Review* 64 (1973): 140-51; P. Haidu, "Making It (New) in the Middle Ages: Towards a Problematics of Alterity," *Diacritics* 4 (1974): 2-11.

7. For what follows, see, among others, W.T.H. Jackson, *The Literature of the Middle Ages*, New York, 1960, chaps. 3 and 5; J. Frappier, *Etude sur la Mort le Roi Artu*, 2d ed., Paris, 1961; id., "Le concept de l'amour dans les romans arthuriens," *Amour courtois et Table Ronde*, Geneva, 1973; A. Pauphilet, *Le legs du Moyen Age*, Mehun, 1950; C. S. Lewis, *The Allegory of Love*, Oxford, 1936; F. Bogdanow, *The Romance of the Grail*, New York, 1966; A. Micha, "Sur la composition du Lancelot en prose," in *Etudes de langues et de litérature du Moyen Age offerts à Félix Lecoy*, Paris, 1973, pp. 417-25; C. E. Pickford, *L'évolution du roman arthurien en prose vers la fin du moyen âge*, Paris, 1960.

8. *Orlando Furioso*, I. 1.

9. H. O. Sommer, ed., *The Vulgate Version of the Arthurian Romances*, 8 vols., Washington, D.C., 1908-16, IV, p. 259.

10. R. Tuve, *Allegorical Imagery: Some Medieval Books and Their Posterity*, Princeton, 1966, p. 381.

11. Ibid. pp. 338, 379, 380.

12. See N. Frye, *The Secular Scripture: A Study of the Structure of Romance*, Cambridge, Mass., 1976, p. 60.

13. See R. S. Loomis, *Arthurian Tradition and Chrétien de Troyes*, New York, 1949, p. 254.

14. Ibid. pp. 64, 245.

15. Sommer, *Vulgate Version*, IV, p. 262.

16. See R. Barber, *The Knight and Chivalry*, New York, 1975, p. 148.

17. Sommer, *Vulgate Version*, IV, pp. 267–68.

18. Ibid. V, p. 414, lines 25, 32.

19. P. Menard, *Le rire et le sourire dans le roman courtois en France au moyen-âge, 1150–1250*, Geneva, 1969, pp. 421ff., 703; F. Godefroy, *Dictionnaire de l'ancienne language française et de tous ses dialectes du IXe au XVe siècle*, 10 vols., Paris, 1880–1902, III, p. 320. Synonyms for *envoïseure* were *deduit, deport, solaz, gab* (Menard, pp. 423–24).

20. Menard, *Rire et sourire*, p. 703.

21. Ibid. pp. 747–48. See also pp. 703, 751–52, 573, 435–36 and review of Menard's book by A. Foulet, *Romance Philology* 26 (1972): 187–92.

22. A. Vallone, *Cortesia e nobiltà nel Rinascimento*, Asti, 1955, p. 43.

23. E. Auerbach, *Mimesis: The Representation of Reality in Western Literature*, trans. W. R. Trask, Princeton, 1953, p. 137. Often the terms *chevalerie* and *gentilesse* are used together in opposition to *mal* and *villenie* (Sommer, *Vulgate Version*, V, p. 416).

24. Frye, *Secular Scripture*, p. 161.

25. Tuve, *Allegorical Imagery*, p. 342.

26. P. J. Jones, "Economia e società nell'Italia medievale," in *Storia d'Italia*, vol. 1, *Dal feudalesimo al capitalismo*, Turin, 1978, pp. 355–56. See also R. Lull's treatise on chivalry written in Catalan in 1275, in the Italian edition edited by G. Allegra, *Libro dell'ordine della cavalleria*, Rome, 1972, pp. 180–81 ("La moglie di un Cavaliere che concepisce figlio da un plebeo, disonora la Cavalleria e distrugge la dignità di un antico lignaggio. Il Cavaliere che disonestamente riceve un figlio da plebeo disonora il suo casato e la Cavalleria. Quindi, nobiltà e Cavalleria vanno unite in confacente matrimonio tra gente dello stesso rango; il contrario tende a distruggere la Cavalleria").

27. A. Perosa, ed., *Giovanni Rucellai ed il suo zibaldone*, vol. 1, *"Il zibaldone quaresimale,"* London, 1960, pp. 54, 63. See also Baldassarre Castiglione, *Il Libro del Cortegiano*, bk. 1, chap. 14.

28. ". . . che siati humano verso ogni homo, che benché la humanità sia conveniente a ciaschuno, nientedimanco a chi è nato de bon sangue più se conviene . . ." (letter from Lodovico Gonzaga to Cardinal Francesco Gonzaga, Godi, 27 April 1462, ASMAG, busta 2097). I am grateful to Louise George Clubb for help with the translation. ". . . nostro sudito, non però di mazori, neanche de meza mano, ma ben de bassa condicione" (letter from Lodovico Gonzaga to Bartolomeo Bonatto, Mantua, 20 January 1462, ASMAG, busta 2186).

29. "Giacopofilippo nel suo Supplimento fa nascere questa famiglia da già seicento anni da un Lodovico Tedesco, nato di sangue reale. Alcuni da altri Tedeschi scacciati da Carlo Magno di Germania, i quali vennero ad habitare questa regione . . . assunsero a questa regal dignità Agilundo figliolo d'Agione, ch'era della prosapia de' Gongingi, la qual stirpe era riputata appo loro generosissima. Costui regnò anni trentatre, et dicono alcuni da questa nobiltà haver havuto il primo principio i Gonzaghi, così detti, come accade, con qualche mutatione di lettere. . . . [Altri dicono] che da Alemagna, al tempo che i Longobardi erano in Pavia, vennero in Italia tre fratelli, i quali facevano professione di cavalleria e eccellenza in arme . . . i nomi de' quali erano Gonzago, Crissago e Ugone. Ma Gonzago fu condotto da' Mantovani per Capitano d'arme" (Mario Equicola, *Dell'Istoria di Mantova* [1521], 2d ed., Mantua, 1607, pp. 68–69. "Gran tempo innanzi in Mantova era stata / Questa Famiglia illustre, e immortale / Da un certo Lodovico derivata / Che da Germania per destin fatale / Venne in Italia, la cui gran casata / Pur discendeva da Stirpe reale" (Raffaello Toscano, *L'edificazione di Mantova e l'origine*

dell'anticchissima famiglia de' principi Gonzaghi . . . in ottava rima, Padua, 1586, p. 12); Cesare Campana, *Arbori delle famiglie le quali hanno signoreggiato con diversi titoli in Mantova* . . . Mantua, 1590, p. 10 (who admits that "tutte queste opinioni sono fondate sopra deboli autorità, e accommodate a tesser più tosto poesie ch'istorie"); Lambecius, Commentary to Bartolomeo Platina's *Historia Inclytae Urbis Mantuae et Serenissimae Familiae Gonzagae*, in L. A. Muratori, *Rerum Italicarum Scriptores*, Milan, 1731, XX, col. 622. For Gonzaga suppression of their origins as Corradi, see A. Luzio, "I Corradi di Gonzaga, signori di Mantova," *Archivio Storico Lombardo* 40 (1913): 247–82, 131–78.

30. "Quanto poi alla commemoratione che pensate fare de' nostri progenitori, prima che venir a scriverne sarà necessario che vi assicuriate meglio della verità dell'historia, perché non fu Luigi che portò di Sassonia in Italia la casa nostra, ma Vitichindo; fu ben Luigi primo signore di questo stato, ma altri lo precedetero per le centinaia d'anni, tutti cavalieri d'heroiche qualità" (letter from Duke Vincenzo I Gonzaga to Gabriele Ginani, 22 September 1606, ASMAG, busta 2161, published in Luzio, "I Corradi," pp. 178–79). See also the polemical tract by Duke Ferdinand, "Si deduce con retta discendenza per mille ducento et tanti anni dai Re di Francia cominciando dall'anno 379, la quale poi a ricadere in Hugone che regnò in Italia l'anno 946 dal quale discendono li Gonzaghi" (A. Luzio, *La galleria dei Gonzaga venduta all'Inghilterra nel 1627–28*, Milan, 1913, p. 1 n. 2).

31. Pius Secundus, *Commentarii Rerum Memorabilium*, Rome, 1584, pp. 37–38, 165–66.

32. See M. H. Keen, "Chivalry, Nobility and the Man-at-Arms," in *War, Literature and Politics in the Late Middle Ages*, ed. C. T. Allmand, London, 1976, pp. 32–45, esp. pp. 39ff.

33. *Orlando Innamorato*, I, 1, 21, trans. in R.

Durling, *The Figure of the Poet in the Renaissance Epic*, Cambridge, Mass., 1965, p. 110.

34. *Orlando Innamorato*, II, 24, 3. See also P. Rayna, *Le fonti dell'Orlando Furioso*, Florence, 1900, pp. 28–29; R. Bruscagli, *Stagioni della civiltà estense*, Pisa, 1983, chap. 2.

35. "Così ella, con quella compagnia che può havere più bella de queste sue donete, con ogni gratiosità a questi cortesani per li sacri templi per li giardini per le strate e per lo lago si monstra, salutando or questo a la fenestra . . . or invitando quell'altro al giardino et a pescare. . . et usando ogni benignità verso di ogniuno a quale intenda siano grate. Et tanta è la voluntà che ha de monstrarsi cortese, che qualche volta ha stracorso in usare la cortesia verso de quelli chi molto non l'hanno a grato" (letter from Ottone del Carretto to Bianca Maria Visconti, Mantua, 29 June 1459, Archivio di Stato, Milano, Sforzesco, cart. 392, published in Mahnke, 1975, p. 289 n. 118).

36. See chapter 5, nn. 21, 22.

37. For the repetition, see chapter 6, section II; J. Frappier, "The Vulgate Cycle," in *Arthurian Literature in the Middle Ages*, ed. R. S. Loomis, Oxford, 1959, p. 297.

38. Frye, *Secular Scripture*, p. 44; C. S. Lewis, *The Discarded Image: An Introduction to Medieval and Renaissance Literature*, Cambridge, 1964, pp. 210–11.

39. H. R. Jauss, "Alterity and Modernity," p. 189.

40. Lewis, *Discarded Image*, pp. 9–10.

41. *Inferno*, V, 127, See W.T.H. Jackson, "The Audience for Medieval Literature," *The Literature of the Middle Ages*, New York, 1960, p. 81.

42. See R. S. Loomis and L. H. Loomis, *Arthurian Legends in Medieval Art*, London–New York, 1938, p. 114.

43. *Trionfo d'Amore*, 111. For a discussion of how literature can influence society, see R. Wellek and A. Warren, *Theory of Literature*, New York, 1949, p. 90.

44. See Durling, *Figure of the Poet*, p. 105.

45. See Jauss, "Alterity and Modernity," p. 184; letter quoted in chapter 2, n. 43.

46. *Orlando Innamorato*, I, 22, 62, quoted in Durling, *Figure of the Poet*, p. 108.

47. *Orlando Innamorato*, II, 10, 1.

48. See Durling, *Figure of the Poet*, pp. 91ff.

49. See also J. Woods-Marsden, "Pictorial Style and Ideology: Pisanello's Arthurian Cycle in Mantua," *Arte Lombarda* 80–82 (1987): 132–39.

50. See chapter 7, section I.

51. See chapter 8, n. 122; Gundersheimer, 1972, p. 50.

52. Paris, Bibliothèque Nationale, Ms. N.A. fr. 5243, f. 55, and Ms fr. 343, f. 4v. For bibliography, see *Arte Lombarda dai Visconti agli Sforza* (exhibition catalog with introduction by R. Longhi), Milan, 1958, nos. 69 and 72.

53. L. B. Alberti, *On Painting and Sculpture*, ed. C. Grayson, London, 1972, para. 44.

54. Ibid. para. 45.

55. See chapter 6, section III.

56. Venturi, 1896, pp. 49–50. See also M. Baxandall, *Painting and Experience in Fifteenth Century Italy*, Oxford, 1972, p. 77; M. Boskovits, "Quello ch'e dipintori oggi dicono prospettiva," *Acta Historiae Artium* 8 (1962): 251.

57. ". . . fa ciò con tanta grazia, e con si bella maniera, che non si può veder meglio . . ." (Venturi, 1896, p. 2).

58. J. Shearman, *Mannerism*, Harmondsworth, 1967, p. 17; id., "*Maniera* as an Aesthetic Ideal," in *The Renaissance and Mannerism: Acts of the 20th International Congress of the History of Art*, vol. 2, Princeton, 1963, pp. 202–3; G. Weise, "La doppia origine del concetto di Manierismo," *Studi Vasariani* (Atti del Convegno Internazionale per il IV Centenario della Prima Edizione delle "Vite" del Vasari), Florence, 1952, p. 182.

59. Weise, loc. cit.

60. "Se tu vai, stai o siedi, fa d'aver sempre maniera" (quoted in ibid. p. 183); Shearman, "*Maniera*," pp. 203–4.

61. E. Battisti, "Lo stile cortegiano," in *La corte e il Cortegiano*, vol. 2, *Il modello europeo*, ed A. Prosperi, Rome, 1980, p. 256.

62. "elegante o di buone maniere" (quoted in Weise, loc. cit.); . . . "avisando Vostra Signoria che quella he la più bella madona et de più belle maniere che mai vedesso" (letter from Guido de Paratis to Galeazzo Maria Sforza, Genoa, 28 June 1468, published in C. Magenta, *I Visconti e gli Sforza nel Castello di Pavia*, 2 vols., Milan, 1883, II, p. 315). See also letter from Tristano Sforza to Galeazzo Maria Sforza, Amboise, 23 March 1468, published in ibid. II, p. 273.

63. "Questa nostra sposa è bella e molto mainerosa, como peraltri è sta' dicto a la Signoria Vostra; li ochij ha bellissimi che non se ne poria migliorare, la fronte spaciosa e belissima carne, alegra, humana et piasevole quanto poteria esser; ben è vero che l'è un poco largheta nel volto, non però che la desdica per questo" (postscript to letter from Gianfrancesco Gonzaga to Barbara of Brandenburg, Innsbruck, 26 May 1463, ASMAG, busta 544, published in G. Lanzoni, *Sulle nozze di Federigo I Gonzaga con Margherita di Wittelsbach (1463)*, Milan, 1898, p. 24).

64. For Cennini, the word *aria*, also used by Galli about Pisanello, was synonymous with *maniera* (see chapter 7, text at n. 60). It too was used to signify "mien" or "bearing" in everyday life as, for instance, that of Lodovico's daughter Barbara: "una bella e gentile madona et de bono aere et bone maynere [*sic*]" (letter from Pietro da Pusterla and Tommaso da Bologna to Francesco Sforza, Mantua, 10 April 1470, Archivio di Stato, Milan, Archivio Sforzesco, busta 65, published in A. Tissoni Benvenuti, "Un nuovo documento sulla camera degli sposi del Mantegna," *Italia Medioevale e Umanistica* 24 [1981]: 359). Andrea Schivenoglia, *Cronaca di Mantova dal 1445 al 1484*, transcribed and annotated by C. d'Arco, in *Raccolta di cronisti e documenti storici lombardi*, ed. G. Müller, Milan, 1857, vol. 2, also characterized Cardinal Bessarion and Everard of Württemberg, Lodovico's son-in-law,

as having, respectively, "uno bono aiero" and "asay bon aiero." On his return from Germany, the young Gianfrancesco Gonzaga was described by Francesco Sforza as having "preso tanto de quello aere che, se non lo havesse conosciuto, lo iudicaria alamano" (letter from Bartolomeo Bonatto to Barbara of Brandenburg, Milan, 9 February 1460, ASMAG, busta 1621, c. 424).

65. ". . . dimostri ciò che si fa e dice venir fatto senza fatica e quasi senza pensarvi" (Castiglione, *Il libro del Cortegiano*, bk 1, chap. 26).

66. Chapter 4, section III.

67. "Laeti autem et hilares cum sumus, tum solutos et quibusdam flexionibus gratos motus habemus" (Alberti, *On Painting*, para. 41).

68. "Pinxit Venetiis in Palatio Fridericum Barbarussam Romanorum Imperatorem, et eiusdem filium supplicem: magnum quoque ibidem Comitum coetum et germanico corporis cultu, orisque habitu: Sacerdotem digitis os distorquentim, et ob id ridentes pueros tanta suavitate, ut aspicientes ad hilaritatem excitent" (Bartholomaeus Facius, *De Viris Illustribus*, Florence, 1745, trans. in M. Baxandall, "Bartholomaeus Facius on Painting: A Fifteenth Century Manuscript of the *De Viris Illustribus*," *Journal of the Warburg and Courtauld Institutes* 27 [1964]: 104).

69. ". . . sed tamen hilaritas illa nostra et suavitas, quae te praeter ceteros delectabat, erepta mihi omnis est" (Cicero, *Epistulae ad Familiares*, 9, 11).

70. "Hilaritatem illam, qua hanc tristitiam temporum condiebamus, in perpetuum amisi . . ." (Cicero, *Epistulae ad Atticum*, 12.40). See translations in D. R. Shackleton Bailey, *Cicero: Letters to Atticus*, Cambridge, 1965–70, v, p. 282; E. O. Winstedt, *Cicero: Letters to Atticus*, London, 1925, III, p. 85. "Et ad hilaritatem et ad tristatem saepe deducimur" (Cicero, *De Oratore*, 3, 197). "Tristitia deductis, hilaritas remissis ostenditur"

(Quintilian, *Institutio Oratoria*, 11, 3, 79). See H. E. Butler, *The Institutio Oratoria of Quintilian*, Cambridge, 1958, IV, pp. 295–97.

71. Alberti, *On Painting*, para. 42.

72. "Alia est enim triclinii ratio, alia fori; aliam faciem epularum licentia, aliam severitas iudiciorum requirit; aliud bibentis est munus, aliud consulentis. In his prudentia, gravitas, fides postulatur, in aliis hilaritas, iocus, remissio animi" (letter from Poggio Bracciolini to Antonio Loschi, Summer 1426, in Poggio Bracciolini, *Opera Omnia*, ed. R. Fubini, Turin, 1969, IV, p. 599).

73. ". . . sed voltum tuum precamur solita hilaritate exhibeas . . ." (letter from Emperor Sigismund to Gianfrancesco Gonzaga, Iglavia, 9 June 1436, ASMAG, busta 428, c. 126). For King Arthur's behavior, see text at n. 19.

74. ". . . et era tuto iocundo et hylare . . ." (letter from Marchese da Varese to Francesco Sforza, 1 November 1459, cited in G. B. Picotti, *La dieta di Mantova e la politica de' Veneziani*, Miscellanea di Storia Veneta, ed. R. Deputazione Veneta di Storia Patria, ser. 3, 4, Venice, 1912, p. 233).

75. Fazio was in Verona until 1426 as Guarino da Verona's student, coinciding with Pisanello's work on the S. Fermo Annunciation, and he was in Venice in the late 1420s as tutor to the Doge's son after Pisanello had worked in the Ducal Palace. He stated in the preface to *De Viris Illustribus* that "we shall mention only those works of which we have some distinct knowledge" and used the phrase "as I heard from him [Pisanello]" when discussing the poor condition of the frecoes in St. John Lateran. See Baxandall, "Bartholomaeus Facius"; P. Kristeller, "The Humanist Bartolomeo Facio and His Unknown Correspondence," in *From the Renaissance to the Counter-Reformation: Essays in Honor of Garrett Mattingly*, ed. C. H. Carter, London, 1966, pp. 56–74.

76. See chapter 8, nn. 23–43.

77. ". . . ad iusticiam in omnes, ad benefi-centiam in suos, ad punitionem et interdum misericordiam in malos, ad liberalitatem cum moderatione, ad amicos comparandos, ad inimicitias fugiendas, *ad hilaritatem, ad splendorem vitae*, ad magnanimitatem et ad omnia denique morum ornamenta, quae et utilitatem afferant et famae non obsint" (letter from Antonio Ivani to Lodovico Fregoso, Sarzana, 27 December [1464], quoted in R. Fubini, "Antonio Ivani da Sarzana: un teorizzatore del declino delle autonomie comunali," in *Egemonia fio-rentina ed autonomie locali nella Toscana nord-occidentale del primo rinascimento: vita, arte, cultura* [VII Convegno Interna-zionale, Pistoia, 1975] Centro Italiano di studi di Storia e d'Arte, Pistoia, 1978, p. 135; emphasis added). I am grateful to Riccardo Fubini for the reference.

78. "Tutto quello adunque che move il riso esilara l'animo e dà piacere, né lascia che in quel punto l'omo si ricordi delle noiose molestie, delle quali la vita nostra è piena" (Castiglione, *Il libro del Corte-giano*, bk 2, chap. 45).

79. "La prima regula e ordine che se debe servare è de stare continuo in piaceri e bandire ogni melenconia" (letter from Alessandro Gonzaga to Barbara of Brandenburg, 6 May 1461, ASMAG, busta 1100, cc. 40–41, published in A. Portioli, ed., *I Gonzaga ai bagni di Petriolo di Siena nel 1460 e 1461*, Mantua, 1869, p. 32).

80. ". . . Nondimanco, vedendolo nui stare tanto melencolico e non rehaverse in cosa alcuna, ne fa stare tute dubiose e perplexe"; ". . . Non c'è parso de dirne altro a lo Illustre signor tuo patre per non dargli affanno, perché, come te scri-vessemo, questa mattina el se rescaldoe pur un poco, non che doppo habia altro male, ma el sta tuto melenconico" (let-ters from Barbara of Brandenburg to Federico Gonzaga, 29 and 25 June 1473, ASMAG, busta 2101, cc. 482, 480). I am grateful to Elisabeth Swain for these archival references. See also E. Swain, "Faith in the Family: The Practice of Religion by the Gonzaga," *Journal of Family History* 8 (1983): 186. For Lodovi-co's natal horoscope, see chapter 3, text at nn. 85ff. For the characteristics of those born with Leo in the ascendant (who were "molto apto ad contristarsi" as well as being industrious, intelligent, magnanimous, cautious and astute), see Pietroadami de Micheli, *Horologio*, Mantua, 1473, c. 23r–v.

81. "Pisanus Veronensis in pingendis rerum formis, sensibusque exprimendis ingenio prope poetico putatus est" (Bax-andall, "Bartholomaeus Facius," p. 105).

82. Venturi, 1896, p. 35. The translation is taken from C. Gilbert, *Italian Art 1400–1500: Sources and Documents*, Englewood Cliffs, N.J., 1980, p. 174.

83. ". . . in pingendis equis, ceterisque ani-malibus peritorum iudicio ceteros ante-cessit" (Baxandall, loc. cit.).

84. "E perché si dilettò particolarmente di fare animali . . . dipinse . . . un cane . . . [che] si rivolta col capo indietro, quasi che abbia sentito rumore, e fa questo atto con tanta vivezza che non lo farebbe meglio il naturale" (Venturi, 1896, p. 2).

85. See also C. S. Lewis's comment, rele-vant to Pisanello's nature studies: "The characteristically medieval type of imag-ination . . . is not a transforming imag-ination like Wordsworth's or a pene-trating imagination like Shakespeare's. It is a realising imagination. Macaulay noted in Dante the extremely factual word-painting; the details, the compar-isons, designed at whatever cost of dig-nity to make sure that we see exactly what he saw. . . . The Middle Ages are unrivalled, till we reach quite modern times, in the sheer foreground fact, the 'close-up'" (*Discarded Image*, p. 206).

86. Alberti, *On Painting*, para. 41.

87. "Cavalieri innamorati, cortesi damiselle

e graziose" (Boiardo, *Orlando Inna-morato*, III, 1, 2).

88. See E. Vinaver, *A la recherche d'une poé-tique médiévale*, Paris, 1970, p. 164 ("Jamais dans les monologues [du Tristan en prose] l'émotion ne fait l'objet d'une analyse, jamais elle ne sert à une étude profonde des états d'âmes"); P. Zumthor, "Recherches sur les topiques dans la poésie lyrique des XIIe et XIIIe siècles," *Cahiers de Civilisation Médiévale* 2 (1959): 426 ("Le style . . . est plus décoration qu'expression, ou plutôt, l'expression cherche sa voie à travers l'ornement et conserve de ce fait un caractère plus ou moins froid d'im-personnalité").

89. See M. Schapiro, "Style," in *Anthro-pology Today*, ed. A. Kroeber, Chicago, 1953, p. 292.

90. See Frye, *Secular Scripture*, p. 38; text at n. 25.

91. ". . . un' arte chessi chiama dipingnere, che conviene avere fantasia e hopera-zione di mano, di trovare cose non vedute, chacciandosi sotto ombra di naturali, e fermarle con la mano, dando a dimostrare quello che nonne sia" (Cennino Cennini, *The Craftsman's Handbook: "Il libro dell'arte,"* trans. D. V. Thompson, Jr., 2 vols., New Haven, 1933, chap. 1).

92. See also L. Martines, "Style and Patronage: A Congress of Signs," paper given in the "Style and Historical Con-text" session, College Art Association of America, Los Angeles, 1985; id., *Power and Imagination*, New York, 1979, chaps. 12 and 13.

93. See n. 47.

94. Letter from Luchino Visconti to Lodovico Gonzaga, Cremona, 15 June 1378, ASMAG, busta 1606, c. 33, quoted in chapter 2, n. 43.

95. N. Frye, *Anatomy of Criticism*, Princeton, 1957, p. 186.

96. See chapter 4, n. 161; n. 30 above.

97. Venturi, 1896, p. 56. I am grateful to James Russell and Reginald T. Foster for help with the translation.

SELECTED BIBLIOGRAPHY

The bibliography has been divided into the following broad categories: Pisanello, The Gonzaga and Art in Mantua, starting p. 255, and Other Works, starting p. 258.

Pisanello

AMADEI, G., "Il Pisanello a Mantova," *Civiltà Mantovana* 3 (1968): 287–320.

BAXANDALL, M., "Guarino, Pisanello and Manuel Chrysoloras," *Journal of the Warburg and Courtauld Institutes* 28 (1965): 183–204.

—— review of Paccagnini, *Pisanello e il ciclo cavalleresco di Mantova, Art Bulletin* 57 (1975): 130–31.

BELLÙ, A., "Pisanus pinctor debet habere . . ." *Arte Lombarda* 80–82 (1987): 125–31.

BIADEGO, G., "Pisanus Pictor," *Atti del Reale Istituto Veneto di Scienze, Lettere ed Arti* 67 (1908): 837–59; 68 (1909): 229–48; 69 (1909): 183–88; 69 (1910): 797–813, 1047–54; 72 (1912–13): 1315–29.

BISCARO, G., " 'Pisanus pictor' alla corte di Filippo Maria Visconti nel 1440," *Archivio Storico Lombardo* 38, vol. 15 (1911): 171–74.

BRENZONI, R., *Pisanello*, Florence, 1952.

CHIARELLI, R., "Due questioni pisanelliane," *Atti e Memorie dell'Accademia di Agricoltura, Scienze e Lettere di Verona* 143/144 (1967): 373–81.

—— *Tutta l'opera del Pisanello*, Milan, 1972.

DEGENHART, B., *Pisanello*, Turin, 1945.

—— "Zu Pisanellos Wandbild in S. Anastasia in Verona," *Zeitschrift für Kunstwissenschaft* 5 (1951): 29–50.

—— "Di una pubblicazione su Pisanello e di altri fatti," *Arte Veneta* 7 (1953): 182–85; 8 (1954): 96–118.

—— "Ludovico II. Gonzaga in einer Miniatur Pisanellos," *Pantheon* 30 (1972): 193–210.

—— "Pisanello in Mantua," *Pantheon* 31 (1973): 364–411.

—— "Pisanellos Mantuaner Wandbilder," *Kunstchronik* 26 (1974): 69–74.

DELL'ACQUA, G. A., *I grandi maestri del disegno: Pisanello*, Milan, 1952.

FASANELLI, J., "Some Notes on Pisanello and the Council of Florence," *Master Drawings* 3 (1965): 36–47.

FOSSI TODOROW, M., "The Exhibition Da Altichiero a Pisanello in Verona," *Burlington Magazine* 101 (1959): 10–14.

—— "Un taccuino di viaggio del Pisanello e della sua bottega," in *Scritti in onore di Mario Salmi*, vol. 2, Rome, 1962, pp. 133–61.

—— *I disegni del Pisanello e della sua cerchia*, Florence, 1966.

—— *I disegni dei maestri: l'Italia dalle origini a Pisanello*, Milan, 1970.

—— "Pisanello at the Court of the Gonzaga at Mantua," *Burlington Magazine* 114 (1972): 888–91.

GNOLI, D., "Passaporto di Pisanello," *Archivio Storico dell'Arte* 3 (1890): 402–3.

GNUDI, C., "Il ciclo cavalleresco del Pisanello alla corte dei Gonzaga: 1. Il Pisanello e la grande scoperta di Mantova," in *Studies in Late Medieval and Renaissance Painting in Honor of Millard Meiss*, ed. I. Lavin and J. Plummer, 2 vols., New York, 1977, I, pp. 192–204.

GOODMAN, E. L., "The Prose Tristan and the Pisanello Murals," *Tristania* 3, no. 2 (1978): 22–35.

GRAPE, W., "Pisanello und die unvollendeten Mantuaner Wandbilder," *Pantheon* 34 (1976): 14–17.

GUIFFREY, J., *Les dessins de Pisanello et de son école conservés au Musée du Louvre*, 4 vols., Paris, 1911–20.

HILL, G. F., *Pisanello*, London, 1905.

—— "Some Drawings from the Antique Attributed to Pisanello," *Papers of the British School at Rome* 3, no. 4 (1905): 297–303.

—— "Notes on Various Works of Art: New Light on Pisanello," *Burlington Magazine* 13 (1908): 288.

HILL, G. F., "Recent Research on Pisanello," *Burlington Magazine* 17 (1910): 361–62.

—— *Dessins de Pisanello*, Paris–Brussels, 1929.

—— "A Lost Medal by Pisanello," *Pantheon* 8 (1931): 487–88.

—— "On Some Dates in the Career of Pisanello," *Numismatic Chronicle*, ser. 5, 11 (1931): 181–96.

Istituto Centrale di Restauro, Rome, "Accertamento dello stato di conservazione ed analisi dei pigmenti leganti dell'affresco di Antonio Pisano raffigurante l'*Annunciazione*, Verona, Chiesa di San Fermo: scheda di analisi n. 392," unpublished typescript, Rome, 1970.

JUREN, V., "A propos de la médaille de Jean VIII Paléologue par Pisanello," *Revue Numismatique*, ser. 6, 15 (1973): 219–25.

—— "Pisanello," *Revue de l'Art* 27 (1975): 58–61.

KELLER, H., "Bildhauerzeichnungen Pisanellos," *Festschrift Kurt Bauch*, Munich, 1957, pp. 139–52.

KRASCENINNIKOVA, M., "Catalogo dei disegni del Pisanello nel codice Vallardi del Louvre," *L'Arte* 23 (1920): 5–23, 125–33, 226–29.

MAGAGNATO, L., *Da Altichiero a Pisanello*, catalog of the exhibition held in Verona, Venice, 1958.

MARTINDALE, A., "The Sala di Pisanello at Mantua—A New Reference," *Burlington Magazine* 116 (1974): 101.

MELLINI, G. L., "Problemi di archeologia pisanelliana," *Critica d'Arte* 8, fasc. 47 (1961): 53–56.

—— "Pisanello esce dal muro," *Comunità*, no. 168 (December 1972): 327–44.

MIDDELDORF, U., review of Degenhart, *Pisanello*, *Art Bulletin* 24 (1947): 278–82.

—— "A New Medal by Pisanello," *Burlington Magazine* 123 (1981): 19–20.

MITCHELL, C., "The Great Medallist: Pisanello's Achievement in Art" (review of Degenhart, *Pisanello*), *Times Literary Supplement*, 14 September 1946: 433.

PACCAGNINI, G., "Il ritrovamento del Pisanello nel Palazzo Ducale di Mantova," *Bollettino d'Arte*, ser. 5, 52 (1967): 17–19.

—— "Il Pisanello ritrovato a Mantova," *Commentari* 19 (1968): 253–58.

—— *Pisanello e il ciclo cavalleresco di Mantova*, Milan, 1972.

—— "Il ciclo cavalleresco del Pisanello alla corte dei Gonzaga. II. Tecnica e stile del ciclo murale," in *Studies in Late Medieval and Renaissance Painting in Honor of Millard Meiss*, ed. I. Lavin and J. Plummer, 2 vols., New York, 1977, I, pp. 205–18.

—— "Note sulla formazione e la tecnica del ciclo cavalleresco della 'Sala del Pisanello,'" in *Mantova e i Gonzaga nella civiltà del rinascimento* (Atti del Convegno, Mantua, 6–8 Octobre 1974), Mantua, 1978, pp. 191–215.

PACCAGNINI, G., and M. FIGLIOLI, *Pisanello alla corte dei Gonzaga*, Milan, 1972.

PIGNATTI, T., "La mostra Pisanello alla corte dei Gonzaga," *Arte Veneta* 26 (1972): 294–97.

PIZZORUSSO BERTOLUCCI, V., "I cavalieri del Pisanello," *Studi Mediolatini e Volgari* 20 (1972): 37–48.

PUPPI, L., "La Principessa di Trebisonda," *Verso Gerusalemme: Immagini e temi di urbanistica e di architettura simboliche*, Rome, 1982, pp. 44–61.

RICHTER, G. M., "Pisanello Studies," *Burlington Magazine* 55 (1929): 59–66, 128–39.

—— "Pisanello Again," *Burlington Magazine* 58 (1931): 235–41.

R[ICHTER], G. P., "Il Pisanello graziato," *Archivio Storico dell'Arte* 2 (1889): 38.

ROSSI, U., "Il Pisanello e i Gonzaga," *Archivio Storico dell'Arte* 1 (1888): 453–56.

SALMI, M., "Appunti su Pisanello medaglista," *Annali dell'Istituto Italiano di Numismatica* 4 (1957): 13–23.

—— "La 'Divi Julii Caesaris Effigies' del Pisanello," *Commentari* 8 (1957): 91–95.

SCHMITT, A., *Disegni del Pisanello e di maestri del suo tempo*, exhibition catalog, Venice, 1966.

—— "Herkules in einer unbekannten Zeichnung Pisanellos," *Jahrbuch der Berliner Museen* 17 (1975): 51–86.

SINDONA, E., *Pisanello*, Milan, 1961.

TELLINI PERINA, C., "Considerazioni sul Pisanello," *Civiltà Mantovana* 6 (1972): 305–17.

TOESCA, I., "Lancaster e Gonzaga: il fregio della 'Sala del Pisanello' nel Palazzo Ducale di Mantova," *Civiltà Mantovana* 7 (1973): 361–77.

—— "A Frieze by Pisanello," *Burlington Magazine* 116 (1974): 210–14.

—— "More about the Pisanello Murals at Mantua," *Burlington Magazine* 118 (1976): 622–29.

—— "Altre osservazioni in margine alle pitture del Pisanello nel Palazzo Ducale di Mantova," *Civiltà Mantovana* 11 (1977): 349–76.

—— "Postilla a proposito di un fiore," *Civiltà Mantovana* 12 (1978): 233–36.

VENTURI, A., "Il Pisanello a Ferrara," *Archivio Veneto* 30 (1885): 410–20.

—— "Documento sul Pisanello," *Archivio Storico dell'Arte* 1 (1888): 424–25.

—— *Le vite dei più eccellenti pittori, scultori ed architettori scritte da Giorgio Vasari*, vol. 1, *Gentile da Fabriano ed il Pisanello*, Florence, 1896.

—— *Pisanello*, Rome, 1939.

VICKERS, M., "Some Preparatory Drawings for Pisanello's Medallion of John VIII Paleologus," *Art Bulletin* 60 (1978): 417–24.

WEISS, R., *Pisanello's Medallion of the Emperor John VIII Paleologus*, London, 1966.

WOODS-MARSDEN, J., "Observations on Fresco Technique: Pisanello in Mantua," in *La pittura nel XIV e XV secolo: il contributo dell'analisi tecnica alla storia dell'arte*, ed. H. W. van Os and J.R.J. van Asperen de Boer, *Acts of the 24th International Congress of Art History* (Bologna, 1979), vol. 3, Bologna, 1983, pp. 189–210.

—— "French Chivalric Myth and Mantuan Political Reality in the *Sala del Pisanello*," *Art History* 8 (1985): 397–412.

—— "The Sinopia as Preparatory Drawing: The Evolution of Pisanello's Tournament Scene," *Master Drawings* 23–24 (1986): 175–92.

—— "Pictorial Style and Ideology: Pisanello's Arthurian Cycle in Mantua," *Arte Lombarda* 80–82 (1987): 132–39.

—— "Preparatory Drawings for Frescoes in the Early Quattrocento: The Practice of Pisanello," in *Drawings Defined*, ed. W. Strauss and T. Felker, preface by K. Oberhuber, New York, 1987, pp. 49–62.

ZANOLI, A., "Sugli affreschi di Pisanello nel Palazzo Ducale di Mantova," *Paragone* 227 (1973): 23–44.

The Gonzaga and Art in Mantua

AMADEI, F., *Cronaca universale della città di Mantova*, Mantua, 1745, ed. G. Amadei, E. Marani, and G. Praticò, 5 vols., Mantua, 1954–57.

AMADEI, G., *Un secolo a Mantova*, Mantua, 1968.

AMADEI, G., and MARANI, E., *I Gonzaga a Mantova*, Milan, 1975.

ANTOLDI, F., *Descrizione del Regio Cesareo Palazzo di Mantova*, Mantua, 1815.

ARGAN, G. C., "L'arte a Mantova," in *Mantova e i Gonzaga nella civiltà del rinascimento* (Atti del Convegno, Mantua, 1974), Mantua, 1978, pp. 163–66.

BELLONCI, M., "Piccolo romanzo di Dorotea Gonzaga," *Nuova Antologia* ser. 2, 77 (1942): 36–45, 92–99.

BELTRAMI, L., "L'annullamento del contratto di matrimonio fra Galeazzo Maria Sforza e Dorotea Gonzaga (1463)," *Archivio Storico Lombardo* 16 (1889): 126–32.

BERTOLOTTI, A., *Le arti minori alla corte di Mantova nei secoli XV, XVI e XVII*, Milan, 1889.

BETTINELLI, S., *Delle lettere e delle arti mantovane*, Mantua, 1774.

BILLO, L., "Le nozze di Paola Gonzaga a Bolzano," *Studi Trentini di Scienze Storiche* 15 (1934): 3–22.

BORIANI, E., *Castelli e torri dei Gonzaga nel territorio mantovano*, Brescia, 1969.

BRAGHIROLLI, W., "Leon Battista Alberti a Mantova," *Archivio Storico Italiano*, ser. 3, 9 pt. 1 (1869): 1–31.

BRAGHIROLLI, W., "Donatello a Mantova con documenti inediti," *Giornale de Erudizione Artistica* 2 (1873): 4–10.

—— *Sulle manifatture di arazzi in Mantova*, Mantua, 1879.

—— "Virgilio e i Gonzaga," in *Album virgiliano*, Mantua, 1883, pp. 175–83.

BROWN, B. L., "The Patronage and Building History of the Tribuna of SS. Annunziata in Florence: A Reappraisal in Light of New Documentation," *Mitteilungen des Kunsthistorischen Institutes in Florenz* 25 (1981): 59–146.

BROWN, C. M., "Luca Fancelli in Mantua," *Mitteilungen des Kunsthistorischen Institutes in Florenz* 16 (1972): 153–66.

—— "Gleanings from the Gonzaga Documents in Mantua—Gian Cristoforo Romano and Andrea Mantegna," *Mitteilungen des Kunsthistorischen Institutes in Florenz* 17 (1973): 153–59.

CALZONA, A., *Mantova, città dell'Alberti. Il S. Sebastiano: tomba, tempio, cosmo*, Parma, 1979.

CARPEGGIANI, P., *Il palazzo gonzaghesco di Revere*, Mantua, 1974.

—— "I Gonzaga e l'arte: la corte, la città, il territorio (1444–1616)," *Mantova e i Gonzaga nella civiltà del rinascimento* (Atti del Convegno 1974), Mantua, 1978, pp. 167–90.

CHAMBERS, D. S., "Sant'Andrea at Mantua and Gonzaga Patronage," *Journal of the Warburg and Courtauld Institutes* 40 (1977): 99–127.

COLOMBO, A., "L'abbozzo dell'alleanza tra lo Sforza ed il Gonzaga," *Nuovo Archivio Veneto*, N.S., 13 (1907): 143–51.

CONIGLIO, G., *Mantova: La storia*, vol. 1, Mantua, 1958.

—— *I Gonzaga*, Varese, 1967.

COTTAFAVI, C., "Mantova: Palazzo Ducale—Palazzo del Capitano," *Bollettino d'Arte* 25 (1931–32): 377–82.

—— "Palazzo Ducale di Mantova: restauro del pianterreno e del porticato di Piazza Sordello," *Bollettino d'Arte* 29 (1935): 238–47.

—— *Ricerche e documenti sulla costruzione del Palazzo Ducale di Mantova dal secolo XIII al secolo XIX*, Mantua, 1939.

DALL'ACQUA, M., "Storia di un progetto albertiano non realizzato: la ricostruzione della Rotonda di San Lorenzo in Mantova," in *Il Sant'Andrea di Mantova e Leon Battista Alberti* (Atti del Convegno 1972), Mantua, 1974, pp. 229–36.

DAVARI, S., "Il matrimonio di Dorotea Gonzaga con Galeazzo Maria Sforza," *Giornale Linguistico di Archeologia, Storia e Letteratura* 16 (1889): 363–90.

—— *I palazzi dei Gonzaga in Marmirolo*, Mantua, 1890.

—— *Notizie storiche topografiche della città di Mantova nei secoli XIII, XIV e XV*, 2d ed., Mantua, 1903; reprinted 1975.

DINA, A., "Qualche notizie su Dorotea Gonzaga," *Archivio Storico Lombardo* 14 (1887): 562–67.

EQUICOLA, M., *Dell'istoria di Mantova* (1521), 2d ed. Mantua, 1607.

FACCIOLI, E., *Mantova: le lettere*, Mantua, 1961, vol. 2.

GEROLA, G., "Vecchie insegne di casa Gonzaga," *Archivio Storico Lombardo* 45 (1918): 97–110.

—— "Un'impresa ed un motto di casa Gonzaga," *Rivista d'Arte* 12 (1930): 381–402.

GIANNANTONI, N., *Il Palazzo Ducale di Mantova*, Rome, 1929.

GIROLLA, P., "Pittori e miniatori a Mantova sulla fine del '300 e sul principio del '400," *Atti e Memorie dell'Accademia Virgiliana di Mantova*, N.S., 9–13 (1929): 177–200.

HARTT, F., "Gonzaga Symbols in the Palazzo del Te," *Journal of the Warburg and Courtauld Institutes* 13 (1950): 151–88.

HOFFMAN, B., *Barbara von Hohenzollern, Markgräfin von Mantua*, Ansbach, 1881.

INTRA, G. B., "Donatello e il Marchese Lodovico Gonzaga," *Archivio Storico Lombardo* 13 (1886): 666–69.

KRISTELLER, P., *Andrea Mantegna*, London, 1901.

LAMOUREUX, R. E., *Alberti's Church of San Sebastiano in Mantua*, New York, 1979.

LANZONI, G., *Sulle nozze di Federigo I Gonzaga con Margherita di Wittelsbach (1463)*, Milan, 1898.

LAWSON, J., "New Documents on Donatello," *Mitteilungen des Kunsthistorischen Institutes in Florenz* 18 (1974): 357–62.

—— "The Palace at Revere and the Earlier Architectural Patronage of Lodovico Gonzaga, Marquis of Mantua (1444–78)," Ph.D. thesis, University of Edinburgh, 1979.

LETTS, R. M., "Paola Malatesta and the Court of Mantua 1393–1453," M.Phil. thesis, Warburg Institute, University of London, 1980.

LUZIO, A., *La galleria dei Gonzaga venduta all'Inghilterra nel 1627–28*, Milan, 1913.

—— "Bertolino da Novara e il Castello di Mantova," *Archivio Storico Lombardo* 40 (1913): 179–83.

—— "I Corradi di Gonzaga, signori di Mantova," *Archivio Storico Lombardo* 40 (1913): 247–82, 131–78.

—— *L'Archivio Gonzaga di Mantova*, vol. 2, Verona, 1922.

MAGNAGUTI, A., "Luci pisanelliane e mantegnesche sulle monete dei Gonzaga," *Rivista Italica di Numismatica*, ser. 5, 6 (1958): 1–17.

MAHNKE, E. W., "The Political Career of a *Condottiere*-Prince: Lodovico Gonzaga 1444–1466," Ph.D. thesis, Harvard University, 1975.

—— See also publications by E. Swain.

MARANI, E., in G. Amadei and E. Marani, *I Gonzaga a Mantova*, Milan, 1975.

—— *La massaria a Mantova: città e castelli alla fine del Medioevo*, Mantua, 1983.

MARTINDALE, A., *The Triumphs of Caesar by Andrea Mantegna in the Collection of Her Majesty The Queen*, London, 1979.

MAZZOLDI, L., *Mantova: la storia*, Mantua, 1961, vol. 2.

MOZZARELLI, C., "Lo stato gonzaghesco: Mantova dal 1382 al 1707," in *I ducati Padani, Trento e Trieste: storia d'Italia*, ed. G. Galasso, vol. 17, Turin, 1979, pp. 359–495.

PACCAGNINI, G., *Mantova: le arti*, vol. 1, Mantua, 1960.

—— *Il Palazzo Ducale di Mantova*, Turin, 1969.

PACCHIONI, G., *Il Palazzo Ducale di Mantova*, Florence, 1921.

PERINA, C., *Mantova: le arti*, vol. 2, Mantua, 1961.

PICOTTI, G. B., *La Dièta di Mantova e la politica de' Veneziani* (Miscellanea di Storia Veneta, ed. R. Deputazione Veneta di Storia Patria, ser. 3, vol. 4), Venice, 1912.

PORTIOLI, A., "La giornata di Caravaggio ed i sigilli di Lodovico II Gonzaga secondo marchese di Mantova," *Periodico di Numismatica e Sfragistica per la Storia d'Italia* 3 (1871): 125–36.

—— *La Zecca di Mantova*, Mantua, 1879.

—— *Divi Ludovici Marchionis Mantuae Somnium*, Mantua, 1887.

—— "Giacomo Galopini, prete e miniatore mantovano del secolo XV," *Archivio Storico Lombardo* 26, vol. 11 (1899): 330–47.

PORTIOLI, A., ed., *I Gonzaga ai bagni di Petriolo di Siena nel 1460 e 1461*, Mantua, 1869.

PRATICÒ, G., "Lorenzo il Magnifico e i Gonzaga," *Archivio Storico Italiano* 107 (1949): 155–71.

RESTI-FERRARI, M. P., "Aggiunte al codice diplomatico mantegnasco del Kristeller," *Atti e Memorie dell'Accademia Virgiliana Mantovana*, N.S., 19–20 (1926–27): 263–80.

ROSSI, U., "Cristoforo Geremia," *Archivio Storico dell'Arte* 1 (1888): 404–11.

SAMEK LUDOVICI, S., *Miniature di Belbello da Pavia*, Milan, 1954.

SAVIOLI, E., "Per la storia della burocrazia gonzaghesca: attività diplomatica e consistenza patrimoniale di Bartolomeo Bonatto (c. 1420–1477)," tesi di laurea, University of Padua, 1976–77.

SCARAVELLI, G., "Barbara di Brandeburgo, Marchesa di Mantova, e la politica dei Gonzaga nel secolo XV," tesi di laurea, University of Padua, 1971–72.

SCHIVENOGLIA, Andrea, *Cronaca di Mantova dal 1445 al 1484*, transcribed and annotated

by C. d'Arco, in *Raccolta di cronisti e documenti storici lombardi*, ed. G. Müller, Milan, 1857, vol. 2.

SESTAN, E., "La storia dei Gonzaga nel rinascimento," *Mantova e i Gonzaga nella civiltà del rinascimento* (Atti del Convegno, 1974), Mantua, 1978, pp. 17–27.

SIGNORINI, R., "Appendice: l'elevazione di Francesco Gonzaga al cardinalato," *Mitteilungen des Kunsthistorischen Institutes in Florenz* 18 (1974): 247–49.

—— "Federico III e Cristiano I nella Camera degli Sposi del Mantegna," *Mitteilungen des Kunsthistorischen Institutes in Florenz* 18 (1974): 227–46.

—— "Lettura storica degli affreschi della 'Camera degli Sposi' di A. Mantegna," *Journal of the Warburg and Courtauld Institutes* 38 (1975): 109–35.

—— "Nui da Mantua non se teniamo ponto esser cussì brutte," *Gazzetta di Mantova*, no. 308 (5 November 1976): 10.

—— "Two Notes from Mantua: A Dog Named Rubino," *Journal of the Warburg and Courtauld Institutes* 41 (1978): 317–21.

—— " 'Manzare poco, bevere acqua asai e dormire manco': suggerimenti dietici vittoriniani di Ludovico II Gonzaga al figlio Gianfrancesco e un sospetto pitagorico," in *Vittorino da Feltre e la sua scuola: umanesimo, pedagogia, arti*, ed. N. Gianetto, Florence, 1981, pp. 115–48.

—— "Cristiano I in Italia," *Il Veltro* 25 (1981): 23–58.

—— "Lodovico muore," *Atti e Memorie dell'Accademia Virgiliana di Mantova*, N.S., 50 (1982): 91–129.

—— *Opvs Hoc Tenve: la camera dipinta di Andrea Mantegna*, Mantua, 1985.

Splendours of the Gonzaga, ed. D. S. Chambers and J. Martineau, London, 1981.

SWAIN, E., "Faith in the Family: The Practice of Religion by the Gonzaga," *Journal of Family History* 8 (1983): 177–89.

—— " 'My Excellent and Most Singular Lord': Marriage in a Noble Family of Fifteenth Century Italy," *Journal of Medieval and Renaissance Studies* 16 (1986): 171–95.

—— "Strategia matrimoniale in casa Gonzaga: il caso di Barbara e Lodovico," *Civiltà Mantovana*, n.s., 14 (1986): 1–13.

—— See also publication by E. W. Mahnke.

TARDUCCI, F., "Gianfrancesco Gonzaga signore di Mantova (1407–1420)," *Archivio Storico Lombardo* 29 (1902): 310–60, 33–88.

TISSONI BENVENUTI, A., "Un nuovo documento sulla 'Camera degli Sposi' del Mantegna," *Italia Medioevale e Umanistica* 24 (1981): 357–60.

TORELLI, P., "Capitanato del popolo e vicariato imperiale come elementi costituitivi della Signoria Bonacolsiana," *Atti e Memorie della R. Accademia Virgiliana di Mantova*, N.S., 14 (1921): 73–221.

VASIC VATOVEC, C., *Luca Fancelli, architetto: epistolario gonzaghesco*, Florence, 1979.

VOLTA, L. C., *Compendio cronologico-critico della storia di Mantova*, Mantua, 1827.

Other Works

ALBERTI, L. B., *Opere volgari*, vol. 1, *I libri della famiglia*, ed. C. Grayson, Bari, 1960.

—— *De Re Aedificatoria*, trans. J. Leoni, ed. J. Rykwert, New York, 1965.

—— *L'architettura: De Re Aedificatoria*, trans. G. Orlandi, ed. P. Portoghesi, 2 vols., Milan, 1966.

—— *On Painting and Sculpture*, ed. C. Grayson, London, 1972.

AMES-LEWIS, F., "Domenico Veneziano and the Medici," *Jahrbuch der Berliner Museen* 21 (1979): 67–90.

—— "Early Medicean Devices," *Journal of the Warburg and Courtauld Institutes* 42 (1979): 122–41.

—— *Drawing in Early Renaissance Italy*, New Haven–London, 1981.

ANGELUCCI, A., *Armilustre e torneo con armi da battaglia tenuti a Venezia addì 28 e 30 maggio 1458*, Turin, 1866.

ARONBERG, M., "A New Facet of Leonardo's Working Procedure," *Art Bulletin* 33 (1951): 235–39.

—— See also publication by M. A. Lavin.

Arte Lombarda dai Visconti agli Sforza, exhibition catalog with introduction by R. Longhi, Milan, 1958.

AUERBACH, E., *Mimesis: The Representation of Reality in Western Literature*, trans. W. R. Trask, Princeton, 1953.

AVERLINO, Antonio, detto il Filarete, *Trattato di architettura*, ed. A. M. Finoli and L. Grassi, Milan, 1972.

BALDINI, U., "Dalla sinopia al cartone," *Studies in Late Medieval and Renaissance Painting in Honor of Millard Meiss*, ed. I. Lavin and J. Plummer, 2 vols., New York, 1977, I, pp. 43–47.

BARBER, R., *The Knight and Chivalry*, New York, 1974.

BARONI, C., and S. SAMEK LUDOVICI, *La pittura lombarda del Quattrocento*, Messina–Florence, 1952.

BATTISTI, E., *Cicli pittorici: storie profane*, Milan, 1981.

BAXANDALL, M., "A Dialogue on Art from the Court of Leonello d'Este: Angelo Decembrio's 'De Politia Litteraria' Pars LXVIII," *Journal of the Warburg and Courtauld Institutes* 26 (1963): 304–26.

—— "Bartholomaeus Facius on Painting: A Fifteenth Century Manuscript of the *De Viris Illustribus*," *Journal of the Warburg and Courtauld Institutes* 27 (1964): 90–107.

—— *Giotto and the Orators: Humanist Observers of Painting in Italy and the Discovery of Pictorial Composition 1350–1450*, Oxford, 1971.

—— *Painting and Experience in Fifteenth Century Italy*, Oxford, 1972.

BELTRAMI, L., *Il Castello di Milano*, Milan, 1894.

BERTI TOESCA, E., "Un romanzo illustrato del Quattrocento: il romanzo di Lancillotto, codice palatino 556," *Arte*, N.S., 10 (1939): 135–43.

BERTONI, G., *La biblioteca estense e la coltura ferrarese ai tempi del Duca Ercole I (1471–1505)*, Turin, 1903.

—— "Buffoni alla corte di Ferrara," *Rivista d'Italia* 6, fasc. 3–4 (1903): 495–505.

—— "Lettori di romanzi francesi nel Quattrocento alla corte estense," *Romania* 45 (1918): 117–22.

BOCCIA, L. G., *Le armature di S. Maria delle Grazie di Curtatone di Mantova e l'armatura lombarda del Quattrocento*, Varese, 1982.

BOGDANOW, F., *The Romance of the Grail*, New York, 1966.

BOMBE, W., "Un roman français dans un palais florentin," *Gazette des Beaux-Arts*, ser. 4, 6 (1911): 231–42.

—— "Die Novelle der Kastellanin von Vergi in einer Freskenfolge des Palazzo Davizzi-Davanzati zu Florenz," *Mitteilungen des Kunsthistorischen Institutes in Florenz* 2 (1912–17): 1–25.

BORSOOK, E., *The Mural Painters of Tuscany*, 2d ed., London, 1980.

—— "Jacopo di Cione and the Guild Hall of the Judges and Notaries in Florence," *Burlington Magazine* 124 (1982): 86–88.

BRAGHIROLLI, W., P. MEYER, and G. PARIS, "Inventaire des manuscrits en langue française possédés par Francesco Gonzaga I, Capitaine de Mantoue, mort en 1407," *Romania* 9 (1880): 497–514.

BREILLAT, P., "Le ms. Palatin 556: la Tavola Rotonda et la liturgie du Graal," *Mélanges d'Archéologie et d'Histoire de l'Ecole Française de Rome* 55 (1938): 341–73.

BREVENTANO, Stefano, *Istoria delle antichità, nobilità, e delle cose notabili della città di Pavia*, Pavia, 1570.

BRIONI, C., "Per la biografia di Vittorino da Feltre," tesi di laurea, Università Cattolica del Sacro Cuore, Milan, 1967–68.

BUCCI, M., et al., *Camposanto monumentale di Pisa: affreschi e sinopie*, Pisa, 1960.

CADOGAN, J. K., "Reconsidering Some Aspects of Ghirlandaio's Drawings," *Art Bulletin* 65 (1983): 274–90.

CAMUS, J., "Notices et extraits des manuscrits français de Modène antérieurs au XVIe siècle," *Revue des Langues Romanes* 35 (1891): 169–262.

CANAL, Martin da, *Les estoires de Venise*, ed. A. Limentani, Florence, 1972.

CAPPELLI, A., "La biblioteca estense nella prima metà del secolo XV," *Giornale Storico della Letteratura Italiana* 14 (1889): 1–30.

CASACCI, A., "Un trattatello di Vittorino da Feltre sull'ortografia latina," *Atti del Reale Istituto Veneto di Scienze, Lettere ed Arti* 86, pt. 2 (1926–27): 911–45.

CASTAGNO, R., "Nascita e formazione delle scuderie dei Gonzaga," *Civiltà Mantovana* 10 (1976): 14–31.

CASTIGLIONE, Baldassarre, *Il libro del Cortegiano.*

CAVRIANI, C., *Le razze gonzaghesche dei cavalli nel Mantovano e la loro influenza sul puro sangue inglese*, Mantua, 1909.

CENNINI, Cennino, *The Craftsman's Handbook: "Il libro dell'arte,"* trans. D. V. Thompson, Jr., 2 vols., New Haven, 1933.

CHRISTIANSEN, K., *Gentile da Fabriano*, Ithaca, N.Y., 1982.

CLARK, K., with the assistance of C. Pedretti, *The Drawings of Leonardo da Vinci in the Collection of Her Majesty The Queen at Windsor Castle*, 3 vols., London, 1968.

CLEPHAN, R. C., *The Tournament: Its Periods and Phases*, New York, 1919.

CLOUGH, C. H., "The Library of the Gonzaga in Mantua," *Librarium: Revue de la Société Suisse des Bibliophiles* 15 (1972): 50–63.

—— "Federigo da Montefeltro's Patronage of the Arts 1468–1482," *Journal of the Warburg and Courtauld Institutes* 36 (1973): 129–44.

COLASANTI, A., *Gentile da Fabriano*, Bergamo, 1909.

CORTESI, M., "Libri e vicende di Vittorino da Feltre," *Italia Medioevale e Umanistica* 23 (1980): 77–113.

COX-REARICK, J., *Dynasty and Destiny in Medici Art: Pontormo, Leo X, and the Two Cosimos*, Princeton, 1984.

CRIPPS-DAY, F. H., *The History of the Tournament in England and in France*, London, 1918.

CUPPINI, M. T., "L'arte gotica in Verona nei secoli XIV e XV," *Verona e il suo Territorio*, vol. 3, Verona, 1969.

D'ANCONA, P., "Gli affreschi del Castello di Manta nel Saluzzese," *L'Arte* 8 (1905): 94–106, 183–98.

D'ANJOU, René, *Traité de la forme et devis d'un tournoi*, ed. E. Pognon, Paris, 1946.

DEGENHART, B., and A. SCHMITT, "Gentile da Fabriano in Rom und die Anfänge des Antikenstudiums," *Münchner Jahrbuch der Bildenden Kunst*, ser. 3, 2 (1960): 59–151.

—— *Corpus der italienischen Zeichnungen 1300–1450*, 7 vols., Berlin, 1968– .

—— "Frühe angiovinische Buchkunst in Neapel: die Illustrierung französischer Unterhaltungsprosa in neapolitanischen Scriptorien zwischen 1290 und 1320," *Festschrift Wolfgang Braunfels*, ed. F. Piel and J. Traeger, Tübingen, 1977, pp. 71–92.

DELCORNO BRANCA, D., *I romanzi italiani di Tristano e la Tavola Ritonda*, Florence, 1968.

—— *L'Orlando Furioso e il romanzo cavalleresco medievale*, Florence, 1973.

—— *Il romanzo cavalleresco medievale*, Florence, 1974.

DE ROBERTIS, D., "Ferrara e la cultura cavalleresca," in *Storia della letteratura italiana*, ed. E. Cecchi and N. Sapegno, Milan, 1966, III, pp. 570–74.

Descrizione della giostra seguita in Padova nel giugno 1466, ed. G. Visco, Padua, 1852.

D'HULST, R. A., *Flemish Tapestries from the 15th to the 18th Centuries*, New York, 1969.

Diario ferrarese dall'anno 1409 sino al 1502, ed. G. Pardi, in L. A. Muratori, *Rerum Italicarum Scriptores*, vol. 24, part 7, 2d ed., Bologna, 1928.

DIONISOTTI, C., "Entrée d'Espagne, Spagna, Rotta di Roncisvalle," *Studi in onore di Angelo Monteverdi*, Modena, 1959, pp. 207–41.

Documenti marciani e principale letteratura sui codici veneti di epopea Carolingia, supplement to the exhibition catalog, Venice, 1961.

DURLING, R., *The Figure of the Poet in the Renaissance Epic*, Cambridge, Mass., 1965.

Filarete's Treatise on Architecture, trans. J. R. Spencer, 2 vols., New Haven–London, 1965.

FIOCCO, G., "Disegni di Stefano da Verona," *Proporzioni* 3 (1950): 56–64.

FLÛTRE, F., *Table des noms propres avec toutes leurs variantes figurant dans les romans du*

Moyen âge, écrits en français ou en provençal et actuellement publiés ou analysés, Poitiers, 1962.

FOLENA, G., "La cultura volgare e 'l'umanesimo cavalleresco' nel Veneto," in *Umanesimo europeo e umanesimo veneziano* (Atti del Convegno), Florence, 1963, pp. 141–58.

FRAPPIER, J., "The Vulgate Cycle," in *Arthurian Literature in the Middle Ages*, ed. R. S. Loomis, Oxford, 1959, pp. 295–318.

—— *Etude sur la Mort le Roi Artu*, 2d ed., Paris, 1961.

—— "Le concept de l'amour dans les romans arthuriens," in *Amour courtois et Table Ronde*, Geneva, 1973.

FREEDBERG, S. J., *Painting in Italy 1500–1600*, Harmondsworth, 1971.

FREY, A. L., *The Swan Knight Legend*, Nashville, Tenn., 1931.

FRYE, N., *Anatomy of Criticism*, Princeton, 1957.

—— *The Secular Scripture: A Study of the Structure of Romance*, Cambridge, Mass., 1976.

GANDINI, L. A., *Tavola, cantina e cucina della corte di Ferrara nel Quattrocento*, Modena, 1889.

—— "Viaggi, cavalli, bardature e stalle degli Estensi nel Quattrocentro," *Atti e Memorie della R. Deputazione di Storia Patria per le Province di Romagna*, ser. 3, 10 (1892): 41–94.

GARDNER, E. G., *The Arthurian Legend in Italian Literature*, London, 1930.

GARIN, E., *Il pensiero pedagogico dello umanesimo*, Florence, 1958.

GEROLA, G., "Per la datazione degli affreschi di Castel Roncolo," *Atti del R. Istituto Veneto di Scienze, Lettere ed Arti* 82, pt. 2 (1923): 511–21.

GIROLLA, P., "La biblioteca di Francesco Gonzaga secondo l'inventario del 1407," *Atti e Memorie della R. Accademia Virgiliana di Mantova* 14–16 (1923): 30–72.

GOLDTHWAITE, R., "The Florentine Palace as Domestic Architecture," *American Historical Review* 77 (1972): 977–1012.

GOLOUBEW, V., *Les dessins de Jacopo Bellini au Louvre et au British Museum*, 2 vols., Brussels, 1908–12.

GOMBRICH, E. H., *Art and Illusion*, London, 1960.

—— "Leonardo's Methods of Working Out Compositions," *Norm and Form*, London, 1966, pp. 58–63.

—— "Style," in *International Encyclopedia of the Social Sciences*, New York, 1968, pp. 352–61.

—— "Huizinga's 'Homo Ludens,' " *Bijdragen en Mededelingen Betreffende de Geschiedenis der Nederlanden* 88 (1973): 275–96.

—— *Means and Ends: Reflections on the History of Fresco Painting*, London, 1976.

GRABAR, O., "History of Art and History of Literature: Some Random Thoughts," *New Literary History* 3 (1971–72): 559–68.

GRASSI, G. de', *Taccuino di disegni: codice della Biblioteca Civica di Bergamo*, Milan, 1961.

GUNDERSHEIMER, W. L., *Ferrara: The Style of a Renaissance Despotism*, Princeton, 1973.

—— "The Patronage of Ercole I d'Este," *Journal of Medieval and Renaissance Studies* 6 (1976): 1–19.

GUNDERSHEIMER, W. L., ed., *Art and Life at the Court of Ercole I d'Este: The "De Triumphis Religionis" of Giovanni Sabadino degli Arienti*, Geneva, 1972.

HAIDU, P., "Making It (New) in the Middle Ages: Towards a Problematics of Alterity," *Diacritics* 4 (1974): 2–11.

HARTSHORNE, A., "Notes on Collars of SS," *Archaeological Journal* 39 (1882): 376–83.

HARWARD, V. J., *The Dwarfs of Arthurian Romance and Celtic Tradition*, Leiden, 1958.

HAUG, W., J. HEINZLE, D. HUSCHENBETT, and N. H. OTT, *Runkelstein: Wandmalerei des Sommerhauses*, Wiesbaden, 1982.

HEIKAMP, D., and A. GROTE, eds., *Il tesoro di Lorenzo il Magnifico*, vol. 2, *I vasi*, Florence, 1972.

HERALD, J., *Renaissance Dress in Italy 1400–1500*, London, 1981.

HERMANN, H. J., "Zur Geschichte der Miniaturmalerei am Hofe der Este in Ferrara," *Jahrbuch der Kunsthistorischen Sammlungen des Allerhöchsten Kaiserhauses* 21 (1900): 117–271.

HEYDENREICH, B., *Ritterorden und Rittergesellschaften: ihre Entwicklung vom späten Mittelalter bis zur Neuzeit*, Würzburg, 1960.

HILL, G. F., "Milanese Armourers' Marks," *Burlington Magazine* 36 (1920): 49–50.

—— *A Corpus of Italian Medals of the Renaissance before Cellini*, 2 vols., London, 1930.

HOMMEL, L., *L'histoire du noble ordre de la Toison d'or*, Brussels, 1947.

HUET, G., "Sur quelques formes del la légende du *Chevalier au Cygne,*" *Romania* 34 (1905): 206–14.

HUIZINGA, J., "The Political and Military Significance of Chivalric Ideas in the Late Middle Ages," *Men and Ideas*, New York, 1959, pp. 196–206.

Illustrierter Führer durch das Hohenzollern-Museum im Schlosse Monbijou, Berlin, 1914.

JACKSON, W.T.H., *The Literature of the Middle Ages*, New York, 1960.

JAFFRAY, R., *The Two Knights of the Swan: Lohengrin and Helyas*, New York–London, 1910.

JANSON, H. W., *The Sculpture of Donatello*, Princeton, 1963.

JAUSS, H. R., "The Alterity and Modernity of Medieval Literature," *New Literary History* 10 (1979): 181–227.

JENKINS, A.D.F., "Cosimo de' Medici's Patronage of Architecture and the Theory of Magnificence," *Journal of the Warburg and Courtauld Institutes* 30 (1970): 162–70.

JONES, P. J., "Economia e società nell'Italia medievale," in *Storia d'Italia*, vol. 1, *Dal feudalesimo al capitalismo*, Turin, 1978, pp. 187–372.

KEEN, M. H., "Chivalry, Nobility and the Man-at-Arms," in *War, Literature and Politics in the Late Middle Ages*, ed. C. T. Allmand, London, 1976, pp. 32–45.

—— *Chivalry*, New York, 1984.

KIBRE, P., "The Intellectual Interests Reflected in the Libraries of the Fourteenth and Fifteenth Centuries," *Journal of the History of Ideas* 7 (1946): 257–97.

KRISTELLER, P., "The Humanist Bartolomeo Facio and His Unknown Correspondence," in *From the Renaissance to the Counter Reformation: Essays in Honor of Garrett Mattingly*, ed. C. H. Carter, London, 1966, pp. 56–74.

LANZONI, G., "Note sul costume cavalleresco del Quattrocento: il demenino," *Archivum Romanicum* 9 (1925): 456–57.

LAVIN, M. A., "Piero della Francesca's Fresco of Sigismundo Pandolfo Malatesta before St. Sigismund," *Art Bulletin* 56 (1974): 345–74.

—— See also publication by M. Aronberg.

LAZZERONI, E., "Il viaggio di Federico III in Italia (l'ultima incoronazione imperiale in Roma)," *Atti e Memorie del Primo Congresso Storico Lombardo*, Milan, 1937, pp. 271–397.

LECOUTEUX, L., *Mélusine et le chevalier au cygne*, Paris, 1982.

LEJEUNE, R., and J. STIENNON, "La légende arthurienne dans la sculpture de la cathédrale de Modène," *Cahiers de Civilisation Médiévale* 6 (1963): 282–93.

LEVEY, M., *Painting at Court*, New York, 1971.

LEVI, E., "I cantari leggendari del popolo italiano nei secoli XIV e XV," *Giornale Storico della Letteratura Italiana*, suppl. 16 (1914): 1–159.

LEVI PISETSKY, R., *Storia del costume in Italia*, Milan, 1964, vol. 2.

LEWIS, C. S., *The Allegory of Love*, Oxford, 1936.

—— "Edmund Spenser," in *Major British Writers*, ed. G. B. Harrison, New York, 1954, pp. 91–102.

—— *The Discarded Image: An Introduction to Medieval and Renaissance Literature*, Cambridge, 1964.

LOESETH, E., *Le roman en prose de Tristan . . . Analyse critique d'après les manuscrits de Paris*, Paris, 1891.

LOOMIS, R. S., "Chivalric and Dramatic Imitations of Arthurian Romance," in *Medieval Studies in Memory of A. Kingsley Porter*, ed. W.R.W. Koehler, Cambridge, Mass., 1939, I, pp. 79–97.

—— *Arthurian Tradition and Chrétien de Troyes*, New York, 1949.

LOOMIS, R. S., and L. H. LOOMIS, *Arthurian Legends in Medieval Art*, London–New York, 1938.

LOT, F., *Etude sur le Lancelot en prose*, Paris, 1918.

LULL, R., *Libro dell'ordine della cavalleria*, ed. G. Allegra, Rome, 1972.

LUZIO, A., "Isabella d'Este e l'Orlando Innamorato," *Giornale Storico della Letteratura Italiana* 2 (1883): 163–67.

—— "Cinque lettere di Vittorino da Feltre," *Archivio Veneto* 36 (1888): 329–41.

—— "Contribuito alla storia delle suppellettili del Palazzo Ducale di Mantova," *Atti e Memorie della R. Accademia Virgiliana di Mantova*, N.S., 6 (1913): 71–112.

LUZIO, A., and R. RENIER, "Il Platina e i Gonzaga," *Giornale Storico della Letteratura Italiana* 13 (1889): 430–40.

—— "I Filelfo e l'umanesimo alla corte dei Gonzaga," *Giornale Storico della Letteratura Italiana* 16 (1890): 119–217.

—— "Buffoni, nani e schiavi dei Gonzaga ai tempi d'Isabella d'Este," *Nuova Antologia di Scienze, Lettere ed Arti*, ser. 3, 34 (1891): 619–50; 35 (1891): 113–46.

MAGNAGUTI, A., *Ex Nummis Historia*, Rome, 1957.

MALLETT, M., *Mercenaries and Their Masters*, London, 1974.

MANCINI, G., *Vita di Leon Battista Alberti*, Florence, 1911.

MANDACH, A. de, "A la découverte d'un nouvel 'Aspremont' de la Bibliothèque des Gonzague à Mantoue," *Cultura Neolatina* 21 (1961): 116–22.

MANN, J. G., "The Sanctuary of the Madonna delle Grazie, with Notes on the Evolution of Italian Armour during the 15th Century," *Archaeologia* 80 (1930): 117–42.

—— "A Further Account of the Armour Preserved in the Sanctuary of the Madonna delle Grazie near Mantua," *Archaeologia* 87 (1938): 311–52.

—— "The Lost Armoury of the Gonzagas," *Archaeological Journal* 95 (1939): 274–83.

MARLE, R. VAN, *Iconographie de l'art profane au Moyen-âge et à la Renaissance et la décoration des demeures*, 2 vols, The Hague, 1931–32.

MARTINDALE, A., "Painting for Pleasure: Some Lost 15th Century Secular Decorations of Northern Italy," in *The Vanishing Past: Studies of Medieval Art, Liturgy and Metrology Presented to Christopher Hohler*, ed. A. Borg and A. Martindale, Oxford, 1981, pp. 109–31.

MEISS, M., *The Great Age of Fresco: Discoveries, Recoveries, and Survivals*, New York, 1970.

—— *The Great Age of Fresco: Giotto to Pontormo, Catalogue of Mural Paintings and Monumental Drawings*, preface by M. Meiss, introduction by U. Procacci, New York: Metropolitan Museum of Art, 1968.

MELLINI, G. L., *L'arte di corte nel secolo decimoquarto*, Cremona, 1965.

MENARD, P., *Le rire et le sourire dans le roman courtois en France au moyen-âge, 1150–1250*, Geneva, 1969.

MERONI, U., ed., *Mostra dei codici gonzagheschi*, Mantua, 1966.

MEYER, P., "De l'expansion de la langue française en Italie pendant le Moyen-Age," *Atti del II Congresso Internazionale di Scienze Storiche* (Rome, 1903), vol. 2, *Storia medievale e moderna*, Rome, 1906, pp. 61–104.

MICHA, A., "Les manuscrits du Lancelot en prose," *Romania* 81 (1960): 145–87; 84 (1963): 28–60, 478–99.

—— "La tradition manuscrite du Lancelot en prose," *Romania* 85 (1964): 293–318.

—— "Sur la composition du Lancelot en prose," in *Etudes de langue et de litérature du Moyen Age offerts à Félix Lecoy*, Paris, 1973, pp. 417–25.

MICHA, A., ed., *Lancelot, roman en prose du XIIIe siècle*, 9 vols., Paris–Geneva, 1978–83.

MOTTA, E., "I libri francesi della libreria sforzesca in Pavia (1470)," *Bollettino Storico della Svizzera Italiana* 6 (1884): 217–18.

—— *Musici alla corte degli Sforza*, Milan, 1887.

MÜNTZ, E., *Les arts à la cour des papes pendant le XVe et le XVIe siècle*, Paris, 1878.

NEGRI, R., *La Cappella di Teodolinda a Monza*, Milan–Geneva, 1968.

NEWMAN, H., *An Illustrated Dictionary of Jewellery*, London, 1981.

NOVATI, F., "I codici francesi de' Gonzaga secondo nuovi documenti," *Romania* 19 (1890): 161–200 (repr. in Novati, *Attraverso il Medioevo*, Bari, 1905, pp. 225–326).

OERTEL, R., "Wandmalerei und Zeichnung in Italien: die Anfänge der Entwurfszeichnung und ihre monumentalen Vorstufen," *Mitteilungen des Kunsthistorischen Institutes in Florenz* 5 (1937–40): 217–314.

OSIO, L., *Documenti diplomatici tratti dagli archivi milanesi*, 3 vols., Milan, 1864.

OTT, N. H., "Katalog der Tristan-Bildzeugnisse," in H. Frühmorgen-Voss, ed., *Text und Illustration im Mittelalter*, Munich, 1975, pp. 140–71.

OTT, N. H., and W. WALLICZEK, "Bildprogramm und Textstruktur: Anmerkungen zu den "Iwein"-Zyklen auf Rodeneck und in Schmalkalden," *Deutsche Literatur im Mittelalter, Kontakte und Perspektiven: Hugo Kuhn zum Gedenken*, ed. C. Cormeau, Stuttgart, 1979, pp. 473–500.

PÄCHT, O., "Early Italian Nature Studies," *Journal of the Warburg and Courtauld Institutes* 13 (1950): 13–47.

PAGLIA, E., "La Casa Giocosa di Vittorino da Feltre in Mantova," *Archivio Storico Lombardo* 11 (1884): 150–55.

PANOFSKY, E., *Early Netherlandish Painting*, Cambridge, 1953.

PATTERSON, L. W., "The historiography of Romance and the Alliterative Morte Arthure," *Journal of Medieval and Renaissance Studies* 13 (1983): 1–32.

PAUPHILET, A., *Etude sur la Queste del Saint Graal*, Paris, 1921.

—— *Le legs du Moyen Age*, Mehun, 1950.

PELLEGRIN, E., *La bibliothèque des Visconti et des Sforza ducs de Milan au XVe siècle*, Paris, 1955.

PELLEGRINI, O., "Su di un particolare delle terrecotte di S. Anastasia in Verona," *Studi Storici Veronesi* 2 (1950): 209–14.

PEROSA, A., ed., *Giovanni Rucellai ed il suo zibaldone*, vol. 1, "Il zibaldone quaresimale," London, 1960.

PHILELPHUS, Franciscus, *Epistolarum libri XVI*, Venice, 1492.

PICKFORD, C. E., *L'evolution du roman arthurien en prose vers la fin du moyen âge*, Paris, 1960.

Pitture murali nel Veneto e tecnica dell'affresco, exhibition catalog, ed. M. Muraro with introductions by U. Procacci and G. Fiocco, Venice, 1960.

Pitture murali restaurate: Soprintendenza ai Monumenti di Verona, exhibition catalog with introduction by M. T. Cuppini, Verona, 1971.

PIUS SECUNDUS, *Commentarii Rerum Memorabilium . . .* Rome, 1584.

—— *The Commentaries of Pius II*, trans. F. A. Gragg, introduction by L. C. Gabel, *Smith College Studies in History* 22 (1936–37), 25 (1939–40), 30 (1947), 35 (1951), 43 (1957).

PLATINA, Bartolomeo, *Historia . . . Urbis Mantuae*, in L. A. Muratori, *Rerum Italicarum Scriptores*, vol. 20, Milan, 1731.

POLIDORI, F. L., *La Tavola Ritonda o l'istoria di Tristano*, Bologna, 1864.

PONTANO, Giovanni, *I trattati delle virtù sociali*, trans. Francesco Tateo, Rome, 1965.

POPE-HENNESSY, J., *The Complete Work of Paolo Uccello*, London, 1969.

—— *Fra Angelico*, London, 1974.

POPHAM, A. E., and P. POUNCEY, *Italian Drawings in the Department of Prints and Drawings in the British Museum: The Fourteenth and Fifteenth Centuries*, London, 1957.

PREYER, B., "The Rucellai Palace," in *Giovanni Rucellai ed il suo zibaldone*, vol. 2, *A Florentine Patrician and His Palace*, London, 1981, pp. 155–225.

PROCACCI, U., *La tecnica degli antichi affreschi e il loro distacco e restauro*, Florence, 1956.

—— *Sinopie e affreschi*, Milan, 1961.

RASMO, N., "Il codice palatino 556 e le sue illustrazioni," *Rivista d'Arte*, ser. 2, 11 (1939): 245–81.

—— *Castelroncolo*, Bolzano, 1975.

RAYNA, R., "Ricordi di codici francesi pos-

seduti dagli estensi nel secolo XV," *Romania* 2 (1873): 49–58.

—— "Contributi alla storia dell'epopea e del romanzo medievale: gli eroi brettoni nell'onomastica italiana del secolo XII," *Romania* 17 (1888): 161–85, 355–65.

—— *Le fonti dell'Orlando Furioso*, Florence, 1900.

—— "Intorno a due antiche coperte con figurazioni tratte dalle storie di Tristano," *Romania* 42 (1913): 517–79.

—— "Arturi regis ambages pulcerrime," *Studi Danteschi* 1 (1920): 91–99.

REICHENBACH, G., *Costumi della rinascenza: una giostra*, Padua, 1925.

RIEDEL, A. F., *Codex Diplomaticus Brandenburgensis*, 21 vols., Berlin, 1838–69.

ROBATHAN, D. M., "Libraries of the Italian Renaissance," in *The Medieval Library*, ed. J. W. Thompson, New York, 1939, pp. 509–88.

RONCAGLIA, A., "La letteratura franco-veneta," in *Storia della letteratura italiana*, ed. E. Cecchi and N. Sapegno, Milan, 1965, vol. 2, *Il Trecento*, pp. 727–59.

ROSENBERG, C. M., "Notes on the Borsian Addition to the Palazzo Schifanoia," *Musei Ferraresi* 3 (1973): 32–37.

—— "Some New Documents Concerning Donatello's Unexecuted Monument to Borso d'Este in Modena," *Mitteilungen des Kunsthistorischen Institutes in Florenz* 17 (1973): 149–52.

—— "The Iconography of the Sala degli Stucchi in the Palazzo Schifanoia in Ferrara," *Art Bulletin* 61 (1979): 377–84.

ROSSI, G., ed., *Un torneo del 1462*, Reggio Emilia, 1883.

RUDORFF, R., *Knights and the Age of Chivalry*, New York, 1974.

RUGGIERI, R. M., *L'umanesimo cavalleresco italiano: da Dante al Pulci*, Rome, 1962.

RYDING, W., *Structure in Medieval Narrative*, The Hague, 1971.

SABBADINI, R., ed., *Epistolario di Guarino Veronese*, 3 vols., Venice, 1915.

—— *Carteggio di Giovanni Aurispa*, Rome, 1931.

SALMI, M., "Nota su Bonifazio Bembo," *Commentari* 4 (1953): 7–15.

SANDOZ, E., "Tourneys in the Arthurian Tradition," *Speculum* 19 (1944): 389–420.

SANSOVINO, F., *Della origine de' cavalieri libri 4*, Venice, 1583.

SANTORO, C., "La biblioteca dei Gonzaga e cinque suoi codici nella Trivulziana di Milano," in *Arte, pensiero e cultura a Mantova nel 1° rinascimento: Atti del IV Convegno Internazionale di Studi sul Rinascimento* (Florence–Venice–Mantua, 1961), Florence, 1965, pp. 87–94.

SCHAPIRO, M., "Style," in *Anthropology Today*, ed. A. Kroeber, Chicago, 1953, pp. 287–312.

—— "On Some Problems in the Semiotics of Visual Art: Field and Vehicle in Image-Signs," *Semiotica* 1 (1969): 223–42.

SCHELLER, R. W., *A Survey of Medieval Modelbooks*, Haarlem, 1963.

SCHENDEL, A. VAN, *Le dessin en Lombardie*, Brussels, 1938.

SCHLOSSER, J. VON, "Ein veronesisches Bilderbuch und die höfische Kunst des XIV. Jahrhunderts," *Jahrbuch der Kunsthistorischen Sammlungen des Allerhöchsten Kaiserhauses* 16 (1895): 144–230.

—— "Die Werkstatt der Embriachi in Venedig," *Jahrbuch der Kunsthistorischen Sammlungen des Allerhöchsten Kaiserhauses* 20 (1899): 220–82.

SCHUHMANN, G., *Die Markgrafen von Brandenburg-Ansbach*, Ansbach, 1980.

SCHULTZE, J., *Die Mark Brandenburg*, vol. 2, *Die Mark unter Herrschaft der Hohenzollern (1415–1535)*, Berlin, 1963.

SCHULZ, J., and A. M. SCHULZ, "The Great Age of Fresco in New York," *Burlington Magazine* 111 (1969): 51–55.

SERRA, G., "Le date più antiche della penetrazione in Italia dei nomi di Artù e di Tristano," *Filologia Romanza* 2 (1955): 225–37.

SETTIS FRUGONI, C., "Per una lettura del mosaico pavimentale della cattedrale di Otranto," *Bollettino dell'Istituto Storico Italiano per il Medio Evo e Archivio Muratoriano* 80 (1968): 213–56.

SHEARMAN, J., *Mannerism*, Harmondsworth, 1967.

—— "The Collections of the Younger Branch of the Medici," *Burlington Magazine* 117 (1975): 12–27.

SIGNORINI, R., *In traccia del Magister Pelicanus: mostra documentaria su Vittorino da Feltre*, Mantua, 1979.

—— "Acquisitions for Ludovico II Gonzaga's Library," *Journal of the Warburg and Courtauld Institutes* 46 (1981): 180–83.

SIMONETTA, Cicco, *I diarii di Cicco Simonetta*, ed. A. R. Natale, Milan, 1962.

SOMMER, H. O., ed., *The Vulgate Version of the Arthurian Romances*, 8 vols., Washington, D.C., 1908–16.

SPENCER, J. R., "Il progetto per il cavallo di bronzo per Francesco Sforza," *Arte Lombarda* 38/39 (1973): 23–35.

STILLFRIED, R. VON, *Alterthümer und Kunstdenkmale des Erlauchten Hauses Hohenzollern*, 2 vols., Berlin, 1858–67.

STILLFRIED, R. G., and S. HAENLE, *Das Buch vom Schwanenorden*, Berlin, 1881.

STILLFRIED-RATTONITZ, R., *Der Schwanenorden, sein Ursprung und Zweck, seine Geschichte und seine Alterthümer*, Halle, 1845.

STONES, A., "The Earliest Illustrated Prose Lancelot Manuscript?" *Reading Medieval Studies* 3 (1977): 12–43.

TERVARENT, G. de, *Attributs et symboles dans l'art profane 1450–1600*, Geneva, 1958.

THOMPSON, D. V., *The Materials of Medieval Painting*, New Haven, 1936.

TIETZE-CONRAT, E., *Dwarfs and Jesters in Art*, New York, 1957.

TINTORI, L., "Conservazione, tecnica e restauro degli affreschi," *Mitteilungen des Kunsthistorischen Institutes in Florenz* 19 (1975): 149–80.

—— "Golden Tin in Sienese Murals of the Early Trecento," *Burlington Magazine* 124 (1982): 94–95.

TINTORI, L., and E. BORSOOK, *Giotto: The Peruzzi Chapel*, New York, 1965.

TINTORI, L., and M. MEISS, *The Paintings of the Life of St. Francis in Assisi*, New York, 1962.

TOESCA, P., *La pittura e la miniatura nella Lombardia*, 2d ed., Turin, 1966.

TRAVERSARI, A., *Hodoeporicon*, in A. Dini-Traversari, ed., *Ambrogio Traversari e i suoi tempi*, Florence, 1912.

TRUFFI, R., *Giostre e cantori di giostre: studi e ricerche di storia e di letteratura*, Rocca San Casciano, 1911.

TUVE, R., *Allegorical Imagery: Some Medieval Books and Their Posterity*, Princeton, 1966.

VALLONE, A., *Cortesia e nobiltà nel rinascimento*, Asti, 1955.

VANCE, E., "The Modernity of the Middle Ages in the Future," *Romanic Review* 64 (1973): 140–51.

VASARI, G., *Le vite de' più eccellenti pittori, scultori ed architettori*, ed. G. Milanesi, 9 vols., Florence, 1878–85.

Vasari on Technique, trans. L. S. Maclehose with introduction by G. B. Brown, New York, 1960.

VIALE-FERRARO, M., *Arazzi italiani*, Milan, 1961.

VIANELLO, G. A., "Gli Sforza e l'impero," *Atti e Memorie del Primo Congresso Storico Lombardo*, Milan, 1937, pp. 193–269.

VINAVER, E., *A la recherche d'une poétique médiévale*, Paris, 1970.

—— *The Rise of Romance*, Oxford, 1971.

VISCARDI, A., *Letteratura franco-italiana*, Modena, 1941.

—— "La quête du Saint Graal dans les romans du Moyen Age italien,' in *Lumière du Graal*, ed. R. Nelli, Paris, 1951, pp. 263–81.

VITRUVIUS, *De Architectura*, trans. from the Latin into Italian with commentary and illustrations by Cesare di Lorenzo Cesariano, Como, 1521; reissued in facsimile, New York–London, 1968.

Vittorino da Feltre: pubblicazione commemorativa del V centenario della morte, ed. G. Avanzi, Brescia, 1947.

Vittorino da Feltre e la sua scuola: umanesimo, pedagogia, arti, ed. N. Giannetto, Florence, 1981.

WAGNER, A. R., "The Swan Badge and the Swan Knight," *Archaeologia* 97 (1959): 127–38.

WARD, H.L.D., *British Museum: Catalogue of Romances in the Department of Manuscripts*, London, 1883.

WATSON, P., *The Garden of Love in Tuscan Art of the Early Renaissance*, Philadelphia, 1979.

WELLEK, R., and A. WARREN, *Theory of Literature*, New York, 1949.

WELSFORD, E., *The Fool: His Social and Literary History*, London, 1935.

WILLEFORD, W., *The Fool and His Sceptre*, London, 1969.

WOHL, H., *The Paintings of Domenico Veneziano*, New York, 1980.

WOLEDGE, B., *Bibliographie des romans et nouvelles en prose française anterieurs à 1500*, Geneva, 1954.

—— *Bibliographie . . . Supplement 1954–1973*, Geneva, 1975.

WOODWARD, W. H., *Vittorino da Feltre and Other Humanist Educators*, Cambridge, 1897.

ZUMTHOR, P., *Recherches sur les topiques dans la poésie lyrique des XIIe et XIIIe siècles,"* *Cahiers de Civilisation Médiévale* 2 (1959): 409–27.

—— *Essai de poétique médiévale*, Paris, 1972.

—— "From Hi(story) to Poem, or the Paths of Pun: The Grands Rhétoriqueurs of 15th Century France," *New Literary History* 10 (1979): 231–63.

INDEX

Acciauoli family, 27
Accolti, Francesco, 24
Agoiers li Fel, 14, 17, 121
Agrocol li Bials Parliers, 15, 117
Alberti, Leon Battista, 73, 75, 78–79, 81–84, 90, 104, 106, 111, 116, 124, 127, 128, 130, 132, 141, 143, 154, 156, 158, 221n
Aleotti, Ulisse degli, 33
Altichiero, 32
Andreasi, Marsilio, 78
Angelico, Fra, 33, 88
Anjou, René of, 70, 84
Aragon, Alfonso V of, King of Naples, 36, 37, 40–44, 48–49, 53, 67, 68, 86, 87, 139, 140, 157
Aragon, Maria of, 35, 36
Aretino, Pietro, 130
Arfassart li Gros, 14, 16, 62
Arienti, Sabadino degli, 130, 141–42, 153
Ariosti, Giacomo, 24
Ariosti, Nicolo degli, 138
Ariosto, Lodovico, 85, 146
armor, 139–40
Arthur, King, 13, 21, 27, 64, 69, 70, 84, 148, 156
Arthurian cycle. *See* Mantua, Ducal Palace, *Sala del Pisanello*
Arthurian knights. *See* Round Table, knights of the
Arthurian romance, 19, 20, 21–23, 26–31, 62, 84, 92–97, 134–35, 144–53; readers of, 21–23, 145, 151–52; variants in spelling names, 16–17, 62
Artu, La Mort le Roi, 13, 27
Aspremonte, 23
astrology, 45–46, 60, 68
Aue, Hartman von der, 28
Aurispa, Giovanni, 74, 224n
Averlino, Antonio. *See* Filarete
Avignon, Papal Palace, *Chambre du Cerf*, 93

Baldovinetti, Alessio, 80
Barbiri, Jacomo, 23
Basinio da Parma, 34, 161, 217n
Baxandall, Michael, 97, 145
Belbello da Pavia, 83, 86
Bellini, Jacopo, 20, 33, 98, 189n, 243n
Belluzzi, Amedeo, 169n, 176n
Bembo, Bonifacio, 27, 98
Bentivoglio, Annibale, 129
Berri, Duke of, 12, 89

Bertazzolo, Gabriele, 3, 4
Biondo, Flavio, 37
Bisticci, Vespasiano da, 75
Blood of Christ. *See* Holy Blood, relic of the
Boccaccio, Giovanni, 133
Bohort, 13–15, 18–20, 30–31, 42, 57, 61–65, 67, 69, 71, 90, 94, 98, 103, 122, 132–35, 147, 148, 212n, 239n
Boiardo, Matteo Maria, 85, 150–52, 157, 160
Bolzano, Castelroncolo, *turnyr camer*, 20, 28, 61, 70, 92, 97, 98, 103
Bolzano, Castle of Rodengo, 28
Bonacolsi, 3
Bonatto, Bartolomeo, 79, 150
Bondeno, Petrecino del, 24
Bracciolini, Poggio, 156
Brandenburg, Albert Achilles, Margrave of, 50–53, 137, 139, 150, 207n, 208n
Brandenburg, Barbara of, xxiii, 3, 5, 6, 12, 30, 47, 49–52, 58–59, 61, 63, 76–78, 83, 127, 128, 131–34, 136–37, 151, 155, 157, 172n, 210n, 218n, 237n
Brandenburg, Frederick I, Elector of, 47, 50, 76, 200n, 210n
Brandenburg, Frederick II, Elector of, 50, 51, 57, 58, 59, 61, 62
Brandenburg, John the Alchemist, Margrave of, 47, 51, 62, 201n
Brandenburg, Marches of, 58, 60, 210n
Brandolini, Tiburto, 68
Brangoire, daughter of, 13–16, 18–19, 30–31, 63–65, 122, 133–35, 147, 148
Brangoire, King, 13–14, 17–20, 61, 62, 65, 69, 90, 94, 98, 121, 129, 147, 212n
Brangoire's Castle. *See* Chastel de la Marche
Brunelleschi, Filippo, 81, 223n

calendula, 56, 206n
cane alano, 56, 60–61, 64, 120, 206n
Capello, Guglielmo, 83
Caravaggio, Battle of, 68
Carbone, Ludovico, 196n
Carretto, Ottone del, 202n
cassoni, 20
Castagno, Andrea del, 80, 88
Castelroncolo. *See* Bolzano, Castelroncolo
Castiglione, Baldassarre, 131, 155, 157, 247n
Cattani, Giovanni, 45
Cavriana, Castle of, 77

ILLUSTRATIONS

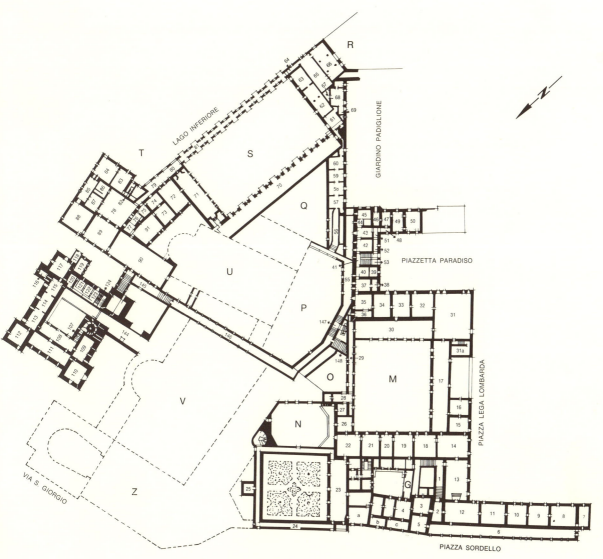

1. *Piano nobile* of the Ducal Palace in Mantua today.

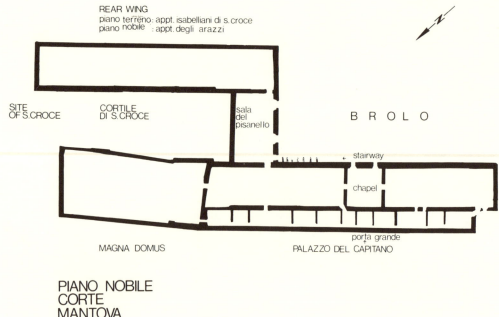

REAR WING
piano terreno: appt. isabelliani di s.croce
piano nobile : appt. degli arazzi

SITE
OF S.CROCE

CORTILE
DI S.CROCE

sala
del
pisanello

B R O L O

stairway

chapel

MAGNA DOMUS

porta grande

PALAZZO DEL CAPITANO

PIANO NOBILE
CORTE
MANTOVA
circa 1450

PIAZZA S. PIETRO

2. Schematic plan of the *piano nobile* of the *Corte* in Mantua, ca. 1450.

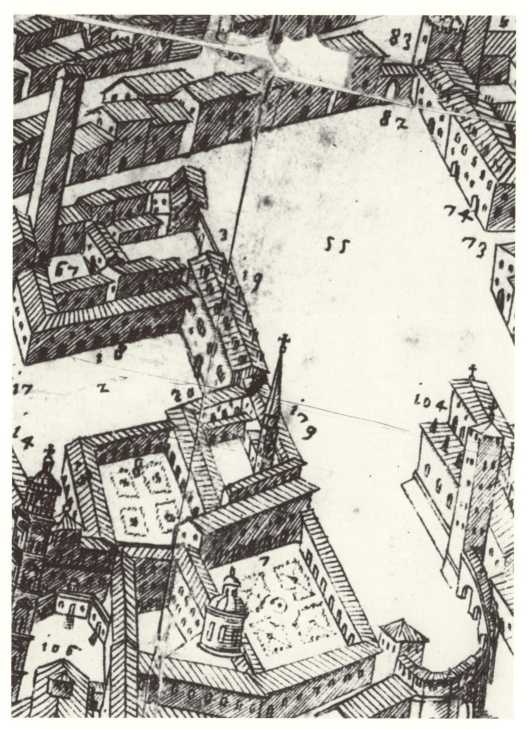

3. Gabriele Bertazzolo, detail of *View of Mantua* showing Ducal Palace. Engraving, 1628.

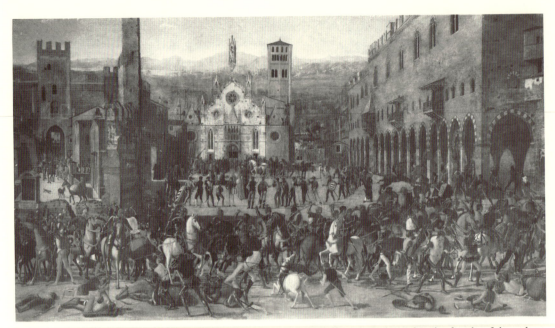

4. Domenico Morone, *The Expulsion of the Bonacolsi in 1328*, showing, on the right, the facade of the palace as it appeared in the Quattrocento. Oil on canvas, dated 1494. Coll.: Ducal Palace, Mantua.

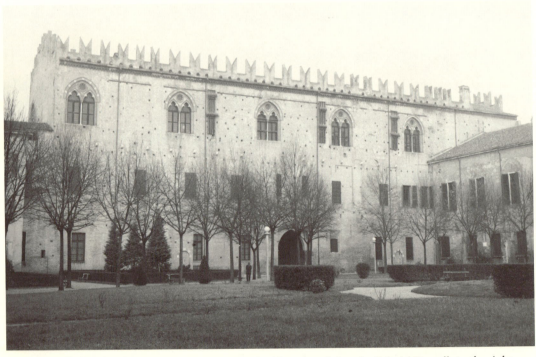

5. Rear facade of the Palazzo del Capitano with building containing the *Sala del Pisanello* to the right.

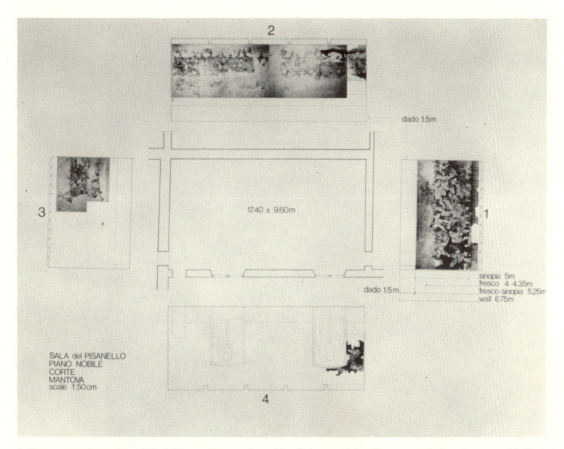

6. Reconstruction of the *Sala del Pisanello* to scale, with all the surviving frescoes and *sinopie* reassembled within the hall.

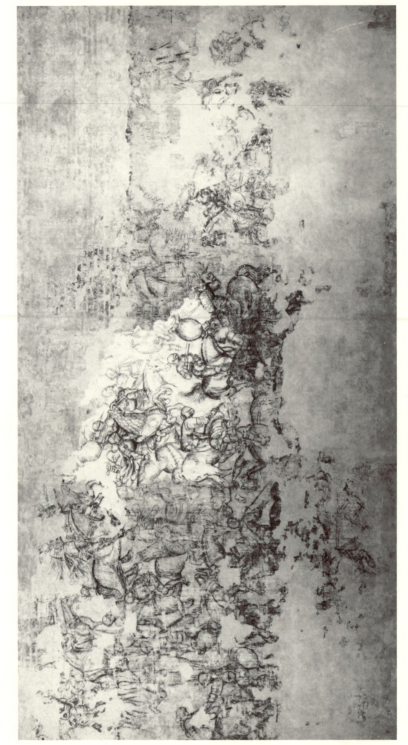

7. *Sinopia* of the tournament on Wall 1.

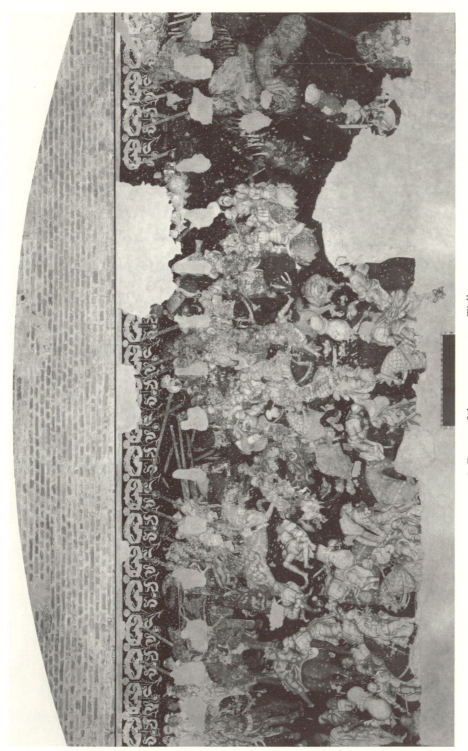

8. Fresco of the tournament on Wall I.

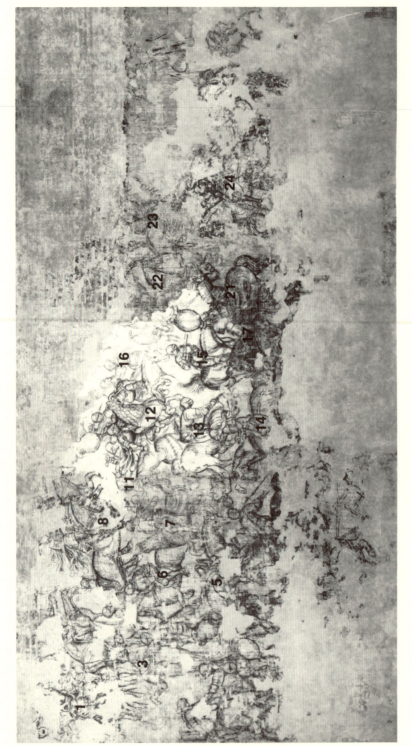

9. *Sinopia* of the tournament with knights identified by arabic numerals.

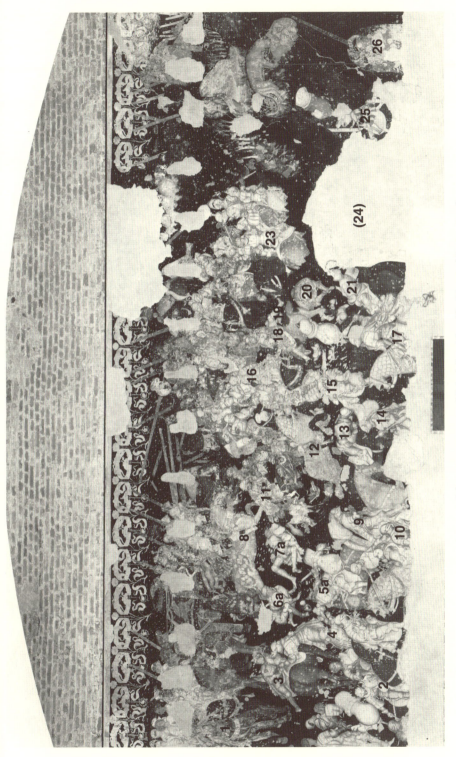

10. Fresco of the tournament with knights identified by arabic numerals.

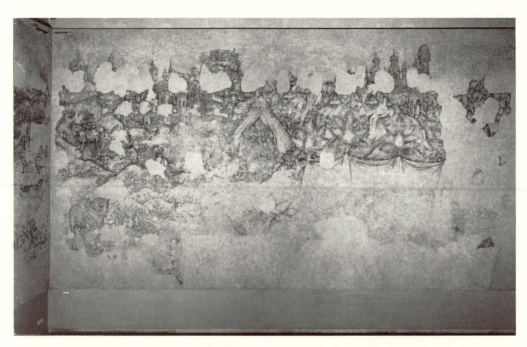

11. *Sinopia* on Wall 2 showing, from right to left, the maidens in the tribune,

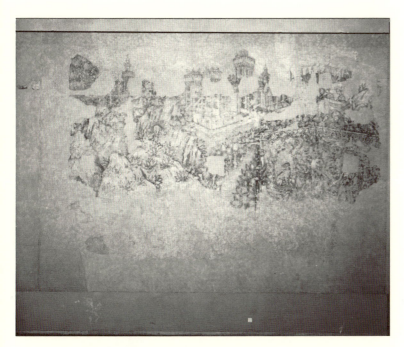

the castle, and the landscape with knights-errant.

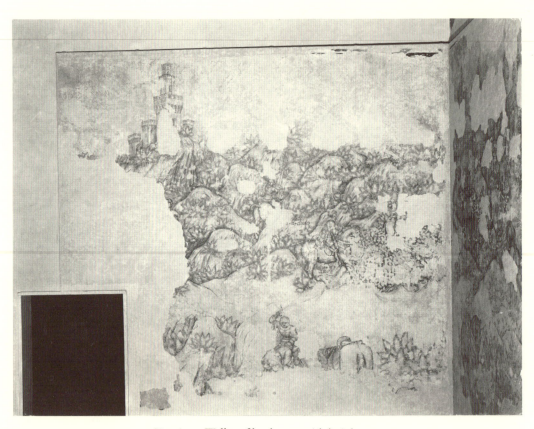

12. *Sinopia* on Wall 3 of landscape with knights-errant.

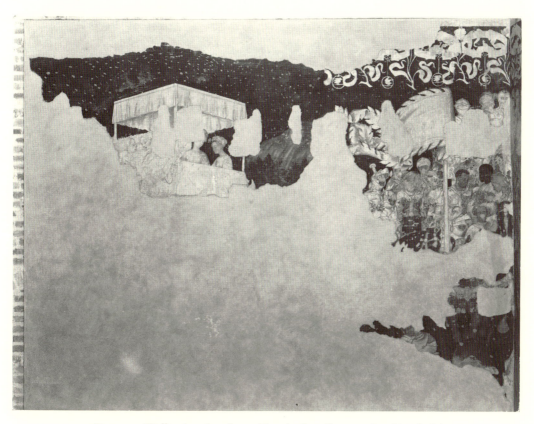

13. Fresco on Wall 2 showing the maidens in the tribune and waiting knights.

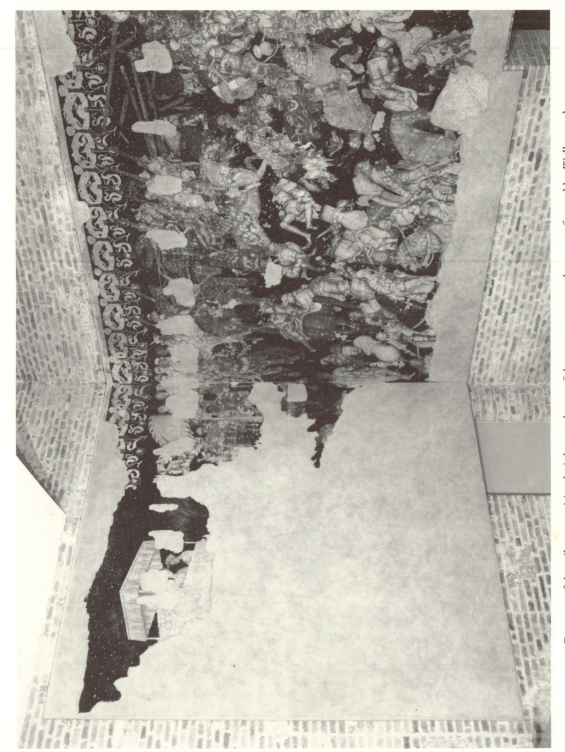

14. Frescoes of the tribune, waiting knights, and part of the tournament at the corner formed by Walls 1 and 2.

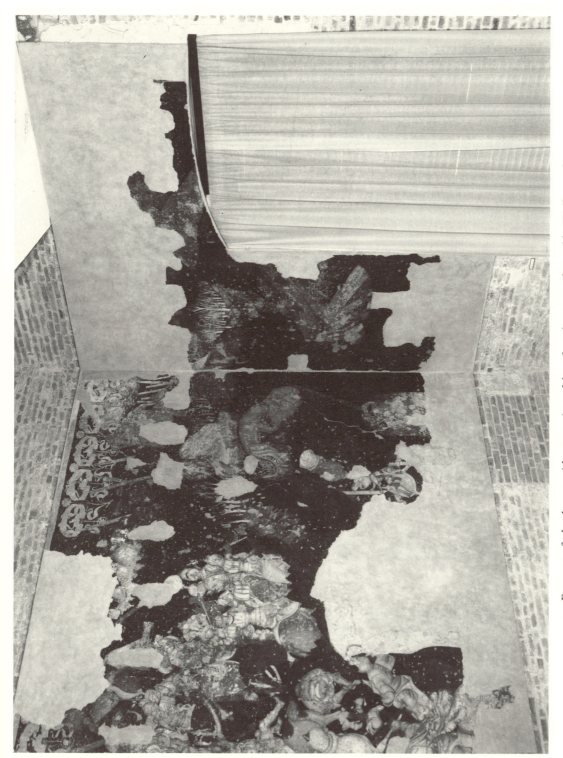

15. Frescoes of a landscape with procession of dwarfs at the corner formed by Walls 1 and 4.

17. *Sinopia* of a dwarf from Wall 4.

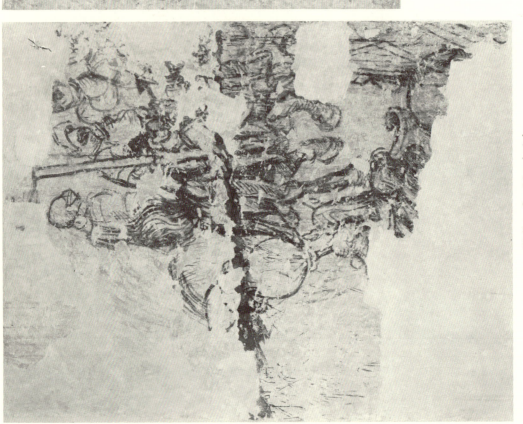

16. *Sinopia* on Wall 2 of waiting knights.

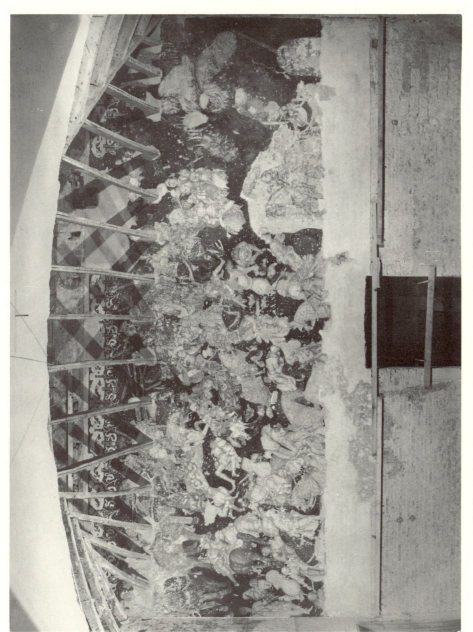

18. Wall 1 before the *strappo* of the tournament, showing fresco and *sinopia*, ca. 1966.

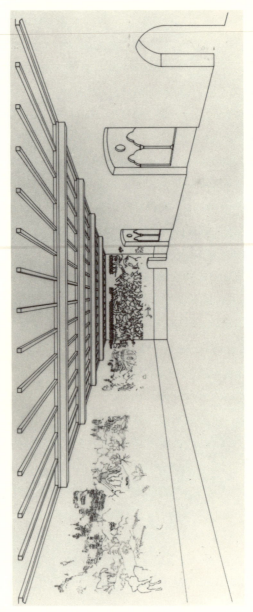

19. Reconstruction of the appearance of the *Sala del Pisanello* when Pisanello abandoned it, showing the dado in place.

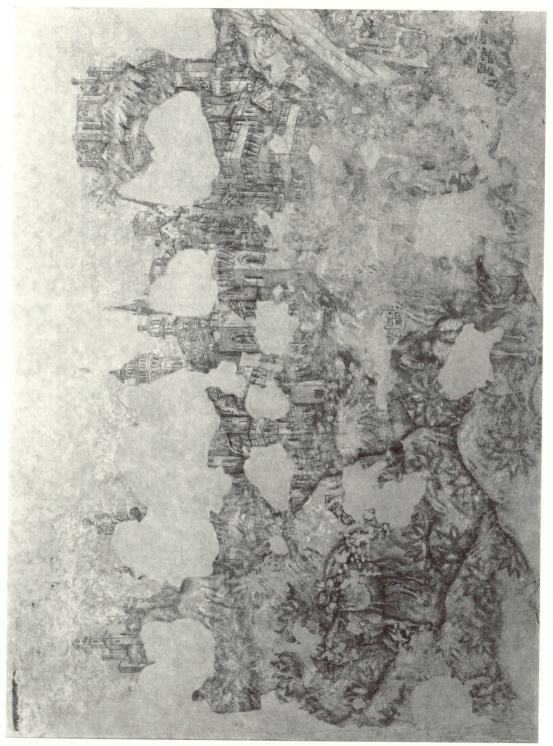

20. Detail of *sinopia* on Wall 2, showing Sardroc li Blont, Arfassart li Gros, and Sabilor as Dures Mains.

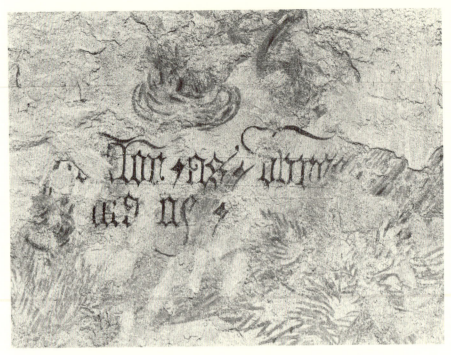

21. Details of the *sinopia* on Wall 2 with inscription . . . *lor as dures ma.ns*.

22. Detail of *sinopia* on Wall 2 showing inscription *arfassart li gros*.

23. Detail of *sinopia* on Wall 2 showing inscription *iiij . . . droc.*

24. Detail of *sinopia* on Wall 3 with inscription *maliez de lespine.*

25. Detail of *sinopia* on Wall 3 with inscription . . . *ns li envoissiez*.

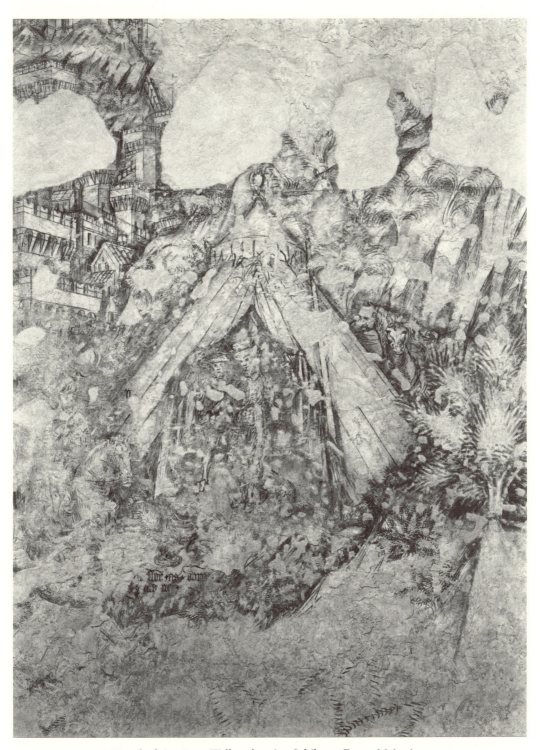

26. Detail of *sinopia* on Wall 2, showing Sabilor as Dures Mains in a tent.

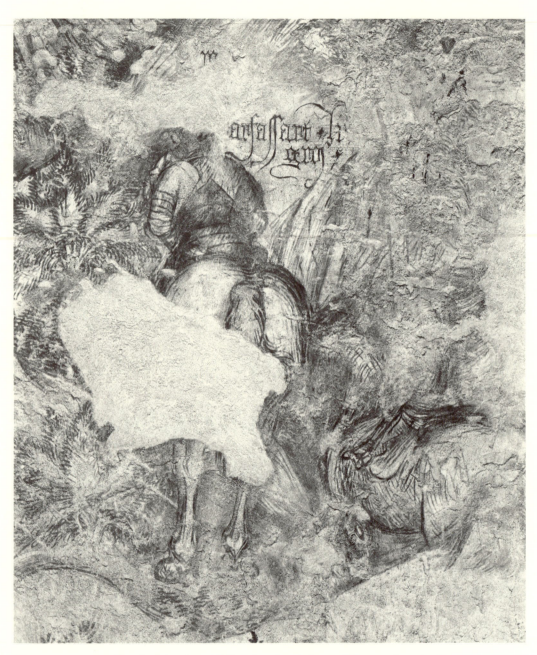

27. Detail of *sinopia* on Wall 2, showing Arfassart li Gros on horseback.

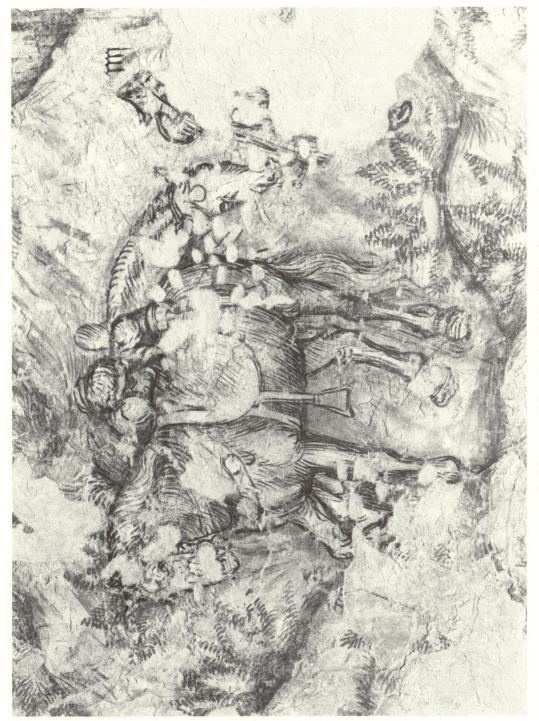

28. Detail of *sinopia* on Wall 2, showing Sardroc li Blont dismounted.

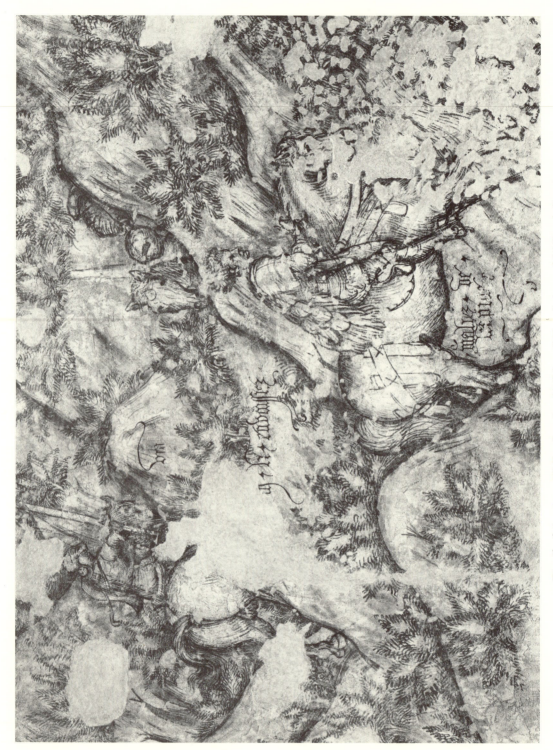

29. Detail of *sinopia* on Wall 3 showing Meliduns li Envoissiez and Maliez de Lespines.

30. Detail of *sinopia* on Wall 3 showing Agoiers li Fel.

31. Detail of *sinopia* on Wall 2 showing Garengaus li Fors.

32. Detail of *sinopia* on Wall 2 showing, on the right, maidens in the tribune decorated with Gonzaga emblem of *cane alano* and, on the left, the Chastel de la Marche.

33. Detail of *sinopia* on Wall 2 showing small tent pitched for King Brangoire.

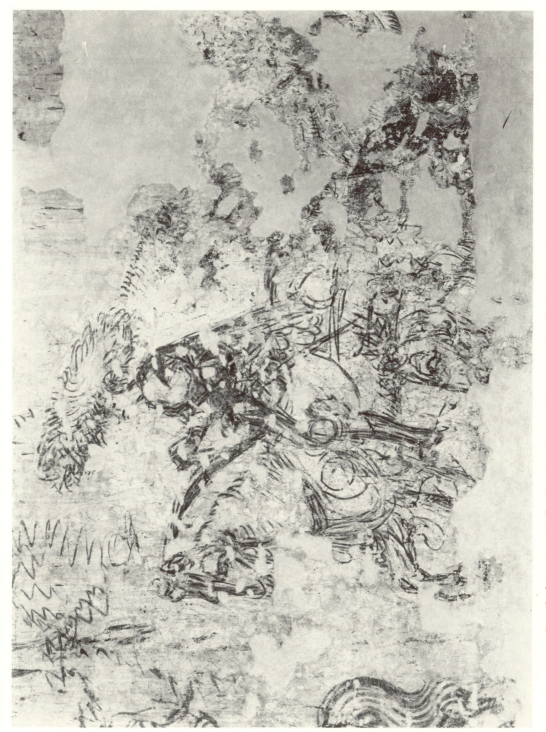

34. Detail of *sinopia* on Wall 1 showing Gonzaga Knight 24 (identified as Bohort) approaching the tournament.

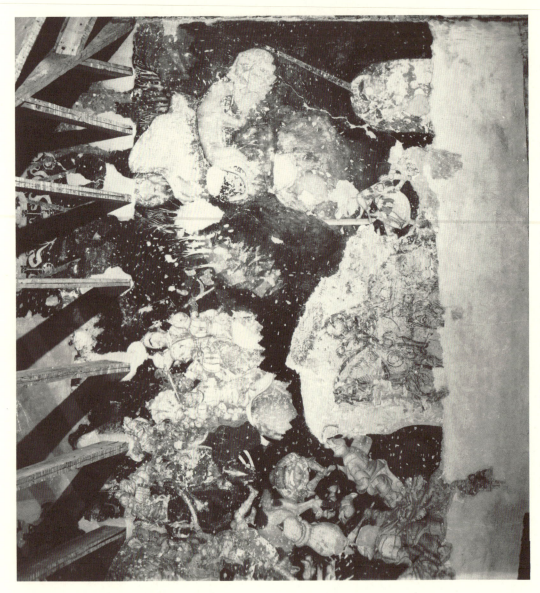

35. Detail of *sinopia* on Wall 1 showing the image of Knight 24 (perhaps Bohort) integrated into the tournament scene before the *strappo* of the fresco, ca. 1966.

36. Tapestry showing Caesar crossing the Rubicon and the Battle of Pharsalus. Flemish, fifteenth century. Coll.: Musée d'Histoire, Berne.

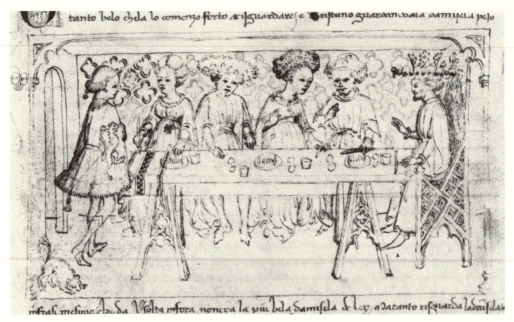

tanto belo chela lo comenzo forto a risguardare e Tristano guardandoala damisela pelo

mfrah mesimo che da Violta mfora noncra la vui bela Samisela d' ley, e Jatanto risguarda ladamisela

37. Bonifacio Bembo, banquet scene from the manuscript of the *Tavola Ritonda*. Drawing, 1446. Florence, Biblioteca Nazionale, Cod. Pal. 556, c. 24.

38. Bonifacio Bembo, bedchamber scene from the manuscript of the *Tavola Ritonda*. Drawing, 1446. Florence, Biblioteca Nazionale, Cod. Pal. 556, c. 79v.

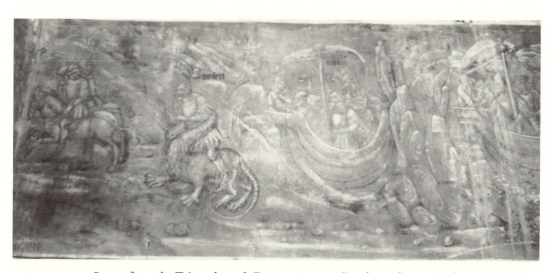

39. Scenes from the Tristan legend. Fresco, ca. 1400. Castelroncolo, near Bolzano.

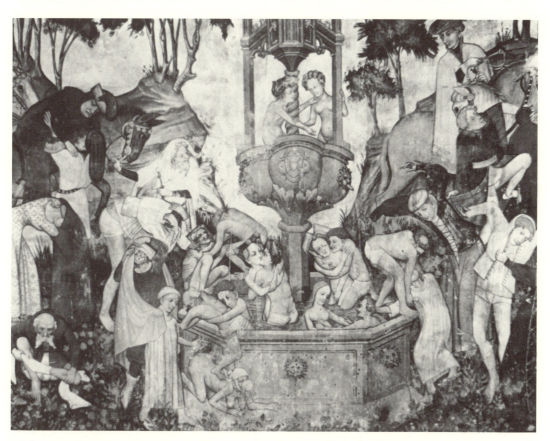

40. The old and infirm immersing themselves in the Fountain of Youth. Fresco, ca. 1420–30. *Sala Superiore*, Castello della Manta, near Saluzzo.

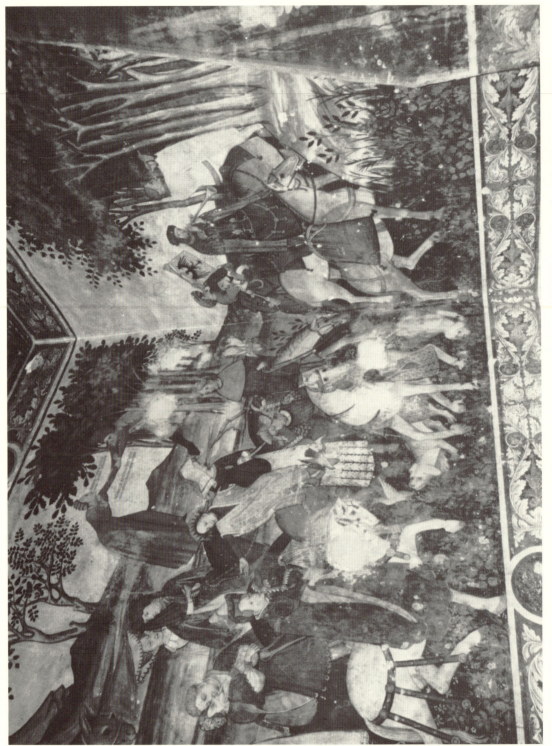

41. Enjoying life after the recovery of youthful vigor. Fresco, ca. 1420–30. *Sala Superiore*, Castello della Manta, near Saluzzo.

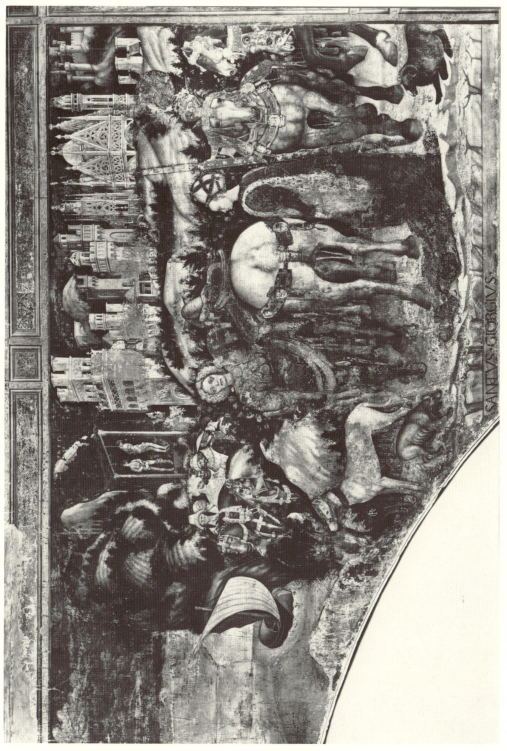

·SANCTVS·GIORGIVS·

42. Pisanello, *St. George and the Princess*. Fresco, ca. 1438. Formerly Pellegrini Chapel, S. Anastasia, Verona.

43. Pisanello, sketches of the authorities attending the Church Council of Ferrara. Pen drawing, 1438. Cabinet des Dessins, Musée du Louvre, inv. M.I. 1062r.

45. Fresco of the tournament with detail of Knight 9.

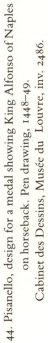

44. Pisanello, design for a medal showing King Alfonso of Naples on horseback. Pen drawing, 1448–49. Cabinet des Dessins, Musée du Louvre, inv. 2486.

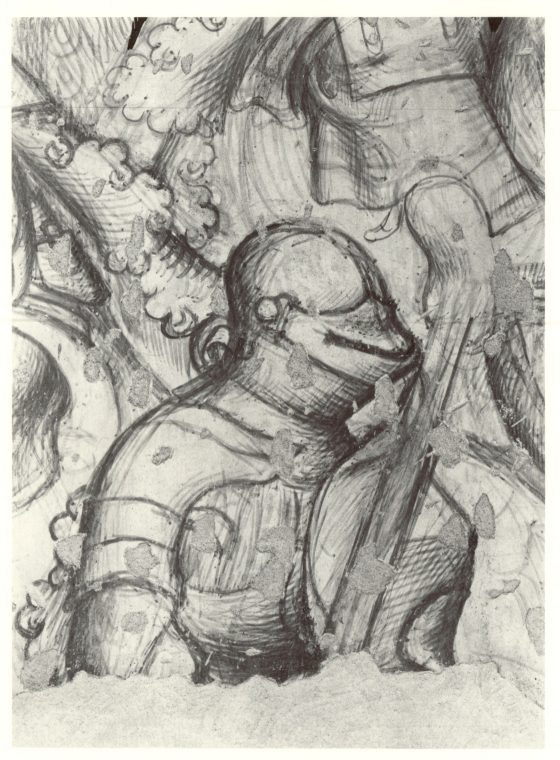

46. Fresco of the tournament with detail of Knight 10.

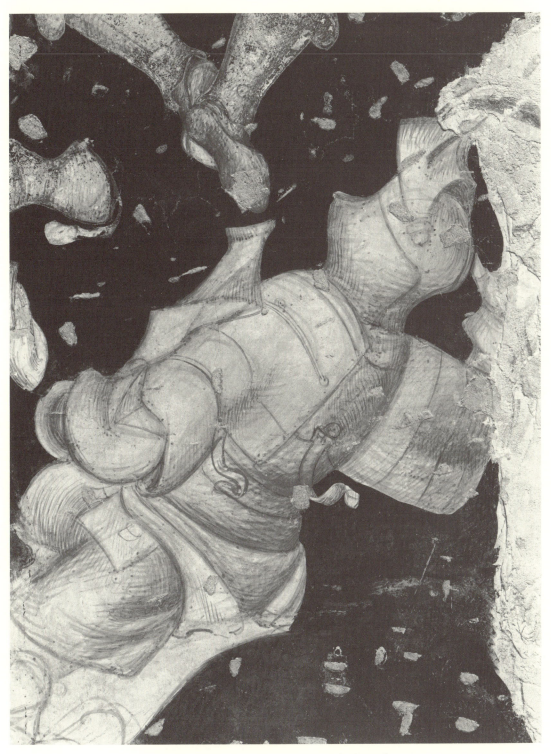

47. Fresco of the tournament with detail of Knight 21.

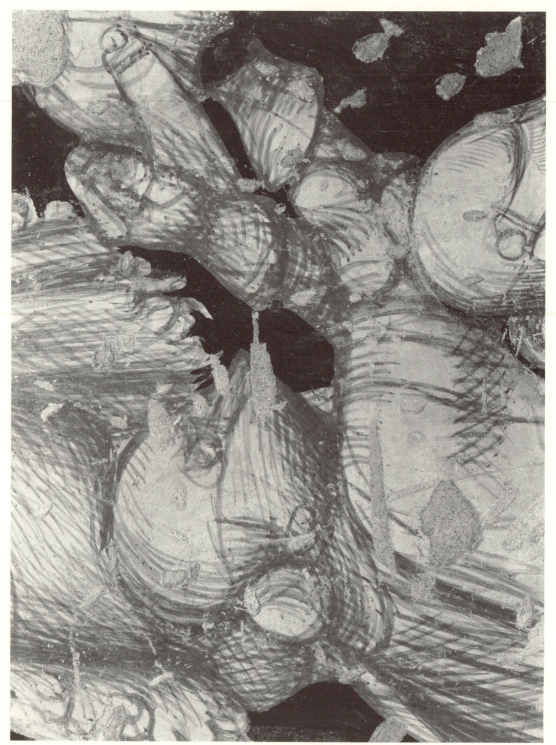

48. Fresco of the tournament with detail of Knight 4.

49. Pisanello, designs for medals for King Alfonso. Pen drawing, 1448–49. Cabinet des Dessins, Musée du Louvre, inv. 2318r.

50. Pisanello, design for a medal showing bust of King Alfonso. Pen drawing, 1449.
Cabinet des Dessins, Musée du Louvre, inv. 2306r.

51. *Sinopia* of the tournament showing detail of Knight 16.

52. Pisanello, obverse and reverse of bronze medal for Don Iñigo d'Avalos, 1448–49.

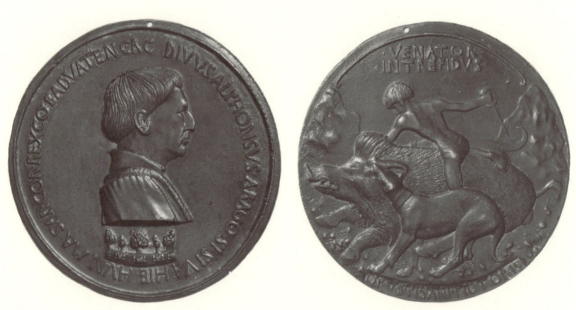

53. Pisanello, obverse and reverse of bronze medal for King Alfonso with inscription VENATOR INTREPIDVS, 1448–49.

54. Gold *marchesano* struck for Lodovico Gonzaga, 1445–46. Obverse shows Lodovico as a knight in contemporary armor holding a shield with Gonzaga arms. Reverse show Saint George slaying the dragon.

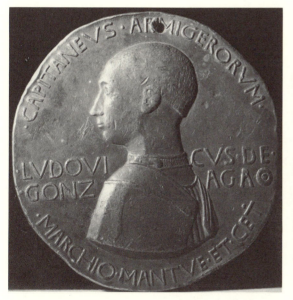

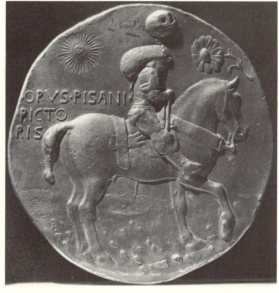

55. Pisanello, bronze medal of Lodovico Gonzaga, ca. 1447. Reverse shows the Marchese dressed in full armor with closed visor, with the emblems of a long-stemmed flower and a sun.

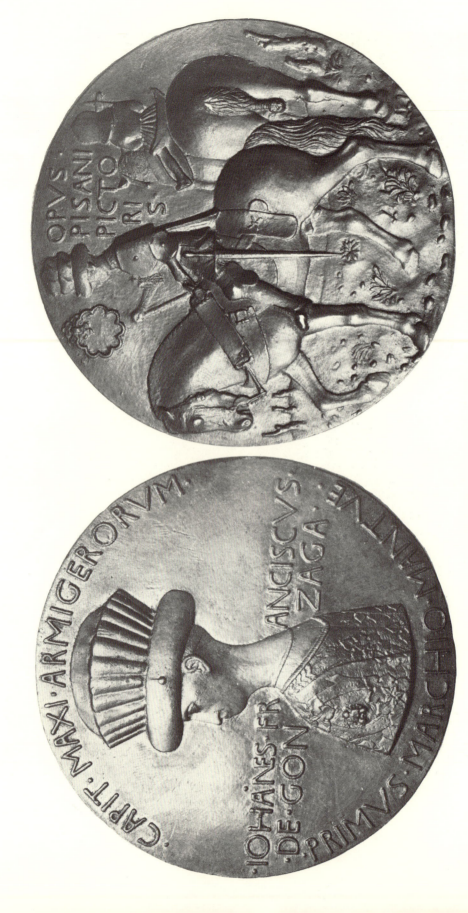

56. Pisanello, obverse and reverse of bronze medal for Gianfrancesco Gonzaga, ca. 1447.

57. Detail of frieze on Wall I showing collar with swan badge with emblem of *cervetta* standing on a cushion inside the center collar.

58. Close-up of frieze showing the emblem of *cane alano* seated on a cushion inside the collar with swan badge and, on either side, the long-stemmed flowers.

59. Detail of *sinopia* on a Wall 2 showing the emblem of *cane alano* on the tapestry hanging from the maidens' tribune.

60. Detail of the frieze of an early-15th-century fresco showing the emblems of *cane alano* and long-stemmed flower. Ducal Palace, Mantua.

61. Detail of the frieze of a late-14th-century fresco showing the emblem of *cervetta*. Corridoio del Passerino, Ducal Palace, Mantua.

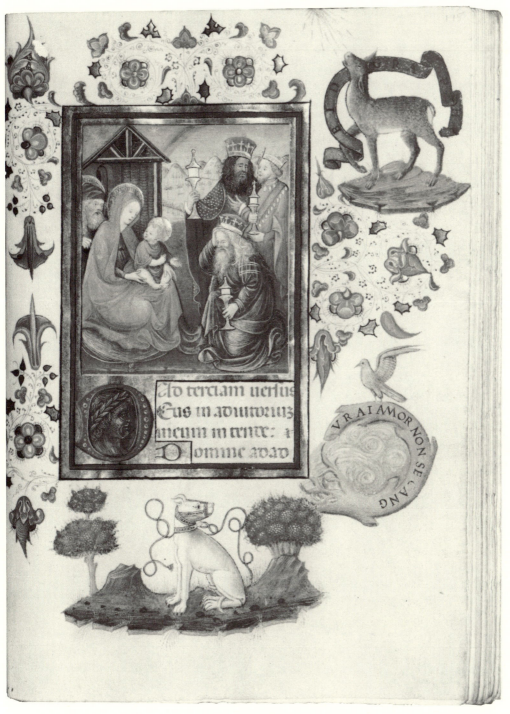

62. Folio from a Book of Hours for Lodovico Gonzaga's daughter Cecilia showing the emblems of *cervetta*, at upper right, and *cane alano*, below. Italian, mid-15th century. Pierpont Morgan Library, New York, M. 454, 195.

63. Reverse of medal of Lodovico Gonzaga showing emblem of long-stemmed flowers. Mantua, 16th century or later.

64a. Tracing of Gonzaga Knight 12 (Fig. 97) in the tournament.

64b. Tracing of the caparison of Gonzaga Knight 12's horse.

64c. Tracing of the devices of collar and flower on the caparison of Knight 12's horse.

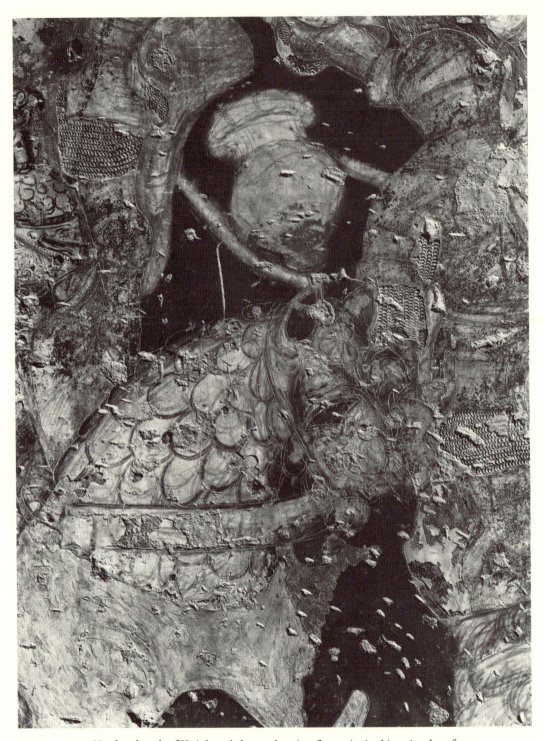

65. Head and neck of Knight 12's horse showing flower incised into its chamfron.

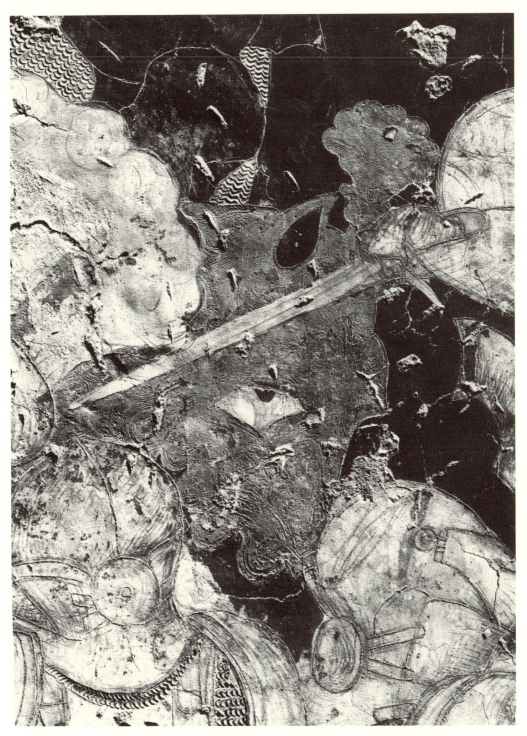

66. Detail from upper right of tournament showing horse with flower crest.

67. Detail of the breastcloth of Knight 17's horse showing emblem of Hohenzollern collar.

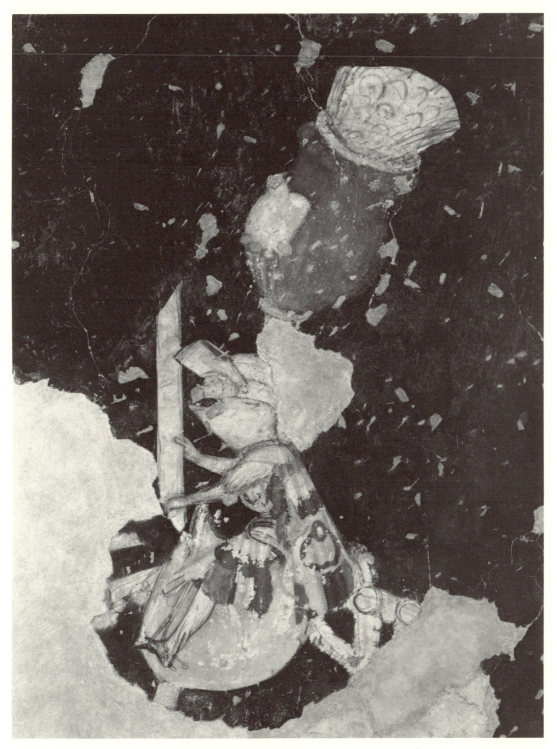

68. The dwarf (no. 25) who follows Gonzaga Knight 24 and wears a *giornea* with the Gonzaga family colors.

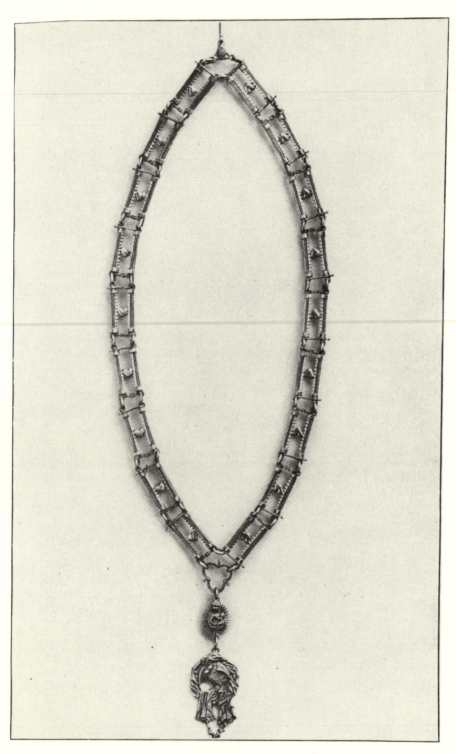

69. Collar of the Order of the Swan. German, mid-15th century.

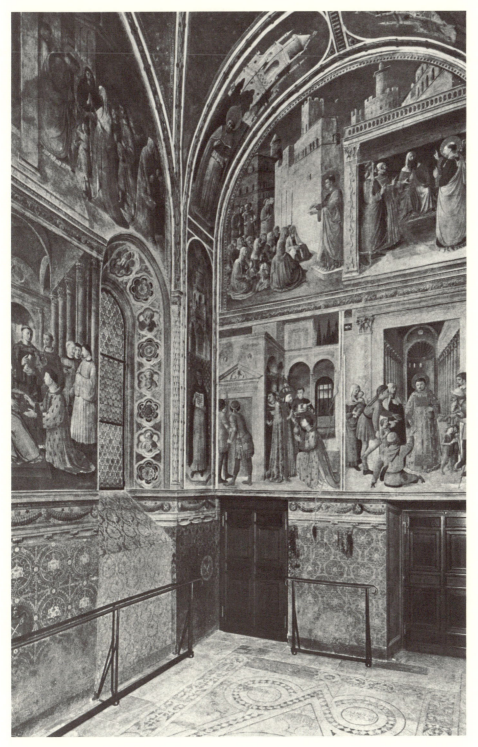

70. Fra Angelico, Chapel of Pope Nicholas V, Vatican Palace, Rome. Frescoes, 1447–49.

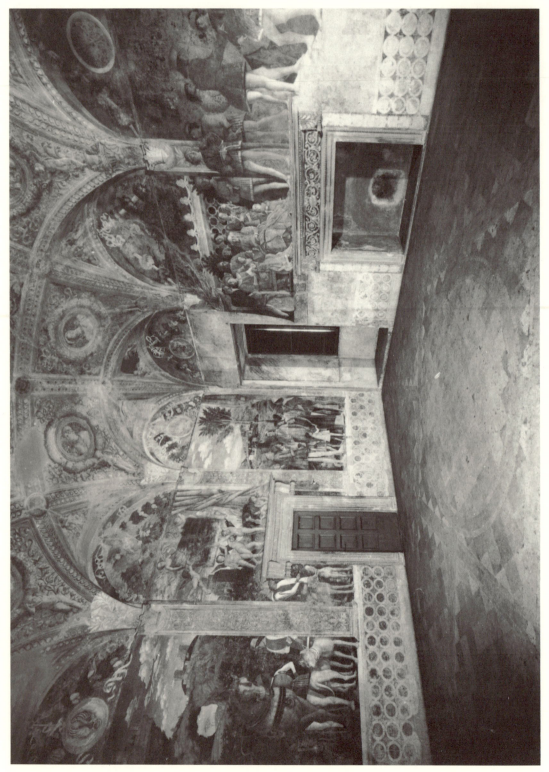

71. Mantegna, *Camera dipinta*. Frescoes, 1465–74. Castello, Mantua.

72. Corner between Walls 1 and 2 of the *Sala del Pisanello* showing a knight and a horse straddling the angle.

73. Corner between Walls 1 and 4 of the *Sala del Pisanello* showing a rock straddling the angle.

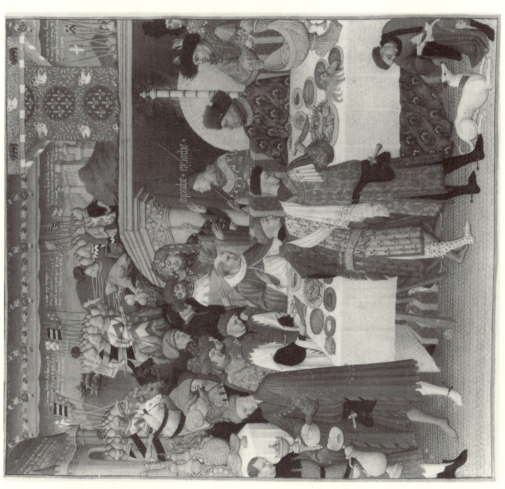

74. Limbourg Brothers, *January*, miniature from the *Très Riches Heures* of the Duke of Berry. Chantilly, Musée Condé, f. 1 v (detail).

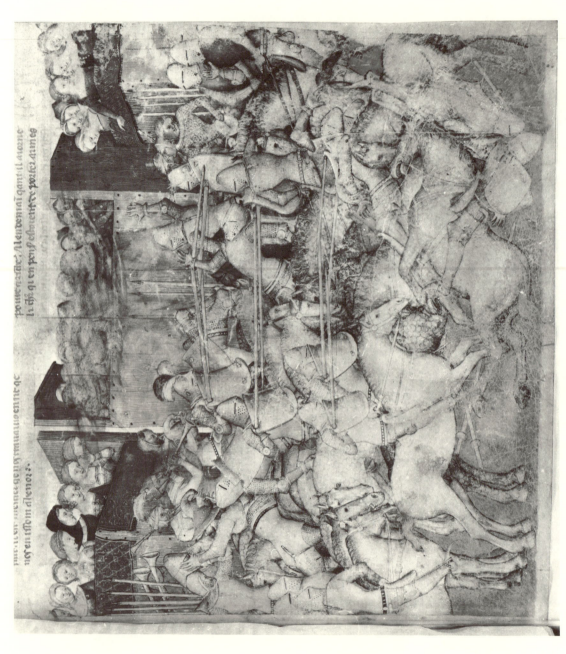

75. Jousting with lances, from the manuscript *Guiron le Courtois*. Lombard, ca. 1400. Bibliothèque Nationale, Paris, Ms. N.A. fr. 5243, f. 55.

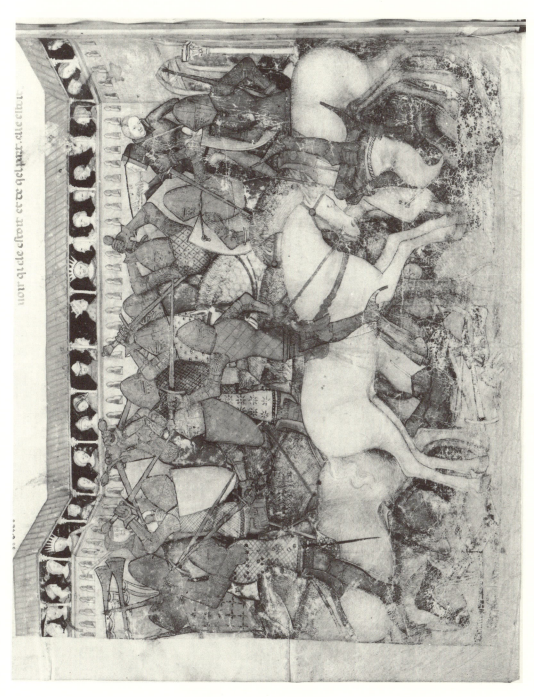

76. *Grande mêlée* from the manuscript *La Queste del Saint Graal*. Lombard, ca. 1400. Bibliothèque Nationale, Paris, Ms. fr. 343, f. 4v.

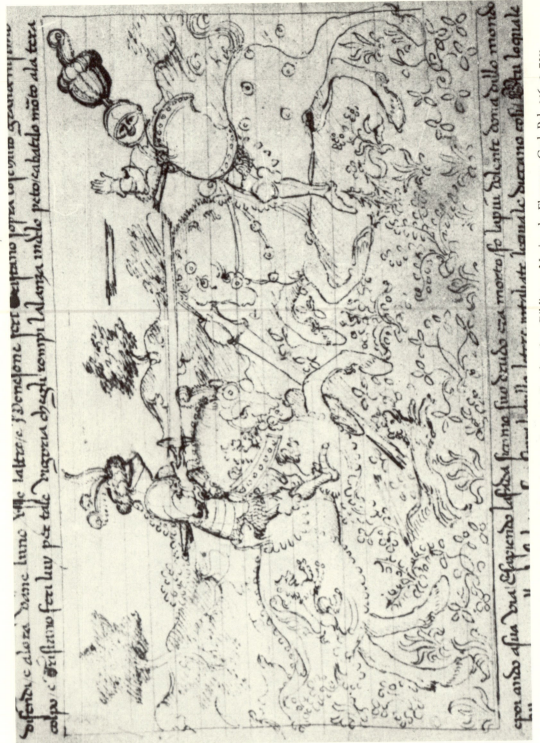

77. Bonifacio Bembo, joust from the *Tavola Ritonda*, 1446. Pen drawing. Biblioteca Nazionale, Florence, Cod. Pal. 556, c. 71v.

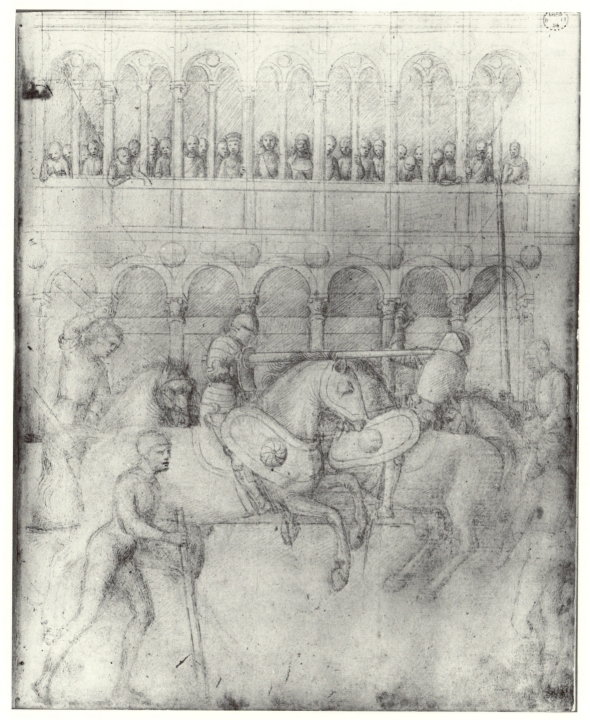

78. Jacopo Bellini, *Joust*. Drawing, mid-15th century. British Museum, London, inv. 1855–8–11, f. 54.

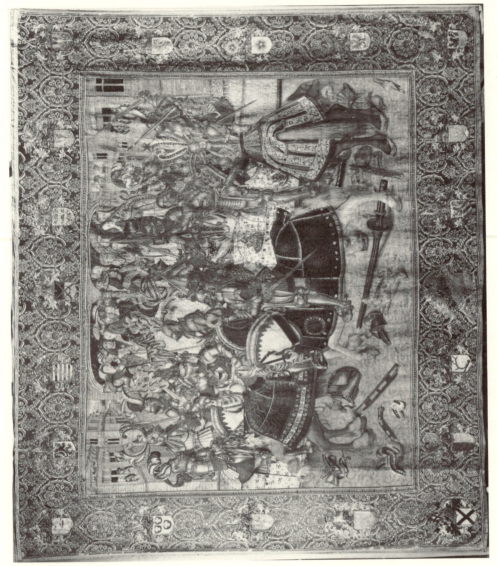

79. Tapestry showing a tournament. Flemish, late 15th century. Musée des Beaux-Arts, Valenciennes.

80. Tournament frescoed in Nicolaus Vintler's *turnyr camer*, ca. 1390, showing Vintler winning against Albert of Habsburg and Henry of Rothenburg. The frieze shows the coats of arms of the seven Imperial electors. Castelroncolo, near Bolzano.

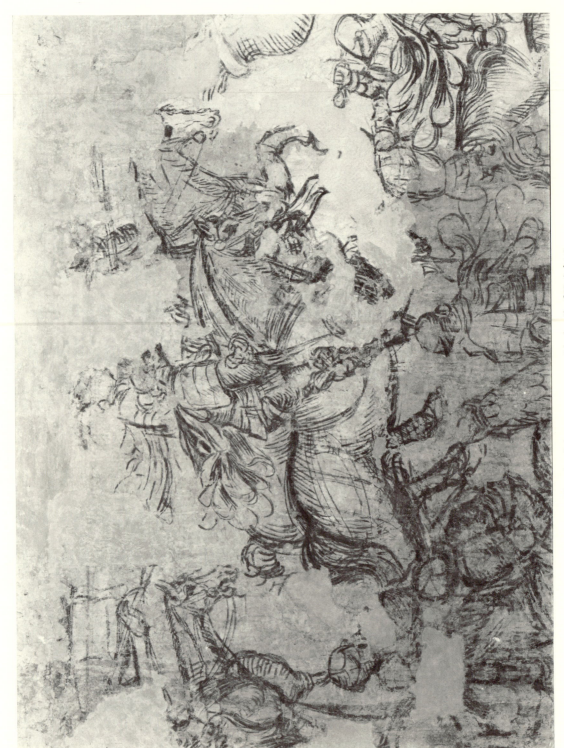

81. *Sinopia* of the tournament with detail of Knight 8.

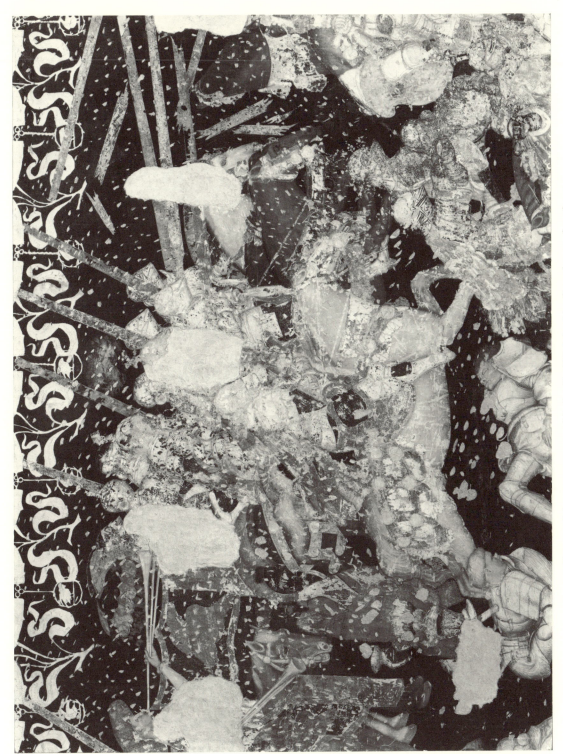

82. Fresco of the tournament with detail of Knight 8 leading the cavalry charge.

83. *Sinopia* of the tournament with detail of Knight 23 in center.

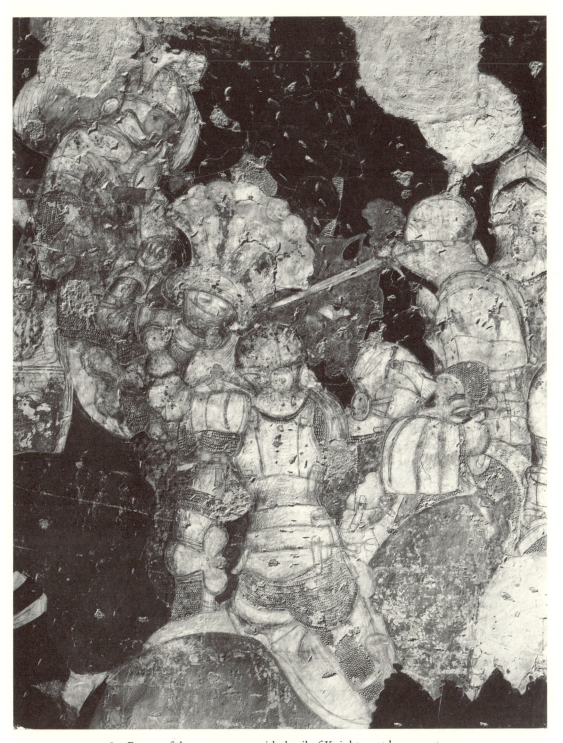

84. Fresco of the tournament with detail of Knight 23 at lower center.

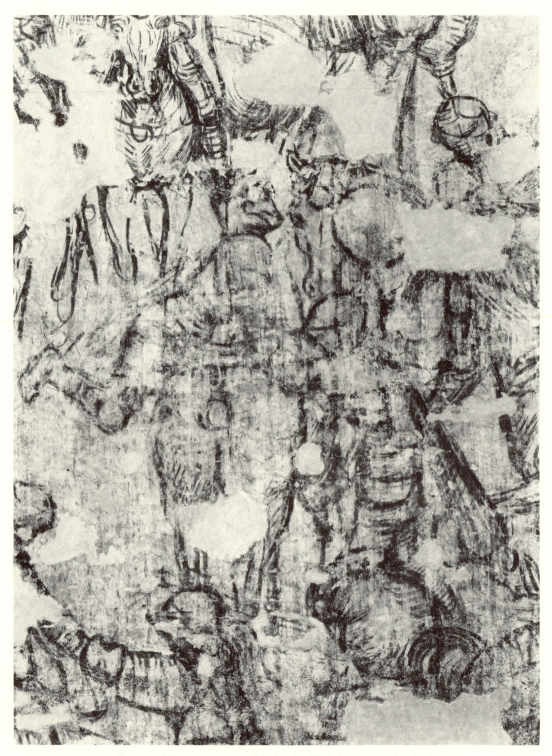

85. *Sinopia* of the tournament with detail of Knight 3 mounting his horse.

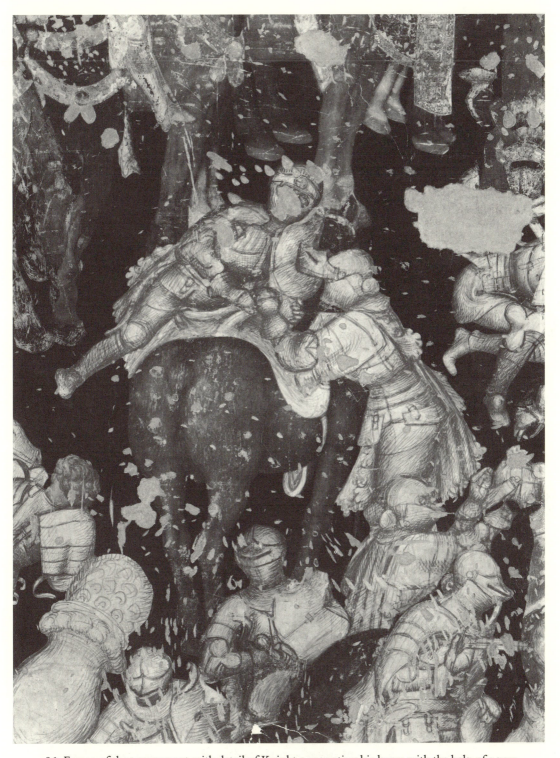

86. Fresco of the tournament with detail of Knight 3 mounting his horse with the help of a peer.

87. *Sinopia* on Wall 2 with detail of three maidens in the tribune.

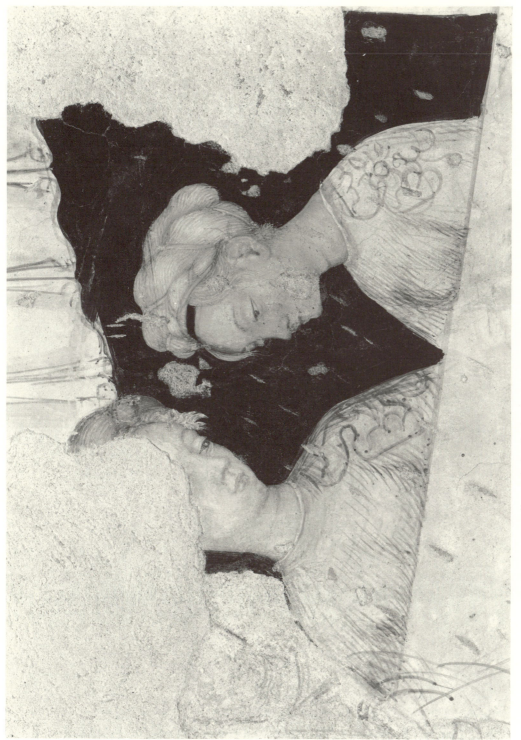

88. Fresco on Wall 2 with detail of two maidens in the tribune watching the tournament.

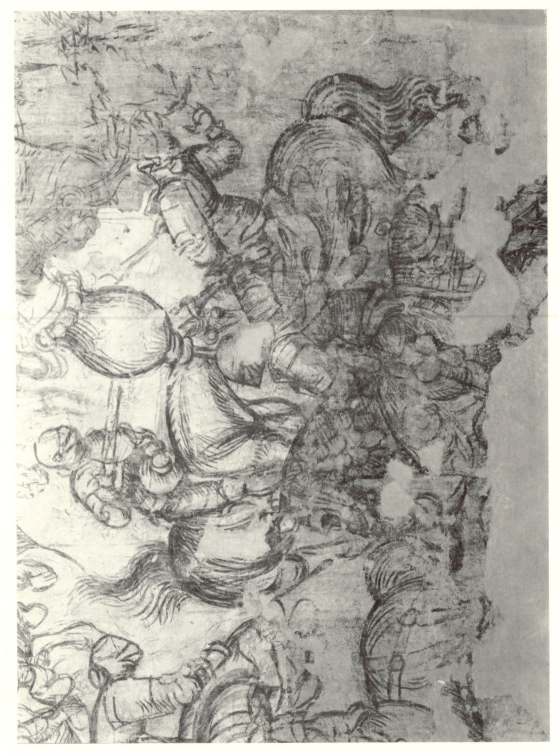

89. *Sinopia* of the tournament with detail of Knights 15, 17, and 21.

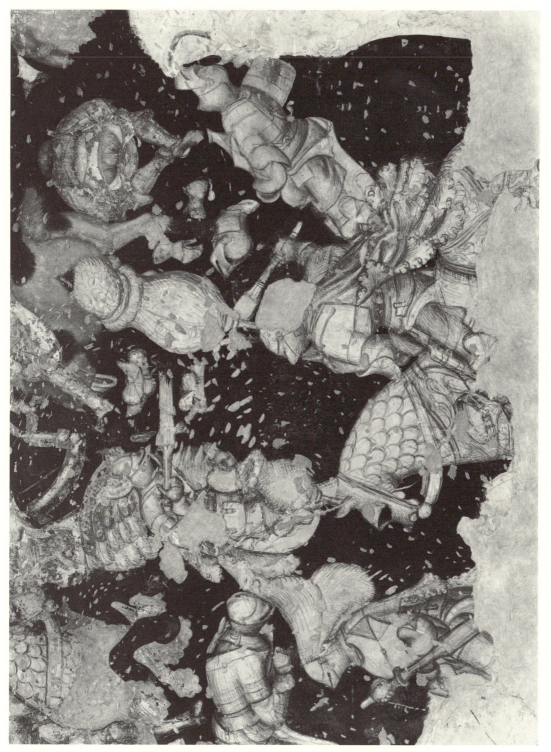

90. Fresco of the tournament with detail of the joust between Knights 15 and 21. Below, Knight 17 brandishes his mace.

91. Joust from a manuscript of *La Queste del Saint Graal*. Lombard, ca. 1400. Bibliothèque Nationale, Paris, Ms. fr. 343, f. 83v.

92. Joust from a manuscript of *La Queste del Saint Graal*. Lombard, ca. 1400. Bibliothèque Nationale, Paris, Ms. fr. 343, f. 36.

93. Second *sinopia* of the tournament showing scheme E (lower left of the tournament).

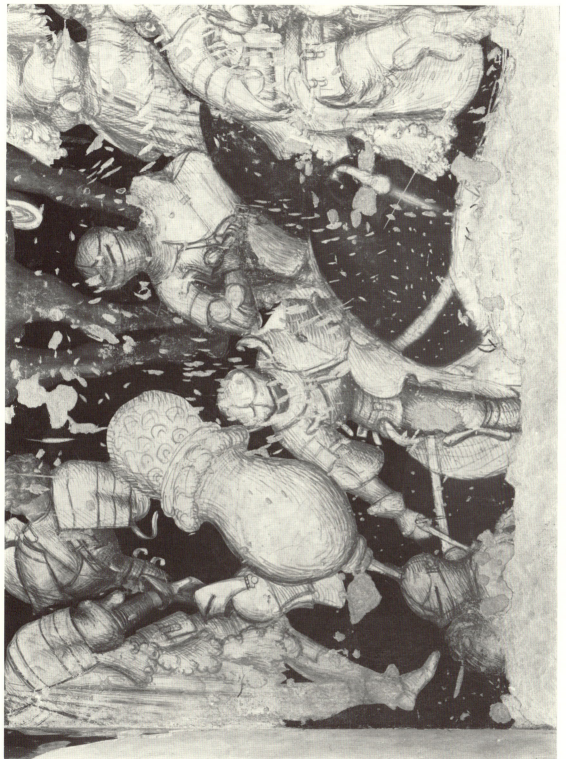

94. Fresco of the tournament with detail of area at lower left with Knight 2.

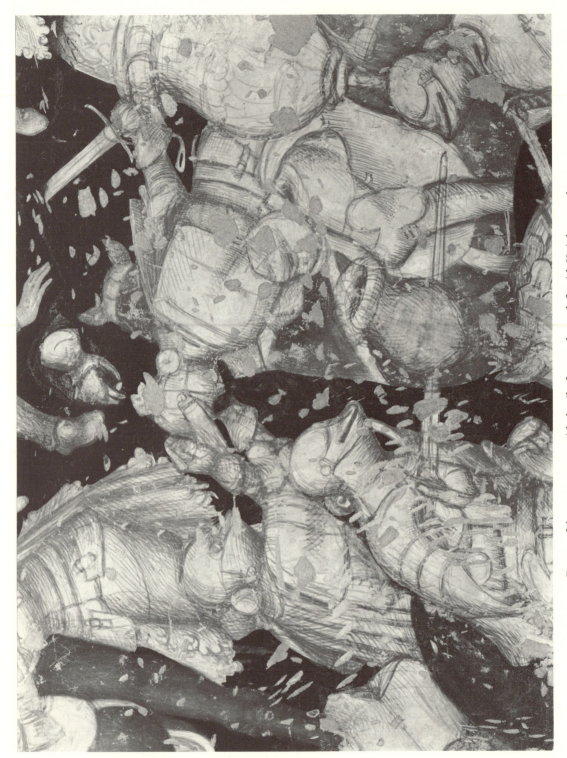

95. Fresco of the tournament with detail of area at lower left with Knights 4 and 5a.

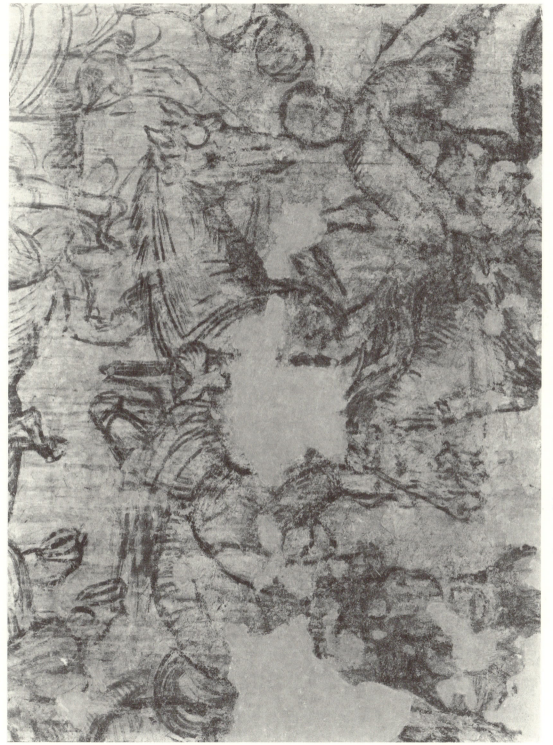

96. *Sinopia* of the tournament showing Knight 5 falling from his horse head first.

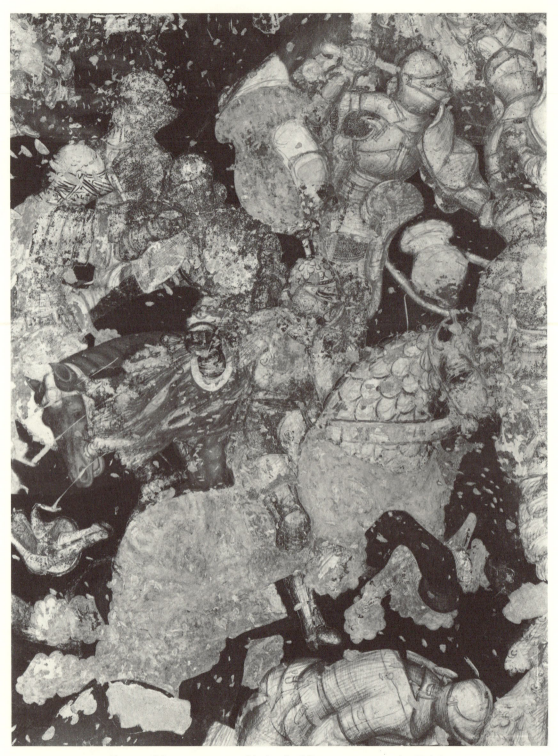

97. Fresco of the tournament with detail of Gonzaga commander Knight 12.

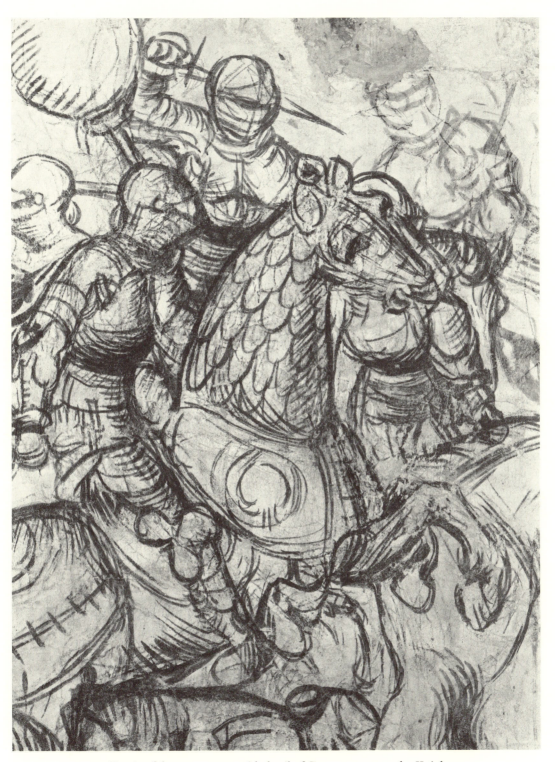

98. *Sinopia* of the tournament with detail of Gonzaga commander Knight 12.

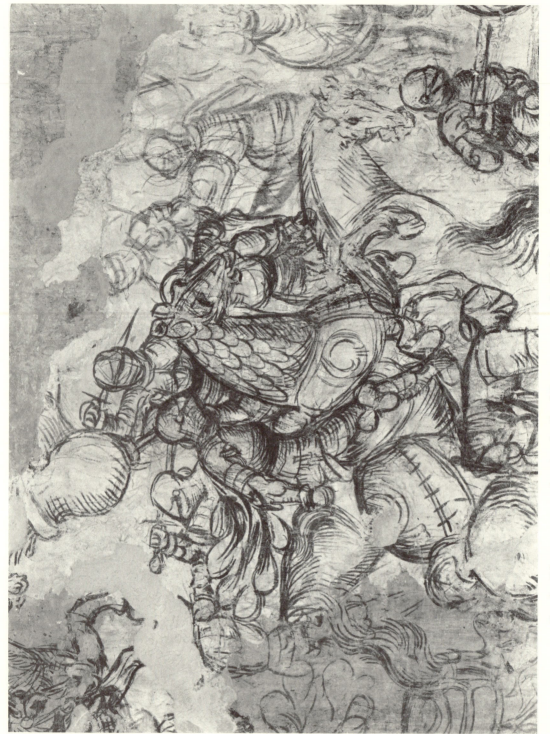

99. *Sinopia* of the tournament showing details of Gonzaga commander Knight 12 and surrounding knights.

100. Fresco of the tournament with detail of Knights 11 and 12.

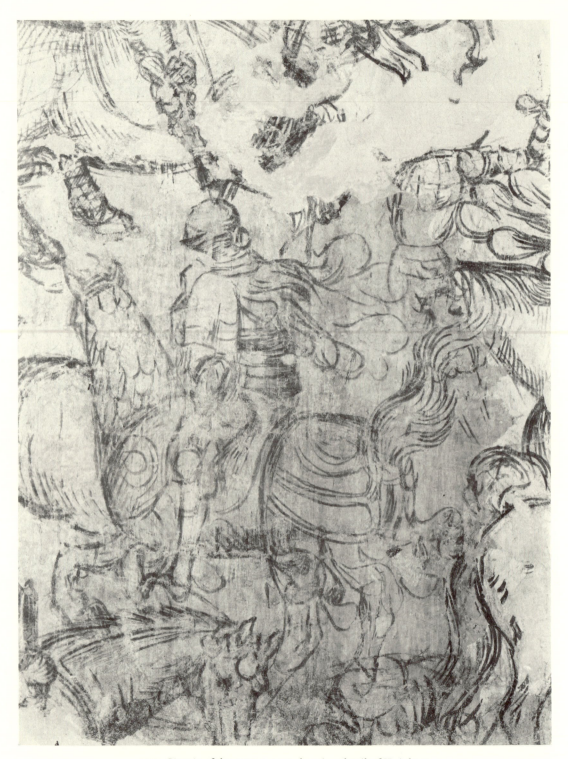

101. *Sinopia* of the tournament showing detail of Knight 7.

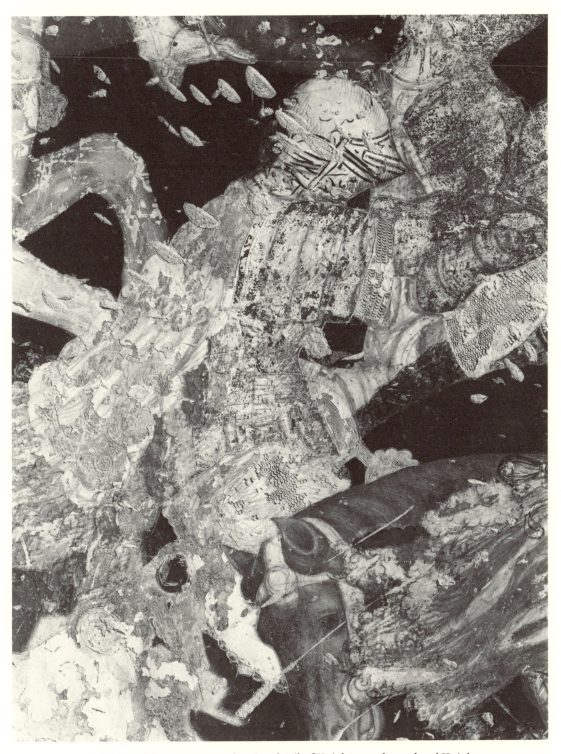

102. Fresco of the tournament showing detail of Knight 11, who replaced Knight 7.

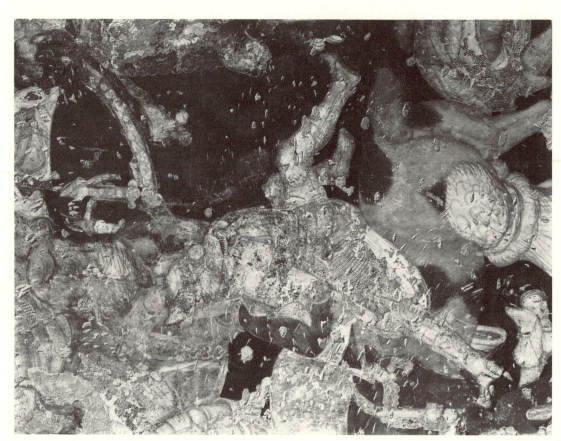

103. Fresco of the tournament with detail of Knight 18.

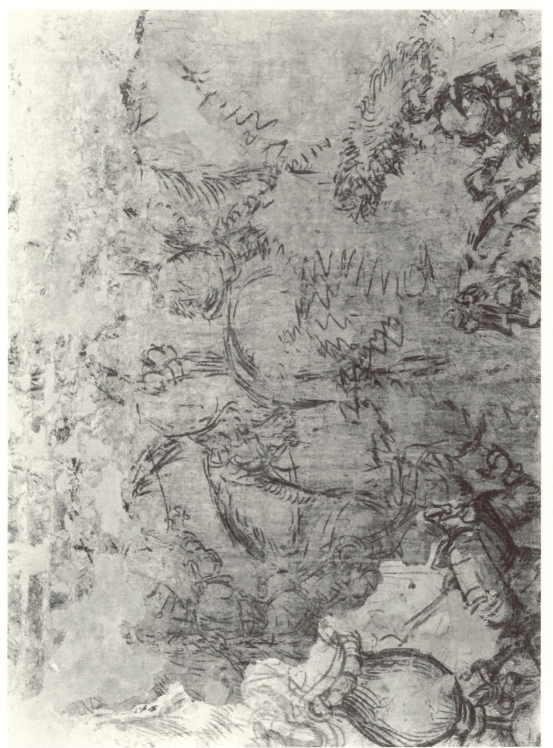

104. *Sinopia* of the tournament with details of Knights 22 and 23.

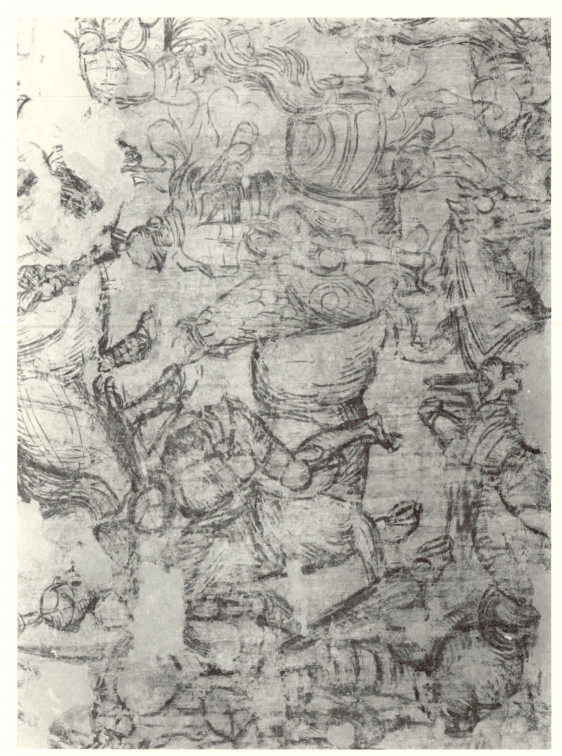

105. *Sinopia* of the tournament with details of galloping Knights 6 and 7.

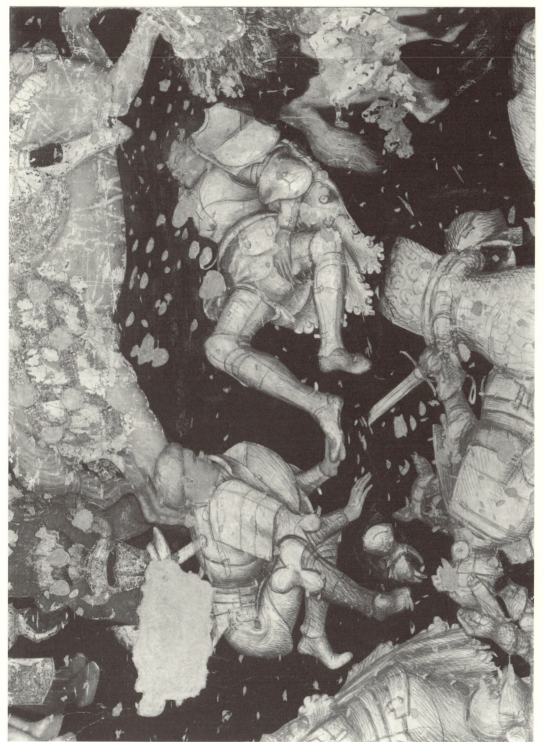

106. Fresco of the tournament with details of fallen Knights 6a and 7a, who replaced equestrian Knights 6 and 7.

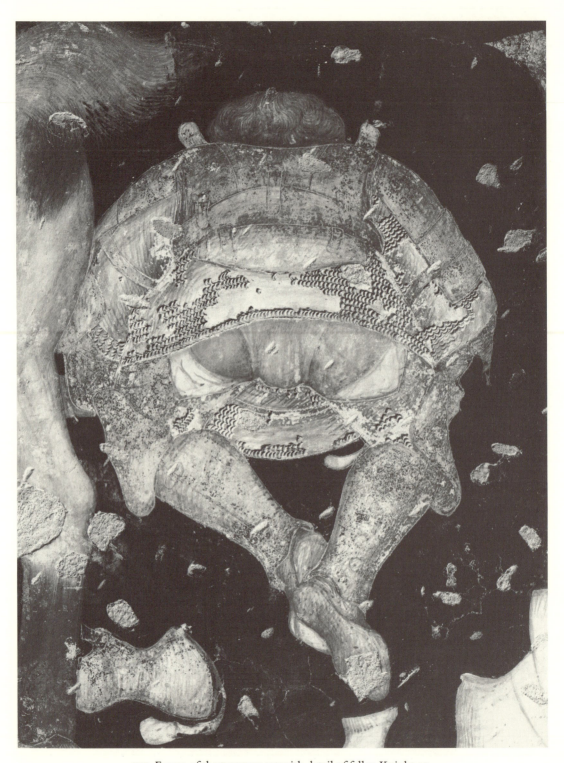

107. Fresco of the tournament with detail of fallen Knight 20.

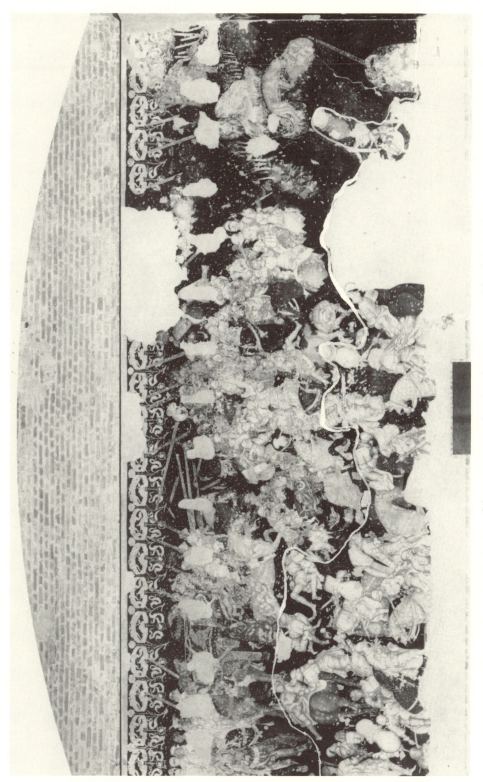

108. Fresco of the tournament showing the two stages of finish on Wall 1.

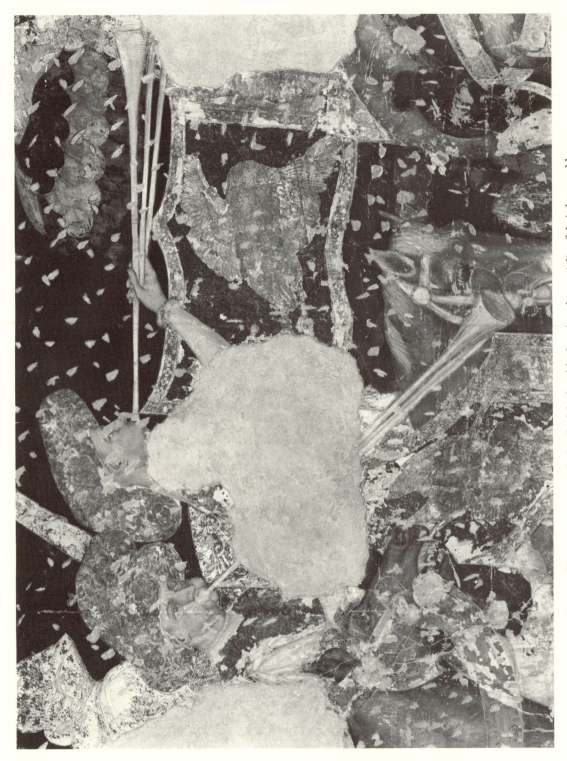

109. Fresco of the tournament with detail of the heralds showing the *pastiglia* of their hats and banners.

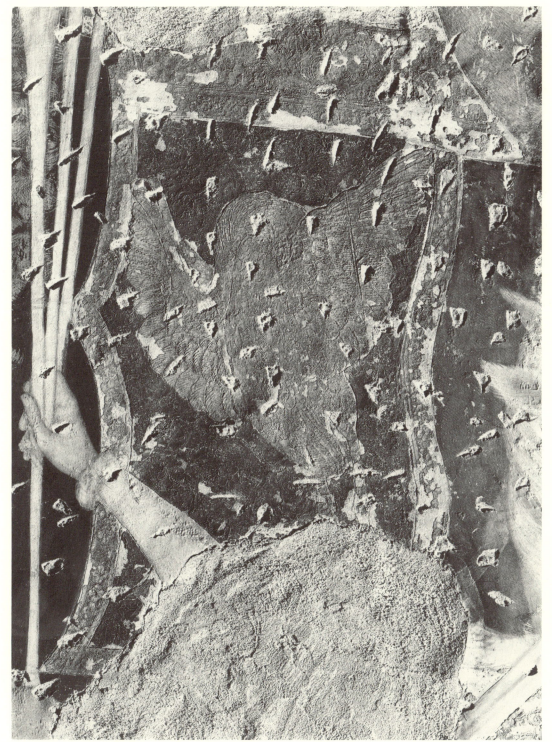

110. Close-up of the *pastiglia* of a herald's banner.

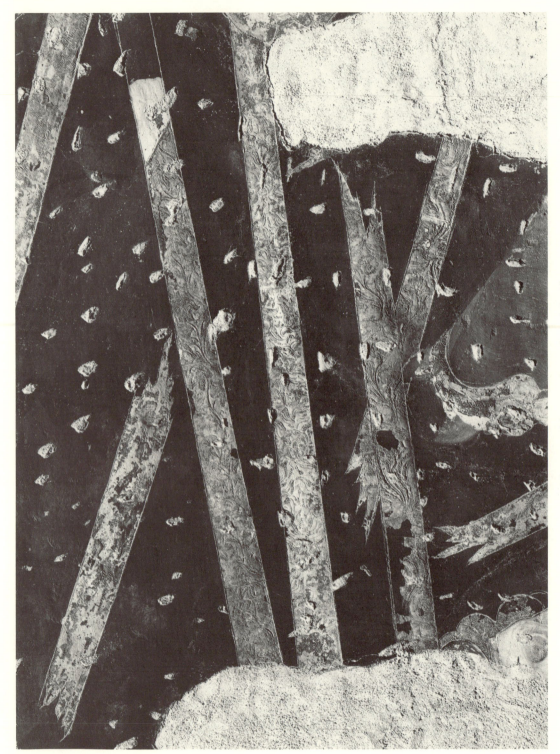

111. Close-up of the *pastiglia* on the knights' lances.

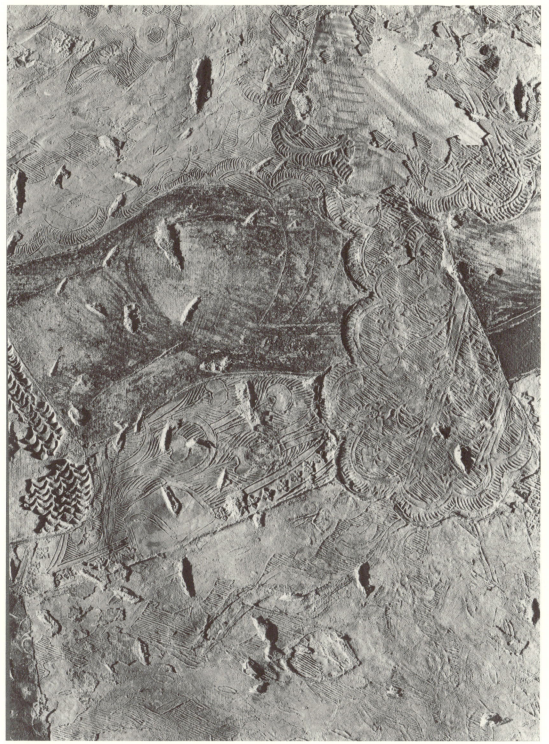

112. Close-up of the *pastiglia* on the caparison of Knight 12's horse.

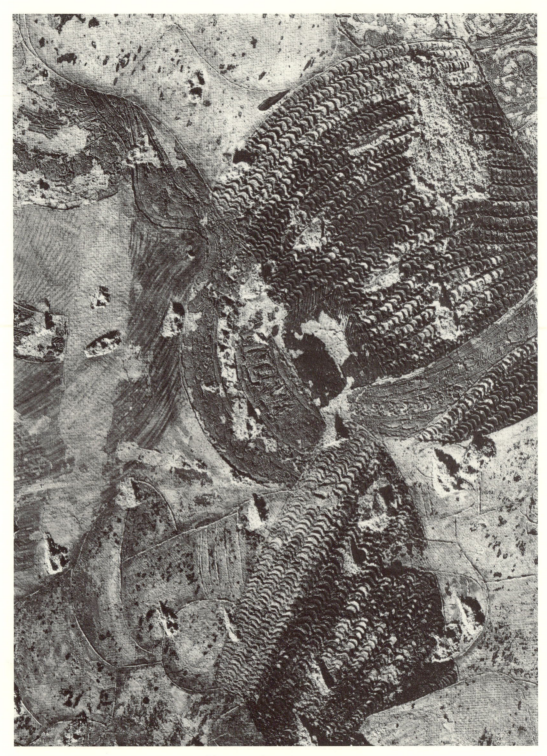

113. Close-up of Knight 8's chain mail.

114. Pisanello, drawing of brocaded textile. Pen and wash, ca. 1448–49. Cabinet des Dessins, Musée du Louvre, inv. 2533.

115. Close-up of the caparison of Knight 11's horse.

116. Close-up of the caparison of Knight 12's horse.

117. Close-up of the helmet of a knight on Wall 2.

118. Fresco of the tournament showing Knights 9, 12, 13, and 14.

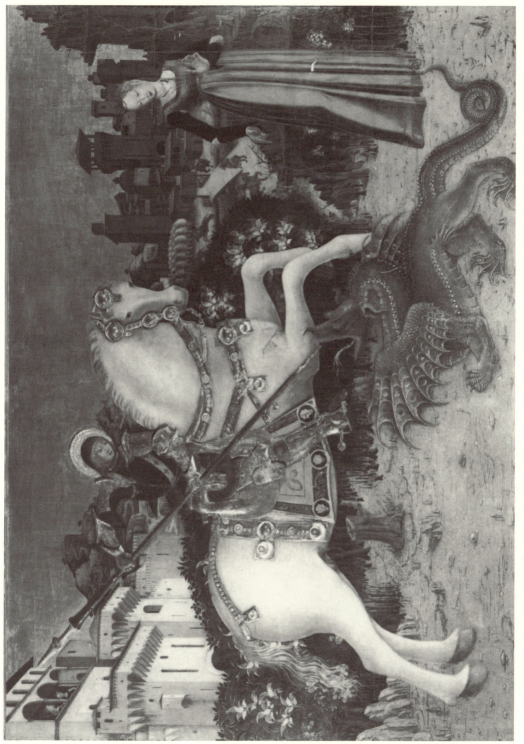

119. *St. George and the Dragon.* Brescia, ca. 1450–70. Oil on panel. Coll.: Pinacoteca Tosio Martinengo, Brescia.

120. Zavattari Brothers, details of the cycle frescoed in the Chapel of Teodolinda, Monza Cathedral, 1444.

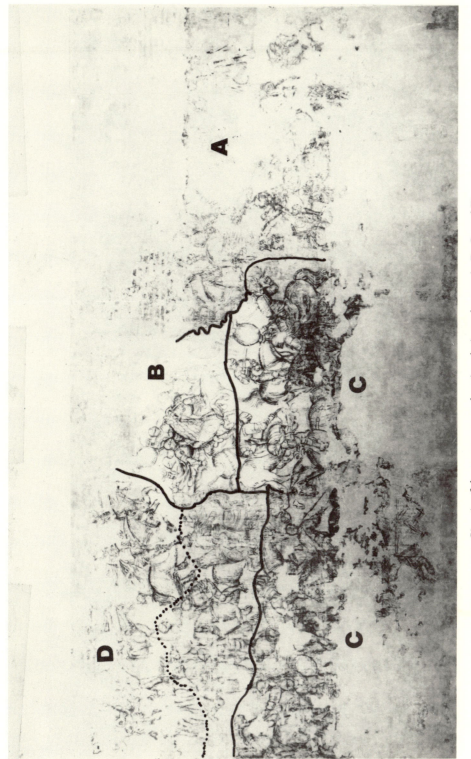

121. *Sinopia* of the tournament showing design schemes A, B, C, and D.

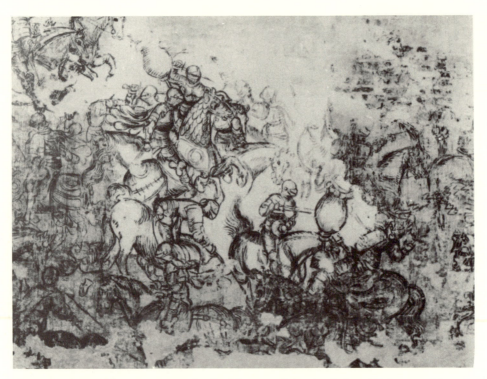

122. *Sinopia* of the tournament: detail of the second *sinopia* of scheme B (center of the tournament).

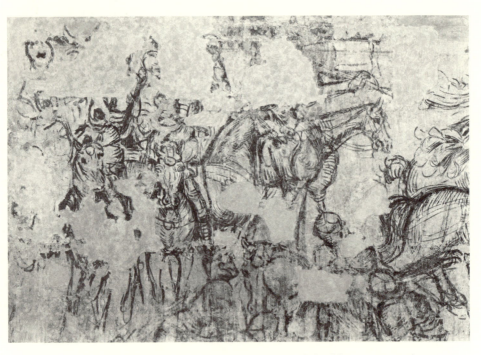

123. *Sinopia* of the tournament: scheme D (upper left of the tournament).

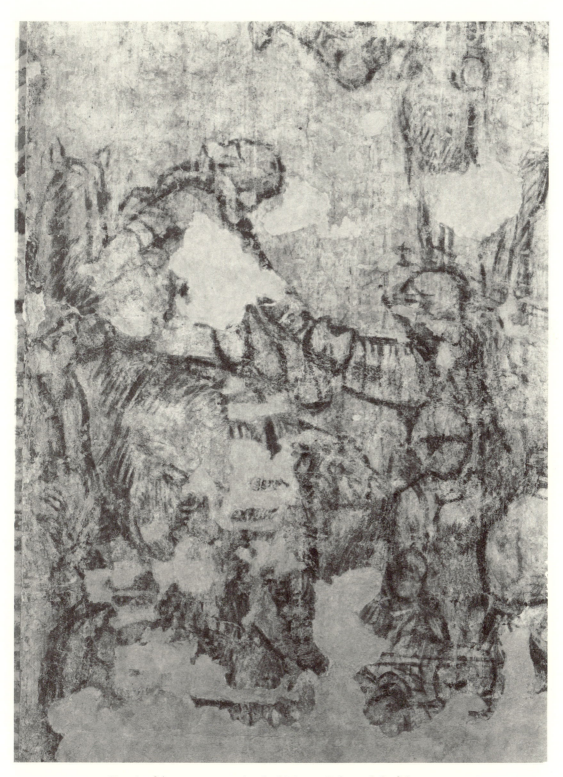

124. *Sinopia* of the tournament: detail of Scheme C (lower left of the tournament).

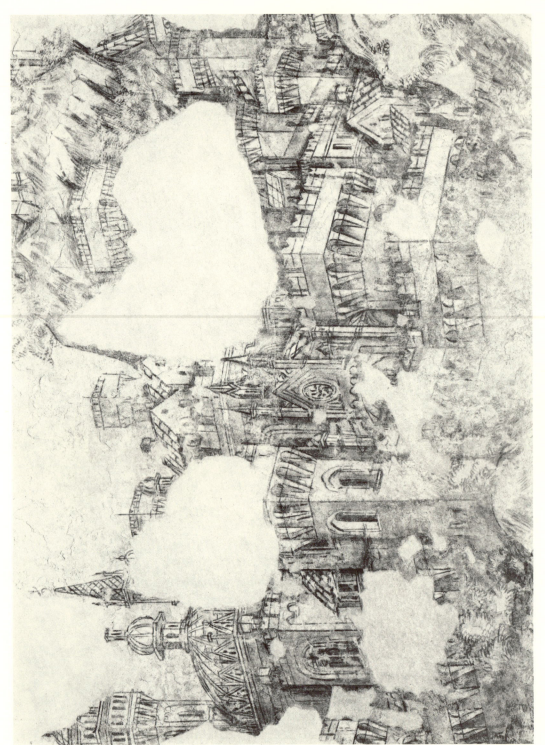

125. *Sinopia* on Wall 2 showing detail of a town.

126. Fresco of the tournament with detail of Knight 17 brandishing his wooden mace.

127. Pisanello, sketches of motifs for a painting including the emblem of *cane alano*. Pen drawing, 1440s. Cabinet des Dessins, Musée du Louvre, inv. 2277

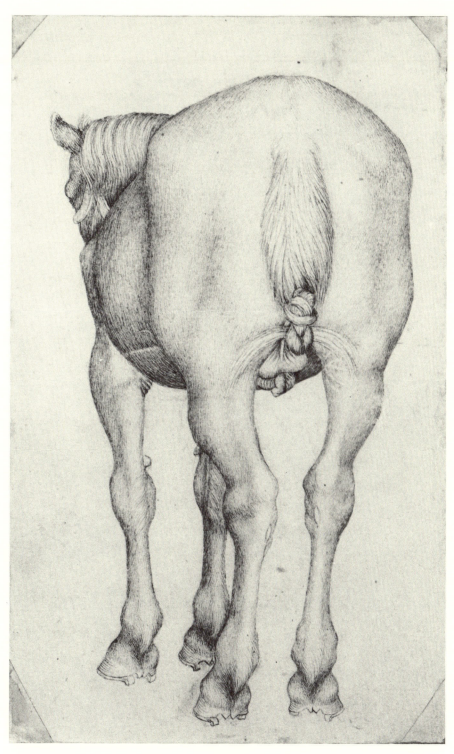

128. Pisanello, drawing of horse in foreshortening seen from the rear. Pen. Cabinet des Dessins, Musée du Louvre, inv. 2444.

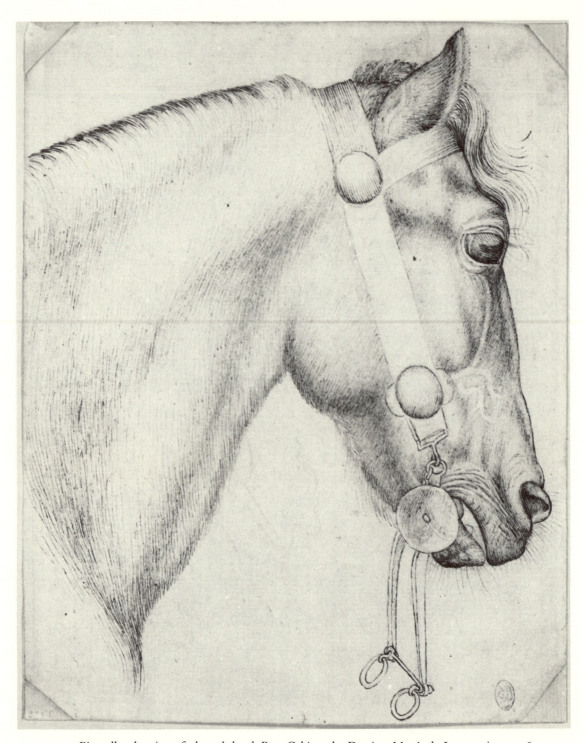

129. Pisanello, drawing of a horse's head. Pen. Cabinet des Dessins, Musée du Louvre, inv. 2358.

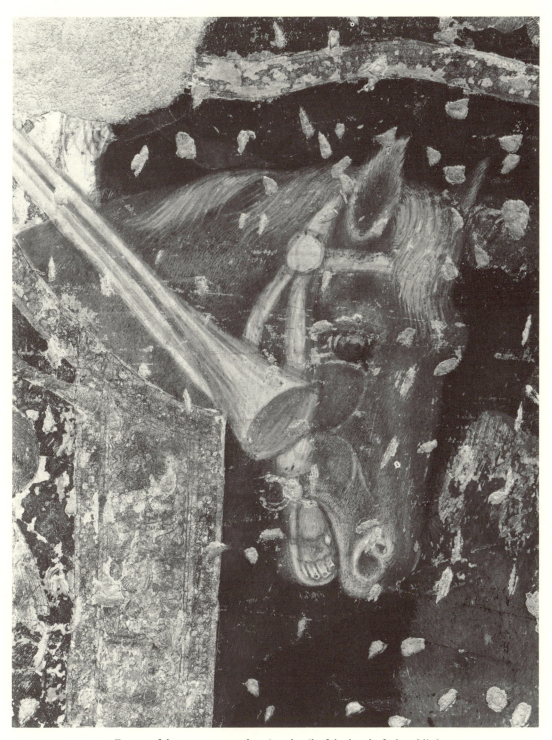

130. Fresco of the tournament showing detail of the head of a herald's horse.

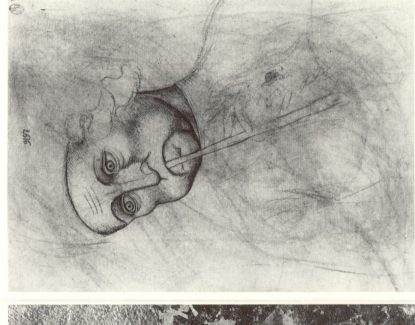

132. School of Pisanello, drawing of a piper's head.
Pen and chalk. Cabinet des Dessins,
Musée du Louvre, inv. 2616v.

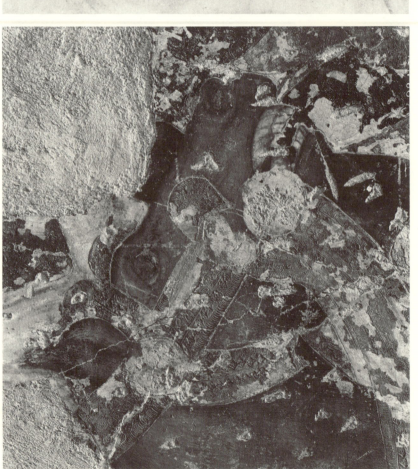

131. Fresco of the tournament with detail of horse's head.

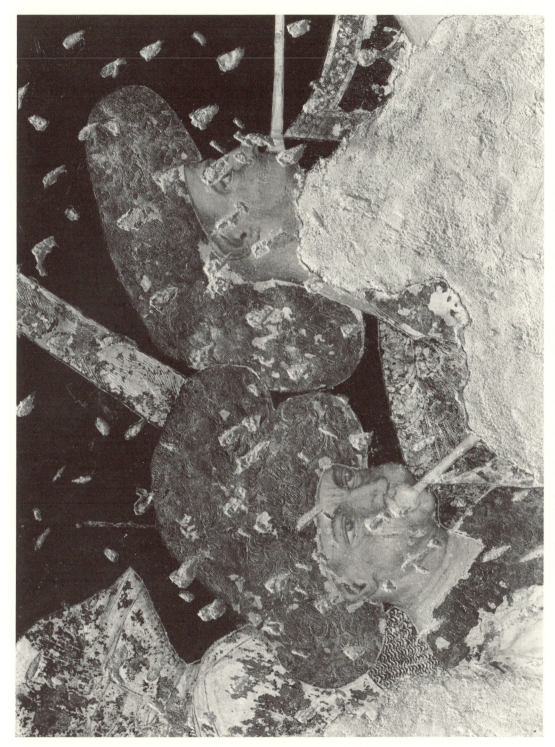

133. Fresco of the tournament with detail of the heralds' faces and *pastiglia* hats.

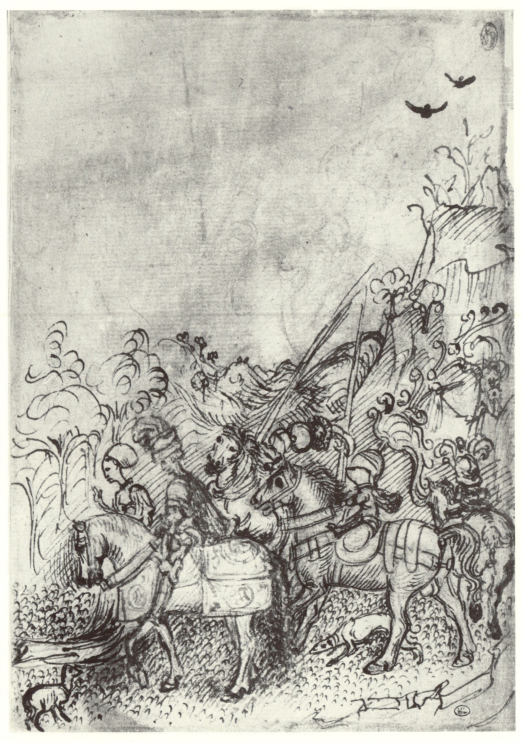

134. Pisanello, sketch of equestrian knight accompanied by a lady on foot and followed by three dwarfs. Pen, 1440s. Cabinet des Dessins, Musée du Louvre, inv. 2595r.

135. Fresco of the tournament with detail of Knight 1's horse.

136. Fresco on Wall 2 showing detail of a redheaded youth in profile talking to two knights.

137. Fresco of the tournament with detail of the knights taken prisoner (upper right of tournament).

138. *Sinopia* of the tournament showing detail of three dwarfs following Knight 24.

139. Fresco of the tournament with detail of Dwarf 26 peering around his steed's neck.

140. Fresco of the tournament showing the *grande mêlée*.

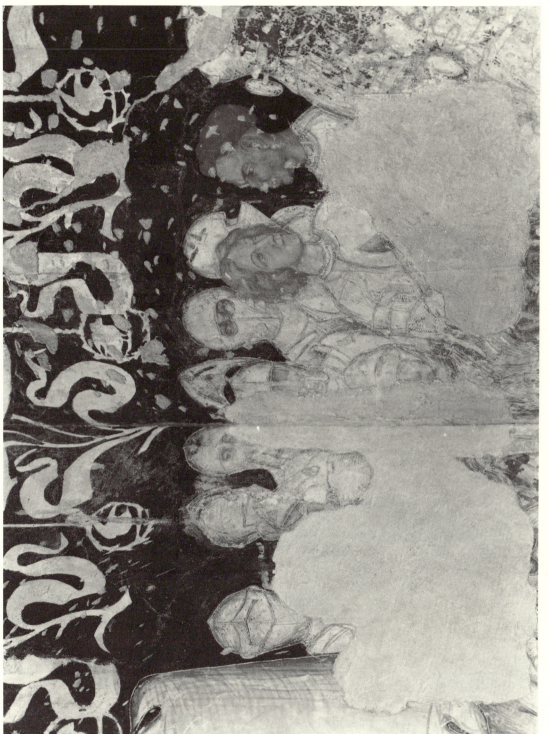

141. Fresco of the tournament with close-up of knights at the corner between Walls 1 and 2.